THE AG

WATTEAU

CHARDIN

AND FRAGONARD

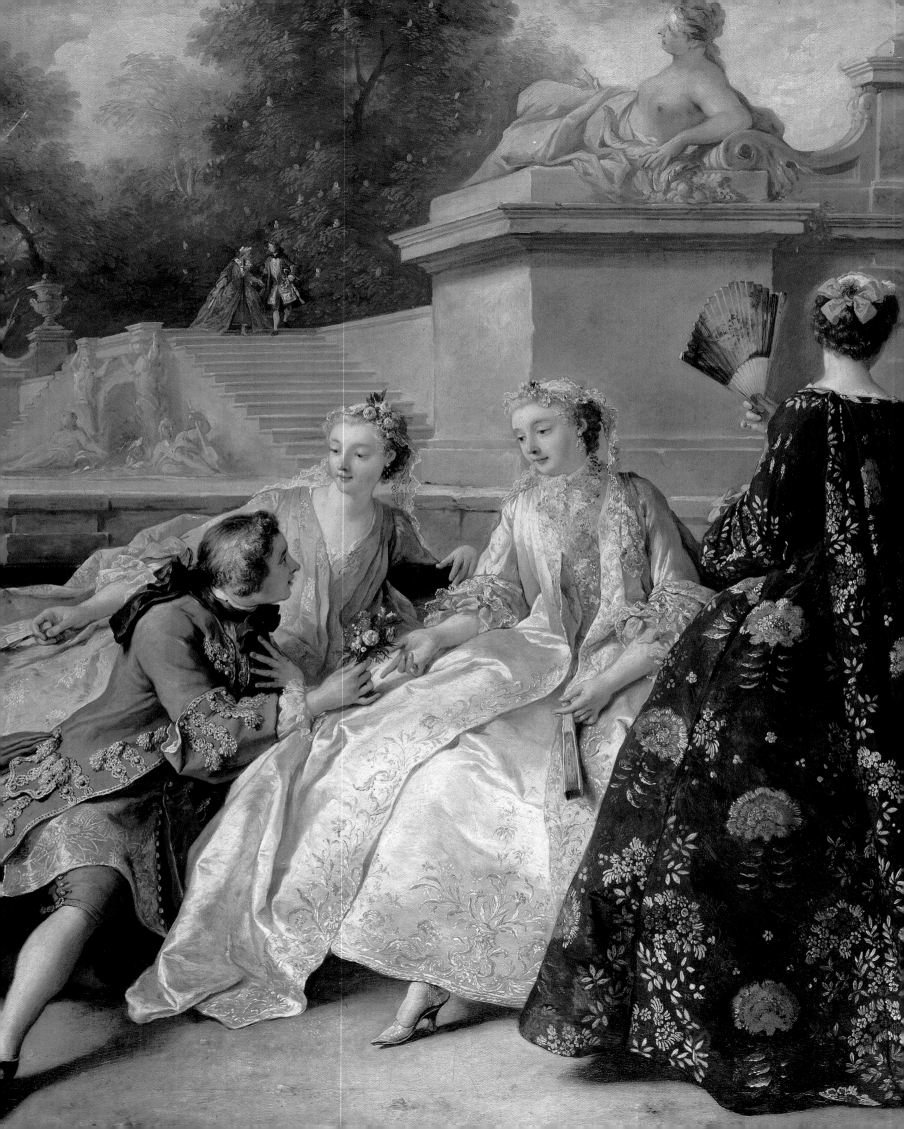

THE AGE OF WATTEAU CHARDIN AND FRAGONARD

MASTERPIECES OF FRENCH GENRE PAINTING

COLIN B. BAILEY

PHILIP CONISBEE

THOMAS W. GAEHTGENS

EDITED BY COLIN B. BAILEY

YALE UNIVERSITY PRESS, NEW HAVEN AND LONDON

IN ASSOCIATION WITH THE

NATIONAL GALLERY OF CANADA, OTTAWA, 2003

Published in conjunction with the exhibition *The Age of Watteau, Chardin, and Fragonard: Masterpieces of French Genre Painting,* co-organized by the National Gallery of Canada, Ottawa, the National Gallery of Art, Washington, D.C., and the Staatliche Museen zu Berlin, Gemäldegalerie.

ITINERARY
National Gallery of Canada, Ottawa
6 June – 7 September 2003

National Gallery of Art, Washington, D.C.
12 October 2003 – 11 January 2004

Staatliche Museen zu Berlin, Gemäldegalerie
8 February – 9 May 2004

Published by Yale University Press, New Haven and London, in association with the National Gallery of Canada

NATIONAL GALLERY OF CANADA
Chief, Publications Division: Serge Thériault
Editors: Lynda Muir and Denise Sirois
Picture Editor: Colleen Evans
Assistant Picture Editor: Anne Youldon

YALE UNIVERSITY PRESS
Design and production: Gillian Malpass
Editorial assistant: Sandy Chapman
Index: Margaret Binns
Typeset in Adobe Garamond by SNP Best-Set, Hong Kong
Colour separations by Evergreen Colour Separation (International), Hong Kong
Printed and bound by C. S. Graphics, Singapore

Library of Congress Cataloging-in-Publication Data

The age of Watteau, Chardin, and Fragonard : masterpieces of French genre painting / edited by Colin B. Bailey.
 p. cm.
Exhibition catalog.
Includes index.
 ISBN 0-88884-767-X (pbk: alk. paper)
 ISBN 0-300-09946-0 (cl: alk. paper)
 1. Genre painting, French–18th century–Exhibitions. I. Bailey, Colin B.
ND1452.F84 A44 2003
754′.0944′0747468–dc21

2003000024

FRONT COVER: Chardin, *The House of Cards*, c. 1737 (detail; cat. 35)
BACK COVER: Watteau, *Venetian Pleasures*, c. 1718–19 (detail; cat. 9)
FRONTISPIECE: De Troy, *The Declaration of Love*, 1731 (detail; cat. 26)

Contents

Lenders to the Exhibition

Public Collections

CANADA
Montreal, The Montreal Museum of Fine Arts
Ottawa, National Gallery of Canada

FRANCE
Aix-en-Provence, Musée Granet
Lyon, Musée des Beaux-Arts
Montpellier, Musée Fabre
Paris
 Musée Carnavalet–Histoire de Paris
 Musée de la Chasse et de la Nature
 Musée Jacquemart-André
 Musée du Louvre
Perpignan, Musée Hyacinthe-Rigaud
Roanne, Musée des Beaux-Arts et
 d'Archéologie J. Déchelette
Rouen, Musée des Beaux-Arts
Saint-Étienne, Musée d'Art Moderne
Saint-Jean-Cap-Ferrat, Fondation Ephrussi-
 de-Rothschild, Académie des Beaux-Arts

GERMANY
Berlin
 Staatliche Museen zu Berlin, Gemäldegalerie
 Stiftung Preussische Schlösser und Gärten
 Berlin-Brandenburg,
 Charlottenbourg Palace
 Neues Palais, Potsdam
 Sanssouci Palace, Potsdam
Karlsruhe, Staatliche Kunsthalle
Munich, Bayerische Staatsgemälde-
 sammlungen, Alte Pinakothek
Schwerin, Staatliches Museum

GREAT BRITAIN
Birmingham, The Barber Institute of Fine Arts
Cambridge, The Fitzwilliam Museum
Edinburgh, National Gallery of Scotland
London
 The Dulwich Picture Gallery
 Her Majesty Queen Elizabeth II
 The National Gallery
 The Victoria and Albert Museum

THE NETHERLANDS
Rotterdam, Museum Boijmans Van Beuningen

RUSSIA
Saint Petersburg, The State Hermitage
 Museum

SPAIN
Madrid, Museo Thyssen-Bornemisza

SWEDEN
Stockholm, Nationalmuseum

SWITZERLAND
Lausanne, Musée Cantonal des Beaux-Arts

UNITED STATES
Boston, The Museum of Fine Arts
Cambridge, Massachusetts, Fogg Art Museum
Champaign, Illinois, Krannert Art Museum
 and Kinkead Pavilion
Chicago, The Art Institute of Chicago
Detroit, The Detroit Institute of Arts
Fort Worth, Texas, Kimbell Art Museum
Hartford, Connecticut, Wadsworth
 Atheneum Museum of Art
Los Angeles, The J. Paul Getty Museum
New York
 The Frick Collection
 The Metropolitan Museum of Art
Norfolk, Virginia, Chrysler Museum of Art
Richmond, Virginia Museum of Fine Arts
Saint Louis, Missouri, The Saint Louis Art
 Museum
Toledo, Ohio, Toledo Museum of Art
Washington, D.C.
 The Corcoran Gallery of Art
 National Gallery of Art
Williamstown, Massachusetts, Sterling and
 Francine Clark Art Institute
Worcester, Massachusetts, Worcester Art
 Museum

Private Collectors and Galleries

Anonymous lenders
Galerie Didier Aaron, Paris
Martin L. Cohen, M.D., and Sharleen Cooper
 Cohen
The Michael L. Rosenberg Collection, Dallas,
 Texas
Maurice Segoura, Paris

Directors' Foreword

The Age of Watteau, Chardin, and Fragonard: Masterpieces of French Genre Painting brings together an outstanding selection of paintings whose subjects of daily life, both real and imagined, provide a constantly changing mirror of Parisian society at many levels during the Ancien Régime. This exhibition – co-organized by the National Gallery of Canada, Ottawa; the National Gallery of Art, Washington; and the Gemäldegalerie of the Staatliche Museen zu Berlin – marks the first such collaboration for these institutions. The exhibition was first proposed by Colin B. Bailey, formerly Deputy Director and Chief Curator at the National Gallery of Canada, and Philip Conisbee, Senior Curator of European Paintings at the National Gallery of Art. Dr. Bailey (now Chief Curator of The Frick Collection, New York) and Mr. Conisbee jointly undertook the lengthy and often arduous negotiation of loans for this exhibition, and are responsible for its presentation in Ottawa and Washington, respectively. In 1999, the Gemäldegalerie became a third partner, under the curatorial leadership of Dr. Thomas W. Gaehtgens, Director, Deutsches Forum für Kunstgeschichte, Paris, and Professor at the Freie Universität Berlin, who has drawn upon an exceptional body of recent German scholarship and research in French eighteenth-century art.

We would like to extend our sincere gratitude to these three accomplished *dix-huitièmistes* whose passionate engagement with the period is clearly the reason for the success of this exhibition. They were assisted in the preparation of the catalogue by a team of sixteen scholars who have jointly contributed a most authorative, thoroughly documented, and beautifully illustrated account of genre painting, co-published with Yale University Press. The catalogue adds enormously to our understanding of this rich period of French art and will stand as the definitive source for the study of eighteenth-century genre painting for many years to come.

We have been overwhelmed by the immense generosity and enthusiastic response of the lenders. It is thanks to them that this exhibition has grown to be so comprehensive in the range of artists and subject matter represented. We also would like to express our sincere gratitude to those who have helped make this exhibition financially possible, including the Florence Gould Foundation in Washington. The Department of Canadian Heritage has provided assistance for the Ottawa venue through the Canada Travelling Exhibitions Indemnification Program.

In this exhibition, such distinctive artistic personalities as Watteau, Chardin, Boucher, Greuze, and Fragonard have been assembled under a unifying theme, allowing us to discover fresh, thought-provoking relationships among them. We are confident that this unprecedented assembly of paintings will contribute to a new awareness and expansive view of the importance of genre painting to the development of French painting in the eighteenth century.

Pierre Théberge, o.c., c.q.
Director
National Gallery of Canada

Earl A. Powell III
Director
National Gallery of Art

Jan Kelch
Director
Gemäldegalerie, Staatliche Museen zu Berlin

Curators' Preface and Acknowledgements

Despite the lowly position ascribed to genre painting by the Academy during the eighteenth century, subjects from everyday life engaged some of the most original and gifted artists of the Ancien Régime. The vitality of the lesser genres has often been remarked upon by historians, who have sometimes argued that the more exalted categories of narrative painting – subjects from mythology, the Bible, and national history – failed to inspire members of the Academy to produce a body of work that was equally compelling and of such consistently high quality. Since all painters who pursued their calling as a liberal art were either trained by the Academy or obliged to gain admittance to it, we are faced with the paradox that academic precepts and instruction may have succeeded best in the categories that were accorded the least recognition in the hierarchical value system so vigorously promoted in the eighteenth century.

While artists such as Watteau, Oudry, Chardin, and Fragonard were highly esteemed in their own day and are among the most beloved and recognized in ours (Greuze's critical fortunes, then and now, have been more shaky), their achievements have been considered almost exclusively in monographic terms, both in art-historical literature and in exhibitions. Artists whose careers were made primarily as history painters, but who also produced masterpieces of genre painting – the most important of whom was Boucher, but this category would also include Jean-François de Troy, Carle Van Loo, and Noel Hallé – have rarely been situated within this wider context. And it is only very recently that artists who worked exclusively as genre painters, from Lancret at the beginning of the century to Boilly at the end, have received serious scholarly re-appraisal.

With the exception of David, every eighteenth-century figure painter of any stature produced genre works at some point in his career: either on commission from private collectors, for exhibition at the Salon, or as part of decorative schemes that allowed him to tackle the larger formats generally reserved for history painters. Watteau's amorous and nostalgic *fêtes galantes*; de Troy's ardent, yet cynical *tableaux de mode*; Boucher's lyrical pastorals; Chardin's dignified "little pieces of common life"; Greuze's hot-house family dramas; Fragonard's multi-faceted dangerous liaisons; Boilly's immaculately polished domestic interiors: an exhibition devoted to genre painting will thus chart the development and transformations within an art form that functioned, at one level, as a constantly changing mirror of Parisian social life and culture.

Many thanks go to our colleagues who contributed essays and entries to this catalogue: John Collins, Jörg Ebeling, Anik Fournier, Barbara Gaehtgens, Frances Gage, Margaret Morgan Grasselli, Christophe Leribault, Rainer Michaelis, Marianne Roland Michel, Martin Schieder, Katie Scott, Helge Siefert, Susan Siegfried, Christoph Martin Vogtherr, Nicole Willk-Brocard, and Alan Wintermute. For their untiring efforts in preparing the catalogue material for publication, we would like to thank Serge Thériault, chief of Publications; the English editor, Lynda Muir, and French editor, Denise Sirois; as well as Colleen Evans, picture editor, and her assistant, Anne Youldon. Gillian Malpass of Yale University Press has provided an attractive catalogue design.

Our gratitude goes also to the many people who have offered valuable information and advice in matters both curatorial and scholarly, and who have facilitated the loan of crucial works: Hervé Aaron, Claude d'Anthenaise, Mathilde Arnoux, Alexander

Babin, Kristin Bahre, Joseph Baillio, Isabelle Bardiès, Emma Barker, Jean-Luc Baroni, Reinhold Baumstark, Graham W.J. Beal, Jacques Beauffet, Brent R. Benjamin, Roger M. Berkowitz, Kornelia von Berswordt-Wallrabe, Jan Blanc, Brigitte Bouret, Michael Brand, Michael Clarke, Timothy Clifford, Guy Cogeval, Michael Conforti, Michael Cormack, Denis Coutagne, Laura Coyle, James Cuno, Jean-Pierre Cuzin, Alain Daguerre de Hureaux, Michel David-Weill, Béatrice Debrabandère-Decamps, Chris Dercon, Ekaterina Deriabina, Céline Deruelle, Alice Dugdale, Everett Fahy, Benjamine Fiévet, Alexandre Gady, Bénédicte Gady, Florence Getreau, Hans-Joachim Giersberg, Maria Gordon-Smith, Gerhard Graulich, Gabriele Diana Grawe, Deborah Gribbon, Torsten Gunnarson, Nicholas Hall, Jefferson Harrison, Joseph Helfenstein, William J. Hennessey, Christophe Henry, Michel Hilaire, Mary Tavener Holmes, Margaret Iacono, David Jaffé, Catherine Johnston, Nicolas Joly, Mark Jones, Isabelle Julia, Eik Kahng, Rachel Kaminsky, George Keyes, Alastair Laing, Ulrich Leben, Mark Ledbury, Catherine Lepdor, Jean-Marc Léri, David C. Levy, Tomás Llorens, Christopher Lloyd, Henri Loyrette, Dietmar Lüdke, Emmanuel Marty de Cambiaire, Christian Michel, Philippe de Montebello, Edgar Munhall, Janie Munro, Mikhail Piotrovsky, Joachim Pissarro, Vincent Pomarède, Timothy Potts, Richard Rand, Duncan Robinson, Malcolm Rogers, Pierre Rosenberg, Samuel Sachs II, Marie-Catherine Sahut, Nicolas Sainte Fare Garnot, Xavier Salmon, Laurent Salomé, Charles Saumarez Smith, Scott Schaefer, Silke Schmickl, Klaus Schrenk, David Scrase, Kate M. Sellers, George Shackelford, Elena Sharnova, Desmond Shawe-Taylor, Joanna Sheers, Paul Spencer-Longhurst, Marie-Claude Valaison, Richard Verdi, Anthony Vershoyle, James A. Welu, Guy Wildenstein, Humphrey Wine, James N. Wood, Eric Zafran, Jörg Zutter.

At the National Gallery of Canada, we would like to thank Daniel Amadei, director of Exhibitions and Installations, and Karen Colby-Stothart, chief of Exhibitions; Christine La Salle and Christine Dufresne, project managers; Ellen Treciokas, senior designer; Anne Ruggles, conservator; Louise Filiatrault, chief of Education and Public Programmes; Joanne Charette, director of Public Affairs; Delphine Bishop, chief of Collections Management; Caroline Ishii, chief of Marketing; Monique Baker-Wishart, exhibition interpretation manager; David Monkhouse, education officer; Irene Lillico, publications coordinator; and others who have contributed to the preparation of the catalogue including Douglas Campbell, Danielle Chaput, Julie Desgagné, Jacques Pichette, and Didi Pollock.

At the National Gallery of Art, we would like to thank D. Dodge Thompson, chief of exhibitions; Naomi Remes, exhibition officer; Abbie Sprague and Tamara Wilson, Department of Exhibitions; Susan Arensberg, head of Exhibition Programs; Mark Leithauser, chief of Design; Donna Kirk, design coordinator; Bill Bowser, production coordinator; Judy Metro, editor-in-chief; Melissa Stegeman, registrar of exhibitions; Michael Pierce, conservator; Isabelle Raval, assistant general counsel; Missy Muellich, Development Office; Deborah Ziska, press and public information officer; and Michelle Bird, assistant in the Department of French Paintings.

At the Staatliche Museen zu Berlin, we would like to thank Peter-Klaus Schuster, general director; Gisela Helmkampf, chief conservator at the Gemäldegalerie; Hartmut Dorgerloh, general director of the Stiftung Preussische Schlösser und Gärten Berlin-Brandenburg; and Bärbel Jackisch, chief conservator of the Berlin-Brandenburg Castles at Potsdam.

Colin B. Bailey
Philip Conisbee
Thomas W. Gaehtgens

Surveying Genre in Eighteenth-Century French Painting

COLIN B. BAILEY

*Au nom de Dieu et de la bonne peinture, supprimez à jamais
ce mot genre.*
 – [Renou], *Dialogues sur la peinture* (1773), p. 53

*Ces genres qu'ils appellent petits, et qui ne le sont que quand
ils sont traités petitement.*
 – Cochin, *Essai sur la Vie de Chardin* (1780), p. 428

"Peintre dans un talent particulier" (Lancret, Octavien);[1] "peintre dans le talent des animaux et des fruits" (Chardin);[2] "peintre dans le talent particulier comme Téniers et Wauvermanns [*sic*]" (Bonaventure de Bar);[3] "peintre dans le talent particulier des fêtes galantes" (Pater);[4] "peintre de genre particulier" (Greuze, Jeaurat de Bertry);[5] "peintre dans le genre des figures vêtues à la moderne" (Favray);[6] "peintre dans le genre des vues et paysages ornés de figures" (Leprince);[7] "peintre dans le genre des sujets familiers" (Wille); "peintre dans le même genre des sujets populaires" (Théaulon);[8] "peintre en petit dans le genre des Flamands" (Debucourt).[9]

As the above listing would suggest, throughout the eighteenth century the Académie royale de peinture et de sculpture availed itself of a wide and somewhat cumbersome repertory of terms for the genre painter – first defined (in English) in 1873 as one who practises "a style of painting which depicts scenes and subjects of common life."[10] Only three artists would be designated by the Academy as "genre painters": Michel-Barthélemy Ollivier (1712–1784), Peintre du Prince de Conti, who was directed to paint a *Death of Cleopatra* as his reception piece in February 1766 (hardly a genre subject);[11] Marc-Antoine Bilcoq (1755–1838), admitted to the Academy in September 1785;[12] and, most notoriously, Jean-Baptiste Greuze (1725–1805), whose admission to full membership in July 1769 stipulated that he had been received as a "peintre de genre."[13]

In place of the designation that has long been part of the art historian's vocabulary, eighteenth-century artists and writers had a battery of terms with which to refer to the painting of everyday life and its practitioners: "peintres de talens,"[14] "peintres à talens,"[15] painters "dans le goût flamand,"[16] painters of "petits sujets galants,"[17] painters of "petits sujets naïfs."[18] By far the most commonly used, however, at least until the 1770s, was that of "painter of *bambochades*" – Watteau and Greuze were both so described, as were the Le Nain brothers, retrospectively[19] – and the word "bambochade" is first defined in Lacombe's *Dictionnaire portatif des beaux-arts* of 1752 as "paintings of gallant or country scenes, fairs, smoke dens, and other cheerful subjects."[20] The reference here was to the *bambo'ciata* of the Haarlem artist Pieter Van Laer (1599– c. 1642), known as "il Bamboccio" (ugly puppet), and his followers: small-scale works showing naturalistically observed scenes of everyday life (and low life) invented in Rome during the middle decades of the seventeenth century.[21]

It is hardly surprising that the term "genre painter" was so little used in the eighteenth century, since "genre painting" as we think of it today did not exist as a discrete category within the Academy's ordering of the arts. André Félibien's hierarchy, first articulated in the preface to his *Conférences* of 1667, remained more or less unchallenged throughout the Ancien Régime.[22] In asserting the liberal (or intellectual) nature of the artist's profession over its mechanical (or manual) aspects,

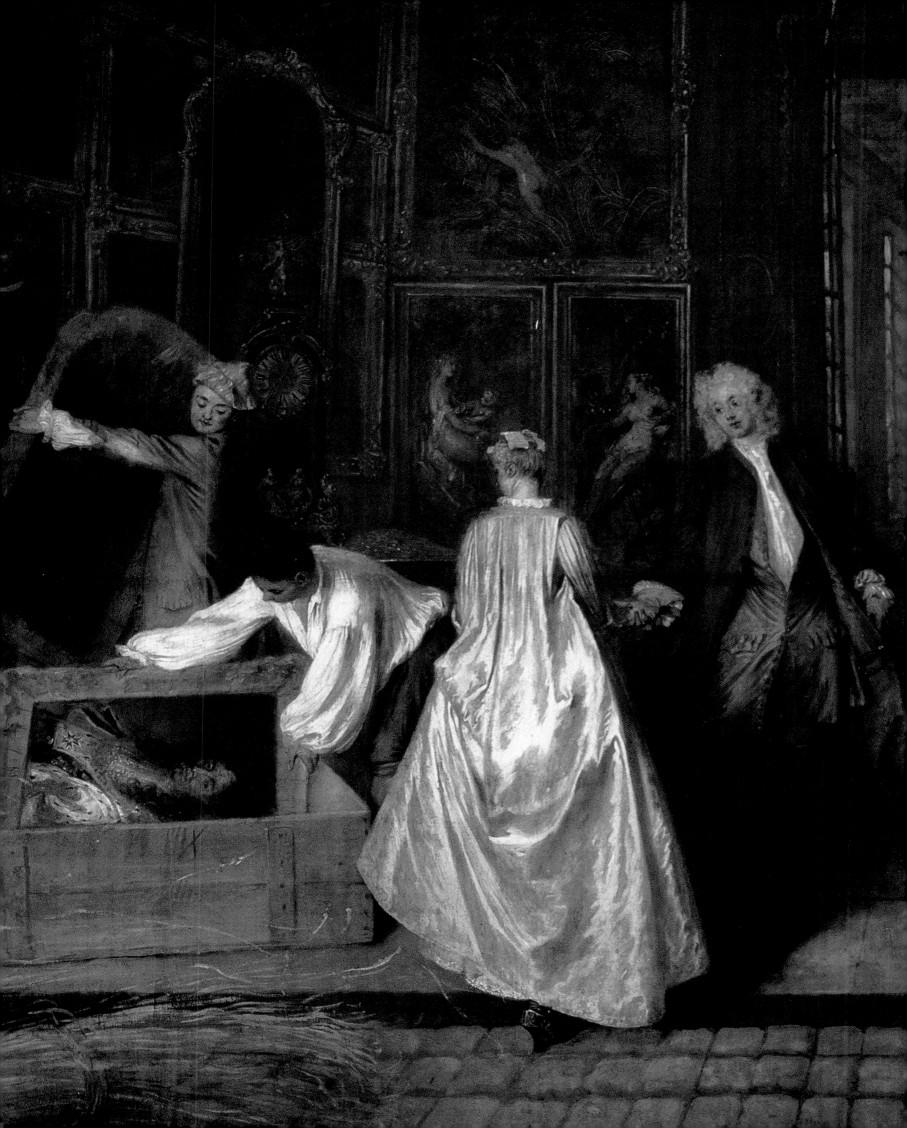

Félibien gave pride of place to history painting, which required that the artist invent compositions originating in his imagination and "which one can know without being a painter,"[23] while recognizing the legitimacy of the subordinate genres of portraiture, landscape, and still-life. Thus:

> He who paints landscapes perfectly is above the artist who paints only fruits, flowers, or shells. He who paints living animals is worthy of more esteem than he who only represents things that are dead and no longer moving. And since man himself is God's most perfect work on earth, it is certain that he who imitates God in painting the human figure is far more excellent than all the others. . . . Nonetheless, a painter who only makes portraits has not reached the summit of his art and cannot aspire to the honours that are due the most learned. For those, one must go beyond the single figure to the representation of several figures together: one must treat history and mythology, represent great actions as an historian, or agreeable subjects as a poet.[24]

As has recently been noted, academic doctrine did not as yet conceive of an independent category of figural painting apart from history and portraiture.[25]

Like Félibien, Roger de Piles ignored scenes of everyday life while listing "landscapes, animals, seascapes, fruits, and flowers" as legitimate areas of specialization for the artist who is unable to aspire to history painting, the primacy of which remained absolutely uncontested:[26]

> Painters quite properly use the word "history" to indicate the most significant type of painting which consists in arranging several figures together. And so one says, "this painter does history, this one does animals, another does landscapes, yet another does flowers, and so on and so forth."[27]

Outside the Academy, writers on the fine arts, as well as connoisseurs and critics, reinforced these categories with remarkable consistency. In the first edition of his *Abrégé de la vie des plus fameux peintres*, published between 1745 and 1752, Dezallier d'Argenville discussed the Academy's various categories without mentioning genre painting: "History, it is true, is the most noble object of painting and . . . requires the greatest knowledge; landscape, animals, fruits and flowers are all accessories, which most often serve only to embellish subjects from history."[28] Similarly, Watelet's definition of "genre" in the *Encyclopédie* depended upon the by-now classic distinction between history painting as "invention" and the lesser genres as "imitation." The term "genre" was most properly used for those who are not history painters, and who "restrict themselves to certain objects only, devote themselves to their study, and make it a law to paint nothing else. Thus the artist for whom animals, fruits, flowers, or landscapes constitute the subject of his paintings is called a genre painter."[29]

As might be expected, Diderot provided the most nuanced and provocative discussion of the topic, but when he used the term "genre," he tended to think primarily of still-life painting. Confronted by eight still-lifes by Chardin at the Salon of 1765, six of which were of considerable scale, Diderot ruminated: "The category of painting we call genre is best suited to old men or to those born old: it requires only study and patience, no verve, little genius, scarcely any poetry, much technique and truth, and that is all."[30] Roland de La Porte's still-lifes at the same Salon were referred to as "un Morceau de genre,"[31] and in the *Pensées détachées* of a decade later, Diderot argued that "in genre painting, one must sacrifice everything to the picture's effect," citing Chardin and Van Huysum as his models here.[32]

In Diderot's writing, there is a distinction between "genre painting" (as still-life) and Greuze's multifigured compositions of everyday life which are termed "la peinture morale," and which, like dramatic poetry, succeed "in touching us, instructing us, correcting us, and leading us to virtue" – the traditional function of history painting.[33] But despite his encouragement of Greuze, Chardin, and Vernet, his frustration with Boucher and his "school," and his dissatisfaction with the current state of history painting in general, Diderot was less interested in undermining the hierarchy of the genres than in renewing its primary component. Like critics and commentators of a slightly earlier generation (Caylus, Cochin, La Font de Saint-Yenne), he campaigned for history painting of greater conviction and authenticity. The artist should be a passionate observer of nature, like Greuze, so that he will create works with "the simplicity and truth of Le Sueur."[34]

In the *Essais sur la peinture*, the first installment of which appeared in the *Correspondance littéraire* in August 1766, Diderot came closer to a definition of genre painting consonant with our current usage of the term. Alluding to a mutual antipathy between history painters and the other practitioners, none of whom was prepared "to admit openly the contempt in which they hold each other," Diderot reluctantly accepted the traditional distinction between history painting and the lower genres, while remaining troubled by the breadth of the term "genre": "The appellation 'genre painter' is indiscriminately applied both to painters of flowers, fruits, animals, woods, forests, and mountains, *as well as to those borrowing their scenes from everyday and domestic life*."[35]

This was not the first time that "scenes from everyday and domestic life" had been included as a distinct category within the lower genres. Such a formulation was first made by La Font de Saint-Yenne in 1754, as part of his attack on the degraded canon of mythological subjects which (in his opinion) was ruining the French school. As preamble to his repertory of acceptable subjects from ancient and modern history, La Font de Saint-Yenne allowed that painters might initially consider representing "the simplest and most familiar kinds of human behaviour, either in town or country, pastorals, country

festivals, fairs, village weddings, even scenes from the kitchen, the smoke den, or the stable."[36]

Although La Font de Saint-Yenne did not characterize the above-mentioned subjects as "genre," a similarly expansive definition of the category appeared in the second edition of Dezallier d'Argenville's *Abrégé*, published in 1762. In contrast to his first edition cited above, the author now took a stand (mild though it was) against the overly rigorous *rappel à l'ordre* initiated around mid-century in the first years of Lenormant de Tournehem's ministry.[37] Like La Font de Saint-Yenne, in his description of "genre" he included various "common life" subjects (of the sort we consider the stock-in-trade of genre painting today), even if they were listed as something of an afterthought:

> We are quite opposed to the feeling of certain authors, who, in their esteem for history painters alone, consider as greatly inferior those who paint portraits, landscapes, battles, seascapes, animals, architecture, fruits, flowers, *village weddings, smoke dens, and kitchen scenes.*[38]

"Village weddings, smoke dens, and kitchen scenes": both La Font de Saint-Yenne and Dezallier d'Argenville borrowed these terms from descriptions of seventeenth-century Dutch and Flemish genre painting, the practitioners of which had been criticized in the writings of Félibien and de Piles for their slavish, if unsurpassed, imitation of a brute, unreformed nature (in contrast to "la belle Nature" that the history painter sought to re-create). In the theory of imitation articulated in his *Réflexions critiques*, published in 1719, the abbé Dubos had argued that the object represented in a painting or a poem must be worthy of the viewer's attention and capable of moving him. How could we be attracted by a painting of a villager walking or ploughing, he asked, if the activity itself is so trivial? "Subjects treated by Teniers, Wouwermans, and other such painters could arouse in us only the slightest interest, for there is nothing in a village festival or in the diversions of the guard room that is capable of moving us."[39] French genre painting was damned by association.

For Diderot, the low connotations of genre painting's traditional repertory disinclined him to group the practitioners of "la peinture morale" alongside "specialists in trivial subjects, in little domestic scenes lifted from street corners."[40] And since, for Diderot, Greuze's *Marriage Contract* (cat. 71) and Vernet's seascapes were no less "history paintings" than Poussin's *Seven Sacraments* and Lebrun's *Family of Darius*, he recast the distinction between history and genre as that between the painting of sentient and non-sentient subjects: with history painting now expanding to include the representation of all "intelligent, living nature;" and with genre limited to that of "dead, brute nature."[41]

However, Diderot's initial enthusiasm for Greuze's ill-fated reception piece *Septimius Severus Reproaching Caracalla* (see fig. 41) suggests how deeply committed he remained to classicizing history painting as an ideal – chimerical though this may have been before the appearance of David and other members of d'Angiviller's "youth movement."[42] "Greuze has suddenly (and successfully) made the leap from the *bambochade* to great painting" was Diderot's breathless comment to Falconet after seeing Greuze's initial sketch for the subject in August 1767: note the use of a term that left no doubt as to the status of the artist's earlier "moral paintings."[43] By the time Greuze showed the finished picture itself and suffered the indignity of being received "in the genre of his admission," Diderot no longer sought to revitalize the Academy's categories. "Genre painting," in his definition, remained a term that encompassed *all* the subordinate categories, with scenes from everyday life grudgingly recognized as a distinct component. In explaining the "affaire Greuze" to his foreign readers, Diderot reminded them that the Academy divided its painters into two classes, and that those who were "relegated" to the class of "genre painters" comprised "the painters who confine themselves to imitating base nature and scenes from the country, the city, and domestic life."[44]

Lapidary though this was, it suggests that "scenes from the country, the city, and domestic life" were gradually imposing themselves in public discourse as part of the genre painter's brief.[45] That this type of figure painting assumed tardy recognition by theorists – always more conservative than dealers and journalists – is borne out by Watelet's expanded definition of "genre" for his *Dictionnaire des arts et de peinture*, published in 1792. While adhering to the customary definition of genre painters as landscapists, animal painters, and "painters of flowers and fruits," Watelet now added the category of "those modern artists who take as their subjects the actions or particular scenes of everyday life."[46] Officialdom had yet to catch up even with these faltering articulations. The reformed Statutes of the Academy, registered in September 1777, listed the various categories fostered in that institution as "painting and sculpture of historical subjects, the portrait, landscape, flowers, miniatures, and the other genres of the said arts."[47] It was a formulation with which Félibien and the founding members of the Academy would have felt entirely at home.

PRACTICE

Hesitant terminology, ambivalent definitions, disparaging associations: the eighteenth century's theoretical prevarications stand in marked contrast to the vitality of genre painting itself throughout the century, particularly during the middle decades. If one accepts the Ancien Régime's distinction between history painting and the remaining genres, it can be argued that genre painting – considered in the broadest sense as single, or multifigured compositions of subjects in modern costume –

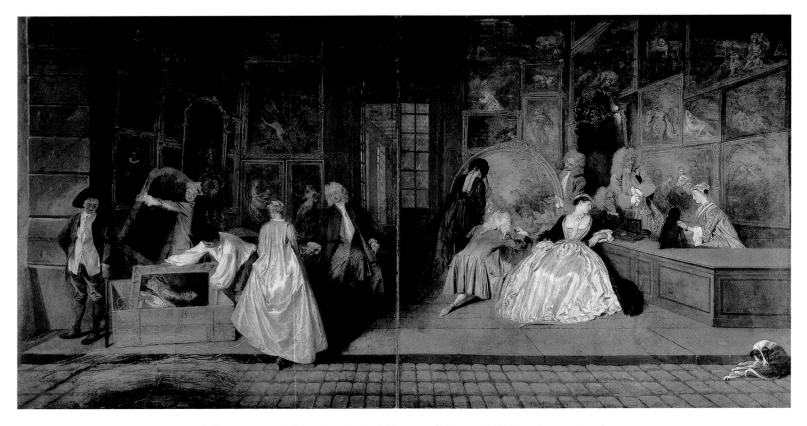

Fig. 1 Jean-Antoine Watteau, *Gersaint's Shopsign*, 1721. Stiftung Preussische Schlösser und Gärten Berlin-Brandenburg, Potsdam

maintained a rich and complex production. Schematic and summary though the following listing is, genre painting in this wide definition can be shown to have engaged successive generations of Academicians: from the military scenes, theatrical subjects, and *fêtes galantes* of Watteau and his followers; the hunt pictures and *tableaux de mode* of de Troy, Oudry, and Lancret; the rustic genre and pastorals pioneered by Boucher; Chardin's "little pieces of domestic life;" exotic genre and fancy dress in Boucher and Van Loo; and Greuze's "moral pictures" and "bourgeois dramas;" to "fishwife subjects" (the *genre poissard*) by Jeaurat and Greuze; panoramas of the Enlightenment in landscapes and townscapes by Vernet and Robert, and in family scenes by Fragonard and "l'école de Greuze;" "paintings for the boudoir" by Fragonard; neo-Dutch cabinet pictures by Fragonard and Marguerite Gérard; and the painting of modern life in Boilly.

Genre painting, then, is not a phenomenon of the last decades of the century, encouraged on the peripheries of the Academy; it is not, generally speaking, a discredited or oppositional form of production; it is not confined in scale, format, or handling; and it is not practised by one type of artist alone.[48] Until the arrival of d'Angiviller as Surintendant des Bâtiments in August 1774 and the ascendancy of the Premier peintre, Pierre (director of the Academy and "chargé du Détail

des Arts" since 1770), most history painters were also genre painters on occasion.[49]

Consider size and finish for example, customarily regarded as two of the defining characteristics of genre painting. For much of the century, size may be said not to matter, since as the subject of tapestries and decorative schemes, genre could aspire to a format and facture commensurate with the most elevated stories from ancient history and the Bible. Watteau's *Shopsign* (fig. 1), painted for his friend and dealer the recently incorporated *marchand mercier* Edme Gersaint,[50] is comparable in scale to Lancret and de Troy's hunt suppers for Fontainebleau (cat. 16),[51] Boucher's early set of village pastorals (cat. 51),[52] or Fragonard's youthful pendants, *Blindman's Buff* (cat. 75) and *The Seesaw* (Museo Thyssen-Bornemisza, Madrid), originally six and a half feet in height.[53] And these examples are dwarfed by tapestries such as Oudry's *Amusements champêtres* and Boucher's *Fêtes italiennes* for the Beauvais manufactory – the latter over thirteen feet in length and nine in height[54] – as well as Fragonard's rejected decorations for the apse-shaped gaming room of Madame Du Barry's new *pavillon* at Louveciennes, ten and a half feet in height and eight in width (fig. 2).[55]

While genre paintings without a decorative purpose were rarely of the scale of the examples cited above, it does not follow that those exhibited at the Salon or painted for the

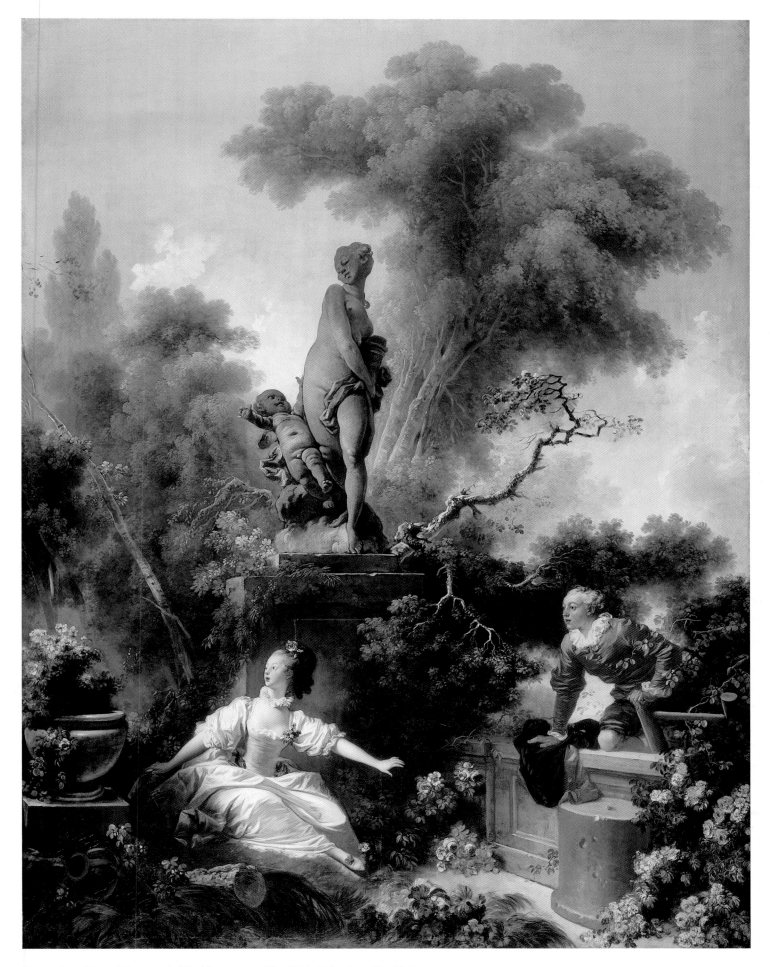

Fig. 2 Jean-Honoré Fragonard, *The Meeting*, 1771. The Frick Collection, New York

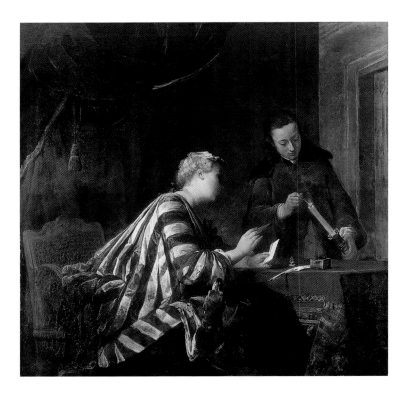

delicate mythologies for the private market, prized for their refined handling and exquisite craftsmanship.[61] Although de Troy and Boucher may have resented having to finish their cabinet pictures (both charged more "quand il y a du fini"),[62] they adapted this manner to their small-scale mythologies as well.[63] In Boucher's case, it was not merely form that was shared: content too might be porous, as in *The Birth of Venus* and *Toilette of Venus* (fig. 4; both private collection) – oval pendants shown at the Salon of 1743 – where silks, satins, and ribbons migrated from the lady of fashion's morning room (cat. 52) to the goddess's retreat on the island of Cythera.[64]

One of the many arguments for accepting Greuze's *Septimius Severus Reproaching Caracalla* as a genre painting was that it was crafted as one, "a subject taken from history, but treated by a genre painter."[65] In its too meticulous technique (as well as its perceived lack of idealization), *Septimius Severus* was found wanting by all the critics. Greuze had "overstepped" his genre; "scrupulous imitator of Nature," he had been "unable to reach the sort of exaggeration demanded by history."[66] Yet an equally sober and polished facture would gradually impose itself as the appropriate style for history painting in the 1780s, as exemplified in the royal commissions awarded to David, Peyron, Ménageot, and Suvée.[67]

How to approach this topic, faced with semantic confusion (or silence) on the one hand, and a plenitude of production on

collector's picture cabinet were always diminutive in size (although, of course, many of them were). Certain of Watteau's late *fêtes galantes*, hunting pictures, and *commedia* pictures share the *Shopsign's* monumentality in scale and conception;[56] the figures in Chardin's *Lady Sealing a Letter* (fig. 3), one of the artist's earliest genre paintings, were noted to be "life-size" (might the picture have been conceived as an overdoor?).[57] Several of Pierre's *bambochades* exhibited at the Salons of the 1740s (see fig. 7) were oversize in format, as were Van Loo's *Conversations* (fig. 11) for Madame Geoffrin.[58] Greuze's most ambitious genre scenes, the neo-Poussinist *Father's Curse* and *The Punished Son* (see fig. 39), painted for the Marquis de Véri, were somewhat larger than his ill-fated *morceau de réception*, exhibited at the Salon of 1769; within the confines of his studio in the Louvre, their scale would have imposed itself even more aggressively on spectators.[59]

By the same token, a polished facture and attention to finish were by no means the preserve of genre painters alone. Artists such as Antoine Coypel, Nicolas Bertin, Noël-Nicolas Coypel, and François Lemoyne – history painters in some ways exceptional for not treating genre subjects[60] – each produced

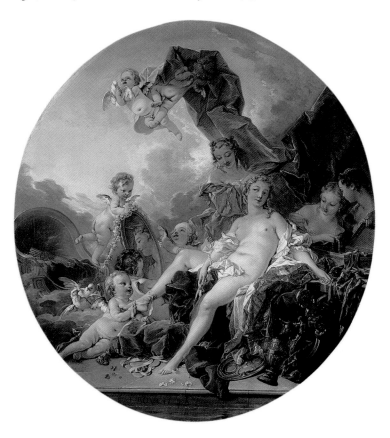

the other? If an expansionist view of genre can be sustained – and that it can and should be is the thesis of this exhibition – we need to consider the paradox of an unregulated, undefined category of painting flourishing within a hierarchical system whose values were shared by all constituencies having an interest in artistic production (artists, administrators, collectors, and critics).[68] In practice, the Academy's hierarchy presented itself as a duality between history painting and the remaining genres: the acknowledged primacy and superiority of the former did not result in the discredit or discouragement of the latter during the Ancien Régime. Acceptance of the hierarchy (and coexistence within it) was the normal state of affairs.[69]

How could it be otherwise, given that until the Revolution all artists of any ambition were trained at the Academy, or sought to gain admission to it in order to exhibit at the biennial Salon? Initially, at least, students were provided with the skills required of the history painter. Drawing after the human figure was the cornerstone of Academic pedagogy, access to the live model the distinguishing component of its instruction. Chardin's often quoted lament on this onerous apprenticeship, which might last from age seven to twenty and was more stringent than that undergone "by doctors, lawyers, and professors of the Sorbonne," is worth attending to once again, since it emphasizes the shared artistic experience of all future academicians, regardless of genre:

> The chalk holder is placed in our hands at the age of seven or eight years. We begin to draw eyes, mouths, noses, and ears after patterns, then feet and hands. After having crouched over our portfolios for a long time, we're placed in front of the *Hercules* or the *Torso*, and you've never seen such tears as those shed over the *Satyr*, the *Gladiator*, the *Medici Venus*, and the *Antinoüs*. . . . After having spent entire days and even nights, by lamplight, in front of an immobile, inanimate nature, we're presented with living nature and suddenly the work of all the preceding years seems reduced to nothing: it's as though one were taking up the chalk for the first time. The eye must be taught to look at nature; and many are those who've never seen it and never will.[70]

As Cochin noted in his biography of the battle painter Charles Parrocel (1688–1752), the artist had started his career as a history painter "because it is the best way to achieve perfection in whatever genre one chooses."[71] Oudry, painter of the King's hunts, director of the Beauvais tapestry manufactory, and one of the richest artists of his day, "could not resist the attractions of ascending to the most honourable rank of the Company," despite the advantages he enjoyed in his genre.[72] In March 1743, at the age of fifty-seven, he received the rank of full professor, which conferred the right to position the model for students in the Academy's life class.[73] Jean-Jacques Bachelier (1724–1806), received in September 1752 as "peintre de fleurs," was allowed to upgrade his membership a decade later and

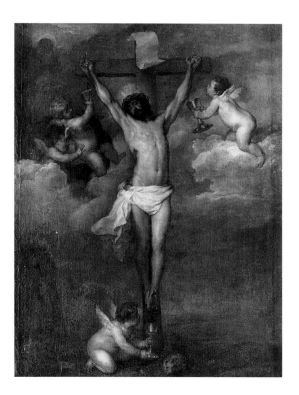

submitted two history paintings, *The Death of Abel* (location unknown), exhibited at the Salon of 1763, and soon replaced by the lacklustre *Roman Charity* (École des Beaux-Arts, Paris), shown at the Salon of 1765 (Diderot repeatedly advised him to "return to his tulips").[74]

Thanks to Caylus, in his thirties Watteau continued to draw after the female nude, normally the prerogative of history painters who hired such models in their private studios.[75] Lancret attended life drawing sessions at the Academy well into old age, until friends prevailed upon him to remain at home during the winter months.[76] Desportes let it be known that he regarded drawing as the basis for painting, "regardless of the genre for which one was destined."[77] Chardin, whom Michael Baxandall has characterized as "a very history-regarding painter," destined his son for that rank (with terrible consequences). And in his painting of an apprentice sharpening his crayon (cat. 34), we note that the boy has just completed a drawing of a Satyr's head, without shedding any tears.[78]

During their formation, the future practitioners of genre painting were exposed to the same models, both artistic and art historical, as those destined to become history painters. As

Watteau put it, "One could not beat the drum well without first knowing how to play the flute;" and for Cochin, this picturesque manner of speech signified "that to succeed in any one genre, one had to know far more than what was required by that genre alone."[79] Watteau's intense study of Crozat's collection of Old Master drawings was a case in point; as Caylus noted, "he conceived of his art more nobly than he practised it."[80] On at least one occasion, his opinion was solicited on how best to represent a historical subject for admission to the Academy.[81] But the inventor of the *fête galante* was by no means exceptional (or eccentric) in immersing himself in the art of the past. Lancret studied Old Masters in the royal collection, in the company of his friend François Lemoyne: each promised to paint for the other a copy of Van Dyck's *Christ on the Cross* (fig. 5) before they died.[82] Greuze and Baudouin were among the many artists permitted to study Rubens' *Medici* series in the Luxembourg Palace, as Watteau had done nearly half a century before.[83] Greuze's student Pierre-Alexandre Wille spent his afternoons studying and copying Le Sueur's *Life of Saint Bruno* cycle at the Carthusian cloister; and thanks to his protector, Jacques-Augustin de Silvestre (drawing master to the Enfants de France), as a student, Étienne Aubry had the run of royal collection at the Surintendance at Versailles.[84]

Both history painters and genre painters prepared their compositions through drawings, however wayward or original the approach of individual artists might be.[85] In this regard, Watteau and Lancret's *fêtes galantes* and Oudry's hunts are as mediated and carefully considered as Boucher and Natoire's mythologies or Restout's religious paintings; while Chardin and de Troy both stand out as exceptions for largely dispensing with this essential process.[86] Given the Academy's insistence on drawing, it is significant that over two hundred of Greuze's expressive heads and figure studies were acquired in 1769 as a teaching tool for the fledgling Imperial Academy of Fine Arts in Saint Petersburg. Might Greuze, a genre painter, have relinquished them after his hopes to succeed to a vacant professorship following Louis-Michel Van Loo's appointment as director of the École des Élèves protégés were dashed in the unseemly conclusion to his bid to gain full admission to the Academy as a history painter?[87]

If genre painters shared the same formation as history painters, until the 1780s successive generations of history painters were more than willing to produce and exhibit genre paintings. David, Peyron, and Ménageot broke with tradition by disdaining such subjects: David exhibited only one genre painting at the Salon, a *Mother Nursing her Child* (location unknown), shown in 1781 and described by Diderot as "well drawn and of a beautiful form."[88] Yet to have specialized in one genre alone may have been considered aberrant in the early decades of the century. This, at least, was the implication of the chevalier de Valory's remark that François de Troy was exceptional in limiting himself to portraiture: "It was by no means usual that painters attached themselves exclusively to this genre."[89] As examples of history painters who made genre paintings, one could cite the following (and this listing is by no means complete): Bon Boullogne, Claude Gillot, Jean Raoux, Jean-François de Troy (cat. 23–28), Charles Coypel (cat. 29), Jean-Baptiste Oudry (cat. 43), Étienne Jeaurat (cat. 44, 45), Pierre Subleyras (cat. 46, 47), Michel Dandré-Bardon (cat. 48, 49), François Boucher (cat. 51–55), Carle Van Loo (cat. 56), Jean-Baptiste Pierre (see fig. 7), Noel Hallé (cat. 57–59), Jean-Honoré Fragonard (cat. 75–88), Jean-Baptiste Deshays, Joseph-Marie Vien, Nicolas-Bernard Lépicié (cat. 96, 97), Hugues Taraval, Louis Durameau, and François-André Vincent.[90]

History painting encompassed a "vast career," absorbing as it did all the lower genres.[91] Cochin grew somewhat weary with the history painter's presumption of superiority across the board – "artists who take up the grand genre are too easily persuaded that once one has achieved success in history painting, one can succeed without any difficulty in what are termed the little genres, and which are only such when they are treated trivially"[92] – but the history painter's universality was deeply enshrined in academic doctrine, since it was rare that the highest genre did not require skill in those subordinate to it.[93] Despite Mariette's disapproval,[94] de Troy's *Declaration d'Amour* (fig. 6), exhibited at the Place Dauphine in June 1724, received an enthusiastic reception: "We note from M. de Troy le fils, already known for his large paintings, a work that brings much honour to his brush, thanks to the harmony, the gallant taste, and the truthfulness with which it is composed."[95] It was precisely the "universality" of his genius that so commended Boucher to clients at home and abroad. In his lists for 1745, Louis Petit de Bachaumont noted admiringly that "[Boucher] excels in Landscapes, *Bambochades*, and Grotesques and Ornaments in the manner of Watteau. He also paints flowers, fruits, animals, architecture, and little gallant and fashionable subjects equally well."[96]

Given his uncompromising orthodoxy in later life, it is ironic that Pierre's decision to exhibit *bambochades* in several Salons of the 1740s (fig. 7) should have caused a minor controversy (he had been admitted as a history painter in April 1741).[97] Those critics who took exception to such low subjects described them as "a pernicious diversion" that might prevent him from "making discoveries" and producing "grave and sublime compositions."[98] However, there was no consensus, as there would be twenty years later, that genre painting necessarily brought ruin upon the history painter (I am thinking of Madame d'Épinay's celebrated dismissal of Fragonard as one who "wastes his time and his talent earning money").[99] Quite the opposite argument, in fact, was made by Greuze's future patron, the abbé Louis Gougenot, who thanked Pierre for charming the public with works of such "original and seductive naïvety":

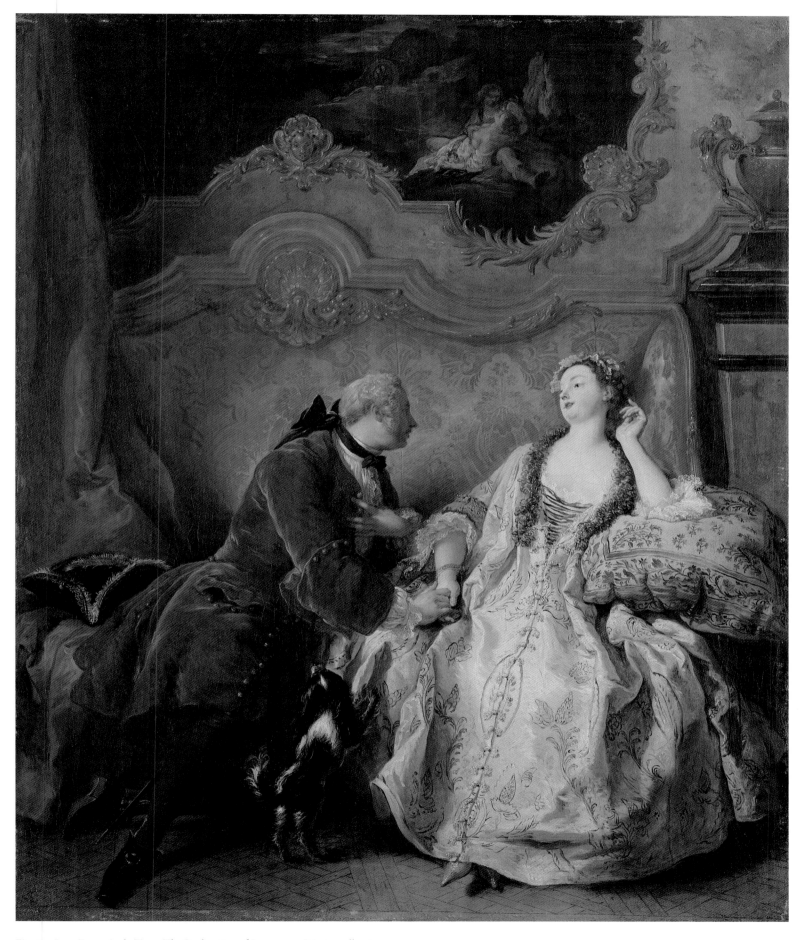

Fig. 6 Jean-François de Troy, *The Declaration of Love*, 1724. Private collection

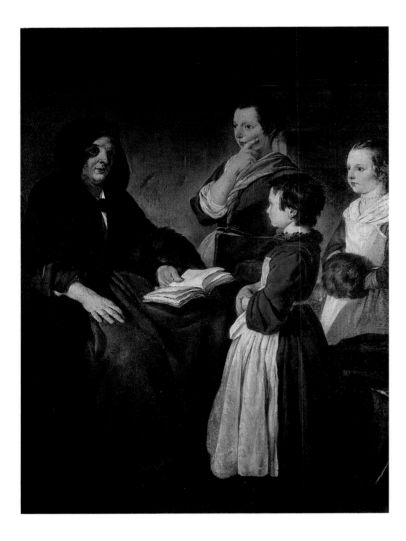

A history painter may, without any dishonour to his genius, occasionally indulge himself in this type of composition. Since the mind cannot always be engaged upon grand and elevated ideas, these little compositions provide it with useful recreation, which in turn offers the artist's imagination the rest it needs.[100]

In the 1750s, both Hallé's and Jeaurat's incursions into genre painting, also considered "délassement" (diversion), would be welcomed as instances of "distinguished athletes" descending temporarily from the summits to engage in "learned banter" and produce the "simple subjects that are the charm of picture cabinets."[101]

Indeed, for much of the century there was general encouragement and support for genre painting on an institutional level; both the Academy and the Bâtiments showed themselves remarkably open to hybrid forms and newly-minted variants. While Watteau's *Embarkation from Cythera*, 1717 (Musée du Louvre, Paris) might have been conceived of and even accepted as a history painting,[102] the *fête galante* itself was palpably genre, and thus unclassified within the Academy's existing categories (hence the decision to let Watteau present a "subject of his choosing" for his reception piece).[103] Both Lancret and Pater, painters "sur un talent particulier," were admitted to the Academy as "painters of *fêtes galantes*;" Lancret, like Chardin after him, rose to become one of the *Conseillers dans les talens particuliers*, the highest rank open to those who were not history painters.[104] In the 1720s, Lajoüe, Chardin, and Bonaventure de Bar were each admitted and received as full members on the same day, something that Mariette considered an exceptional honour.[105] Even engravers of genre painting were encouraged. After Jacques-Philippe Le Bas had been stripped of his title of *graveur du Roi* because "of the mediocrity of his portraits," he was allowed to reapply to the Academy in January 1742 with prints after Wouwermans and Berghem.[106] For his *morceau de réception* he was directed to engrave the *Conversation galante* (fig. 8) with which Lancret, now in his fifty-second year, had gained full admission to the Academy in March 1719.[107]

In the late 1740s and early 1750s, with Caylus's new-found political correctness beginning to cast its shadow over the Academy's conferences and debates, it is perhaps all the more surprising to find in these very circles expressions of regret for the disappearance of the *fête galante*. Mariette, for example, paid homage to Lancret and Pater as "the only two painters who maintained the taste for those fashionable and gallant subjects, of which Watteau had been both the model and inventor."[108] While far from promoting a taste that could become "prejudicial to the noble and historical genre," Mariette argued that it was desirable for the progress of the fine arts that "talented artists be formed in many genres, each of which have their merit and their degree of difficulty, and in each of which one can acquire a respectable renown when one succeeds."[109]

In his review of the Salon of 1749, Gougenot also regretted the passing of the *fête galante*, and with this in mind urged Chardin to create his own "school":

> One cannot encourage him too fervently to form students capable of maintaining the genre in which he excels, since it is for want of students that many genres have fallen by the wayside. Since the death of M. Lancret, for example, there is no one who cultivates the art in which the famous Watteau was once so illustrious.[110]

That the "glory of the Academy depended on the success of *all* the genres" was the thrust of Massé's lecture delivered in April

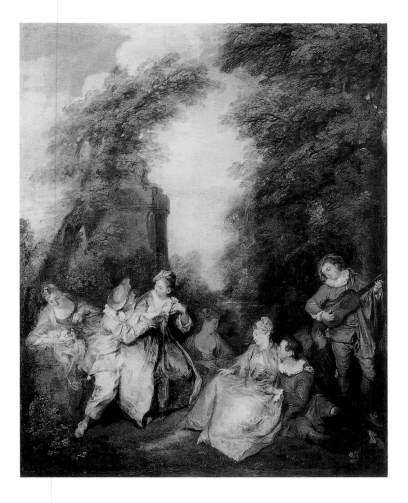

1750: "It is with sadness that we have noted for some time that certain genres are neglected and others even extinct."[111] Among the latter he cited the *fête galante*, in which Watteau had "so distinguished himself," and architectural painting of the sort practised by Pannini.[112] Mariette had stressed the importance of encouraging landscape painting;[113] and Cochin agonized over the need to find a worthy successor to Charles Parrocel, since battle painting seemed also in decline.[114]

Even as Caylus and his fellow honorary Academicians were delivering lectures intended to reform history painting – hence the introductory disclaimer in his *Life of Watteau* that "on doit plus aimer l'art que les artistes"[115] – both the Academy and the Bâtiments continued to grant special favour to promising genre painters at the start of their careers. As a student at the Academy, Greuze was encouraged by Natoire, Pigalle, and

Silvestre, and following an enthusiastic maiden appearance at the Salon of 1755, he was invited on a Grand Tour of Italy by the abbé Gougenot, who would be elected as an honorary member of the Academy in recognition of his generosity. Travelling with Gougenot at his expense for almost a year, Greuze decided to remain in Rome in May 1756, not only for that city's views and monuments, as Barthélemy informed Caylus, but also to study Raphael.[116] Natoire, director of the French Academy in Rome, informed the Directeur-général des Bâtiments, the Marquis de Marigny, that Greuze "might well raise his genre to a new level,"[117] and in turn Marigny allowed the artist to be lodged at the Palazzo Mancini, in a room "with the light that is necessary for his work."[118] Marigny, who five years later would commission Greuze's *Marriage Contract* (cat. 71) for his private collection, also arranged for the unofficial *pensionnaire* to receive a commission for two ovals for Madame de Pompadour's state apartments at Versailles (cat. 68), paintings which "will be seen by all the court and could lead to great advantages for him if they are considered good."[119]

Greuze may have been the most favoured genre painter of the eighteenth century, but he was by no means the sole recipient of administrative largesse. Thanks to his family's connection with the Marquis de Stainville (whose son, the future Duc de Choiseul, would become the French Ambassador in Rome in 1753), Hubert Robert, "peintre d'architecture," remained for eleven years in the Eternal City, the first six of which were spent as a supernumerary *pensionnaire* at the French Academy.[120] With Greuze and Robert as precedents, Cochin hoped to formalize this arrangement in 1763. By limiting the stay of student architects at the Palazzo Mancini to three years, he explained to Marigny, their fourth year could be offered as "grace and favour places" to those whose genre of painting disqualified them from competing for the Grand Prix.[121] (Here Cochin was overly optimistic in his assessment of the potential of the fledgling battle painters Le Paon and Duplessis-Bertaux.)

As Marigny's private and official commissions to Greuze demonstrate, genre painting was hardly discriminated against by the Crown. Indeed, until the 1770s it can be argued that genre *subjects* enjoyed almost equal favour with history in the commissions originating with the *Maison du Roi* and the state-run tapestry manufactories.[122] The decorative cycles and tapestry series from the 1730s that coincide with Louis XV's majority – the *chasses exotiques* for Versailles, the dining room decorations at Fontainebleau (see cat. 28), Oudry's *chasses royales* for Compiègne – bore witness to a flowering of genre painting on a monumental scale that would be maintained, in a somewhat different format, with Joseph Vernet's commissions of the *Ports de France* two decades later.[123]

Genre paintings could be "programmed," no less than history paintings, since details regarding size, subject, and even

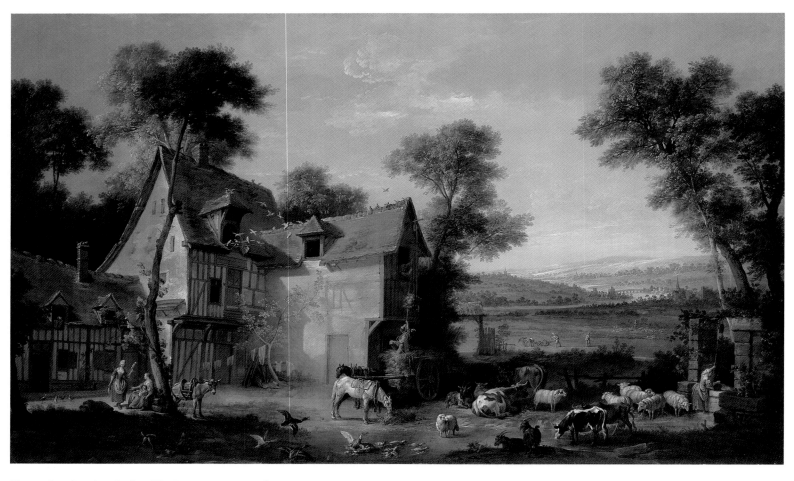

Fig. 9 Jean-Baptiste Oudry, *The Farm*, 1750. Musée du Louvre, Paris

disposition might well be provided by the patron, even if the evidence for such "active patronage" in the private sector is episodic and hard to document.[124] The Regent helped launch Desportes's career (and set the fashion for his still-lifes) by commissioning three "cuisines" or "kitchen subjects" – "dont il donna lui-même les sujets" – for the rooms in the Palais-Royal in which he entertained company with elaborate dishes of his own confection.[125] To record the accident that took place during Maria Leczinska's journey from Strasbourg to Fontainebleau in the autumn of 1725, when the carriage in which she and her entourage were travelling foundered in the mud, the Duc d'Antin commissioned Lancret to paint *The Accident at Montereau* (location unknown), "in the most grotesque manner possible."[126] Six ladies-in-waiting were to be shown on a carthorse, as if they were "calves that one takes to market;" another was to be slung across a carthorse, "like a sack, with her garter showing;" the royal carriage was to be placed in the background: "In a word, the painter is to include the most grotesque and messy details he can."[127]

A more earnest brief was given Oudry by the Dauphin Louis in 1750, who dictated the subject of *The Farm* (fig. 9) in all its details, and had the artist produce a preparatory sketch in his presence. The Dauphin had left little to Oudry's imagination: among the motifs indicated for inclusion were the cart of hay harnessed to two horses, which is being unloaded into the barn; the various female figures in the foreground (sewing, holding an infant on the left, drawing water from a well at right); even the labourer with his plough and the shepherd with his flock, barely visible in the background.[128]

In the mid-1740s, Chardin and Boucher both received similarly detailed instructions for genre paintings from diplomats acting on behalf of Crown Princess Luisa Ulrike of Sweden. Whereas Chardin paid no attention to the subjects assigned him – instead of "l'éducation sévère" and "l'éducation douce et insinuante" he painted *Domestic Pleasures* and *The Housekeeper* (both Nationalmuseum Stockholm)[129] – Boucher seems initially to have been more receptive to the patron's brief for a series of four pictures representing the times of day (see cat. 54). "I have communicated to Monsieur Boucher my ideas concerning the subjects he is to paint," secretary Carl Reinhold Berch reported to Count Carl Gustav Tessin; "he has not disapproved of any of them, and indeed seems to be most pleased."[130] *Morning* was to be "a woman who has just finished with her hairdresser, still wearing her dressing gown, and

amusing herself by examining the baubles presented to her by her *marchande de modes*."[131] While Boucher followed this description almost to the letter – note the powdering mantle worn by the mistress of the household and her tightly curled coiffure, evidence of the hairdresser's recent handiwork – he soon lost interest in the commission, and, despite the protests and blandishments of the Swedish minister, undertook none of the remaining subjects.[132]

Bachaumont, who in the late 1730s had advised Boucher on episodes from the story of Cupid and Psyche that might be appropriate for Beauvais tapestries,[133] produced in November 1756 a compendium of genre subjects entitled the "Suite des Tableaux agréables à faire" (although it is unclear why he did so, and whether he had any particular artist in mind).[134] Bachaumont's list described in some detail eleven gallant and sentimental subjects of the sort that had been Lancret's speciality (and that Boucher had tackled, albeit reluctantly, during the 1740s). It is hard to imagine for whom this corpus may have been intended: Greuze, the up-and-coming genre painter whom Bachaumont might have considered in need of such assistance, would tackle subjects from "high life" on rare occasions only, and not until the following decade: his *Broken*

Mirror (fig. 10) and *Disconsolate Widow* (Wallace Collection, London) both date to 1763.[135]

The protagonist of Bachaumont's series is a young mistress who is shown in a variety of domestic situations – waking, doing her toilette, drinking coffee, reading, dressing – in most cases assisted by a maid. Wherever possible, Bachaumont directed the artist to show as much flesh as could reasonably be included. In *The Cup of Coffee* (no. 3), for example, the mistress holds out her cup "so that her pretty white chubby arms and sweet little hands" can be seen.[136] In *Clothing* (no. 7), she dresses in front of a large pierglass, and is shown wearing "a white corset and a little white short skirt, both of which emphasize her naked body and allow us to see the back of her legs, her white stockings, her fine thigh, and her little feet."[137]

While these descriptions, which anticipate the *petits-maîtres* of the 1780s, seem never to have been realized in paint, they serve to remind us that genre painting could be programmed in the same way as the more elevated genres. Madame Geoffrin, who claimed that her entire collection of modern genre paintings had been "done before her very eyes,"[138] was credited with inventing the "new" subject of Van Loo's *La Conversation espagnole* (fig. 11) – in fact, a grandiose reprise of the *fête*

Fig. 10 Jean-Baptiste Greuze, *The Broken Mirror*, 1763. The Trustees of the Wallace Collection, London

Fig. 11 Carle Van Loo, *The Spanish Conversation*, 1754. The State Hermitage Museum, Saint Petersburg

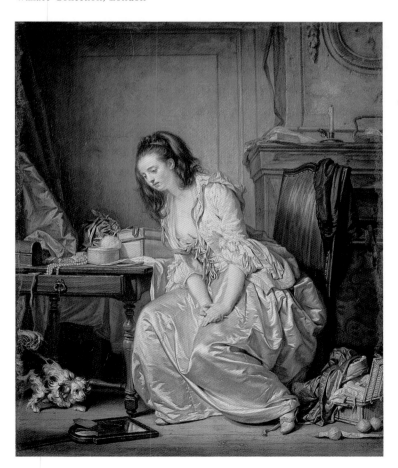

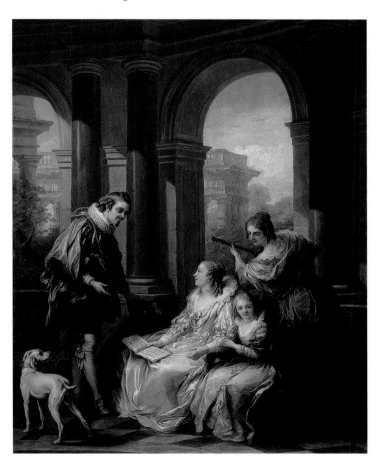

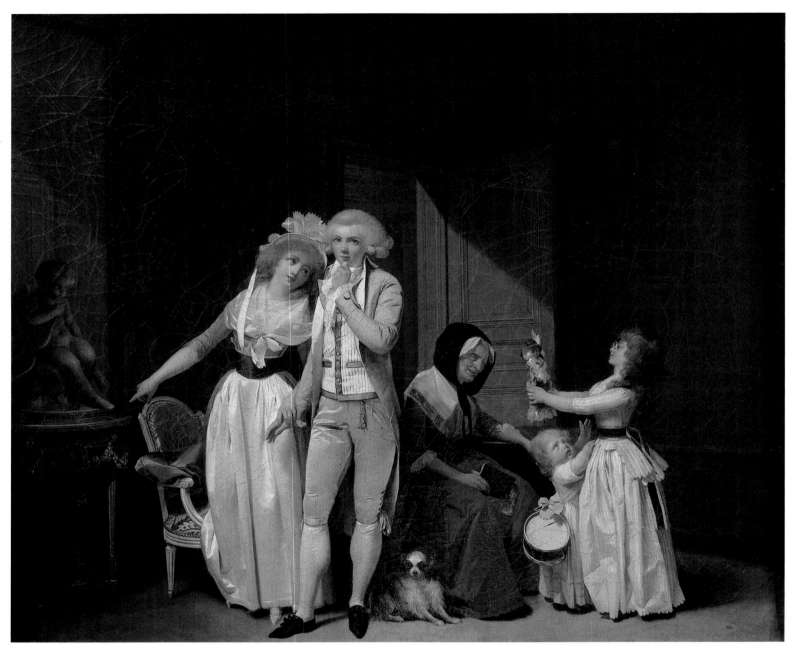

Fig. 12 Louis-Léopold Boilly, *The Young Philosopher*, 1790. Musée de l'Hôtel Sandelin, Saint-Omer

galante[139] – and criticised by Diderot for her tyrannical interference in its production.[140] The subject of Fragonard's *Swing* (fig. 13) – a commission initially offered to the history painter Doyen – was provided in all its particulars by the unnamed courtier for whom it was painted, who requested that he be portrayed looking up at the beautiful legs of his mistress, "and even more, if you wish to enliven your picture."[141] Whether they were aware of it or not, Boilly's *Avignonnais* patrons, Alexandre de Tulle, Marquis de Villefranche, and Antoine Calvet de La Palun (1736–1802) were following a well-established tradition in proposing the subjects of their genre paintings (although rarely have such detailed instructions come

down to us in writing).[142] In *The Young Philosopher* (fig. 12), "invented by M. de Calvet Lapalun [*sic*] and painted by Louis Boilly in 1790,"[143] the activity of each figure was delineated in the patron's brief – from the seated old woman holding a book and laughing at her granddaughter, who has borrowed her glasses and is trying to see her doll through them; to the marble statue of *L'Amour menaçant* (not identified as by Falconet), on whose pedestal can be read the "well-known adage, *Ce qui m'allume m'éteint*" ("What excites me, consumes me"); to the beautiful woman who slips one hand into her suitor's and points to the statue with the other ("and by which gesture informs him of the reason for her refusal").[144] While for the

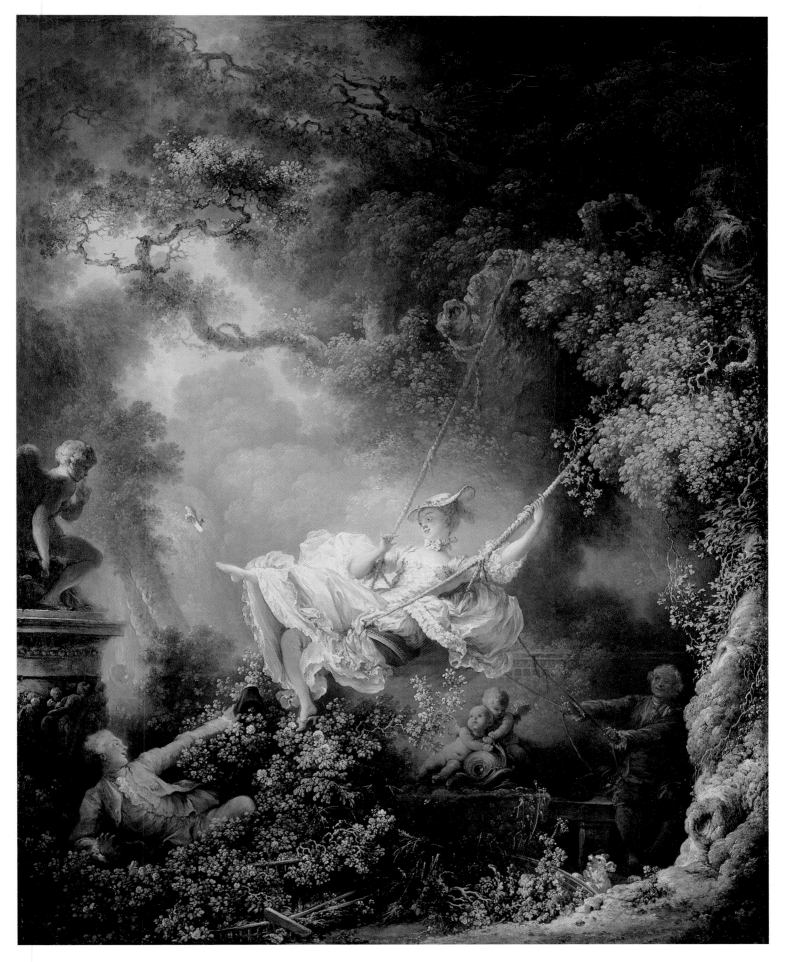

Fig. 13 Jean-Honoré Fragonard, *The Swing*, 1790. The Trustees of the Wallace Collection, London

most part responsive to these written instructions, Boilly deviated from them in certain details. In *The Young Philosopher*, Calvet de La Palun had indicated that the old woman be placed in such a way that she was unable to witness her daughter's dalliance (in fact, she is seated in the middle of the room), and that the young man be shown gazing at the sculpture's inscription with a "dreamy look on his face" (he looks directly at the viewer).[145] Yet as was so often the case with paintings made on command (and as is certainly the case with this early group of masterpieces by Boilly), the artist might well be inspired, rather than constrained, by the patron's involvement in the creative process – to use a term that the eighteenth century would not have recognized.

NORTHERN INFLUENCES

If the Academy and the Bâtiments tolerated a certain hybridity among the lower genres; if royal commissions generally encouraged genre subjects in decorative, often monumental formats; and if private patrons and collectors identified subjects to be treated by the genre painter in a minority of cases only (as would be true for history painters as well), the vitality of genre painting as traditionally conceived – small in scale, finished in facture, domestic in subject matter – was due in large part to the extraordinary vogue among eighteenth-century collectors for Dutch and Flemish cabinet painting of the previous century.[146]

Even with Poussin as his model – an artist whose respect for "great and elevated things" rendered him incapable of tolerating "low subjects and paintings of commonplace activities"[147] – Félibien responded with measured enthusiasm to the meticulous genre paintings of Gerrit Dou, whose "little pictures surpassed all the others of his time," and whose "beautiful brushwork, colours, and chiaroscuro were handled with admirable skill."[148] In his "Life of Watteau" delivered in February 1748, Caylus would commend Dou for the fastidiousness of his technique and immaculate preparation.[149] He also recalled that Watteau had been obliged to copy Dou's *Old Woman Reading a Letter* when he worked as an assistant to a hack painter on the Pont Notre-Dame.[150]

In de Piles's "Balance des Peintres," from which Dutch and Flemish genre painters were generally excluded because of their "poor taste" in everything but "fidelity to Nature,"[151] David Teniers II was ranked the equal of Poussin and Leonardo in composition, and given higher marks than Raphael for his colour.[152] Antoine Coypel, in one of the lectures he had given to the Academy, published in 1721, praised Willem Kalf unreservedly for the "objects imitated after Nature": "He seems to me to speak the language of painting as well as Giorgione and Titian."[153] (Watteau and Lancret both made pastiches of Kalf's kitchen scenes).[154]

In the first decades of the eighteenth century, with the taste for seventeenth-century Northern cabinet painting still relatively new, connoisseurs and academicians were generally encouraging of collectors who questioned the prevailing hegemony of the Italian school.[155] Coypel was "angered" that "little Dutch and Flemish paintings" were "entirely banished from picture cabinets which assemble only the Italian Old Masters."[156] Dezallier d'Argenville promoted collections "of an assortment of Flemish and French painting, mixed with one or two Italians," arguing (outrageously) in the *Mercure de France* in June 1727 that "the Flemish are the only real painters, and if their drawing were as accomplished as their colour, they would be the leading painters in the Universe."[157] Among the desirable Flemish masters, he listed Teniers, Bamboccio, Rembrandt, Dou, van Mieris, Netscher, Wouwermans, Berghem, and Ostade:[158] it would be at least another generation before Metsu, Steen, Terborch, and de Hooch were welcomed into this pantheon.[159] In March 1744, Gersaint stated that Dutch and Flemish cabinet painting, now "tout à la mode," was the ornament of nearly every picture collection.[160]

The dealer Gersaint was hardly a disinterested party – it was he, after all, who during the 1720s and 1730s had promoted the taste for Dutch and Flemish cabinet painting[161] – but it is the case that by the middle decades of the century commentators on the art scene were of one mind that Northern cabinet pictures now constituted the preference of the collecting elite. The earliest formulation of an argument that would become a common-place of Salon criticism is to be found in a letter of 1739 written by the thirty-year-old *parlementaire* Charles de Brosses (1709–1777), travelling in Italy in the company of the seasoned medievalist La Curne de Saint-Palaye. Discussing the popularity of Dutch and Flemish painting in France, he fulminated:

> Have we not seen . . . the excessive prices to which they have risen, with no other merit than that of finish and colouring. For the most part, they treat only low, puerile subjects, or on occasion, grand subjects executed in a trivial manner. Colour is now all the rage with us . . . but don't imagine that these voracious collectors of the Flemish school seek out the work of Van Dyck or the great Rubens, artists who are true colourists. No, it is the paintings of Teniers, van Mieris, Gerrit Dou that they buy at any price.[162]

Initially respectful of the priorities of those "precious collections," whose preference was for the "smoothness, freshness, and naivety of the Flemish brush" (magical lighting effects, perfectly imitated fabrics, well-chosen equestrian scenes),[163] La Font de Saint-Yenne, writing in 1747, allowed that "so many agreeable qualities predispose us to overlook the lowliness of the subject matter, which is for the most part vulgar, ignoble, without ideas and without interest."[164] Five years later, in a second edition of his *Réflexions*, he took a far

more extreme position, blaming the decline of painting in France on the "violent and uncontrollable taste" of collectors for the work of Flemish painters – now almost "beyond price" in the salesroom – which "had succeeded in practically banishing the great masters of France and Italy from our picture cabinets."[165]

After mid-century, when artists or critics sought to account for the perceived failings of the current school, they looked no further than the "debased" taste of the private sector. The French nation wanted nothing but "rose-coloured painting," Pierre explained to Marigny in June 1772,[166] and Flemish colour could hardly remedy the situation, since only the lesser artists were sought after: "How much to blame are our artists and art lovers, having become fanatical for Flanders, *the taste for which will be the ruin of painting in France.*"[167] That Dutch and Flemish cabinet painting of the seventeenth century had caused the decline of modern history painting – the logic of which seems never to have been questioned – emerged as a serviceable trope in much art journalism of Louis XVI's reign. The *Mercure*'s introduction to its review of the Salon of 1775 is a typical example: "Is it not appropriate to make mention of the courage required of the history painter in ploughing such an infertile field, infertile because of the frivolous and petty taste of wealthy art lovers for *bambochades* and little pictures of bloodless finish by the Flemish masters."[168]

French eighteenth-century genre painting was the beneficiary, and at times the victim, of the growing taste for its Northern seventeenth-century predecessors. Since, as has been noted, for most of the century French art theory did not recognize subjects from everyday life as a distinct category within the hierarchy of genres, either Teniers's authority or that of the Bamboccianti, or that of "the Flemish taste" in general was invoked to valorize and define an otherwise nameless practice. La Roque had characterized Watteau's "easel paintings of little figures" as "in the Flemish taste," adding that his colouring came close to Rubens.[169] Following Voltaire, Boyer d'Argens compared Watteau to Teniers, noting further "that he painted nothing other than *bambochades.*"[170] Largillière had apparently mistaken Chardin's *Ray Fish* of 1728 (Musée du Louvre, Paris) for "the work of a good Flemish painter."[171] Chardin's genre paintings exhibited at the Place Dauphine in June 1734 were referred to as "subjects in the taste of Teniers;"[172] a decade and a half later, Gougenot was still calling Chardin "le Téniers françois," and Bachaumont listed him as excelling "in little subjects in the Flemish taste."[173] With greater originality, Mariette considered Chardin's early "cuisines" for La Roque (*Woman at the Urn* and *The Washerwoman*, both Nationalmuseum, Stockholm) to be Rembrandtesque in handling.[174]

Oudry's stately *Farm* (fig. 9), painted for the Dauphin Louis (see above) was listed in the *livret* of the Salon of 1751 as "a painting in the Flemish genre."[175] Baron Grimm described

Greuze's *The Father Reading from the Bible* (private collection, Paris), *The Blindman Deceived* (Pushkin Museum, Moscow), and *The Sleeping Schoolboy* (cat. 63) – three rustic genre paintings presented in support of his candidacy to the Academy, and which were lent to the Salon of 1755 by La Live de Jully (1725–1779) – as "easel paintings in the Flemish taste."[176] Gougenot referred to Greuze's talent as "that of painting *Bambochades*;"[177] Saint-Aubin scribbled "See Greuze" next to Terborch's *The Glass of Lemonade* (The Hermitage, Saint Petersburg) in his catalogue of the Gaignat sale of February 1769.[178]

More than providing French genre painting with a convenient (if derivative) nomenclature, seventeenth-century Dutch and Flemish cabinet painting helped define (and legitimate) both the repertory of subjects and the manner in which they were painted. Chardin's subjects have recently been characterized as "Northern genre cleansed of its uncongenial moralizing or uncomfortably low humour" – a description that could be extended, on one level, to eighteenth-century genre painting as a whole.[179] Not infrequently were genre painters called upon to produce pendants or companion pieces to Northern examples; more generally, their work would be expected to adorn the walls of collections in which Dutch and Flemish Old Masters predominated and set the visual tone.[180]

While it is well known that Watteau borrowed freely from seventeenth-century examples – the *Pleasures of the Dance* (cat. 4) depends on Hieronymus Janssens' painting of the same subject,[181] the *Shopsign* (fig. 1) takes Teniers's depictions of imperial picture galleries as its starting point – he was also commissioned by the Regent to paint a tiny *Monkey Painter* (*Singe peintre*), on copper, as a pendant to a work by Pieter Breughel in his collection.[182] Boucher and Pierre looked to engravings after Teniers for their rustic kitchen maids with monumental pots and oversized vegetables.[183] At the Salon of 1746, Chardin painted a second version of *Saying Grace* (fig. 14), first shown six years earlier, "with an addition so that it can serve as the pendant to a Teniers."[184] The addition consisted of a long-handled copper pan holding two eggs in the bottom right-hand corner.[185]

Such was the convention of hanging pictures in pairs – either pendants by the same artist, pendants by different artists, or pendants by a living artist and an Old Master – that it is hardly surprising that so many genre paintings were produced in twos (or fours). As individual works, they had far less appeal for collections that were rigorously symmetrical in their arrangement, hence Tessin's fury with Boucher for sending only one painting from the series of the *Four Times of the Day* commissioned by Luisa Ulrike in 1745.[186] Arriving as a single item in June 1747, *The Milliner* (cat. 54) had made far less of an impression than Chardin's *Domestic Pleasures* and *The Housekeeper* (see above) – "pictures for which one goes down on bended knee" – in large part "because it came alone."[187] Tessin

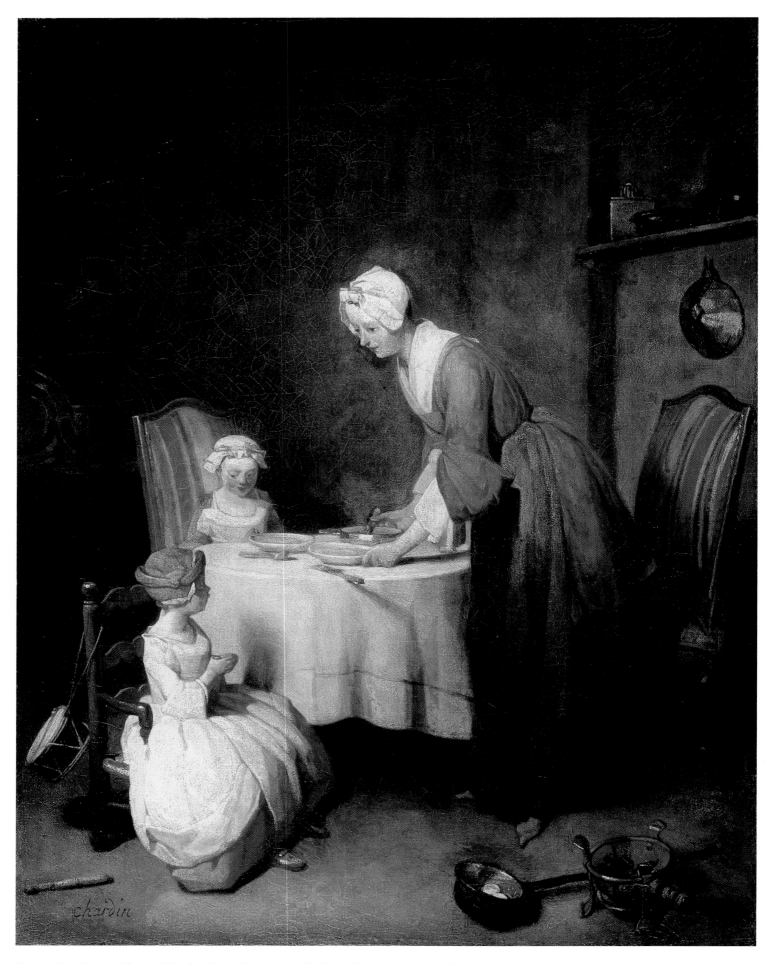

Fig. 14 Jean-Baptiste-Siméon Chardin, *Saying Grace*, 1740. The State Hermitage Museum, Saint Petersburg

insisted upon having a pendant: if Boucher would not provide one, Gersaint "or another connoisseur" could be applied to for "a Flemish painting of good taste."[188] Threatening Boucher with a Flemish pendant may have focused his attention temporarily: in August 1750, he made a "hasty drawing" of his idea for a pendant (hopes for a series had evaporated) which showed, in the words of the hapless Scheffer, a painter occupied in finishing the portrait of Madame Royale, in her chamber, observed by a well-dressed lady.[189] Perhaps to sweeten the pill, Boucher assured his patron that the lady would be wearing "a fine satin dress in the manner of van Mieris."[190]

Fragonard, who had studied under Boucher and at the École des Élèves protégés (which offered three years additional training for prize-winning history painters prior to their departure for the Academy in Rome), abandoned the grand genre soon after returning to Paris, and, much to the administration's displeasure, devoted himself primarily to the private market and genre painting.[191] He proved particularly adept at crafting cabinet paintings in various Northern idioms: from Rembrandtesque *Heads*, family scenes, and outright copies (the copy of Fabritius' *Mercury and Argus*, then thought to be by Rembrandt), to landscapes inspired by Ruysdael, whose paintings he would "borrow" from the dealer Lebrun.[192] So established was the Flemish taste and such was Fragonard's virtuosity in it, that "to show off his genius" he was requested by a patron to pair an *Adoration of the Shepherds* "dans la manière de Rembrandt" with a companion piece, *The Bolt* (cat. 84), in the more polished style of Metsu or Terborch.[193] The taste for seventeenth-century cabinet painting thus inspired a masterpiece of modernity – tempestuous in its rhythms, brittle in its eroticism – with a libertinism as palpable as Laclos's *Liaisons dangereuses*.

Fragonard's *Adoration of the Shepherd* and *The Bolt* were owned by Louis-Gabriel, Marquis de Véri (1722–1785), who also commissioned Greuze's *Father's Curse: The Ungrateful Son* and *Father's Curse: The Punished Son* (see figs. 38 and 39). The pre-eminent collector of contemporary art during Louis XVI's reign, he was last in the line of *noblesse d'épée* from the Comtat Venaissin that traced its lineage to the Crusades.[194] Following the model for collecting French art established by La Live de Jully in the 1750s, patrician collectors of French painting began to assemble examples of the national school, old and new, in an encyclopedic fashion, on occasion even hanging them apart from their Italian and Northern counterparts.[195]

By contrast, during the first half of the century, collectors of genre painting – which included emperors and monarchs, military nobility and honorary academicians – were more likely to have been primarily collectors of Dutch and Flemish Golden Age cabinet painting. Jeanne-Baptiste d'Albert de Luynes, Comtesse de Verrue (1670–1736), owned works by Watteau, Lancret, Pater, and Bonaventure de Bar, but it was for Wouwermans and Teniers that her cabinet was renowned.[196]

Antoine de La Roque (1672–1744), war hero, dramatist, and after 1724 director of the *Mercure de France* – who had sat to Watteau (and Lancret),[197] and had written the former's obituary – was a voracious collector of Watteau's military paintings and Chardin's early genre scenes. French painting was only a small part of his collection, however, in which Dutch and Flemish painting predominated, with Rembrandt's *Artist in his Studio* (Museum of Fine Arts, Boston) being among the finest. Along with two early genre paintings by Chardin, Tessin acquired three Wouwermans, a Berghem, and a "Teniers of his best period" from the sale of La Roque's cabinet in May 1745.[198] Watteau's great patron and promoter, Jean de Jullienne (1686–1766) – the dyer, cloth merchant, and from 1718 director of the Gobelins tapestry manufactory – was a passionate collector of Dutch and Flemish cabinet painting, forming what Mariette described as "a very large and very fine group of paintings, above all of the Flemish School."[199] Greuze's *Silence!* (cat. 69) was among his modern genre paintings, and Chardin's *Governess* (cat. 39) was initially destined for him.[200]

As these summary examples are intended to show, genre painters such as Chardin or Greuze may not have portrayed the domestic routines of the "aristocratic or the illustrious," but more often than not they painted *for them*.[201] Similarly, Lancret was patronized by the diplomat and member of the Académie française, Jean-François Leriget de La Faye (1674–1731), the protector of Bonaventure de Bar, who was living at his house on the Rue de Sèvres at the time of his death.[202] Another highly-born enthusiast of Lancret, Oudry, and to a lesser degree Boucher, was the master of the King's hunts, Henri Camille, Marquis de Béringhen (1693–1770) (fig. 15), boon companion to Louis XV and Premier écuyer de la Petite Écurie du Roi since 1724 (he was appointed governor of the royal hunting estates of La Muette and Madrid in 1734).[203] The most avid Parisian collector of de Troy's *tableaux de mode* was Germain-Louis Chauvelin (1685–1762), Garde des Sceaux, Minister of Foreign Affairs, and the executor of the Comtesse de Verrue's will, whose fall from office in February 1737 apparently prevented him from taking possession of *Before the Ball* (cat. 27) and *After the Ball*.[204] The list of well-born (or well-placed) collectors of genre subjects could be extended well beyond the small sample given above.[205]

URBANITY

If lexical confusion, typological diversity, and dependence on seventeenth-century models have so far presented themselves as governing principles in this introduction, are there also themes and preoccupations particular to genre painting that shape its production over the century as a whole? Can the historian find certain meaningful continuities linking the various

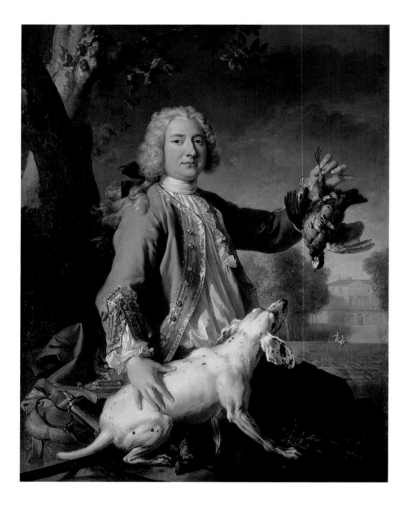

Fig. 15 Jean-Baptiste Oudry, *Portrait of the Marquis de Béringhen*, 1722. National Gallery of Art, Washington, D.C., Eugene L. and Marie-Louise Garbaty Fund, Patrons' Permanent Fund and Chester Dale Fund

and are mediated by their current (or prior) treatment in other art forms (the print media, the theatre in its many manifestations).[207] With its use of symbols and allusions, genre painting is no less multivalent than history; but it is the engagement with the real that defines its practices and offers the possibility of renewal. Watteau's *Shopsign* (fig. 1) inverts the proportions of Gersaint's haberdasher's shop on the Pont Notre-Dame, which was long, narrow, and dark.[208] Of the mythological and religious Old Master works in their elegant frames that adorn its walls, not a single one can be identified.[209] The *Portrait of Louis XIV* that is being lowered into the case is a reference to the name of Gersaint's shop, "Au Grand Monarque" (a name inherited from its previous owner, Antoine Dieu).[210] Yet in its sympathetic presentation of a group of fashionable men and women, faithful depiction of furnishings, costumes, and coiffures, and understated yet dignified treatment of work, Watteau crafted an authentic documentary idyll, which, as Francis Haskell noted, "enabled much of his own century to see itself through his eyes, and posterity to accept this vision as genuine."[211]

Furthermore, it is not only with social activities that genre is concerned; states of mind, and more specifically states of the heart, are a constant theme.[212] The central preoccupation of the *fête galante* is the erotic; the grandest of its examples has recently been interpreted as showing "the immense reverberations of a most profane coition."[213] In rustic genre and the pastoral, a panoply of gallant symbols is marshalled to delineate the burgeoning of desire and its fulfilment.[214] From the peripheries, as the stock-in-trade of arabesque decoration, motifs such as shepherdesses, gallant gardeners, caged birds, restless animals, even fruits and vegetables assume centre stage as ciphers of sexual anticipation and sexual satisfaction.[215] Related to pastoral imagery is the representation of children's games, which appear in tapestry cartoons, decorative panels, and easel paintings: swinging (see fig. 13), seesaw (Museo Thyssen-Bornemisza, Madrid), blindman's buff (cat. 12, 75), as well as diversions that are lost to an audience of today – such as "le pied-de-boeuf" (cat. 23, 102) and "la main chaude" (fig. 16).[216] While such games continued to be played by adults throughout the century – the *Mercure galant* of August 1714 noted that participants at the Tuileries's nocturnal ball descended from their carriages to dance and "play blindman's buff and other games,"[217] and Marie-Antoinette resurrected these pastimes among her intimate circle at Versailles[218] – they infiltrated genre painting as symbols for altogether less innocent desires and occupations.[219]

Adult entertainments enjoyed a more transparent representation in the *fête galante* and the *tableau de mode*. In inventing the new genre, Watteau was inspired by the performances of the itinerant players at the foire Saint-Germain and the foire Saint-Laurent, who had adapted the characters and stories of the *commedia dell'arte* after the Italian comedians

manifestations of genre, despite its range of subjects, formats, and functions?

A consideration of subject matter offers a tentative answer to these questions. With the greatest caution it can be argued that genre painting invents pictorial forms for certain aspects of Parisian leisure and domesticity; that it offers visual equivalences for the practices of elite sociability in the capital; and that, as the century progresses, the resonance of its themes broadens from the aristocratic to include the rituals of domestic life as they played themselves out at various levels of Parisian society.[206] The correspondences (and dissonances) between various social practices and their representation in high art must be identified rather than assumed. Different social groups and their activities present themselves obliquely, are filtered through a matrix of art-historical precedent and iconographic tradition,

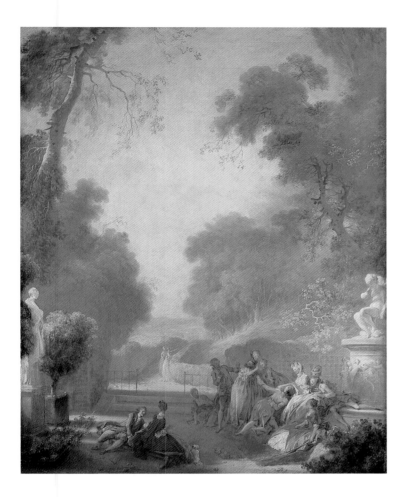

also responded to modes of sociability that were distinctly modern.[223] Amateur theatricals (*parades*) staged in the country retreats of well-to-do Parisians such as Guellette and Caylus, for example, brought together urbane guests, masked and costumed, with actors in theatrical and peasant dress – a mixing of types characteristic also of the *fête galante* (cat. 7).[224] In his biography of Watteau of 1727, Dubois de Saint-Gelais noted that the artist had "perfectly represented the concerts, dances, and other amusements of civil life; and had made a point of showing real costumes, so that his pictures may be considered a history of the fashion of his times."[225]

Yet as Thomas Crow has pointed out, Watteau's *fêtes galantes* were hardly a "literal rendering of the life around him, however much accuracy of description they might contain."[226] While in his theatrical paintings, the prominence of Mezzetin and Pierrot reflected the priorities of the fair – Pierrot in particular had become a favourite character – Watteau's presentation of them as lyrical, sensitive figures (cat. 10) departed radically from their rough-and-tumble presentation on stage.[227] Similarly, although the *fête galante* responded in many of its particulars to the experience of the masquerades, participants in the balls were always masked (as the term implies), and the balls were always held at night.[228] With the single exception of the torchlit *Love in the Italian Theatre* (cat. 6), Watteau's *fêtes galantes* are bathed in radiant sunlight and his revellers never go masked.

De Troy would prove himself a more accurate chronicler of the diversions of the beau monde: both *Before the Ball* (cat. 27) and the *After the Ball* (fig. 17) are properly nocturnal scenes, in which the protagonists wear dominoes and carry masks.[229] (Had Boucher completed his series of the *Times of the Day* for Luisa Ulrike, *Night* would have shown a group of "foolish women setting off in their ball costumes.")[230] De Troy's immaculate *tableaux de mode* are selective in their "realism," however, despite the pleasure so evidently taken in the brocades and patterned silks of the *robe volante* and the embroidered buttons and buttonholes of the collarless *justaucorps* (cat. 26). In *The Garter* (fig. 19), for example, the bracket clock that shows half past eleven is an exact rendering of a type designed by Martinot and Boulle; the bronze statuette on the console table is after Giambologna's *Architecture*.[231] Yet the model for the low-slung armchairs in *The Reading from Molière* (cat. 25) has never been identified, just as the *boiserie*, over which an improbable curtain falls, conforms to no known design.[232] Nor have the "supremely policed" seductions that take place in *The Reading from Molière* and its pendant *The Declaration of Love* (cat. 26) – which share their stately, unhurried rhythms with Marivaux – fully liberated themselves from an older emblematic tradition. In *The Reading from Molière*, the fire that is burning in the afternoon and the screen that protects the company from the draft reminds us that this is a winter scene;[233] just as the outdoor setting and highly patterned dresses of *The Assembly in the Park* confirm the season as summer.[234] The lack of any obvious narrative

had been banished from Paris in 1697. (Their repertory was also taken up in danced *divertissements* at the Opéra and Comédie Française, and in private amateur theatricals.)[220] Similarly, the elegant lovers of the *fête galante* who, dressed in both contemporary and historical costume, engaged in decorous (and not so decorous) flirtation in parks and country settings, bore witness to the extraordinary popularity of balls and masquerades in Regency Paris.[221] In carnival season there might be as many as five balls weekly; ticketed masked balls were held at the Opéra in December 1715 and at the Comédie Française the following year; public balls at the Champs-Élysées enjoyed a huge attendance, "where, having no seat but the grass, one sat down without ceremony."[222]

While Watteau's highly-charged outdoor gatherings, suggestive of the elegant pleasures of an aristocracy in retirement, may have communicated a certain nostalgia, they

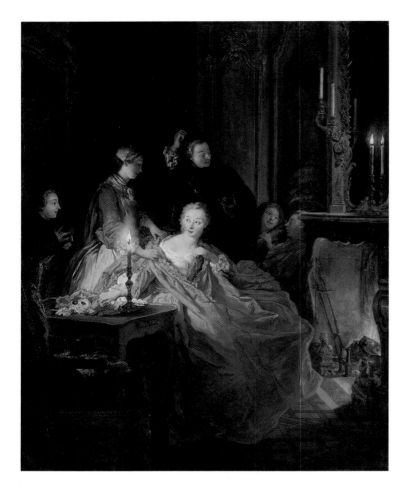

repose, having lunch on the grass or at a nearby village inn, more or less appropriately attired. Lemoyne's and Watteau's hunters wear seventeenth-century costume and "Spanish dress;"[238] Van Loo and Lancret's women participate in the hunt and are dressed accordingly "en Amazone;"[239] de Troy's impeccably attired seigneurs, resplendent in their *habits de chasse*, offer food and wine to women in fashionable city clothes who have just arrived by carriage to join them for lunch.[240] Given the court's continuing obsession with this sport – to say nothing of its popularity among the nobility and upper classes – its disappearance from the genre painter's repertory after mid-century has yet to be accounted for.[241] Such was the hunt's appeal during the 1720s and 1730s, however, that the most poetic of its interpreters was an artist who in his genre scenes resolutely avoided adult masculine activity of any sort. As the Goncourts were the first to note, the game bags, powder flasks, and recently shot game and fowl of Chardin's still-lifes transform them into the most poignant "retours de chasses" (fig. 18).[242]

The epicurean pleasures of the *fête galante*, *tableau de mode*, and hunting scene would gradually yield to the delights of a more conjugal domesticity in portrayals of families, children, and servants. Before Greuze and Fragonard, this domesticity was unrepentantly Parisian, attentive to fashion, interior decoration, even forms of eating and drinking. Note, for example, the stocking clocks, backless mules, and knotting bag of Boucher's *Lady Fastening her Garter* (cat. 52) and *Presumed Portrait of Madame Boucher* (cat. 53); the aproned servant pouring coffee from the bulbous high-spouted pot in Boucher's *The Luncheon* (fig. 21), who reappears three years later, along with the child's fashionable doll in a hooped dress, in Lancret's

Fig. 18 Jean-Baptiste-Siméon Chardin, *Still-life with Hare*, c. 1726. Philadelphia Museum of Art, Gift of Henry P. McIlhenny

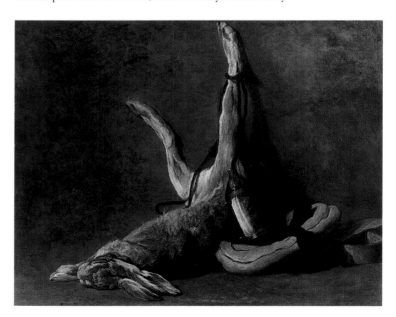

connecting the two pendants raises the possibility that de Troy may initially have conceived of them serially, as allegories of the Seasons in a resolutely mondain incarnation.

The male participants in de Troy's *tableaux de mode* are nearly always members of the grandest nobility, since the artist rarely missed the opportunity to show their red heels ("les talons rouges"), a distinction conferred only on those who had been presented at court (fig. 20).[235] Indeed, no subject was more courtly than the hunt, which in the 1720s and 1730s inspired a series of masterpieces of genre painting (as well as tapestries, portraits, and still-life).[236] Whereas Oudry's tapestries recorded in meticulous (and bloodthirsty) detail the various stages of this "noble exercise reserved for the pleasure of kings and the nobility,"[237] genre paintings by Watteau, Lancret (cat. 15, 16), Lemoyne (cat. 22), Van Loo, and de Troy (cat. 28) portrayed elegant hunters and their female companions in

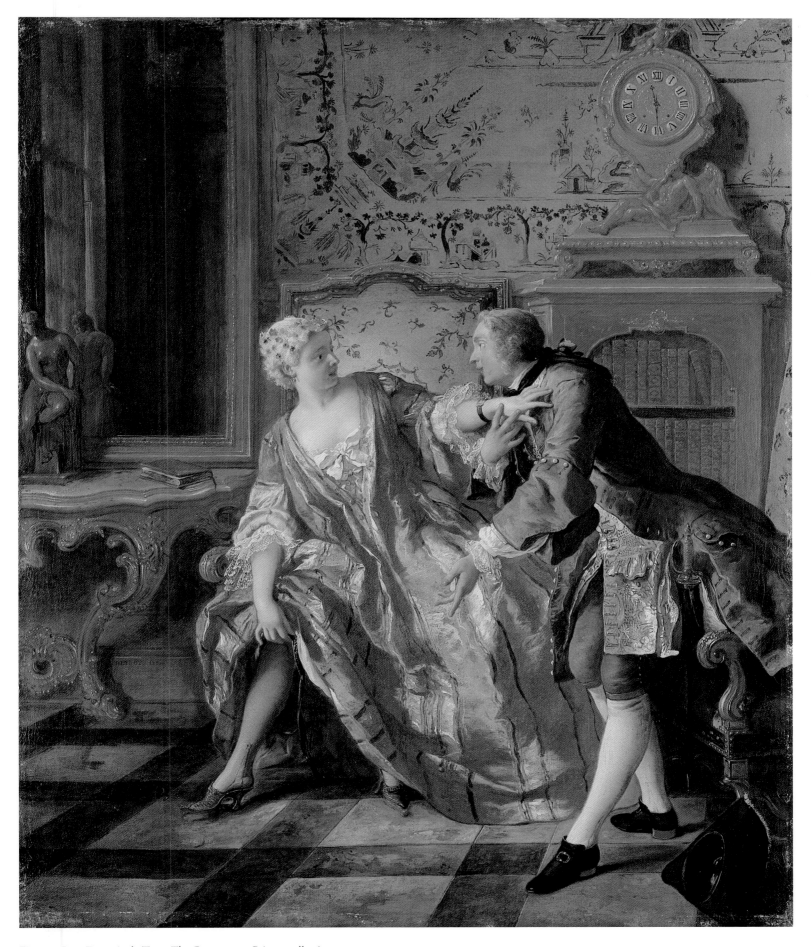

Fig. 19 Jean-François de Troy, *The Garter*, 1724. Private collection

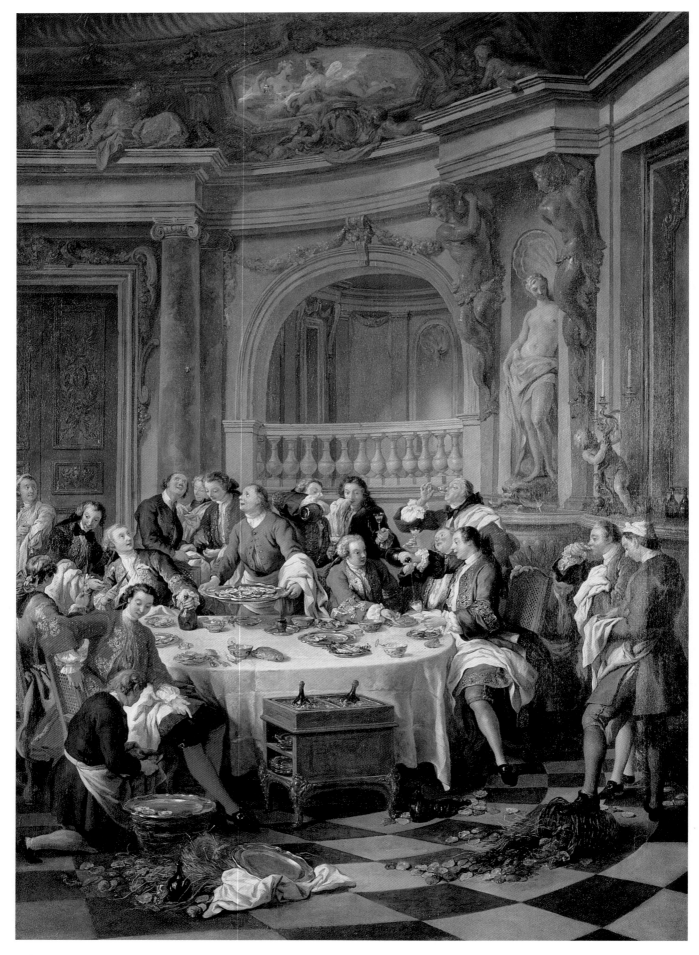

Fig. 20 Jean-François de Troy, *The Oyster Luncheon*, 1734. Musée Condé, Chantilly

Fig. 21 François Boucher, *The Luncheon*, 1739. Musée du Louvre, Paris

Lady in a Garden Taking Coffee with Some Children (cat. 17). And whereas de Troy's protagonists conduct their gallantry in front of tradesfolk and ignore the servants,[243] Boucher's and Lancret's are, at the very least, prepared to acknowledge theirs. Such is the intimacy of Boucher's *Luncheon* that it was long considered to represent the artist and his family.[244] Eighteenth-century viewers, on the other hand, would have had no hesitation in identifying the servant as a "*garçon Limonadier* who has served the coffee."[245]

At first glance, Chardin, the most Parisian of all genre painters – born and trained in the city which he rarely left, and in which he worked all his life – seems little interested in the details of urban domesticity. In the singularity of his pictorial technique, the hermeticism of his genre scenes, and the priority given to children and servants in his desexualized canon, he seems wilfully to distance himself from the practices of adult sociability.[246] Yet it is in Chardin's genre painting that the representation of such sociability, however chastened, is for the first time liberated from the burden of allegory: in breaking with the conventions of serial imagery, Chardin depicts his children as children, not as emblems of the Elements, the Seasons, or supporting figures in the Four Ages of Man.[247]

Fig. 22 Jean-Baptiste-Siméon Chardin, *The Diligent Mother*, 1740. Musée du Louvre, Paris

Furthermore, while selective in his subjects – husbands never appear; mothers only occasionally; children, if not playing alone or with each other, are most often shown with their servants – Chardin's concerns are not narrowly self-regarding, but engage with issues of interest to a patrician audience, above all in the regulating of an ideal domestic economy, and the upbringing and education of children after they have returned to the family from the wet-nurse (unlike Greuze and Fragonard, Chardin never shows infants).[248] Chardin's children are encouraged in game playing, which serves as a legitimate recreation from the duty of learning to read and write. Fénelon, taking up John Locke's reforms in his *De l'éducation des filles*, first published in 1687, urged: "Let us make studies pleasant. Let us allow children to relax and play so that their spirit can refresh itself."[249] Following Locke's recommendations, Chardin's children are portrayed helping each other to read (cat. 40).[250] Even at play, they are always ready to return to some useful occupation: the girls have their scissors and needles at hand; the boys, their pens and books.[251]

Chardin also pictorializes the domestic responsibilities of the exemplary mistress of the household, "charged with the education of her children and the behaviour of her servants."[252] His mothers examine their daughters' embroidery (fig. 22) or accompany them to morning Mass (cat. 41). It is the governesses who prepare the children for their lessons (cat. 39) and give them their meals.[253] Note the presence of only two bowls of soup in *Saying Grace* (fig. 14); the maid in her blue serge apron – referred to by a contemporary as "une sage gouvernante" – does not join her charges at table.[254]

Thus, while Chardin rejects nearly all external references to Parisian domesticity, details of which so colourfully infiltrate the genre scenes of de Troy, Lancret, and Boucher, his genre paintings are nevertheless engaged with the rituals of a domestic economy that would have been familiar to the grandest households. Audiger's precepts in *La maison reglée* – a handbook for the running of "the residence of a great lord," first published in 1692 – find a remarkable correspondence in Chardin's representations.[255] "A good servant," Audiger notes, "should know her meats well, and how to buy them; cook appropriately for the type of people she serves; ensure that the dishes and pots and pans are always clean; and . . . be prompt and diligent in returning from the errands she is given."[256] Chardin's *Return from the Market* (cat. 38), in which a servant has just returned to her scrupulously clean pantry with the bread and poultry she has bought, becomes an *exemplum virtutis* of the humblest kind.[257]

Similarly, Chardin's governesses (cat. 39 and fig. 14) are shown to be following their duties, as defined in Audiger's handbook, almost to the letter:

The duty of a children's governess is to take good care of those who are placed under her direction. She must always

make sure they are kept very clean, and show much kindness and understanding to them. . . . She must feed them, put them to bed, and wake them up at the regular and appropriate hours. . . . And she must also teach them to pray to God and make the sign of the cross from the tenderest age.[258]

Despite Cochin's claim that paintings like *The Governess* (cat. 39) and *The Morning Toilette* (cat. 41) "were ennobled by a more elevated rank of personage,"[259] a critic to the Salon of 1741 noted that it was "always the Bourgeoisie that he calls into play. . . . Does a woman of the Third Estate ever pass by without believing that she is looking at an image of herself, her home life, her simple ways?"[260] While preferring to situate his figures in relatively modest surroundings, Chardin had them engage in rituals of service and recreation that also would have been carried out in far grander households. (As is well known, Louis XV, Frederick the Great, Catherine II, and Prince Joseph Wenzel of Liechtenstein were among the first owners of his genre paintings).[261] That modern historians have failed to reach any consensus on the precise status of the families depicted in Chardin's genre painting seems consistent with the elusive social topography the artist so wilfully pursued. For Marie-Catherine Sahut, Chardin paints "the well-regulated childhood of a plebian elite;"[262] Crow came to the conclusion that middle-class life "evidently held no great interest for him."[263]

If Chardin's world was mysterious – at times the servants' quarters are barely distinguishable from the rooms upstairs – Greuze and Fragonard preferred unambiguously rustic settings, peasant households of modest appearance in which offspring are numerous and servants a rarity.[264] As critics recognized, in Greuze's Salon submissions of the decade 1757 to 1767 there was a strong family resemblance: his multifigured compositions showed large, devoted families celebrating marriage (cat. 71), assisting at a patriarch's demise (cat. 72), or witnessing the consequences of an elder son's rebellion. Less ambitious genre paintings returned almost obsessively to maidservants, young mothers, and nursemaids in varying states of decency and disarray – their dresses more or less dishevelled, their breasts more or less exposed (cat. 66, 69) – or to gullible adolescents awakening to the first stirrings of love (cat. 68).[265] Greuze's rural elite – a prosperous, hardworking, and fecund peasantry – was a fiction of enormous appeal (and novelty) to Parisian sensibilities, tiring somewhat of the tender and "realistic" tales of the loves of shepherds and shepherdesses, pioneered in the 1740s by Favart at the fair theatre and by Boucher in his painted pastorals.[266] When Greuze tackled the portrait of Jean-Joseph de Laborde and his family in 1769 – the banker to Louis XV was one of the richest men in France – he placed the happy parents, mother-in-law, and six children (three of

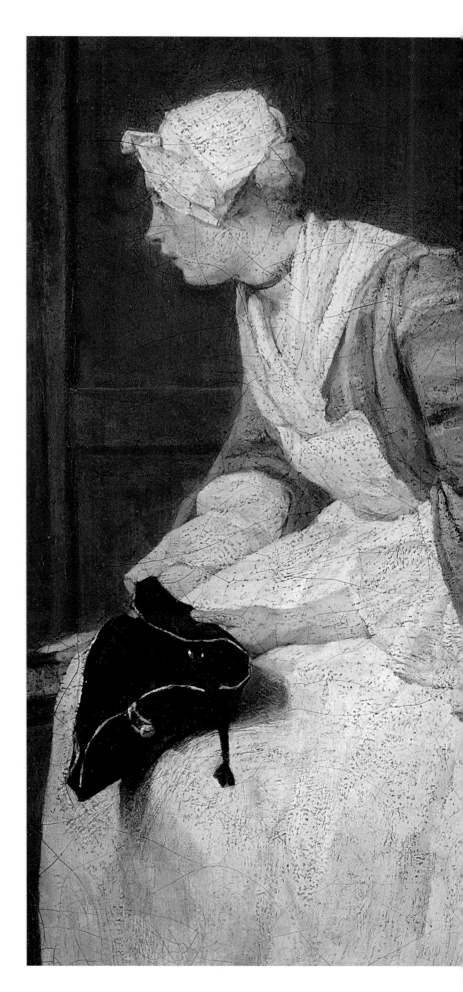

Detail of cat. 39

Fig. 25 Jean-Baptiste Greuze, *The Well-Loved Mother*, c. 1765. National Gallery of Art, Washington, D.C., New Century Gift Committee

Fig. 23 Jean-Baptiste Greuze, *The Beloved Mother*, 1769. Private collection, Madrid

Fig. 24 Jean-Baptiste Greuze, *The Drunken Cobbler*, c. 1780. Portland Art Museum, Oregon, Gift of Marion Bowles Hollis

whom had not yet been born) in the same setting as *The Marriage Contract* (cat. 71) and *Filial Piety* (cat. 72).[267] Returning from the hunt, gun in hand and dogs at his side, the joyful father greets a wife almost overpowered by their loving offspring – one of which has just been nursed at the breast. Set in a spotless room, with scrubbed floorboards and bare walls, *The Beloved Mother* (fig. 23) is aristocratic fiction in distinctly physiocratic form.[268]

If Greuze's genre paintings pictorialized many of the social concerns dear to Enlightenment thought – the primacy of agriculture, the bonds of family, the encouragement of population – they were also responding to the *genre poissard*, a comic sub-genre in popular literature and theatre that

flourished during the 1740s and 1750s and took as its subject the fishwives and boatmen along the Seine and the stallholders of the Paris markets, Les Halles.[269] Like the *commedia dell'arte* for Watteau and his generation, the *genre poissard* with its amorous entanglements and colourful, if foulmouthed, vernacular received its most enthusiastic reception on the fringes of the official literary and theatrical world. *Poissard* characters and dialect appeared in aristocratic *parades* (Caylus wrote several *poissard* stories); they infiltrated the repertory of the Parisian fairs (Favart also wrote plays in the *genre poissard*), and during the 1750s the impresario Jean Monnet, responsible for refurbishing the fair theatres and revitalizing the moribund Opéra Comique, introduced the plays of Jean-Joseph Vadé – "the Teniers of poetry" – to a wide and appreciative Parisian audience.[270]

Capitalizing on this sophisticated fascination with popular types, around 1760 Greuze also took many subjects from Caylus and Bouchardon's recent reworking of the *Cris de Paris*: among his drawings, made to be engraved, one might cite *The Seller of Baked Apples, The Seller of Chestnuts, The Chimney Sweep*. At the same time, he also treated one of Caylus's *poissard* tales,

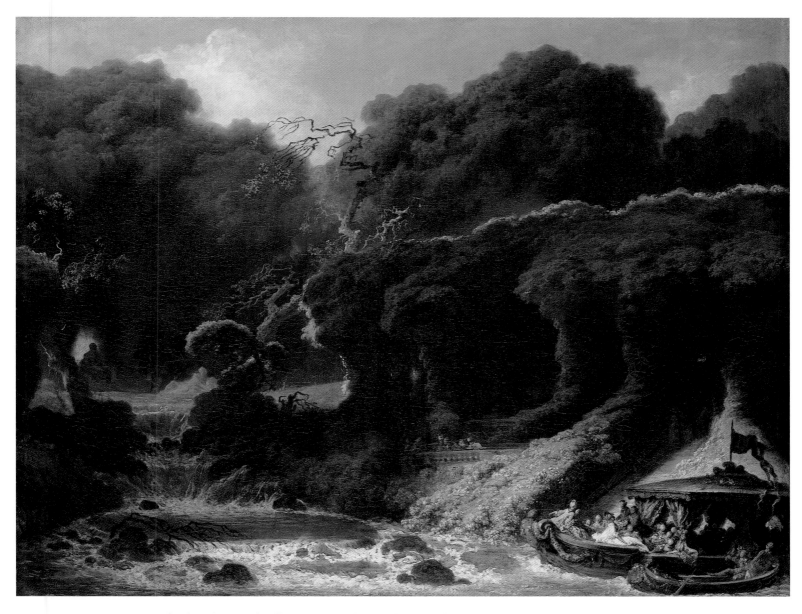

Fig. 26 Jean-Honoré Fragonard, *The Fête at Rambouillet*, c. 1770. Fundação Galouste Gulbenkian, Lisbon

The Pea Shellers, known today only from Le Bas's engraving.[271] Recruiters who betrayed young men into the King's service (*La Rapée, Les Racoleurs*) and drunken shoemakers pursued by shrewish wives (*Le Savatier petit maître à la Foire*) were stock characters in the *poissard* repertory, and would be the subjects of two of Greuze's most Poussinesque genre paintings, *The Punished Son* and *The Drunken Cobbler* (fig. 24).[272] Contemporaries had little difficulty in identifying Greuze's more ribald maidservants and laundresses as *poissard* types, and the denizens of Les Halles were recognized in his more ambitious multifigured compositions as well. This, at least, was the insight of a "femme d'esprit," which Diderot admiringly repeated in his review of *The Marriage Contract* (cat. 71). She had noted that whereas the male figures in this composition were recognizable countryfolk, the mother, fiancée, and other

female characters all came from Les Halles: "The mother is a robust fruitseller or fishwife; the daughter a pretty flower girl."[273] Four years later, at the Salon of 1765, Diderot responded to the drawing of *The Well-Loved Mother* (fig. 25) in similar terms: "Just look at this fine, fat fishwife."[274]

Having started in Chardin's studio before being accepted as a student by Boucher, and having first met Greuze (whom he referred to as an "amorous cherub") in Rome,[275] Fragonard was steeped in the various modes of genre painting – high and low, old and new. Thus, rustic laundresses (cat. 76, 77) and happy peasant families (cat. 79) attract him no less than their urban cousins who involve themselves in bringing up their own children (cat. 87) and dally while their elders play cards (cat. 86). Fragonard's depictions of children's games and pastoral subjects look back to well-established modes: so "naturalistic"

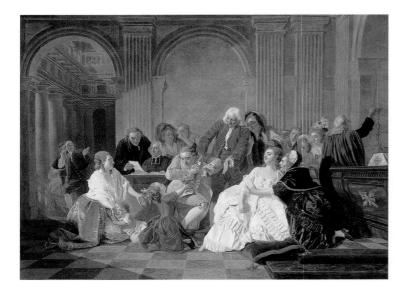

Fig. 27 Étienne Aubry, *The Broken Marriage*, 1777. Private collection

Fig. 28 Pierre-Alexandre Wille, *Begging*, 1777. Musée des Beaux-Arts, Angers

is his treatment of them, that the true subject of *The Stolen Kiss* (cat. 86), which represents the end of a game of "le pied-de-boeuf," has been overlooked by modern commentators.[276]

In his grandest landscapes and decorations (fig. 2), with their costumed gallants and impossibly verdant gardens (fig. 26), Fragonard seems consciously to resurrect the poetry and longing of the *fête galante*. Yet unifying his diverse and thematically nostalgic production, which treats various modes in various languages, is a flagrant eroticism – the Goncourts' "polisonnerie érotique" – overpowering and at times obliterating the slightest immersion in the real.[277] Fragonard's retreat from the agendas of Enlightenment into a purely fictive world, whose dramatis personae are nearly always fresh-faced adolescents on the threshold of adulthood – Lafontaine's "striplings" (*jouvenceaux*) – repeats on a different register the cleansing and generalizing demanded of the history painter for his most noble compositions. Even the most Parisian of Fragonard's genre paintings resists any profound engagement with the documentary, or the specific. In *The Bolt* (cat. 84), for example, the tunnelling draperies of the magisterial *lit à la polonaise* and the voluminous folds of the woman's elegant satin dress appear out of place in this dramatically lit (attic?) bedroom, with its plain walls, bare floor, and sparse furnishings (of which the lock is by far the most prominent). What is the respective status of this well-shod woman and her barefoot suitor, whose long-sleeved shirt and tight breeches suggest a

more menial occupation? That such details remain ambiguous, in no way impedes our pleasure in this picture, whose meaning is reinforced by the juxtaposition of the single apple resting on the draped table with the overturned chair and discarded bouquet of flowers on the floor.[278]

By the 1780s these very details, divorced from any allegorical or philosophical agenda, will overwhelm genre painting, whose canon is now established, and whose subjects are passed down, second-hand. Urban and rustic families, with their courtships, costumes, and dramas (figs. 27, 28), are uniformly treated with the meticulous finish of the *fijnmaler* (fine painter): legible, anecdotal, charming, and journalistic. In keeping with the values of the Academy's revitalized hierarchy, genre painting, reassigned to the peripheries and soon to become the stock-in-trade of the "petit-maître" (the terms are now synonymous), finally polices itself. Diderot's condescending characterization of genre painters as "those who paint trivial subjects, little domestic scenes lifted from street corners" becomes a self-fulfilling prophecy in the exquisite promenades and diversions of Boilly and his generation.[279]

NOTES

I thank John Collins, Anik Fournier, and Joanna Sheers for their research assistance, and am particularly grateful to Philip Conisbee, Mary Tavener Holmes, and Christophe Leribault for their generosity. Without the unflagging support and inexhaustible energy of Margaret Iacono, curatorial assistant at The Frick Collection, this essay would not have seen the light of day. For his patience and forbearance, I thank Alan Wintermute.

1 *Procès-Verbaux*, IV, p. 216 (Lancret, received 26 February 1718); ibid., IV, p. 404 (Octavien, received 24 November 1725).

2 Ibid., V, p. 47 (Chardin, admitted and received 25 September 1728).

3 Ibid. (Bonaventure de Bar, admitted and received 25 September 1728).

4 Ibid., IV, pp. 51–52 (Pater, received 31 December 1728).

5 Ibid., VI, p. 418 (Greuze, received 28 June 1755); ibid., VII, pp. 2–3 (Jeaurat de Bertry, admitted and received 31 January 1756).

6 Ibid., VII, p. 206 (Favray, admitted and received 30 October 1762).

7 Ibid., p. 243 (Leprince, admitted 7 April 1764).

8 Ibid., VIII, pp. 151–52 (Wille and Théaulon, admitted 25 June 1774).

9 Ibid., IX, p. 71 (Debucourt, admitted 27 July 1781).

10 Stechow and Comer 1975–76 remains the best introduction to usage and terminology. Two unpublished doctoral dissertations have surveyed eighteenth-century genre painting and its reception: see McPherson 1982 and Anderman 2000. Recent fine studies of Greuze and genre painting are Barker 1994 (soon to be published) and Ledbury 2000. For the most recent introduction to the topic as a whole, see Rand 1997.

11 *Procès-Verbaux*, VII, p. 322 (22 February 1766), noted in Anderman 2000, p. 109. For two of his *fêtes galantes* recently acquired by the Musée de Valenciennes, see *Revue du Louvre*, pp. 5–6 (December 1997), p. 116.

12 *Procès-Verbaux*, IX, p. 257 (24 September 1785).

13 Ibid., VIII, pp. 18–19 (23 July 1769). "M. Greuze, Peintre de genre a présenté le tableau qu'il a fait pour sa réception, dont le sujet est l'Empereur Sévère qui reproche à Caracalla, son fils, d'avoir voulu l'assassiner." For the classic account of Greuze's admission to the Academy, see Seznec 1966.

14 Gougenot 1749, p. 108.

15 Bachaumont, *Mémoire concernant l'Estat des Academies royales . . . en l'année 1737*, Bibliothèque de l'Arsenal, Ms. 4041, fol. 320. Among the "peintres à talent," he lists Desportes, Oudry, Chardin, Lancret, Parrocel, and La Joue.

16 In his obituary of Watteau published in *Le Mercure* (August 1721), Antoine de La Roque claimed that his easel paintings "en petites figures" were all done "dans le goût Flamand" (see Rosenberg 1984, p. 5); the abbé Raynal (*Correspondance littéraire* [1750], I, p. 464) characterized Chardin as excelling in "petits sujets naïfs dans le goût flamand"; Grimm (ibid. [September 1755], III, p. 94) described Greuze's *envoi* to the Salon of 1755 as "tableaux dans le goût flamand."

17 "Le génie de cet Artiste le portait à composer de petits sujets galants" (La Roque on Watteau; see Rosenberg 1984, p. 6); Lancret's paintings at the Place Dauphine were described by the *Mercure de France* as "divers sujets galants" (1722) and "petits tableaux . . . dans un goût tout à fait galant" (1723; see Wildenstein 1924, pp. 46–47).

18 Bachaumont on Chardin: "Il excelle . . . aux petits sujets naïfs" (in *Mémoire concernant l'Estat des Académies royales . . . en l'année 1746*, Bibliothèque de l'Arsenal, Ms. 4041, fol. 335).

19 Dezallier d'Argenville (1745–52) on Watteau: "le goût qu'il a suivi est proprement celui des bambochades" (cited in Rosenberg 1984, p. 50); and see Boyer d'Argens 1768, cited at n. 170 below. Mariette (1851–60, II, pp. 329–30) claimed that Greuze "a choisit pour son genre celui des bambochades," as did Gougenot ("son talent de peindre des Bambochades," cited in Munhall 1976). In the 1750s, the Le Nain brothers were similarly categorized: "Ils peignoient des bamboches dans le style françois" (Mariette 1851–60, c. 1750); in Hulst's *Tableau chronologique de tous les peintres*, c. 1753, Louis Le Nain is listed as "P[eint]re de Bambochades" (see Thuillier 1964, pp. 265–66).

20 "On appelle ainsi des Tableaux où le Peintre a représenté des Scènes galans et champêtres; des Foires, des Tabagies, et autres Sujets réjouissans." Lacombe 1752, p. 53. Three years earlier Gougenot (1749, p. 103) had explained the origins of a term whose usage, while not sanctioned by Furetière's *Dictionnaire universel* (The Hague and Rotterdam, 1690), was current: "Le nom qu'on a donné à ce genre de composition vient de BANBOCHE [*sic*], Peintre Hollandois qui s'est adonné particulièrement à des sujets familiers, & quelquefois bas."

21 For the fullest eighteenth-century definition, see Watelet and Levesque 1792, I, pp. 173–77. It is clear that the term was still the preferred synonym for "genre painting" as we understand it today: "On appelle aussi, dans le langage plus sérieux de la Peinture, *Bambochade*, une sorte de genre qui embrasse la représentation de la nature rustique, les habitations des Villageois, leurs usages ou leurs mœurs vulgaires."

22 Noting the absence of "genre painting" in both Perrault's and Félibien's hierarchies, Thomas Kirchner has emphasized the *étatique* function of these theoretical programmes, articulated (or restated) in conjunction with ambitious decorative campaigns being undertaken in the royal palaces (the east wing of the Louvre; Versailles in the 1680s): "Chez Félibien, comme chez Perrault, la peinture de genre est absente. Cette dernière, genre bourgeois par excellence, ne concernait pas les châteaux" (Kirchner 1997, p. 193).

23 "Que l'on peut savoir sans être peintre." Félibien 1660, pp. 57, 59.

24 "Ainsi celui qui fait parfaitement des paysages est au-dessus d'un autre qui ne fait que des fruits, des fleurs, ou des coquilles. Celui qui peint des animaux vivants est plus estimable que ceux qui ne représentent que des choses mortes & sans mouvement: & comme la figure de l'homme est le plus parfait ouvrage de Dieu sur la terre, il est certain aussi que celui qui se rend l'imitateur de Dieu en peignant des figures humaines, est beaucoup plus excellent que tous les autres. . . . Néanmoins un Peintre qui ne fait que des portraits, n'a pas encore atteint cette haute perfection de l'Art et ne peut pas prétendre à l'honneur que reçoivent les plus sçavans. Il faut pour cela passer d'une seule figure à la représentation de plusieurs ensemble; il faut traiter l'histoire & la fable; il faut representer de grandes actions comme les Historiens, ou des sujets agréables comme les Poëtes." Félibien 1725, V, pp. 310–11.

25 Ledbury 2000, especially pp. 1–20.

26 De Piles 1699, pp. 28–29; see Anderman 2000, p. 27.

27 "Les peintres se servent avec raison du mot d'histoire pour signifier le genre de Peinture le plus considérable, et qui consiste à mettre plusieurs figures ensemble; et l'on dit: ce peintre fait l'histoire, cet autre fait des animaux, celui-ci le paysage, celui-là des fleurs, et ainsi du reste." De Piles 1989, p. 31.

28 "L'histoire, il est vrai, est le plus noble objet de la peinture . . . & celui qui demande le plus de connoissances; le paisage, les animaux, les fruit & les fleurs n'en sont que l'accessoire, ils ne servent le plus souvent qu'à orner les sujets d'histoire." Dezallier d'Argenville 1745–52, I, p. ix.

29 "Le mot *genre* . . . sert proprement à distinguer de la classe des peintres d'histoire, ceux qui, bornés à certains objets, se font une étude particulière de les peindre, et une espece de loi de ne représenter que ceux-là: ainsi l'artiste qui ne choisit pour sujet de ses tableaux que des animaux, des fruits, des fleurs ou des paysages, est nommé *peintre de genre*." Watelet, in Diderot and d'Alembert 1751–76, VII, p. 597.

30 Goodman 1995, I, p. 60; "C'est que cette peinture qu'on appelle de genre, devrait être celle des vieillards ou de ceux qui sont nés vieux; elle ne demande que de l'étude et de la patience, nulle verve, peu de génie, guère de poésie, beaucoup de technique et de vérité; et puis c'est tout" (Diderot 1984b, p. 118).

31 Goodman 1995, I, pp. 93–94; Diderot 1984b, pp. 172–73.

32 "Dans la peinture de genre il faut tout immoler à l'effet." Diderot, *Oeuvres esthétiques*, Paris, 1968, p. 772.

33 "A nous toucher, à nous instruire, à nous corriger et à nous inviter à la vertu." Diderot 1984b, p. 232, responding with enthusiasm to Greuze's *Filial Piety* (cat. 72).

34 Goodman 1995, I, p. 195; Diderot 1984b, p. 16.

35 Goodman 1995, I, p. 230, translation slightly amended and my italics; "On appelle du nom de peintres de genre indistinctement *et* ceux qui ne s'occupent que des fleurs, des fruits, des animaux, des bois, des forêts, des montagnes, *et* ceux qui empruntent leurs scènes *de la vie commune et domestique*" (Diderot 1984b, p. 66; my italics).

36 "La représentation des actions humaines les plus simples et les plus familières, soit à la ville ou à la campagne, scènes pastorales, fêtes

champêtres, foires, noces de village, enfin jusqu'aux cuisines, aux tavernes, aux écuries." *Sentiments sur quelques ouvrages de peinture, sculpture et gravure*, 1754; cited in Jollet 2001, p. 299.

37 For these reforms, see Locquin 1978, pp. 2–13.

38 "On est fort éloigné du sentiment de quelques auteurs qui, n'estimant que les peintres d'histoire, regardent comme fort inférieurs ceux qui peignent le portrait, le paysage, les batailles, les marines, les animaux, l'architecture, les fruits, les fleurs, *les noces de village, les tabagies et les cuisines*." Dezallier d'Argenville 1762, I, p. xviii (my italics). It should not be assumed that Dezallier was attacking the Academy's hierarchy: in his Life of Watteau he criticized the artist for following Gillot in his choice of genre, and thereby not treating history "dont il paroissoit fort capable." Ibid., IV, p. 407.

39 "Les sujets que Teniers, Wouwermans et les autres peintres de ce genre ont représentés n'auraient obtenu de nous qu'une attention très légère. Il n'est rien dans l'action d'un fête de village ou dans les divertissements ordinaires d'un corps de garde qui puisse nous émouvoir." Dubos 1993, p. 18.

40 Goodman 1995, I, p. 230; "Gens à petits sujets mesquins, à petites scènes domestiques prises du coin des rues" (Diderot 1984b, p. 66).

41 Goodman 1995, I, p. 230; "Il fallait appeler peintres de genre les imitateurs de la nature brute et morte; peintres d'histoire les imitateurs de la nature sensible et vivante" (Diderot 1984b, p. 67).

42 Crow 1985, p. 195.

43 "Greuze s'est élancé tout à coup de la bambochade dans la grande peinture, at avec succès." Diderot to Falconet, 15 August 1767, cited in Seznec 1966, p. 342.

44 "On a relégué dans la classe des peintres de genre les artistes qui s'en tiennent à l'imitation de la nature subalterne et aux scènes champêtres, bourgeoises et domestiques." Diderot 1995a (*Salon de 1769*), pp. 84–85.

45 The use of the term "genre painting" as a reference to scenes from everyday life seems to have gained currency only in the 1770s, more often than not as a convenient comparison when alluding to the parlous state of current history painting. For example: "Il y avoit très peu de tableaux d'histoire, mais beaucoup de ceux qu'on appelle genre" (*Plaintes de M. Badigeon*, Paris 1771, p. 7 [Collection Deloynes no. 144]); at the Salon of 1775, "les Tableaux de genre" were considered "le triomphe de l'Ecole française dans notre siècle" (*Observations sur les ouvrages exposés au Sallon du Louvre*, Paris 1775, p. 34 [Collection Deloynes no. 160]); see Anderman 2000, p. 276. The term still carried negative connotations, however; the abbé Lebrun described Charles Eisen's *envoi* to the Académie de Saint-Luc's Salon of 1774 as the work of a "history painter," preferring this term to "celui de peintre de genre, qui ne dit rien de précis et qui est peu flatteur pour un artiste" (cited in Locquin 1978, p. 140, n. 1).

46 "Quelques artistes modernes qui ont pris pour objet des actions ou des scènes particulières de la vie commune." Watelet and Levesque 1792, II, p. 412.

47 "Tel que la Peinture et la Sculpture des sujets historiques, celles du portrait, le paysage, les fleurs, la miniature, et les autres genres des dits Arts." *Procès-Verbaux*, VIII, p. 284 (2 September 1777), article 2.

48 Despite the invaluable survey in Crow 1985, I am taking exception to his device of the "surprise invader," which requires that certain talented genre painters such as Chardin and Greuze storm the citadel of the Academy in order to gain recognition. Crow's conflictual model has been enormously influential, and may also account for a tendency in recent writing on genre painting (and on Watteau and Greuze in particular) to overwork the ironic or subversive qualities of this form of painting.

49 Locquin 1978, pp. 41–43. For d'Angiviller's reformist agenda as he explained it to Vien in February 1790, "J'ai cherché à encourager les genres si peu lucratifs de l'histoire et de la sculpture," see Crow 1985, pp. 200–09, and Bailey 2002, pp. 204–05.

50 On which see, most recently, Glorieux 1998.

51 Cuzin 1991; Lancret's lost *Village Wedding*, painted in 1737 for the *office* of the King's *petits appartements* at Fontainebleau, was over seven feet high and five feet wide.

52 See Laing 1986a, pp. 163–68, for a discussion of "one of the most remarkable decorative ensembles produced by Boucher in his early years," the origins of which remain mysterious. The first secure reference to them in the literature is in 1852.

53 Rosenberg 1987a, pp. 46–50.

54 Standen (in Laing 1986a, p. 508) calculated that for the *Fêtes italiennes* Boucher would have produced "nearly a hundred and ten running feet of paintings."

55 Davidson and Munhall 1968, II, pp. 94–120.

56 Posner 1984, pp. 196–205; for *Gilles* (Musée du Louvre, Paris) see Grasselli and Rosenberg 1984, pp. 430–36.

57 See Rosenberg 1999, pp. 190–91, for the most recent summary.

58 Pierre's *Schoolmistress* (Musée d'art et d'histoire, Auxerre; see fig. 8), shown at the Salon of 1741, is catalogued in Lille 1985, pp. 135–36; for his *Old Man and Savoyard Girl* of the same dimensions (130 × 97 cm), shown at the Salon of 1745, see Nemilova 1986, p. 225. On Van Loo's *La Conversation espagnole* and *La Lecture espagnole*, see, most recently, Sahut, in Diderot 1984a, pp. 370–72.

59 All the more so, since it was Greuze's custom to greet his visitors on the landing of his studio, lead them by both hands straight to the window, and finally have them turn to the right to see his paintings. This was described as "une manière bien séduisante de montrer ses ouvrages" (see [Renou] 1773, p. 44). On Véri's pendants, see Munhall 1976, pp. 170–73, 178–81.

60 Although notable exceptions would include Vleughels' La Fontaine series, done in 1735 and engraved by Larmessin, and Lemoyne's *A Hunting Party* (cat. 22) and his magisterial *Bather* of 1724 (private collection, Dallas), part of a set of mythological and allegorical paintings for his patron François Berger; see Hercenberg 1975, pp. 106–09, and Bailey 1998.

61 See the examples catalogued in Bailey 1992: nos. 8, 9, 11, 24, 26, 29, 31.

62 For Boucher's comment, as relayed by Berch to Tessin in October 1746, see Laing 1986a, p. 224. De Troy had initially requested 4,000 *livres* for *The Oyster Luncheon* (1735; Musée Condé, Chantilly), commissioned for the dining room of the king's *cabinets intérieurs* at Versailles, stipulating that "ce tableau tout petit qu'il est est d'un fort grand detail et extremement finis [*sic*]"; he was paid 2,400 *livres*. See Leribault 2002, p. 342.

63 For examples, see Bailey 1992, nos. 17, 18, 45, 46.

64 For Boucher's *Birth of Venus* and *Toilette of Venus* (both private collection), exhibited at the Salon of 1743 and engraved in June 1748, see Ananoff 1976, I, pp. 358–64. Although such cabinet mythologies are today considered among Boucher's very greatest works, their status in the artist's lifetime may have been undermined by their small scale and polished facture (contamination as genre?). *Diana at her Bath* (1742; Musée du Louvre, Paris) fetched 409 *livres* at Blondel d'Azincourt's sale of 10 February 1783; Tessin paid Boucher 372 *livres* for *Leda and the Swan* (Nationalmuseum, Stockholm) in 1742. These sums are consistent with the prices Boucher charged for his genre paintings in these years.

65 "Un sujet tiré de l'histoire, mais traité par un peintre de genre." Cochin to Marigny, July 1769, in Seznec 1966, p. 342.

66 "Greuze est sorti de son genre. Imitateur scrupuleux de la Nature, il n'a pas su s'élever à la sorte d'exagération qu'exige la peinture historique." Diderot 1995a (*Salon de 1769*), p. 89. For a full account of the painting and its reception see also Munhall, in Diderot 1984a, pp. 253–58.

67 See Locquin 1978, pp. 251–58; Rosenberg and van de Sandt 1983; Crow 1985, pp. 211–54.

68 As Richard Wrigley (1993, p. 286) has noted of the centrality of the hierarchy of the genres, "While the Académie in the eighteenth century may have been the prime exponent of the essentially hierarchical nature of art practice, it is clear that the hierarchy was accepted as a cornerstone of common sense by artists and critics of all persuasions."

69 Thus, while Ledbury's notion of "hybridity" in all the genres is a brilliant insight into eighteenth-century practice, it is hard to accept his model of "ambitious" genre painters in conflict with "relaxed" history painters (Boucher is described, with other senior academicians, as "wallowing in a tempting off-duty role while minor figures around them, the genre painters, carried more authority and interest" [Ledbury 2000, p. 53]). For a more nuanced and meticulously documented examination of the interrelationship between academicians, administrators, and critics, see Michel 1993.

70 Goodman 1995, I, pp. 4–5; Diderot 1984b (*Salon de 1765*), p. 23: "On nous met, disait-il, à l'âge de sept à huit ans le porte-crayon à la main. Nous commençons à dessiner d'après l'exemple des yeux, des bouches, des nez, des oreilles, ensuite des pieds et des mains. Nous avons eu longemps le dos courbé sur le porte-

feuille, lorsqu'on nous place devant *l'Hercule* ou *le Torse*, et vous n'avez pas été témoins des larmes que ce *Satyre*, ce *Gladiateur*, cette *Vénus de Médicis*, cet *Antinoüs* ont fait couler.... Après avoir séché des journées et passé des nuits à la lampe devant la nature immobile et inanimée, on nous présente la nature vivante, et tout à coup le travil de toutes les années précédentes semble se réduire à rien; on ne fut pas plus emprunté la première fois qu'on prit le crayon. Il faut apprendre l'oeil à regarder la nature; et combien ne l'ont jamais vue et ne la verront jamais!"

71 "Parce qu'en effet c'est le chemin le plus sûr pour arriver à la perfection dans quelque genre que ce soit." Dussieux 1854, II, p. 405, read at the Academy on 6 December 1766.

72 "Il ne put cependant resister à l'attrait de monter aux grades les plus honorables de cette compagnie" (ibid., p. 370); Gougenot's life was read to the Academy on 16 January 1761.

73 Opperman 1977, I, pp. 107–08. It is also noted, however, that he was so busy with his responsibilities at Beauvais and the Gobelins (where he would be named Inspector in 1748) that in June 1747 the students complained that "M. Oudry ne se trouve jamais au jugement des médailles et ne veut plus faire d'élèves." Cited in ibid., pp. 132–33.

74 Bachelier 1999, pp. 164–66, 168–71. Caylus was so infuriated that his erstwhile protégé had been allowed to re-enter the Academy as a history painter that he boycotted the institution in the last years of his life. See Cochin 1880, p. 45: "Il en fut si offensé qu'il . . . cessa de venir à l'Académie; lui qui plus de trente ans n'y avoit presque jamais manqué."

75 See, most recently, Wintermute 1999, pp. 31, 162–65.

76 "Qu'il n'allât plus les hyvers, comme il avoit fait longtems avant, dessiner à l'Académie d'après le modéle." Guiffrey 1874, p. 26, reprinting Ballot de Savot's *Eloge de M. Lancret*, 1743.

77 "Comme la base de la peinture, à quelque genre qu'on se destine." Dussieux 1854, II, p. 100, Claude-François Desportes's life of his uncle, read at the Academy on 3 August 1748.

78 Baxandall 1985, p. 89.

79 "C'est pourquoi le célèbre *Watteau* disoit qu'on ne pouvoit bien battre le tambour qu'on ne sût bien jouer de la flûte; manière de s'exprimer pittoresque, et qui signifie que pour réussir dans un genre, il faut savoir beaucoup plus que ce que ce genre ne semble exiger." Michel 1987a, p. 111, quoting from Cochin's letter of October 1771 to Falconet (Cochin must have heard Watteau's reminiscence from his father, who had engraved several of his compositions).

80 "Il voyait l'art beaucoup au-dessus qu'il le pratiquait." Rosenberg 1984, p. 67.

81 Antoine Pesne, via their joint friend Nicolas Vleughels, requested Watteau's opinion on his drawing of *Samson and Delilah* (Musée du Louvre, Paris) before submitting his reception piece: "Montre le aussi à Monsieur Watau [*sic*]. Il a des lumieres que je nez point." Michaelis 1994. Eidelberg (1997a) has discussed Watteau's assistance around 1712 to Antoine Dieu, who had been commissioned to provide the cartoon

for a tapestry showing *Louis XIV placing the Cordon bleu on Monsieur de Bourgogne* as part of the resurrected Gobelins series of *L'Histoire de Louis XIV* (Watteau's sketch is in Muzeum Narodowe, Warsaw). La Roque's erroneous designation of Watteau as "Professeur de l'Académie" is less misguided than it initially seems.

82 Wildenstein 1924, p. 18, citing Ballot de Savot. Part of the Jabach collection and engraved by Chéreau in the *Tableaux du Roi* (1686), Van Dyck's *Christ on the Cross* has only recently been identified; see Brejon de Lavergné 1987, p. 142.

83 In July 1760, Greuze and the engraver Wille had climbed ladders in order to study the paintings more carefully after the Luxembourg palace was opened specially for them; see Munhall 1976, p. 70 (citing Wille's journal entry for that date). Baudouin and Fragonard were granted permission in November 1767; see Rosenberg 1987a, p. 227. Watteau had copied the Medici series at several stages of his brief career; see Wintermute 1999, pp. 23–25.

84 Wille 1857, I, p. 241 (10 December 1763); *Notice sur M. Aubry, peintre* (Collection Deloynes no. 1903), p. 1.

85 Primarily, the reluctance of Watteau and his followers to make compositional drawings and their preference for individual figure studies; see Wintermute 1999.

86 Chardin's few extant drawings date from early in his career; see Rosenberg 1979, pp. 99–108. On de Troy's drawings, see Rosenberg 1995.

87 On the donation of 224 drawings to the Imperial Academy of Fine Arts by its president, General Ivan Ivanovitch Bestkoy (1704–1795), see Novosselskaya, in Munhall 2002, pp. 29–31. The notion that Greuze may have hoped for a professorship at the Academy, hence the necessity of being admitted as a history painter, is a brilliant speculation first advanced by Munhall, in Diderot 1984a, p. 256 (taking his lead from a comment made by Diderot in his Salon of 1767).

88 "Le tableau est bien dessiné et d'une belle forme." Diderot 1995b (*Salon de 1781*), p. 351.

89 "Il n'étoit point encore d'usage que les peintres s'attachassent uniquement à ce genre." Dussieux 1854, II, p. 258, the chevalier de Valory's life of Jean-François de Troy.

90 See the listing of genre painting exhibited in eighteenth-century salons beginning on p. 393. of this catalogue.

91 "La vaste carrière que parcourent les peintres d'histoire rend en général leurs vies plus intéressantes que celle de tout autre peintre" (Gougenot's opening sentence in his life of Oudry, read 16 January 1761). Dussieux 1854, II, p. 365.

92 "Les artistes qui embrassent ce grand genre se persuadent assez facilement que, quand on a quelque succès dans l'histoire, on doit réussir sans peine dans tous ces genres qu'ils appellent petits, et qui ne le sont que lorsqu'ils sont traités petitement." Cochin, *Essai sur la Vie de Chardin* (1780), in Beaurepaire 1876, p. 428.

93 In the *Cours de Peinture*, for example, de Piles had explained the various manners of portraying landscape, architecture, and drapery for

the history painter's benefit; see de Piles 1989, especially pp. 72–127.

94 "Je ne pense pas que c'est sur ces ouvrages qu'il fonde sa réputation." Mariette 1851–60, II, p. 101.

95 "On voyoit de M. de Troye, le fils, déjà connu par de plus grands ouvrages, un Tableau qui fait beaucoup d'honneur à son pinceau, par l'entente et le goût galant & vrai dont il est compose." *Mercure de France* (June 1724).

96 "Il excelle aussi au Paisage, aux Bambochades, aux grotesques et ornamens dans le goût de Vateau. Il fait également bien les fleurs, les fruits, les animaux, l'architecture, les petits sujets galants et de mode." Bachaumont, *Memoire concernant l'Estat des Academies royales . . . en l'année 1745*, Bibliothèque de l'Arsenal, Ms. 4041, fol. 330 (cited also in Laing 1986b, p. 62). Five years later, and the Bâtiments' programme of reform notwithstanding, Bachaumont's enthusiasm remained undiminished: "Il a tout les Talents qu'un peintre peut avoir. Il réussit également au grand et au petit. Il peint bien l'histoire, le Paisage, l'architecture, les fruits, les fleurs, les animaux." *Memoire . . .*, fol. 337. The abbé Gougenot (1749, p. 91) praised Boucher's "universality" in similar terms: "Son génie créateur lui rend tout facile. Histoire, Pastorale, Sujets sérieux, Sujets légers et galans, Tableaux de Dévotion, tout lui est propre."

97 Pierre's *Old Man and Savoyard Girl* (The Hermitage, Saint Petersburg) might have been inspired by Teniers's *Old Man and Woman at Table*, in the Comte de Vence's collection (and later engraved by Le Bas); see Snoep-Reitsma 1973, p. 160, and Atwater 1988, III, p. 1325.

98 "Délassement pernicieux . . . chaque instant que nous nous donnons à des sujets étrangers nous dérobe une découverte dans l'Art qui fait le principal objet de nos études." Saint-Yves 1748, p. 38. La Font de Saint-Yenne (1747, p. 63) had been even more outspoken in his concern that history painters who indulged in such forms of "relaxation" would sink to the depths of "la vile multitude de peintres de ce genre qui inondent les cabinets bourgeois de nos petits curieux dont ils font les délices."

99 "M. Fragonard? Il perd son temps et son talent: il gagne de l'argent." Rosenberg 1987a, p. 300, citing her letter of 4 October 1771 to the abbé Galiani.

100 "Un Peintre d'histoire peut *sans déshonorer son génie*, s'amuser quelquefois à ces sortes d'ouvrages: comme l'esprit ne peut être toujours tendu et occupé d'idées grandes et élevées, ces petites compositions sont pour lui autant d'amusements utiles, qui, en procurant à l'imagination un repos nécessaire, sont de nouvelles preuves de son étendue et de sa fecondité." Gougenot 1749, pp. 103–04.

101 "On sçait que l'Histoire est son premier genre [Jeaurat]; ce n'est que pour se délâsser qu'il traite des sujets badins et familiers.... Un athlète distingué [Hallé] daigne descendre de son genre et badiner savament. . . . Il sait que les sujets simples font le charme des cabinets." *La Peinture Ode de Milord Teilliab*, London, 1753, p. 8 (Collection Deloynes no. 57).

102 Fumaroli 1996, p. 46, n. 25, referring to

Christian Michel's discovery in the Academy's archives of references to Watteau as a "peintre d'histoire."

103 Ibid., p. 36, "Une fête galante n'est pas un peinture d'histoire." For the terminology (and tergiversations) of Watteau's reception at the Academy, see Grasselli and Rosenberg 1984, pp. 25, 396–401.

104 For the election of Lancret (and Parrocel) as *conseillers* on 2 July 1735, see Wildenstein 1924, p. 56. Among the unsuccessful candidates at this time was the thirty-five-year-old Chardin, who presented "quatre petits morceaux excellens représentant de petites femmes occupées dans leur ménage et un jeune garçon s'amusant avec des cartes." *Mercure de France* (June 1735), cited in Rosenberg 1979, p. 384. Chardin would succeed Lancret as *conseiller* on 28 September 1743.

105 *Procès-Verbaux*, IV, p. 313 (26 April 1721, Lajoüe); ibid., V, p. 47 (25 September 1728, Chardin, Bonaventure de Bar). Of Chardin's reception, Mariette (1851–60, I, p. 357) noted, "Ce qui ne se voit guères, on se contenta pour ses deux morceaux de réception de deux de ces tableaux qu'il avoit présentés."

106 *Procès-Verbaux*, V, pp. 312–13 (5 January 1742). The Academy recognized that Le Bas's skills were not those "de graver le portrait," but that "il s'étoit adonné à un genre particulier où il réussissoit."

107 McAllister Johnson 1982, pp. 122–25, 128–29. Like Le Bas, during the 1730s Nicolas de Larmessin would establish his reputation as an engraver of genre subjects; his series after Lancret were regularly presented to the Academy (for example, the *Four Ages of Man* in July and December 1735, the *Four Hours of the Day* in February 1741).

108 "Les deux seuls Peintres qui donnoient dans le goût des Modes & des Sujets galans, dont Watteau étoit l'inventeur & le modèle." Gersaint, *Catalogue raisonné des diverses curiosités du Cabinet de feu M. Quentin de Lorangère*, Paris, 2 March 1744, p. 197.

109 "Il est vrai qu'il seroit pas avantageux pour la Peinture que l'on se livrât trop à ce goût; cela pourroit devenir préjudiciable pour le genre noble & historique; mais aussi il n'est point désavantageux pour le progrès & l'entretien de cet Art, qu'il se forme d'habiles gens en divers genres, qui ont chacun leur mérite, & leur difficulté, & dans lesquels on acquiert une égale réputation, quand on y réussit." Ibid.

110 "On ne peut trop l'inviter à faire des Elèves qui puissent perpétuer le genre de talent dans lequel il excelle; c'est faute d'élèves que nombre des talens se sont éteints peu à peu. Personne, par exemple, depuis la mort de M. LANCRET, ne cultive plus celui qui a autrefois si fort illustré le célèbre VATEAU." Gougenot 1749, p. 110.

111 "La gloire de l'Académie étant fondée sur la réussite de tous les genres qui la composent, elle voit depuis longtemps avec douleur qu'il en est de négligés et d'autres même fortement éteints dans cette Ecole." Michel 1993, p. 508.

112 Ibid.; Michel is quoting from Massé's unpublished lecture, *Examen qu'il faut faire pour*

connaître ses dispositions, in the archives of the École des Beaux-Arts (Ms. 190).

113 "On sent assez de nos jours combien on a trop négligé depuis quelque tems la partie du Paysage. Il ne se forme dans aucun Pays, nul élève en ce genre." Gersaint, *Catalogue raisonné des diverses curiosités du Cabinet de feu M. Quentin de Lorangère*, Paris, 2 March 1744, p. 197.

114 Michel 1993, p. 509.

115 Rosenberg 1984, p. 55.

116 Munhall 1976, pp. 18–20; Bailey 2000b, pp. 3–4.

117 "Il a beaucoup de méritte et peut porter for loin son genre." *Correspondance des Directeurs*, II, p. 138, Natoire to Marigny, 12 May 1756.

118 Ibid., II, p. 165, Marigny to Natoire, 28 November 1756.

119 "Ils seront vus de toutte la cour et il pourroit en naître de gros avantages pour luy s'ils sont trouvés bons." Ibid. Greuze took more than four years to complete the commission for Madame de Pompadour (see cat. 68).

120 Cuzin and Rosenberg 1990.

121 Michel 1993, p. 491.

122 As a starting point, see the chronological survey of paintings commissioned by the Bâtiments du Roi between 1709 and 1792, in Engerand 1901, pp. xxxix–lxiii.

123 On these commissions, see Salmon 1995; Cuzin 1991, and Marandel 1991–92; Opperman 1982, pp. 126–54; Manœuvre and Rieth 1994.

124 Bailey 2002, pp. 2–15.

125 Dussieux 1854, II, p. 106.

126 Wildenstein 1924, p. 48: "le plus crotesquement [*sic*] qu'on pourra," citing d'Antin's instructions to Lancret.

127 Ibid.: "Il faut représenter les six dames . . . dans le goust qu'on porte les veaux au marché; . . . il faut une dame en travers, sur un autre cheval de charrette, comme un sac, et que le panier relève, de façon que l'on voye jusques à la jarrettière . . . enfin tout ce que le peintre pourra mettre de plus crotesquement et de plus dépenaillé." Lancret received payment of 400 *livres* for this painting on 10 October 1727.

128 Opperman 1982, pp. 252–54.

129 Rosenberg 1999, pp. 252–53.

130 "J'ai communiqué à M. Boucher mes idées sur la disposition des sujets: il ne les a pas désapprouvés et a paru en être fort content." Ananoff 1976, I, p. 27, Berch to Tessin, 17/27 October 1745.

131 "Le matin sera une femme qui a fini avec son friseur, gardant encore son peignoir, et s'amusant à regarder les brinborions qu'une marchande de modes étalent." Ibid.

132 Laing 1986a, pp. 224–29.

133 Hiesinger 1976.

134 Bachaumont, "Suite des Tableaux," Bibliothèque de l'Arsenal, Ms. 4041, fols. 354–60.

135 Ingamells 1989, pp. 205–09.

136 "Afin d'avoir occasion de faire voir ses jolis bras blancs et potelés et ses jolies petites mains mignonnes." Bachaumont, "Suite des Tableaux," Bibliothèque de l'Arsenal, Ms. 4041, fol. 356, no. 3.

137 "La dame seroit en corset blanc et petit jupon blanc et fort court, le tout marquant le nud et

laissant voir la moitié des jambes par derrière, des bas blancs, des souliers blancs, la jambe fine et les pieds petits." Ibid., fol. 358, no. 7.

138 "Ils ont tous été faits sous mes yeux." Ségur 1897, p. 406.

139 Several months before its appearance at the Salon of 1755, the *Correspondance littéraire* (II, pp. 410–11 [1 October 1754]) referred to this painting as representing "une comtesse flamande."

140 Sahut, in Diderot 1984a, pp. 370–72.

141 "Et mieux si vous voulez égayer davantage votre tableau." Collé's journal entry for October 1767, cited most recently in Bailey 2002, p. 1.

142 Hallam 1984; Siegfried 1995, pp. 2–8.

143 "Inventé par M. de Calvet Lapalun, peint par Louis Boilly, 1790." Hallam 1984, p. 189, quoting from the "Rôle des tableaux de Boilly," Lapalun's manuscript catalogue of the eleven paintings that Boilly made according to his instructions, ten of which can be located today.

144 Ibid., from Lapalun's "Sujets pour des Tableaux," a second manuscript containing lengthy descriptions for nineteen pictures (more than half of which were never realized in paint).

145 Ibid., no. 3, Lapalun's entry for *The Young Philosopher*.

146 On this essential topic, which still awaits a monograph, see Banks 1977, Lille 1985, Atwater 1988, Cornelis 1998, Karlsruhe 1999, Altes 2000–01, and Thomas Gaehtgens's essay in this catalogue.

147 Félibien 1725, IV, p. 81.

148 "Dans les petits tableaux qu'il a faits, et les sujets qu'il a choisis, [il] a surpassé tous ceux de son tems. . . . Pour ce qui regarde la beauté du pinceau, les couleurs, les lumières et les ombres, il a traité tout cela avec une entente admirable." Ibid., VII, pp. 465–66.

149 "Combien cette manière de procéder n'était-il point éloignée des soins extraordinaires qu'ont pris certains peintres Hollandais pour travailler proprement! L'on cite entre autre Gérard Douw." Rosenberg 1984, p. 77.

150 Ibid., p. 58.

151 "On aurait pu comprendre, parmi les Peintres les plus connus, plusieurs Flamands qui ont représenté avec un extrême fidelité la verité de la nature et qui ont eu l'intelligence d'un excellent coloris; mais parcequ'ils ont eu un mauvais goût dans les autres parties, on a cru qu'il valait mieux un faire une classe séparée." De Piles 1989, p. 237.

152 Ibid., pp. 239–41.

153 "Le Calfe, dans les objets qu'il a imités d'après nature me paraît parler le langage de la peinture aussi bien que le Giorgione et le Titien." Mérot 1996, p. 414.

154 For Watteau's *Woman Cleaning Copper* (Musée des Beaux-Arts, Strasbourg), see Grasselli and Rosenberg 1984, pp. 256–58; on Lancret's *Girl in a Kitchen* (*La Chercheuse de puces*) in the Wallace Collection, which may be the work of two hands, see Ingamells 1989, pp. 219–20.

155 Schnapper (1994, pp. 23–25) observed that the relatively low estimations of paintings by Teniers and Wouwermans (and copies after these artists) in inventories from the middle of

the seventeenth century on hardly anticipated "l'extraordinaire triomphe des Flamandes et des Hollandais dans le goût français vers le milieux du XVIII^e siècle." Bailly's inventory of the royal collection, done in 1709–10, listed eight works attributed to Teniers and four to Dou (see Engerand 1899, pp. 262–63, 268–69), and the catalogue of the Orléans collection published in 1727 included eleven Teniers and four Dous (see Dubois de Saint-Gelais 1727, pp. 111–15, 178–80).

156 "Je suis quelque fois fâché que l'on les banisse entièrement des cabinets où l'on rassemble des tableaux des anciens maîtres d'Italie." Mérot 1996, p. 414. Coypel's eclecticism was fully in line with Academic values, however; in the same lecture he noted that Dutch and Flemish painting was characterized "par la bassesse des sujets et leur petit goût du dessin."

157 "Un amas de bons Tableaux Flamans & François mêlé de quelques Italien. . . . On peut dire en général, que les vrais Peintres sont les Flamans, & que s'ils avoient la partie du Dessein aussi accomplie que celle du Coloris, ils seroient les premiers Peintres de l'Univers." Dezallier d'Argenville 1727, pp. 1297–98.

158 Ibid., p. 1298.

159 Descamps (1753–64, I, p. vii) attributed the growth in collecting Dutch and Flemish cabinet painting (and the extension of the canon) to French participation in the War of the Austrian Succession (1740–48): "Le séjour que nos troupes ont fait en Flandres a donné lieu aux amateurs d'étendre leurs connoissances et de rechercher les tableaux des plus célèbres maîtres." Indeed, just before the end of the war, the twenty-six-year-old Marc-René de Voyer d'Argenson (1722–1782) acquired a group of distinguished Dutch and Flemish cabinet pictures from the collector and dealer Willem Lormier (1682–1758) in The Hague; see Altes 2000–01, pp. 268–76. Descamps had singled out the collection of another aristocratic commander, Claude-Alexandre de Villeneuve, Comte de Vence (1702–1760), the dedicatee of his volumes, who owned paintings by Steen, Metzu, and Maes (Vence, he claimed, was the only collector of Maes in the country) (Descamps 1753–64, II, pp. 243, 458; III, p. 28). Vence was also an early enthusiast of Chardin, Boucher, Greuze, and Pierre; see Bailey 2002, pp. 23–24.

160 Heidner 1982, pp. 7–8.

161 McClellan 1996; Glorieux 1998.

162 "Ne voyons-nous pas aujourd'hui en France quelle faveur ont pris les tableaux flamands et hollandais, à quel prix excessif ils sont montés, sans avoir d'autre mérite que celui du fini et du coloris? Ce sont, pour la plupart, ou de petits sujets bas et puérils, ou de grands sujets pris d'une petite manière. . . . Voilà le coloris qui est à la mode parmi nous; . . . car n'ayez pas peur que ces curieux compilateurs d'école flamande recherchent des ouvrages de Van Dyck ou du grand Rubens, où est le vrai coloris. Non, ce sont des Téniers, des Mieris, des Gerard Dow [sic], qu'ils achètent à tout prix." De Brosses 1986, II, p. 150, letter XLIII.

163 "Ces précieux Cabinets . . . la suavité, la fraîcheur, et la naïveté des Pinceaux Flamands."

164 "Tant d'agréables parties doivent leur faire pardonner la bassesse de leurs sujets, la plupart grossiers, ignobles, sans pensées et sans intérêt." Ibid.

165 "Tel est aujourd'hui le goût violent et effréné chez les Amateurs des Tableaux et les possesseurs de ces Cabinets. . . . Voilà donc tous les ouvrages des grands maîtres d'Italie et de France, autrefois si précieux et si recherchés, presque entièrement bannis de chez nos curieux." La Font de Saint-Yenne 1752, p. 216.

166 "Une nation qui veut tout couleur de rose." Michel 1993, p. 633, Pierre to Marigny, draft of a letter dated 4 June 1772.

167 "Mais quels travers ne pourroit-on reprocher à plusieurs artistes et amateurs devenus fanatiques de la Flandre, goût qui perdra la Peinture en France." Ibid.

168 "N'est-il pas juste d'ailleurs de tenir compte au peintre historien du courage qui lui est nécessaire pour cultiver un champ stérile, grâce au goût frivole et mesquin de la plupart des riches amateurs pour les bambochades et les petits tableaux froidement terminés des peintres flamands." Mercure de France (October 1775), in Collection Deloynes no. 165.

169 "Ses Tableaux de Chevalet en petites figures . . . dans le goût Flamand." Rosenberg 1984, p. 5.

170 "Il n'a presque peint que des Bambochades." Boyer d'Argens 1768, p. 470.

171 "Sûrement de quelque bon peintre flamand." Cochin, Essai su la Vie de Chardin (1780), in Beaurepaire 1876, p. 424.

172 "Autres sujets dans le goût de Téniers." Mercure de France (June 1734), p. 1405.

173 Gougenot 1749, p. 108; "Il excelle aux petits sujets naïfs dans le goust flamand" (Bachaumont, Mémoire concernant l'Estat des Académies royales . . . en l'année 1750, Bibliothèque de l'Arsenal, Ms. 4041, fol. 340). The Mercure de France (December 1739) advertised Filloeul's engravings after Soap Bubbles and The Game of Knucklebones as "figures à mi-corps dans le goût de Girardow [Gerrit Dou]"; cited in Rosenberg 1979, p. 208.

174 "Une manière à lui qui est original et qui vise au Rembrandt." Mariette's annotations to the livret of the Salon de 1737, in Wildenstein 1933, p. 64. In his biography of Chardin, written twelve years later, Mariette (1851–60, I, p. 359) made the more conventional observation that the artist's choice of "simple and naive" subjects "a le plus contribué jusque ici à donner de la vogue à ses tableaux et à leur mériter une place auprès des Téniers et des autres peintres flamands."

175 "Un Tableau dans le genre Flamand"; see Opperman 1982, p. 254.

176 "Ses tableaux sont dans le goût flamand." Correspondance littéraire, III, p. 94.

177 "Son talent de peindre des Bambochades." L. Gougenot, Album de voyage en Italie, I, p. 139, unpublished manuscript, cited in Munhall 1976, p. 18.

178 "Voy. Greuse [sic]." Dacier 1909–21, XI, p. 66. Terborch's Glass of Lemonade entered Gaignat's

collection in 1754; see Dutch and Flemish Paintings from the Hermitage, New York, 1988, p. 3.

179 Crow 1985, pp. 136–37.

180 On the conventions of picture hanging in the collector's cabinet de tableaux, see Bailey 1987. One documented example from the end of the period is Pierre-Michel Henin's commissions to Jacques Sablet in Rome, made via the diplomat attaché François Cacault: "Il faudroit encore Monsieur que vous le previenniez que c'est pour mettre sur une ligne de petits tableaux flamands fort soignés afin qu'il jugeât que les siens n'y seroient pas déplacés." Henin to Cacault, 28 October 1786, Paris, Bibliothèque de l'Institut, Ms. 1256, fol. 17.

181 Grasselli and Rosenberg 1984, pp. 367–68.

182 Dubois de Saint-Gelais (1727), in Rosenberg 1984, p. 22.

183 For examples of possible models, consult the catalogue of Le Bas's engravings after Teniers in Atwater 1988, III, nos. 1550, 1551, 1576, 1577, 1581, 1582, 1595, 1598.

184 As specified in the livret of the Salon of 1746: "Répétition du Benedicité, avec addition pour faire pendant à un Teniers, placé dans le cabinet de M. XXX"; see Rosenberg 1999, pp. 246–47. While the nineteenth-century tradition that this version belonged to La Live de Jully is not supported by any mention of the work in either his Catalogue historique or the sale of his collection in May 1770, it is worth noting that La Live had owned seven paintings by Teniers (and two by Rembrandt) before turning his attention to the French school in the mid-1750s; see Bailey 2000b, p. 97, n. 80.

185 Scott 2000, p. 70.

186 Laing 1986a, pp. 224–29.

187 "Les tableaux de Chardin sont à se mettre à genoux devant. . . . Celui de Boucher est tres bien; mais on lu'y a fait moins d'accueil qu'il ne merite, puisqu'il est venu seul." Heidner 1982, pp. 155–56, Tessin to Scheffer, 6 June 1747.

188 "S'il me manque de parole, je ne balancerai plus d'une minute . . . d'acheter pour les 600 livres payés d'avance sur les ouvrages de Boucher quelques tableaux Flamands de bon goût, que je ferais choisir par Gersaint ou par quelqu'autre connoisseur." Ibid., p. 200, Scheffer to Tessin, 12 December 1749. Such optimism was misplaced, however, since although Tessin himself had acquired several Dutch and Flemish cabinet pictures at the La Roque sale of May 1745 for under 500 livres for a painting (Chardin's "cuisines" had cost 482 livres for the pair), it would become increasingly difficult to buy them at such low prices after mid-century. At the Fontpertuis sale of February 1748, Gersaint had sold Teniers's Rejouissances Flamandes (The Hermitage, Saint Petersburg), formerly owned by the Comtesse de Verrue, to the Marquis d'Argenson for 6,000 livres (and such a price would seem modest from the vantage point of the 1770s); for Tessin's purchases from Gersaint, see Heidner 1984.

189 Heidner 1982, pp. 214–15, Scheffer to Tessin, 21 August 1750, reproducing a preliminary sketch for the painting. I agree with Laing (1986a, p. 227), who argues that this drawing is in all likelihood by Boucher himself.

190 "Un bel habit de satin blanc dans le gout de Miris [*sic*]." Heidner 1982, pp. 215–16, Scheffer's annotations to Boucher's drawing. As is well known, Boucher never delivered this painting, and it is possible that Pieter de Hooch's *Interior with a Young Lady Reading a Letter* (Nationalmuseum, Stockholm), acquired in 1760, did service as a pendant to *The Milliner*. It is the only Dutch genre painting listed in the Queen's Green Cabinet (or Study Chamber), where most of the eighteenth-century French pictures hung (see cat. 54); for this information I am extremely grateful to Mikael Ahlund and Merit Laine.

191 "M. Fragonard, ce jeune artiste qui avait donné, il y a quatre ans, les plus grandes espérances pour le genre de l'histoire. . . . On prétend que l'appât du gain l'a détourné de la belle carrière où il était entré et qu'au lieu de travailler pour la gloire et pour la postérité, il se contente de briller aujourd'hui dans les boudoirs et dans les gardes-robes." *Mémoires secrets* (10 September 1769), Fort 1999, p. 49.

192 Rosenberg 1987a, pp. 184–209, 249–54.

193 "Comme l'amateur lui en demandait un second [tableau] pour servir de pendant au premier, l'artiste, croyant faire preuve de génie, par un contraste bizarre lui fit un tableau libre et rempli de passion." Alexandre Lenoir (author of the entry on Fragonard in Michaud's *Biographie universelle* [1816]), cited in Rosenberg 1987a, p. 483.

194 Bailey 2002, pp. 100–30 and passim.

195 Ibid., pp. 18–32.

196 See Lawrence and Kasman 1997, and Rambaud 1971, II, pp. 890–92, for the high valuations of her paintings by Teniers. In its frontal presentation, Watteau's *The Marmot* (cat. 2) recalls Teniers's *Summer* and *Autumn*, from his cycle of the Four Seasons on copper (National Gallery, London) in Verrue's collection. In June 1738, Lebas announced that his engraving of Lancret's *Repas italien* was intended as a companion piece to his engravings after Teniers's *Les Rejouissances Flamandes* and *La Fête de village*, made when they were in Verrue's collection. All three prints were of the same horizontal format; see *Mercure de France* (June 1738), cited in Wildenstein 1924, p. 59, and Atwater 1995, p. 6.

197 For the handiwork of both artists in the *Portrait of Antoine de La Roque* (c. 1718; Fuji Art Museum, Tokyo), see Grasselli, in Grasselli and Rosenberg 1984, p. 191, and Wintermute 1999, pp. 208–09.

198 Heidner 1984; see n. 188 above. On La Roque, see Moureau 2001.

199 "Un très-grand et très-bel assemblage de tableaux, surtout flamands." Mariette 1851–60, III, pp. 15–16.

200 Bailey 2000b, p. 36.

201 Goncourt 1981, p. 146; "Chardin n'a jamais peint d'illustrations" (Goncourt 1880–82 [1880], p. 100); from the essay on Chardin first published in 1863–64, in which they glorified him as "cet historien et ce témoin de la petite bourgeoisie."

202 Wildenstein 1924, pp. 40–42; Holmes 1991a, pp. 42, 70.

203 See Joseph Baillio's entry on Oudry's *Portrait*

204 *of the Chevalier de Béringhen* in the forthcoming volume of the systematic catalogue of the National Gallery of Art, Washington. On Béringhen's patronage of Oudry, see Opperman 1982, pp. 75–76, 132–40, and of Lancret, see Sahut, in *Nouvelles Acquisitions* 1991, pp. 110–13.

204 Leribault 2002, pp. 69, 334–35, 343–44. Chauvelin's small collection of French painting included Watteau's *Young Lady and a Flute Player (La Lorgneuse)* (private collection) and *Guitarist, Flautist, Girl and Young Couple (L'Accord parfait)* (Los Angeles County Museum of Art), and de Troy's *Lady at her Toilette Receiving her Suitor* (1734) and its pendant *Lady Attaching a Bow to a Gentleman's Sword* (1734; both private collection).

205 One also should mention the bibliophile and *receveur-général de la chambre de requêtes* Louis-Jean Gaignat (1697–1768), whose extensive collection of Dutch and Flemish cabinet pictures – which Diderot tried to convince Catherine the Great to buy in its entirety – was considered exemplary: "Allez chez Gaignat, voyez la Foire de Tenières, peintre de paysages, et dites-vous à vous-même, voilà ce qu'il faut savoir faire." Diderot 1995a (*Salon de 1767*); on Gaignat and his collection, see Dacier 1909–21, XI.

206 For models of this sort of approach, see Crow 1985 and Scott 1995.

207 For the most nuanced methodology, see Baxandall 1985, especially pp. 42–50. On the influence of the theatre on genre painting in the middle decades of the century, see Ledbury 1997.

208 Neuman 1984; Glorieux 1998.

209 Grasselli and Rosenberg 1984, p. 452.

210 Neuman 1984, p. 156; Scott 1995, p. 29. A decade earlier, Watteau's *Portal of Valenciennes* (cat. 1) had included a similar, if more elliptical, homage to the premises of the artist's first dealer, Pierre Sirois – Gersaint's future father-in-law. The crowned shield with the French royal arms that appears, somewhat incongruously, on the inner surface of the arch, and against which an oversize lance is resting, may refer to Sirois's shop on the quai Neuf, "Aux Armes de France"; see Munhall 1992a, pp. 21–22.

211 Haskell 1984, p. 28.

212 Here the emphasis shifts to amorous and erotic preoccupations, away from the much-discussed state of absorption, on which see Fried 1980.

213 Fumaroli 1996, p. 38; "*Le Pèlerinage à Cythère* est l'immense résonance de cette 'petite mort' très profane qui a eu lieu, et dont nous ne voyons que les suites un peu lasses et en voie d'extinction."

214 For an exemplary interpretation, with Fragonard's early pastoral series *The Four Seasons* (Detroit Institute of Arts) as a case study, see Sheriff 1990, pp. 95–116.

215 Posner 1982; Scott 1995, pp. 123–36.

216 See the discussion of such subjects in Holmes 1991a, pp. 100–02, Milam 1998 and Milam 1999. The most ambitious treatment of children's games (in terms of scale, if nothing else) is Oudry's *Les Amusements champêtres* for Beauvais, a series of eight tapestries woven

between 1730 and 1732 representing, among others, *Le cheval fondu*, *Le colin-maillard*, *Le pied de boeuf*, *Le joueur d'osselets*, and *Le balanceur*. As Opperman (1969) notes, this was a reworking of the earlier *Jeux d'enfants*, but with adults, in fashionable dress, playing the children's games.

217 "On y danse aux chansons ou au son des instruments quy s'y rendoit, on y joue à Colin-Maillard et à d'autres jeux." *Le Mercure galant* (August 1714), cited in Cohen 2000, p. 221.

218 "On établit le goût des petits jeux, les questions, la *guerre-panpan*, le colin-maillard." Campan 1988, p. 128.

219 See Lancret (cat. 12); Boucher (cat. 50); Fragonard (cat. 75 and 86); Sablet (cat. 102). On the emblematic tradition and the representation of children's games by Lancret and Boucher, see Goodman-Soellner 1983 and Goodman (E.) 1995.

220 The essential essays on Watteau's theatrical subject matter remain Moureau 1984, and Crow 1985, pp. 45–74.

221 See, most recently, Plax 2000, pp. 108–53, and Cohen 2000, pp. 209–41.

222 "Là, n'ayant pour tout siège que le gazon, on s'y asseoit sans cérémonie." *Le voyageur fidèle* (1716), cited in Plax 2000, p. 123.

223 See Crow 1985, pp. 66–74, for an evocative discussion of Watteau's "tardy visual realisation" of the aristocratic cult of *honnêteté*.

224 Plax 2000, pp. 126–28.

225 "Il a parfaitement bien représenté les concerts, les danses et les autres amusements de la vie civile. . . . Il s'est attaché aux habillements vrais, en sorte que ses tableaux peuvent être regardés comme l'histoire des modes de son temps." Rosenberg 1984, p. 21.

226 Crow 1985, p. 57.

227 Moureau 1984, pp. 487–92.

228 "Women have the Priviledge of going maskt at all times, concealing or showing themselves when they please. With a Black-Velvet-Visor they go sometimes to Church as to a Ball or Play . . . unknown to God and their Husbands." *The Present State of the Court of France*, London, 1712, cited in Ribeiro 2002, p. 41.

229 Leribault 2002, pp. 343–44. De Troy's monumental *The Masked Luncheon (Déjeuner en habit de bal)* (1725; The Detroit Institute of Arts), illuminated by "un rayon de soleil," probably represents the "morning after" a nocturnal party; this, at least, was the understanding of the compiler of the de Vigny sale (1 April 1773), who described the work as "Une récréation au retour du bal" (ibid., p. 277).

230 "La Nuit peut être représentée par des folles qui vont en habit de bal, et se mocquent de quelqu'un qui s'est endormi." Ananoff 1976, I, p. 27, Berch to Tessin, 17 October 1745.

231 Fahy and Watson 1973, pp. 284–92.

232 Leribault 2002, p. 72.

233 The clock reads half past three in the afternoon (see ibid., pp. 73–74). Lancret's *Winter* for Leriget de La Faye had shown fashionable company reclining in a similarly furnished dining room (see Dacier and Vuaflart 1921–29 [1925], pl. XVIII).

234 Ribeiro 2002, pp. 38–39.

235 Scott 1995, p. 97.

236 For a general introduction, see Thomson 1981 and Salmon 1995.

237 "Un exercise noble reservé pour le plaisir des rois et de la noblesse." Decree of October 1722, cited in Thomson 1981, p. 49.

238 See Bordeaux 1984, pp. 88–89; Ingamells 1989, pp. 366–70.

239 Sahut, in *Nouvelles Acquisitions* 1991, p. 110.

240 Cuzin, in ibid., p. 126.

241 Greuze approached it in *The Beloved Mother* (fig. 23) and, more obliquely, in *The Marriage Contract* (cat. 71), where the father's gun hanging on the wall suggests that he goes out shooting, despite his seigneur's exclusive right to hunt; see Barker 1997, p. 47. The *Encyclopédie* was outspoken in its criticism of the hunt: "Que le goût pour la chasse dégénère presque toujours en passion, qu'alors il absorbe un tems précieux, nuit à la santé & occasionne des dépenses qui dérangent la fortune des grands & qui ruinent les particuliers." Diderot and d'Alembert 1751–76, IV, p. 225.

242 Goncourt 1880–82 (1880) p. 70; Goncourt 1981, p. 114.

243 See, for example, de Troy's *Lady at her Toilette Receiving her Suitor* and *Lady Attaching a Bow to a Gentleman's Sword* (1734; both private collection; replicas in The Nelson-Atkins Museum of Art, Kansas City), reproduced in colour in Leribault 2002, pp. 66–67. In the former, the mistress is helped into her sacque dress by an immaculately attired lady's maid while entertaining her suitor; in its pendant, she and her suitor engage in provocative dalliance, oblivious to the *marchande de modes* on the floor at right.

244 That it does not remains the burden of Alastair Laing's exhaustive disclaimer; see Laing 1986a, pp. 179–82.

245 "Un garçon Limonadier qui a servi du caffé," as described in the Prousteau sale catalogue of 5 June 1769; see Laing 1986a, p. 181.

246 See Bailey 2000a for a summary of recent writing on Chardin.

247 For an example of Lancret's emblematic representation of children, see *The Four Elements*, done for Béringhen in 1732, in which *Air* (known today from Tardieu's engraving and from a version in Waddesdon Manor, Aylesbury, Bucks.) includes children blowing bubbles, making a house of cards, playing with kites and windmills, "a veritable catalogue of vanity symbols," as Conisbee (1986, pp. 142–43) has noted.

248 On the family in eighteenth-century France, see Flandrin 1979; on Chardin's engagement with it, see the excellent articles by Snoep-Reitsma (1973) and Johnson (1990).

249 Fénélon 1687, cited in Snoep-Reitsma 1973, p. 188.

250 "A Set of Children thus ordered and kept from the ill example of others, would all of them . . . learn to read, write, and what else one would have them, as others do their ordinary plays: And the eldest being thus entered, and this made the Fashion of the Place, it would be as impossible to hinder them from learning." Locke 1964, pp. 23–24.

251 The well-bred protagonist of Chardin's *Little Girl with a Shuttlecock* (1737; private collection) has her scissors and pin cushion tied to her hooped dress; the *Child with a Top* (1737–38; Musée du Louvre, Paris) – admittedly a portrait of nine-year-old Auguste-Gabriel Godefroy – is shown with quill pen, porte-crayon, books and writing paper (the tools of study) on the table. See Rosenberg 1999, pp. 222–25.

252 "Chargée de l'éducation de ses enfants . . . de la conduite des domestiques, du détail de la dépense, des moyens de faire tout avec économie et honorablement." Fénelon 1687, cited in Snoep-Reitsma 1973, p. 222.

253 For example, Mariette (1851–60, I, p. 359) described Chardin's *Good Education* (c. 1753; Museum of Fine Arts, Houston) as showing "une mère ou gouvernante, qui fait réciter l'Evangile à une petite fille."

254 The Goncourts' romantic notion that the Parisian housewife constituted "that favourite figure to whom Chardin always returned" prevented them (and many subsequent historians) from distinguishing between servants, governesses, and the more formidable *maîtresse de maison* in Chardin's genre paintings; on which see Bailey 2000a, p. 94. Sahut (1999, p. 110) is the first to question the status of the woman serving food in *Le Bénédicité*.

255 Italian born, Audiger was *maître d'hôtel* successively to the Comtesse de Soissons, the président de Maisons and the Duc de Beauvilliers before opening his own café in the Palais-Royal (he was known as the "prévôt des marchands pour les boissons glacés"). Babeau 1886, pp. 262–63.

256 "Une bonne servante doit se connoître en viande, savoir bien acheter, bien faire la cuisine suivant les gens qu'elle sert, faire que la vaisselle et la batterie soient toujours bien propres . . . aller promptement partout où l'on l'envoie, et revenir de même." *La maison réglée*, book III, ch. 3, cited in Franklin 1906, pp. 643–44.

257 It engages in an exquisite libertinism, however, in the gallant conversation that takes place in the background between the young lady's maid in her white apron and the tricorn-wearing young man at the door, through which the smallest triangle of blue sky can be seen; see Démoris 1969.

258 "Le devoir d'une gouvernante d'enfans est d'avoir bien soin de ceux dont on lui donne la direction. Elle doit les tenir toujours bien proprement, avoir beaucoup de douceur et de complaisance pour eux . . . leur donner à manger et les coucher et lever à leurs heures réglées et ordinaires. . . . Elle doit aussi leur apprendre à prier Dieu et à faire le signe du chrétien dès leur âge le plus tendre." Audiger, *La maison réglée*, book II, ch. 3, cited in Franklin 1906, p. 88.

259 "Un nombre de tableaux très-intéressants dont les sujets se sont ensuite annoblis par un choix plus élevé dans les personnages." Cochin, *Essai sur la vie de Chardin* (1780), in Beaurepaire 1876, p. 426.

260 "C'est toujours de la *Bourgeoisie* qu'il met en jeu. . . . Il ne vient pas là une Femme du Tiers-État qui ne croie que c'est une idée de sa figure, qui n'y voit son train domestique, ses manières rondes." *Lettre à Monsieur de Poiresson-Chamarande*, Paris, 1741. For a thor-ough interpretation of this pamphlet, see Crow 1985, pp. 96–103.

261 Rosenberg 1979, pp. 74–76; Crow (1985, p. 136) has noted that "as time went on, his figural pictures were almost entirely purchased or commissioned for foreign princely clients."

262 "Chardin ne peint guère que l'enfance policée des élites routurières." Sahut 1999, p. 64.

263 Crow 1985, p. 136.

264 There has been something of a cottage industry in interpretations of the family in Greuze, Fragonard, and their acolytes. Among the most influential articles are Duncan 1973 and Duncan 1981; see also Sheriff 1991, Rand 1996, Barker 1994, and Barker 1997.

265 Bailey 2000b, pp. 27–30.

266 On Boucher's pastorals and their links to the *Théatre de la Foire* and the newly formed Opéra Comique, see the essential article by Laing (1986b). Régis Michel (Michel 1985, p. 39) has characterized Greuze's rustic universe as "a mirror-like exoticism, which constantly oscillates between ethnography and the picturesque, triviality and the ideal, manners and morality."

267 As noted by Munhall (2002, pp. 136–37, 200–03), in creating this family portrait Greuze elaborated upon a genre composition shown at the Salon of 1765, *The Beloved Mother* (location unknown), in which his own wife had served as a model.

268 For Greuze's selective filtering of Enlightenment agendas, see Barker 1997.

269 Moore 1935 remains the essential introduction; see also Ledbury 1997, pp. 53–54; Ledbury 2000, pp. 71–76; and Bailey 2000b, pp. 59–69.

270 Ledbury 2000, pp. 62–76; Bailey 2000b, pp. 63–65.

271 Examples of Greuze's *poissard* subjects are reproduced in Bailey 2000b, pp. 68–69.

272 Moore 1935, pp. 5, 149, 212, 245. Vadé's *Les Racoleurs*, his most fully *poissard* play, which opened on 11 March 1756, has a recruiter named Jolibois; Toussaint-Gaspard Tacconet's *Le Savetier Petit-Maître à la Foire* was written in 1768 (the playwright was an actor who had been renowned for his role as a drunken cobbler).

273 "La mère est une grosse marchande de fruits ou de poissons; la fille est une jolie bouquetière." Diderot 1984b (*Salon de 1761*), pp. 169–70.

274 Goodman 1995, I, p. 102; Diderot 1984b (*Salon de 1765*), p. 188. On the pastel itself, see Munhall 2002, pp. 129–33.

275 Montaiglon 1860, p. 254.

276 For the sketch of the painting in The Hermitage and the extraordinarily refined painting itself (cat. 86), see Rosenberg 1987a, pp. 79–83, and Rand 1997, pp. 138–39.

277 Sheriff 1990.

278 Rosenberg and Compin 1974b; Rosenberg 1987a, pp. 481–84.

279 Goodman 1995, I, p. 230; "Gens à petits sujets mesquins, â petites scènes domestiques prises du coin des rues" (Diderot 1984b, p. 66). For genre painting on the eve of the Revolution, see Eliel 1989, and Michel and Bordes 1988, pp. 46–51, 302–04.

The Theory of French Genre Painting and Its European Context

BARBARA GAEHTGENS

Detail of fig. 38

Long before the various meanings of the word *genre* in an artistic and literary sense had been examined by Watelet and Voltaire in volume seven of the *Encylopédie*, there had already been a theoretical debate on genre painting – namely, the depiction of everyday scenes of human life lacking any historical significance.[1] Despite a long prior history, it was not until the eighteenth century that an attempt was made to recognize and define the painting of figures and scenes from everyday life as a separate category. Although Watteau, Chardin, Boucher, Greuze, and Fragonard were already exhibiting their paintings, and even though in seventeenth-century Holland the painting of scenes from simple everyday life had flourished, and these works had in the meantime found their way into important collections not only in France but elsewhere in Europe, there was still no precise term that positively acknowledged the existence of this particular kind of painting.[2] Admittedly, the term *peinture de genre* already existed in France. But on closer examination, it can be seen that this was initially just a classificatory designation *ex negativo* referring to a style of painting ranked below the noble history painting. It denoted the painting of minor subjects such as landscapes, still-life, and battles, which were lacking in scholarly or edifying content and were concerned mainly with the depiction of banal reality.

What was the reason for this lack of interest by theorists in a type of painting that was obviously so popular with the public at large? To start with, French contemporary society was not aware of this paradox. Indeed, genre painting was a style of painting that was practised by certain artists who did not enjoy a very high social status (but also by those who did). It did not, however, deal with subjects that would have played an important role in the Salon – the exhibition room of the Académie royale at the Louvre – where the major historical paintings claimed the attention of the public and the critics. Genre painting was not a category of painting to which art lovers and critics gave any thought, or for which they sought a theoretical basis. In the minds of most contemporaries, genre painting was lacking in historical and theoretical background and was artistically inferior.

In France, the conflict between theory and practice in the case of *peinture de genre* did not surface until the middle of the eighteenth century. A discussion of this type of painting did not develop until Greuze started to paint pictures that attempted to be more than merely little scenes of imitated reality, and Diderot discovered in him an artist who was beginning to introduce moral pretensions into the realistic depiction of the world. Thus, a theory of genre painting only began to emerge at a time when the hitherto rigidly structured ranking of the genres was being called into question.

In order to understand the history leading up to this emerging style known as genre painting, and also to give some

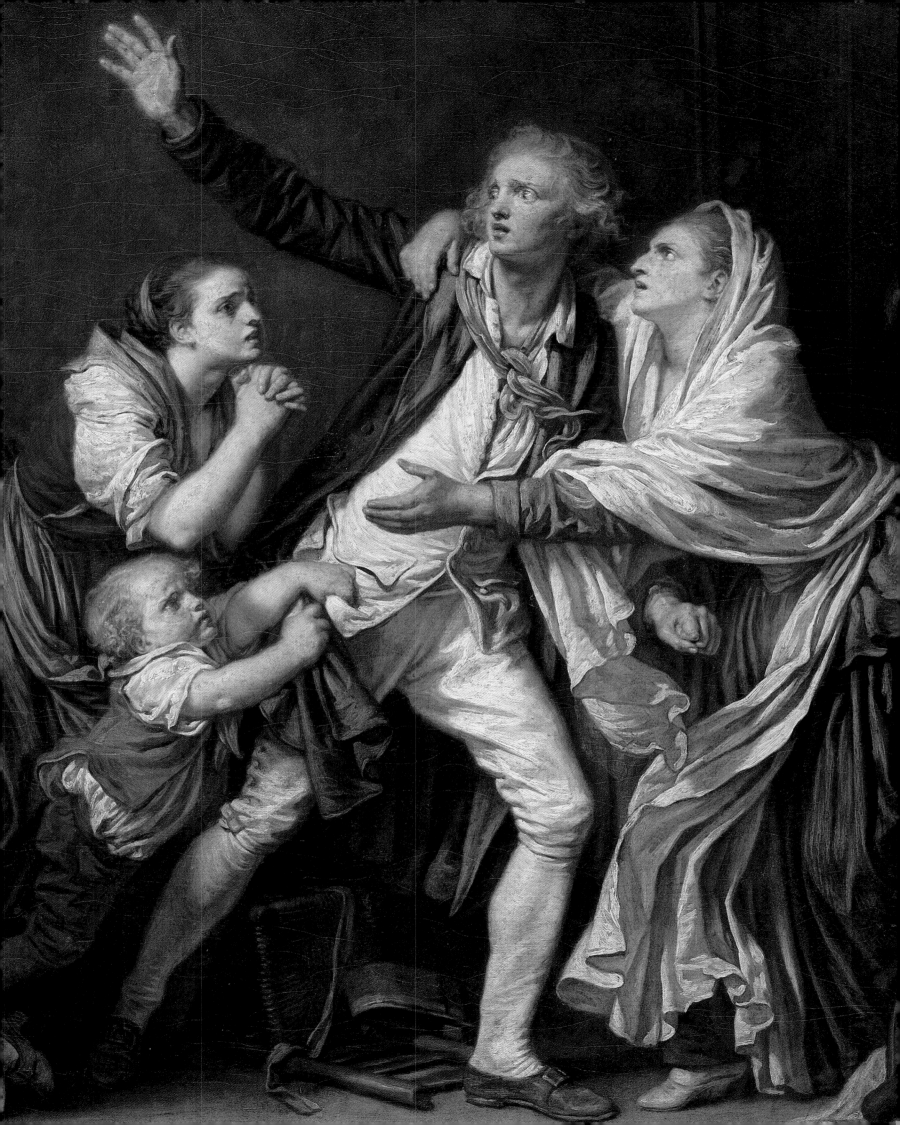

idea of the fundamental principles that helped create the theory behind it, we will make two short digressions into the problematic nature of this style, which was practised but remained undefined.[3] The first digression will take us back to its sources in antiquity. The second will remind us of the importance of genre painting in relation to the founding of the French Académie royale de peinture et de sculpture.

THE THEORY OF COMEDY IN ANTIQUITY

Already in the ancient world, thought had been given to the problem of providing a theoretical basis for ranking the various forms of expression. The directives drawn from the fields of poetics and rhetoric were to some extent valid not only for the performing arts but also for the plastic arts, and Horace's formula, *ut pictura poesis*, which reminded people of the related nature of poetry and painting, was an early reference to the long-standing common theoretical foundation of both *art forms*. This notion assumed a unity of art, where the same goals could be achieved by applying the same rules.

It is with this in mind that, from the Renaissance onwards, Aristotle's *Poetics* was repeatedly quoted whenever it was necessary to provide a theoretical basis for the painting of everyday scenes. It can be shown that Aristotle's succinct and concise definition of comedy provided sufficient arguments also for judging genre painting for centuries to come. His premise that all art imitates human activity was intended to include not only tragedy and comedy but also painting. The system of rules that he drew up for the various poetic genres has therefore also been regarded as a model for the "sister arts."

Aristotle made the distinction between tragedy and comedy by comparing the two painters Polygnotus and Pauson, the former depicting men as more noble than they are, the latter depicting them as less noble. The aim of comedy is to present men as worse than they are in reality, and to expose them to laughter in comic situations where they are unmasked. These comical humans were drawn mostly from the lower social orders – they were citizens, peasants, or the marginalized. Their simple colloquial language, their actions, and their emotions were intended to portray realistically, even to the point of exaggeration, the facts and circumstances of everyday life.

This resulted in a natural ranking of the genres in order of importance. Depictions of exemplary human beings and of their important actions could claim a higher rank than the imitation of simple people whose actions were derided. Already in antiquity it was a characteristic feature of these lower-ranked depictions that they would be true-to-life and would treat their subjects with unvarnished realism which, through comic exaggeration, could often turn satirical or grotesque. Even the way in which reality was observed and reproduced was clearly an essential characteristic of the genre.

Aristotle's view that ultimately the stylistic level of an imitation should decide the ranking of a genre was always upheld. In his *Poetics*, he writes: "The question may be raised whether the epic or tragic mode of imitation is the higher. If the more refined art is the higher, and the more refined in every case is that which appeals to the better sort of audience, the art which imitates anything and everything is manifestly most unrefined."[4] Thus, the theory of genre painting, which had been developing since the Renaissance, owes much to Aristotle's definition of comedy in certain fundamental areas.

Another source – which has lost none of its popularity – is Pliny's report about the painter Piraikos. Much to the annoyance of educated persons, who preferred morally uplifting, heroic or historical topics, Piraikos had more success with his "small" paintings (that is, small in size and unpretentious in nature) than the painters of exemplary and "grand" subjects. Pliny reported only facts, or so it would seem. But at the same time, there is the suggestion in his comments that any art that depicts small and unimportant subjects has abdicated its true task, which is to instruct and educate; and that, in a certain respect, such an art is useless – unless it simply serves to provide recreation and pleasure. But, as is also implied in his sparse remarks, this is not by itself an adequate goal for art to pursue.

At another point he writes about *parerga*, partly comic and partly tragic figures that appear as "staffage" (playing a secondary role) in historical paintings. He thus regards anecdotal scenes taken from the observed reality of everyday life as sub-plots that provide a commentary, but do not make a statement as such. It is at all times clear that the *parerga* are subordinate to an overriding theme. Here again, observed and depicted life functions merely as an accompanying, subordinate element in a larger and more important context.

The short passages from Pliny have come to form the basis of all analyses of paintings which, instead of presenting lofty and educational themes, deal with the everyday, historically insignificant circumstances of human life. They repeatedly emerge as art-theoretical *topoi* whenever an academic system for evaluating painting is involved.

TENSION BETWEEN THEORY AND PRACTICE

When the French Académie royale de peinture et sculpture was established in 1648, its founding members included painters who were not just known for their historical works but who also depicted scenes of bourgeois society and rural life, artisans and peasants – in other words, the third estate. Long before the Academy was founded, the Le Nain brothers, for example, not only created subjects drawn from the Bible or from history, along with allegories and portraits, but also painted burghers in towns and cities and peasants in villages. Their art encompassed

Fig. 29 Matthieu Le Nain, *A Blacksmith in his Forge*. Musée du Louvre, Paris

the whole breadth of painting: from high and lofty themes, down to simple and humble topics, from paintings of saints for the bedroom of Louis XIII, to the dark workshop of a blacksmith with his family (fig. 29).[5]

They thus fully satisfied the requirement that was soon to be advanced by André Félibien in his preface to the first reports of the meetings of the Academy, namely that a painter of historical scenes should simultaneously be capable of mastering all other styles of painting. His comprehensive training and ability should permit him to render everything that appears in nature, from human beings performing every kind of action, through to animals and inanimate objects, including landscapes and still-lifes of all manner of items. In addition to his role as someone who, under commission to the King, produces canvases depicting important national themes, a history painter is also an experienced practitioner who can handle all the minor genres as well – namely the *peinture de genre.*

With the founding of the Académie royale, and the desire to help its members achieve a higher rank compared with the artisan painters of the *Maîtrise* (guild), a restructuring of the artistic community was launched, and the various themes of painting were re-evaluated using models taken from antiquity as well as Italian art theory as the basis. Behind all this was the ambitious wish to create a new art form that would outdo Italy as a model and would establish a new school of art in France. It was reasonable, in this connection, that chief minister Colbert and Academy director Le Brun tried to declare Poussin a founding father of the new national school of painting, and hailed him as the foremost exponent of history painting because of his closeness to Raphael.[6]

The aim was thus to define a French way of painting historical subjects and coming to terms with the works of the Great Masters. No thought was given to representations of daily life; they were tainted by the banality of what was merely factual, decorative, and meaningless; they represented a style of painting that called for nothing more than craftsmanlike skill, but not invention. For a long time, Italian art and art theory had been regarded in France as the basis on which to develop a French school of art. As a result, since Bellori's severe condemnation of Caravaggio's "street scenes," such representations of the lower orders of society engaged in trivial activities had been completely excluded from the discussion of what could be considered serious topics for paintings.[7] In addition, it was not possible to emulate the great Italian model by painting "minor" and insignificant themes. In 1663 Colbert ordered that only painters of historical scenes, that is to say representatives of the most noble genre of art, could belong to the Academy.

The guidelines for the new policy in the field of art were clearly revealed in Félibien's minutes of the first meetings of the Academy in 1667. In his famous preface to the *Conférences,* he very clearly advanced the view that only two categories of painter exist: artists and craftsmen. Similarly, in painting there are only two classes, namely history painting and the painting of lesser subjects (*peinture de genre*).[8] The old contradiction between mind and matter was conjured up and used to lay the foundation for a strict division of the classes.

The progression from the mechanical skill of painting to the ennobled art of conceiving historical scenes and allegories consisted of refining and idealizing the process of invention and painting. There was very obviously a desire to implant painting firmly among the *Artes liberales*, and to downgrade its purely craftsmanlike aspect. From now on, the social standing of the artist would be determined also by the rank of the topics that he painted. The academic hierarchy of genres proposed by Félibien placed History and Fable at the top, followed by, in descending order but thematically linked, portraiture, animals, landscapes, and still-life. Astonishingly, his list did not include the painting of figures in everyday situations.

At the outset, therefore, the Academy trained only painters of history. This training included the lesser genres, which were regarded as component parts of historical painting. If it turned out that a painter felt that the task of painting historical scenes was beyond him, or if he developed a special talent in one of the minor genres, he was encouraged to concentrate on a particular genre. According to Félibien's often quoted remark, it was much better to be a good genre painter than to be a bad or mediocre history painter.

It was not until 1688, in his *Entretiens*, that Félibien devoted a passage to the paintings of the Le Nain brothers, which were in his estimate the embodiment of figure-based genre painting. He described their subjects as "often simple and without beauty" and categorized their genre paintings as "base, often ridiculous action pictures" that give pleasure for no more than a short while before they become tedious.[9] It can be assumed that by using the term *sujets d'actions basses* he was attempting to describe figure paintings of inferior rank as a subdivision of history painting. And his use of the word *ridicule* was intended to draw attention to the link with the human beings of comedy, as characterized in Aristotle's *Poetics*. Thus, to him, genre painting was absolutely the lowest level of figure painting.

However, it should not be overlooked that Félibien and his *Conférences*, which were repeatedly cited as representing the official point of view, were just one side of the coin – the side of Colbert and Le Brun. Félibien did not put forward the side of the artists, who perhaps saw things differently and from a more practically oriented standpoint. His treatment of *peinture de genre* is inadequate and unsatisfactory. It is clear, however, that he was merely concerned with defining "history" as the only topic worthy of theoretical analysis by the Academy. The palpable tension between Félibien's loyalty to academic principles, on the one hand, and a possibly more complex dynamic between theory and practice, on the other, should therefore be borne in mind in all the following arguments.

Although Félibien later modified his definition of the hierarchy of genres, once it was established, the strict system of rules retained its validity. In his article on the concept of *Genre (Peinture)*, published in 1757 in volume seven of the *Encyclopédie*, Claude-Henri Watelet still adhered strictly to Félibien's pronouncements on the subject. Watelet defined *genre* in the sense of "class and category," and he noted that in painting, the concept is used solely for the purpose of distinguishing those artists who contented themselves with depicting quite specific subjects from those who painted historical works. The examples he cited were those who painted animals, fruits, flowers, and landscapes.[10] The conclusion of his article, in which he discusses the individual genres in detail, is that a history painter must be perfect in all the genres, while

a genre painter needs to be perfect solely in the genre of his choice.

"Genre painting" is here still synonymous with the painting of various types of subject matter, in contrast to the representation of historical scenes, which had to include all the other genres. Watelet also emphasized that it is better to be an excellent painter of genre scenes ("un habile peintre de genre"), working with limited means in a narrow field, than a mediocre painter of history, skilled in all the genres. But even in 1757 there was still no mention anywhere of the painting of figures as a genre.

Another thirty years passed before Robin, in the *Encylopédie méthodique*, under *Peinture*, developed a more precise theory of genre painting, which indicated that the formerly rigid rules had been loosened.[11] Naturally, he writes, history painting remains the pinnacle of all the genres. Immediately beneath it, however, comes *genre*, which he prefers to accord the second

Fig. 30 David Teniers, *Interior of a Cabaret*. Musée du Louvre, Paris

rank, because after the depiction of historical scenes it calls for the greatest power of imagination. He chooses this position for the "genre of everyday life," which he referred to as the *genre familial* – this was the type of painting executed by Jan Miel, Michel-Ange des Batailles, Le Nain, Watteau, Teniers (fig. 30), and Brouwer. He alluded here specifically to the comic genre, and thus to the style of painting that, starting with Teniers and Brouwer, depicted simple unknown persons in everyday comic scenes. He included Watteau among such painters; but where were his other contemporaries – Boucher, Fragonard, and Greuze? Despite acknowledging new developments and trends in genre painting that obviously encouraged him to elevate it in rank, Robin proved himself to be a conservative theoretician, still clinging to the old doctrine of the Academy.

Not only Watelet and Robin but also other eighteenth-century French art critics were late to react to the new type of art that was developing with a great deal of vigour, namely that of figure painting. It is true to say that the signs of a reorientation in the field of genre painting were noticed and understood in other European countries, such as Holland, England, and Germany, before France and Paris became aware of them. But it was in Paris that Diderot's criticism of Greuze's new type of genre paintings sparked the most intense debate about the problems of genre-specific painting, problems that mark the start of revolutionary changes in the rigid structure of the Academy's artistic doctrine.

DE LAIRESSE AND THE SOCIAL ELEVATION OF GENRE PAINTING

Theoretical discussion does not commence until practice has already created the new facts that require analysis. That is to say, art theory develops *a posteriori*. This is especially true where the theory of Dutch genre painting is concerned. In the seventeenth century, genre painting had developed with astonishing success in local studios and schools in the seven free provinces of the Netherlands, without any influence from a state-run Academy and without any official policy on art. But despite the large number of known genre paintings and their wide distribution throughout Dutch and European collections, right up to the end of the seventeenth century surprisingly little theoretical thought had been given to the purpose and tasks of such a style of painting. The *Groot Schilderboek* (*The Art of Painting*) by Gérard de Lairesse (1640–1711), in which he examined in detail the category of genre painting, did not appear until 1707.[12] It should be noted that de Lairesse, as the leading proponent of classical painting and theory in Holland, was by no means a champion of genre painting. On the contrary: much of his book, which was intended as a manual for painters and art lovers, consists of instructions on how to

paint historical subjects. But the popularity and the broad compass of genre painting in Holland and the rest of Europe challenged him to take a position and to engage in a detailed theoretical discussion of the topic. Quite clearly, in developing his theory, de Lairesse was reacting to the reality of artistic practice in Holland.

Book three of his *Groot Schilderboek* contains the first and most important tract on genre painting that European art history was able to offer at the start of the eighteenth century; long before Diderot, it examined all the painting-related, theoretical and social circumstances associated with this category of art. Behind de Lairesse's remarks it is possible to sense the need to take this genre, which in his opinion had largely sunk to the portrayal of comic and vulgar scenes, and adapt it to contemporary social conditions, thus providing it with a new awareness of elevated bourgeois decorum. De Lairesse described in lively terms how it was almost impossible to enter a beautiful hall or an elegant apartment in Holland without "being greeted from the walls by beggars, brothels, drunken feasts, smokers, gamblers, or grubby children." And although these are only paintings, the art of painting is nevertheless an imitation of life that can either edify people or

repel them.[13] Art must therefore take account of the current way of living and provide an artistically and morally ideal counterpart to true life. The subject matter and style of the genre paintings used to decorate the homes of the bourgeoisie must meet the social and moral needs of that stratum of society, and should comment on them and reflect them in an exemplary manner.

De Lairesse therefore developed a concept for improving genre painting. He introduced the two terms "antique" and "modern" to contrast the different modes of representation found in history painting and genre painting. The antique style, as represented by Raphael and Poussin, is timeless and ideal, and takes antiquity as its model. In contrast, the modern style of Dou and van Mieris is subject to contemporary taste and is thus constantly changing. Since the modern painter is merely concerned with copying what is visible, he will always remain a mere craftsman. These arguments, just like the terms "antique" and "modern," were not original.[14] What was new were de Lairesse's proposals that the modern category of genre painting should be improved by adapting the antique style, in order to bring it closer to the painting of historical scenes (fig. 31).

He described three different levels of style which, like a *gradus ad Parnassum*, characterize the various modes of representation used in genre painting – from the comic, via the elegant, to the classical moral painting. He called this highest level of genre painting *cierlyk modern* ("gracefully modern"), by which he meant that it presents a picture of society that is modern, but has been improved and upgraded by antique models. Also, he asserted that genre painters finally should commit themselves to the task of correcting nature according to the antique model, in the same way that painters of history had always been required to do.

As a painter himself, de Lairesse always had practical considerations in mind; therefore he drew up examples of various types of paintings in order to depict a scale of emotions that he considered appropriate for the new, elevated, bourgeois social stratum of the eighteenth century. His detailed suggestions on how to characterize the forms and standards of behaviour of the higher ranks of society – through their gestures and emotions – are studies for a genre that ranges from lofty to base according to the social standing of the protagonists appearing in it. The higher the social status of the persons depicted in a modern scene, the higher the ranking of the genre. Through its moral content, propriety, and controlled feelings, or by copying an antique model and making a moral statement, a modern figure scene could thus be assigned a rank that it would never have attained in the past. At the same time, de Lairesse supported the theory that, as a citizen and member of a state, the painter was fully familiar with the morals and characteristics of this bourgeois society and was therefore ideally qualified to reproduce them in a responsible manner.

We do not know whether he had in mind the genre scenes painted by Frans van Mieris, Eglon Hendrik van der Neer, and

Fig. 31 (FACING PAGE) Adriaen van der Werff, *Children Playing in front of a Statue of Hercules*, 1687. Alte Pinakothek, Munich

Fig. 32 Arnold Houbraken, *Family Scene*, 1707. Illustration from: Gérard de Lairesse, *Groot Schilderboek* (1707)

Adriaen van der Werff, which were also popular in France; what is certain, however, is that long before the engravings of Daniel Nikolaus Chodowiecki (1726–1801) depicting bourgeois emotions, the *Schilderboek* already contained studies on the social psychology of the bourgeoisie around 1700.[15] As well, de Lairesse's remarks demonstrate very clearly how the contemporary discussion on the depiction of emotion in history painting also found its way, admittedly in modified form, into the theory of genre painting, which thus acquired the status of an academically upgraded genre.

Consequently, in his *Schilderboek* de Lairesse developed a new and differentiated type of genre painting which, because it was far removed from the comic depictions and coarse emotions for which Dutch painting had become known, demanded a new method of representation: based on the ideal of antique models, it would present a purified image of bourgeois life in Holland (fig. 32). The genre painter is given a moral and educational task to perform, which should be affirmative, not destructive; which should strengthen the fabric of society, and not weaken it by the introduction of comic elements. De Lairesse, living and working in Holland, wanted at all costs to break away from the old notion of genre painting as a comic art form and to pave the way for it to become a noble one.

The Englishmen Henry Fielding (1707–1754) and William
Hogarth (1697–1764) stand for something quite different.
Almost forty years later, and under completely changed social
conditions, Fielding developed a new literary genre for his
comic novel *Joseph Andrews* by referring to similar efforts made
by the painter William Hogarth. Instead of denying the old
link between the everyday genre and the comic art form, as de
Lairesse had done, Fielding made specific reference to the comic
form and took it as the basis for a new and positive valuation
of his own work.

He did this in the preface to *Joseph Andrews*, which the
author himself asserted that he had written "in the style of
Cervantes" with the desire that it would stand as a successor to
Don Quixote. There he alludes to Aristotle's theory of comedy
and above all to the fact that comedy imitates lower types
of individuals – not bad but ridiculous ones, that which is
ridiculous being part of that which is ugly. Comedy, therefore,
arises from an exact portrayal of unembellished everyday life.

He called his new type of novel "comic epic-poems in
prose" – basically comedies in the form of novels. By merging

Fig. 33 William Hogarth, *Characters and Caricaturas*, 1743. The Charles
Deering McCormick Library of Special Collections, Northwestern University
Library, Evanston, Illinois

fundamentally incompatible elements into a new concept,
Fielding was clearly attempting to mix literary forms and in this
manner to break away from the given definitions of the genre.
He observed similar efforts being made by his contemporary,
the painter William Hogarth. Consequently, in a brief passage
he characterized the artist as a "comic history painter."[16] The
very concept was a sacrilege, since it connected dissimilar
attributes of genres. *Comic history* was a contradiction in terms,
a neologism that attempted to bridge the gap between comedy
and tragedy, nature and the ideal, low and high, and to
combine these elements into a new genre: history painting of
daily life, dramatic occurrences without sublimity, humble
events with high moral pretension – in effect, linking elements
that had previously seemed irreconcilably disparate.

Hogarth took note of the new type of genre, and his reaction
to it can be seen in an inscription on his engraving *Characters
and Caricaturas* (fig. 33). In this physiognomical panorama,
he demonstrated the full range of his delineation of bourgeois
types, distinguishing them from the grotesque characters
of Italian art. However, he did not employ Fielding's term.
Instead, in his *Autobiographical Notes* he called himself a painter
of "modern moral subjects." By linking "modern," in the sense
of contemporary, current, but also base and comic, with the
word "moral," in the sense of virtuous and didactic, the painter
felt that he had given a better description of himself. The
concept was intended to characterize a modern work of art,
depicting events and containing a moral message. This form
of painting clearly distanced itself from the traditional forms.
However, Hogarth's intention was to create a new genre, "a
different kind of subject . . . an intermediate species of subjects
for painting, between the sublime and the grotesque."[17]

Whether or not Hogarth's dramatic series tend more towards
history painting or towards genre painting is a question that
must remain unanswered (see fig. 34). Horace Walpole
associated him more with the latter when he referred to him as
a "writer of comedy with a pencil." Later, in his *Discourses on
Art*, Sir Joshua Reynolds summed up Hogarth's art critically as
"dramatic painting" and thus as not belonging to any particular
genre. What is certain, however, is that Hogarth was the person
who most consistently diagnosed the possibilities inherent in a
genre that was in a state of flux; and he made use of this
situation for his new ideas concerning a type of bourgeois and
socio-critical art.

The German physicist and satirist Georg Christoph
Lichtenberg (1742–1799), a professor at the university of
Göttingen, recognized in Hogarth's series an enlightening
impetus that was related in some respects to his own interests.
He realized that the new art form of creating dramatic
sequences of pictures, which Hogarth had invented and put
into practice in his engravings, demanded analysis. In 1794
he published his *Ausführliche Erklärung der Hogarthischen
Kupferstiche* ("Detailed Commentaries on Hogarth's

Fig. 34 William Hogarth, *Marriage à la Mode: 1. The Marriage Settlement*, 1742–43. The National Gallery, London

Engravings").[18] Although he did not put forward a conclusive theory, he re-created the scenes in explanatory language that captured what was essential, innovative, and provocative about Hogarth's themes. In his description of the cycle entitled *Marriage à la Mode*, Lichtenberg entered into the latent fray between the categories of history and genre, viewing Hogarth's series of engravings as a multilayered modern tale containing comic, satirical, moral, and historical elements. He thus identified Hogarth's new genre as a mixture of literary and artistic elements, and termed it as such.

However, at that time the question of genre was no longer a subject for aggressive debate. Hogarth's moral-comic series drawn from the lives of the bourgeoisie and nobility had already been adopted in Germany, and had been integrated as moral examples into the enlightened bourgeois art of an artist like Chodowiecki.

A EUROPEAN DIALOGUE?

Fielding, Hogarth, and Lichtenberg embody a particular aspect of the debate surrounding the theory of art that was conducted during the eighteenth century. In England, the writer Fielding and the painter Hogarth sparked a kind of "national dialogue." But that was by no means all. The many different publications on the subject give the impression that around mid-century a wide range of international dialogues about genre painting was taking place in Europe, provoking questions and answers, suggestions and rejections, revolutionary change and restoration. What de Lairesse or Arnold Houbraken wrote in Holland was also read in England. What Hogarth painted and engraved in England also reached a German public. And what happened in Paris was transmitted to the various principalities of Europe in the form of travellers' reports and correspondence,

including Grimm's *Correspondance littéraire*, for which Diderot wrote his art critiques.

The debate about the various rankings of paintings and themes thus developed into a topic of discussion throughout Europe, and the arguments were not restricted to painting. Similar questions regarding the sense and purpose of hierarchical boundaries between the genres, and their breakdown, were raised also in the fields of music, theatre, and literature.[19] The "emancipation" of the lower genres was pursued in various places, and simultaneously attacked and defended by the guardians of academic doctrines. At this point, we will merely ask in passing whether all this shaking up of the hierarchical structures – in whatever discipline – was perhaps indicative of deeper political and social questions.

THE RECEPTION OF ART AND THE RETURN TO TRADITIONAL VALUES

Around the mid-1700s, the conflict between what the Académie in Paris had defined as history painting, and what the public preferred, became increasingly obvious. The theoretical debate centred on the works of Watteau and Chardin, which were controversial because of their simple subject matter, but which were also in very high demand and much admired.

The observation that all theoretical discussion has a practical basis was true in Chardin's case as well. The popular success that he enjoyed forced the newly emerging discipline of Salon criticism to reflect on the category of genre painting. Étienne La Font de Saint-Yenne was one of the first art critics to take as the subject of his address to the Salon the way in which a work of art is received by the viewer. Although he was a strict defender of the hierarchy of genres, he set out to interpret Chardin for the public:

> What we admire in him is the talent to depict, with a veracity that is entirely his own and remarkably naive, certain moments in everyday activities of no particular importance – moments undeserving of our interest that neither merit being singled out by the artist, nor are of the kind of beauty we admire: and yet, these are what have created a reputation for him, at home and abroad [fig. 35].[20]

Saint-Yenne described the genre again a few years later, in his *Sentimens* (1754).[21] According to him, an imitation of nature not only encompasses a wide range of objects and landscapes, but also is devoted to the "depiction of pastoral scenes, rural festivities . . . kitchens, inns, horse stables, that is, the popular and plebeian themes of the Flemish people." He stated that its usefulness consists solely in the pleasure that the beauty of the painting offers to the eye; the banal motif is converted into something picturesque. He distinguished between "portraits of nature" and simple "representations" of no historical import:

the former being depictions of inanimate objects including landscapes, and the latter, pastoral scenes and *fêtes champêtres*.

For Saint-Yenne, Chardin's achievement was merely that he transposed reality into painting without imparting any deeper meaning to it. The critic thus placed the French genre painter on a higher level than the Flemish painters of peasants. But because Chardin's paintings only gave pleasure to the eye and not to the soul, Saint-Yenne refused to concede that they had any moral-educational pretensions – these belonged properly only in the domain of history painting.

On 23 February 1748, the Comte de Caylus (1692–1765), one-time friend and pupil of Watteau and later an important archeologist and *homme de lettres*, arranged for a commemorative speech about Watteau to be read to students and professors of the Académie royale. The speech was not so much a recollection of shared experiences as an academic manifesto against the genre of *fêtes galantes*. This took place at a time when the Académie, under its new director Charles-Antoine Coypel, was thinking of reviving the tried and proven ideas and doctrines of the seventeenth century. Caylus, who was a member of the Académie as an *Amateur honoraire*, supported this return to past values by initiating the restorative phase with a philippic against Watteau and the *petit goût* in painting.

Watteau had died in 1721; but twenty-seven years later, the genre of *fêtes galantes*, a specialty of his, was still able to seduce even some very conservative art lovers. Although Watteau was admitted to the Academy as a history painter, afterwards he never painted any historical subjects.[22] Caylus therefore accused him of all manner of omissions during his short career. He had allegedly not created any heroic or allegorical topics and was not capable of painting large figures or of depicting passions. The most serious of Caylus's accusations was that Watteau's paintings were devoid of theme or action: they were monotonous and all alike. There were only four canvases that Caylus allowed were exceptions to this statement: *The Village Wedding*, *The Pleasures of the Ball*, *Gersaint's Shopsign*, and *The Embarkation from Cythera*.

Without a doubt, Caylus was treating Watteau as a genre painter of gallant and pastoral scenes. He compared Watteau's paintings not with Titian's mythologies and Arcadian subjects but with those of the Dutch painter Gerrit Dou, and thus moved him closer to the minor masters whose work – although it was appreciated by the public – was lacking any deeper significance and therefore had to occupy a lower rank. Caylus was totally committed to the classical renewal of the art of antiquity and was unable to accept the inspired but disorderly fusion of history and genre in Watteau's work.

* * *

Fig. 35 Jean-Baptiste-Siméon Chardin, *La Pourvoyeuse*, 1739. Musée du Louvre, Paris

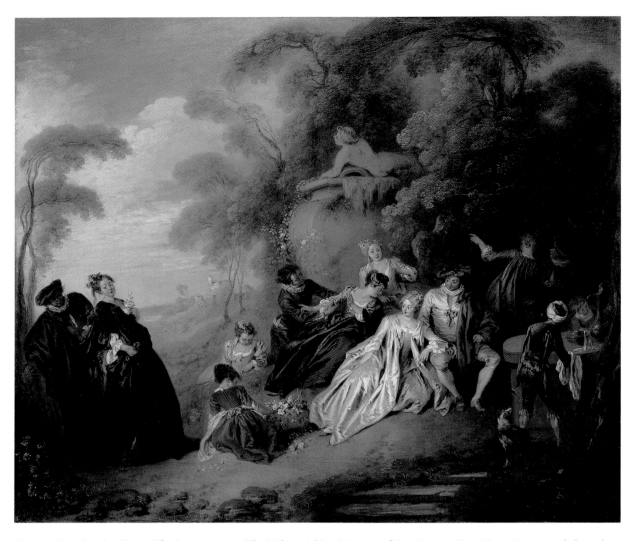

Fig. 36 Jean-Baptiste Pater, *The Picnic*, c. 1720. The Nelson-Atkins Museum of Art, Kansas City, Missouri, Acquired through the bequest of Helen Foresman Spencer

THE NEW TASTE AND HAGEDORN'S PAINTINGS OF SOCIETY

Despite the attempts at reform made by the Académie royale to re-establish history painting as the most important genre, in 1762 the cosmopolitan Christian Ludwig von Hagedorn (1712–1780) noted in his *Betrachtungen über die Mahlerey* ("Observations on Painting"):

> Take us quickly to the magical islands of Watteau and into the social gatherings of Lancret! All the wall coverings cry out to us that this is the taste of our century. . . . We love change. Even though we may concentrate with great intensity on the depictions of gods and heroes, or on the most moving events in history, our interest at some point gives way to the yearning to find ourselves amongst our own kind, enjoying the pleasures of bourgeois life. Are we lowering ourselves in so doing? I would not like to believe that good society is capable of that.[23]

Diplomat, collector, engraver, art theorist, and from 1764 general director of the art collections in Dresden, who corresponded with Winckelmann, Sulzer, and Gessner, Hagedorn was a connoisseur of contemporary art, but his collecting activity was chiefly devoted to Dutch, Flemish, and French tastes. He was familiar with and quoted the works of de Lairesse and Johan van Gool. He defended antiquity as a model and history painting as the noblest of the genres, but nonetheless recognized the beauty of Dutch landscape painting and the importance of bourgeois genre scenes, which he called *Gesellschaftsgemälde* ("paintings of society").

The leitmotif that runs throughout his chapter on *Gesellschaftsgemälde* is the notion that the established hierarchy of genres was undergoing a process of re-evaluation. This process was rooted in the viewer's desire finally to have the opportunity to see paintings that depicted not gods and heroes, but people like himself; that did not show examples taken from antiquity, but rather portrayed the pleasures of modern society. Art should be pleasing to the viewer and reflect his own bourgeois

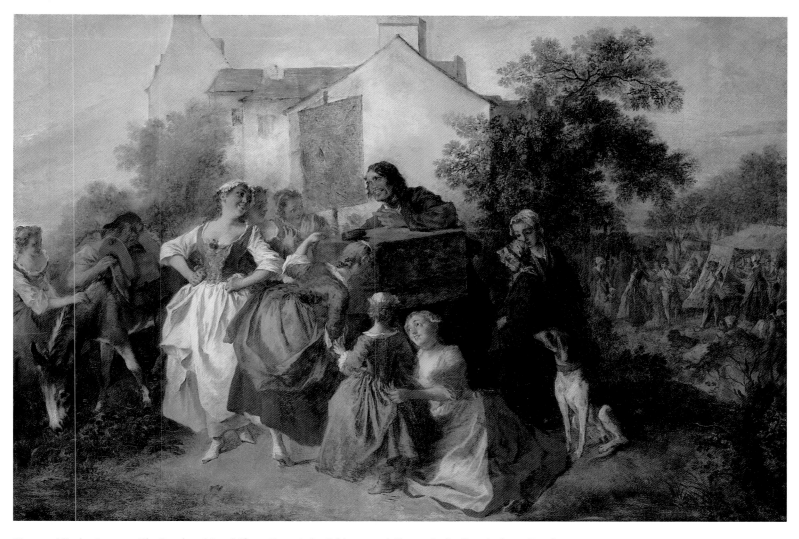

Fig. 37 Nicolas Lancret, *The Peepshow Man*. Stiftung Preussische Schlösser und Gärten Berlin-Brandenburg, Potsdam

experience of life. The depictions of society "in the style of Watteau" represented a new branch of painting, which was not low and vulgar compared with historical subject matter but was an image of well-mannered "good society."[24]

In the meantime, according to Hagedorn, the taste of a self-aware and aesthetically educated bourgeois public had turned towards the rococo paintings of Watteau, Lancret, and Pater, while the major themes and painters of the Renaissance had already, to some extent, lost their ability to arouse people's interest or pleasure (fig. 36). What form should the new bourgeois picture of society take, and if it wished to be an image of society, what properties should it reflect? To start with, he posited that it had to be "respectable" and not affected, as was the case in many French paintings.[25] Hagedorn called for emotional values: "The language of the heart . . . innocence, the truly naive, speaking from the heart," and he noted that "these characteristics properly reside in bourgeois society or in the games played by carefree youth (fig. 37)."[26] What is naive can be just as moving as what is sublime, particularly when the

"unexpected" gives the action a "meaning" of its own – here Hagedorn uses the word *Höhe* ("importance").[27]

No one could have described more clearly the current paradigm shift – away from admiring the sublimity of a dramatic historical event, to being touched by the genuine and naive emotions expressed in a depiction of bourgeois society. Hagedorn describes vividly the new repertoire of methods for depicting bourgeois emotions, and also the need for an appropriate artistic means of rendering facial expression. Because of its almost imperceptible gradations, the character of innocence is incomparably more difficult to portray than the expression of violent passions. He stressed the turning away from the depiction of heroic passions and dramatic gestures, and the move towards the representation of refined bourgeois feelings. By appealing to the viewer, Hagedorn tried to draw him "into the picture" as an important protagonist. He writes: "In you, my observer (or so I would like to say to people), must be found the first trait of the character that you see or feel in nature, and which, if you are an artist, you want to borrow

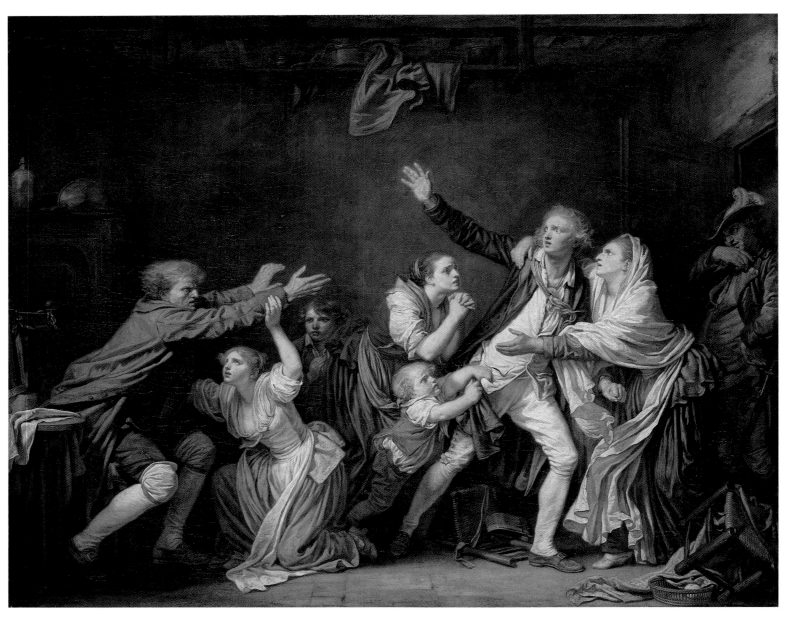

Fig. 38 Jean-Baptiste Greuze, *The Father's Curse: The Ungrateful Son*, 1777. Musée du Louvre, Paris

from nature."[28] It would be hard to set forth more clearly the moral tasks to be performed by a new type of genre painting. Hagedorn's theory of the aesthetic effect of bourgeois paintings, at the same time that Diderot was publishing his Salon criticism, finally helped genre painting to gain general recognition under the heading of "social painting."

DIDEROT AND THE NEW MORAL FORM OF GENRE PAINTING

However, it took Denis Diderot (1713–1784) and his analysis of the work of the painter Jean-Baptiste Greuze to launch a new epoch in the theory of art as it pertained to genre painting. In

1759, when Diderot started to write his first reports on the Paris Salon for Grimm's *Correspondance littéraire*, he was forced to invent a new terminology that would make the effect of individual works of art directly understandable, even to a distant reader. Two years later, he gave for the first time an enthusiastic and sensitive description of a painting by Jean-Baptiste Greuze, *The Marriage Contract* (cat. 71). In 1763, when discussing Greuze's *Filial Piety* (cat. 72), he was already engaged in a fundamental analysis of genre painting, a category in which he recognized traits that were associated with his own literary works. As an author of bourgeois-realistic tragedies, Diderot was familiar with the tension between the genres of tragedy and comedy. In Greuze, an ambitious artist who worked in a lower genre, although his formats and dramatic family scenes betrayed

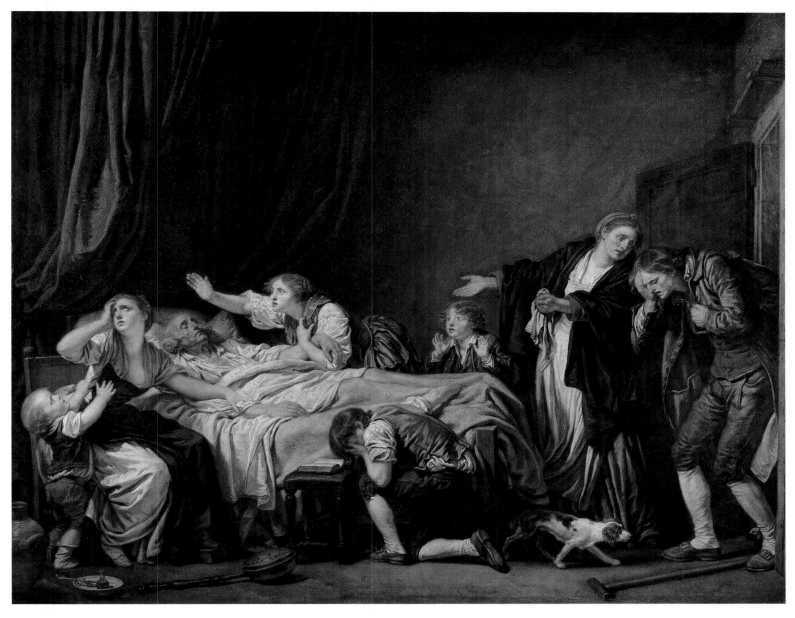

Fig. 39 Jean-Baptiste Greuze, *The Father's Curse: The Punished Son*, 1778. Musée du Louvre, Paris

pretensions to move up into a higher academic category, Diderot intuitively recognized what was forward-looking about his art:

> I really like this Greuze fellow. . . . To begin with, genre appeals to me; it is moral painting. Or haven't brushes spent quite enough, indeed too much time depicting vice and debauchery? Shouldn't we then be pleased to see them finally take on dramatic poetry to touch us, instruct us, correct us, and lead us to virtue? Take heart, Greuze, my friend, and practise morality in painting![29]

In his description of Greuze's paintings, Diderot impressively describes his discovery of an entirely new genre which, through its dramatic character, its serial form, and its educational appeal

had taken on tasks that up until then had been reserved for history painters. With its depictions of dramas involving anonymous individuals, the new style of painting was able not only to move viewers but also to instruct and improve them. Bourgeois themes in paintings and bourgeois observers went together, according to Diderot, and intensified the effect and the moral message of the art work (see figs. 38 and 39).

Diderot left no room for doubt that he still considered Greuze a *peintre de genre* and not a history painter, yet one who had succeeded in introducing progressive elements into the limited scope of his genre. He therefore fully approved of this, as long as it all took place within the framework of an informal ambience and among the petty bourgeois personages of his genre pictures.

Greuze's paintings challenged Diderot to become the first to give some thought to the special status of a style of genre painting that had acquired a measure of importance. In his *Essai sur la Peinture*, written in 1766, he reminded the reader of all the old prejudices that history painters held about genre painters: namely, that they were narrow-minded persons, lacking in genius, who slavishly copied nature, artisans good only for paltry subjects, for minor domestic scenes of the kind that can be observed on any street corner. On the other hand, genre painters regarded history painters as dreamers who created false and exaggerated characters that had nothing to do with the movements and actions of real life.

The point, however, was not to tear down the boundaries between the genres but to respect and expand them. A scene painted by Greuze could not, in principle, be compared with history paintings by Poussin and Le Brun. In Diderot's opinion, history painting called for sublimity, whereas a genre scene called for truth – and this truth was not a mere copy of nature but an imitation that is modified by the artist's personal experiences. Expanding but not exceeding its spheres of competence in this way allowed genre painting, of the kind practised by Greuze, to occupy for the first time a prominent position in the academic structure of the genres.

But, a short time later, when Greuze attempted to gain admission to the Académie as a history painter with his *Septimius Severus Reproaching his Son Caracalla* (for having plotted to assassinate him in the passes of the Scottish highlands), Diderot withdrew his good will. Even more than that: he passionately rejected the painting. The critic now turned against the attempts by a genre painter to encroach on the domain of history painting, and he protested the hubris of a genre painter wanting to paint historic scenes without having adequate training or qualification to do so. To Diderot, the academic hierarchy of the genres was fundamentally acceptable; for him the genres remained separate from each other. In this respect he found himself in full agreement with the members of the Académie who insisted that Greuze should be admitted solely as a *peintre de genre* and that he should be accorded a suitable place among the minor genres.

REVOLUTION AND RE-EVALUATION: GENRE PAINTING AS A NATIONAL TASK

The discussion about the boundaries between the genres – and about crossing those boundaries – which took place and was resolved in 1769 was still focused on traditional values, but it foreshadowed future events: along with the overthrow of political hierarchies during the French Revolution, the state institutions and their hierarchical structures also underwent a change. The system of the arts was now brought into line with

Fig. 40 Pierre-Nicolas Legrand de Sérant, *A Good Deed Is Never Forgotten*, 1794–95. Dallas Museum of Art, Texas, Foundation for the Arts Collection, Mrs. John B. O'Hara Fund

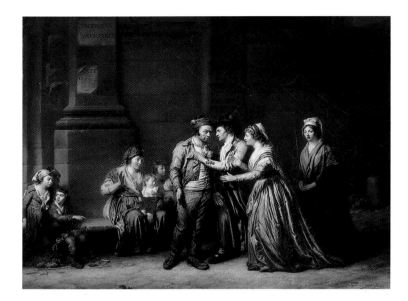

the political system. In 1791 the Salon opened its doors for the first time to all artists, whether they belonged to the Academy or not. Two years later, the newly established National Convention, of which Jacques Louis David was a member, dissolved the Académie royale de peinture et de sculpture.[30]

In 1799, in the seventh year of the French Republic, an enquiry was sent by Nicolas-Marie Quinette, the Minister of the Interior, to the president of the Institut national, in which he put forward the complaint raised by various *citoyens* that not only had the old genres established under Louis XIV been reintroduced, but also that patriotic themes had been relegated to the category of genre painting. It was obvious that the old genre of costume and history painting had re-established its dominance. In addition, the citizens charged, it was only history painters and not genre painters who were ever awarded any prizes (fig. 40).

The Minister of the Interior intervened administratively, requesting that the system be amended, and stating that paintings that were formerly designated as genre works now had to assume new patriotic and republican duties. The government was interested in having "a greater number of moving and true scenes of domestic drama," and he further insisted that from the standpoint of morality, Greuze had without doubt been a more beneficial influence than Le Brun.[31] He closed his letter with the request that the old hierarchy of the genres should be

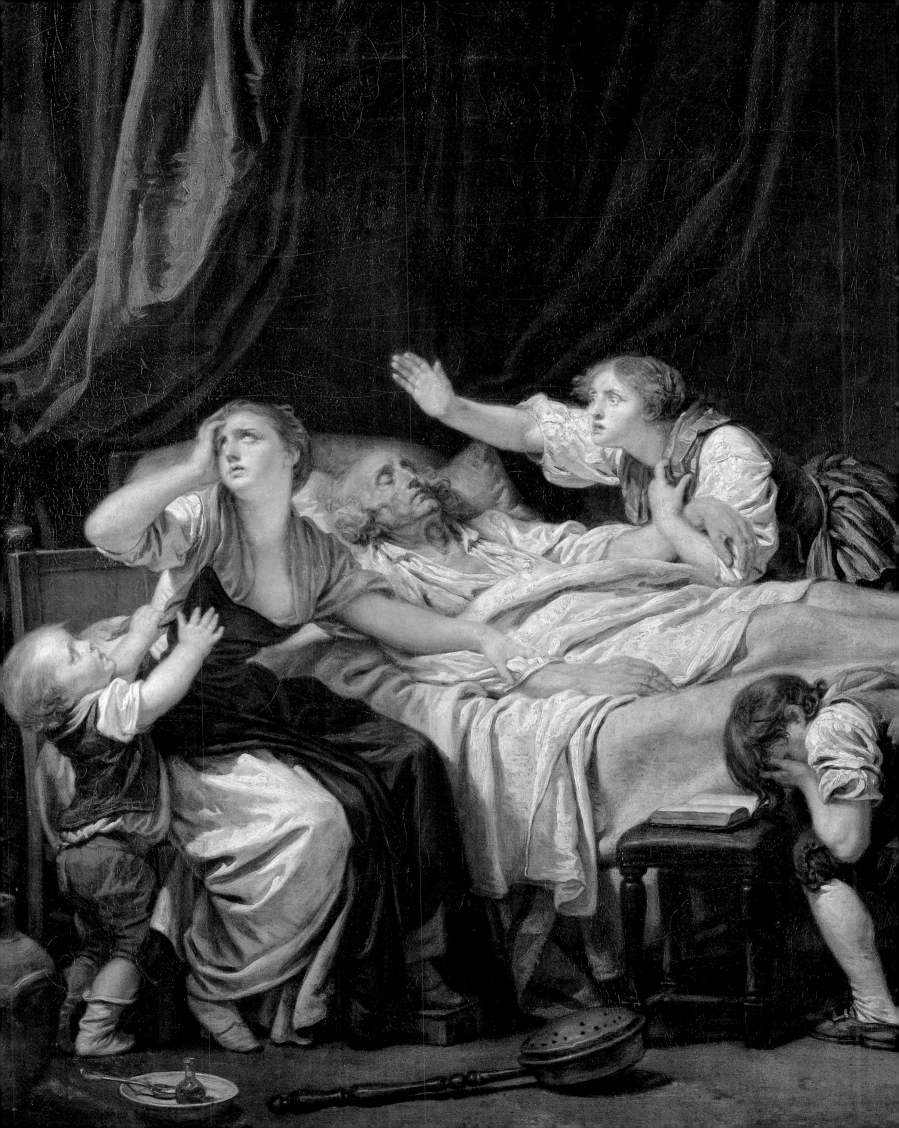

revised, and that from now on genre painting should be honoured with the same prizes as history painting.

GENRE PAINTING AS A EUROPEAN PROBLEM

The formation of a theory of genre painting must be seen as a European problem, and in this regard our attention is repeatedly drawn towards France. Just a few examples have been given here to demonstrate how the passionate discussion of a newly evolving genre gained momentum throughout the eighteenth century until, in the post-revolutionary era, it led to a re-evaluation of history and genre.

But this development was more than just a French national phenomenon. It is true that in France the discussion was more consistent because it was always dependent on the values established by the Académie royale; but it was only in the context of similar considerations elsewhere in Europe, where ideas and modifications were developed on the basis of national practice, that the theory of genre painting also gained in depth and intensity.

The intellectual and political emancipation of the bourgeoisie played an important role in this process. De Lairesse, Hogarth, Hagedorn, Lichtenberg, and Diderot all noted the change in taste taking place in a public that wanted to recognize itself in the new genre paintings. Reading between the lines in many texts, it was possible to detect a distrust of history painting based on traditional values. Writers and artists reacted in different ways to the challenges of genre painting as it became emancipated. Diderot, in particular, remained true to the traditional system of rules of the Academy despite his initial enthusiasm for Greuze. The unfortunate attempt Greuze made to move out of the class of genre painter by presenting a history painting was decried as a damnable sacrilege by Diderot, who then pilloried the painter as a kind of heretic, while his readers watched.

With this, the battles over a genre that was growing ever more liberated, and that had been regarded as both comic and realistic since the days of antiquity, reached their climax but also their turning point. It was not until the nineteenth century that genre painting gradually acquired a level of importance that finally allowed it to oust history painting from its throne.

NOTES

I would like to thank H. Hymans, Paris, for reading the English manuscript.

1 Diderot and d'Alembert 1751–76, VII (1757), pp. 597–99. For a detailed analysis of the topic, see Gaehtgens 2002.

2 For a general discussion of the problem, see Wrigley 1993; see also Colin Bailey's essay in this volume.

3 See also Raupp 1983, pp. 401–18.

4 *Aristotle's Poetics*, translated by S.H. Butcher, New York, 1986, p. 116.

5 For additional information about the brothers Antoine, Matthieu, and Louis Le Nain, see the biography by Jacques Thuillier in Paris 1978.

6 On this topic, Fontaine 1909 is still a standard work; see also Gaehtgens and Fleckner 1996.

7 More details can be found in the account of the life of Michelangelo Da Caravaggio in Giovan Pietro Bellori, *Le Vite de' pittori, scultori, et architetti moderni*, Rome, 1672; reprinted Geneva, 1968, pp. 243–65.

8 See Félibien 1668. For a detailed study of Félibien, see Germer 1997; on the *Conférences*, see Mérot 1996; on the question of genres, see Kirchner 1997; on the *Entretiens*, see Démoris 1987, pp. 1–92.

9 "Représentant souvent des sujets simples & sans beauté"; ". . . ces sujets d'actions basses et souvent ridicule." Félibien 1705, IV, pp. 170–71. On this topic, see also Gaehtgens 2002, pp. 28–29, 158–71.

10 In Diderot and d'Alembert 1751–76, VII (1757), p. 597.

11 The *Encylopédie méthodique: Beaux-Arts* (Watelet and Levesque 1792), frequently bound in four volumes, was published in two parts, the first in 1788, the second in 1792. Following the death of Watelet, the work was completed by Pierre-Charles Levesque et al. The so-called *Watelet-Levesque* was planned as a supplement to the large *Encylopédie méthodique* published by Charles-Joseph Panckoucke. On the developmental history, see Michel 2000.

12 Gérard de Lairesse, *Groot Schilderboek*, Amsterdam, 1707.

13 *Des Herrn Gerhard de Lairesse . . . Grosses Mahler-Buch*, Nuremberg, 1728, part 1, book 3, ch. 1, p. 3.

14 The terms "antique" and "modern" had already been contrasted in Dutch tradition, in the work of van Mander (Carel van Mander, *Het Schilder-Boeck*, Haarlem, 1604), and since that time had frequently been encountered in the literature. Nevertheless, it is possible that de Lairesse was additionally referring to Charles Perrault's *Parallèles des Anciens et des Modernes*, which had been reprinted in Amsterdam in 1695.

15 On this subject, see Busch 1993, pp. 317–20; on the ennoblement of genre painting by de Lairesse, see Kemmer 1998, pp. 87–115; for de Lairesse's influence on Adriaen van der Werff, see Gaehtgens 1987.

16 Henry Fielding, *Joseph Andrews: The Author's Preface*, London, 1742.

17 William Hogarth, *The Analysis of Beauty. With the rejected passages from the Manuscript Drafts and the Autobiographical Notes (1764)*, edited by Joseph Burke, Oxford, 1955, pp. 215–16. For a standard work on the artist, see Ronald Paulson, *Hogarth*, 3 vols., Cambridge, 1993.

18 Reprinted in *Lichtenbergs Hogarth. Die Calender-Erklärungen von Georg Christoph Lichtenberg mit den Nachstichen von Ernst Ludwig Riepenhausen zu den Kuperstich-Tafeln von William Hogarth*, edited by Wolfgang Promies, Munich, 1999.

19 On the interrelation between drama and painting, see Ledbury 1997, pp. 49–67.

20 La Font de Saint-Yenne 1747, p. 109 [our translation]. On Saint-Yenne's contribution to the development of French art criticism, see Fontaine 1909, Dresdner 1915, Crow 1985, Pochat 1986, pp. 392ff., and Gaehtgens 2002, pp. 245–52. On the history and theory of French genre painting, see also two dissertations: McPherson 1982 and Anderman 2000.

21 La Font de Saint-Yenne 1754, reprint 1970, pp. 74–75, and Gaehtgens 2002, pp. 247–52.

22 Watelet and Levesque (1792, II, part 1, pp. 132–33, Paris, 1791) stated incorrectly that Watteau had won first prize at the Académie royale as a history painter.

23 Christian Ludwig von Hagedorn, *Betrachtungen über die Mahlerey*, 2 vols., Leipzig, 1762, I, p. 403.

24 Ibid., p. 405.

25 Ibid., p. 409.

26 Ibid., p. 411.

27 Ibid., p. 410.

28 Ibid., p. 411.

29 Our translation; see Seznec and Adhémar 1975, I, p. 233.

30 For a detailed analysis of this topic, see van de Sandt 1989.

31 Nicolas-Marie Quinette, "Lettre du Ministre de l'Intérieur au Président de l'Institut National (1799)," in Bonnaire 1937–43, I, pp. 281–83.

"Sorti de son genre": Genre Painting and Boundary Crossing at the End of the Ancien Régime

MARTIN SCHIEDER

When, at the insistence of France's Royal Academy of Painting and Sculpture, Jean-Baptiste Greuze applied for admission in 1769, he could already look back on a successful career as a portraitist, but especially as a genre painter. To the surprise of many, though, it was not a genre picture he submitted as his reception piece, but a historical painting of a subject taken from the Roman past: *Septimius Severus Reproaching Caracalla* (fig. 41). Greuze's hope that this work would earn him the designation of history painter was vain. The Academicians did agree to admit him to their ranks, but only "as a genre painter."[1] They cited his "previous excellent works" as key to this decision, saying they had had to shut their eyes to his actual submission, "which was not worthy of [the Academy] nor of yourself."[2]

The vote scandalized the Paris art world. Greuze berated the committee and withdrew his painting from the Salon; only after the Revolution would he exhibit there again. Concerned about the Academy's reputation, its secretary Charles-Nicolas Cochin had to explain to the Directeur des Batiments du roi, the Marquis de Marigny, why the institution had snubbed an artist who was highly regarded in France and beyond its borders. He insisted that the picture was "full of mistakes" and "of the greatest mediocrity," but said the deciding factor was that Greuze had executed a historical theme in the manner of a genre painter like David Teniers or Gerard Terborch, giving his protagonists "the traits of simple and common people."[3] The verdict was unanimous among art critics as well; they complained they could neither understand the composition nor identify the figures, and pointed out anatomical inaccuracies and weaknesses in the rendering of gesture and mien, the "*expression of passions.*" Even Diderot, who otherwise greatly admired Greuze, sounded like an Academy official when he wrote that the painter ought to respect the hierarchy of the genres: "You know . . . that artists who only imitate subservient nature and pastoral, bourgeois, and domestic scenes have been relegated to the class of genre painters, and that history painters alone make up the other class." He criticized Greuze for giving the emperor and his son the bearing and features of tramps and rogues, at odds with their historical significance and social status. Diderot described such faithful renderings of the baser aspects of human nature as contrary to the noble standards of historical painting: "Greuze est sorti de son genre" ("Greuze has overstepped his genre").[4]

The painter, now roundly censured, used a public letter to repudiate the "injustices" perpetrated against him and to explain his "new genre," which he saw as taking account of the fact that the character of an *honnête homme* is independent of social standing and historical importance.[5] While for Greuze, character had a human or even moral dimension, for the critics, it was tied to social status. These incompatible stances reflect the ambivalence that defined the relation between genre and history painting from mid-century to the French Revolution.

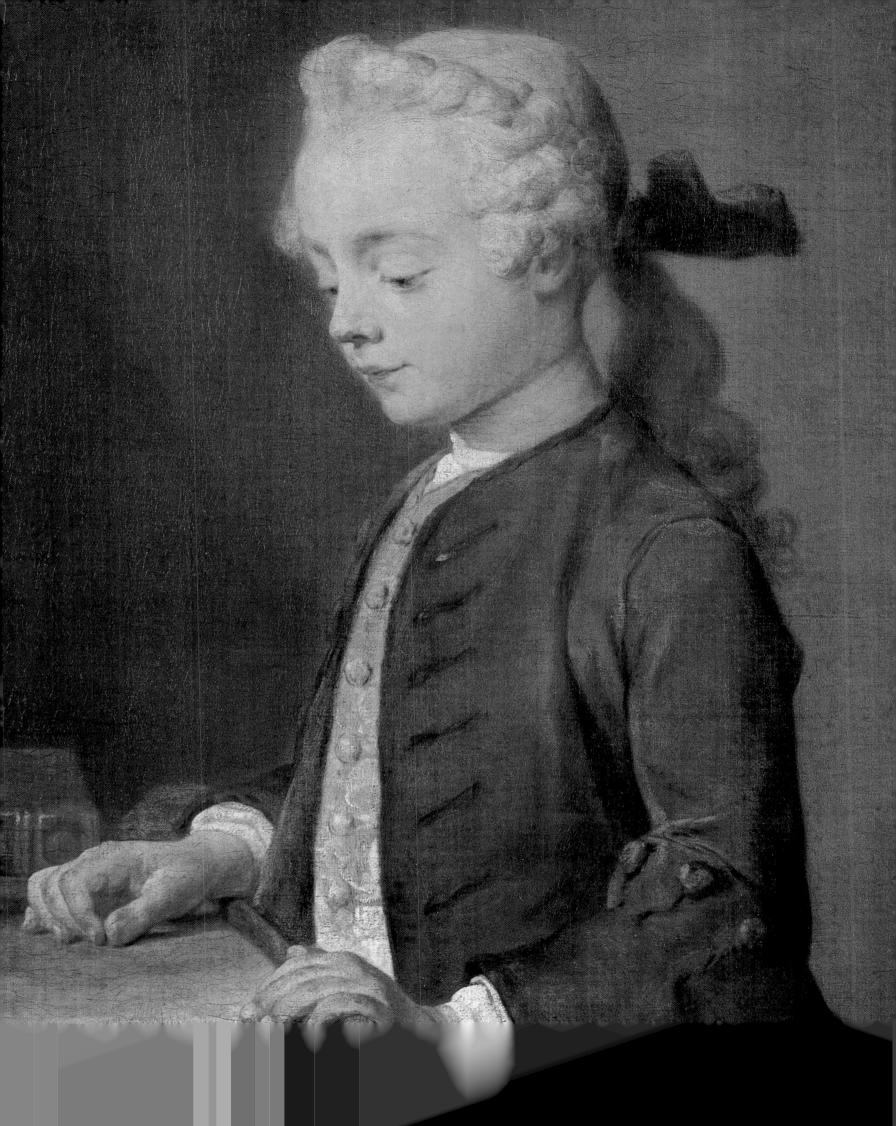

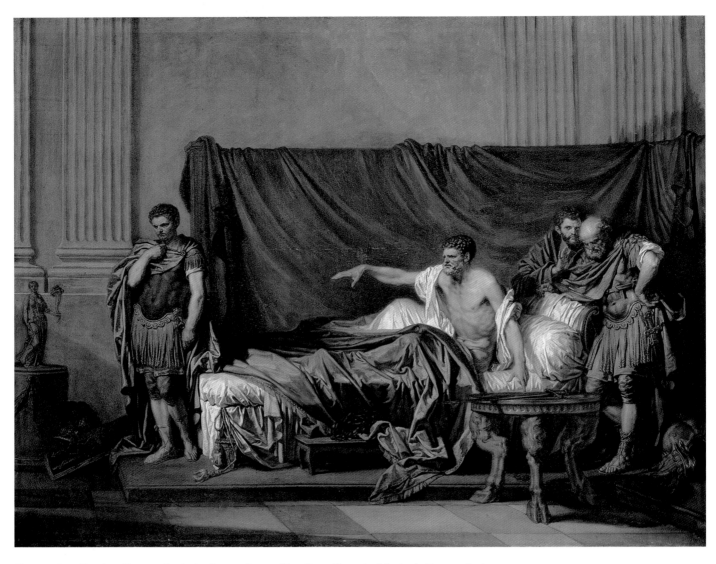

Fig. 41 Jean-Baptiste Greuze, *Septimius Severus Reproaching Caracalla*, 1769. Musée du Louvre, Paris

As a genre painter, Greuze could ennoble his *peinture morale*, as he did in the large-format *The Marriage Contract* of 1761 (cat. 71), by creating a Poussinesque composition illustrating a climactic narrative moment, and giving the facial features the emotiveness of Charles Le Brun's heads. The work of William Hogarth offered ample evidence of the genre theme blended with classical iconography; prints of his "modern moral subjects" and "comic history paintings" had been widely circulated in France from 1750 on.[6] However, in the view of the Academy, the reverse was untenable: they could not countenance history painters availing themselves of the representational modes and *decorum* judged seemly for lower genres, substituting *imitation* for *invention*. A Roman emperor, all agreed, could not appear as a ruffian; to make his features those of an ordinary human being was to deny him his function as a moral exemplar.

Nor was Greuze the only artist to disappoint Cochin in 1769. When the Salon opened in August, Cochin realized that a

protégé of his, Jean-Honoré Fragonard, was not among the artists exhibiting. This situation was not without irony, because, on being accepted by the Academy four years earlier on the merit of his *Coresus and Callirhoë* (Musée du Louvre, Paris), Fragonard had become the new hope for historical painting. But he, too, had turned his back on the Academy and on a prestigious career as a history painter, to serve a wealthy private clientele – free from thematic and formal constraints. They were prepared to pay high prices for his work, since with his extraordinary imagination and artistic virtuosity, he was almost unequalled in his ability to play with traditions of painting and conventions of aesthetic taste.[7] His most daring stroke of genius may have been two pictures he made for the Marquis de Véri. After Fragonard had given the collector an *Adoration of the Shepherds*, c. 1772 (Musée du Louvre, Paris) – a pastiche after different Adorations by Giovanni Benedetto Castiglione, Nicolas Poussin, and Le Brun – Véri asked for a companion piece; and "the artist, feeling that he was showing his genius,

by a strange contrast painted him a picture that was free and full of passion, widely known as *The Bolt* (cat. 84)."[8] Here Fragonard staged the tempestuous seduction of a young woman in the manner of a history painting: a cool burst of light illuminates the theatrical scene, an overturned chair and a drapery swept aside heighten the drama, and the apple in the foreground appears to be an ironic allusion to the fall of man. This intimate genre picture in the Dutch style serves as an antithesis to a religious gallery painting in the Italian style, a juxtaposition of earthly passion and heavenly love. Fragonard owed his success to his calculated breaking up of the sacrosanct hierarchy of the genres.

The examples of Greuze and Fragonard demonstrate the chasm that had opened up between academic discourse and aesthetic reality in the second half of the eighteenth century, how André Félibien's classical art doctrine had been superseded by actual developments in the form and content of painting. In frankly conceding that he was more interested in Greuze's *Marriage Contract* (cat. 71) than in *The Judgement of Paris*, Diderot was paraphrasing the vital change in taste that was making itself felt as the Ancien Régime drew to a close.[9] The Academy may have had moral and aesthetic grounds for wanting to hold fast to the *beau idéal* and the hierarchy of the genres – but the emancipated public was looking less and less to history painting for an *exemplum virtutis*. Rather, it was primarily from genre painting that people now drew moral edification, also deriving a connoisseur's pleasure and gallant enjoyment from it. In painting's less esteemed genres, they found values and emotions they could recognize from their own experience.

In researching eighteenth-century French genre painting, art historians have long approached the changes in production and reception from the vantage point of autobiography, social history, as well as feminist and gender issues. New approaches have emerged only quite recently: Mark Ledbury has traced the influence of the Opéra Comique on genre painting, and others have considered its role in the disintegration of the hierarchy of the genres.[10] However, it would be a mistake to focus on the theoretical understanding of genre painting, towards the end of the Ancien Régime, at the expense of the works themselves. Yet it is fascinating to distance ourselves from discourse and concepts and, in examining artistic practice in the middle years of the century, to see a fluidity developing in the classical boundaries between the genres. To what extent did the representational modes and content of genre painting affect other painting genres – mythology, religious history, portraiture? Why were more and more painters in all genres accentuating the everyday, the human element, and true-to-life depictions? Finding answers to these questions promises to be very instructive if we take a phenomenological approach that views art-historical findings in the light of social history and *histoire des mentalités*.[11]

THE LOVE OF THE GODS

When, around 1750, a dialogue began on reforming history painting and expanding the thematic canon, mythological painting was at the core of the debate.[12] Art critic Étienne La Font de Saint-Yenne held that *la fable* could not convey morally edifying content because it confronted the viewer with an "uninterrupted succession of horrors and the eclipse of reason," and displayed a distinct preference for "obscenity and feasts of abominations."[13] François Boucher's mythological pictures were deemed the epitome of this hedonistic but empty art: he was repeatedly accused of giving the Olympian gods "all the earthly graces," thus robbing the "great paintings" of their moral substance and contravening the rules of "decency, and often even of modesty."[14] Paintings such as *Diana in the Bath*, 1742 (Musée du Louvre, Paris), or *Venus and Mars Surprised by Vulcan* (fig. 42) clearly illustrate what disturbed the critic. In

Fig. 42 François Boucher, *Venus and Mars Surprised by Vulcan*, 1754. The Trustees of the Wallace Collection, London

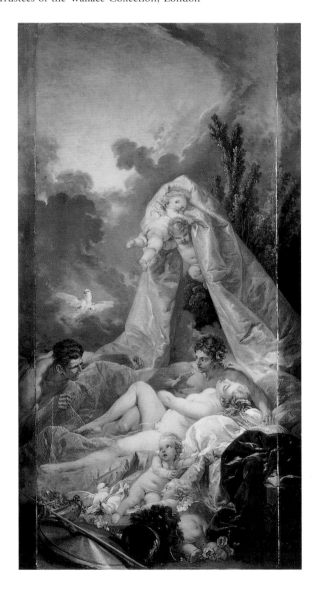

Fig. 43 Joseph-Marie Vien, *The Cupid Seller*, 1763. Musée national du Château de Fontainebleau

presenting the heroes of antique mythology as nudes painted from life, as people with their physical charms on display, Boucher was divesting them of "heavenly solemnity and anchoring them in an earthly realm of experience."[15] The gods put aside their divine attributes in order to indulge their (and the viewer's) fantasies. The sensual feast for the eyes was relegating the *beau idéal* and erudite narrative to the background. The fable no longer served the *honnête homme* as an intellectual distinction, as it had done in the age of Louis XIV; instead, it often had degenerated into nothing more than a pretext for erotic scenes. And from Venus surrendering herself to the god of War on the bed of Olympus, it was but a short leap to the courtesan *Louise O'Murphy*, 1752 (Alte Pinakothek, Munich), awaiting her lover on a sofa. This secularization of

myth and the decline in its moral authority led to ambiguity in both iconography and genre boundaries, and to a general loss of credibility for history painting; and this formed the starting point for criticism of the antique epic as a literary model.

| | - | - | - -

Despite many reservations, there were influential voices among those instigating the reform of history painting who did not want to dispense with the *fable*. Comte de Caylus himself, an archeologist and advisory member of the Academy, considered the fable the most fertile ground for artists searching for new themes: "Their expression . . . is clear to all people, and that,

together with antique costumes that lend elegance even to trivialities, must be regarded as a goldmine."[16] Caylus even went so far as to express his opinion that portrayals of women at the "age of pleasing" were precisely what made a painting interesting.[17] Influenced by archeological finds at Herculaneum and Pompeii, he attached enormous weight to the historically and scientifically accurate representation of clothing, accessories, and decor: "All evidence of the requisite research into costume."[18]

The artist who most consistently put Caylus's ideas into practice was Joseph-Marie Vien. In the 1760s, Vien created a series of pictures in the *goût grecque*, reflecting the importance of the new discoveries from antiquity, and heralding Neo-Classicism. For *The Cupid Seller* (fig. 43), Vien adapted an illustration from the multi-volume compendium *Pitture antiche d'Ercolano*, which Carlo Nolli had engraved after a mural uncovered at Herculaneum. Although the oil painting was intended as an allegory, contemporaries supposed that what they were seeing was a depiction of daily life in antiquity. Thus we have Diderot praising Vien for his historically accurate representation of *costume*: "Furthermore, the accessories are in exquisite taste The background makes an excellent setting." The critic likewise stressed the elegance and finesse of execution: "This is a brief, thoroughly Anacreontic ode."[19] *The Cupid Seller* is, in fact, a programmatic example of *peinture anacréontique*, which treats the theme of *carpe diem* against an antique backdrop – akin to the freely rendered imitations of the odes to love ascribed to the Hellenistic poet Anacreon which were then so popular. As in the poems, which the *Encyclopédie* qualified as "gallant and graceful," what might be termed the "1760s taste" comes through in Vien's "Greek-style" canvases as well, despite their archaizing historicism and restrained visual language. One model was seventeenth-century Dutch and Flemish genre painting, whose allegorical content and refined technique Vien modified to suit the taste of his own times.[20] And he was also able to turn to good account the popular trends of the second third of the century: after Augustin Nadal had published his *Histoire des vestales* in 1725, many aristocratic women had themselves painted as vestal virgins by Jean-Marc Nattier, Carle Van Loo, and Jean Raoux, in so-called *portraits historiés*. In his pendants, *The Virgins of Ancient Times* and *The Virgins of Modern Times* (fig. 44), Raoux contrasted the luxurious, presumably rather unchaste life of contemporary nobility with the lives of young Roman women, assumed to have been more virtuous and religious. The nature of the vestal virgin, "being at the same time historical, poetic, and moral," the ambiguity created by juxtaposing enlightened bourgeois values and lasciviousness, indeed, the alternation between moral genre painting and gallant history painting – all greatly appealed to artists and collectors.[21]

Noël Hallé's later work also created a dialectical opposition between demure past and pleasure-seeking present. After

painting the pendants *The Education of the Rich* and *The Education of the Poor* (cat. 58, 59) in 1765, he tackled the pedagogical theme again in 1779 but in a modified form, transposing the subject into Roman history. In the painting *Cornelia, Mother of the Gracchi* (fig. 45), the mother of the Roman reformers Tiberius and Gaius Gracchus receives a well-to-do female visitor who has come to the city from the Campagna. The visitor is clad in the latest Rococo fashions, has an equally elaborate coiffure, and haughtily parades her jewels before Cornelia. In contrast, the hostess – in modest antique dress – who has been left to raise her children on her own, proudly presents her three sons, the eldest holding a scroll featuring a line from the *Iliad*: "This is my luck, these are my jewels." This ideal of a devoted mother is matched by the selfless paternal love depicted in the pendant, *Agesilaus Playing with his Children*, 1779 (Musée Fabre, Montpellier). Pre-dating Jean-Auguste-Dominique Ingres's *Henry IV Playing with his Children* by nearly forty years, it shows the Spartan king playing "horsey" with his children as a friend arrives unexpectedly; Agesilaus admonishes: "Don't say a word about what you see until you yourself are a father."[22] In the same period,

Fig. 44 Jean Raoux, *The Virgins of Modern Times*, 1728. Musée des Beaux-Arts, Lille, France

Fig. 45 Noël Hallé, *Cornelia, Mother of the Gracchi*, 1779. Musée Fabre, Montpellier

Fig. 46 (BELOW) Jacques-Louis David, *Belisarius Begging Alms*, 1781. Musée des Beaux-Arts, Lille

Jacques-Louis David was already working on *Belisarius Begging Alms* (fig. 46), which he would submit to the Academy in 1781 as a *morceau d'agrément*. From its publication in 1767, Jean-François Marmontel's didactic political novel *Belisarius* had found favour among artists; it tells the story of Belisarius, a general who had been crowned with glory but was later blinded and exiled for alleged treason against the Roman emperor Justinian. Whereas Greuze had failed with *Septimius Severus*

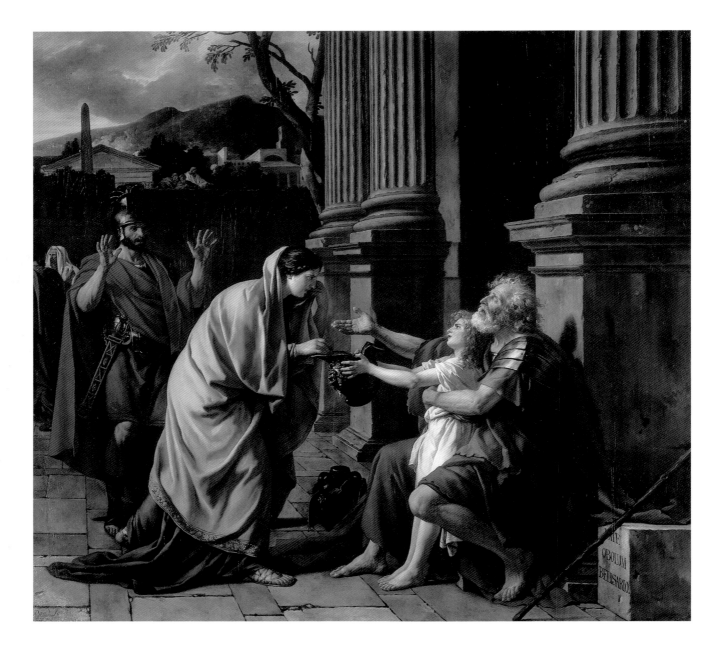

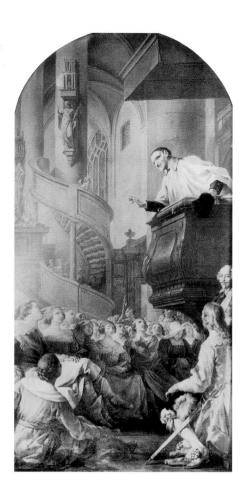

Reproaching Caracalla, because of his unacceptable mixing of
genres, and Vien's "Greek-style" canvases had given vital
momentum to Neo-Classicism but no longer offered an
exemplum virtutis, David was now forging a new concept: in his
large-format historical paintings he fused drama and moral
impetus, human interaction and antique decorum.[23]

THE LOVE OF GOD

Secular history painting was not the only art form whose visual
language was being sentimentalized between about 1730 and
1765; the same happened to the iconography of religious
painting.[24] In the sacred works of artists such as Van Loo,
Boucher, or Louis Lagrenée, a harmonious atmosphere became
more important than plot, and *sentiment* superseded *passions.*
The artists openly departed from the biblical model and
pictorial traditions to enrich their pictures with anecdotal, genre
details. The Flight into Egypt became a serene journey through
a picturesque landscape; the Birth of Christ metamorphosed
into a Nativity play; given the "freshness of the carnations and
the roundness of certain body parts," female saints were
seductive instead of inspiring religious devotion;[25] and the
rousing sermon delivered by a saint was turned into a soporific
Sunday mass. In short: "All those characters [were] not from
the heavens," but rather, "ordinary beings."[26] Christendom's
protagonists lost their heroic status and were made human.
A surprised critic, faced with David's *Saint Roch,* 1780 (Musée
des Beaux-Arts, Marseille), whose naturalistic appearance was
devoid of any saintly aura, commented: "But it is the poor
who beg for alms, not saints and not Christian heroes."[27]

Saint Vincent de Paul Preaching (fig. 47), which Hallé painted
for the church of Saint-Louis in Versailles in 1761, also testifies
to this shift in emphasis. It shows the Saint preaching in the
Paris church of Saint-Étienne-du-Mont, surrounded by a
congregation dressed in Louis XIII period fashion. This attempt
at *vérité historique* unleashed a controversy. Diderot considered
the work a history painting that lacked intensity of action,
expression and *passion.*[28] But the Baron von Grimm praised its
authenticity: as he saw it, Hallé's painting was not of a saint
sermonizing, but rather of a *bon curé* explaining the catechism
to his parishioners in a way that had been heard a thousand
times before, "and to which no more thought is given once it is
over." The congregation is thus pictured as "good members of

the bourgeoisie," declared Grimm, "who attend the sermon
from Christian duty, and not in order to be moved."[29] Jean-
Baptiste-Henri Deshays's canvas *Saint Anne Teaching the Holy
Virgin to Read,* 1761 (Musée des Beaux-Arts, Angers), did not
evoke a historically unique religious exemplar either; it pointed
to religion's everyday dimension, to the secularized piety of
contemporary viewers.

Even so, the secularization of religious painting had been
disputed since mid-century: for many critics, this constituted a
disregard for the rules (*licences*) and for propriety (*convenance*).
Debate raged especially over what was stylistically apt for a
portrayal of the Virgin Mary: her *dignité* and *noblesse* or
her *grâce* and earthly *volupté.* "The greatest weakness . . .
of all Virgins today is that they have no dignity in their
countenances, which are depicted as those of beautiful ordinary
women," complained La Font de Saint-Yenne, for example.[30]
For Guillaume-François-Roger Molé, the "enthusiasm of
painters for the beauty of the Virgin" was incompatible with
the moral message of religious painting. After all, he said, the
Virgin was not displayed in churches "to incite ardour; a saint,
a Virgin, should inspire respect, not love."[31] The worldly
Madonnas of Boucher would especially agitate the soul. Mary's
demeanour in *The Child Jesus Sleeping* (fig. 48) was perceived
as "neither simple nor modest, but instead gallant and

Fig. 48 François Boucher, *The Child Jesus Sleeping*, 1758. The Pushkin
Museum, Moscow

Fig. 49 Étienne Fessard, *Chapel of the Hospice-des-Enfants-Trouvés: Perspective
View*, 1759. Bibliothèque nationale, Cabinet des Estampes, Paris

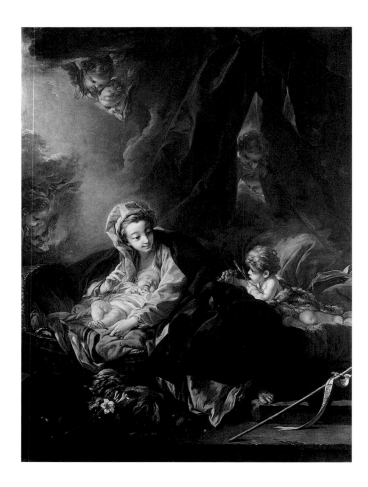

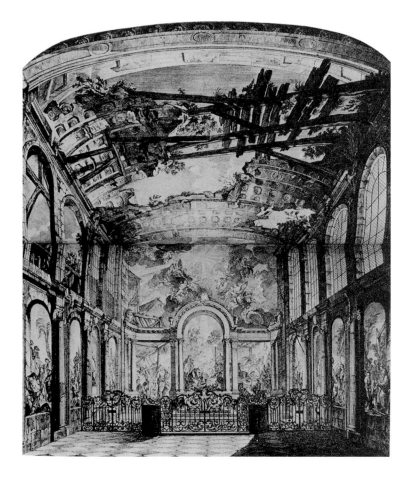

voluptuous," her face comparable to that of a badly made-up
dancer.[32] However, others emphasized "that those two ideas of
virginity and grace" were by no means contradictory; they felt
that the Mother of God would leave more of an impression if
she were portrayed with a naturalness befitting the situation, if
her "bodily character" matched her "spiritual state."[33] Criticism
was levelled at Lagrenée for his Holy Family paintings, too. The
artist's depiction of the baby Jesus having fun in his bath was
indeed true-to-life but "not very appropriate in this century
when divinity should not be overly humanized."[34] A *Holy
Family*, 1753 (lost), painted by Hallé, was the target of similar
contention; it showed Mary feeding the Baby Jesus porridge.
Critics alleged that Hallé had depicted biblical figures in a
cabinet painting; their objections culminated in the lecturing
tone of this comment: "The gluttony of that child would
degrade the Christ Child, whom one should never represent

in a way that reveals the baseness of humanity. This is not
a painting of the Holy Family, it is a pleasant revelling
(*Bambocciade*)."[35] Yet some did place Hallé's work on a level
with history painting. Élie Fréron, for one, insisted: "However
elevated the historical genre may be, the genre of the *tableau de
cabinet* in the style of Gerard Dow [*sic*] is no less elevated."[36]

The profanation of sacred art was by no means limited
to private devotional pictures. Between 1746 and 1751, in
collaboration with the *quadraturisti* (painters of perspectival
scenes) Gaetano and Paolo Brunetti, Charles Natoire produced
a unique *trompe l'œil* decoration in the chapel of the Hospice-
des-Enfants-Trouvés in Paris (fig. 49). Except for the high
altarpiece, *The Adoration of the Magi* in the choir section,
the iconography of the chapel, which was destroyed in the
nineteenth century, gave no hint of the Holy Story. The
Procession of the Magi was a Middle Eastern spectacle unfolding

across the chapel's north side: kings astride camels and horses filing past palm trees, sand dunes, and obelisks, before reaching the choir-section stable in Bethlehem. The opposite side of the chapel set forth the shepherds and their large families in all their pastoral tranquility. Above the kingly procession, Natoire integrated another genre scene into two walled-up clerestory windows: leaning over a wooden balustrade, nuns and their foundlings watched both painted and real events in the chapel. The orphans looking onto the Adoration scene were a reference to the "circumstances of misery and abandonment that accompanied the birth of the Saviour,"[37] and an unmistakable invitation to chapel visitors to be charitable – a coincidence of biblical and earthly events on a single plane of reality.

It is tempting to discount any religious substance in the innumerable sweet representations of Mary, or in the pastoral and gallant depictions of the saints, and to dismiss them as purely decorative. One might suspect that the profanation of religious painting, which brought it closer to genre painting and was a trend that continued into the 1780s, was an eclectic adaptation to the *petit goût* of the Rococo. But was this phenomenon truly intrinsic to art alone and indicative only of aesthetic taste? If we consider patterns of religious ways of thinking and behaviour in the middle decades of the century, we notice remarkable concordances with the sentimentalization of religious art just discussed. The society of three estates was undergoing profound structural changes in the late phase of absolutism, and these effected a paradigm shift within French Catholicism as well: the post-Tridentine "Christianity of fear" was gradually giving way to an internalization of religion that was freed from pointedly Baroque gestures. As Charles de Neuville enthused in a sermon entitled "On the Love of God": "The God of anger and vengeance, the God of power and majesty has almost disappeared; he reveals himself to you everywhere as the God of peace and silence, as a tender God who offers you his heart."[38]

Since the waning of the Grand Siècle, Catholic moralists and Jesuit apologists had been questioning Jansenist teachings on grace, which held that human will is meaningless in the face of divine omnipotence, and that religious virtue is irreconcilable with secular moral concepts. They sought to align religious faith with the new bourgeois philosophy and world view and developed the model of the Christian man of honour (*Chrétien parfait honnête homme*), who strove for both worldly happiness (*bonheur*) and spiritual salvation (*salut*). This "humanization of the sacred" explains why a gallant style and the idea of happiness found expression in both religious art and music, well into the second half of the eighteenth century.[39] In several of his canvases, Fragonard fused painterly and iconographic elements to produce a happy Christianity that turned viewers into voyeurs of their own earthly visions of happiness. What difference was there, really, between Mary's tender adoration of the boy-child Jesus in *The Rest on the Flight into Egypt*

(Musée des Beaux-Arts, Troyes) and the mother's heartfelt affection for her children in Fragonard's genre painting *The Happy Family* (cat. 79)? The latter is allied with the pictorial tradition of the Holy Family, but is suffused with a positively Rousseauian familial bliss. By the same token, *The Rest on the Flight into Egypt* departs from traditional iconography and depicts Mary's maternal joy as something intimate and entirely earthly. Greuze's *peinture morale* marked another extreme in the crossing of the boundaries that distinguished religious history painting from genre painting: he lent a quasi-sacred aspect to his genre paintings by alluding to the conventional figural types of religious painting, such as the Pietà, as in *The Punished Son* (fig. 39). At the same time, he transformed Christian precepts into enlightened bourgeois maxims, turning "charity" for instance into "benevolence."

ALCHEMY

In 1734, Jean-Baptiste-Siméon Chardin completed a painting that was exhibited in the Salon of 1737 as *A Chemist in his Laboratory* (fig. 50). Several years later, François-Bernard Lépicié made an engraving of it, which he called *The Alchemist*. In 1753, Chardin showed it once again at the Salon, and the *livret* now titled it *A Philosopher Reading*. It was the critic Fréron who identified the figure as the painter Jacques Aved. What actually is the subject of this painting? Is it an alchemist? A philosopher? Or is it not a genre painting at all, but rather a fantasy portrait of Chardin's colleague Aved, even if it bears scant resemblance to other portraits of him? The two artists were friends, and at a time when Chardin was painting only still-lifes, it was doubtless Aved who persuaded him to try his hand at genre and portraits in the early 1730s. The decision to take up new art forms, for reasons of income and prestige, opened up new technical and intellectual challenges for Chardin. He clearly wanted to match skills with the grand manner of the Old Masters, Rembrandt especially, and he devoted a canvas to his friend, portraying him not as a simple imitator of nature but as an alchemist, "able to create important work out of the 'base' ingredients of genre painting."[40]

Even later, when he was painting portraits of the children of his friends and patrons, Chardin subtly pushed the boundaries between the genre category and that of portraiture. This is clear on comparing the *Portrait de Charles-Théodose Godefroy* (fig. 51) with one of the sitter's younger brother, Auguste-Gabriel (fig. 52), shown at the Salon of 1738 as *Le Portrait du fils de M. Godefroy, Joaillier, appliqué à voir tourner un Toton* ("Portrait of the son of Mr. Godefroy, jeweller, watching a top spin"). In the former, Chardin abided by the formal requirements of portraiture: the subject fixes his gaze on the viewer, the half-length figure takes up almost the entire height and width of the painting, the violin serves as an attribute of

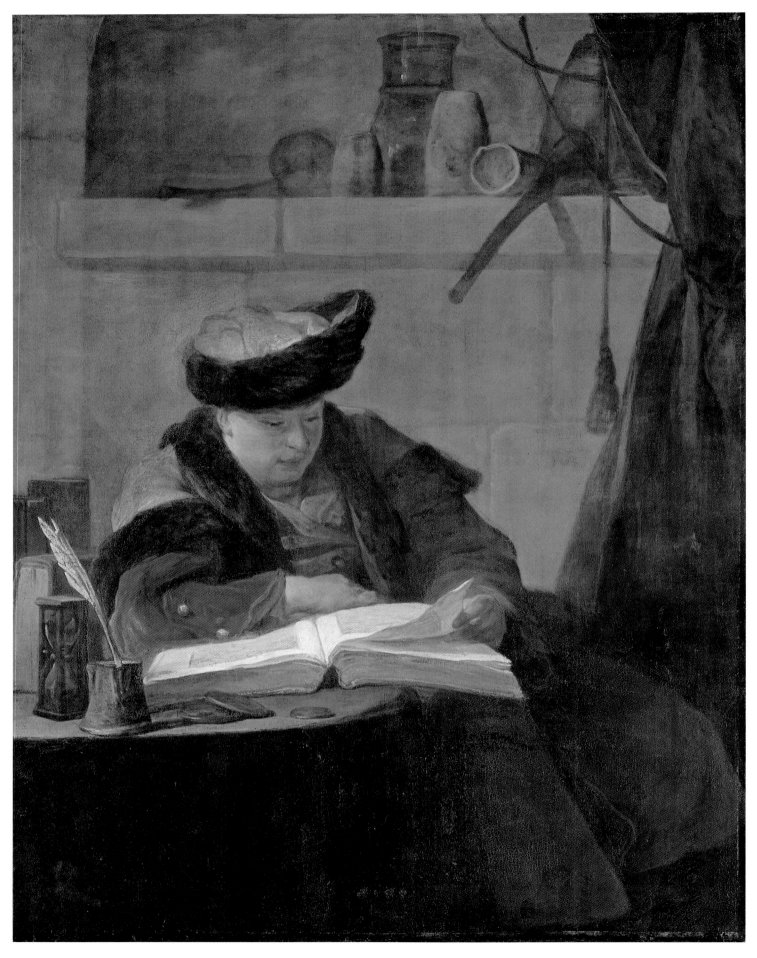

Fig. 50 Jean-Baptiste-Siméon Chardin, *A Chemist in his Laboratory*, 1734. Musée du Louvre, Paris

Fig. 51 Jean-Baptiste-Siméon Chardin, *Portrait of Charles-Théodose Godefroy*, 1737–38. Musée du Louvre, Paris

Fig. 52 Jean-Baptiste-Siméon Chardin, *Boy with a Top* (*Auguste-Gabriel Godefroy*), 1738. Musée du Louvre, Paris

the musically inclined boy, and the depiction of the interior is limited to the music stand and the table edge. The second portrait, however, offers a scene drawn from everyday life: instead of doing schoolwork, the younger Godefroy is fascinated by a twirling top, so taken by its spinning that he does not notice the viewer. Otherwise, he would hastily slip the toy into the open drawer that marks the dividing line between the image and the reality outside it.

As Chardin was engaged in painting these two pictures around 1740, portraiture was changing fundamentally. Status-conscious Baroque portraits had used a standard repertoire of gestures, affected poses, even role-play (in the *portrait historié*), and sitters who seek eye contact with viewers, but these were being supplanted by a modern concept of representation. Natural likenesses (*ressemblance*), unaffected body-language (*grâce*), and the rendering of emotion (*sentiment*) were intended to reflect not so much the social status of portrait subjects, but their personality, their character. New bourgeois values were being incorporated into the portrait: friendship, family, the upbringing of children, and domesticity. A humanity liberated from social constraints took centre stage in portraiture, as it had already done in genre painting. Introspective subjects and an intimate setting were features of these two art forms. For instance, in Aved's portrait of Madame Crozat, 1741 (Musée Fabre, Montpellier), she pauses in the midst of a domestic task, a motif also encountered in Chardin's kitchen pictures, for example, *The Kitchen Maid* (cat. 37).

A new type of group picture, the "action portrait," effectively produced the illusion of naturalness and everyday reality by depicting an anecdotal scene taken from the domestic realm. As in a history painting, the subjects would make eye contact with each other to produce an *unité de l'action*. La Font de Saint-Yenne praised the painter Donat Nonotte for his "knowledge of composition" in a double portrait wherein he intensified "veracity" by having the figures talk to each other instead of having them "turn their eyes from the business at hand, in order to stare at the spectator stupidly and impertinently." The latter approach, he declared, led to pictures such as Robert Tournières's portrait of the Lallemant family, where all the figures face the viewer, "resembling statues, or people who act as if they have seen the Medusa, and are forced to keep the same position that they had when they were taken by surprise."[41]

From about 1760, portrait subjects sought not only visual contact but also physical contact. At that time, Chardin, Greuze, and others were painting genre scenes illustrating a woman's responsibilities as defined by the *encyclopédistes*, namely that of wife, mother, and steward of her children's upbringing. At first glance, Greuze's *The Beloved Mother*, 1769 (fig. 23) appears to be "a scene of love and affection that is renewed every day."[42] In actual fact, it is a portrait of the family of financier Jean-Joseph de Laborde, commissioned by his mother-in-law. A *portrait de famille* in the guise of a genre painting?

A *peinture morale* whose protagonists are of the financial aristocracy, but which is set in a rustic ambience? In Rousseau's concept of society, the rural ideal enabled "one to distance oneself from the bourgeois work ethic, as was necessary for family harmony." Of course, it was only in the virtual world of art that the social elite, in their "striving for moral self-sufficiency," could escape the reality of lives that were circumscribed by etiquette and convention, and take refuge in a "world sheltered from the world outside."[43]

Even more unequivocal is François-Hubert Drouais's famous portrait of an affluent upper-class family of three, with its discreet glimpse into the boudoir (fig. 53). The wall clock lets us deduce that it is the first of April; and while the daughter is already dressed and ready for the start of spring, her parents are not yet fully attired: the mother wears a negligee, the father has thrown on a stylish housecoat. The intimate togetherness, relaxed postures, and affectionate gestures and looks reinforce the impression of family intimacy.[44] We can see the extent to which the representational mode has changed if we compare this portrait with *The Luncheon*, 1739 (fig. 21) and *The Milliner (Morning)* (cat. 54), two of Boucher's *tableaux de mode*, after which Drouais had patterned his composition and many of the portrait's particulars. However, unlike his teacher, Drouais abstained from *vanitas* motifs and sexual symbolism to situate his models in the homely (fictitious) reality of a morning toilette. He almost seems to have borrowed the people and objects of Chardin's *The Morning Toilette* (cat. 41), but raised the social level of the scene; this is a picture about which one critic remarked: "There is not one woman of the Third Estate who doesn't fancy that she is seeing an image of herself, her home life . . . her daily occupations."[45]

Although it remained unthinkable to portray the royal family in similar domestic intimacy, *Marie-Antoinette and her Children*, 1787 (Musée national du Château et de Trianon, Versailles), proves that even the state portrait was also experiencing a transformation: Elisabeth Vigée-Lebrun depicted Marie-Antoinette not only as guarantor of the dynasty, but also as a woman and a "beloved mother." Thus the Enlightenment's ideals of motherhood and femininity were making their way into the Queen's antechamber, with grace claiming its place next to majesty.

CONVERSATION

By around 1765, several group portraits further refined the ingenious interaction between genre scene and portrait. Although French art critics classified these pictures as history paintings, they can also be described as "conversation pieces" on the English model.[46] Unlike the *tableaux de mode* of Jean-François de Troy or Boucher, these scenes depict historical figures in the context of their social way of life. One notable

72

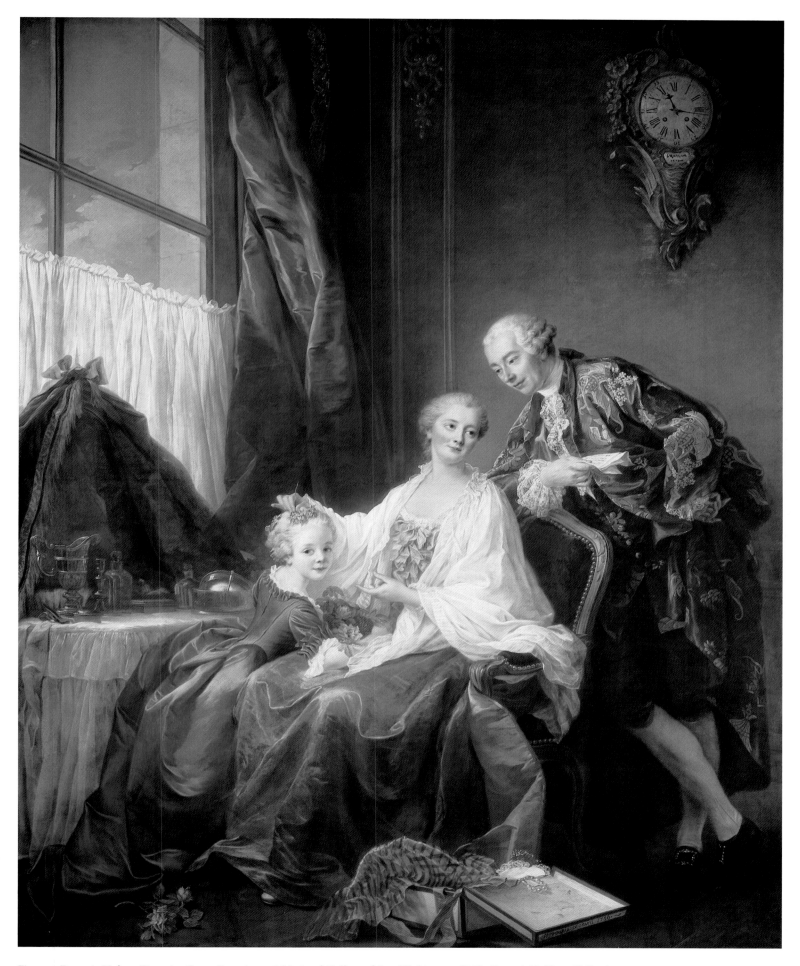

Fig. 53 François-Hubert Drouais, *Group Portrait*, 1756. National Gallery of Art, Washington, D.C., Samuel H. Kress Collection

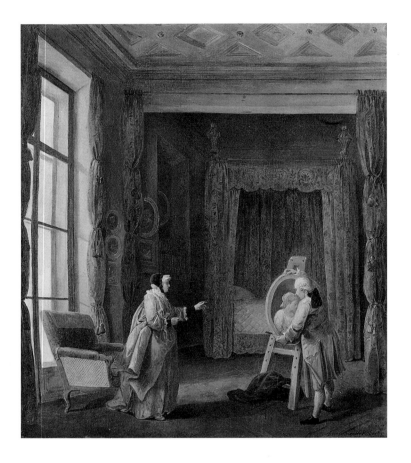

in the Rue Saint-Honoré. There, Madame Geoffrin held her celebrated salon, frequented on Wednesdays by *gens de lettres* and on Mondays by artists and collectors. As a patron of Robert, Van Loo, Vernet, and others, she owned a select collection of contemporary paintings. Her friendly relations with the artists is illustrated in *The Artist Presents a Portrait to Madame Geoffrin* (fig. 54), in which that lady receives Robert in her *boudoir*. The reason for this unusual portrait cycle remains to be discovered. Apparently, its intention was to juxtapose two different worlds, spiritual and social, in which this cultivated bourgeois woman was equally at home, and which had one element in common: cultured conversation. For the new cultural elite, wherein women were the formative force, one's origins and gender meant less than *esprit* and *goût*, qualities that brought about a previously unknown measure of social equality.[48] It would be interesting if we could establish a connection between the relaxing of the standards regulating society and those governing genres in art. One thing is certain in any case: Madame Geoffrin did own some works that revealed an understanding of art that deviated from Academy standards. She had enjoined Van Loo to paint a portrait of her daughter in the *Conversation espagnole*, 1755 (The Hermitage, Saint Petersburg), and asked Vernet to insert a scene from a Marmontel story in his *Shepherdess of the Alps*, 1763 (Musée des Beaux-Arts, Tours), which is also reproduced in Robert's *Madame Geoffrin's Luncheon*, 1768 (The Hermitage, Saint Petersburg). One tidbit handed down to us is that Madame Geoffrin evidently disliked Greuze, who, after she had criticized his painting *The Beloved Mother*, made good on his threat – "if she makes me angry, she had better watch out, I'll paint her" – and caricatured her as a village schoolmarm: "A whip in hand, and she will strike fear in all the children there and those yet to be born."[49]

"NATURELLE ET SIMPLE!"

Shortly before his death, Carle Van Loo was commissioned to replace the cycle that Michel Corneille had created in the Saint-Grégoire chapel of the Dôme des Invalides, but which had been destroyed by damp. In fact, Van Loo died just after completing only six sketches for the frescoes, which were displayed in the 1765 Salon. The naturalness and humanity of Saint Gregory, one of the Fathers of the Church, impressed the art critics: "The leading characters are taken from common and ordinary life. . . . How natural and simple it is! This is not an academic exercise."[50]

Simplicité, le vrai, le naturel – these are the criteria that set the standard for artistic production as well as aesthetic reception in French painting between 1740 and 1780. As in literature and theatre, content and style in painting captured the longing of a society of three estates that was facing

example is *English Tea* (Musée national du Château et de Trianon, Versailles), which the Prince de Conti commissioned from Michel-Barthélemy Ollivier in 1766; it shows the prince and his court in the salon of the Palais du Temple during a concert given by the young Mozart. Other artists moved the scene out of doors. Hubert Robert, for example, painted Louis XVI and Madame du Barry into his *Decentring of the Pont de Neuilly*, 1772 (lost; preparatory study in the Musée Carnavalet, Paris). The critic of the *Mémoires secrets* praised Vernet's pendant *Constructing a Main Road* (cat. 89) because the artist, "despite the prodigious variety of his figures, makes them all participate in the main action, even Mr. Perronet, the chief engineer."[47]

Similar effects are evident in five works that Robert painted for Madame Geoffrin in 1773. Three of them show the enlightened Catholic woman visiting the nuns of the aristocratic abbey of Saint-Antoine-des-Champs outside the gates of Paris, while the other two are set in her city residence

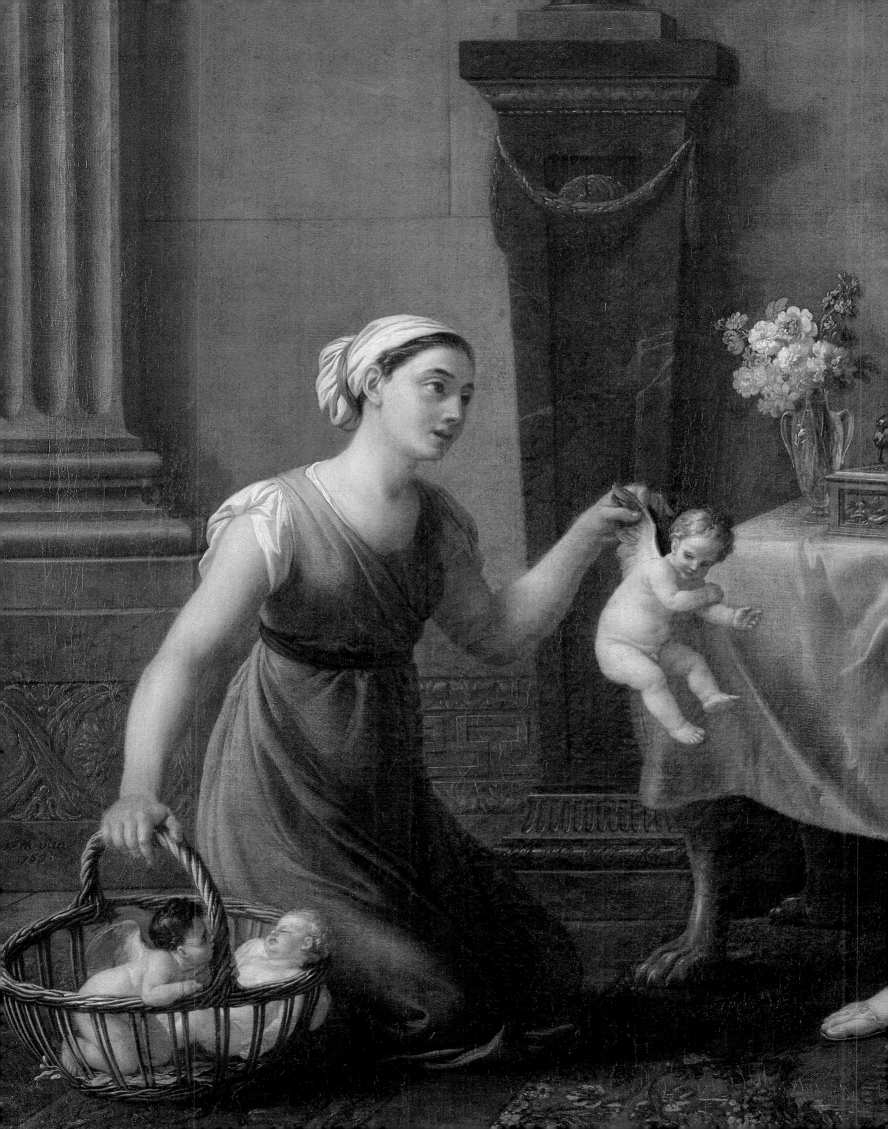

disintegration, and its yearning for expressions of private and sentimental moments. A highly refined elite, its image of itself grounded less in status and possessions than in an interest in art and culture, was drawn to painting that played with or even broke away from traditional pictorial conventions. Taste in art became intellectualized and individualized, and "natural" art grew in popularity; and these factors contributed to the progressive deconstruction of the former hierarchy of the genres. Playing a key role in this process of emancipation from the hierarchy of the genres was the process of interaction, even osmosis, between genre painting, history painting, portraiture, and last but not least, landscape. Nevertheless, although tastes had long since changed to the point of prizing genre painting and other art forms once held in lower esteem, and aesthetic discourse had caught up with and even overtaken classical doctrine, the Academy continued to deny genre painters official recognition. Nor would the French Revolution change much in this regard. As late as 1799, the Minister of the Interior, Nicolas-Marie Quinette, forwarded the president of the Institut national a petition signed by artists who were protesting that the Institut "only gave awards of honour to those who distinguished themselves in history painting." The time had come, they said, to finally do away with Félibien's stringent distinction between history painting and genre painting. Artists and the public, continued the petition, were convinced that no style of painting would touch people's minds and hearts more "than a series of sentimental scenes, moral paintings appropriate for all ages and for all classes."[51]

NOTES

1 "Mémoire de Cochin à Marigny ajouté en note au procès-verbal de l'Assemblée de l'Académie royale du mercredi 23 juillet 1769," cited in Seznec 1966, p. 341.

2 Versini 1996, pp. 864–65.

3 "Mémoire de Cochin à Marigny 1769," cited in Seznec 1966, p. 345.

4 Versini 1996, p. 867.

5 L'Avant-Coureur, 25 September 1769, cited in Seznec 1966, pp. 349–51.

6 See Busch 1993, pp. 239ff.

7 See Schieder 1993.

8 Lenoir 1816, p. 601.

9 Versini 1996, p. 328.

10 See Ledbury 2000, Rand 1997, Anderman 2000, and Gaehtgens 2002.

11 See, most recently, Gaehtgens 2001.

12 See Bailey 1991.

13 La Font de Saint-Yenne 1754, cited on pp. 74, 68, 71.

14 Ibid., pp. 36, 42.

15 Gaehtgens 2000, p. 152.

16 Comte de Caylus, L'Histoire d'Hercule le Thébain, tirée de différens auteurs, à laquelle on a joint la description des tableaux qu'elle peut fournir, Paris, 1758, p. 3; cited in Kirchner 1990, p. 117, n. 18.

17 Caylus 1755, p. 29.

18 Ibid., p. 14.

19 Versini 1996, p. 252.

20 See Gaehtgens and Lugand 1988, pp. 78–86.

21 Versini 1996, p. 306; see Steland 1994; Hilberath 1993, pp. 152–57.

22 Coup d'œil sur les ouvrages de peinture, sculpture et gravure . . . au Sallon de cette année, Geneva, 1779, pp. 9–10 (Collection Deloynes no. 211).

23 The actions and bearing of the central pair of figures are strikingly similar to those of the father and son in Greuze's Marriage Contract (cat. 71).

24 See Schieder 1997.

25 "Observations des Amateurs, sur les Tableaux exposés au Salon," in Observateur littéraire IV (1761), p. 126, about Carle van Loo's Madeleine pénitente.

26 Versini 1996, pp. 956–57.

27 Le Pourquoi ou l'ami des Artistes, Geneva, 1781, p. 27.

28 Versini 1996, p. 210.

29 Seznec and Adhémar 1975, I, pp. 117–18.

30 La Font de Saint-Yenne 1754, pp. 25–26.

31 Molé 1771, II, p. 116.

32 "Lettre critique à un ami sur les ouvrages . . . exposés au Sallon du Louvre," Paris, 1759, pp. 22–23 (Collection Deloynes no. 90).

33 Observations sur l'exposition des peintures, sculptures, et gravures du Salon du Louvre, tirées de l'Observateur littéraire, 1759, pp. 839–40 (Collection Deloynes no. 1259).

34 Fort 1999, p. 54.

35 [Abbé Jean-Bernard Leblanc], Observations sur les ouvrages de MM. de l'Académie de peinture et de sculpture, exposés au Sallon du Louvre en l'année 1753 . . . , Paris, 1753, p. 22 (Collection Deloynes no. 63).

36 [Élie Fréron], Lettres sur quelques écrits de ce temps. Au sujet des Tableaux qui ont été exposés dans le grand salon du Louvre en 1753, Paris, 1753, p. 338 (Collection Deloynes no. 66).

37 Laugier 1771, p. 232.

38 Cited in Schieder 1997, p. 332.

39 Starobinski 1977, p. 997.

40 Ledbury 2000, p. 47.

41 La Font de Saint-Yenne 1747, p. 116.

42 Lettres d'un voyageur à Paris à son ami Sir Charles Lovers, demeurant à Londres. Sur les nouvelles Estampes de M. Greuze . . . , London and Paris, 1779, p. 10; see following note.

43 This and previous citation from Hilberath 1993, p. 81.

44 See Ranum 1990.

45 "Lettre à M. de Poiresson-Chamarande . . . au sujet des tableaux exposés au Salon du Louvre," Paris 1741, p. 33 (Collection Deloynes no. 14).

46 See Trope-Podell 1995.

47 Fort 1999, p. 143.

48 See Radisich 1998, ch. 2.

49 Diderot to Sophie Volland, 30 September 1760, in Denis Diderot, Œuvres complètes, edited by J. Assézat and M. Tourneux, 20 vols., Paris 1875–77, XVIII, p. 469; ibid., XI, p. 443, n. 2.

50 Versini 1996, pp. 303–04.

51 Nicolas-Marie Quinette, "Lettre du Ministre de l'Intérieur au Président de l'Institut National (1799)," in Bonnaire 1937–43, I, pp. 281–83.

Genre Painting in Eighteenth-Century Collections

THOMAS W. GAEHTGENS

In recent decades, art historians have made substantial progress towards understanding the richness and variety of French genre painting of the eighteenth century. They have built up a better framework of knowledge about the artists, documenting their lives in monographs and systematically organizing their works in catalogues raisonnés. Recent studies illuminate the cultural and social background of the times, providing a historical fabric for the content found in these paintings. It is worth citing a few examples in this regard. We now know that during this period there was a shift in the understanding of a mother's role within the family. This awareness allows us to look anew at Fragonard's many representations of young mothers embracing or nursing their children, against the backdrop of contemporary societal change.[1] Or, faced with a Greuze canvas depicting the signing of a marriage contract, it is useful to know about certain legal changes of the same time.[2] Similarly, Chardin's paintings of governesses and their charges make reference to an alteration in child-rearing principles around mid-century.[3]

Inquiries of this nature open up new possibilities for interpreting eighteenth-century genre painting in France, but also raise significant methodological problems, in that we cannot readily explain how the pictorial themes relate to the social reality. Did the paintings illustrate social conditions?[4] And if so, exactly what purpose did they serve? Were they intended as social criticism, or were they a depiction of the ideal life? Of course, works of art are never completely faithful representations of reality; they are rather the aesthetic interpretation of it. A landscape is an impression of nature that has been filtered through the medium of the artist, and a portrait represents someone as visualized by a given artist within the client's terms of reference. However, the function of these two categories of art is relatively easy to determine: portraiture transmits a likeness to posterity or conveys image and status, whereas landscapes may remind clients of their travels or suggest an atmosphere that collectors might wish to re-create in their homes.

But why would collectors choose to hang paintings of farmhouse interiors in their elegant residences? Why would anyone want to include a painting of washerwomen on a wall in his art collection? Who was willing to pay a substantial sum for a scene of a governess apparently reprimanding a young boy? We have no definitive answers to these questions as yet, nor have art historians made systematic studies of the subject, despite its urgency. Only one thing is certain: the pictures were clearly not intended for the people portrayed in them. Neither washerwomen nor governesses could have afforded them. Doubtless, the paintings present a certain social reality, or an artistic version of it, but they were bought by people who themselves lived a very different reality. If we are to understand genre painting, it is important to reconstruct its circle of collectors. Who collected genre painting, and why?[5]

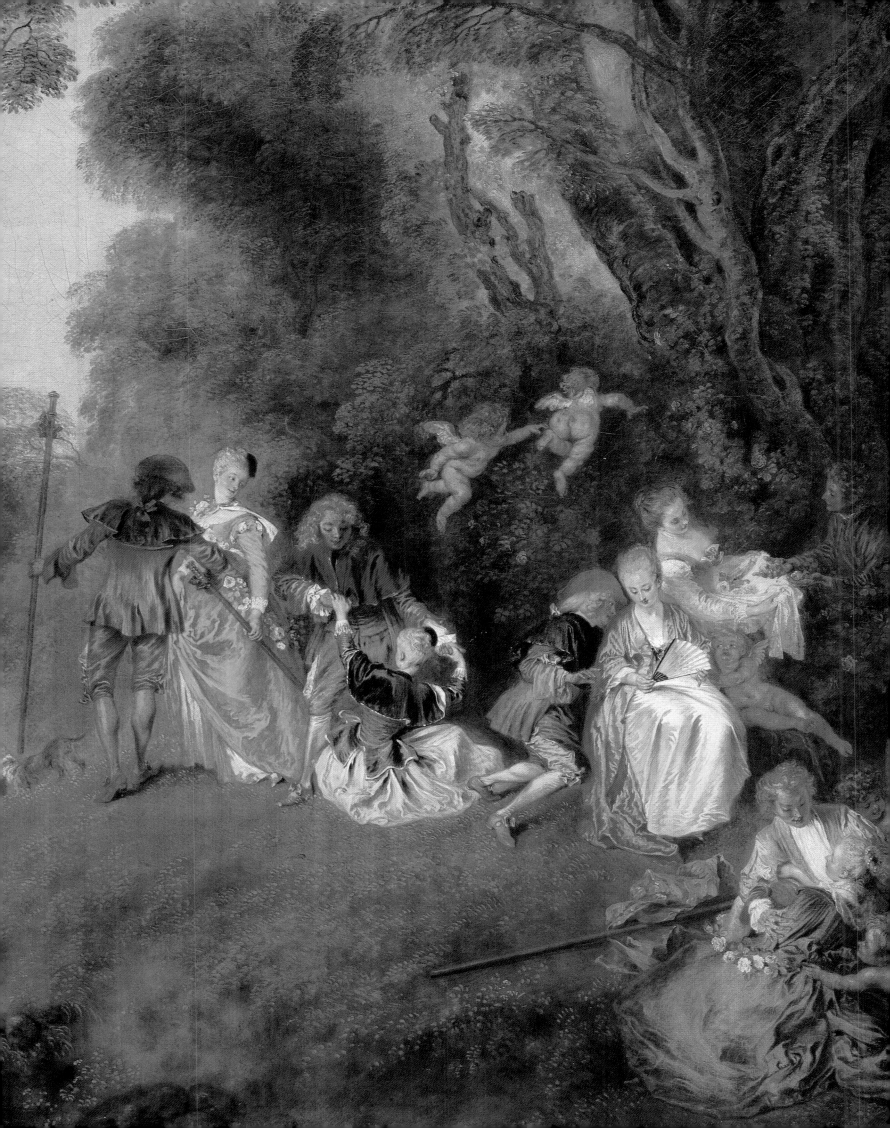

There are, however, obstacles in the way of answering these complex questions. Few written sources touch on such matters. Over the course of the eighteenth century, art theory devoted increasing attention to genre painting, although in fact it was only after 1750 that it was defined as an art form.[6] On the subject of the relation between social realities and art, however, the treatises are virtually silent. Nevertheless, the theoretical statements and especially the information about the artists' careers do indicate a growing respect for genre painting during the century.

A look at the art market of the period in France and throughout Europe confirms the tremendous rise in the prices being paid for genre paintings and above all for seventeenth-century Dutch and Flemish genre works. And of course, an art market that was becoming ever more organized also required a steady supply of new merchandise. Art writers such as Roger de Piles and Jean-Baptiste Descamps acted in concert with dealers to open collectors' eyes to Dutch and Flemish painting and to promote it as a new realm to explore. Supply and demand also regulated Europe's art market back in the eighteenth century.[7] To keep pace with this development, more genre paintings were created in France. Witness, for example, the ever-growing number of genre works on exhibit in the Paris Salon. A statistical analysis of titles of paintings in the Salon *livrets* reveals an increase in this regard after mid-century, peaking in the 1790s.[8] This naturally led art critics to pay more attention to genre painting, which in turn sparked increased interest among the art-loving public and also prompted collectors to look closely at these works.

THE PARTIALITY FOR DUTCH AND FLEMISH PAINTING

Interest in seventeenth-century Dutch and Flemish painting is therefore inseparably linked to the production of French genre canvases in the eighteenth century. Insights can be gleaned from this fact: if the earlier Dutch and Flemish painting was especially prized by later collectors, one possible explanation for this preference is that the pictorial themes attracted people's notice. Peasant interiors, romantic scenes, and depictions of Dutch bourgeois reality may have epitomized an idyllic life, giving artistic expression to the viewer's own hopes for social change. In this sense, it is sometimes suggested that Dutch painting spoke to the growing self-assurance of the bourgeoisie in Paris during the eighteenth century.

Apart from the challenge of trying to define this bourgeoisie, we must guard against oversimplification, because there were certainly many aristocrats acquiring seventeenth-century Dutch and Flemish paintings and specifically genre works. Although attitudes and behaviour had changed among members of this social class as well, one can only cautiously conclude that they

regarded Dutch painting as depicting an ideal world. Perhaps these collectors felt a playful and lighthearted connection with the themes of everyday life in Holland, seeing in them a moment's release from etiquette and ceremony. After the nobility, most collectors belonged to the emerging upper middle class, which was at the same time trying to approximate its social mores to those of aristocratic circles. These are the *amateurs* who may have identified more eagerly with the genteel world of the Dutch bourgeoisie as represented in art, especially that of the second half of the seventeenth century.

Like the princes of earlier eras, eighteenth-century art collectors were occasionally motivated by personal image.[9] A well-chosen collection could serve to confer status on its owner and to document his wealth, but ambitious considerations such as this were hardly the norm. Rather, Dutch and Flemish genre painting was a distinctly individual passion for most. They collected because they were enthusiasts, and they meticulously noted particulars, made comparisons, and exercised their critical judgement, just as Roger de Piles had advocated. De Piles's writing helped to foster an appreciation of the painterly qualities of Dutch art over the course of the eighteenth century. *Amateurs* became connoisseurs, particularly in the very lively Parisian art scene. Not surprisingly, prices for Dutch and Flemish paintings surged upwards, and French artists saw an opportunity to capitalize on the trend. The higher the esteem for Dutch art, the more French genre painting blossomed. One neat proof of this is the notation attached to a painting (see fig. 14) exhibited in the Salon of 1746: "Repetition of *Saying Grace* (*Bénédicité*) with an addition, as a pendant to a Teniers in the gallery of M. XXX,"[10] indicating that Chardin's pictures were deemed to be on an equal footing with the Flemish paintings that were commanding such high prices. We might say that Dutch and Flemish painting was the standard that French painters followed, which is not to suggest that they did not chart their own artistic course.

AMATEURS AND CONNOISSEURS

Since 1700, art writers had been recommending as a matter of course that one collect Dutch and Flemish paintings. To cite a single example, in the *Mercure de France* in 1727, Antoine-Joseph Dezallier d'Argenville published an essay with the interesting title "Lettre sur le choix et l'arrangement d'un cabinet curieux," in which he advised collectors to acquire "good Flemish and French paintings, and some Italians, too."[11] In referring to French art, he likely meant not only artists of previous centuries but also contemporaries such as La Fosse, Coypel, Watteau, Pater, and Lancret. And in proposing a mix that included some Italian works, he would have been thinking of the contrast such intermingling would produce, bringing diversity and life into an interior. Dezallier d'Argenville was not

speaking expressly about genre painting. However, since genre made up a significant part of Netherlandish art, his words imply that genre painting had become a recognized commodity with a wide appeal.

This mix of Flemish, Italian, and French painting is apparent in the merchandise on offer at Edme Gersaint's Parisian art shop, immortalized on canvas by Watteau in his famous *Gersaint's Shopsign* (see fig. 1). After all, the art dealer did travel to the Low Countries five times between 1733 and 1740 to buy paintings for his clients.[12] In 1744, in the auction catalogue for the Quentin de Lorangère collection, Gersaint confirmed the widespread dispersal of Netherlandish painting in French collections: "The Flemish school is very much in fashion here and is universally pleasing." Also, Paris apartments were not spacious enough to accommodate large-format Italian paintings, quite apart from the fact that historical subjects were simply not eliciting much interest,[13] either in the early eighteenth century or in its latter half.

But to whom was Dezallier d'Argenville speaking in his essay? There is no easy answer. Publication in the *Mercure de France* suggests that he was likely targeting an audience of a considerable size, not just someone like Philippe d'Orléans, a collector in the princely tradition of owning works of art as a matter of prestige.[14] The writer, who himself had amassed an impressive collection of drawings, was using his essay to address the broader group of collectors that had meanwhile emerged. This clientele did not generally have the financial means of a French prince; they were *amateurs*, collecting for their own private residences not for palaces. Such art connoisseurs would not purchase large-format Italian altar paintings even if they had the means to do so.

There was now a definite place in society for acquiring works of art. Watteau's *Shopsign* is the clearest illustration of this. Only rarely were artists being commissioned to paint large-format historical works for private collections; instead, people were simply buying paintings at art galleries. Aristocrats, moving away from Versailles, sought in their Parisian *hôtels particuliers* a more unconventional and intimate milieu. The heroic paintings that adorned the monarch's grand apartments had no place here; the decor tended to feature mythological subjects after Ovid's *Metamorphoses*, or genre scenes and landscapes.[15]

This meant, however, that prospective buyers needed to acquire some expertise in the field themselves or to consult an expert. Seventeenth-century Flemish and Dutch paintings, with their characteristically smaller format and domestic scenes, were a kind of art ideally suited to the desire for less imposing appointments and to the resulting more intimate atmosphere. The aristocracy were furnishing their homes in this fashion, and so were the prosperous upper middle class, which included bankers and tax collectors.[16] In a period when fortunes could be won and lost in gambling and speculation, there was an emerging class of affluent people one might label *nouveau riche*,

who were often the clients of art dealers selling Netherlandish paintings.

If a Paris *amateur* in the Regency period wanted to get an idea of the quality of seventeenth-century Dutch and Flemish painting, the Duc d'Orléans's collection supplied ample reference material. Most of the masterpieces the prince had assembled for the Palais Royal were of Italian origin. However, presumably on the advice of the affluent collector Pierre Crozat, who owned many Netherlandish works, Philippe d'Orléans had hung several of his galleries with Dutch paintings of superb quality.[17] The early decades of the eighteenth century, therefore, readily provided direction for artists and for those wishing to build their own collections, particularly as the works in the possession of the Duc d'Orléans were made widely available through a monumental body of engravings.[18]

JEAN DE JULLIENNE AND WATTEAU

Antoine Watteau's oeuvre is quite simply inconceivable without its close connection to the art of northern Europe.[19] Not surprisingly, therefore, collectors who prized Dutch and Flemish paintings were also drawn to his work, among them his illustrious friend Jean de Jullienne.[20] Born in 1686, Jullienne hardly seemed destined to become one of the pre-eminent collectors of art in eighteenth-century France. A drapery merchant like his father, he made a fortune from that trade and from his work as a dyer. It was not his occupation, however, but painting that was his passion, particularly the art of Watteau, who bequeathed a sizable number of his drawings to his friend upon his death in 1721. Jullienne published them in 1726, under the title *Figures de différents caractères*, which contained 279 pages of engravings. But Jullienne did not stop there: he wanted to circulate the entire corpus of Watteau's paintings in reproductions, a costly undertaking that was not an unqualified success. Still, 680 pages were published as *L'oeuvre gravé de Watteau* in 1763, long after the artist's death.

Jullienne's interest in Watteau's painting was nothing short of obsession. Often finding it difficult to obtain the works to make engravings of them, he set out to buy as many as possible. At one point he owned as many as forty Watteaus, but eventually parted with many of them; on his death in 1766, there were only eight left in his estate. His financial success and expertise in the art world made his reputation and brought him a title, as well as the Order of Saint-Michel. In 1739, France's Royal Academy of Painting and Sculpture admitted him as *Conseiller honoraire et amateur*.

Jean de Jullienne collected more than just Watteaus; he possessed paintings by Italian artists such as Veronese, and many seventeenth-century Dutch and Flemish masters including Rubens. The sale catalogue for his collection shows 124 canvases by various contemporary French artists including

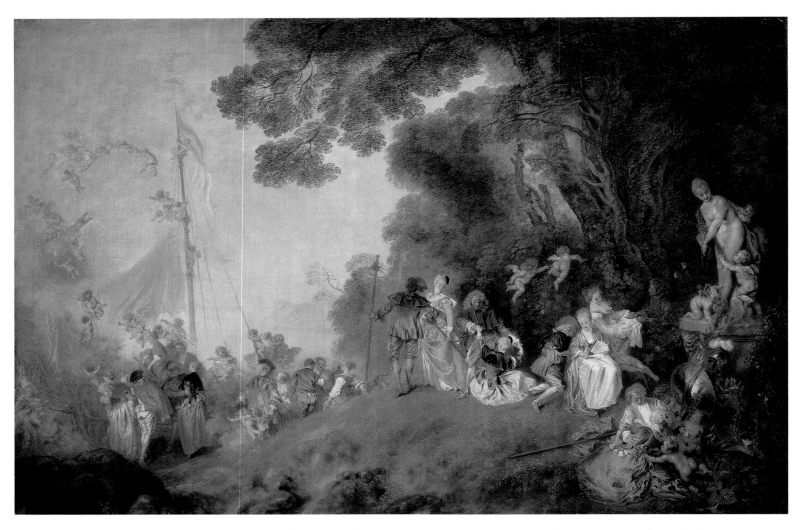

Fig. 55 Jean-Antoine Watteau, *The Embarkation from Cythera*, 1717. Stiftung Preussische Schlösser und Gärten Berlin-Brandenburg, Schloss Charlottenburg

Boucher, Van Loo, and Trémolières; this constituted the largest single group of works, followed by 96 pieces of Dutch and Flemish art. His collection thus mirrored the evolution of French taste during the first half of the eighteenth century, namely the growing preference for Dutch and French over the Italian painters who had previously predominated. This is substantiated by the prices paid at the auction of Jullienne's estate: a Veronese went for 845 *livres*, two Poussins for 662 *livres*. However, the winning bid for a Brouwer was a hefty 2500 *livres*, nearly triple the price of the Veronese. To cite one last figure: two peasant weddings by Teniers commanded 7600 *livres* at the 1767 auction; and a Wouwermans fetched far more than a Rubens. Specifics such as these speak eloquently of changing tastes, from which French artists took their cue. Like Chardin, Greuze, and Fragonard, they drew inspiration from eighteenth-century Holland, and by this means acquired collectors for their own creations.

* * *

FREDERICK II AND THE *FÊTES GALANTES*

Frederick II of Prussia was one of the most celebrated collectors of French genre painting, especially of Watteau and his school. While few sources tell us anything precise about the king's artistic judgement and why he was so enamoured of *fêtes galantes*, a few clues exist.[21] Frederick was not the type of connoisseur who could, for example, identify the works of particular artists, nor was his knowledge of art history at all extensive. We know that he frequently acquired copies, believing them to be originals. Poor advisors and profiteers made the economical king mistrustful: what he was willing to spend was often too little, and so he ended up with second-rate pieces.

However, as crown prince living in the small Rheinsberg Palace, it was his own taste that truly shaped his collection. He bought works by Watteau and his followers, and over his lifetime acquired almost a hundred examples for his various residences, with genre scenes by Lancret, Pater, Raoux, de Troy, Lemoyne, and Boucher numbering among them. Twelve such

paintings are in fact attributed to Watteau and are on display in the museums and palaces of Berlin and Potsdam, amounting to the largest collection of this painter outside the Louvre.[22] Among Frederick's purchases were works as important as *Gersaint's Shopsign* (see fig. 1) and the second version of *The Embarkation from Cythera* (fig. 55), a painting he acquired not as crown prince but after ascending the throne, which attests to his abiding fondness for the works of Watteau. Frederick's propensity for French art was, of course, very closely linked to his general interest in French culture. He immersed himself in French history, literature, and philosophy. In the various libraries he set up for himself as crown prince and later added to as king, the same works could be found – and French books were always a focal point.

The Rheinsberg years of 1737–40 were among the happiest of Frederick's life. Away from his stern and unyielding father, he gathered around him in the small palace a circle of friends who encouraged his inclinations. *View of Rheinsberg* (fig. 56) by artist and architect Georg Wenceslaus von Knobelsdorff is more than a veduta: with the tiny figures that Antoine Pesne painted into the foreground, it recalls Rheinsberg's typical atmosphere of cheery conviviality, free of constraining ceremony. The Rheinsberg circle has repeatedly and justly been described as Watteau's Arcadian world come to life. *Peaceful Love* (cat. 8), one of Watteau's most beautiful works, probably acquired from Jullienne's collection, seems to anticipate the mood of the *fête galante* as it would subsequently be lived out at Rheinsberg. But

Jean-François de Troy's pendants (cat. 25, 26), only one of which remains in Potsdam, likewise represented for him the gallant and sociable diversions and erudite conversation that he viewed as idyllic.

This point is critical to our understanding of Frederick's passion for collecting the art of Watteau and his followers. The crown prince saw these works not primarily as artistic masterpieces but as images of an Arcadian world. By surrounding himself with as many pictures as possible evoking that world, he could feel that he was living inside a panorama of the lighthearted vision that was his own life's dream. The genre paintings owned by the Prussian king decorated the spaces he actually lived in, and it is instructive to note how they were hung in Rheinsberg Palace. To begin with, there was no picture gallery as such: paintings were not amassed in rooms set up for viewing and admiring art; they were simply part and parcel of the decor. Rheinsberg's antechamber exemplifies how the pictures fit into an artistic and intellectual context (fig. 57). On smoothly plastered walls without any architectural divisions, the magnificently framed canvases of the Watteau school were rather like windows opening onto the landscape of a *fête galante*. French Regency decor invariably retained architectural features such as panelling, and as lively and detailed as these may have been, they were rejected by Knobelsdorff, Frederick's architect. His approach accentuated the flatness of the wall and the pictures that offered framed glimpses of a world beyond.

Fig. 56 Georg Wenceslaus von Knobelsdorff, *View of Rheinsberg*, c. 1735. Stiftung Preussische Schlösser und Gärten Berlin-Brandenburg, Schloss Charlottenburg

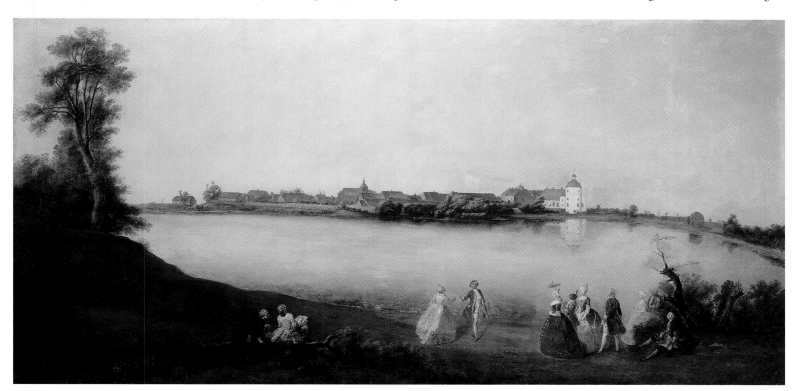

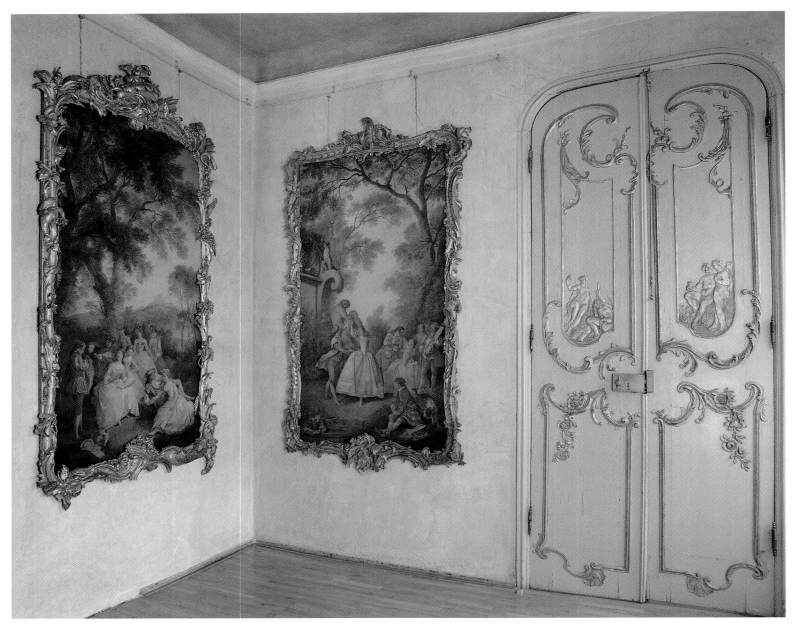

Fig. 57 The Antechamber in Rheinsberg Palace. Courtesy Stiftung Preussische Schlösser und Gärten Berlin-Brandenburg

This experience was enhanced by the door panels decorated with scenes from Ovid's *Metamorphoses*. On another narrative level, the gilt reliefs show literary and mythological love scenes to which the paintings of the Arcadian world correspond. In Knobelsdorff's view, these two realms were complemented by a third experiential level: that of reality itself. This three-part world – drawn from antique literature, a French painterly vision, and a reality of one's own making – paralleled the crown prince's life in Rheinsberg. And when Frederick assumed the throne in 1740, he took his *fête galante* pictures with him to Sanssouci Palace. There, they adorned the *Small Picture Gallery* (fig. 58) and, arranged as in a museum, served to remind the king of the carefree Rheinsberg days.

Louis XV also surrounded himself with contemporary genre paintings. In 1734 and 1737, he commissioned two decorative cycles with vignettes from the aristocratic, courtly milieu for the dining rooms of the small apartments at Versailles and Fontainebleau. These scenes were in keeping with the Parisian partiality for *sujets français* and *sujets galants*. They were not collectors' pieces like those owned by Frederick the Great, but were set into the wood panelling as part of the overall design of the suite. Although we cannot be sure just how these pictures were received by the French king and his court, it is clear that hunts and outdoor feasts were preferred over heroic subjects for the decoration of their private apartments in the early eighteenth century.

Fig. 58 The Small Picture Gallery in Sanssouci. Courtesy Stiftung Preussische Schlösser und Gärten Berlin-Brandenburg

Netherlandish and French art works shared wall space in the collection of the Duc de Choiseul (1719–1785),[23] with genre painting figuring prominently. Étienne-François de Choiseul-Stainville, later the Duc de Choiseul et d'Amboise, was a prominent figure in French politics between 1748 and 1770. His distinguished service as ambassador to Rome added to the king's glory. At his second posting to Vienna, he conducted negotiations of weighty political import. Choiseul was among those advocating a close link with Austria; and Louis XVI's marriage to Marie-Antoinette was one outcome of this entente. His rise to Minister of Foreign Affairs, Minister of War, and Minister of the Navy, and his strong position at court, were due in no small measure to Madame de Pompadour, whom he had saved from an intrigue that would otherwise have been her downfall. Choiseul subsequently relied on her support over a good many years, until late in 1770 when he himself fell from favour and was forced to retire to his estate at Chanteloup.

We are well acquainted with the treasures assembled by Choiseul, who was an exceptionally talented collector. One source of information is a snuffbox with captivating miniatures painted by van Blarenberghe (fig. 59); they depict the minister's residence so precisely that one can even reconstruct how all the individual pictures were hung. Another source is the

Fig. 59a and b Louis-Nicolas van Blarenberghe, *Views of the Duc de Choiseul's Residence on a Snuffbox* (detail reproduced larger than actual size)

catalogue printed when the collection was being auctioned, something the duke had to do after his fall, to cover debts. And finally, Choiseul commissioned the noted engraver Basan to publish his pictures in an album, which made his collection well known to contemporaries and enables us to identify the works today.

The duke made a very advantageous union in 1750, marrying Louise-Honorine Crozat de Châtel, granddaughter of Antoine Crozat and grandniece of Pierre Crozat. She brought to the marriage not only a large fortune but also some valuable paintings, especially Italian works, all of which were probably kept at the couple's country seat at Chanteloup. Moreover, she inherited Pierre Crozat's house in the Rue de Richelieu, and the Choiseuls moved there following some renovations. The Blarenberghe views painted on the snuffbox are thus of the newly refurbished rooms in this residence, which had previously held Pierre Crozat's splendid collection. Over the course of two generations, then, this building was home to two esteemed yet very different collections.

For two decades Choiseul had bought the best pictures – primarily Dutch, Flemish, and French contemporary – at all the important auctions. After being appointed minister in 1758, he made purchases at the sales of the Comte de Vence (1760), Gaillard de Gagny (1762), Jullienne (1767), and Gaignat (1768). He also instructed Boileau to keep an eye out for high-quality paintings in Brussels, Antwerp, and Amsterdam. This was the genesis of the best collection of Netherlandish art that had ever been seen in France, although it bears repeating that Philippe d'Orléans had a choice collection of works from these schools, too. The Choiseul residence was a repository for, among others, ten pictures by Wouwermans, eight Rembrandts, seven Teniers, six Berghems, five Terborchs, and five Metsus; Steen, Ruisdael, Dou, van Mieris, and van der Werff were also represented. His select group of French works boasted examples by Lorrain and Watteau, as well as Le Nain's famous *Forge* (now in the Louvre), a genre picture comparable to the Dutch paintings.

Choiseul was no less alert to the artistic development of his contemporaries. He was receptive to Greuze, whose work would have been unthinkable without the influence of Dutch genre painting. Also among his acquisitions were several paintings by Joseph-Marie Vien, whose genre scenes were peopled with young Greek females, a reinterpretation of Dutch genre in an antique mode (fig. 60). The decor of the rooms in Choiseul's Paris home fused Netherlandish and French art into a unified aesthetic, with genre painting accounting for a substantial portion of the rest.

By about the middle of the eighteenth century, genre painting was exciting more and more interest, even among classes of buyers we would not necessarily consider great collectors. A look at Chardin's clientele bears this out. Certainly a number of princes were among them: Frederick the Great, his sister Luisa Ulrike of Sweden, as well as Caroline-Louise,

Margravine of Baden, Prince Joseph-Wenzel of Liechtenstein, Count Friedrich Rudolf von Rothenburg, and Count Tessin sought to acquire his still-lifes and genre canvases.[24] The exceptional painterly refinement of Chardin's work very quickly spread his fame throughout Europe, so that the great collectors aspired to possess his pictures. But these same artistic qualities also persuaded Chardin's painter colleagues to acquire canvases by his hand. A remarkably large number of artists and architects owned Chardins, among them Aved, Bouchardon, Caffieri, Denon, Desfriches, Le Bas, Le Lorrain, Lemoyne, Pigalle, Silvestre, de Troy, and Jean-Baptiste Van Loo.[25] While this may be attributable in part to the fine quality of Chardin's art, it also proves that by mid-century, more levels of society were showing an interest in this type of painting. Soon, the printing industry was disseminating reasonably-priced copies of Dutch, Flemish, and French genre paintings, to meet the large-scale demand for such reproductions.

MORAL STANDARDS IN GENRE PAINTING

Not surprisingly then, midway through the century, La Font de Saint-Yenne and other critics began urging the Director General of Royal Buildings to promote history painting. Only that category of work, they argued, could offer moral exemplars worthy of imitation by viewers.[26] In the same vein, the authors of the 1756 catalogue of the Duc de Tallard's collection voiced their fear that the abundance of Dutch paintings in France would create a widespread taste for the superficial.[27] Their verdict was that these works were finely made, yet incapable of involving the spectator intellectually: "Truly admirable for their subtle execution and elegant colouration; but their composition, making no attempt to seriously engage one's mind and spirit, purveys a merely superficial and momentary beauty."[28] Such pronouncements influenced official arts policy, but the interest in genre painting did not slacken; rather, it increased from 1750 on.

The debate about genre painting became more intense after Greuze's declaration that its moral content put it on a level with history painting. The composition of his own works reflected his academic training; they were executed in a larger format than that of the Netherlandish genre paintings. Greuze's canvases – at once controversial and appreciated – found their way into the great collections of princely houses, despite the Academy's refusal to accept him as a history painter. The Marquis de Marigny acquired his paintings, as did Catherine II of Russia; and Diderot gave his informed opinion of them in Grimm's *Correspondance littéraire*. Most of Greuze's pictures were distributed as engravings as well, greatly popularizing his art and genre painting in general.

La Live de Jully was Greuze's most influential patron and collector, having started assembling his comprehensive

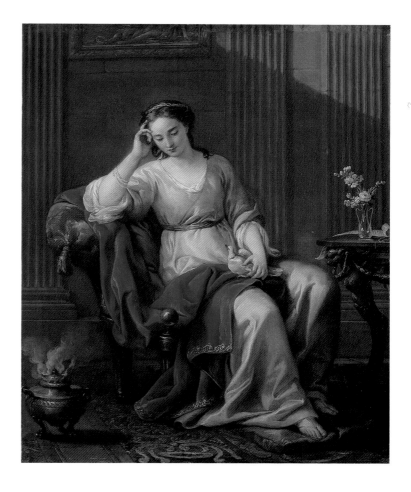

Fig. 60 Joseph-Marie Vien, *Sweet Melancholy.* Cleveland Museum of Art, Ohio, Mr. and Mrs. William H. Marlatt Fund 1996

collection in the 1750s. He too initially concentrated on Dutch and Flemish artists before turning to his French contemporaries. In 1764, La Live de Jully published a guide to his collection and described his interest in French art as indicative of a patriotic cast of mind.[29] From the Salon *livrets*, estate sales, and descriptions of the city of Paris, we can infer that the number of collectors grew rapidly after mid-century. By the end of the 1700s, there may have been up to 500 *amateurs* collecting a wide variety of art works and curios.[30] While Netherlandish art remained a highly desirable acquisition, more and more French paintings were being purchased. As early as 1757, Dezallier d'Argenville voiced the opinion that La Live de Jully did the French school credit.[31] Increasingly, French genre painting was usurping the place of its Netherlandish counterpart in the residences of such well-to-do collectors as the abbé de Saint-Non, Charles Alexandre

de Calonne, Le Roy de Senneville, Randot de Boisset, and Bergeret de Grandcourt – a good many of whom had made their fortune as tax collectors.[32] Among Parisian collections of this sort, that of the Marquis de Véri took pride of place, being devoted chiefly to contemporary French art.[33] His treasures included excellent genre paintings by Greuze and Fragonard, among others.

Quite obviously, therefore, Italian painting and large-format historical works were less important in this milieu. Even given what we know today, it is difficult to determine the reasons for the preferences of this era: we are left largely to our own assumptions and conjectures. One factor, no doubt, was that the Netherlandish works and the French creations they inspired could be incorporated into the decor of the collectors' residences, as evidenced by the Duc de Choiseul and the Marquis de Véri.[34] Another consideration may have been that in their living spaces, people were turning away from the heroic and the dramatic, towards a more intimate and harmonious atmosphere. Finally, we note that collectors came to appreciate the artistic and aesthetic expertise demonstrated by practitioners of both schools in their refined style of execution. At the same time, however, collectors also recognized that genre subjects afforded an opportunity for intellectual exchange on contemporary issues.

THE RECEPTION OF GENRE PAINTING IN THE SALONS

Of course, these same factors also motivated collectors of landscapes and still-lifes. There was a growing demand for genre scenes from the everyday life of a social class very different from that of the collectors; in all likelihood, this indicates that genre themes also gave rise to discussion of serious social issues. Greuze's moralizing works, the archaizing genre creations of Vien and Lagrenée the Elder, and family life or erotic subjects from Fragonard's hand adorned the walls of salons. At these salons, representatives of aristocratic and bourgeois culture met and interacted, both socially and intellectually, and developed a common mode of exchange. One such forum for intellectual and artistic discourse in Paris was Madame Geoffrin's salon, where artists met on Mondays. In his portrait of this lady, Morellet described the gatherings and the conversations: "An enthusiast might be intending to purchase a painting; it would be brought to Madame Geoffrin's, and art connoisseurs would evaluate it. . . . The worldly men and women who were admitted to this company knew the artists personally and were well-positioned to spread word of their talents. In holding her Monday receptions, Madame Geoffrin might be said to have had a hand in the creation of many of the pictures of the modern French school that are now gracing the galleries of Europe."[35]

In this sense, genre painting answered the bourgeoisie's need for qualities that were lacking in the noble aspirations and elevated emotions of classical history painting. Dutch and Flemish art, in contrast, seemed to represent an idealized other world to which one might be transported as in a dream. In his assessment of the Salon of 1777, amusingly entitled "The opinion of a young maiden of fourteen years about the Salon of 1777," an anonymous writer wryly observes the appeal of this seemingly happier world to the people of his time: "Has it struck you that we are drawn ever more to things pastoral, physically but also morally. Anyone noticing the pull such things have on us might almost believe us all to be farmers and peasants."[36] Inspired by its Dutch antecedents, French genre painting in the eighteenth century developed into an art form that greatly pleased established collectors and went on to attract new ones. Genre's manifold themes and styles satisfied widely divergent interests. It met aesthetic and decorative needs, and stood the tests of social criticism and art theory. Genre painting contributed to the social metamorphosis that occurred during the Age of Enlightenment; in some ways, it was also a product of this process, which had such far-reaching historical and intellectual consequences.

NOTES

I should like to express my appreciation to Dr. Herbert Hymans, Silke Schmickl, and Jörg Ebeling for their assistance.

1 Richard Rand, "Love, Domesticity, and the Evolution of Genre Painting in Eighteenth-Century France," in Rand 1997, pp. 3–19. The catalogue contains other important articles and comprehensive literary references to the history of genre painting in eighteenth-century France.

2 Rand 1996.

3 Johnson 1990.

4 Colin B. Bailey (2000b) discusses this question relative to one of Greuze's paintings.

5 Regarding collections in eighteenth-century France, see in particular Pomian 1978; Bailey 2002 focuses on fundamental analyses of the collections of La Live de Jully, Marquis de Véri, Duclos-Dufresnoy, Girardot de Marigny, Comte de Vaudreuil, and Grimod de la Reynière.

6 In this regard, see especially Barbara Gaehtgens (2002), and her essay in this catalogue.

7 Gerson 1983; Duverger 1967; Schieder 1993; Edwards 1996; Karlsruhe 1999, pp. 59ff.; Altes 2000–01; Patrick Michel, "Quelques aspects du Marché de l'art à Paris dans la 2ᵉ moitié du XVIIIᵉ siècle: collectionneurs, ventes publiques et marchandes," in Michael North, ed., *Kunstsammeln und Geschmack im 18. Jahrhundert*, Berlin, 2002, pp. 24–46. Regarding Holland, see North 1992.

8 Koch 1967, pp. 160–61; Smith 1979.

9 Thomas W. Gaehtgens, "L'image des collections en Europe au XVIIIᵉ siècle," Collège de France, Chaire européenne, Inaugural lecture, 29 January 1999.

10 *Répétition du Bénédicité avec une addition pour faire pendant à un Tenier placé dans le Cabinet de M. XXX.* See also Gaehtgens 1980, p. 94.

11 Dezallier d'Argenville 1727; Labbé and Bicart-Sée 1996, p. 35; McPherson 1982; Eliel 1989.

12 *Mercure de France* (1735), p. 2460, and (1739), pp. 240ff.; Atwater 1988, I, pp. 302–03.

13 Gersaint, *Catalogue raisonné des diverses curiosités du cabinet de feu M. Quentin de Lorangère*, Paris, 1744, p. 5.

14 Françoise Mardrus, "Le Régent, mécène et collectionneur," in *Le Palais Royal*, exhib. cat. edited by Bernard de Montgolfier, Musée Carnavalet, Paris, 1988, pp. 79ff.; Mardrus 1993.

15 Scott 1995.

16 Bonfait 1986.

17 Stuffmann 1968.

18 Unlike the Regent, the Countess of Verrue concentrated almost exclusively on collecting Netherlandish and contemporary French masters, which were on view in her Salon, one of the most highly regarded and popular among the intellectual and social elite. When her collection of paintings was auctioned after she died in 1736, their appreciation in value proved how highly France now regarded the art of its northern neighbour. Brieger 1931, pp. 198–201; Scott 1973a; Lawrence and Kasman 1997.

19 See, among others, Banks 1977.

20 Essential studies of Jullienne's collection are *Catalogue raisonné des tableaux, dessins, estampes et autres effets curieux après le décès de M. de Jullienne*, edited by P. Remy and C.F. Julliot, Paris, Louvre, 30 March–22 May 1767; Dacier and Vuaflart 1921–29; P.G., "Catalogue des Tableaux de Mr. de Jullienne," *Connaissance de l'Art* I (1956), pp. 65–69.

21 Seminal articles on this topic include Seidel 1922 and, more recently, Bartoschek 1986; Börsch-Supan 1988; Hohenzollern 1992.

22 Helmut Börsch-Supan, "Friedrich der Grosse und Watteau," in Grasselli and Rosenberg 1984, pp. 553–62.

23 There are a number of important studies of Choiseul's collection, including "Catalogue des tableaux qui composent le cabinet de Monseigneur le duc de Choiseul dont la vente se fera le lundi 6 avril 1772 par J.F. Boileau"; "Recueil d'estampes gravées d'après les tableaux de Monseigneur le Duc de Choiseul"; and Lavallet 1925; Dacier 1949; Watson 1963; Scott 1973b; Roland Michel 1993.

24 Pierre Rosenberg, "Vûs avec beaucoup de plaisir, Chardin und Deutschland," in Fleckner, Schieder, and Zimmermann 2000, I, pp. 194–208.

25 Rosenberg 1979, pp. 73–76.

26 Locquin 1978; Rosenblum 1967. At the same time, La Font de Saint-Yenne held that the predilection for Flemish and Dutch painting had led to skyrocketing prices and stifled interest in the Italian *grande manière*: "La prévention en leur faveur est portée à un point d'enthousiasme qu'ils n'ont presque plus de prix dans les ventes. Voilà donc tous les ouvrages des grands maîtres d'Italie et de France, autrefois si précieux et si recherchés, presque entièrement bannis de chez nos curieux." La Font de Saint-Yenne 1752, pp. 215–16.

27 J.-B. Descamps, through his *La vie des peintres flamands, allemands et hollandais* (Descamps 1753–64), helped expand the knowledge of Netherlandish painting in France. Later, a French edition was also published of Gerard de Lairesse's important art-theoretical treatise, *Le Grand Livre des Peintres, ou l'Art de la Peinture*, 2 vols., Paris, 1787.

28 P. Remy and J.B. Glomy, *Catalogue raisonné des Tableaux, sculptures . . . qui composent le Cabinet de feu Monsieur le Duc de Tallard*, Paris, 1756, p. 4.

29 The foreword to La Live de Jully's second volume (1764) reads: "Le goût que j'ai toujours eu pour le Peinture dès ma plus tendre jeunesse, le soin & l'application que j'ai donné à l'étude du Dessin, m'ont fourni souvent les occasions d'aller admirer les belles collections de Peintures rassemblées à Paris dans plusieurs Cabinets. J'ai été étonné de voir que le goût des François, amateurs des Arts, les avoit portés à faire des collections de Tableaux étrangers, & surtout de l'Ecole Flamande, & que les Tableaux François ou n'avoient point l'entrée dans leurs Cabinets, ou ne s'y trouvaient placés qu'au dernier rang, & pour ainsi dire pour avoir de tout." See Bailey 1988; also Bailey 2002.

30 Pomian 1979; Bailey 1989a. One notable collection that also included French genre paintings was the Prince of Conti's; see Chappey 2000.

31 Antoine-Joseph Dezallier d'Argenville, *Voyage pittoresque de Paris*, 3rd ed., Paris, 1757, p. 149.

32 Thiery (*Almanach du voyageur à Paris*, Paris, 1784, pp. 157–60) cites several collections, commenting specifically that they contain French paintings.

33 Bailey 1985.

34 Ibid., p. 71: "La collection du Marquis de Véri constituait un ensemble frappant de tableaux à la fois contemporains et à la mode. Divers genres et divers groupes étaient représentés, mais l'absence totale de peintures d'histoire de style classicisant et de sujets religieux est remarquable."

35 Cited in Hellegouarc'h 2000, pp. 144–45.

36 Bibliothèque Nationale, Paris, Cabinet des Estampes, Collection Deloynes, IX; Bailey 1985, p. 80, n. 68. See also the words of art dealer Paillet in the auction catalogue for the Giustiniani collection (1808), pp. I–III: "Les tableaux des écoles flamande et hollandaise ont trop longtemps, et trop exclusivement en France, occupé le goût et borné les jouissances des amateurs de la peinture . . . , les amateurs fixaient toute leur attention sur les seuls ouvrages flamands et hollandais; les beaux tableaux même de notre école étaient regardés légèrement"; see also Edwards 1996, p. 178.

Child's Play

KATIE SCOTT

One day a lady came to M. Aved for her portrait;[1] she wanted it down to her knees, and she intended to pay only four hundred *livres*. She left without having made a deal, for, although M. Aved was not as fully employed then as he has been since, this offer seemed to him far too modest; M. Chardin, on the contrary insisted that he should not let this chance go by, and wanted to prove that four hundred *livres* was a good price for someone who was as yet only half known. "Yes," said Aved, "if a portrait were as easy to do as a sausage." That was because M. Chardin was at that time painting a chimney-screen, with a sausage on a plate.[2] This retort made its impression on him, and, taking it less as a joke than as a truth, he examined his talent seriously, and the more he considered it, the more he persuaded himself that he would never gain much from it.

So begins Pierre-Jean Mariette's tale of the transformation of a simple still-life painter, Jean-Baptiste-Siméon Chardin, into a fashionable painter of genre. Having set the scene, Mariette continues:

From that day he resolved to abandon his earlier talent; another had to be found; once again chance intervened. He had occasion to paint the head of a young man blowing bubbles, of which there is a print; he had painted him carefully *d'après nature*, and had sought to lend him a *naïf* expression. He showed his work; nice things were said about it; masters of the profession praised his efforts and achievement and the *curieux*, by expressing demand for this new genre, gave him the determination to pursue it.[3]

This lengthy anecdote appears, with variation, in other eighteenth-century lives of Chardin,[4] and while we should not necessarily believe it, we can learn something important from it about the value assigned in the eighteenth century to genre painting and to the motivation to paint it. To pick out the pertinent leit-motifs: Chardin's decision in the early 1730s to drop still-life for figure painting is represented as the consequence of a joke, a joke that Chardin cannot take as such, but which he accepts as a challenge. Calculation and chance then set him on the road to genre.[5] Thereafter, a childhood game, which itself depends on an element of luck, is identified as the inaugural work (see fig. 61), the origin, if you like, of the genre production to follow.[6] Finally the adjectives "d'après nature" and "naïf" by which Mariette characterizes *Soap Bubbles* suggest that the subject of childhood prompted an unstudied, childlike manner of painting. In sum, by presenting the rise from still-life to genre as a passage from sausages to soap bubbles, a passage accompanied moreover by no visible maturation or elevation of style, Mariette undermines through play the ostensibly affirmative tone of his narration. Though "masters of the profession" and the "curieux" confirm and

Detail of cat. 33

legitimize Chardin's choice, Mariette nevertheless locates the motivation for genre and the reasons for its success as an art form not at the Académie, but in the marketplace.

At the time of Mariette's writing in 1749, Chardin was arguably at the height of his success and prestige. Two of his genre scenes, *Saying Grace*, 1740, and *The Diligent Mother*, c. 1738–39, had, as Mariette is careful to note, entered the royal collection, and two more were in the process of realization for Princess Luisa Ulrike of Sweden. Mariette is no less scrupulous in relating that significant financial returns from both paintings and reproductive prints followed this change in artistic direction.[7] It was the extraordinary and unexpected success of Chardin's enterprise that very likely drew so ambivalent a response from Mariette. In a market regarded as essentially determined and static, Chardin's genre scenes must necessarily have displaced other works, other genres. In the context of the prints, Mariette is explicit. Reproductions of Chardin, he charges, "having become prints *à la mode*," levelled a terminal blow at the "serious engravings," namely the reproductions of history paintings after Poussin, Le Sueur, Le Brun, and Antoine Coypel.[8]

Though Mariette brackets Chardin with Teniers, Lancret, and Wouwermans in this accusation, we are invited, I think, to read him as *the* representative, better still, the *figure* of genre in the text. Thus the scandal of his success, if that is not overstating the case, is also the scandal of genre painting as a whole around 1750, a genre that had seemingly exceeded all expectations and burst established bounds to become the focus of popular and critical attention at the Salons.[9] This alone justifies a close look at Chardin's work, not because he was outside his time,[10] but on the contrary, because he was in the thick of it, shaping it. Furthermore, the disparaging contrast Mariette makes between genre and historical prints, in terms of an opposition between frivolous fashion and moral seriousness, dramatically raises questions about the status of genre and about the interpretation of depictions of the everyday. How could something so popular, so easily enjoyed, have serious content, that is, have a meaning that inspired and motivated? And today, how are we to discuss this art of the obvious? In formulating an answer, I want to begin by focusing on the image of the child in the eighteenth century, and then on play. Both eighteenth-century debates about games and recent psychoanalytic theories support an interpretation of games, toys, and play, not as fixed attributes of childhood, but as markers of a condition of liminality, of the dynamic realm between absolute infant dependency and relative adult autonomy. The sustained preoccupation with middle-ness, the in-between of genre, of the emergent subject, and the bourgeoisie, adds a certain pattern to the argument.

* * *

The question of the usefulness of the textual glosses appended to the reproductive prints after Chardin's genre scenes remains a vexed one.[11] While not necessarily proposing a privileged status for them in the interpretation of individual works, I do want to argue that the verses as a corpus provide a starting point (at least as significant as Salon criticism) for exploring eighteenth-century genre painting in general and Chardin's treatment of children in particular. Slight in length and light in tone, a conspicuous feature of this verse is, rather, the paradoxically rich variety of narrative voices. At times, the narrator is a ventriloquist for the child: *The Young Soldier*, 1738 (destroyed in WWII), modestly declares: "Without care, without sorrow, calm in my passions / A windmill, a drum, fulfil all my pleasures." At others, he is the figure's interlocutor: to the young boy in *Soap Bubbles*, 1739 (fig. 61), he is a source of enlightenment, charging him with learning a lesson of love from the fragility and volatility of his bubbles;[12] with "Lisette" in *Knucklebones*, 1739, he plays the disciplinarian, teasingly admonishing her for her childishness, for not outgrowing her game.[13] Elsewhere again, he counsels the viewer, staying our tendency to think ourselves superior to the child and our actions above childish things. For instance, parallels are drawn between the castle under construction in *The House of Cards*, 1736–37 (fig. 68), and our fantasies, our castles in the air.[14] Likewise the child's toy in *The Top*, 1742 (Musée du Louvre, Paris), becomes, under Lépicié's hand, a sign of our universal subjection to "caprice."[15] In sum, the captions variously vocalize, extend, and interpolate Chardin's scenes; as such, they instantiated relations with contemporary viewers that ranged from the neutral to the exhortatory or "injunctive."[16] The critical point to note is that even in the case of the prints, only a minority illustrated values in such a way as to strengthen adherence to a moral principle, and fewer still did so as *exempla*, that is, with a view to modifying attitudes and behaviour.[17] The remaining majority (the non-models) was not relegated to the category of mere description or, to use the eighteenth-century term, imitation, but insofar as it invited generalization – about children, childhood, or play – assumed a narrative function in the guise of example.[18] Furthermore, it is that sense of these works as example, as telling the story of some larger category, without necessarily having an exemplary or a morally improving function, which qualifies them as genre and distinguishes them from the particularities of portraiture on the one hand and the prescriptive ideals of history painting on the other.

To explain further, it is worth comparing Chardin's *Soap Bubbles* (cat. 33) with two earlier works: Pierre Mignard's *Young Girl Blowing Bubbles* (fig. 62) and Hendrick Goltzius's *Qvis Evadet?* (fig. 63). Respectively a portrait and a *putto*, two categories of image that Philippe Ariès has linked closely with

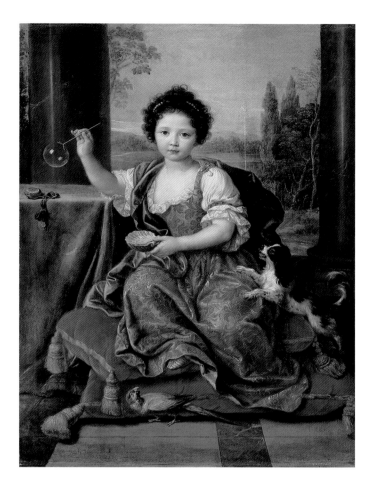

Fig. 62 (RIGHT) Pierre Mignard, *Young Girl Blowing Bubbles.* Musée national du Château de Versailles et de Trianon, Versailles

LES BOUTEILLES DE SAVON

Contemple bien jeune Garçon, Et leur éclat si peu durable.
Ces petits globes de Savon: Te feront dire avec raison,
Leur mouvement si variable Qu'en cela mainte Iris leur est assez semblable.

Fig. 61 Pierre Filloeul, after Chardin, *Soap Bubbles*, 1739. National Gallery of Art, Washington, D.C., Rosenwald Collection

QVIS EVADET?

Flos nouus, et verna fragrans argenteus auru
Marcescit subitò, perit, ah, perit illa venustas.
Sic et vita hominum iam nunc nascentibus, eheu,
Instar abit bullæ vanaq elapsa vaporis.

Fig. 63 Hendrick Goltzius, *Qvis Evadet?* 1594. British Museum, London

"the discovery" of the child in the early modern period,[19] Chardin's picture shares with them a protagonist and an occupation. However, Mignard's exhaustive use of the conventions of portraiture defines his *fillette* as unique. The central orientation of the child before the viewer, the confrontation of the gaze, the particularization of facial features, the sumptuousness of the dress, the rarity of the interior accoutrements, the characterization of the animals as pets, and the *re*framing of the child within the frame (by the classical columns to left and right and the strips of blue sky and grey floor to top and bottom) together emphasize that this child is not an *exemplaire*, a sample child, but an original. Moreover, the childish activity of bubble blowing is put at the service of that identity, since, in conjunction with the watch on the table, it alludes to an untimely death.[20] Rarely is it possible to view as example such a portrait, because it presents itself unequivocally as a manifestation of a class of one.

By contrast, Goltzius's *putto* is utterly generic, one in a long line of *pueri aeterni* stretching back via the Renaissance to Antiquity, who, by virtue of this classical pedigree, function as signs of universality. In this case, the *invraisemblance*, or *in*appropriateness, of the context – the nudity of the babe, its solitary exposure in the landscape, the playthings beyond its ken – alerts the viewer to an allegorical intention. Here, blowing bubbles does not tell us about the child; rather the child lends general application to the lesson of the bubble – or the smoke, or the skull, or the flower – all interchangeable and reinforcing symbols of mortality, placed in a circle about the rim of the figure like numbers on a clock. The image thus serves as a warning against death,[21] rather than a memorial to a particular death; and as a warning, it may be termed an *exemplum*. The *exemplum* can take many forms, most familiarly in eighteenth-century French art, that of history and allegory. The objective, no matter the form, is first to communicate a moral truth, accomplished more efficiently by allegory because it is invented, made to measure, so to speak. History must be adjusted, made *vraisemblable* for the purpose, because the absolute nature of the moral principle demands the totality of the action by which it is to be represented.[22] Thus, in the Goltzius, the playfulness of the child and the tangible properties of the pipe and shell might seem momentarily to pull the image towards the contingent, but the words of the text below direct attention firmly and exclusively to the symbolic value of his newness: "the life of man, ebbing in the newborn babe, disappears like a bubble . . ."[23] Determined by its end, the *exemplum* is always complete, finished, actually beyond question. As such, it belongs necessarily both to the ideal and to the past; or put another way, it is classically historical.

Chardin's *Soap Bubbles*, and his depictions of child's play more generally, share certain characteristics with both the portrait and the *putto* types without being reducible to either.

Like Mignard, Chardin used formal means, among them portrait conventions, to set his scene apart from the run of the mill, or more accurately, to clear a space around it in order for it to be recognized *as* the run of the mill. The window frame in Washington's version of *Soap Bubbles* (cat. 33) doubles the frame of the picture, suggesting both the whole, the larger edifice of life, of which it is a part, and its discontinuity from it. Metaphorically, the boundedness of the image also invokes its status as a copy, just one particular instance of the infinite number of other such occasions of childish diversion. In the versions of the painting at the Metropolitan Museum of Art and the Los Angeles County Museum, those rhetorical functions are concentrated more or less exclusively in the sill, a line that cuts through the painting as it cuts out the children, a kind of *découpage* which dramatizes the process of setting apart that lies at the root of example.[24] More speculatively, we might say that attention is further drawn to the act of exemplification by Chardin's use of quotation. The original *Soap Bubbles* (fig. 61), as Philip Conisbee has shown, owes several salient features of its composition, notably the framing devices and the bas-relief of *putti* playing with a goat, to a celebrated bubble picture by Willem van Mieris, then in the Carignan collection.[25] Insofar as Chardin sought rather to reveal than to hide his source, to count on the recognition of informed viewers, he used references to another work to enclose and set off his own production.[26] Framing, cutting, and quoting are all different instances of the way in which examples are formally produced and made manifest. They constitute a recurrent feature in Chardin's genre scenes, particularly those that depict children alone, playing games.

However, not all Chardin's images of children were in fact genre paintings. Some, like the *House of Cards*, 1736–37 (National Gallery, London), and the *Boy with a Top*, 1737–38 (see fig. 52), were commissioned portraits, respectively of the sons of the cabinetmaker Jean-Jacques Le Noir and the jeweller Charles Godefroy. That the images enjoyed an afterlife as genre in the form of autograph replicas and reproductive prints,[27] which made no reference to their original portrait function, testifies in some small measure to the efficacy of the pictorial strategies just outlined. In the *Boy with a Top*, for instance, the highlighted edge of the open drawer, seconded by the dark rim of the *chiffonnier*, serve, like the sill in *Soap Bubbles*, to set aside the child, while the red stripes on the wall, which line up with the boy's right hand and the flare of his coat, further separate him from the continuum of history, or from the time of the viewer. Discontinuity alone is not, of course, sufficient to transform the particular into an example, or portraiture into genre. More significant here is the confusing equality of space and attention apportioned to the likeness of the child, and to action: are we called upon to recognize the sitter, or to read and interpret the act of playing? That ambivalence is perfectly figured by the boy's hands poised centrally on the cusp of that

division: they appear both conspicuously particularized and itching to play. The absorption of the child, meanwhile, has the effect of ruling out the kind of engaged or personal relationship expected between a viewer and a portrait. Instead, it distances the work emotionally, reconfiguring a beloved son, Auguste-Gabriel, as an anonymous referent to an objective, exterior reality. In the words of the reviewer for *Le Pour et le contre*, the picture represents simply "a young schoolboy who has abandoned his books . . . in order to spin his top."[28] Chardin's formal and narrative decisions have thus simultaneously allowed both the narrowing and the expansion of the originally intended "text"; which is to say that the multifaceted Auguste-Gabriel has been reduced to a single statement, "the boy with the top," and that this very reduction has freed the image to represent not just one child, but any. In this it was brought closer to Goltzius's *Qvis Evadet?*, but with several important differences. Firstly, Chardin's picture describes a different order of truth, an in-between truth, if you like, neither an abstract moral principle nor yet an irreducibly particular fact, but rather, the world as we *typically* find it. Secondly, where the generality of the child was *represented* in the Goltzius (thematized, even, in the nudity of the child), in the *Boy with a Top* it is merely implied.[29]

If we can say that Chardin represents children, even particular children, as examples, what are they examples of? Of the vanities of earthly life following Goltzius? Of the inconstancy of women, or the capriciousness of fortune – interpretations proposed respectively for *Soap Bubbles* and *The Top* by their printmakers? Of Lockean ideas concerning education, as suggested much more recently by such scholars as Ella Snoep-Reitsma and Dorothy Johnson?[30] Before attempting to develop an answer, it is important to note that the early modern rhetoric of example has been strongly identified by one recent scholar with the forces of absolutism and reaction. John Lyons has analyzed the definition of example formulated by the Académie française at the end of the seventeenth century, according to which, example is said to be first and foremost, "That which is worthy of being put forth to be imitated or to be avoided," and secondly, "a thing which is similar to the matter at hand and which serves to authorize and confirm it." Lyons points out that the first definition corresponds to a stable, self-replicating Ancien Régime, and that the second, while demonstrating awareness of the potentially neutral value of similarity, nevertheless ties such instances of example-as-copy to the reproduction of judgements already made, to confirmation and authorization.[31] Synonyms for "example" thus defined include "evidence" and "precedent," reminders that the Académie's definition of example took shape in the context of late seventeenth-century debates about historical writing, which saw the tradition of royal panegyric mercilessly satirized and dramatically opposed to the evidentially based and plainspeaking narratives of dissenting and often Protestant

historians.[32] Critical to the debate was the factual status of example.[33] Thus, connections are there to be drawn between the use of example, the deployment of a plain, informative, or "realist" style and the perpetuation of values, principles, or ideas already established, if not universally approved. Although Chardin's work is easily identified with some of these characteristics, it has rarely been considered conventional. On the contrary, his paintings are almost invariably associated with the forces of change, that is to say, with empiricism, the rise of the bourgeoisie, and the emergence of modern aesthetics. How then can we reconcile this apparent contradiction?

Certainly Chardin construed example quite differently from the pictorial tradition of *jeux d'enfants* found in print culture and decoration in France from the late sixteenth century. Simply to observe that this tradition articulated games and children in the plural is to note a fundamental difference. Claudine Bouzonnet Stella's highly influential print series after Jacques Stella's drawings, *Jeux et plaisirs d'enfance* of 1657,[34] represents, for instance, fifty different games and pastimes, vigorously pursued by a press of *putti* (fig. 64). The constitution of the images as a printed series, as a running list of related examples, is underlined formally by occasional recourse to single figures standing apart or explicitly excluded from the game in question, who point, so to speak, beyond the frame, to

Fig. 65 Jean-Baptiste-Siméon Chardin, *Eight Children Playing with a Goat*, 1732. Private collection, Paris

Fig. 66 François Boucher, *Autumn*, 1735. Art Market, Switzerland

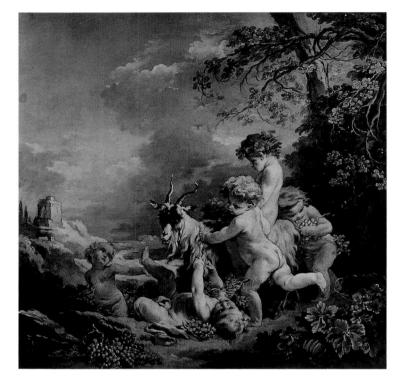

preceding or succeeding instances. In Chardin's works, single figures are not links or linked, but just that; this is not to deny that the prints were collected in number or reproduced in pairs, but to insist on the priority of their rhetoric of one. Moreover, the way the often lone child is depicted thematically as absorbed or turned in upon him- or herself, and the way he or she is captured formally against a generous expanse of neutral ground, like a specimen on a page, suggests that the painter reversed conventional narrative strategy. Instead of presenting a multiplicity of examples to lead the viewer to a general rule or conclusion (that experience follows innocence like night follows day), an abstract idea (of childhood) articulated in advance is confirmed and grounded by a single vivid example.[35]

That Chardin knowingly discarded convention is strongly suggested by the fact of his having toyed with the *putto* in one of his earliest exhibited paintings, *Eight Children Playing with a Goat* (fig. 65), a *trompe l'œil* rendition of François Duquesnoy's famous marble original, now at the Villa Doria Pamphili.[36] Duquesnoy had with Stella formed part of Poussin's circle in Rome in the 1620s and 1630s, for which the study of antique and Renaissance *putti*, often in the context of the bacchanal, had formed an important thematic preoccupation.[37] François Boucher, almost exactly a century later, developed that theme further into an independent genre for decorative purposes, and extended allegorical coherence to the proliferation of his *putti*'s many pastoral pursuits by linking them in sequences of *Seasons* (fig. 66), *Elements,* and so on.[38] Chardin, by contrast, remained fixated by the appearance of the original Duquesnoy bas-relief sculpture, and pursued the opportunities it afforded for games of pictorial illusion by the exact replication of its bronze or

plaster surface. Meanwhile, in the first version of *Soap Bubbles*, engraved by Filloeul (fig. 61), Chardin juxtaposed a bas-relief of *putti* with the scene of bubble blowing. At one level, we could say that Chardin set off the modern reality of play against an ancient depiction but, cut from below and overwhelmed from above, a certain violence has been done to the *putto*, its regime overturned perhaps. Why? Paradoxically, in view of its imitation of bas-relief, the *putto* functions here as an emblem of flatness: literal flatness, in the close connectedness of *putti* and ground in comparison with the dramatic disengagement of the boy above from the interior behind him, and metaphorical flatness, in the self-similarity and the lack of hierarchy among the *putti* in comparison with the sorting of the children into older and younger, primary and secondary. The multiplicity of *putti* – implicitly or explicitly – always stands in contrast to the uniqueness of the adult hero, the *exemplum*. While Chardin's boy blowing bubbles is no hero, he nevertheless lays claim to singularity, individuation, and distinctiveness, characteristics of that of which he is an example.

If we can easily recognize the modern in Chardin's *jeu d'enfant*, where do we locate the conventional, the established,

which must necessarily have been at the heart of its rhetoric, by virtue of the fact that, as example, it stood for any number of other instances of child's play through time? Ariès's classic history of childhood identifies the sixteenth and seventeenth centuries as the period in which attitudes towards the child were profoundly recast, and the concept of the infant as adult in miniature gave way to the notion of childhood as an autonomous and positively charged moment in the lifespan of the individual.[39] The chronology of this change has been confirmed repeatedly by detailed scholarly studies of the conditions, discourses, and representations of childhood for the same period.[40] Chardin's depiction of the child as both individual and playfully puerile thus reinforced already familiar arguments.

Ariès's reliance on evidence drawn from the upper echelons of court society, from memoirs and portraits, resulted in a certain lack of precision about the relation of the history of the idea of childhood to the history of class. Was the individuation of the child and of childhood a product of the concern for bloodlines or of the bourgeois family? Chardin's relocation of the child from the never-never land of the pastoral to the domestic interior of the urban middle class might be taken as evidence of a change in social structure and of an ideological *prise de pouvoir* by the bourgeoisie, were it not for the fact that the nuclear family, the intimacy of which the pictures presuppose, was the norm in pre-industrial Europe long before genre imagery appeared in celebration of it.[41] Chardin's genre scenes depicted, it would seem, a familiar reality. However, the very fact of that depiction was rare, and made his scenes of bourgeois domestic life something of a novelty. The oft-quoted remark by a critic at the Salon of 1741 according to which no woman of the Third Estate looked at *The Morning Toilette*, c. 1741 (cat. 41) without finding herself, her occupations, her children, and her things depicted in it, is significant I think, not just with respect to the credulity attributed to the middle-class viewer, but also because relief for the woman's vanity was, by implication, so rarely found at the exhibitions. "Rarity," according to Lyons, an essential ingredient of example in order for it to be recognized as such, was thus located not in the subject-matter – the bourgeois family – but in the selection of it for pictorial representation. Moreover, the closeness of Chardin's focus, the frequency with which children at play were depicted half-length and within a hand's reach, could not but have brought the viewer to an acute awareness, to a heightened consciousness, of observing something rarely attended to aesthetically.[42]

* * *

If Chardin made good examples, were these good examples also examples of good? To reformulate the question in terms of Sarah Maza's recent review of the happy family,[43] did they contribute to the idealization of the middle class? And by their rhetoric of the typical, which tends necessarily to erase social difference for the sake of inclusiveness, did they further serve to construct an image of social unity? The answer from the reproductive prints is a qualified no. In the case of those games where the object in play, by virtue of long-standing tradition, packed considerable symbolic punch, such as the top or the game of the goose (*Le Jeu de l'Oye*), the images were interpreted as emblems of the fall of man, of the futility of human exertion in the face of fate or fortune.[44] The emphasis was on the game not the child, and though the child was certainly construed as an example, he exemplified not the social category – childhood, but a moral one – humanity. Thus the verses connected the prints to an emblematic and proverbial pictorial tradition within which the game invariably functioned subversively to spoil social harmony and to unsettle settled hierarchies.[45] However, there is little evidence that the paintings themselves were read this way. They belong in fact to a different economy of the image, and, given the open-ended possibilities of substituting one example for any other, one predicated on exchange rather than (moral) use-value. This suggests that the works had less in common with *exempla* than with the so-called *tableaux de mode* by Lancret, de Troy, and Boucher, and with representations of the trades by Bouchardon and Boucher. To

Fig. 67 Jean-Baptiste-Siméon Chardin, *The Laundress*, 1733. Nationalmuseum, Stockholm

understand how different the stakes are in such paintings, we can start by considering Chardin's *Laundress*, 1733 (fig. 67). This painting was reproduced without explanatory verse, but with a title that aligns her rhetorically, though not pictorially, with the printed representations of the urban trades or the *Cris de Paris*.[46]

The washerwoman is accompanied by a child. Mute, she glances off to the side, while the boy looks down. Though they do not interact, their bodies form brackets in white, brown, red, and blue that circumscribe an enclosed interior space. Within that space the disconnected figures are united by water, the element that supports both their activities: at one end of a ladder of hands, clothes are washed, at the other, bubbles are blown.[47] The relationship of the figures to their respective objects and activities differs, however. For the washerwoman, soap and water constitute the objective reality that she must work to live; for the child, the soap bubble is a plaything of his own creation, a source of illusion. Paradoxically perhaps, it is the child for whom the activity is gratuitous, who is pre-occupied by what he is doing, by his plaything, almost to the point of withdrawal, while the worker allows herself to be distracted. The tendency of children to over-invest in objects was remarked upon with amused indulgence at the time. At the beginning of the seventeenth century, St. François de Sales noted that a child with a new pen knows no rest until he has shown it off to all his little friends; at the close, Fénelon remarked, "it is the child jealous of an apple who cries to possess it."[48] Such "jealous" attachment arises in the case of the bubble, as René Démoris has recently shown, from its symbolic identification with the mother, the source of the soapy liquid, "milky" in appearance, which the child brings to his mouth.[49] Yet, in another sense the bubble is not the mother. The child looks at it with detachment down the elegant length of the straw. More importantly, his creation is the product not only of imagination, an internal process, but of manipulation, of the careful, coordinated action of hand and breath on matter out there. As such, the bubble becomes another obstacle, however seemingly fragile, between the body of the boy and the hold of the mother.

An object, a bubble, that paradoxically both fills and forms the gap between mother and child as it does in Chardin's painting, is, according to psychoanalytic theory, a very special kind of object, a "transitional object." "Transitional," as D.W. Winnicott explains in *Playing and Reality* (1971), does not qualify the plaything, rather, "the object represents the infant's transition from the state of being merged with the mother to a state of being in relation to the mother as something outside and separate."[50] According to Winnicott therefore (and in sharp contrast to the *vanitas* tradition), play and its objects are respectively forces and signs of good and health. They allow the child to achieve a non-traumatic break with the mother and a more or less smooth transition into language and culture.

Winnicott argues that this intermediate realm of play survives childhood and is prolonged in the intense adult response "that belongs to the arts and to religion and to imaginative living, and to creative scientific work."[51]

Applying Winnicott's theory of the "transitional object" to the interpretation of Chardin's images may seem problematic. Winnicott is certainly not without his critics.[52] Moreover, given the modern origin of the psychoanalytic discourse on play, it must at some level seem anachronistic to model our understanding of a historically distant object upon it. Yet the late seventeenth century witnessed the articulation of a theory of education to which play was of prime importance. "Do let the child play, and mix instruction with games; wisdom should be revealed to him only intermittently and with a laughing face."[53] Fénelon, in this passage from *De l'éducation des filles* (1687), holds wisdom and play conceptually apart, to be sure, but he also acknowledges that a certain social process takes place when a child plays, and that the teacher can put this primitive activity to good use. For both Winnicott and Fénelon, play (and culture more generally) serves to liberate rather than frustrate the fulfilment of self-possessed individuality.[54] By shifting attention to play, Winnicott's theory also has the merit of setting aside the often reductive, emblematic reading of particular games, without abandoning narrative altogether. The linkage of play with transition, with a journey of maturation, points to the significance of age in Chardin's depiction of children: to the contrast he often makes between adolescents and infants. In *Soap Bubbles,* the generative force of nature is alive also in the plaything itself, in the swelling curve of the bubble, just as it is evident in the burst seam of the youth's jacket and the white froth of shirt that issues in unexpected folds. The homonymous relation between the bubble and the boy prompts the further reflection that before long the child will cross the threshold, vault the sill – in short, burst forth into adulthood. "Transitional objects" are thus symbols in time, they reach back to a moment of absolute dependence and forward to a future of relative autonomy, a future in which they will lose their special significance, gradually become detached, and finally forgotten.

If the *Laundress* inaugurated a recurrent preoccupation with play in Chardin's genre scenes, it also established limits within which play could be represented positively. Exhibited at the Académie in 1735, the picture prompted the critic for the *Mercure de France* to report that the painter had been praised for his "truth," the "smoothness" of his handling, and the "uncommon intelligence" with which he treated a common subject.[55] Despite this unqualified endorsement, servants and children nevertheless go their separate ways thereafter. Indeed, from then on the working-class child disappears altogether from Chardin's oeuvre, and children – bourgeois children – are depicted playing alone, beyond adult care. Explanations for some of these changes are not hard to find. Chardin places a cat

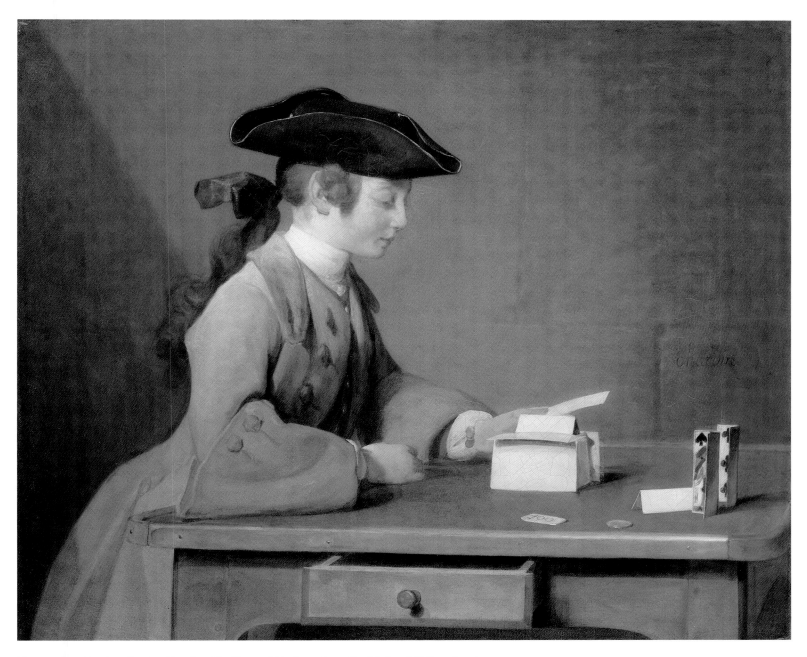

Fig. 68 Jean-Baptiste-Siméon Chardin, *The House of Cards*, 1736–37. The National Gallery, London

parallel to the child blowing bubbles. The connection is not explicit,[56] for the cat does not play *like* the boy. Its presence is consistent, however, with a body of prejudice that assigned to the lower-class (rural or urban) child the nature and instincts of an animal,[57] making it difficult therefore to sustain the idea of such a child as an example of social and cultural maturation in process. From the mid-seventeenth century, moreover, parents were repeatedly advised not to leave their children "below stairs" in the company of lesser servants. Varet in *De l'éducation chrétienne des enfants* (1666) explains, "These people, in order to ingratiate themselves and to get on well with children [in their care], tell them, ordinarily, only nonsense and inspire in them only a love of play, entertainment and vanity."[58] Likewise, in

Marivaux's story *Le Bilboquet* (1714) two servants are the first to be seduced by the infant personification of cup and ball. They then proceed to corrupt the household for which they work.[59] The servant – typically a *laquais* not a washerwoman – functioned discursively as a negative version of the playing child.[60] The servant is the child who never grows up (*puer aeternus*), who remains, like Cupid, stuck in play, attached to the mother/master,[61] an example of failed masculinity. A possible interpretation of the conspicuous solitude of Chardin's children playing games, given that educationalists insisted that children should never be left unsupervised,[62] is that the empty zones of space that surround them served to individualize the child by identifying play specifically with separation, with the

potential of the maturing, bourgeois child (unlike his working-class brother or the servant) to stand alone.

Although Chardin empties out the "playground," portrays the area around the table, card table, low cabinet, or chair as isolated in time and place, cut off from the daily course of events,[63] allusions to the adult world nevertheless remain. The dedicated furniture, playing cards, gambling chip, and coin in *The House of Cards*, 1736–37 (fig. 68), were things inventoried in the public spaces of the house, not tucked away in the nursery.[64] In other instances, adulthood is the very object of play. In *The Little Schoolmistress*, c. 1740 (cat. 40), a girl plays the role of mother for a younger child. Of all of Chardin's depictions of girls playing, it was this one rather than *Knucklebones*, c. 1733 (fig. 101), or *A Girl with a Shuttlecock*, 1737 (private collection), that gave rise to the greatest number of autograph and studio copies, testimony to the success of its illustration of feminine play.[65] There are no playthings in evidence here; rather, play assumes the form of imitation, or what Roger Caillois categorizes as "mimicry."[66] According to Caillois, "mimicry" designates an archaic order of play, almost pre-cultural in its motivation, and is so labelled to suggest its relation not to theatre, but to biology; that is, to emphasize the elementary and quasi-instinctual impulse to copy, observable, he says, particularly in insects.[67] "Archaic" seems to describe accurately the construction of infant femininity in Chardin's work. The closeness of the fit between the child and the role so far collapses performance into essence that the girl resurrects, in a manner of speaking, the conventions of the child-as-miniature-adult that dominated representation before the "discovery" of childhood. By contrast, the card play of Chardin's boys visibly involved the adaptation of an adult game in the pursuit of childish dreams. The suggestion of a jack of hearts protruding from the open drawer in the Washington *House of Cards*, c. 1737 (cat. 35) puts a trump in the hand of the the viewer/player, while the child/architect, with same resources of skill and chance required in a card game like *reversi*, improvises a castle; that is, repeats, but with variation.[68]

Four different versions of *The House of Cards* survive, making it Chardin's most thoroughly worked game. Of these, the London and Washington pictures, painted within a year or so of each other, represent the gamut of Chardin's variations, some of them formal – the reversals of the figure from left-facing to right-facing – some of them of the order of narrative. Most significantly, the dress of the boys differs subtly. In the London version, no doubt because the scene also served as a portrait, the boy is dressed with particular care and refinement, which is matched by a delicacy of gesture in the shaping of the "castle."[69] With no loss of lightness and poise, the Washington child aligns his "troops," but he does so standing in his apron.

Detail of cat. 35

Only the apron, however, refers to an alternative world of work. The boy's hands, face, and clothes are conspicuously clean; his hair carefully curled and tied with a bow. The conventional contrast of work and play is elided further by the continuity of colour across the scene, from the apron on the child to the baize on the table; across, if you like, the infrastructures of work and play. This is a world in which play conditions work rather than vice versa. By virtue of its status as a superfluity, a luxury,[70] play lends the products of craft their polished form and refinement: the subtle curves of the table's under-carriage, the shine on the heads of screws, the whiteness of card, and the clearness of printed suits and numbers. Pleasure and utility unite in a reworking of the discourse on *honnêteté* that distinguishes it not only from labour, but also from aristocratic leisure.

From a close attention to the function of the things on the table, Kate Tunstall has recently argued that in all the versions of *The House of Cards*, the child is depicted as having "pushed the gambling counter to one side," and therefore that Chardin's image "reinforces the widespread eighteenth-century criticism of people who spend their leisure time playing games of chance."[71] Yet, while we can agree that the gambling token and the coin are not at stake, there is nonetheless a sense in which they remain formally and constitutionally in play. In the London picture, Chardin draws attention to the shape of money, to the circularity of the silver *jeton* or token, to the double zero on the gambling chip. What is more, this form is not confined to signs of exchange, but becomes a currency throughout the work, studding the surface with circles: the dowels holding the corners of the table, the knob of the drawer, and more significantly, the gold links on the child's cuff and the fabric-covered buttons of his mouse-coloured coat. This incorporation of a modality of play in the body of the child suggests that if Chardin's project was to distinguish between socially acceptable and unacceptable forms of play, acceptability was not simply a matter of repudiating all financial interest.

In his survey of eighteenth-century writing on games, Robert Mauzi distinguishes the first half of the century for its "nuanced response" to games of chance.[72] Citing the abbé du Préaux's *Chrétien parfait honnête homme* (1749), according to whom, "The game considered in itself and in its own nature is neither sin nor virtue," Mauzi shows that up until mid-century, debate focused primarily on the manner of play.[73] In aristocratic gambling, high stakes and a near-suicidal disregard for strategy were taken as an indication of contempt for money as a universal measure of value.[74] In contrast, bourgeois play was characterized, according to Le Maître de Claville, by a companionable moderation.[75] Lordelot in *Les devoirs de la vie domestique* (1706) had earlier insisted that, "One must always play quietly and with pleasure," while d'Ablincourt in Bourdot de Suilly's *Dialogue sur les plaisirs* (1700) cited the laughter and chat that accompanied bourgeois play as an example

of *honnêteté* in practice.[76] In *The House of Cards*, the self-possession of the head in profile, the one-handed play – as if only half the self were engaged – the raking light that strikes the figure from behind and exaggerates the distance travelled between the head and the hand on the table, and finally, the pool of shadow that dislocates that hand and forearm from the rest of the body are all characteristics that seem to mark the boy out as a *beau joueur*. Moreover, since he is alone, it is a self-control that goes beyond the public display of *insouciance* enacted by the aristocratic gambler in the face of Fortune, and represents rather a growing purchase on reality.

However, if in this context, we understand the child as standing in wait for the future subject, see his taking possession of a created object – a "castle" – in the vicinity of a real one – a pack of cards – thus anticipating an eventual reach for the "real" or independence, in another sense, play in Chardin also describes a past. It points a way back. Dorante, speaking up in favour of games in Ortigue de Vaumorière's *L'Art de plaire par la conversation* (1701) argues that games serve the purpose of sustaining social intercourse when conversation fails.[77] By implication, play is a more basic form, a temporally prior mode of human interaction. The silence so often observed in Chardin's work denotes perhaps this cessation of speech, which is at the same time also a return to the realm of the pre-lingual. If we apply these insights from the literature of *honnêteté* specifically to the London *House of Cards*, the playing boy emerges as liminal. He stands on a threshold, so to speak, facing neither forward nor back in relation to the viewer. He is caught between a past order based on touch, still evident in his intimate contact with his "object," and a future one based on language, on a commerce of signs. This future order is latent in the cards, token, and coin as "instruments" of a game, and in the castle, which the adult viewer reads as metaphor. We can find support for this argument in the verses of the reproductive prints which themselves illustrate, often self-consciously, the transition from an order of play to one of language, which the adult viewer experiences, but the depicted child does not.[78] By adult acts of poetic substitution, Folly, Vanity, and Chance take the place and extend the currency of banal playthings: castles, bubbles, and tops.

This game of substitution by which tangible example was elevated to metaphor did not occur, however, when the paintings were confronted at the Salon. There they were praised as "naive" and "simple," suggesting that eighteenth-century critics and the viewers for whom they spoke admired those aspects of the paintings that were associated with nature and childhood rather than with culture. According to the 1727 edition of the *Dictionaire universel*, "*naïf*" means "true, sincere, life-like, natural; without make-up, without artifice," and "implies of itself a *je ne sçai quoi* of smallness." It could therefore not be said of *le grand* or "the sublime,"[79] or, in other words, of *exemplum* and history. Moreover, its smallness was not

simply physical and moral, but also intellectual, for *naïf* was opposed to all forms of thought and reflection. It was related rather to feeling. With near dictionary precision the *Mercure de France* commended *The Governess*, 1739 (cat. 39), for the "naïveté" with which the boy's shame and regret was expressed, thus alerting the viewer to all the various smallnesses of the work: the child, the crime, the feelings provoked by the quiet reprimand, the intimacy of the domestic scene, and finally Chardin's depiction of these.[80] The following year, a critic ascribed this same childlike quality to all of Chardin's exhibits at the Salon:[81] "Nature is imitated with such judgement and *naïveté* that some Connoisseurs have been led to say that the Painter had discovered by his application the means of painting Nature directly [*sur le fait*], and of stealing away her most naive and picturesque traits."[82] The child, therefore, was not only a sub-genre in Chardin's oeuvre, it functioned also as a sign for the qualities of accessibility, simplicity, and truthfulness that attracted adults to the painter's genre scenes as a whole.[83]

What meaning did the contemporary viewer discover in these pictures of children at play, pictures that did not elevate the subject, or suggest hidden grandeur or sublimity, but on the contrary, revelled in the small, the unadorned, and the obvious? On the surface, the naive qualities of handling would seem to be in conflict with an interpretation of the imagery in terms of a progress towards civility. Viewed in this way – as a relation of opposites, between child and adult, *naïveté* and sophistication, the haptic and the verbal – Chardin's works and the critics' responses to them would seem to suggest that maturation was experienced by the contemporary viewer as a two-way process, the pleasures of which lay as much in a return to infancy as in the emergence of *honnêteté*.[84] Alternately, if we attend rather to the interplay between the "progressive" and "regressive" elements in the works, a more interesting case can be made for suggesting that the preoccupation with *enfance* served in fact to naturalize the discourse on bourgeois politeness through play, in ways that set it apart from the natural artifice of aristocratic *honnêteté*. In this ideological sense, *naïveté* served to deny social and cultural distinctions (the lifeblood of nobility) by universal appeal to a common origin. Chardin's works, as one critic was happy to note, by pretending to the typical and the natural, forged consensus: "This artist's paintings are constantly admired by the public; everyone, intellectuals as well as the ignorant, those of all ages and all estates, everyone praises him."[85] The unity of the typical is, however, only ever implicit, and unstable, because argument from example always falls short of absolute proof.[86] It is a fallen rhetoric that deals with probabilities, not revelation or moral truth.

* * *

THE END

On 2 August 1780, shortly after Chardin's death, Haillet de Couronne addressed a eulogy in praise of the painter to the *Académie royale des sciences, belles-lettres et arts* at Rouen. Based on the notes of Charles-Nicolas Cochin, Chardin's intimate friend, play once again featured prominently in related anecdotes concerning Chardin's early life. For example, we are told that in his "first youth" Chardin had been commissioned to paint a shopsign for a barber surgeon. The surgeon had wanted

> [a representation of] the instruments of his profession: a lancet, a trepan, and so on. This was not what Chardin had in mind; he painted instead a composition with numerous figures. The subject was a man wounded by the thrust of a sword who had been brought to a surgeon's shop to have the wound dressed. One day, before anyone in the surgeon's household was abroad, Chardin hung the painting in position. From his window, the surgeon saw a crowd of passers-by gathered before his door, which prompted him to ask what all the fuss was about. He saw the sign and was tempted to get cross, since he could find in it none of the ideas he remembered having communicated to the painter. But the praise of the public mollified him a little, and he moderated his objections. You can imagine what a stir the painting caused; everyone hurried to pass judgement on it. The entire *Académie* came to know of the talent of the young Chardin.[87]

Not long thereafter, the Académie suffered its own surprise at the painter's hand:

> Encouraged by the praise of various artists, Chardin determined to present himself to the Académie, but wanting to know in advance the opinions of the principal officers of the company, he allowed himself to play an innocent trick. In the first room, as if by chance, he placed a selection of his works, then went and stood in the second. M. Largillière, an excellent painter . . . arrived; struck by the paintings, he stopped and looked at them before going through to the second room . . . where the candidate was to be found. Upon entering, he said, "You have there some very fine paintings, no doubt by some good Flemish artist . . . ; now let's see your own works." "Monsieur, you have seen them." "What! Are these the paintings which . . . ?," "Yes, monsieur." "Oh!" said M. Largillière, "present yourself, my friend, present yourself."[88]

"Trick" and illusion had worked again, and though feelings had been hurt (notably those of Cazès, Chardin's former master), the young pretender was immediately admitted to the rank of *agréé*.

Many of the salient points we noted "once upon a time" in Mariette's life of Chardin are just as much in evidence in

de Couronne's eulogy. Once again Chardin's success is represented as essentially commercial, first in the sense that the pictures function conspicuously as signs of value, either of the surgeon's art or of Chardin's. Secondly and more importantly, the play of signs clearly depends on their equivalence and interchangeability – genre for emblem, French for Flemish, new masters for Old – in relation to an abstract standard of monetary value. Moreover, pictures mediate relationships between people: painters and clients, artists and academicians. In short, they circulate as commodities. However, Chardin emerges from these later anecdotes less as the innocent child, awakened to the realities of the market by friendly advice, than as a knowing and manipulative master of the game: the shop sign is transformed from mere utility to work of art by the painter's deliberate stratagem; a place at the Académie is secured in record time by a sleight of hand that lays waste the usual time-consuming, bureaucratic formalities. In the forty-odd years that separate the two accounts of Chardin's life, the most dramatic change is one in tone. The undercurrent of anxiety noted in Mariette's text is absent. In de Couronne's story, chance and play provide innocent pleasures, their potential for disrupting established hierarchies apparently forgotten. At the same time, genre painting had found its proper place within the Académie. At the close of the eulogy, de Couronne records that Chardin, like all great Masters, encouraged emulation. History painters apparently wanted to try their hand at his genre, the "*petit genre*," as they called it; but, noted de Couronne, "genres are small only if they are treated pettily."[89] The implied "greatness" of Chardin's genre, so threatening in 1750, had meanwhile been domesticated by a resurgent Académie for which Chardin constituted, in fact, not an *exemplum*, or master *to* copy, but an example, or a master-copy.

If it had become safely conventional to think about commerce in terms of play, it was, by the second half of the eighteenth century, becoming increasingly difficult in polite society to place a positive construction on games, especially gambling.[90] Thomas Kavanagh has shown the extent to which notions of play and credit (personal and financial) had become enmeshed during the Regency, which undertook experiments with a paper currency and an unregulated stock market.[91] To simplify a little, the dramatic swings in the private fortunes, and thus the "credit" of investors, and the eventual collapse of Law's System in 1720, which spoiled in its wake the futures of many, profoundly shook a society disposed on the whole to respect the status quo. As a delayed response to the trauma of this public gambling with the economy, the old equivocation towards games of chance privately pursued gave way to a hardening of attitudes under the Enlightenment, which left little room for a positive role for play as a creative cultural force.

Chardin's images of child's play closed as they had opened with a work in which an adult is present at the scene. *The Governess* (cat. 39) depicts a child preparing for school. He turns his back on play, the magic of his brightly coloured things draining away in a meaningless scattering of stuff across the wooden floor. He carries instead, without touching, the dull forms of scholarship. Thus, in contrast with the *Boy with a Top* (see fig. 52), in which a certain continuity of culture was established between the ludic and the scholastic by the delicately off-set angles of the top and the quill, and by the haptic quality of the multicoloured books and the intellectually fascinating pirouette of the toy, language and play in *The Governess* are divorced. Moreover, the proper place of the former lies implicitly beyond the confines of the playground. This child must leave to learn; not learn to leave. In other words, the space between the child and the "mother" is no longer portrayed as "transitional," or emotionally full, but as a gap. Across that gap, the governess intervenes to prevent or discipline play.[92] The cards, bat, and shuttlecock have lost their goodness, their innocence. They now operate more crudely, signifying the moral dangers of frivolity that only education by adults can effectively forestall. According to de Couronne, not only did this painting secure Chardin's reputation, it also marked his move to more elevated subjects, explicitly a comment on the social class of the figures depicted.[93] Perhaps this was also an acknowledgement that from now on, Chardin's work had a simpler, more injunctive narrative, associated with history and *exemplum*. The painting put an end to play.

NOTES

This essay is written in memory of my father.

For their encouragement, generosity and constructive criticism, I thank Colin B. Bailey, Mignon Nixon and, most especially, Stephen Deuchar and David Solkin.

1 Jacques-André-Joseph Aved was a portrait painter who had arrived in Paris from Holland in 1721 and was *reçu* at the Académie in 1734. This anecdote presumably relates events that occurred just prior to his official establishment as a portraitist.

2 This has often been identified with Chardin's *The White Tablecloth* (1730; The Art Institute of Chicago).

3 Mariette 1851–60, II, pp. 357–58. For the first passage, I have quoted Philip Conisbee's translation of Mariette (*Chardin* [London, 1985], p. 106); the translation of the second excerpt is my own. Unless otherwise indicated, all further translations are my own.

4 See C.N. Cochin, "Essai sur la vie de M. Chardin" (1780), reprinted in Roland Michel 1994, pp. 267–69; Haillet de Couronne 1854, I, pp. 436–37.

5 The element of calculation involved a judgement that an alternative upward move from the depiction of dead to living animals was blocked by the prior claims and established reputations of Jean-Baptiste Oudry and François Desportes. See Mariette 1851–60, pp. 357–58.

6 Conisbee argues persuasively that the first version of the subject was probably the painting engraved by Pierre Filloeul and now lost. See Conisbee 1990, p. 16.

7 Mariette 1851–60, p. 359.

8 Ibid.

9 See ibid., where Mariette explains Chardin's success with the public.

10 This view conflicts with that expressed by Pierre Rosenberg on the occasion of the recent Chardin exhibition. See "Un peintre subversif qui s'ignore," in Rosenberg 1999, pp. 27–35.

11 Ella Snoep-Reitsma (1973) sparked off the debate by insisting that the moralizing verse attached to some of the prints "settles the matter [of interpretation] conclusively" (p. 165). For a measured discussion of the issue specifically in relation to children playing games, see Fried 1980, pp. 46–47. For a notably subtle and insightful use of the texts, see Démoris 1991; in the present context, see especially pp. 84–90.

12 "Contemple bien jeune Garçon / Ces petits globes de savon: / Leur mouvement si variable / Et leur éclat si peu durable / Te feront dire avec raison / Qu'en cela mainte Iris, leur est assez semblable."

13 "Déjà grande et pleine d'attraits / Il vous est peu séant, Lisette, / De jouer seule aux osselets, / Et désormais vous êtes faite / Pour rendre un jeune amant heureux, / En daignant lui céder quelque part dans vos jeux."

14 "Vous vous moquez à tort de cet adolescent / Et de son inutile ouvrage / Prest à tomber au premier vent / Barbons dans l'âge même où l'on doit être sage / Souvent il sort de vos cerveaux / De plus ridicule châteaux."

15 "Dans la main du Caprice, auquel il s'abondonne / L'homme est un vrai tôton, qui tourne incessament; / Et souvent son destin dépend du mouvement / Qu'en le faisant tourner la fortune lui donne."

16 The term is borrowed from Susan Suleiman, who argues from a study of parable that *exemplum* proceeds in three stages: narrative, interpretation, injunction. See S. Suleiman, "Le récit exemplaire," *Poétique* 32 (1977), pp. 468–89.

17 C. Perelman and L. Olbrechts-Tyteca, in *The New Rhetoric: A Treatise on Argumentation* (trans. J. Wilkinson and P. Weaver [Notre Dame, Indiana, 1969], pp. 350–71), draw distinctions between "example," "illustration," and "model," though the authors admit that the differences are slippery, and that the self-same instance can serve respectively as an example, illustration, and model to different readers or, in this case, viewers. See p. 351.

18 I have drawn extensively on John D. Lyons' text on *Exemplum* (Lyons 1989) throughout this essay, paying particular attention to the seven characteristics of example outlined on pages 25–34.

19 Ariès 1960, pp. 23–41.

20 On the painting see T. Bajou, "A propos de quelques tableaux de Mignard conservés au château de Versailles," in Boyer 1997, pp. 197–223. See also Albaric 1987, p. 7.

21 On Goltzius and the related Northern Bubble imagery, see Ingvar Bergstrom, "Homo Bulla: La boule transparente dans la peinture hollandaise à la fin du XVIᵉ siècle et au XVIIᵉ siècle," in *Les Vanités dans la peinture au XVIIᵉ siècle*, exhib. cat., Musée des Beaux-Arts, Caen, 1990, pp. 49–54.

22 For a discussion of the relationship between the unity of form, or completeness, and history, see Stierle 1972, especially p. 181.

23 Conisbee first compared the Goltzius and Chardin versions of *Soap Bubbles*, and I have gratefully drawn on his discussion and on his translation of the Latin verse. See Conisbee 1986, pp. 133–34.

24 For the etymology of "example," see ibid., p. 3.

25 Ibid., p. 136 and fig. 128.

26 It might be worth considering whether Chardin's "debts" to the Northern school, noted scrupulously by his contemporaries, functioned more generally to separate the representation from its referent, to mark it off as a fragment, an instance of the larger whole. For a discussion of Chardin *flamand*, see Roland Michel 1994, pp. 118–27.

27 See Rosenberg 1979, p. 182.

28 *Le Pour et le contre* 16 (1738), p. 83.

29 For a wider discussion, see Stierle 1972, especially p. 182.

30 Snoep-Reitsma 1973; Johnson 1990, pp. 47–68.

31 Lyons 1989, pp. 15–16.

32 On debates about history and their relationship to developments in history painting in the early eighteenth century, see Scott 1995, pp. 177–85.

33 See Perelman and Olbrechts-Tyteca (n. 17, above), p. 353.

34 On this series, see most recently J.K. Dabbs, "Not Mere Child's Play: Jacques Stella's *Jeux et plaisirs de lenfance*," *Gazette des Beaux-Arts* 125 (1995), pp. 303–12.

35 See Perelman and Olbrechts-Tyteca, op. cit. (n. 17, above), pp. 357–62.

36 On the painting, see Rosenberg 1979, no. 33.

37 See A. Colantuono, "Titian's Tender Infants: On the Imitation of Venetian Painting in Baroque Rome," *I Tatti Studies* 3 (1989), pp. 207–34.

38 On Boucher's *putti*, see Laing 1986a, no. 15; also Standen 1994.

39 Ariès 1960, passim; see also a resumé of the same argument in Gélis 1989.

40 See for instance the collection of essays published in a special issue on the child in *Littératures classiques* (Jan. 1991).

41 Maza 1997.

42 Lyons 1989, pp. 32–33. See also Norman Bryson, *Looking at the Overlooked: Four Essays on Still Life Painting* (London, 1990), which deals with a rarity of gaze in relation to still life.

43 Maza 1997.

44 For the verse on the "top," see n. 15, above; of *Le Jeu de l'Oye* (1745) the verses had the following to say: "Avant que la carrière à ce jeu soit finie / Que de risques à craindre et d'éceuils à franchir; / Enfants, vous ne pouvés trop tôt y réfléchir / C'est une image de la vie."

45 See, for example, Nicolas Guérard's print.

46 Colin Bailey has explored the relationship of Greuze's *Laundress* (cat. 70 in this exhibition) to that tradition, in Bailey 2000b.

47 Démoris (1991, pp. 78–83) has drawn out the importance of water in this work and its companion piece *La Fontaine* (1733; Nationalmuseum, Stockholm).

48 St. F. de Sales, *Recueils des entretiens spirituels* (1628); Fénelon, *Lettres spirituelles*, quoted in Oppici 1991, p. 212.

49 Démoris 1991.

50 Winnicott 1971, pp. 14–15; see also pp. 96–97 and passim.

51 Ibid., p. 14; see also ch. 7, "The Location of Cultural Experience," pp. 95–103.

52 For a particularly incisive feminist critique of the role Winnicott assigns to the mother, see ch. 1, "From Kline to Winnicott: A New Mise-en-Scène for the Mother," in Doane and Hodges 1992. My thanks to Mignon Nixon for this reference and for sundry conversations about Winnicott, from which I have gained much.

53 Fénelon 1687, p. 104. See the excellent article on Fénelon and education by Dominique Bertrand (1991). For a discussion of the influence of Fénelon on eighteenth-century theories of education, see Cherel 1918.

54 Though Winnicott owed much to Freud, with respect to the role of culture their views differed fundamentally: in Winnicott, culture enables, like the mother; in Freud, it hinders, frustrates, like the father.

55 *Mercure de France* (1735), pp. 1385–86.

56 Snoep-Reitsma (1973, pp. 178–80) argues for an interpretation of the cat as an emblem of sensual love, a view rejected outright by Rosenberg (1979, p. 200).

57 For a discussion of this issue, see Poutet 1991.

La Bruyère (1965) seems to take a universal view of the bestiality of infants in ch. 49, "De l'homme," only seemingly to contradict himself in ch. 50.

58 As cited in Ariès 1960, p. 122.

59 Marivaux, *Le Bilboquet*, ed. F. Rubellin (Paris, 1995). See also Howells 2000.

60 The interpretation of the servants' behaviour is consistent with Huizinga's notion in *Homo Ludens* that play consists in "a stepping out of 'real' life" (1970, p. 26, and passim). This is in sharp contrast to Winnicott's contention that play functions as a means of reaching the real, of ultimately "feeling real." Unlike the dallying servants, the middle-class child, in a sense, "plays for real."

61 On the relationship between masters and servants, see Maza 1983.

62 See Ariès 1960, p. 119.

63 See Huizinga on the "playground" (1970, pp. 28–29), where he links its separation from the real with the sacred.

64 See, for instance, the contents of the games room at the Château de Bercy, published by Bruno Pons in *Period Rooms*.

65 On the various versions of *The Little Schoolmistress*, see Rosenberg 1979, no. 70.

66 Caillois 1996, p. 61. The idea is more fully developed on pp. 161–94. Caillois divides games into four principles types: *agôn* (competition), *alea* (chance), *mimicry*, and *ilinx* (vertigo) (pp. 50–71).

67 Winnicott would, of course, have had to disagree, insofar as to assume the role of another involves the recognition of that person as "other."

68 The significance of the cards protruding from the drawer is difficult to fathom, and yet the obtrusiveness of the cards seems to demand interpretation. The jack of hearts is trumps in the popular game *Reversi*, introduced from Spain (see *La plus nouvelle académie universelle des jeux ou divertissemens innocens* [Leyden, 1721], p. 102). It is perhaps worth noting that children's and adults' play overlapped in the early modern period: just as children sometimes gambled, so adults (according to the Princess Palatine writing in 1719) also built houses of cards. See A. Franklin, *La vie privée d'autrefois*, XIX, *L'Enfant* (Paris, 1896), p. 268. On the importance of repetition in games, see Huizinga 1970, p. 28. On skill and chance (or *agôn* and *alea*) as qualities in card games, see Caillois 1996, pp. 195–251.

69 Démoris (1991, pp. 84–85) has also drawn attention to this quality of gesture, but relates it to a preoccupation with fragility and transience; that is, to the theme of Vanity.

70 According to Huizinga (1970, p. 27), "Play appears to us as an intermission in daily life, as a relaxation. But by virtue of its regular alternation it constitutes an accompaniment, a complement, and even a part of life in general. *It adorns life*, compensates for the deficiencies of life and in this respect is indispensable." For a probing discussion of the economics of play prompted by this passage, see Ehrman 1968, especially pp. 44–48.

71 Tunstall 2000.

72 Mauzi 1958. See also Armogathe 1976.

73 Mauzi 1958, p. 232.

74 See Kavanagh 1993, pp. 29–66.

75 C.F.N. Le Maître de Claville, *Traité du vrai mérite de l'homme considéré dans tous les ages et dans tous les conditions*, I (Paris, 1734), p. 310. For a rather later example of bourgeois method and moderation, see the account books of the household of André-René Le Boullenger de Capelle, Maître des comptes, who in the 1780s regularly entered his modest monthly losses: Bibliothèque historique de la ville de Paris, Ms. CP 4215–4216.

76 See Mauzi 1958, pp. 232–33; also Mauzi 1979 (1994 reprint, p. 283).

77 Ortigue de Vaumorière, *L'art de plaire dans la conversation* (Paris, 1711), p. 429.

78 See, for example, the verses appended to Filloeul's engraving of *Soap Bubbles* (n. 12, above), in which the child is enjoined to think metaphorically about what he is doing. Likewise, in Surugue's reproduction of *Card Tricks* (1744), the verse, by a play on words, urges the children to project the experience of trickery into future situations: "On vous séduit foible jeunesse, / Par ses tours que vos yeux ne cessent d'admirer; / Dans le cours du bel age où vous alles entrer / Craignés pour votre coeur mille autres tours d'adresse." The assumption in both instances is that children do and adults reflect.

79 A. Furetière, *Dictionaire universel de la langue française*, 4 vols., Paris, 1727, III: "Naïf."

80 *Mercure de France* (December 1739), p. 3112.

81 These included *Le Singe qui peint*, *Le Singe de la philosophie*, *La Mère laborieuse*, *Le Bénédicité*, and *La Maîtresse d'école*.

82 *Mercure de France* (October 1740), p. 2274.

83 Jacques Lacombe noted that Chardin selected "actions simples & naïves" (*Le Salon en vers et en prose ou jugement des ouvrages exposées au Louvre en 1753*, n.d., p. 23). The coupling of *naïveté* with simplicity implies simplification: the ready accessibility and childlike character of the subject matter. The abbé Garrigues de Froment, in *Sentiments d'un amateur sur l'exposition des tableaux du Louvre et la critique qui en a été faite* (n.d., p. 34), equated truth with *naïveté*, which, in terms of handling, suggests an abbreviation of style to the strictly factual and a rejection of ornament and embellishment.

84 Stierle (1972, p. 183) has argued that it is a characteristic of example that it designates not so much moral types but moral relations. The taste for the childlike was not exclusively a phenomenon of painting. The fashion for fairy tales and fables in the last decades of Louis XIV's reign has been discussed by modern scholars in terms of infantilism. See Y. Lostoukoff, "La surenchère enfantine dans les Contes de Perrault," *XVIIᵉ siècle*, 153 (1986), pp. 343–50; Raymonde Robert, "L'infantilisation du conte merveilleux au XVIIᵉ siècle," *Littératures classiques* 14 (1991), pp. 33–46.

85 *Mercure de France* (October 1740), p. 2274.

86 See Lyons's fuller discussion (1989, p. 33) of the "undecidability" of example.

87 Haillet de Couronne 1854, pp. 431–32.

88 Ibid., p. 434.

89 Ibid., p. 440.

90 See Mauzi 1958, pp. 239–41.

91 Kavanagh 1993, pp. 67–104.

92 According to the critic for the *Mercure de France* (December 1739, II, pp. 3112–13), the governess gently corrects the child for "sa malpropreté, son dérangement et sa négligence," which had arisen from the play, the accoutrements of which lie scattered behind him. This interpretation was no doubt prompted by the verses appended to Louis Surugue's print, of the publication of which the *Mercure* was giving notice: "Malgrais le minois hypocrite / Et l'air soumis de cet Enfant / Je gagerois qu'il prémédite / De retourner à son volant." It must be acknowledged that the author of the pamphlet *Description raisonnée des tableaux exposés au Louvre: Lettre a Madame la marquise . . .* (1739), p. 8 (also cited in Wildenstein 1933, p. 69), saw no reference to games in the work, no reprimand, only the recitation of a lesson before school.

93 Haillet de Couronne 1854, p. 437.

Exoticism and Genre Painting in Eighteenth-Century France

MARIANNE ROLAND MICHEL

The remoteness of countries reflects in a way the very great nearness of the times. Because the People barely make note of any difference between that which is a thousand years from them, and that which is a thousand leagues away. . . . These are customs and mores that are very different.
— Racine, *Bajazet* (1676), preface

Oh! Oh! You, sir, are a Persian? What an extraordinary thing! How can one be a Persian?
— Montesquieu, *Lettres persanes* (1721), letter XXX

While the exotic component of Rococo art has often been studied, most of the analyses have dealt primarily with the decorative arts, such as ceramics, furniture, tapestry, and fabrics. We can best begin our inquiry into exoticism and genre painting by asking ourselves what we mean by exoticism, a word that did not exist in the eighteenth century. To simplify matters, let us say that exoticism implies a change of scenery, a mysterious elsewhere, forbidding and seductive, evoking different customs usually inferred from travel stories, or from an iconography with confused rules. Exoticism can be revealed through clothing, architecture, and strange flora and fauna, but also through political, social, philosophical, and religious systems as moral presuppositions or as types of characters. The reality of exoticism passes as much through the imaginary as it does through documented history: it is not by chance that Racine reminds us in the preface to *Bajazet* that he is using actual events that had taken place fairly recently in Turkey, for which he gives the sources as the basis for his depiction of "what we know of Turkish customs and maxims."

EXOTIC LANDS

In eighteenth-century French painting we can distinguish a number of exotic "provinces,"[1] located in the Far East (China, Japan), the Middle East (Persia, Turkey), Africa, America, or even as close as Russia and Spain.[2] For each of these regions, we find depictions both of costumed figures and of scenes showing local customs. We must differentiate between works with an "ethnographic" or historical intention (that is, works meant to provide knowledge of the different modes of dress, functions, official practices and ranks of the inhabitants of far-off countries), and works with a "picturesque purpose" (intended to illustrate customs, entertainments, and family life). To this we might add that the arrival of strangers in France made a curious impression on the French, whether in the case of a historical event, such as the arrival of a foreign ambassador, or a fictional event, such as the voyage Montesquieu dreamed up for Usbek and Rica. Europeans were often portrayed wearing Turkish or Chinese clothing brought back from distant travels. The example of Liotard, who never took his caftan off, is particularly famous, but his was not an isolated case in the eighteenth century.

Even a cursory summary of the research on genre painting shows that the exotic component is varied and abundant. Both form and content evolved over the century, as much because of external political or cultural events as because of the evolution of pictorial awareness. A brief overview of the works exhibited in the Salons provides a connecting thread. It is worth noting the importance given to foreign dignitaries, who were frequently painted on the occasion of their official arrival in Paris. In 1699, Benoist's portraits of the first and second

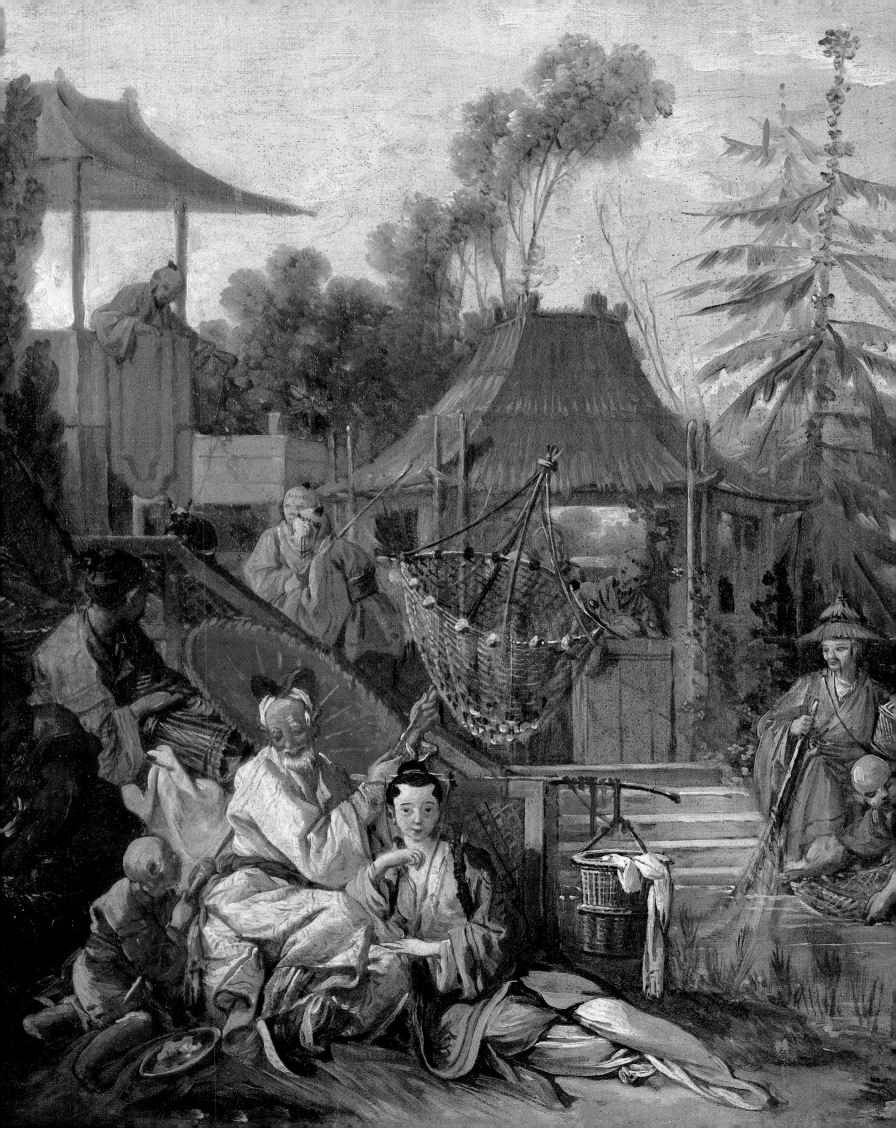

Fig. 69 Jacques-André-Joseph Aved, *Sultana in the Garden of the Seraglio*, 1743. Private collection

Fig. 79 François Boucher, *Tea in the Chinese Manner*, 1742. Little Durnford Manor, Wiltshire, Earl of Chichester's Trustees

could have come from the Jesuits' tales.[55] In addition, the porcelain and the fans were the stock-in-trade of Edme Gersaint, owner of a shop called "À la Pagode," for whom Boucher had designed a pagoda-style business card in 1740, and the musical instruments might have been borrowed from Boucher's own collection.[56] The numerous drawings create a whole little world, whose inhabitants sit, bow low, recline, dance, eat, graciously converse, and entice us to join them.

The year Boucher exhibited the sketches for this Chinese suite at the Salon, he also painted two overdoors in blue camaieu, *The Gallant Chinese* and *Tea in the Chinese Manner* (fig. 79), in which the individuals come together in a curved arabesque.[57] Once again, it is their dress as well as the buildings and the branches in the background that tell us we are in China. These evocative elements appear in many drawings that Boucher made to be engraved. In some instances we find isolated figures, as in the *Collection of Various Chinese Figures from Boucher's Cabinet*, which he engraved himself, or the *Suite of Chinese Figures*, which Houël engraved, or the male and female Chinese musicians engraved by Crozat de Thiers.[58] In other instances we have genre scenes where the theme scarcely differs from that of the pastorals. This is the case with the Chinese subjects engraved by Aveline that complete Baléchou's *Delights of Childhood*, showing a young mother and her two children; but also with the Four Elements and the Five Senses "represented by various Chinese games" engraved around 1740, where exoticism takes over from allegory;[59] or yet again, the twelve *Scenes of Chinese Life* engraved by Huquier between 1738 and 1745, the inspiration for which is close to that of the sketches for Beauvais, highlighting each of the two to five persons engaged in varied occupations.[60] Not only were these

designs used by porcelain decorators and silk-makers,[61] but they were also copied by the painter-decorators to adorn panelling.

This was also the purpose of the engravings made from Pillement's drawings (see fig. 80). His various *Cahiers* of Chinese clocks, birds, games, tents, or swings were in large part destined for the silk factories in Lyon, as was his *Chinese Floral Works, Ornaments, Cartouches, Figures and Other Subjects* of 1776. We should note, moreover, that in 1765 during Pillement's stay in Poland, Stanislas Augustus commissioned him to produce a decorative set for Ujazdow Castle,[62] including two large paintings (Musée du Petit Palais, Paris) showing Chinese figures among trees and Chinese accessories, attesting once again to the persistence of a taste for this type of decor.

However, amidst this swirl of fanciful images, we must remember the special place Boucher accorded to the emblematic figure of the Emperor of China, who was celebrated for his wisdom and skill at farming.[63] This point is made in the physiocratic ideal of the agricultural lesson: when in 1779 Cochin illustrated *The Annual Triumph of the Noblest of the Arts* for Roucher's *The Months* with a drawing of the Chinese emperor pushing a plough, the artist was proposing

Fig. 80 Jean Pillement, *Chinese Fishing*. Private collection

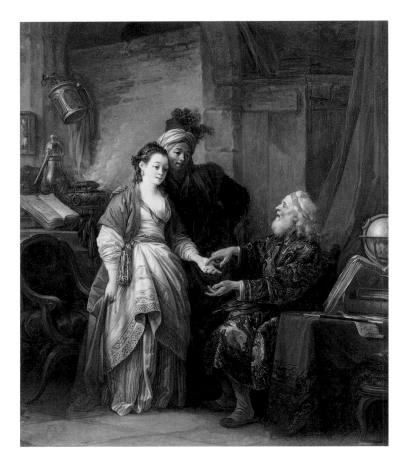

Fig. 81 Jean-Baptiste Le Prince, *The Necromancer*, 1775.
Formerly Stair Sainty Matthiesen collection

Russian landscapes and subjects, including the interior of a peasant's room, and a pastoral in which "a shepherd puts aside his balalaika to listen to a young boy playing a pipe." In 1767, he showed twelve paintings of "the customs and mores of the various Peoples of Russia & of Asia," including fortune-telling subjects, *Russian Concert Given by a Young Woman and her Gallant* and *Girl Instructing an Old Woman to Deliver a Letter*, along with its pendant, *Young Man who Rewards the Zeal of the Old Woman*.[66] Moreover, Le Prince provided the cartoons for the *Russian Games* tapestries woven at Beauvais starting in 1769, and in 1770 he painted *Russian Festival in a Park* (Musée des Beaux-Arts, Angers). His *Necromancer* of 1775 (fig. 81)[67] demonstrates that he continued to make successful use of Russian inspiration. Many of his Russian subjects have been engraved.

Compressed though it is, this overview allows us to see precisely how exoticism provided genre painting with new subjects. With Le Prince's Russia, we leave one Orientalism – Persian or Chinese – that was essentially based on a fascination with foreign costume, to enter the everyday life of another world, where not only the clothing but also the customs differ from those of Enlightenment-era France. The exotic picturesque becomes less of a fantasy; its purpose is now to illustrate the very different daily life in other lands. Exotic fiction henceforth authorizes anthropological enquiry: how are genre scenes lived elsewhere?

the emperor as a model for European sovereigns,[64] and also referring to the furrow traced in 1769 by the future king Louis XVI.

We thus return to a meaningful exoticism reflected in scenes of daily life, of which Le Prince was one of the most adept practitioners. This artist spent time in Russia and in Siberia from 1758 to 1763, returning with many drawings that would inspire his art in the years to come.[65] In 1765, the same year he was received at the Académie with his *Russian Baptism* (Musée du Louvre, Paris), he exhibited at the Salon some twenty

NOTES

1 I use this word deliberately, in reference to the Goncourts, who wrote that Boucher had made China into a "province of the Rococo."

2 Roland Michel 1976.

3 I have adopted the spelling retained by G. Veinstein for the publication of the Ambassador's memoirs (see n. 11 below).

4 *The Arrival* and *The Departure of the Turkish Ambassador* were intended for Gobelins and were paid for in 1727 and 1734. *The Arrival* was acquired by the King only in 1739, and was installed in Versailles as the companion piece to a Van der Meulen. A third work, *The Moment when the Ambassador Enters the Palace*, was planned but never painted.

5 See Salmon 1995.

6 See Wildenstein 1967.

7 *A New General Collection of Voyages* was intended "to form a complete system of modern history and geography which will represent the state of every nation." For the genesis of the collection and details of the illustrations, see Michel 1987b, no. 65.

8 See n. 55 below.

9 One need only refer to the catalogue of the exhibition *L'Amérique vue par l'Europe*, held at the Grand Palais, Paris, in 1976.

10 Saint-Simon 1987, pp. 772–76.

11 Mehmet Effendi 1981.

12 Montesquieu, *Persian Letters* (1721), letter XXX.

13 A good sample of the various engravings of Turkish dress and scenes of the seventeenth and eighteenth centuries can be found in the exhibition catalogue *The Image of the Turk in Europe*, Metropolitan Museum, New York, 1973.

14 See Bettagno 1993.

15 See especially Bouret 1982.

16 Rosenberg and Prat 1996, I, nos. 281–289.

17 See Boppe 1989.

18 These figures are evidently the models for the protagonists of *The Sultan's Caravan to Mecca*, presented in Rome in 1748 by the residents of the Académie de France.

19 Jean-Richard 1978, nos. 878–898.

20 Quoted in Michel 1993, p. 59.

21 Also tambur, or tamboura, a type of lute used in Turkey. I sincerely thank Florence Getreau, who guided me in identifying this instrument.

22 See Stein 1994.

23 Two versions are known: one is preserved at the Hermitage in Saint Petersburg, the other was sold at Sotheby's, New York, 30 January 1997, no. 94.

24 Sahut 1977, nos. 535–550.

25 Ibid., no. 511.

26 Engerand 1901, pp. 494–97.

27 Jean Racine, *Bajazet* (1672). Preface to Racine's *Oeuvres*, published in 1676.

28 I wish to thank Alain Daguerre de Hureaux for his assistance.

29 On this subject, we refer to the excellent study by Grosrichard (1979).

30 Musée de la Cour d'or, Metz. The title, *La Sultane*, is that of an engraving by Demarteau.

31 Formerly Bob Haboldt Gallery, New York.

32 Respectively in the Jablonska Palace, near Warsaw, and in a private collection in Italy. Aaron 2002, pp. 74, 75.

33 Private collection. Roland Michel 1984, nos. P.47, P.48.

34 Private collection. Ibid., nos. P.127, P.128.

35 Ibid., no. P.181.

36 These two engravings are taken from the *Livre nouveau de douze morceaux de fantaisie*, ibid., nos. G.60, G.62.

37 Musée des Beaux-Arts, Dijon. Ibid., nos. D.179–184. *Prosternation chinoise, Observation chinoise, Divertissement chinois, Conversation chinoise*, nos. D.120–123.

38 Pietsch 2001. This remark applies in this instance to the porcelain decorations.

39 Israel Museum, Jerusalem. See Pons 1995.

40 These astronomers are nothing more than Jesuit fathers dressed like Chinese. See, especially, Jarry 1975.

41 Two articles essential to understanding this painter are Eidelberg 1977b and La Gorce 1983.

42 Sotheby's, New York, 23 May 2001, no. 42.

43 Preserved at the museum of Chaalis abbey, they are not dated, but were no doubt based on the Persian diplomatic mission of 1715.

44 Former collection of Jacques Helft. Some sheets are reproduced in the articles cited in n. 41 above.

45 La Gorce 1983.

46 See Dacier and Vuaflart 1921–29, nos. 232–261, and, especially, the article by Eidelberg and Gopin 1997, the most complete study to date of the history of the iconography of this cycle.

47 Mirimonde 1975–77, II, p. 152.

48 ["Soutchovene" is the French spelling.] Belevitch-Stankevitch 1910 and, more recently, Eidelberg and Gopin 1997 have shown that the names and titles were not inventions of the engravers, but show their knowledge of Chinese vocabulary.

49 Sotheby's, New York, 11 January 1996, no. 151.

50 His influence, through his engravings, on the paintings of the following decades is stressed by Honour (1961).

51 Dacier and Vuaflart 1921–29, nos. 134, 135.

52 Dapper 1670, repr. in Eidelberg and Gopin 1997, fig. 26.

53 Saint-Yves 1748.

54 Musée des Beaux-Arts, Besançon. Eight of these appeared at the Salon in 1742, and formed the basis for the cartoons by Dumont (de Tulle?) for the weaving of the tapestries, which began in 1743. The first suite of six was made for the King: *The Meal, The Fair, The Dance, Fishing, The Hunt*, and *The Toilette* (see Jarry 1975, n. 32).

55 Nieuhoff 1665 is of particular interest; he was quickly translated into French and English. See also Kircher 1667, Vries 1682, Bouvet 1697, Le Comte 1696, and Du Halde 1735. We note that Lajoüe based the flora and fauna motifs of his *chinoiseries* on Nieuhoff and Du Halde; see Laing 1986a, nos. 41–44, and more recently the study by Stein (1996) of the models used by Boucher.

56 Cf. Mirimonde 1975–77, II, p. 153.

57 Davids Samling, Copenhagen, and Little Durnford Manor, Wiltshire, Earl of Chichester's Trustees.

58 Jean-Richard 1978, nos. 12–20, 1082–1088, 1609 and 1610.

59 This is also the case of the *Livre de cartouches inventés par François Boucher*, engraved by Huquier, in which the elements and the senses are illustrated by Chinese scenes or figures.

60 Jean-Richard 1978, nos. 198–202, 230–234, 254, 1125–1133.

61 See Gruber 1992 on this subject.

62 My thanks to Maria Gordon-Smith for this information.

63 See Michel 1994 on this subject. This function of the emperor is also illustrated by B. Rodde, who, in 1773, exhibited *The Emperor of China Pushing the Plough*, with its pendant *The Empress Presiding over the Picking* (Gemäldegalerie, Berlin).

64 Michel 1987b, no. 165. In this context, the engraving by Née based on Eisen should be mentioned. Exhibited in 1773, it was entitled *The Father of People, his Hand Resting Heavily on the Plough, Shows his Children the True Treasures of the State*.

65 See, in particular, Rorschach 1986.

66 One of them, with five figures in a lavish interior, would be engraved by Gaillard as *The Russian Fortuneteller*.

67 Formerly with Guy Stair Sainty, New York.

Note to the Reader

The present catalogue contains entries on 113 works. The contents of the exhibition vary in each of the three venues, Ottawa, Washington, and Berlin. The apparatus for each catalogue entry, and the footnotes, can be found in the *Notes to the Catalogue* section that begins on page 355. Dimensions are those provided by the owner and are given in centimetres, height preceding width. The exhibition history refers only to eighteenth-century exhibitions. For a complete listing of genre paintings shown at the Paris Salons from 1699 to 1789, see the Appendix, page 393. Full listings for the cited references are given in the Bibliography, page 379. The author's initials have been given at the end of each catalogue entry:

CBB COLIN B. BAILEY
 Chief Curator, The Frick Collection, New York

JC JOHN COLLINS
 Assistant Curator, European Art, National Gallery of Canada

PC PHILIP CONISBEE
 Senior Curator of European Paintings, National Gallery of Art, Washington, D.C.

JE JÖRG EBELING
 Research Associate, Deutsches Forum für Kunstgeschichte, Paris

AF ANIK FOURNIER
 Research Assistant, European Art, National Gallery of Canada

BG BARBARA GAEHTGENS
 Lecturer in the History of Art, Technische Universität, Berlin

TG THOMAS W. GAEHTGENS
 Chair, History of Art, Freie Universität, Berlin, and Director, Deutsches Forum für Kunstgeschichte/Centre allemand d'histoire de l'art, Paris

FG FRANCES GAGE
 Research Associate, Center for Advanced Study in the Visual Arts, National Gallery of Art, Washington, D.C.

MMG MARGARET MORGAN GRASSELLI
 Curator of Old Master Drawings, National Gallery of Art, Washington, D.C.

CL CHRISTOPHE LERIBAULT
 Curator of Paintings and Drawings, Musée Carnavalet, Paris

MRM MARIANNE ROLAND MICHEL
 Independent Art Historian, Paris

RM RAINER MICHAELIS
 Curator, Staatliche Museen zu Berlin, Gemäldegalerie

KS KATIE SCOTT
 Reader in the History of Art, The Courtauld Institute of Art, London

MS MARTIN SCHIEDER
 Assistant Professor, Freie Universität, Berlin, and Project Manager, Deutsches Forum für Kunstgeschichte/Centre allemand d'histoire de l'art, Paris

HS HELGE SIEFERT
 Curator of French Painting, Alte Pinakothek, Munich

SS SUSAN L. SIEGFRIED
 Professor of Art History, University of Michigan, Ann Arbor

CMV CHRISTOPH MARTIN VOGTHERR
 Curator of Paintings, Stiftung Preussische Schlösser und Gärten Berlin-Brandenburg

NW-B NICOLE WILLK-BROCARD
 Chargé de mission, Département des Peintures, Musée du Louvre

AW ALAN WINTERMUTE
 Head of Pictures, Artemis Fine Arts, New York

Catalogue

Jean-Antoine Watteau (1684–1721)

1 *The Portal of Valenciennes* c. 1710

32.5 × 40.5 cm

The Frick Collection, New York

Valenciennes was a bustling garrison town during the later years of Louis XIV's ruinous War of Spanish Succession (1701–13) and, upon Watteau's retreat there in the autumn of 1709, provided the young artist with many opportunities to make studies of the soldiers stationed within its fortifications. His brief return to his native city coincided with the defeat of the French army at the Battle of Malplaquet and the famine of the winter of 1709–10, where witnesses recalled unshod conscripts being forced to eat their own horses in order to survive. The dozens of drawings that Watteau made of tired and bored soldiers resting between skirmishes are intensely empathetic, and he was careful to record the precise movements, postures, and expressions of the subjects he had captured, perhaps unawares, with an unsurpassed naturalism.[1]

The Portal of Valenciennes was christened with its present title only in 1912, but it seems likely that its setting was inspired by the massive brick and stucco military fortifications surrounding the city that had been erected on Sébastien de Vauban's designs in the early 1680s.[2] In the foreground, a sentinel and six other infantrymen relax beneath a crumbling archway, perhaps representing the city gates. On the far left is a night guard, standing outside his wooden shed, his sword and musket poking out from beneath his watch-cape. He appears to chat to one of two soldiers standing casually near the centre of the composition; the other rests on his musket, conversing – across a group of seated and reclining men – with a standing soldier who leans against the inner wall of the arch. Clothing was always a principal fascination of Watteau's, and he renders the troop's costumes with the realism and exactitude that his contemporaries often referred to with admiration. (Meticulous red chalk studies for three of the soldiers in uniform have survived.)[3] All but one of the men wear the unbleached, light-brown wool uniforms of common soldiers – no officers here – with the blue or red facings that identify their regiments. The soldier holding a short pipe and seated with his back to us shows the blue uniform and red stockings of a drummer; his snare-drum sits beside him. Even the sleeping soldier wears his tricorne; only the stupified looking man smoking a long clay pipe is bareheaded. The season is probably late spring, when the garrison's waistcoats would have been handed in for mending.[4]

Cloaked in a somnolent mood – the tone set by the "vanitas" of meditative smoking, the sleeping dog and soldier, silent drum and discarded weapons – *The Portal of Valenciennes* is one of Watteau's gentlest and most elegiac depictions of ordinary men at war. His tender appreciation of manly camaraderie permeates this rendering of a moment of calm between battles. It is this delicacy of feeling and sensitivity of observation that sets apart *The Portal of Valenciennes* and Watteau's other wartime compositions, approximately ten of which are known today, from the bumptious guardroom and encampment scenes of seventeenth-century Dutch artists such as Philips Wouwermans that were familiar to Watteau and served as his model.[5] The exhaustion, shabby clothes, and decaying fortifications evident in the picture may intimate Watteau's quiet disapproval of the terrible cost inflicted on his country by the last, vain war of Louis XIV (a long pike, itself antiquated as a weapon of battle and no longer of use to the army, points accusingly at the Royal crest atop the arch);[6] but it is, as Hal Opperman has observed, the artist's evocation of "a state of serenity in spite of [the horrors of war]" that defines the painting's originality and profundity.[7]

Nothing is known of its earliest history, but, as is evident from infrared reflectographs (and even to the naked eye), the painting was originally composed in an irregular oval format.[8] This links it to two other military subjects of identical size, *The Halt* (Museo Thyssen-Bornemisza, Madrid) and *The Line of March* (City of York Art Gallery). All three paintings were conceived as ovals and later in-painted at the corners to make them rectangles. It is possible that they were made as a series (or part of a series) of military decorations that would have been installed in boiserie panelling in a small cabinet or library, perhaps for an unknown patron who had himself served in the military and would appreciate Watteau's unvarnished souvenirs of army life.[9] As engravings of *The Halt* and *The Line of March* in their rectangular formats were published in 1729 and 1730, respectively, when the paintings were owned by Watteau's friend Jean de Jullienne, it seems likely that they were removed from their original setting soon after they were painted and altered to their present format, possibly by the artist himself.[10] Might Pierre Sirois, the Paris art dealer who purchased Watteau's first military scenes in 1709, have been behind this commission as well? A clue to his involvement can perhaps be found in the Royal Arms on the portal. In addition to invoking the King, the shield may also serve as a punning reference to the dealer, whose shop on the Quai Neuf was called "Aux Armes de France," as Edgar Munhall has ingeniously observed.[11]

AW

Jean-Antoine Watteau (1684–1721)

2 *The Marmot* c. 1715–16

40.5 × 32.5 cm

The State Hermitage Museum, Saint Petersburg

This striking image of a grinning boy carrying a marmot and a recorder, standing alone before a cold, desolate village square, has always been something of a curiosity among Watteau's paintings. Dressed in a ragged overcoat and stockings, the boy was one of the thousands of rural labourers who, every winter, left the mountain regions of their native Savoy to migrate to the large cities of France, Italy, and Germany, where they worked as chimney-sweeps, knife-grinders, shoeshine boys or – as in *The Marmot* – street entertainers.[1] In this case, the boy would play his flageolet for coins and induce the trained animal to dance on its hind legs atop its wooden box. Watteau's affection for performers, no matter how humble, permeates the picture, which follows in the long tradition of depicting popular types traceable back to seventeenth-century artists such as Jacques Callot, Georges de La Tour, and the Le Nain brothers in France, and David Teniers and the "little Dutch masters" in Holland. Despite the boy's cheerful expression, the reality of a Savoyard's marginal existence in Paris was harsh: most lived in extreme poverty in their own communities, their primary concern being to send money back to their families; in the warm weather they returned home to tend their farms.

Although anomalous among Watteau's paintings, *The Marmot* relates to a series of more than a dozen drawn studies by the artist, of male and female Savoyards of various ages, executed in a vigorous red and black chalk technique, and confidently datable to 1715.[2] These drawings reflect Watteau's growing interest in naturalistic observation and in the close, sympathetic study of "exotic" types. A splendid sheet in the Musée du Petit Palais depicts the figure of our young Savoyard, but in mirror-image of the way he appears in *The Marmot*.[3] Watteau presumably based his painting on a recently discovered counterproof of the drawing, which corresponds in direction to the picture.[4] Both the counterproof and another study showing the church spire (Teylers Museum, Haarlem) that appears in the background of the painting are reworked in coloured washes – a technique that Watteau used only intermittently.[5]

Presumably, Watteau decided to reverse the orientation of the boy in order that *The Marmot* be symmetrical with its pendant, *The Spinner*, a painting that has been lost since the late nineteenth century.[6] The figure of a standing peasant woman holding a spindle and distaff in the drawing that Watteau used as the basis for this painting looks in the same direction as the original study of the Savoyard boy. In order that they face one another in the paintings, one of the figures would have to be reversed; since the spinner could not be shown working left-handed, the boy would have to be changed.[7] Prints made after the pair of paintings were announced in the *Mercure de France* in December 1732; the engravings were made by Benoit II Audran when the paintings were in the collection of his uncle, Claude III Audran (1658–1734), the decorative painter who had been one of Watteau's first employers in Paris.[8] Although both paintings depict single figures standing in open, country landscapes, nothing seemed to link the two pendants thematically except that they represent "popular" or genre types – indeed *The Spinner*, though rustic, is not a Savoyarde. It was Donald Posner who first recognized that the pendants might be understood as illustrations of a salacious proverb, now forgotten, but familiar to an eighteenth-century audience: the spindle and distaff, by both their shape and use, provide visual emblems of the male sex organs, and the act of transforming wool into yarn can be read as an analogy of sexual reproduction.[9] Likewise, "marmotte" was common slang in the eighteenth century for the female genitals – "the furry creature is easily trained to dance to the music played by its master's instrument," as Posner wryly observed. Thus interpreted, the Spinner and the Savoyard "each hold the symbol of the other's sex, and by their occupation they characterize the male and female roles in the sexual act."[10]

This erotic interpretation helps to explain the immediate juxtaposition of the retiring animal, the erect recorder, and the boy's mischievous smile. Yet with its splendid wintry landscape of frost-blue sky, straw-coloured grass, and spare, leafless trees; its indelible image of awkward, self-conscious youth; and its tender depiction of the intimate bond between man and animal, *The Marmot* displays a vitality and beauty that far transcend its origins as one half of an off-colour joke.

AW

Jean-Antoine Watteau (1684–1721)

3 *The Perspective* c. 1716–17

46.7 × 55.3 cm

The Museum of Fine Arts, Boston

The Perspective is among the most poised and stately of Watteau's *fêtes galantes*. Within an autumnal garden clearing, enclosed by a screen of towering trees, a small party of young men and women, accompanied by children and a playful dog, enjoy the quiet pleasures of a sunny afternoon on a country estate. Three couples encircle a vine-covered urn on the left of the composition: a cavalier invites a woman to stroll though the woods; a seated guitarist serenades his lady; a standing man in a beret and cape leans confidently on the plinth, and gestures with familiarity toward a seated woman with whom he is conversing. (Their intimacy is underscored by the presence between them of a smiling child whose glance engages the viewer.)[1] Although it offers no traditional narrative, *The Perspective* takes the developing stages of love as its subject, and the three couples, by their compositional arrangement and physical interaction, create a visual metaphor for the temporal development of romantic ardour.[2] As another couple slips into the woods on the far right and two children play in the foreground, two solitary women gaze dreamily across a pool of water, symbol of unfulfilled longing.[3] The picture reveals the artist's careful study of *The Garden of Love* (The Prado, Madrid) by the seventeenth-century Flemish master Peter Paul Rubens, a composition with which Watteau would have been familiar through a studio replica in the collection of the Comtesse de Verrue.[4] However, the confidence and vitality of the inhabitants of Rubens' painting were alien to Watteau's more equivocal sensibility.

A pronounced harmoniousness and equilibrium characterize *The Perspective*: this Edenic atmosphere is heightened by the enveloping landscape setting that seems to isolate the small community of lovers from the outside world, and by the marble loggia that shimmers in the distance like an enchanted palace. Curiously, this fantastical structure reproduces an actual building, and is the only identifiable site depicted in any of Watteau's *fêtes galantes*. We know from notations left by both the connoisseur Pierre-Jean Mariette and Watteau's close friend, the Comte de Caylus, that the building glimpsed through the opening in the trees is the Château de Montmorency, the property of the banker and art collector Pierre Crozat (1665–1740), located to the north of Paris near Saint-Denis (see fig. 82).[5]

Crozat had acquired Montmorency in 1709, and although he left the gardens as André Le Nôtre had designed them for the court painter Charles Le Brun, the château's first occupant, he commissioned the architect Jean-Silvain Cartaud to build a second, larger château on the model of a sixteenth-century Roman palazzo, in the southeast corner of the property where it would command more spectacular views. This was to become the main residence at Montmorency, while Cartaud gutted the body of Le Brun's mansion (which overlooked a long reflecting pool) and turned its two-storied loggia into an open-air *maison de plaisance*.[6] It is this central, newly transparent section of the old house that Watteau re-creates in the background of his painting.

Crozat and Watteau were well acquainted: the collector commissioned the artist to paint a suite of four oval decorations representing the Seasons for the dining room of his Paris townhouse, and gave him generous access to study and copy his collection of Old Master drawings, one of the largest and most celebrated in Europe.[7] At the end of 1717, Watteau is recorded as living in Crozat's house in Paris, and he is known to have made several drawings recording various views of the property at Montmorency; it is thus probable that the present painting dates from this period of their greatest intimacy, around 1716–17.[8] *The Perspective* is perhaps indebted to Crozat for more than just its setting: Watteau's patron held frequent concerts and musical parties at his country seat, and it has often been suggested that the picture's characters may be members of Crozat's circle. Certainly they are not portraits (at least eight sketches for figures in the painting are known to survive, and they are clearly studies of models posed in Watteau's studio), but it is possible that Watteau had watched Crozat's friends stroll and flirt on the grounds of the estate, and that this inspired his decision to paint a *fête galante* using Montmorency as the setting.[9] Watteau clothed his models in fancy dress, or costumes inspired by the theatre (he kept a trunk of costumes for that purpose), but the wearing of whimsical fancy dress was not uncommon at aristocratic entertainments and amateur *parades* of the type that might have been staged at Montmorency.[10]

AW

Fig. 82 Caylus, after Watteau, *The House of Monsieur Le Brun, Premier Peintre du Roi Louis XI*. Bibliothèque nationale, Paris

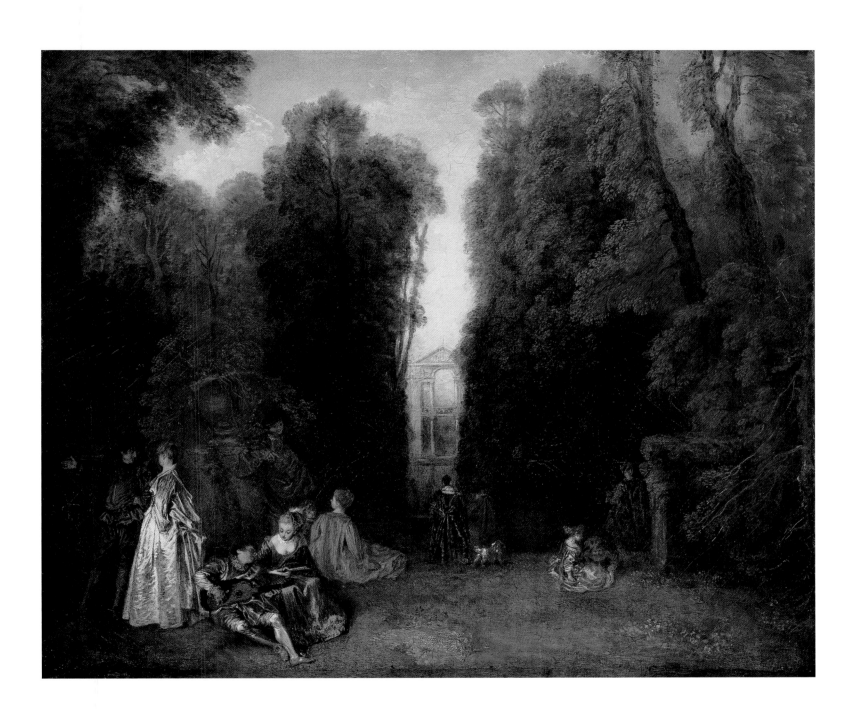

JEAN-ANTOINE WATTEAU (1684–1721)

4 *Pleasures of the Dance* c. 1717

52.6 × 65.4 cm

The Governors of the Dulwich Picture Gallery, London

When Watteau's onetime champion the Comte de Caylus read his "Life of Watteau" before the Academy in February 1748, it contained – among much praise – a sharp criticism of the painter's failure to create fully realized compositions. For Caylus, Watteau's pictures suffered from a uniformity (indeed, a monotony) deriving from their lack of a "precise object"; that is, from the absence of identifiable subject matter. He cited four paintings that escaped this failing: *The Village Wedding* (Soane Museum, London), *Gersaint's Shopsign* (Charlottenburg Palace, Berlin), *The Embarkation from Cythera* (Musée du Louvre, Paris) and *The Ball* (the painting under discussion, in Dulwich).[1] To modern eyes, *Pleasures of the Dance* may seem to differ little conceptually from Watteau's other *fêtes galantes*, but Caylus recognized in its setting, curious mixture of costumes, and subtle array of social types, the threads of a new and contemporary narrative that gave it, in his view, a significance not found in most of the artist's works.

In a soaring, open-air loggia of Renaissance magnificence, a large group of revellers gather for a ball. Watteau's multitudinous cast – sixty-five people in all, and carefully planned in more than a dozen surviving studies – includes celebrants in contemporary silk gowns and satin breeches, in fancy dress evocative of other countries and previous centuries, and in theatrical costumes of the *commedia dell'arte*.[2] There are festively attired musicians, old men with ruff collars and Van Dyck beards reminiscent of characters from Rubens' cycle of the *Life of Marie d'Medici*, and black pageboys straight out of the feast scenes of Paolo Veronese. In a clearing near the centre of the terrace, a single couple dances a stylized minuet. Servants carry food and wine from a banqueting table located beneath the gaze of two remarkably full-blooded marble caryatids. The partygoers drink, converse among themselves, and flirt (demurely, for the most part, except in the case of two men on the left of the composition, who press their suit aggressively). Few, if any of the guests, pay attention to the lone dancers.

As x-rays of the canvas reveal, Watteau gave considerable thought to the setting – which is much more expansive than in most of his paintings.[3] He originally planned to stage the ball beneath a rounded Italianate apse, deriving principally from Bernini's design for the high altar of San Andrea al Quirinale in Rome, which he could have known from an engraved plate in Rossi's 1684 portfolio, *Insignium Romae templorum prospectus*.[4] His decision to abandon this heavier and more enclosing plan in favour of an arcade opening onto a park and fountain may have been inspired by a seventeenth-century Flemish painting that was first proposed as a source by Karl Parker.[5] Hieronymus Janssens' *The Ball on the Terrace of a Palace* (Musée des Beaux-Arts, Lille), which is signed and dated 1656 and is today in the Musée des Beaux-Arts, Lille, bears remarkable similarities to *Pleasures*

of the Dance, including its disposition of large groups of figures on either side of an ornamentally paved floor, a central dancing couple, distant garden and fountain, even lifelike caryatids. The arcade as it finally appears in *Pleasures of the Dance* has no connection with Janssens' painting, however; instead it evokes the grandeur of Renaissance Venice found in paintings by Veronese, whose works Watteau often copied in drawings. In fact, the page who serves a glass of wine to the seated woman in a black dress is based on a drawing from a sheet of sketches that Watteau copied from Veronese's *Christ and the Centurion* (The Nelson-Atkins Museum of Art, Kansas City).[6] The background of Veronese's painting includes a high, columned archway that might have provided Watteau with a model for the loggia in *Pleasures of the Dance*. Indeed, the whole of Watteau's picture – its opulence, shimmering draperies, brilliant high-key palette, harmonious orchestration of dozens of individualized figures, even the group of highly absorbed working musicians to the right – seems to re-create the spirit of the Venetian decorator's vast feast scenes, in micro-miniature.

Despite its obvious debt to Watteau's favourite Old Masters – recognized by the nineteenth-century English painter John Constable, who described the Dulwich painting as an "inscrutable and exquisite thing [which] would vulgarise even Rubens and Paul Veronese" – Caylus would have been struck by the modernity of *Pleasures of the Dance*.[7] The grey and slate-coloured ringed columns, it has long been acknowledged, are based directly on Salomon de Brosse's columns in the Palais du Luxembourg, and would have immediately invoked the Paris of their day to Watteau's contemporaries.[8] Lavish balls and masquerades at court and in private residences had been fashionable since the beginning of the century, but in 1716 the activity was opened to the wider public when, by royal privilege, ticketed masked balls were established as a commercial enterprise at the Opéra three times a week during Carnival season.[9] Easily attended, the balls drew large crowds attracted by the mixing of the classes and sexes. A certain sexual license was encouraged by the anonymity that a mask and costume provide. *Parades*, or informal theatricals, were regular features of the balls, and it was commonplace to see partygoers in Pierrot and Harlequin costumes, much as in Watteau's painting. Men might come disguised as women, nobles as shepherds or *comédiens*, tradesmen as aristocrats, all liberated from the social constraints of their daily lives. Although *Pleasures of the Dance* cannot be considered an accurate re-creation of an early eighteenth-century ball (nocturnal events, at which virtually all of the participants were masked), it nevertheless evokes the easy amusements and intoxicating freedom that such occasions permitted.

AW

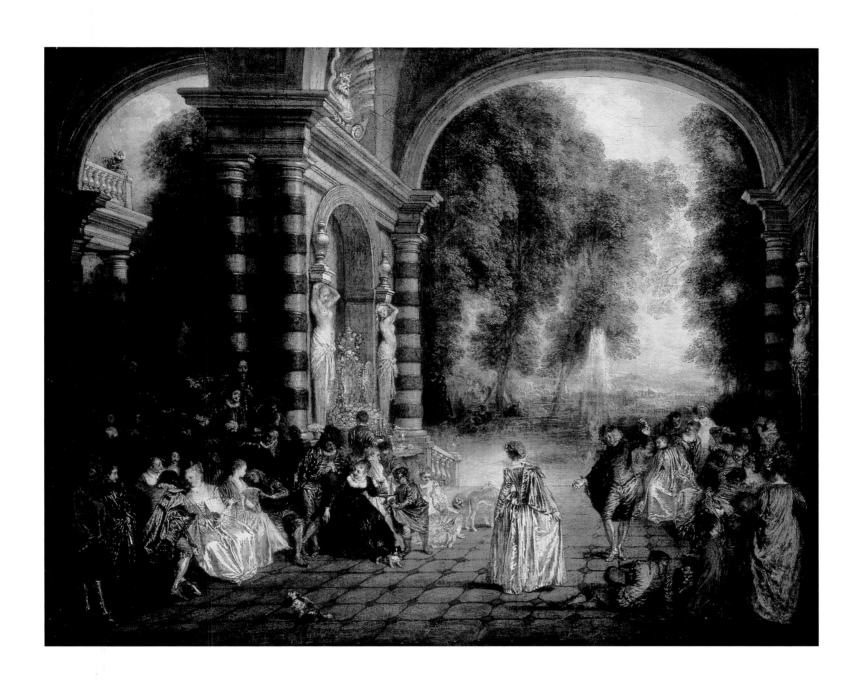

JEAN-ANTOINE WATTEAU (1684–1721)

5 *Love in the French Theatre* c. 1716

37 × 48 cm

Staatliche Museen zu Berlin, Gemäldegalerie

6 *Love in the Italian Theatre* c. 1718

37 × 48 cm

Staatliche Museen zu Berlin, Gemäldegalerie

These two "theatre paintings" share a significant place in Watteau's oeuvre. Charles-Nicolas Cochin's (1688–1754) engravings after them were published in May 1734, long after Watteau's death. Cochin titled them *Love in the French Theatre* and *Love in the Italian Theatre*, and these titles were also given to the paintings that later made their way to Berlin.

In *Love in the French Theatre*, Bacchus, crowned with a garland of vine leaves, reposes on an altarlike garden structure, in the centre of what is presumably a stage set. A glass of red wine in his right hand, he drinks a toast with an elegantly dressed huntsman, identified by the full quiver of arrows as Amor. Compared with the other actors, this figure is depicted rather austerely, like a piece of statuary – and the dark background of the park heightens this impression. Recognizable between the two is Columbine, who, as the female personification of amorous foolishness (*la Folie*), helps to strengthen the connection between the men. Theatre-lover Watteau presumably took his inspiration for this scene from the finale of an intermezzo in Lully's comic opera *Festes de l'Amour et de Bacchus*, which premiered in 1682.

Before the trio, who are central to any understanding of the painting, a couple hesitantly begins dancing to music played by a bagpiper, an oboist, and a violinist over at the left. Set back a little, on a console high above the scene and shadowed by a vine, a veiled bust "watches over" them. This could be a depiction of Momus, son of the Night and personification of the foolish obsession with criticizing the gods. If one accepts this interpretation, the girl standing below in the light might be seen as Venus, gently triumphing over Momus; for mythology (Lucianus, *Hermotimus*, c. 165 A.D.) has it that Momus died of vexation at being unable to find any fault with the charming goddess. The only person in this company to look out at the viewer is Crispin (a character in French comedy), shown at the far right. It has long been speculated that this is actually a portrait of the once famous actor Paul Poisson, who appears to be greeting his audience, hat in hand.

The artist's detailed studies are evidence that the picture in Berlin may have been produced between 1712 and 1716.[8] Watteau had been a member of France's Académie royale since 30 July 1712. But it was not until 1717 that he submitted his famous admission piece, *Embarkation from Cythera* (Musée du Louvre, Paris). In registering this canvas, the Academicians termed it a "fête galante," thus inaugurating the genre label that in future would be inextricably linked with the name of Watteau.

The complex possibilities for interpreting the Berlin painting, dating from this same period, have frequently led to contradictory statements by art historians. This is due primarily to Watteau's pictorial inventiveness, which is marked by great philosophical depth, and in consequence is hard to fathom. In addition, even in Watteau's own day, many of his contemporaries remarked on his introverted nature, which led the artist to say very little about his work.

Around 1770, the two dancers and the violinist from *Love in the French Theatre* were copied, presumably by Johann Friedrich Meyer (1728–c. 1789), on a mural for the library walls in the residence of the Marquis d'Argens (1704–1771) in the Neues Palais, Potsdam.[9] The practically life-size figures are in the narrow corner on the right, beside the window, where spatial conditions produce a right-angled encounter between them. That an able decorative painter was commissioned by Frederick the Great to copy details from Watteau's painting indicates the King's abiding preference for the *fête galante*. *Love in the French Theatre* is considered a significant example of late Frederician decorative art.

The related painting, *Love in the Italian Theatre*, springs from a slightly different source. In 1716, around the beginning of the Regency (Louis XIV died in 1715), the Italian actors who had been expelled from Paris in 1697 were allowed to return to the Seine. Watteau presumably was inspired by the performing art of that theatre troupe for this, his only nocturnal. Twelve actors of the *commedia dell'arte* are standing on a narrow proscenium before a park background. Recognizable from left to right are: Cantarina (the singer), Violetta behind the Doctor, Flaminia (with her mask off), Silvia, Pierrot (holding the guitar), Harlequin, Scapino, Mezzetino (with the torch), Pantaloon, and behind him, Scaramouche. At bottom right, a dog turns towards the moon, which is hidden behind clouds. Here, Watteau has deftly played the role of theatrical lighting engineer with a pronounced chiaroscuro, a technique that places him within the tradition of the great Baroque masters of his Flemish homeland.

Art historians have long been tempted to view the two Berlin "theatre paintings" as pendants, due to their identical format, their common provenance, and to Cochin's reproductive engravings, which lent the works their titles. This idea, however, is not borne out by the facts. The pictures were executed from different points of view: there is a greater angle of inclination to the foreground in the *French Theatre* than in the *Italian Theatre*. The figures in the latter painting are drawn "more compactly" than the somewhat doll-like figures in the *French Theatre*, and the figural arrangements differ significantly. As Rosenberg rightly noted in 1984, the Berlin canvases are therefore pseudo-counterparts.[10] Moreover, stylistic factors suggest that the *Italian Theatre* was not painted until 1718 or so.[11] These considerations aside, if Watteau's entire oeuvre attests to his love of the theatre, his famous Berlin "theatre paintings" are doubtless the surest evidence of this enduring passion.

RM

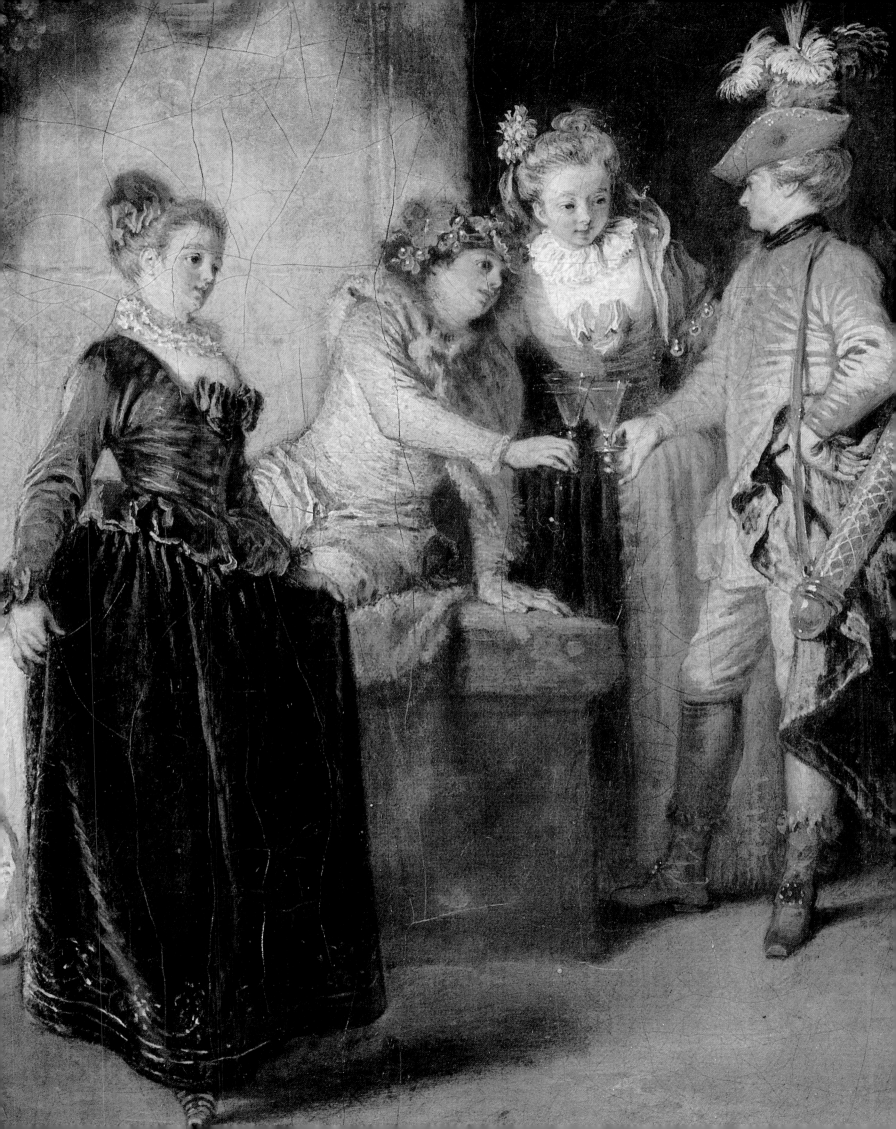

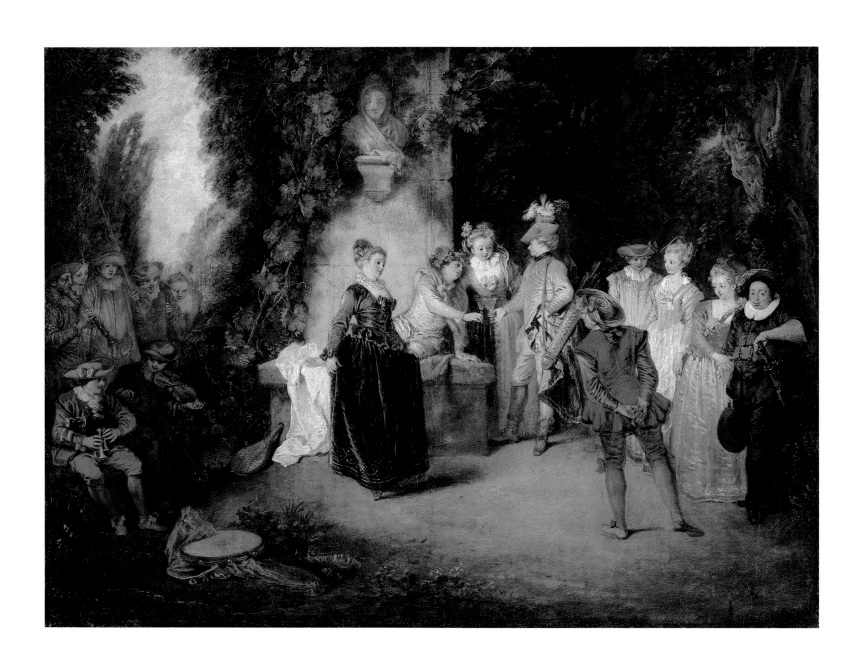

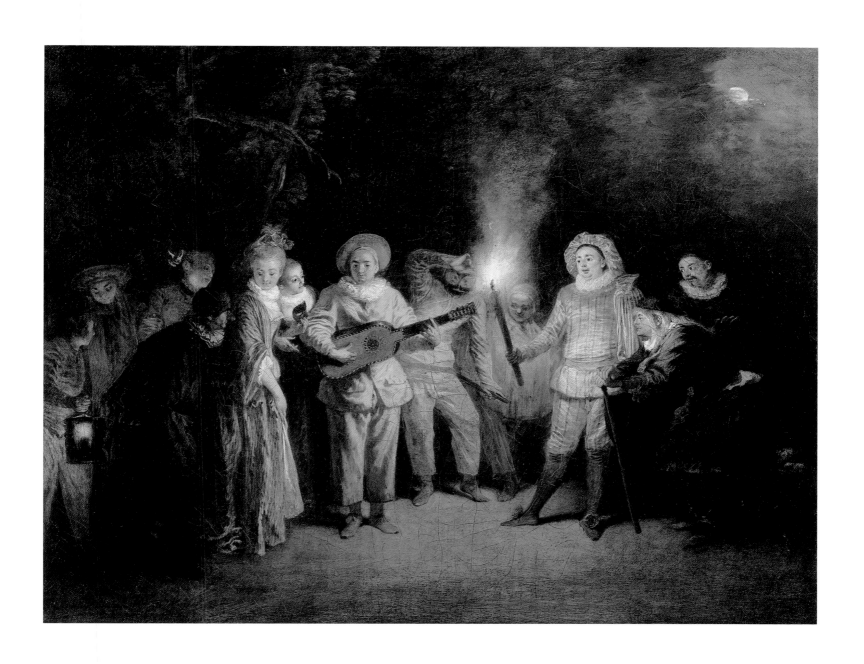

Jean-Antoine Watteau (1684–1721)

7 *The Shepherds* c. 1717–19

55.9 × 81 cm

Charlottenburg Palace, Berlin

Watteau's *Shepherds* can be considered an outstanding, although somewhat atypical example of his *fêtes galantes*. From their costume, we can identify the figures as upper-class city dwellers enjoying an outing in the countryside. While the couple on the right dances in a courtly manner, the level of decorum declines sharply towards the left. In the background is a woman on a swing, apparently set in motion by a man to her right; this was readily understood to symbolize flirtation, changes of heart (and of partners), and the act of love-making itself. It is significant that the swing is seen through a window of greenery, as through a peephole – a view into a moment of intimacy, and into the meaning of the main scene.

Between the dancers and the figures around the swing, two couples and two lone men form a densely knit group. In an unusually open way, Watteau comments on the erotic character and the underlying sexual motives of the encounter. One man aggressively pursues the woman next to him, whose nude breast he is trying to grasp. Another couple behind them watches the dancers, as does an elegant man reclining in the foreground, whose rather inelegant thoughts are openly acted out by the dog at the front of the scene. An older man with long blonde hair is the central figure. Watteau stresses his importance by his frontal position, his isolation within the group (in age, dress, and position), and by the trunks of two large trees right behind him that frame his head and call attention to him. His instrument (a *musette de cour*) is a common symbol of the male sexual organ.

By bringing together heterogeneous pictorial elements – a swing, courtly dancers, a bagpipe player, a rural landscape setting – Watteau

continued the approach of his early arabesques, where diverse elements are combined in an emphatically illogical and spatially incongruous fashion. In such paintings as *The Shepherds*, the artist fuses these elements into one logical whole. A print after an early composition by Watteau, *The Swing* (now lost), offers a comparable blend: a swing, a bagpipe, similar groups of trees, and – as a counterpart to the lusty dog – a ram's head. While Watteau's reliance on the arabesque format continues a distinctly French tradition, *The Shepherds* is also full of allusions to Netherlandish painting, the most prominent example being the man on the left violently embracing a woman.

A painting on panel, *Pastoral Pleasure* (fig. 83), while considerably smaller and usually dated about 1714–16, shows a similar composition, but with several important changes.[2] Most significantly, a reclining man seen from the back stretches out in front of the group, replacing the figure in the lower-left corner of our scene; and the Condé's central character has different features and plays a *cornemuse* (bagpipes). He is accompanied by one onlooker at his left, not by a couple. As well, the vegetation forms a niche rather than a backdrop as in *The Shepherds*. The picture at Chantilly is usually considered an earlier, autograph version by Watteau, which, however, does not manifest the same quality as the Berlin canvas. Numerous preparatory drawings for the painting are preserved.[3] The Berlin *Shepherds* was not included in the *Recueil Jullienne*, although the composition in Chantilly did figure in this famous compendium.

The figure of the bagpiper can be identified as the abbé Pierre-Maurice Haranger, a friend of Watteau's, who inherited an important share of his drawings after the artist's death. As Watteau clearly replaced a male figure in the earlier version of the painting with Haranger, it is conceivable that the Berlin painting might have been done for the abbé. Haranger's inventory after his death in 1735 contains possible references to the Berlin painting, with a fittingly high estimate attached.[4]

CMV

Fig. 83 Jean-Antoine Watteau, *Pastoral Pleasure*, c. 1714–16. Musée Condé, Chantilly

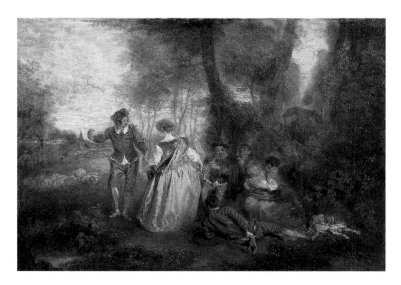

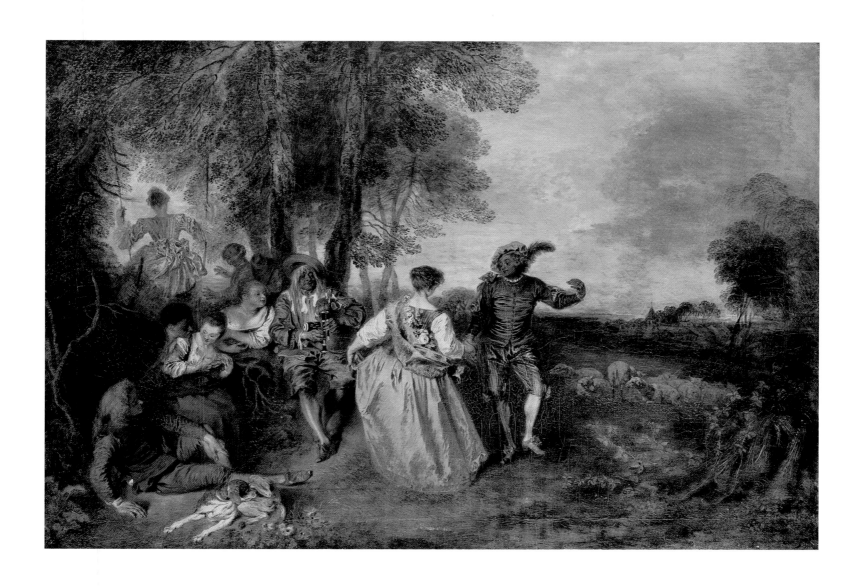

JEAN-ANTOINE WATTEAU (1684–1721)

8 *Peaceful Love* c. 1718

53.5 × 81 cm

Charlottenburg Palace, Berlin

Peaceful Love is a brilliant example of Watteau's *fêtes galantes*, leisurely gatherings of members of the upper class pursuing love, music, and conversation in pleasant, often park-like landscapes. Seven well-dressed people are assembled on a meadow, framed on the right by the branches of a tree and several bushes. As often in Watteau's paintings, a true middle ground is missing. Instead, the view opens out onto a lush landscape that extends below and far beyond the stagelike foreground. Village buildings, a shepherd, and a castle on a hillside cast the scene as an ideal landscape in a pastoral and Arcadian vein. Like Watteau's *Landscape with a Goat* in the Louvre, the setting in *Peaceful Love* is probably inspired by Italian landscapes in the collection of Pierre Crozat, which the artist copied.

Watteau arranged his characters in the foreground, all looking into the landscape as if they were entirely absorbed by the view. The couple on the left sets off on a stroll (immediately after the moment captured here, they would have had to step down along an invisible path to the much lower level of the background). The adjacent couple to their right reclines on the ground; the man puts his arm around the woman with an approach so forceful that she has to lean away to keep her distance from him. At centre, two men and a woman also lounge on the grass. The woman turns her head to listen to a lutenist, who – in turn – is looking out at the spectator. The other man lies behind the woman's back. The arrangement of this group is conspicuous and of key importance: it indicates a precise moment in a conversation and in a more complicated relationship between the characters.

The odd number of figures is a deliberate exception to the otherwise abundant couples in Watteau's images, and is carefully staged. Within this group, the sequence of glances forms a spiral and suggests a similar sequence of interruptions. The lute player gazes at the intruding spectator, the woman turns to regard the lutanist, and only the third man has not yet adapted to her change of pose. All three could well have been looking into the landscape prior to the instant of depiction; they are connected by a conversation that has just been interrupted. And while the musician might seem to be the odd man out in the trio, simultaneously he invites the viewer to join in. His direct gaze out at the viewer isolates him within the scene and makes him a potential commentator on it. The elegantly dressed characters and ideal landscape suggest a world of peace and harmony, as illustrated by the sleeping dog (a common symbol of faithfulness) in front. A slight tension is created by the intrusion of the spectator and by the somewhat aggressive behaviour of the man in the second couple.

Much as he had done in the *Embarkation from Cythera*, Watteau carefully connects the painting's various planes by a subtle interaction of torsions. He often arranges his figures in a foreground that resembles a stage; it is significant, however, that in this instance the characters are scarcely oriented towards the observer. The idealized character of the landscape and the marked difference in elevation of foreground and background emphasize the visionary quality of the setting. This vision, however, is a socially concrete one. The absence of all kinds of theatrical or exotic costuming in *Peaceful Love* lends an exceptionally realistic flavour to the dreamy quality of the painting. All this can be seen as a direct variation of Venetian sixteenth-century landscapes, which we know Watteau had studied. *Peaceful Love* shows Watteau in his most Italianizing mode.

Various authors have assigned dates between 1716 and 1719 to this painting. These differences indicate a diversity of opinions on the position of the picture relative to the first version of Watteau's *Embarkation from Cythera* of 1717 (Musée du Louvre, Paris). In colour and composition *Peaceful Love* seems closer to the second version of the *Embarkation* in Berlin (Charlottenburg),[2] a comparison that would support a dating of around 1718–19. Numerous preparatory drawings for *Peaceful Love* are extant (see fig. 84).[3] The standing couple on the left makes an appearance in several of Watteau's paintings. *Peaceful Love* was engraved for the *Recueil Jullienne* in 1730.

CMV

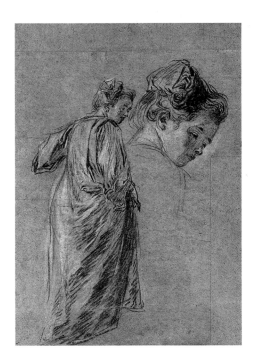

Fig. 84 Jean-Antoine Watteau, *Studies of a Young Standing Woman*, c. 1716. Staatliche Museen zu Berlin, Kupferstich-kabinett

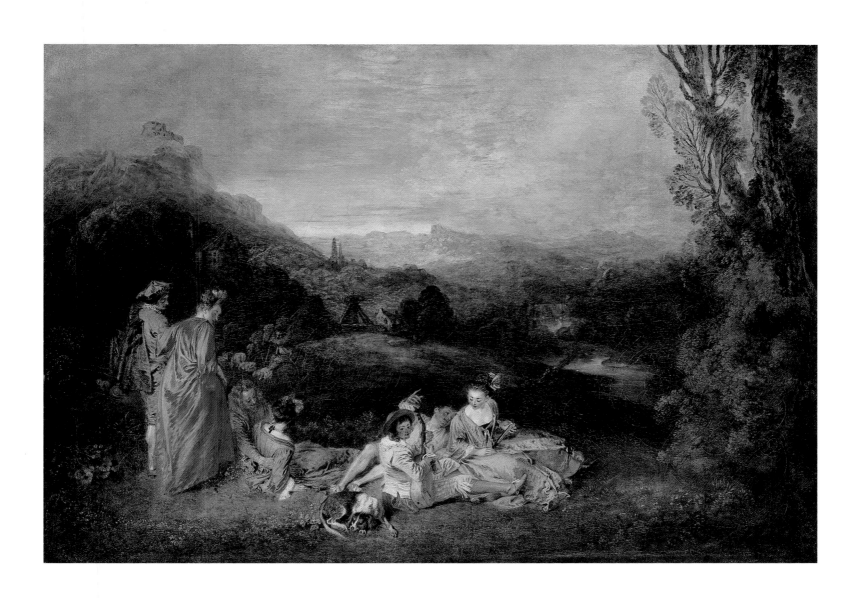

JEAN-ANTOINE WATTEAU (1684–1721)

9 *Venetian Pleasures* c. 1718–19

55.9 × 45.7 cm

National Gallery of Scotland, Edinburgh

The curious title of this famous painting appears on Laurent Cars's engraving of the picture made for inclusion in the *Recueil Jullienne*, and announced in the *Mercure de France* in July 1732.[1] An opera-ballet entitled *Les Festes Vénitiennes*, with music by Campra and choreography by Danchet, had recently been revived in June 1731, and its popular success might have inspired Jullienne's choice of titles for the print.[2] However, the production had had its debut in 1710, and was reprised often by the Opéra until 1740, and so it would likely have been familiar to Watteau himself. It is by no means certain that Watteau intended this musical entertainment as the subject of his composition, but his image of a self-confident male in "oriental" costume dancing a duet in a garden with a beautiful and shy young woman broadly parallels the second entrance of the ballet, which featured a Polish prince arranging a ball to win the favour of lovely Venetian girl.[3]

Curving around the elegant couple in a horizontal screen, seated men and women in opulent fancy dress converse among themselves, most of them paying little mind to the dancers. Directly behind the young woman rises a stone garden urn on a high pedestal, serving – like the vertical format of the picture itself – to stress her absolute centrality in the composition. Placed at equal distance from her on the left is her flamboyant and assertive dancing partner, while on the right sits a sad-eyed musette-player in a shepherd's costume, who looks longingly toward her. Watteau's balancing of the three figures creates a strong sense of erotic tension among them, as does his decision to fill the space between the dancers with a vignette depicting an ardent suitor's gauche advance upon a modestly recoiling woman.

Venetian Pleasures is one of Watteau's most ravishing paintings, not only because its graceful arabesques of interconnecting figures, curving stone walls, and arching trees make it an exemplar of rococo design, but also because its excellent state of preservation allows us to experience the artist's exquisite draughtsmanship, shimmering paint handling, and astringent palette undiminished by the depredations of time. Watteau's method of re-employing figures from other compositions is in evidence: the recoiling woman appeared earlier in the *Assembly in a Park* (Musée du Louvre, Paris), and the reclining jester with his back to the musette-player can be found in the foreground of *Pleasures of the Dance* (cat. 4). Watteau's habit of reconfiguring poses directly on his canvas can also be seen in the *pentimenti* that are especially pronounced in the three main characters. The male dancer, in particular, was originally conceived quite

differently: seen from the back, with a hand extended, his left leg turning inward rather than stepping forward, his face looking more directly at his partner.

Technical examinations make clear that the male dancer and the bagpiper are painted over different figures that were nearly completed when Watteau had a change of mind.[4] Their final poses are based very precisely on two surviving life drawings that the artist had previously employed in other paintings,[5] but for *Venetian Pleasures* he radically altered each head, substituting a portrait of his friend Nicolas Vleughels (1668–1737) for the dancer and a self-portrait for the musician.[6] Like Watteau, Vleughels was an unconventional artist of Flemish descent with a passion for Rubens and Veronese, though unlike Watteau, he worked principally as a history painter.[7] They may have met soon after Watteau arrived in Paris in 1702, but they are recorded in the *Almanach Royal* as sharing rooms in a house "on the Fossez Saint-Victor" (today the Rue du Cardinal-Lemoine) in 1718–19, the period when Watteau executed *Venetian Pleasures*.[8] Watteau made several drawings of Vleughels and also included him in *The Music Party* (*Les charmes de la vie*; Wallace Collection, London), another painting datable to these years.[9]

Watteau's reason for introducing portraits of himself and his friend into the painting at a late stage in its execution is unknown, but Posner suggests persuasively that Watteau would hardly have gone to the trouble of considerable repainting had it not been of some significance for the meaning of the picture.[10] Posner speculates that Watteau and Vleughels may have both been enamoured of the model for the female dancer – she may be the same woman who posed for *Love in the French Theatre* (cat. 5) – though Levey's suggestion that she is the actress Charlotte Desmares seems unfounded.[11] If Posner is right, the picture might represent something of a sophisticated private joke, whose exact meaning is now lost, to be shared by the men and their circle of friends. Although the male dancer and the musette-player seem to face each other down as they look past the object of their desire, it is clear who will succeed in this contest. The young woman keeps her back to the awkward, rustic musician, oblivious to his attentions; only the voluptuous water-nymph carved atop the fountain glances down at him with curiosity. As Levey has noted perceptively, Watteau here portrays himself as Caylus would describe him thirty years later: "agréable, tendre et peut-être un peu berger" ("agreeable, tender, and faintly bucolic").[12]

AW

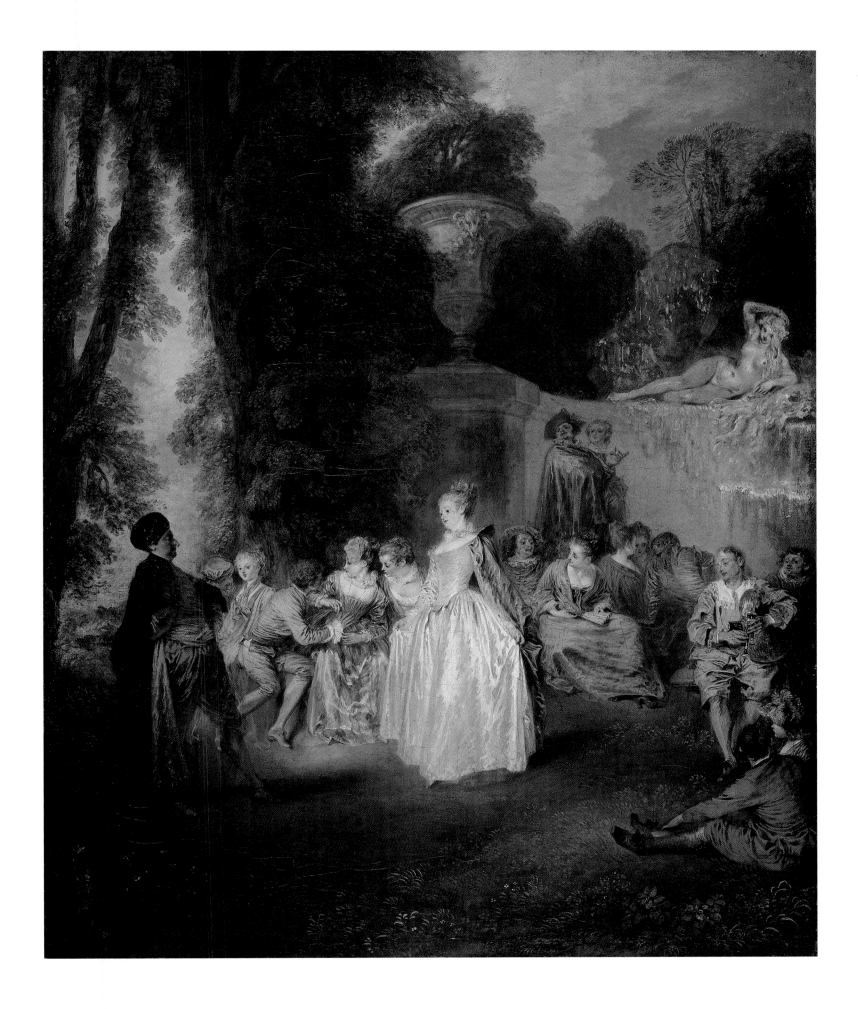

Jean-Antoine Watteau (1684–1721)

10　*Mezzetin*　c. 1718–20

55.2 × 43.2 cm

The Metropolitan Museum of Art, New York

One of Watteau's most celebrated paintings, *Mezzetin* is also among his simplest and most expressive. In a lush corner of a garden, the *commedia dell'arte* clown Mezzetin sits on a stone bench, legs crossed, strumming a guitar. He casts his eyes upwards as he sings, perhaps toward an unseen balcony on the building at his left. Behind him is a marble statue of Venus with her back turned to him – a surrogate for the lady to whom Mezzetin pours out his heart in serenade. As Watteau makes clear, in the eloquent language of statuary so familiar from his paintings, the lady does not share Mezzetin's ardour.

Though a stock character of the Italian theatre, the "modern" Mezzetin was a French creation of the actor Angelo Constantini, who made his debut with the Comédie Italienne in Paris in 1683.[1] Constantini took Mezzetin's traditional character – sidekick to the scheming adventurer Harlequin – and transformed him into a music-making, dancing clown, as well as a master of disguises. The actor had a famously expressive face, and he performed the role without the conventional mask of the *commedia*; henceforth, all Mezzetins kept this custom. As François Moureau observed, it is probable that this innovation was a significant reason for Watteau's attraction to the character, who appears frequently in his art.[2]

It remains the case, however, that the Mezzetin both of the Italian Comedy and of the popular, ribald travelling shows that performed in the Paris fairs was a faithless intriguer, not the idealized lover and kind-hearted musician of Watteau's painting. Luigi Riccoboni, director of the Comédie Italienne from 1716 and himself a celebrated Mezzetin, described the character as "a scheming servant . . . always involved in swindles and disguises."[3] But Watteau sees the poet in the clown, and recognizes the bittersweet comedy in his luckless longing. The quasi-religious aspect of the painting has often been noted, due in part to the heavenward roll of Mezzetin's upturned eyes, so reminiscent of the expression of suffering saints in Baroque altarpieces. The gentle fall of light on his Rubensian face, the remarkable foreshortened perspective of his features, and the sharp flickering accents on his parted lips and piercing eyes communicate an aching but ecstatic longing that serves to render this portrait of Love's martyr exceptional in Watteau's oeuvre, and an unsurpassed image of romantic aspiration and torment.

Much of the painting's power comes from this resonant display of its subject's emotional and psychological state, and many scholars have attempted to identify Watteau's model with one of the contemporary actors closely associated with the role of Mezzetin, Constantini and Riccoboni among them. However, the sitter for *Mezzetin* posed for Watteau on other occasions, and Hélène Adhémar was likely right in asserting that the model is not a famous actor but "one of his friends whose name we shall undoubtedly never know."[4] He is probably wearing one of the theatrical costumes that Watteau's early biographers tell us he kept for dressing his friends when they posed for

him. Watteau has taken great pains to reproduce the comedian's elaborately striped satin tunic and pantaloons, but, typically, he deviates from tradition by introducing pale blue stripes into a costume that should be white and red only, and by rendering Mezzetin's beret in rose-coloured silk, rather than in the same fabric as the tunic.[5]

Although Watteau did not generally make drawings with particular compositions in mind, his famous study for *Mezzetin* seems to be an exception (see fig. 85).[6] The unusual position of the model's head, his upturned glance, and the way the light falls across his face all suggest that Watteau had already laid out the composition of his painting and made the study in order to work out the final nuances of his subject's expression; the faint chalk lines around the head indicate the position of the large beret that the actor wears in the painting. There must once have been a full figure study that elaborated Mezzetin's pose – which evokes memories of the musician in Titian's *Concert in the Country* (Musée du Louvre), a painting that Watteau would have known from the royal collections – and probably studies for his tortured hands, which so eloquently convey his awkward determination to play pleasingly.[7]

Mezzetin was engraved by Benoît Audran for inclusion in the *Recueil Jullienne*, the two-volume compendium of prints reproducing 271 of Watteau's paintings that was published in 1735 by Watteau's friend and champion Jean de Jullienne.[8] A dyer and textile manufacturer by trade, Jullienne is credited on Audran's engraving as the owner of *Mezzetin*, and it is the case that in acquiring Watteau's works in order to have them engraved, Jullienne at one time owned almost all of his paintings. By 1756, however, when a catalogue of his collection was produced, only eight of Watteau's pictures remained in his possession – among them *Mezzetin*, which he retained until his death a decade later. The fact that Jullienne was to keep the painting his entire life has led Pierre Rosenberg to speculate that Watteau may have made it for his patron as a token of their friendship, perhaps around 1720, when the collector was courting his future wife, Marie-Louise de Brecey.[9]

AW

Fig. 85　Jean-Antoine Watteau, *Study for Mezzetin*, c. 1718. The Metropolitan Museum of Art, New York

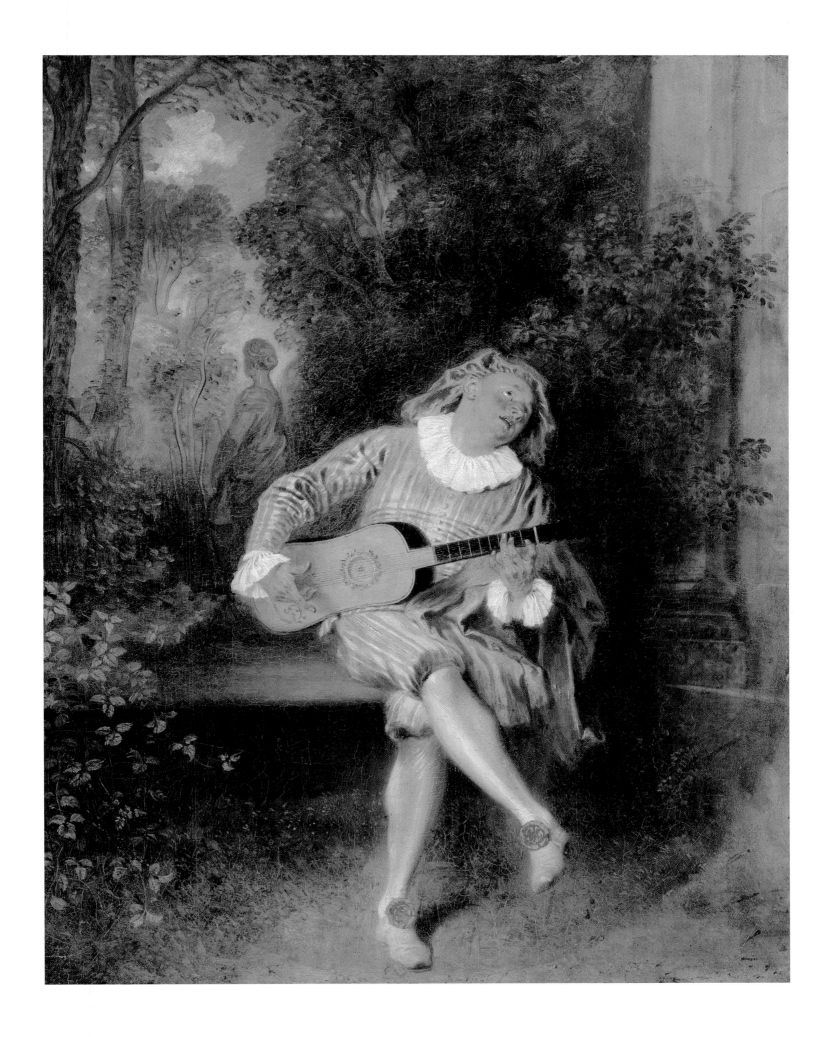

Jean-Antoine Watteau (1684–1721)

II *Iris (The Dance)* c. 1719

97.5 × 116 cm

Staatliche Museen zu Berlin, Gemäldegalerie

Prior to 1729, Charles-Nicolas Cochin produced an engraving of this work, but its composition is a mirror image of the Berlin canvas. Apparently, Cochin had not taken the preparatory step of transposing the image, which would have prevented its being reversed during the printing process. We note that even at this early date, the engraving displayed the painting's present rectangular format.

In the lower margin of the sheet is a quatrain, to which the painting has since owed its title: "Iris, aren't you young to have a feel for the dance, / As knowingly you make gentle movements, / Which daily remind us by their cadence, / Of the taste of the fair sex for instruments?"[7] The figure of the girl is placed monumentally before a low horizon. Another girl and two boys (one is playing an instrument) in modish costume appear to eagerly wait for the pensive coquette to start dancing. *Iris* – here the embodiment of an allegory whose subject is the sensual awakening of an adolescent – hesitates. The girl seems to sense that as childhood ends, the process of maturing towards adulthood begins. So, uncertain, she clasps the folds of her dress (of English silk in a pattern fashionable in 1718) to begin her predestined "Dance of Life." The props placed near the bottom of the picture – a shield with a heart motif and an arrow, and farther back, beside the children, a basket with roses and a dog lying down (an age-old symbol of fidelity) – doubtless portend the passion of love that will determine Iris's future life. The cloud-veiled sky above the wide landscape can be regarded as an echo of Iris's mood, vacillating as it does between joy and melancholy.

Because the dress Iris is wearing reflects the English fashion of 1718, a style that only came to France years later, one can assume with a degree of certainty that Watteau painted *Iris* when he was living in England, from September 1719 to August 1720. This dating is supported by variations in his palette: "Prussian blue" has been detected, a colour in wide use from the second decade of the eighteenth century. Moreover, an x-ray made in the 1980s (fig. 86)

Fig. 86 X-ray of Watteau's *Iris (The Dance)*. Staatliche Museen zu Berlin, Gemäldegalerie

clearly shows that the painting was originally more or less round in format. However, the date of Cochin's aforementioned engraving indicates that the painting must have been enlarged to a rectangular format prior to 1729. The conservator reports: "The microscopic properties of the layers of paint and of the pigments and fillers contained therein do not exhibit any essential differences between the central part and the addition. . . . Since the white lead has that substance's typical lumpy texture and also clearly contains trace elements, there are justifiable grounds for assuming that the formatting changes were made in the eighteenth century itself."[8]

RM

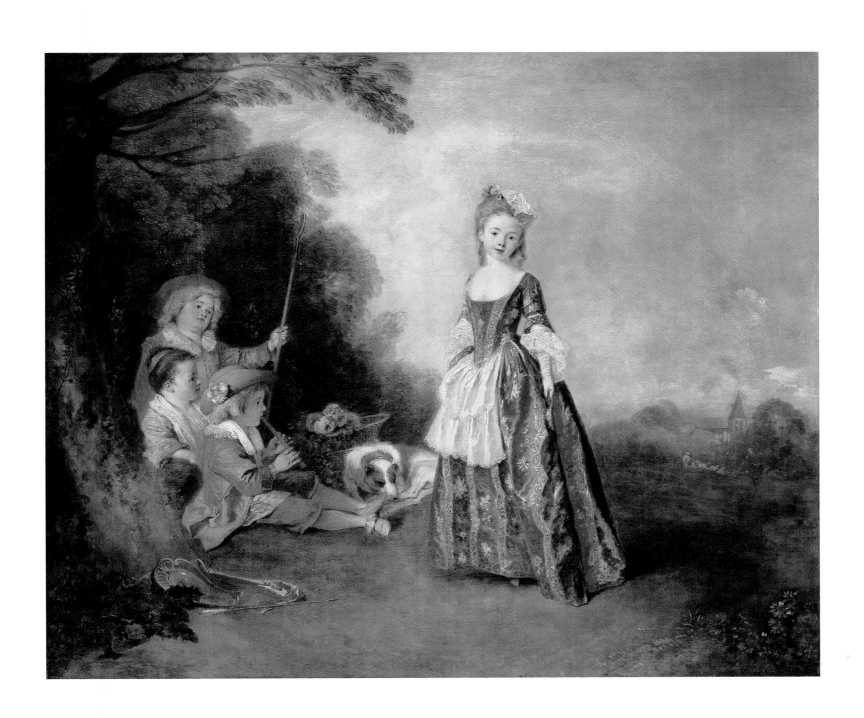

NICOLAS LANCRET (1690–1743)

12 *Blindman's Buff* c. 1728

37 × 47 cm

Nationalmuseum, Stockholm

Lancret must have encountered many of the prints that would subsequently inspire his genre subjects, to which his painting was almost entirely devoted, during his earliest training in an engraver's workshop. Dissatisfied, Lancret requested a transfer, and entered the workshop of the little-known history painter Pierre Dulin. There he probably remained for several years. Later he studied under Claude Gillot, the teacher of Jean-Antoine Watteau. Lancret thereafter worked alongside Watteau himself, although it is not known in what capacity. When Lancret was received into the French Academy as a painter of *fêtes galantes* in 1719, the orientation of his short-lived but prodigious career had, at last, been made fully clear. Upon Watteau's death in 1721, Nicolas Lancret – along with the young Jean-Baptiste Pater – took over this field entirely.

Until recently, Lancret had been regarded as a mere imitator of Watteau's style, a judgement re-evaluated in the 1991 exhibition of the artist. Within his specialization in genre painting, Lancret's oeuvre was not limited to *fêtes galantes*. By the midpoint of his brief career, when he painted *Blindman's Buff*, the artist was departing from subjects represented by Watteau, and setting the stage for subsequent artistic developments, especially in the work of Fragonard (cat. 75). In *Blindman's Buff* no rustic types or stock characters from the theatre, so prevalent in Watteau's paintings, inhabit this airy salon where aristocratic ladies and gentlemen commingle. A lighter palette and greater movement of the primary figures replace the tranquil revelry of Watteau's dark woodland scenes. The pivotal role of the central couple and the underlying theme of love, however, still bind this work to those of Lancret's most important model.

Whether in the form of parlour games relieving the long leisure hours of the elite classes, or more popular children's pastimes, the ludic theme is one to which Lancret frequently returned. A young lady in a rose dress, holding a white feather at arm's length, tickles the nose of a slightly teetering, blindfolded gentleman. With arms outstretched, he attempts to locate the source of his playful torment. The lady, pulling back to avoid his touch, circles about him. All

the while, her dress swirls in a great cone around her. Clusters of onlookers engage in conversation or flirtation, and occasionally look up, we presume, to glimpse the outcome of the game. Among the few spectators intent upon the couple is a little girl who receives an explanation of the game and its significance from her mother.

In northern European art, blindman's buff traditionally represented the foolishness and blindness of love. As Mary Tavener Holmes notes, according to Charles Sorel in 1642, the game was understood to represent "the blindness [of lovers] and the confusion of various passions and affections . . . excited by love."[1] Lancret has pictorially captured the disorientation ensuing from the blindfolded state, or from love itself. The slightly distorted perspective of the walls and ceiling of the circular room, which does not correspond to the perspective of the spokelike pattern on the marble floor, artfully communicates the gentleman's dizzying experience. A similar sense of confusion is created by the torsion of the lady's body, in which the axes of torso and legs scarcely appear to meet, suggesting the extent to which she has successfully dodged discovery by twisting and turning her body.

Lancret's painterly facility and especially his mastery of colour were features of his style remarked upon by his contemporaries. Among those qualities that must have appealed to this painting's first audiences are the reflections on the costumes of the two central figures – the rose highlights of the lady's dress upon the gentleman's grey britches, the dark shadow his figure casts on her skirt, and, upon its lower-left edge, a brilliant streak of red produced by the light streaming in the window. The diplomat and collector Count Gustav Tessin made the final payment for Lancret's *Swing* (Nationalmuseum, Stockholm) and for the present painting on 8 March 1729.[2] Also belonging to the Nationalmuseum, Stockholm, are three sheets of preparatory studies for *Blindman's Buff*, including one for the central female figure.

FG

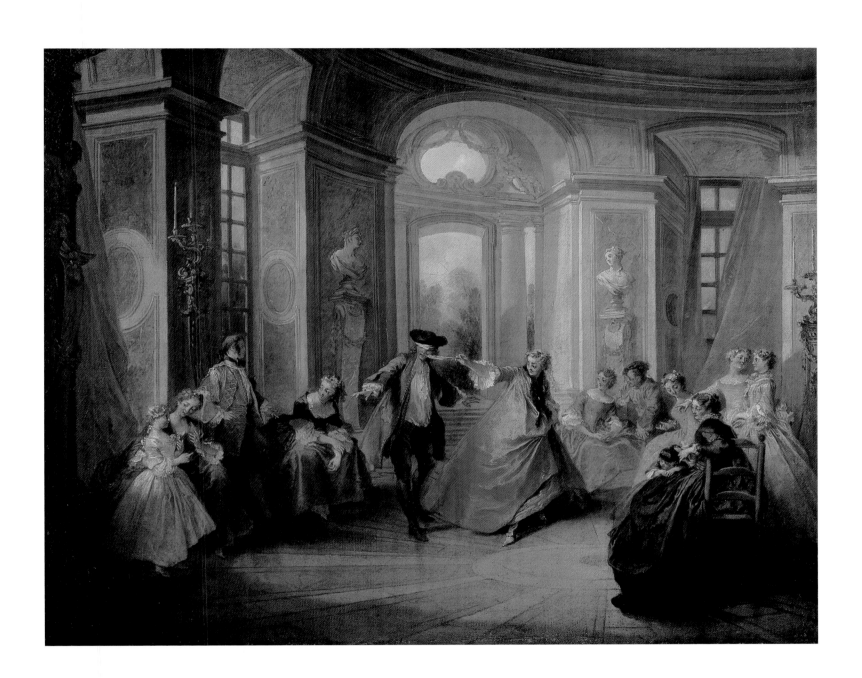

NICOLAS LANCRET (1690–1743)

13 *Luncheon Party in the Park* c. 1735

55.7 × 46 cm

The Museum of Fine Arts, Boston

The tiny *Luncheon Party in the Park* closely replicates Lancret's *Ham Luncheon* (fig. 87), which was originally paired with Jean-François de Troy's *Oyster Luncheon* (both Musée Condé, Chantilly) in Louis XV's *salle à manger* in Versailles, where the King often gathered with close friends after hunting expeditions. Louis XV commissioned the pendants in 1735. It has been said that the important collector Ange-Laurent de La Live de Jully (1725–1779), in whose 1764 inventory *Luncheon Party in the Park* appears, was its patron.[1] This could not have been so, however, for in the year in which the picture in Boston was probably executed, La Live de Jully was only ten years old.

The original setting for the large version led Nicole Garnier-Pelle and others to regard the composition as a ribald interpretation of the hunt picnic,[2] though nothing in it specifically suggests the cynegetic theme. A loose parallel has been drawn between the figures' spirit of *joie de vivre* and the culture of pleasure that the King created in his most intimate circle.[3] In the beginning of Louis XV's reign it was indeed said that he drank a little too much champagne, but the King quickly modified his conduct to meet the standards of decorum.[4] The gatherings in his apartments probably never reached the degree of intemperance depicted in Lancret's painting, which the compiler of the 1738 inventory of the King's pictures described as representing "a party of young people at table, becoming debauched."[5] Yet the *Ham Luncheon* no doubt suggested a relaxation of courtly conventions within this inner sphere, and the drunken giddiness of the figures surely provided beholders with endless entertainment.

Crowded around a table are seven men, one of whom, with a large napkin across his chest and a branch of laurel in his cap, brazenly surmounts the table to toast the red-faced woman wearing a man's wig and her companion, over whose head she makes the sign of the cuckold. They are not celebrating the commencement of festivities, but rather the perilous pleasures accompanying inebriation. On a table arrayed with white linen and set with porcelain plates and crystal goblets, a large, partially eaten ham serves as centrepiece. The merry group has reached a state of abandon well before its meal is over, but it has little appetite for the food. Several figures have left slices of ham on their plates, and leftovers have been set before the cat and dogs, which form an obvious analogy to the men at table. Like the man at far right, one dog sits back, evidently satisfied with his nourishment. Another, perched on his hind legs and with head plunged into a copper pail, mimics the theatrics of the leading reveller. Two servants clutching trays of fruit hang back in the shadows, for the turbaned Moor is already uncorking another bottle. The well-mannered retainers make a poignant and ironic contrast to the wanton behaviour of the diners.

It is not clear whether the company at the table represents a particular social group and whether this is critical to the picture's significance. The costumes are not especially rich, but the Saint-Cloud blue-and-white porcelain, the crystal, and the grandeur of the garden setting suggest they are members of the aristocracy. The Duc d'Aumale, who owned the painting in the nineteenth century, maintained that his father could identify those portrayed, but Lancret's remarkable ability to endow his figures with individual features and personalities has often inspired such myths. The picture was probably meant to invite its audience to join in the amusement, conceding the universal weaknesses of humankind.

FG

Fig. 87 Nicolas Lancret, *The Ham Luncheon* (detail), 1735. Musée Condé, Chantilly

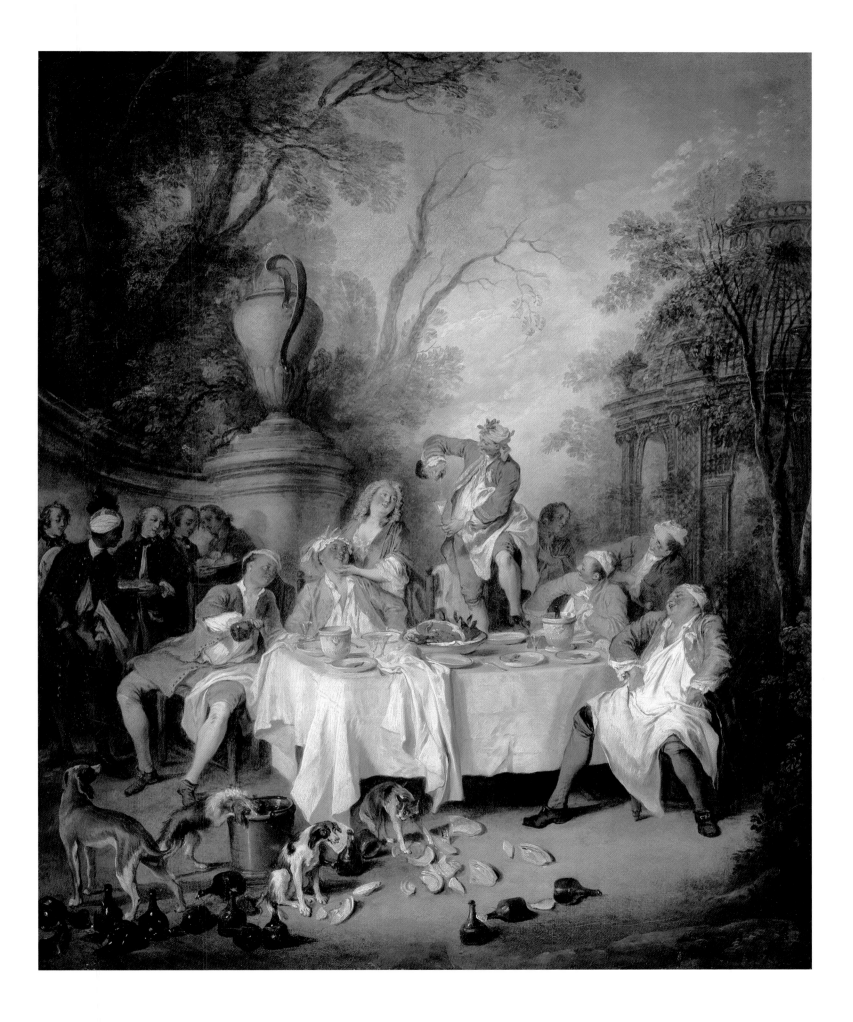

NICOLAS LANCRET (1690–1743)

14 *The Bourbon-Conti Family* c. 1737

49.3 × 66.7 cm

Krannert Art Museum and Kinkead Pavilion,
University of Illinois, Urbana-Champaign

This picture, which was probably never exhibited in the eighteenth century,[1] once belonged to a descendant of the Bourbon-Conti family, and at one time it was assumed that the four female figures in the middle ground were members of this illustrious line. None of the sitters has ever been identified, however, and it is now thought most unlikely that they could be associated with this family.[2] Yet the supposition that the two girls accompanying the older lady are her daughters still holds good. This close-knit group relates less clearly to the fourth lady, who may or may not be a portrait.[3] She observes the bewildering actions of the man in the foreground, lunging awkwardly towards the woman on the ground as if uncertain whether to draw her into his open arms or to help her to her feet. As he approaches, she halts him with her right arm.

By no means a conventional portrait, *The Bourbon-Conti Family* integrates elements of the *fête galante*. The ladies sit on a low wall in front of a dense woodland, bordered by a pasture and a distant hamlet, seemingly displaced from their customary environment. We would sooner imagine the four poised figures, outfitted in satin and embroidered finery, before a prospect of a princely estate or within an elegant garden adorned with classical architecture, than in a pastoral landscape where a shepherd tends his flock. With static and erect poses, their feminine realm contrasts markedly with that in which the sexes actively, if uncomfortably, meet. Whereas the foreground figures are costumed in theatrical garb – the man's beret resembles those worn by the characters of the *commedia dell'arte* – the ladies behind them wear fashionable gowns. Ironically, however, the figures donning the costumes of the theatre ignore the beholder of the painting, while the ladies, who form the couple's audience, pose self-consciously. The significance of such oppositions and the degree to which each group offers a commentary upon the other is not easy to ascertain.

The motif of the lady resisting the man's embrace, which Alan Wintermute shows to derive from Watteau's paintings, notably his *Faux-Pas* (fig. 88), has given rise to various interpretations.[4] Donald Posner argues that the lady has stumbled and fallen, evidently intentionally, and under the guise of gallantry, the man seizes the opportunity to embrace her, while she feignedly resists.[5] Posner's reading of the motif does indeed suggest the flirtatious and light-hearted behaviour of similar figures in Lancret's *fêtes galantes*, such as *Youth* (National Gallery, London)[6] and *The Game of Blindman's Buff* (Sanssouci, Potsdam),[7] which depict the pleasant rituals of courtship. Although the man's expression in the present painting and in a red

chalk preparatory drawing (formerly Mond collection)[8] cannot be determined, the motif of the embracing couple does not appear to be infused with a comic or playful element in either this picture or in Watteau's work (where, according to Mary Vidal, the struggle between male and female figures is a troubled one).[9] This reflects the tension between innate drives and a mode of substituting artistic expression for physical fulfilment, which gives rise to the civilizing process.[10]

Posner's explanation of the *Faux-Pas* is the basis for Mary Tavener Holmes's assertion that *The Bourbon-Conti Family* is an allegory of the older daughter's awakened but still restrained desire.[11] Yet the little girl appears too young to experience the first pangs of love, and she does not even look toward the couple before her. The presence of the couple may perhaps be viewed instead as a reminder to the lady fanning herself – who alone notices them – that if she is to mother children, like her companion, her sexual comportment must conform to the conventions of civility.

FG

Fig. 88 Jean-Antoine
Watteau, *The Faux-Pas*.
Musée du Louvre, Paris

Nicolas Lancret (1690–1743)

15 *A Hunter and his Servant* c. 1737–40

82.5 × 65 cm

Private collection

First published in the catalogue of the 1991 Lancret exhibition, *A Hunter and his Servant* takes up a theme the artist treated in more than ten representations of the hunt picnic: the hunter at rest. The present painting relates directly to two somewhat larger pictures, *The End of the Hunt*[1] and *Hunters Resting*[2] (location unknown), in which a hunter sits on a rock next to a tree, still holding his gun or with it propped beside him, and accompanied by other figures and his dog (or dogs). Although the two central hunters in *The End of the Hunt* and *Hunters Resting* are virtually identical in pose, Lancret modified the related figure in *A Hunter and his Servant*. Instead of reclining against the tree with one leg propped up before him, the jaunty young man leans ever so slightly forward. Setting his right hand on his hip, he turns to look over his right shoulder. Next to his left foot, his dog curls up and rests its chin on the ground in a position that captures the physical exhaustion resulting from the chase. But if the young man in *A Hunter and his Servant* is in need of a short rest, he nevertheless appears invigorated by the lively air and exercise. He remains alert, gazing at an object outside of the picture also observed by his hound. The position of the gun in his hand and the powder bag still belted around his waist suggest his intention to take up the sport again after a brief repose. The rapid movement of the pursuit about to be resumed is suggested by the vigorous brushwork employed for the swirling clouds.

Fig. 89 François-Bernard Lépicié, after Watteau, *Antoine de La Roque*. Bibliothèque nationale, Paris

Mary Tavener Holmes believes *A Hunter and his Servant* to be a double portrait.[3] In support of this idea are the figures' frontal or near frontal poses, and their reduced number and enlarged size relative to the pictorial field; but the latter two attributes are characteristic of Lancret's late paintings in general. The relationship of the current picture to the genre paintings *The End of the Hunt* and *Hunters Resting*, and Lancret's exceptional skill in endowing generic figures with individualized features, make it difficult to judge the present picture. Significantly, all three works share a common source in Watteau's portrait of *Antoine de La Roque* (private collection, New York), which is also known in a reproductive engraving by François-Bernard Lépicié (fig. 89). La Roque sits on a rocky shelf beneath a tree, just left of centre, his dog by his side and surrounded by the attributes of his two occupations, art and war. The frolicking fauns behind his outstretched leg, together with the nymphs accompanying them, representing the sitter's muses, were very probably painted by Lancret himself.[4] The portrait of La Roque thus offers a rare glimpse into the nature of the collaboration between Watteau and Lancret, whose relationship has always remained unclear.

Whereas the identity Watteau constructed for La Roque centred upon his dual vocations, Lancret's portrayal of the hunter in *A Hunter and his Servant* – be he a portrait or a generic figure – highlights his privileged social status (only noblemen were permitted to hunt in pre-Revolutionary France), granting him the leisure to cultivate personal pastimes. Seated on a lower ledge behind the hunter is his servant, who stares vacantly into the distance, as if to suggest that his will is entirely dependent upon that of his master. The emphasis of this particular painting, in contrast to *Picnic after the Hunt* (cat. 16), is not the elegant social ritual associated with the hunt, but rather the benefit accruing to mind and body from a communion with nature.

Next to the hunter's right foot, a beautiful still-life – consisting of a substantial pile of small game, including two pheasants and a rabbit – demonstrates Lancret's skill in describing textures and objects, a talent equally evident in *A Lady in a Garden Taking Coffee with Some Children* (cat. 17) and *Picnic after the Hunt*. But marking a departure from these other pictures is the naturalistic style comprised of loose brushwork, a reduced palette – heavy in browns and greens – and bold modelling in the drapery, which together give perfect expression to the ruggedness of the sport and to the hunter's vigour.

FG

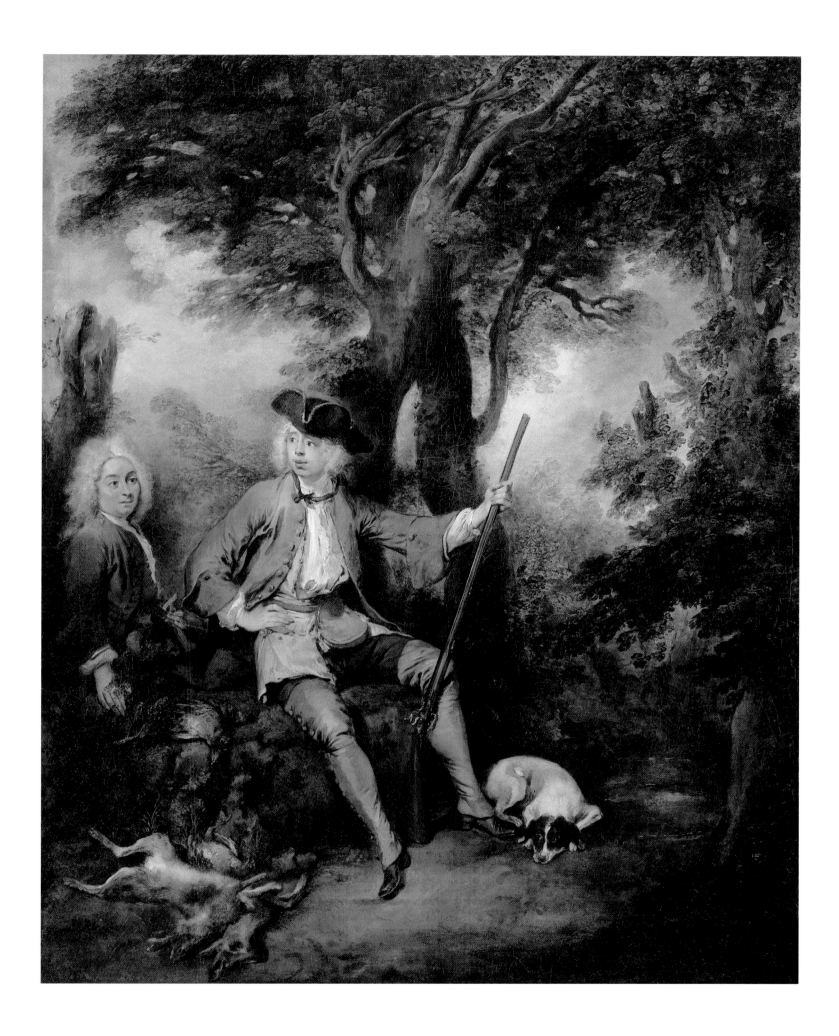

Nicolas Lancret (1690–1743)

16 *Picnic after the Hunt* c. 1738

61.5 × 74.8 cm

National Gallery of Art, Washington, D.C.

Mary Tavener Holmes has suggested that in response to Louis XV's passion for the hunt, Nicolas Lancret "practically invented" the genre of the hunt picnic.[1] His earliest example of this theme, a *Return from the Hunt*, exhibited at the Salon of 1725, was indeed executed more than a decade before Jean-François de Troy or Carle Van Loo painted their large images of this subject for the King's apartments. Already in 1723, however, François Lemoyne had completed his *Picnic and Rest during the Hunt* (Museu de arte, São Paulo; see cat. 22), wherein aristocratic figures and rustic surrounds were synthesized into an idealized whole. In the present painting and in many other representations of the theme which he popularized, Lancret produced a charming and vivid image of aristocratic culture, which had for centuries defined its privileged status by reference to the hunt. In *Picnic after the Hunt* Lancret registered the elevated rank of the hunters by their rich costumes and by the number of retainers serving them.

Lancret almost exclusively oriented his pictures of the hunt toward the pleasant rituals surrounding it, for neither game nor any allusion to bloodshed and violence makes an appearance. Among the varied connotations of the hunt in the eighteenth century was that of amorous pursuit. In Lancret's rendition of the subject in Washington, the hunt and the picnic that follows are a pretext for a highly refined mode of aristocratic courtship. While the gentleman in blue gallantly passes a cup and saucer to the lady in yellow, their eyes become fixed upon each other and hints of tender smiles are exchanged. The man's flushed complexion, no doubt a result of the excitement of the chase, may also double as an expression of his desire. Though the standing lady and gentleman are not intensely engaged, their hands interlock in a mannered gesture.

In addition to describing the sentimental bonds the hunt forged between men and women, Lancret's painting also represents those between the hunters and their animals, which are no less carefully individualized. The lady in red, who stands poised and erect, throws a fond glance towards the horses at right, as if nostalgic for the hunt that has scarcely ended. In front of her, a sprawling male figure holds up a biscuit for one of the dogs. The black-and-white dog furthest from the picture plane addresses the viewer with a direct gaze, as if to elicit his affection. More than simple sport, the hunt is a means of forging emotive bonds.

A surviving figure study of the man reclining in the foreground (fig. 90), in black chalk with white highlights on grey paper, demonstrates Lancret's keen observation of pose. The informality with which the figure leans back on his right elbow, with legs outstretched, enticing the dogs with a biscuit, contrasts sharply with the formality of the poses of the figures behind him. Only slight modifications to the gentleman's left arm and right leg appear in the finished version. In the 1991 exhibition catalogue, Mary Tavener Holmes dated the study approximately fifteen years earlier than the painting. In spite of the consistency of Lancret's interest in representing the hunt, it is unlikely that so much time elapsed between the execution of the drawing and of the painting. According to Margaret Morgan Grasselli and Suzanne McCullagh, the preparatory study should be dated in the late 1730s, slightly earlier than the finished painting.[2]

FG

Fig. 90 Nicolas Lancret, *Study for the Picnic after the Hunt*. Bibliothèque Municipale de Rouen, Collection Hédou

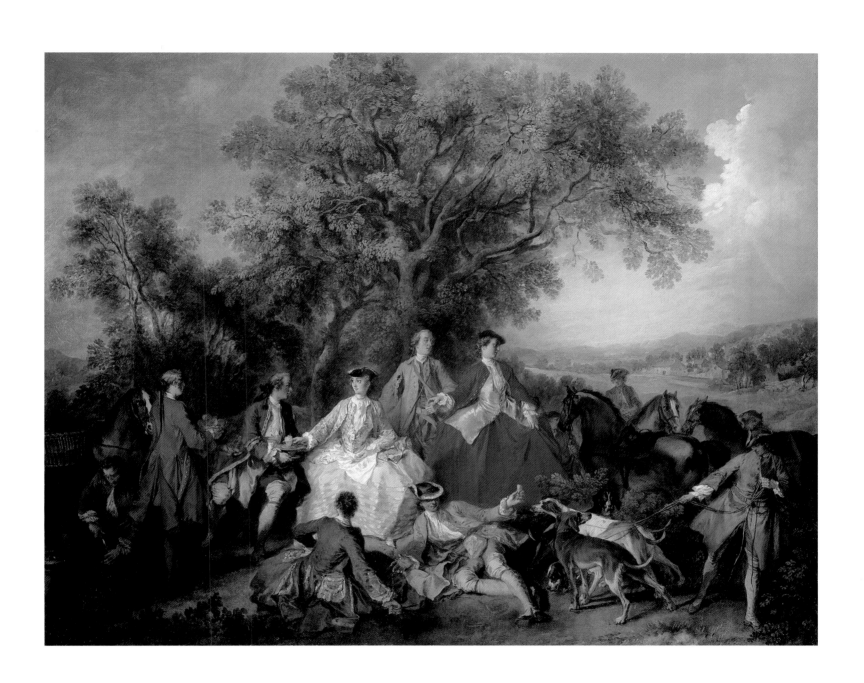

Nicolas Lancret (1690–1743)

17 *A Lady in a Garden Taking Coffee with Some Children* c. 1742

88.9 × 97.8 cm

The National Gallery, London

The present painting is almost certainly identifiable with the picture described in the 1742 Salon catalogue as "a lady in a garden with children, taking coffee;"[1] but since the nineteenth century, no small disagreement has erupted regarding its genre and the identification of the beverage being served. First described as a portrait of a family at tea,[2] it was later christened *The Cup of Chocolate*,[3] doubtless because chocolate seemed a more appealing and appropriate infusion to serve children. This title, rather betokening its status as a genre painting, is still sometimes attached to the image. On the evidence of the eighteenth-century Salon record and the silver *cafetière*, scholars have recently concluded that the brew is actually coffee.[4] But whereas chocolate and coffee pots of the period were so similar as to leave room for ambiguity,[5] the *sucrier* on the tray would only have accompanied coffee. If there are no longer diverging opinions on this issue, the question of whether the painting is a group portrait or a genre scene remains a matter of some debate.

In the first decades of the eighteenth century, especially in England and Holland, group portraits increasingly represented sitters taking tea, coffee, or chocolate. In France, however, these same fashionable activities made a sudden appearance in genre paintings in the second half of the 1730s. In the Salon of 1739, for example, Chardin exhibited his *Lady Taking Tea* (Hunterian Museum and Art Gallery, Glasgow). The same year saw the execution of the work most closely resembling Lancret's own – Boucher's *Luncheon* (*Le Déjeuner*) (see fig. 21), in which a domestic serves coffee to two ladies, who offer spoonfuls of the drink to two small children. Whether or not Lancret knew Boucher's painting before completing *A Lady in a Garden Taking Coffee with Some Children*, his *Le Matin* (National Gallery, London), also of 1739, portrays a partially disrobed lady at her morning toilette serving tea to a gawking priest. Within this satirical scene, Lancret fused genre painting and allegory.

The present picture is pure genre painting, however. Unlike the stiff frontal poses customary in contemporary portraits, members of the family group do not intimate the least awareness of the beholder. Each acts in a relaxed manner wholly befitting age and sex, and expressing the nature, not of an individual, but of childhood or parenthood. The younger daughter is the essence of childish excitement and mild trepidation, but also – in carelessly casting aside her beautifully clad doll for a new diversion – of inattention. The older daughter radiates the first signs of maturity, awaiting her spoonful of the adult drink without a hint of impatience.

A decade after Boucher's *Le Déjeuner* was painted, its subject was described as "agreeable and pleasing" ("sujet galant et agréable").[6] These epithets equally characterize Lancret's image, painted in an appropriately elegant style. The artist lavished no less attention on the silken drapery and luxury items – the silver coffee pot, porcelain cups, the still-life of flowers, and the fish-head spout – than on inventing facial features for each of the figures. The entire surface is animated with arabesque designs, the mood calmed with the harmony of complementary colours. Anecdotal details bestow added charm and significance. The little girl's negligence and the instinctual behaviour of the dog, which devours one of the splendid pink flowers, form a poignant contrast to the refined manners of the mother of the family. To protect their lovely garments, the young mother has folded the blue lining of her own lustrous pink silk skirt over her lap and has tied an enormous white bib over her daughter's dress. By instilling in her daughter a taste for a fashionable adult drink, the mother slowly cultivates the type of sophisticated behaviour that will eventually dispel her daughter's childish ways.

FG

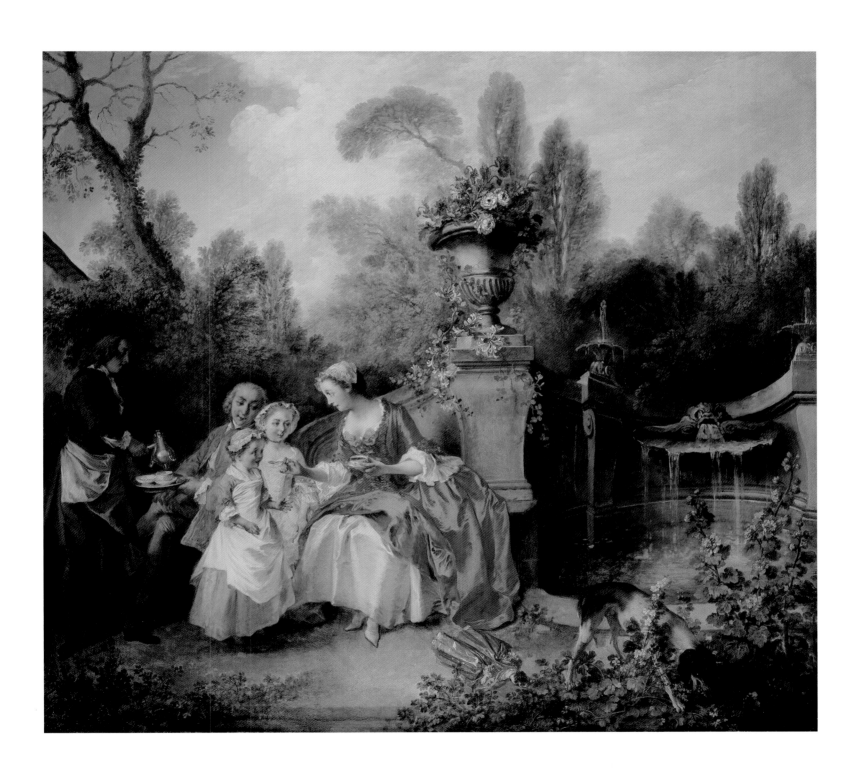

Jean-Baptiste Pater (1695–1736)

18 *The Pyramid of Chicken Wings and Thighs Elevated on a Plate of Destiny by Madame Bouvillon* before 1733

29 × 38 cm

Neues Palais, Potsdam

19 *Madame Bouvillon Opens the Door to Ragotin Who Hits her in the Face* before 1735

29 × 38 cm

Neues Palais, Potsdam

20 *Madame de Bouvillon Who, in order to Tempt Destiny, Asks Him to Look for Lice* before 1733

29 × 38 cm

Neues Palais, Potsdam

Jean-Baptiste Pater painted fourteen episodes of Scarron's *Roman comique* between 1729, when the first print of the series by Surugue was announced, and his death in 1736. They were engraved by Surugue, Scotin, Audran, Jeaurat, and Lépicié between 1729 and 1739. Pater's paintings continued a series that had been begun by Jacques Dumont (known as "le Romain") in 1727. Two engravings after paintings by Dumont, now lost, formed the start of the same suite.

Several cycles of illustrations after Scarron's novel are known. A large series by Jean-Baptiste de Coulomb in the Musée de Tessé in Le Mans dates from around 1712–16 and served as a decorative frieze in the nearby château at Vernie. Jean-Baptiste Oudry's illustrations after Scarron date from between 1727 and 1737 and are thus exactly contemporary with Pater's (and Dumont's) cycle. Not all of Pater's numerous drawings after Scarron, spread over many different collections, were engraved. It is obvious that the two cycles were intended as competing projects.

The illustrations by Pater and Dumont do not faithfully reflect the story line of Scarron's novel. The main plot of the *Roman comique* is interrupted several times by long stories with Spanish subjects told by the book's main characters, and these are not illustrated. But even the main story is not illustrated in any coherent way by Pater (and Dumont), as important episodes are not included. Also, they illustrate considerably fewer scenes of the novel than do Coulomb and Oudry. Comparing the scope and structure of the three cycles, it seems likely that Pater's Scarron illustrations were originally intended to amount to at least twenty. It is not a rare phenomenon, however, that ambitious illustration projects of the eighteenth century, such as this, were abandoned along the way. Similarly, Oudry produced considerably more drawings after Scarron than were finally engraved.

Scarron's *Roman comique* tells the story of a group of travelling comedians in the countryside around Le Mans. The three paintings in the current exhibition illustrate chapters 8 and 10 of the second book, which all centre around the character of *Destin* (Destiny). With many adventures behind them, the members of the troupe have met up again in a country inn. A newly-wed, *La Garouffière*, member of the *parlement* of Brittany, arrives at the inn together with his wife and mother-in-law, Madame Bouvillon, a particularly heavy and short woman. At the dinner table, La Garouffière and Bouvillon compete in serving Destin the best morsels of the meal. As a result, pieces of meat heap on Destin's plate up to his chin. Right before this scene, a blacksmith freed the foot of Destin's fellow traveller Ragotin from a chamber pot he had stepped into, an episode already illustrated by Dumont (fig. 91). Two chapters later, Madame Bouvillon invites Destin over for a meal with the intention of seducing him. When she asks him to search for a louse in her cleavage, Ragotin can be heard shouting outside the room, and Destin is able to free himself by pretending that he has to open the door for Ragotin. Destin stumbles and Bouvillon opens instead, but the door is knocked against her head by Ragotin.

All three canvases exhibited here were among the later works of the cycle. The sequence of Pater's paintings, as established by the dates of the engravings, reveals a gradual development towards a stronger three-dimensionality of the figures and greater spatial depth of the composition.

Fig. 91 (below) Louis Surugue, after Jacques Dumont, *A Blacksmith Cuts the Chamber Pot to Free Ragotin's Foot*, 1728. Stiftung Preussische Schlösser und Gärten, Potsdam, Plankammer

Fig. 92 (bottom) Jean-Baptiste Oudry, *The Pyramid of Chicken Wings and Thighs Elevated on a Plate of Destiny*, 1737. Musée du Mans

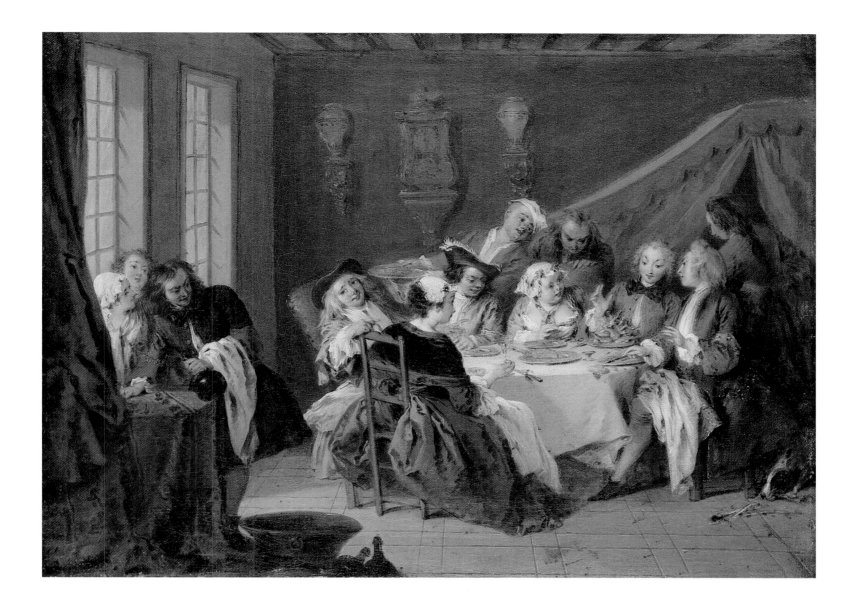

Oudry drew the first scene of the eighth chapter in 1737 (fig. 92) focusing on the same elements of the narrative. His scene is more symmetrical, though, and puts a greater emphasis on the setting of the dinner. The elongated figures, the accent on details, and the clearer and more frontal composition tend to subdue elements of the burlesque that Pater happily stresses in his paintings. It seems that Pater, like Coulomb, has followed the character of Scarron's book much more closely, while Oudry has attempted to raise its style to a nobler level in his drawings.

Frederick II of Prussia acquired the pictures in 1766. His sister Wilhelmine, Margravine of Bayreuth, mentioned the *Roman comique* in her memoirs. Both she and her brother had read Scarron's novel and often compared members of the Prussian court with characters in it. Frederick II owned three different editions of the book in his personal libraries at Berlin, Sanssouci, and Charlottenburg. It is thus safe to assume that the Prussian king acquired Pater's illustrations not only as much appreciated examples of Watteau's circle, but also as reflections of a work of literature important to him personally. Pater's fourteen paintings were all hung in an oval lacquer cabinet in the Neues Palais of Sanssouci in Potsdam, a room which was apparently designed around Pater's works.

CMV

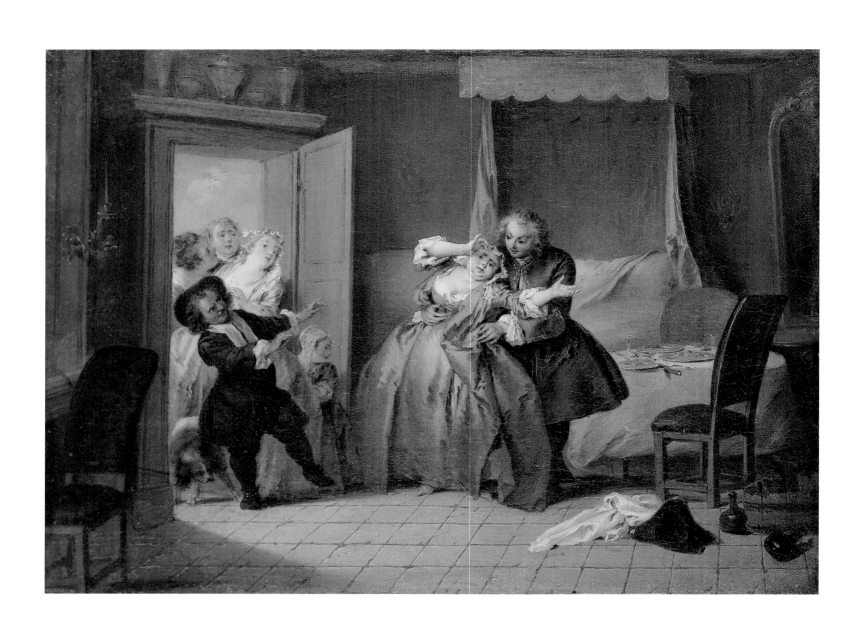

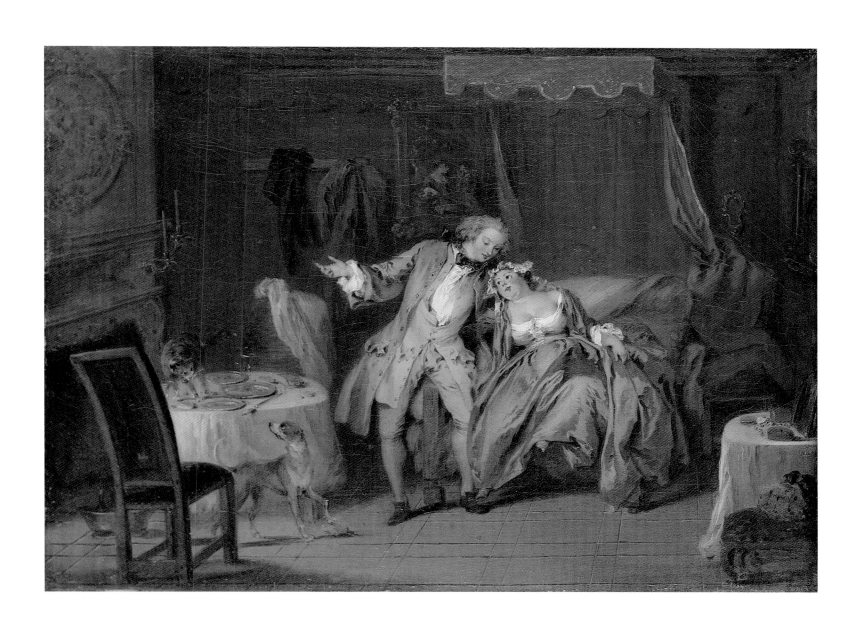

JEAN-BAPTISTE PATER (1695–1736)

21 *The Fair at Bezons* c. 1733–36

106.7 × 142.2 cm

The Metropolitan Museum of Art, New York

The annual fair at Bezons near Versailles was depicted by French artists of several generations, including Callot, Watteau's teacher Gillot, Parrocel, and Lancret. It also served as the subject of François Octavien's *morceau de reception* for the Academy in November 1725 (fig. 93). This tradition explains why Pater's painting offers no realistic rendering of the fair. Comparable to the *fêtes de Saint-Cloud* (a park on the bank of the Seine halfway to Versailles), the fair at Bezons had by Pater's time developed into a symbol for a certain type of gathering, one that could easily be rendered in a park-like southern setting not at all resembling the actual topography of Bezons (to the northwest of Paris, and at that time a small village).

A large meadow is framed by trees and buildings combining elements of rural and ancient architecture in a ruinous state. It stretches diagonally across the painting and offers a view into the countryside in the far distance on the left. Two provisional tents and a stage on which a lone actor performs have been erected. Groups of actors and musicians mingle with the crowds. The visitors to the fair are depicted as socially diverse. Around the stage, village people have assembled. But the vast majority of those attending are of the urban or courtly type, as indicated by their dress and also by the coaches on the right. In fact, the main groups of the composition, carefully highlighted by Pater, are taken directly out of his classic *fêtes galantes*: the entertainment of an urban elite spending a day in the countryside.

Pater painted a closely comparable, although considerably smaller version (90 by 130 centimetres) of the composition, which is signed and dated 1733. Acquired by Frederick II of Prussia, it is today in Potsdam at Sanssouci Palace.[1] In the New York painting the number of figures is considerably higher, the composition appears much more crowded, and the character of the landscape is much less Italianate than in its Potsdam counterpart. Instead, the New York *Fair at Bezons* seems to be a compendium of *fête galante* motifs in Pater's work and to present a greater number of direct quotations of Watteau. Both paintings combine village life and townsfolk, and – as typical fair attractions – a number of masqueraded actors: one on a stage in the

Fig. 93 François Octavien, *The Fair of Bezons*, 1725. Musée du Louvre, Paris

middle ground and, more prominently, a group to the left of the dancing couple at centre, which Pater has also used in a separate painting as an isolated group on a larger scale (The Frick Collection, New York). On the New York version of the *Fair at Bezons*, more attractions have been added, such as the musicians to the right of the central dancers. Here, a number of people are dressed in a vaguely seventeenth-century fashion, a reference jointly to that century's *fête galante* models, to the masquerade character of the fair, and to the work of Jean-Antoine Watteau. Comparison suggests that the New York version is somewhat later than the painting at Sanssouci, and its composition has been developed further and made more complex. Both go back to seventeenth-century Flemish renderings of village festivities or weddings scenes, which Pater here transforms into the more subdued language of Watteau.

CMV

FRANÇOIS LEMOYNE (1688–1737)

22 *A Hunting Party* 1723

211 × 186 cm

Alte Pinakothek, Munich

In an expansive landscape, participants in a hunting party gather for breakfast. The scene is framed on the left by trees and on the right by a mill overlooking a bridge that leads off to the right. In the foreground a man reclines, with a woman seated to either side of him. Their gestures, and the looks they exchange, signal their close relationship to each other; food is laid out on a cloth spread before them, alongside the artistically displayed spoils of the hunt: hares, pheasants, and partridges. Details of their apparel – standing lace collars, sleeve slits, puffed sleeves, and old-fashioned coiffures – are reminiscent of Spanish fashion, or what was viewed as Spanish fashion in contemporary France. Rounding off the group, over at the left, is a man seen from the back, and reclining behind him, another male figure for whom wine is just being poured into an elegant shell-shaped goblet. At centre, a couple arrives by horse, and a servant hurries over to help the woman from her mount. Our eyes take in a broad, mountainous landscape, whose subdued mood reveals a wonderful expertise. The foliage already has a touch of yellow to it, lending an autumnal ambience. To the right and left, servants, horses, and dogs wait for the hunt to resume.

Genre subjects were atypical for François Lemoyne, but here, and not for the only time, he produced two versions of the same theme.[2] Careful restoration work performed in 1987 removed the varnish and overpainting to reveal the high quality of the painting to full advantage once again. This is especially true of the nuanced rendering of the landscape, the rich palette and delicate brushstroke.[3] There is no doubting the authenticity of the signature. A date may have been present once, too, but flaws in the painting make it impossible to substantiate this now. The restoration also disclosed that the image was originally rounded at the top and was made rectangular by way of a complicated series of modifications. The picture still had its original shape in the Hofgartengalerie, which means this change was not made until the Alte Pinakothek opened in 1836.

The Munich version evidently predates the São Paulo painting (fig. 94).[4] Its vista is broader, the figures are more delicate and slender, and more clearly defined. Closer inspection shows that some of the figures were altered considerably as to type, and the numerous *pentimenti* point to intensive work having been done on the canvas. Not only were the costumes modified, but also the facial likenesses, which may indicate the expressly portrait nature of this commission. Some significant compositional changes were made in the São Paulo painting: the scene was executed from a narrower perspective. The figures are larger, the facial likenesses have been switched around, and the head coverings differ as well.

Jacques Wilhelm has convincingly ascribed to Lemoyne several drawings formerly given to Watteau, among them three studies for

the servant at the left and two for the hunter sitting beside him.[5] Wilhelm also assiduously rehabilitated the artist François Lemoyne; he vigorously asserted the poetry inherent in the painter's work, as exemplified in particular in his treatment of landscape. Certain analogies in the depiction of landscape are noticeable on comparing the picture under discussion by Lemoyne with Watteau's work in the Wallace Collection, London. The couples reclining in Watteau's middle ground evoke his celebrated *fêtes galantes*.[6] The detail of the hunter and dog at the left is the only reminder of the hunt as motif. A group of riders to the right constitutes another link with Lemoyne, as a woman is being lifted down from her horse here, too, and the clothing likewise has a Spanish flavour to it. According to the Wallace Collection catalogue, however, the painting was transformed only belatedly from a *fête galante* into a hunting party. The colours used by the two artists distinguish them fundamentally; and Lemoyne seems to have been more oriented toward Flemish and Italian painters. The date of the Munich painting, 1723, suggests that it was probably one of the earliest genre pictures, opening the way for the renowned works of Nicolas Lancret, Carle Van Loo, Jean-François de Troy, and others.

HS

Fig. 94 François Lemoyne, *The Hunt Breakfast*, 1723. Museu de arte de São Paulo

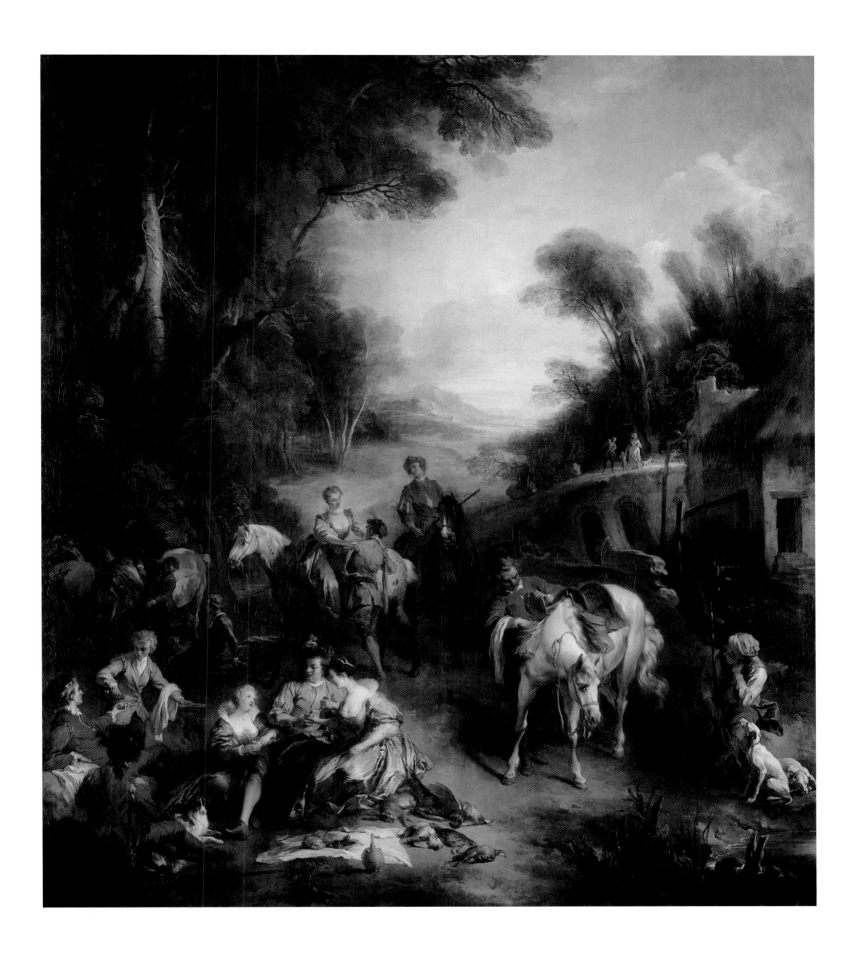

JEAN-FRANÇOIS DE TROY (1679–1752)

23 *The Game of Pied-de-Boeuf* 1725

68.5 × 56 cm

Private collection

In June 1724, Jean-François de Troy presented his work to the Paris public for the first time in the exhibition of young painters held at the Place Dauphine; he chose a genre scene, which was praised in the *Mercure de France* for "the understanding and the charming and real taste that have gone into it. It shows a young gentleman in a velvet suit of a very soft fabric, seated beside a lady on a sofa."[1] When in August 1725 a Salon was once again held at the Louvre, the first since 1699 and the only one organized before the Salon was permanently re-established in 1737, de Troy presented a selection of works representing the various facets of his talent. He exhibited not only history paintings such as *Rinaldo and Armida* (lost), *Leda and the Swan* (Musée d'art et d'histoire, Chaumont), *Diana and Endymion* (lost), the *Sacrifice of Iphigenia* (Sanssouci Palace, Potsdam), but also genre paintings, the *Déclaration d'amour*, which he had shown the previous year, and its pendant, *The Garter* (private collection; see fig. 18), a large *Masked Luncheon* (The Detroit Institute of Arts), and the present painting, *The Game of Pied-de-Boeuf*. The high proportion of modern and courtly subjects de Troy sent to the Salon underlines the importance to him of originality, since at the same time he was engaged in painting immense and more conventional compositions for the Hôtel de Ville of Paris and the church of Sainte-Geneviève, together with his father, the portraitist François de Troy.

It was not until 1735 that the *Game of Pied-de-Boeuf* was engraved by Charles-Nicolas Cochin *père* (see fig. 95). Though it gives no information about its owner, the print brought the painting widespread attention, as shown by the numerous copies it inspired. In a highly favourable notice published in the *Mercure de France*, the writer is pleased that the date is specified on the engraving "because of the clothes and fashions." And indeed, the painting does illustrate various fashions from the end of the Regency: for women, flounced dresses, small hats in lace, shoes with pointed toes and very high heels; for men, the black ribbons of their "purse wigs" knotted on the cravat and under the chin, and shoes with round toes and small buckles. But the painting cannot be reduced to a simple fashion illustration, not least because of its subject and the way in which de Troy has set the scene.

"Pied-de-boeuf" [literally, "cow's foot"] is a game of chance that offers an occasion for flirtation. The first player, placing his hand on the knee of a person seated, counts "one," the second player places his hand on top of the other's, saying "two," the third in his turn, and so on, for as many as there are present; then the first places his other hand, the second the same, and so forth; then the first again moves his hand from the bottom of the pile to place it the top, until one of the participants reaches the number "nine" and at the same time takes hold of the wrist of another player, calling "J'ai mon pied-de-boeuf." The winner has the right to ask three things from the "pied-de-boeuf," and the captive traditionally replies that she will do her best.

There follow two wishes that are impossible to comply with, then the third, which is a kiss – always granted.

As a history painter, having to decide which moment in the narrative to depict, de Troy chooses the prelude to the final question: the three hands still piled on a knee show what the game is about, while the winner holds the wrist of his captive, who has already counted on her fingers the number "two" and indicates that she is awaiting the third ritual question. Popular in the eighteenth century (see also cat. 50), this rustic game was rendered a number of times by Lancret, who exhibited a small painting on the subject at the 1739 Salon.[2] Lancret, however, depicts children, which works against the flirtatiousness of the theme as highlighted by de Troy. In the present example, we have adults from the upper classes – no shepherds and shepherdesses – indulging in an ambiguous game. Destined for a wider public than a private collection, the print has been prudently furnished with moralizing verses that cast the image as a warning: "In vain I would like to resist / You teach me all too well, Iris / In this game, when one thinks to have taken you / He'll not fail to be taken himself."[3]

CL

Fig. 95 Charles-Nicolas Cochin, after de Troy, *The Game of Pied-de-Boeuf*, 1735. Musée de la Bibliothèque nationale, Paris

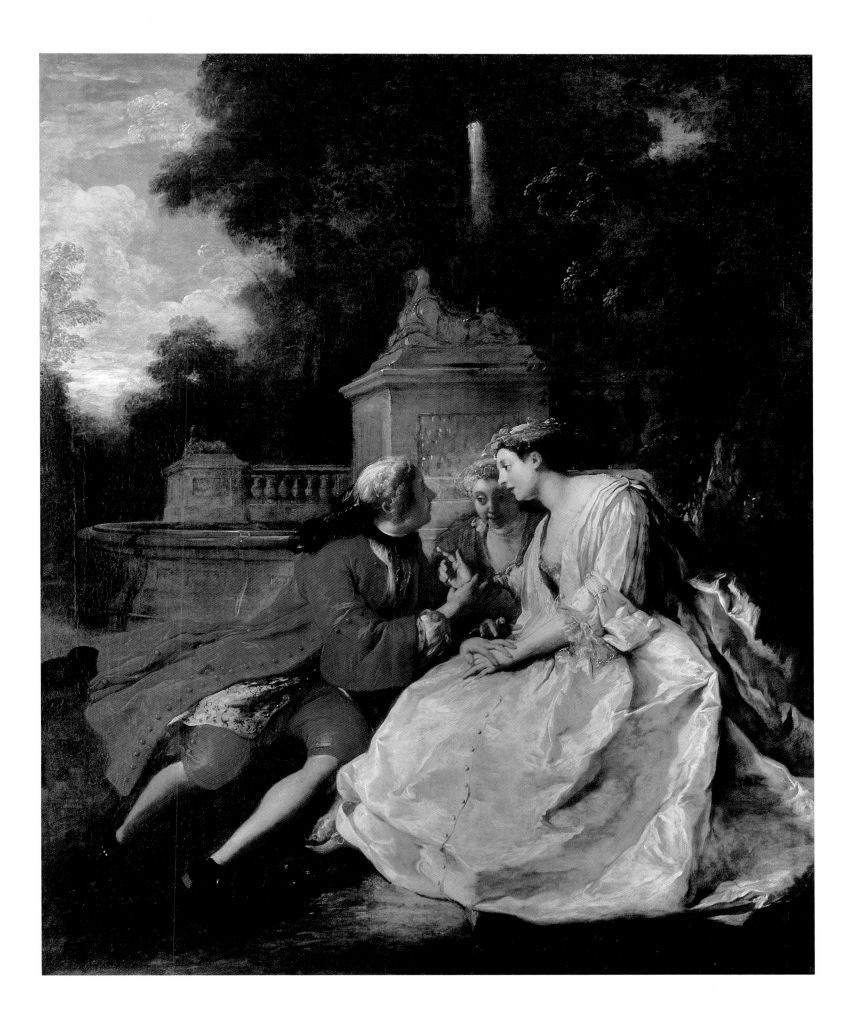

JEAN-FRANÇOIS DE TROY (1679–1752)

24 *The Rendezvous at the Fountain (or The Alarm)*

c. 1727

69.5 × 64 cm

The Victoria and Albert Museum, London

The Rendezvous at the Fountain (or The Alarm) is undeniably one of the most successful genre scenes by Jean-François de Troy, both for its artistic quality and for the clarity with which the anecdote is staged. An illicit rendezvous in a bower is interrupted by the arrival of a maid to warn her mistress of the approach of an unwelcome visitor. Essentially a history painter, de Troy preferred to recount gallant exploits, using the rhetoric of gesture: here the seducer faces his prey, hand on heart, and though dressed in virginal white, she consents. The scene is set in a framework similar to those of his historical works. Even the architectural elements – the balustrade and the fountain – can be found in the images he took from the Old Testament, and here, perhaps, the sculpted decor provides an ironic counterpoint to the painted scene. The composition of *Susannah and the Elders*, 1727 (fig. 96), employs the same contrast: a brightly lit main group is in the middle of an enclosed space, while the statue, just like the servant in *The Rendezvous at the Fountain*, stands out, higher up and backlit against a patch of sky.

Like *The Game of Pied-de-Boeuf* (cat. 23), *The Rendezvous at the Fountain* was engraved about ten years later by Charles-Nicolas Cochin *père*, as a pendant to this composition. A few lines by Danchet added at the bottom of the print take the form of a vague moral admonition about the danger of listening to overly affectionate speeches: "Flee, Iris, flee; beware of lingering here / While you seek coolness from these waters, / From a lover's words defend your heart, / For they light a fire difficult to put out."[1]

The date inscribed on the painting has generally been read as 1723, but it is difficult to decipher. If indeed 1723 were correct, it would make *Rendezvous at the Fountain* the artist's first *tableau de mode*, the style that made him famous. However, since Cochin's engraving gives the date as 1727, as does the *Extrait de la vie de M. de Troy*, we prefer to stay with that year, even though the *Extrait* is not free from errors (*The Game of Pied-de-Boeuf*, exhibited in 1725, is also assigned to 1727).

Whatever the exact date, the work is a departure from the new *fête galante* genre of Watteau and his emulators, whose transparent seduction is here replaced by a more meticulous description. But it is also a departure from the Dutch tradition with which de Troy was identified in his first attempts at the beginning of the decade, with *The Concert* (Musée Hyacinthe-Rigaud, Perpignan), *Young Woman Drinking Coffee* of 1723 (Gemäldegalerie, Berlin), and its vanished pendant, at one time in the collection of Jean de Jullienne, *The*

Reader, an elegant small painting in which a young woman is seen through a window reading by candlelight. We note that neither the legacy of his father, François de Troy, nor that of Antoine Coypel, whose influence is so strong in the artist's mythological compositions, nor even the time the artist spent in Italy, are in evidence in the image under discussion. De Troy's rendering of scenes of this kind – which the engravers of the second half of the eighteenth century made commonplace by exploiting their titillating character (often without such restraint) – stands apart at this date by virtue of its originality. What is important here is a new narrative ambition, emerging from the experience of history painting. As the initiator of a formula repeated successfully by so many artists, de Troy would soon enough depart from this direction, turning instead to the large history paintings that would launch a brilliant official career.

CL

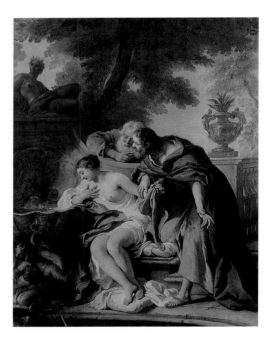

Fig. 96 Jean-François de Troy, *Susannah and the Elders*, 1727. Musée des Beaux-Arts, Rouen

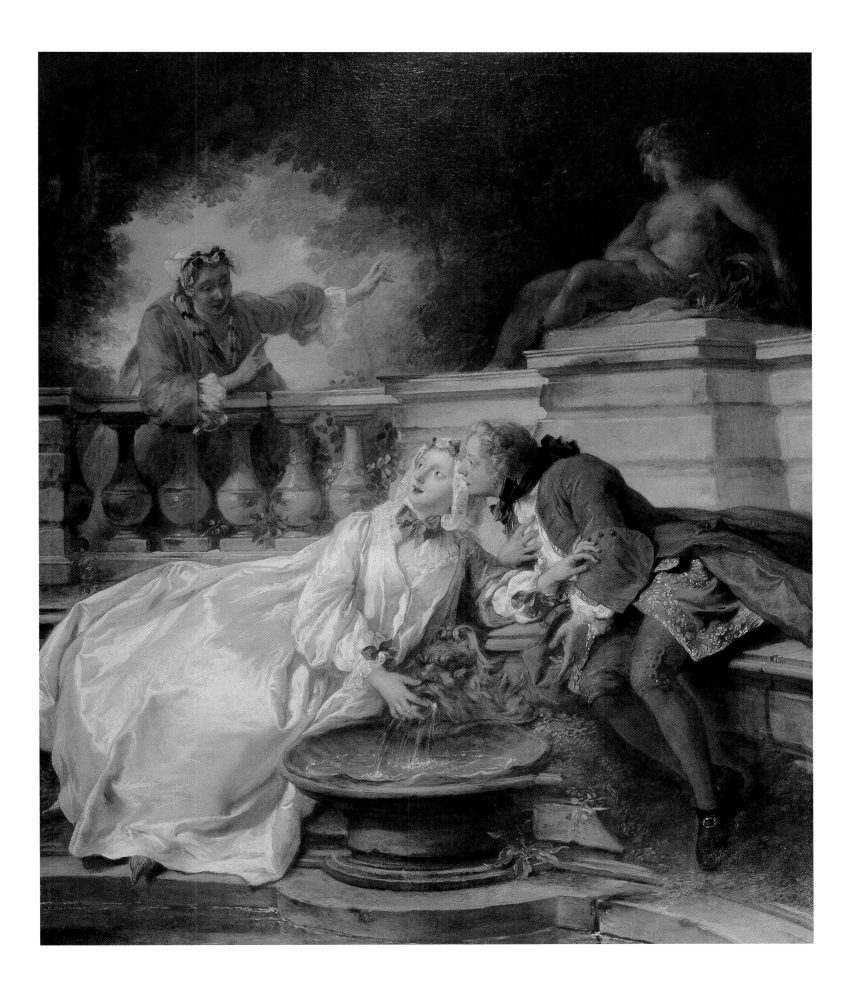

JEAN-FRANÇOIS DE TROY (1679–1752)

25 *The Reading from Molière* c. 1730

74 × 93 cm

Private collection

This agreeable assembly has become the image par excellence of life in the aristocratic residences of the eighteenth century. However, the painting went virtually unnoticed at the time. Neither shown in the Salon, nor engraved, the work, which oddly bears the impossible date "1710," is not cited in any contemporary French source, and we do not know the identity of its first owner. All that is certain is its presence in the collection of Frederick II in 1768, on which date Boyer d'Argens mentions: "in the palace of Sans Souci, two [pictures] representing conversations are in the room where the king dines."

The painting's confiscation during the Empire is confirmed by the record of its arrival in Paris, but it did not enter the holdings of the Muséum central. It was long believed that it discreetly passed into the collection of Baron Vivant Denon, director of the Louvre under Napoleon. This error can be traced to a plate in Denon's *Monuments des arts du dessin*[1] showing a lithograph of a drawing by Charles Coypel in his collection, illustrating the scene of the reading of the sonnet from the *Femmes savantes* of Molière.[2] While Coypel's drawing differs from de Troy's painting, it shows a comparable episode: a man reading in the midst of a group of women seated in an opulent interior. The confusion with the Coypel drawing is undoubtedly behind the current title of de Troy's work, *The Reading from Molière*, which was confirmed only in 1919, and which has now become a part of the history of this painting.

Though it was called a "conversation" in the eighteenth century, it is in fact a group reading. Those present are comfortably installed in armchairs subtly disarranged to show they have been drawn close together for the occasion. The composition, focused on the book, which occupies the exact centre of the painting, contrasts the clarity of organization of the figures with a certain natural disorder of the surroundings, characterized by a mixture of luxurious fabrics. Light, dark, picked out with gold and silver, in solid colours or floral, these fabrics so contrast with each other that their cumulative effect does not merge their shapes together. We note some authentic details, such as the low screen decorated in the style of Watteau, the sconces, and above all, the wall clock by the cabinetmaker André-Charles Boulle (the low armchairs, however, are of a model the artist probably invented). But the success of this kind of composition is not only to

be found in the dazzling depiction of sumptuous dress and decor. The figures of Time and Love on the crest of the clock, which dominates the whole pyramidal composition, seem to suggest an intrigue among the seven characters.

The Reading from Molière is organized around two couples. The first is formed at left by an exchange of looks between the standing man and the woman who turns her head towards him. But it is the play of glances in another group of figures that commands the viewer's attention. While the man with the book, suspending his reading, is the object of the glances of the two young women bracketing him, he is turning towards the one seated more to the right, who seems to protect herself with her fan, open on her breast, and by turning her eyes towards the spectator. The other woman facing us, while at the centre of the composition, acts as a link with the viewer: her hand resting on the back of the reader's armchair, directed at this same woman, the object of desire. As the real centre of the intrigue, this young woman's face stands out clearly against the blue background of a chair; and equally symbolic, perhaps, is the central position of her delicately shod foot.

Far from one of Molière's plays, the book being read is more likely a sentimental novel. Its plot evidently holds the rapt attention of the listeners when the reader arrives at a scene of declaration of love and sends knowing or questioning looks across the group. These looks are addressed to certain persons only, or to the onlooker, who is included by those links that can weave together reality and fiction, as in the play *Les Acteurs de bonne foi*. Never has de Troy come closer to the work of his contemporary Marivaux. As in this play, half-real and half-dream, the figures of the painting are interchangeable, their psychology simple enough: everything is a matter of attraction, of declaration, of feigned resistance, and of feelings that have to be admitted to oneself as much as to others. Without children or old people, without political or financial interests, or even jealous or envious persons, these genre scenes of Jean-François de Troy are idealized illustrations of the eighteenth century, the perfect image of the era's sentimental novels; this painting is a "reading" after all.

CL

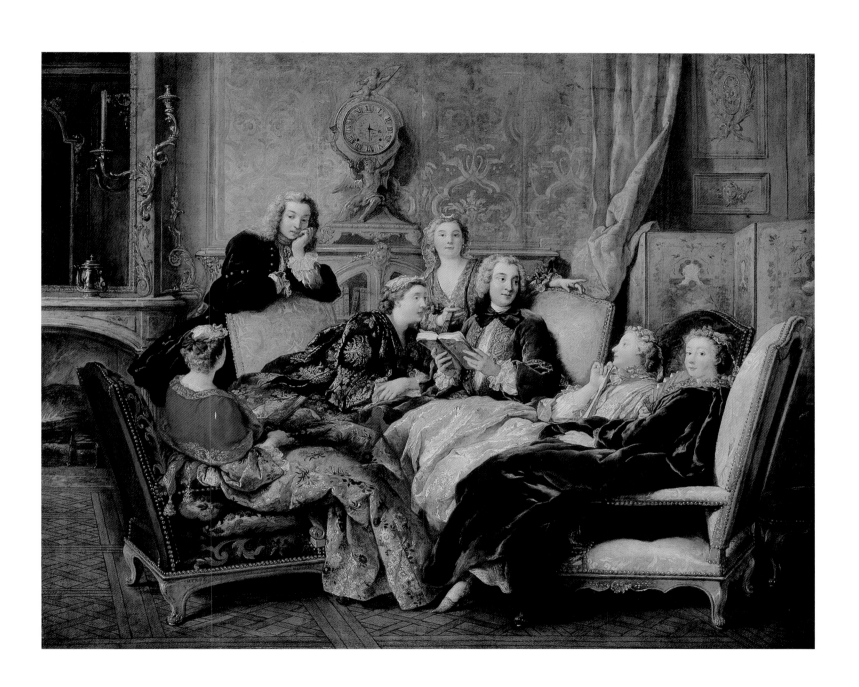

Jean-François de Troy (1679–1752)

26 *The Declaration of Love* 1731

71 × 91 cm

Sanssouci Palace, Potsdam

Only recently returned to the palace of Sanssouci where it once was a pendant to *The Reading from Molière* (cat. 25), *The Declaration of Love* (also titled *The Assembly in the Park*) offers a contrast to the interior setting of the *Reading*, even though the summer landscape is here scarcely more than a background. In this regard, a link can be made with the group portraits the artist painted at the beginning of his career, for example the *Famille de Franqueville* (Musée de la Chartreuse, Douai), where the ease with which the figures are linked together moves beyond the studio techniques de Troy learned from his father and prefigures the British conversation piece.

Like its companion picture, *The Declaration of Love* contains seven main figures, if we leave out the couple descending the distant steps. But they consist of three men and four women, as opposed to two men and five women. In the Sanssouci picture, one of the gallants is declaring his ardour to a young woman, while two other men both appear to be bent on the conquest of a second woman. As in *The Reading from Molière*, only a finely-shod foot stands out at centre, the foot of a woman receiving a small bouquet of flowers as a token of love. As a sign of surrender, her fan is folded and lowered, while displaying the inverse rhetoric, the fan of the woman viewed from behind, who is being courted by the two attentive suitors, is proudly open.

Everything, from the elegance of dress to the agreeable facial expressions, forms a coherent whole, where the seduction being practised by the protagonists of the scene rivals that of the painter, achieved with the mellowest colours and the finesse of his brushwork. Compared with de Troy's usual vigorous attack (he was capable of brushing in a monumental composition in a few days, and has been called "the French Jordaens"), this kind of "porcelainized" finish demanded unaccustomed attention from him. Of the critics of the day, Mariette was the only one to comment on it, even though he qualified his admiration. De Troy, he wrote, "was more warmly applauded in Paris for his small *tableaux de mode*, which in fact show that greater pains have been taken, than for his large history paintings; but I do not think that it is these works that will make his reputation."[1] Although he regretted so much care being expended on a minor genre, Mariette confirmed the public success of the formula. In his genre paintings, de Troy distilled the spirit of a time, which we can easily imagine being divided between the pleasure of conversation and the pleasure of flirtation. The game of seduction is not impeded by scrupulous observation of daily life, nor by the psychological

torments of love: *The Declaration of Love* impresses us as a masterpiece of artifice. In another of his compositions, *The Reading in the Shade*, 1735 (fig. 97), the painter positions the protagonists in an equally improbable manner, seating them on the ground, which works against the richness and stiffness of the costumes. In a way that is uniquely his own, de Troy is a true contemporary of Jean-Antoine Watteau.

But, is it not this very artificiality that is the motivating force of mythological painting? After all, if we forget about decor and costumes, de Troy's genre scenes do not contrast starkly with the rest of his oeuvre. It is an indication that the artist can hardly be thought of as a chronicler of his times, since none of his drawings fixes an instant of daily life or a picturesque element taken from memory. If he sometimes descends from representing the loves of the gods into painting human adventures, Jean-François de Troy remains, above all, a painter of "la fable."

CL

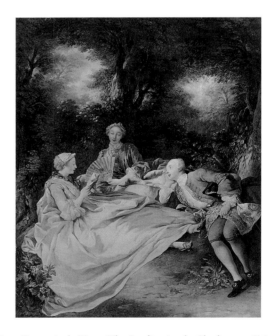

Fig. 97 Jean-François de Troy, *The Reading in the Shade*, 1735. Private collection, Great Britain

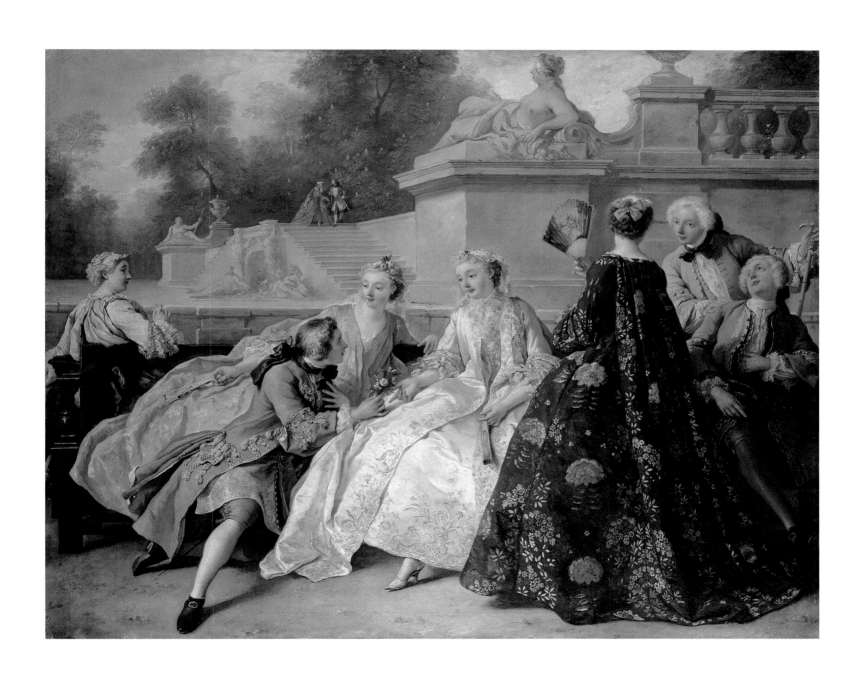

JEAN-FRANÇOIS DE TROY (1679–1752)

27 *Before the Ball* 1735

82 × 65 cm

The J. Paul Getty Museum, Los Angeles

Before the Ball and its recently rediscovered pendant, *After the Ball* (see fig. 17), are distinguished by the originality of their nocturnal lighting. Masks in hand, men and women are mostly wearing dominoes – these long and ample silk cloaks with a hood could cover the entire body and conceal the wearer's identity at a masked ball (in lieu of a disguise). At the centre of *Before the Ball*, a young woman, surrounded by friends and confidants, finishes dressing; while in the other painting, a maid removes the flounced robe. In the right background, we recognize the same couple who appear at the left in *After the Ball*, this time drowsing on a sofa whose back follows the form of the boiserie panelling. The furniture, the fireplace implements, the abundance of mirrors reflecting the gilded bronze sconces – everything breathes opulence. The heavy woven armchairs, still Regency, like the rest of the decor (the two scenes apparently do not take place in the same room) seem rather old-fashioned. The slight uncertainty of perspective, like the haphazard arrangement of the wainscot panelling, suggest in any case that the artist has not sought to transcribe the fashion of the moment as faithfully as we might have thought. The general *bon ton* of de Troy's compositions makes them perfect fashion illustrations, certainly not realistic images of the age. The expression *tableau de mode*, used by Mariette as well as by the *Mercure de France*, seems to suit the genre paintings of Jean-François de Troy, especially with the term's implication of the civilized, even of the artificial.

The provenance of these pictures offers us a rare opportunity to become better acquainted with the collectors of genre paintings. Although de Troy painted a fair number of mythological canvases for himself before trying to sell them, the *Extrait de la vie de M. de Troy* identifies a patron for *Before the Ball* and *After the Ball*: "two pictures, one a preparation for a masked ball, the other a return from the event, both painted in natural light. These two pictures had been made for Minister Chauvelin, but his disgrace prevented them from reaching him."[1] Their sale after the death of the minister (21 June 1762, Paris) shows, however, that Chauvelin owned two other *scènes*

de genre by de Troy, *A Lady Showing a Bracelet Miniature to her Suitor* and *A Lady Attaching a Bow to a Gentleman's Sword* (both of 1734). Chauvelin, who served as Garde des Sceaux and Secrétaire d'État des Affaires Étrangères for a decade, was all the same viewed as an upstart by his contemporaries.[2] Owner of an *hôtel particulier* in the Rue de Richelieu and of the Château de Grosbois, which he had purchased from the banker Samuel Bernard, he had certain similarities, despite his more prestigious titles, to the painter's usual wealthy clientele. The fate of the two unsold pictures also points to the difficulty for such works to gain entrance to prestigious collections, where history paintings, and especially Old Masters, carried the day. And indeed, *Before the Ball* and *After the Ball* surfaced some fifteen years later in the house of a wine merchant, Salomon-Pierre Prousteau, "Capitaine des Gardes de la Ville" as he was usually called on prints. This amateur also owned two works of similar inspiration by Boucher, *The Luncheon* (see fig. 21) and a replica of *The Milliner (Morning)* in the Wallace Collection, London (see cat. 54 for the original in the Nationalmuseum, Stockholm). In confirmation of Mariette's judgement, genre painting seems to have been of no help in founding a reputation – at least in Paris. In far-off Prussia, however, Frederick II showed more sensitivity to the charms of this kind of painting.

Both these de Troy scenes were engraved by Jacques-Firmin Beauvarlet when they entered the Prousteau collection. As was often the case, these prints, later acclaimed by the Goncourts, explain why so many copies were made of the paintings. In 1812, the painting under discussion, or one of these copies described in the catalogue of a public sale in England (where the original was later found), was compared, on the basis of its lighting effect and fineness of execution, to the work of Gerrit Dou. A copy on panel of *Before the Ball*, offered in 1872 to the New York Historical Society (resold in 1995), was certainly the first painting attributed to the artist to join a collection in North America where, much later, the original would also find a home.

CL

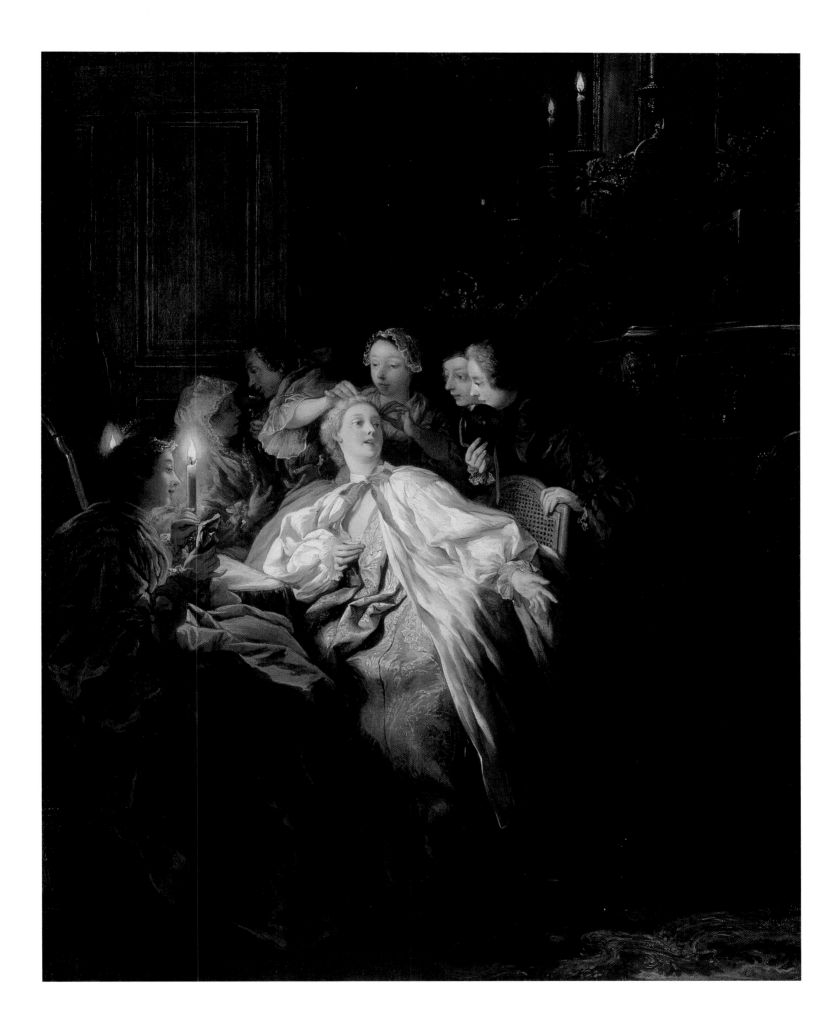

JEAN-FRANÇOIS DE TROY (1679–1752)

28 *The Hunt Luncheon* 1737

241 × 170 cm

Musée du Louvre, Paris

This picture was created two years after de Troy's famous *Oyster Luncheon* of 1735, painted for the private dining room of Louis XV at Versailles (a canvas which, at the donor's behest, may not leave the Musée Condé at Chantilly). *The Hunt Luncheon,* intended to adorn the king's dining room at Fontainebleau, adapts the artist's favoured *style galant* to the scale of royal palace interiors. Unlike the Dutch images of the previous century, the feasts of Jean-François de Troy are not occasions for vulgar excess; they differ from Lancret's *Ham Luncheon,* 1735 (see fig. 87), commissioned as a pendant to the *Oyster Luncheon,* where drunkenness upsets the good order of the table. *Hunt Luncheon* is the last genre subject painted by de Troy before his departure for Rome where he became director of the prestigious Académie de France, and thereafter devoted his efforts exclusively to historical themes, painting vast biblical banquets more in the style of Veronese.

Sometimes referred to as *Luncheon near a Farm,* the scene displays a larger number of figures than in de Troy's previous genre paintings. A table has been set before the entry to a farm or hunting lodge, domestic servants are laying out bottles of wine and wicker baskets of food, and visible in the background are the hunters' horses, unsaddled, and the carriage that has brought the ladies to join the men for lunch. The man in the red habit, cutting the meat, with the gold braid on his back and belt, wears a typical hunting costume; a horn hangs on the back of his chair. The man standing to the left, with a long plait and a tricorne, is a soldier. The painter has multiplied picturesque details to evoke all the animation of the meal in the open air: chairs are added; a valet, at right, brings oil and vinegar; peasant women gaze on the table from the balustrade; while below, two dogs get ready to fight over a piece of meat. From the look of the elegant silver dishes transported for the occasion, or the presence of a young black servant in a turban, we can deduce that there is nothing improvised about this repast. This mixture of the natural and the sophisticated characterizes de Troy's painting, as here he unites the highly refined colours of clothing and table linen with a sweeping forest landscape in the Flemish tradition.

The sketch for the *Hunt Luncheon* is preserved in the Wallace Collection, London. It was approved by the Bâtiments du roi, with a few changes, before the full-scale work was executed for the Fontainebleau apartments. The pendant, *Death of a Stag,* has disappeared; however, the violence of the scene (at least according to the sketch, also in London) very much exceeds that of the *Lion Hunt* (Musée de Picardie, Amiens) painted for Versailles two years later. Of course, its subject was meant to form a contrast with its pendant, and with other scenes of pauses during the hunt painted by Carle Van Loo and Charles Parrocel (both in the Louvre) for the panelling of the room. It is thought that the subsequent redecoration of a dining room in another part of Fontainebleau led to the *Death of a Stag's* being removed in favour of new compositions commissioned from Natoire, Boucher, and Pierre. For its part, the *Hunt Luncheon* remained in place, in perfect harmony with the works of this new generation of artists.

CL

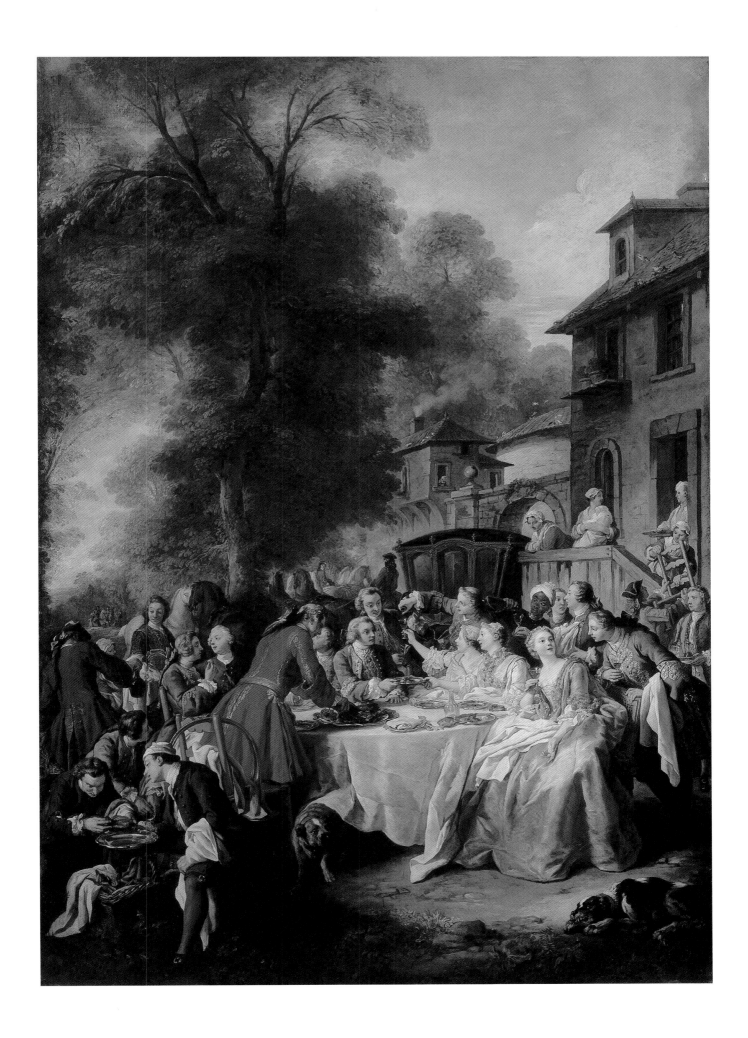

CHARLES-ANTOINE COYPEL (1694–1752)

29 *Children's Games* 1728

64 × 80 cm

Martin L. Cohen, M.D., and Sharleen Cooper Cohen

Because of his father's position as Premier Peintre du Roi, Charles had been immersed in courtly life since his early childhood, which he spent at the Palais Royal with the young Duc de Chartres, son of the Regent. Like his father and grandfather before him, Charles Coypel was easily accepted at the age of twenty-one as a history painter at the Académie royale. For the rest of his life Coypel would enjoy the security of royal patronage and with it an atelier and living quarters at the Louvre. Among his most prominent patrons were Queen Marie Leczinska, the wife of Louis XV, Louis de Fagon, Intendent des Finances, the Comte de Morville, and Frederick II of Prussia.[1] In *Children's Games*, which is dated in accordance with an engraving of the work by Lépicié that appeared in the *Mercure de France* in 1731,[2] Coypel presents us with a comical, even satirical glimpse of everyday life at the court.

In his *Persian Letters* (1721), Montesquieu, that keen and critical observer of French society, offers this apt comment: "The role of a pretty woman is much more serious than one might suppose. Nothing is more important than what happens each morning at her toilette, surrounded by her servants; a general of an army pays no less attention to the placement of his right flank or his reserve than she does to the location of a beauty patch, which can fail, but from which she hopes or predicts success."[3]

Coypel's lively composition features nine children taking on the roles and costumes of a lady and her entourage at her morning *toilette*. Coming into the scene from the right is a young girl, up to her neck in a full-sized *panier*. Across from her, a child floats in a pair of high-heeled shoes as she holds a fan and throws a coquettish glance at us over her shoulder. She is wearing only a *pet-en-l'air*,[4] exposing to the viewer "what she will later have to carefully hide away."[5] Seated beside her is a little lady absorbed in the careful application of a beauty patch.[6] Towards the back, a boy whose round face is framed by a full-bottomed wig watches as a maid attends to her lady's toilette.[7] In fact, a whole mise-en-scène occurs around this central figure, who gazes at her own image in a *duchesse* mirror while a suitor looks on admiringly. A messenger rushes towards her with a letter, presumably sent by a gallant.

There is no denying the theatricality of the picture. Indeed, besides illustrating Cervantes' *Don Quichotte* and several plays by Molière, Coypel was also a playwright. Although most of his literary production remained in manuscript form, and few of his pieces were ever performed, his interest in the theatre formed a dialogue with his art. On 17 July 1730, Coypel's *Triomphe de la Raison* was performed at Versailles for Marie Leczinska, with the themes of vanity and the follies of fashion figuring in acts one and two. In *Children's Games*, the exaggerated facial expressions of the young ladies, the accentuated gestures of the children, as well as the arrangement of the figures around the central group create the impression that a curtain has opened upon a stage-set. It has been argued that it is precisely this theatrical aspect of Coypel's oeuvre that constitutes his most significant artistic contribution.[8]

The use of children to enact adults and their activities can be seen in works by Van Loo of 1752–53, where they personify the arts of painting, sculpture, and architecture, as well as in such paintings by Boucher as *La Petite fermière* and *Le Petit Pasteur* of 1752. With regard to *Children's Games*, the casting of children in adult roles is, no doubt – much in the spirit of his contemporary Montesquieu – an amusing way to make light of something Coypel felt others were taking a bit too seriously.

AF

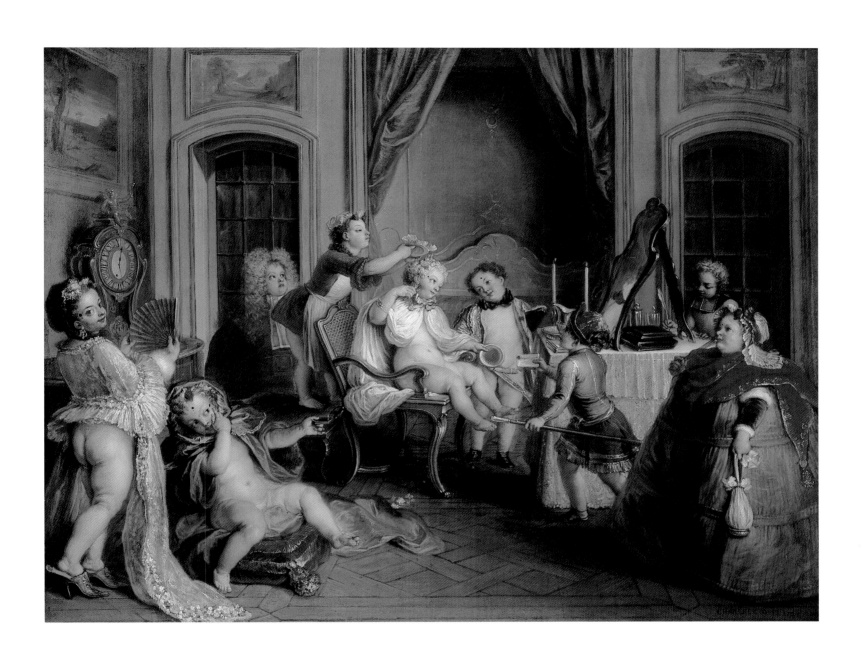

Jean-Baptiste-Siméon Chardin (1699–1779)

30 *The Game of Billiards* c. 1725

55 × 82.5 cm

Musée Carnavalet–Histoire de Paris

Two players and a convivial group of spectators have gathered in a billiard hall. To the left, a waiter serves one of the players a drink, while a boy seems to be taking an admission fee at the door; on the right side, three men are engaged in conversation, rather than attending to the game. Reflecting lamps are suspended above the table, and the house regulations are displayed on a poster attached to the wall at the right. The space of the room is clearly marked out by the perspective of flagstones on the floor, the beams of the ceiling, and the table placed squarely in the centre.

The Game of Billiards is likely the earliest surviving painting by Chardin. Its only recorded predecessor was *The Surgeon's Shopsign* (lost since 1783), which is known through an etching (fig. 98) by Jules de Goncourt (1830–1870), made after a preparatory oil study, itself destroyed by fire in 1871. This large painting – it measured about 4.5 metres in length – depicted a busy street scene with many figures, the main incident being a man injured in a duel and conducted to a surgeon's premises. One of Chardin's first biographers, Haillet de la Couronne, tells us: "The painting was hastily done, yet with much taste. The effect was singularly exciting. . . . The picture caused a stir, and people flocked to form an opinion: the entire Academy learned of the young Chardin's talents."[1] *The Surgeon's Shopsign* was clearly inspired by Jean-Antoine Watteau's equally large *Gersaint's Shopsign*

Fig. 98 Jules de Goncourt, after Chardin, *Sketch for the Surgeon's Shopsign*, c. 1772. Private collection

Fig. 99 Jean-Baptiste-Siméon Chardin, *Servant Pouring a Drink for a Billiard Player*, 1725. Nationalmuseum, Stockholm

(see fig. 1), which the young Chardin certainly knew during its brief and celebrated installation in 1721, over the entrance to the premises of the art and luxury goods dealer Edme Gersaint, on the Pont Notre-Dame (see the painting by Hubert Robert, cat. 93).

It is significant that Chardin's earliest oil paintings should have been genre subjects, inspired by Watteau's work and by the everyday life around him. Although he studied for a time, probably around 1720, under the history painter Pierre-Jacques Cazes (1676–1754), and then for a brief period with Noël-Nicolas Coypel (1690–1734), Chardin never received a thorough grounding in the academic tradition. The art of Watteau provided the most viable alternatives, thematic and stylistic, to the classical tradition promoted by such academic artists. *The Game of Billiards* derives from Watteau's example in its quotidian theme, in the disposition of the interior space, and the style of the figures – and even in its lively handling, albeit on a much smaller scale than *Gersaint's Shopsign*. A preparatory drawing by Chardin – a study of the group with a manservant pouring a drink for a player, at the left of the painted composition – also shows the influence of Watteau in its graphic style and its combination of red, black, and white chalks (fig. 99). Another preparatory drawing, for the figure of an older man seated at the right, was acquired recently by the J. Paul Getty Museum, Los Angeles.[2]

Marianne Roland Michel has suggested that the exhibited painting could be the preparatory study for a larger signboard, perhaps executed for the artist's father, Jean Chardin, who was a manufacturer of billiard tables. This hypothesis is convincing, because the table literally plays such a prominent and central role in Chardin's composition. We might note here that the construction of wooden furniture in Chardin's paintings is always rendered with care.

The style of the painting is quite sketchy; but we should remember that Haillet de la Couronne's description of the much larger *Surgeon's Shopsign* also mentions hasty execution and a noticeable boldness of handling. Such signboards were, after all, intended to be seen from a distance. (In Chardin's later genre paintings, so richly represented in the following items in this catalogue, the paint is applied in a much more meditated way, befitting their roles as cabinet pictures for display in the homes of their owners.) Moreover, a destination as a signboard for the putative full-scale version of *The Game of Billiards* would certainly help to explain this otherwise very unusual subject in French painting during the 1720s. Chardin's homage to Watteau was both practical and intuitive, but was only to be fully developed at a later date when he had absorbed the radical implications of *Gersaint's Shopsign*, with its topical subject matter, its basis in observation, and its engagement with the everyday life of contemporary Paris. Chardin was perhaps the artist who understood best, from the example of Watteau – his real teacher, we could say – the potential of being a "painter of modern life" in early eighteenth-century Paris, and the

alternative this offered to the tired academic precepts of a Cazes or a Coypel.

Like many painters and sculptors in eighteenth-century France, Chardin came from an artisan background, working his way up the social and artistic hierarchy from humble beginnings, through the guildlike Académie de Saint-Luc, which received him with a *maîtrise* in 1724, to his first public exhibition at the Exposition de la Jeunesse (youth fair) on the Place Dauphine in 1728. It was his talents as a still-life painter that were recognized on this occasion, and in that category of painting he was quickly received into the Académie royale de peinture et de sculpture later the same year. From then onwards, Chardin became a member of the artistic establishment, and was able to show his works – still-life and genre paintings – at the Academy's Salon exhibitions, instituted on a regular basis starting in 1737. The presentation of his paintings at these exhibitions was an important factor in establishing the popularity of Chardin's later genre subjects and in developing his international reputation.

PC

JEAN-BAPTISTE-SIMÉON CHARDIN (1699–1779)

31 *The Embroiderer* c. 1733–38

19 × 16.5 cm

Private collection

32 *Young Student Drawing* c. 1733–38

21 × 17 cm

Kimbell Art Museum, Fort Worth, Texas

In 1728 Chardin was received into the Academy with the rather lowly status of "painter of animals and fruits." It seems that it was not until a few years later that he pursued in earnest his interest in genre painting. At the Exposition de la Jeunesse in 1734 he showed *A Lady Sealing a Letter* (fig. 3), dated 1733, along with some unidentifiable "children's games," according to a brief notice in the *Mercure de France*. With its gallant theme of the type popularized by Jean-François de Troy in the 1720s (see cat. 23–27), *A Lady Sealing a Letter* seems to be the first of Chardin's genre scenes conceived on a relatively large scale: at about one-and-a-half metres square, it is the largest, his other large canvases being in the range of 80 to 100 centimetres in their longest dimension. However, like *The Game of Billiards* (cat. 30), it may have been commissioned, or at least had a specific function, in this case as an overdoor decoration. Also dated 1733 is *The Water Urn*, which has a pendant, *The Washerwoman* (both Nationalmuseum, Stockholm): these two modestly-scaled (38 by 43 centimetres) genre scenes are painted with a rugged, impasted handling, which is similar to the execution of Chardin's small still-lifes of familiar kitchen objects of the same period. The richly impasted handling of the even smaller *Young Student Drawing* and *The Embroiderer*, in both the Stockholm and the presently exhibited versions, allies them stylistically, and probably in date, with the two scullery scenes.

Seven autograph versions of *Young Student Drawing* can be accounted for,[1] attesting to its popularity and perhaps to Chardin's own obsessive interest in the theme. An art student dressed in a bicorne hat and an old topcoat sits on the floor of a studio, a portfolio on his knees to support a sheet of paper; with a red crayon in a holder, he is intently copying the red chalk drawing that is attached to the far wall; leaning on the wall to the right is a blank canvas, and another is turned to the wall to reveal its stretcher. The exemplary drawing on the wall is an academic life study of a standing male model. Is this Chardin's own *paragone*, or dialogue, on the relative merits of the art of painting versus academic drawing? It is painting that triumphs here: in a virtuoso performance of tone and texture, surface and depth, substance and shadow, light and reflectivity. The discreet, muted tones are enlivened by the flash of red lining revealed where the student's coat is torn at the shoulder, directing our attention to the young man's hunched absorption in his task.

The version of *Young Student Drawing* in the Nationalmuseum, Stockholm – along with its pendant *The Embroiderer* – was exhibited at the Salon of 1738, although this pair was likely painted earlier,

about 1733–35. Was there a didactic intention on Chardin's part? Absorbed as they are in their work, the two figures can be situated within a tradition of morally exemplary scenes of everyday life, which gained currency especially in Dutch and Flemish art of the seventeenth century. Chardin was certainly aware of this pictorial and moralizing tradition, but its coin was well worn by his day, and there is no evidence that our painter intended to make such moral propositions. Even in Chardin's time, it was the manner of his art, at least as much as its matter, that attracted attention.

Chardin was a regular contributor to the Salon exhibitions as soon as they were instituted in 1737 and until the last year of his life in 1779. Of his submission of such diminutive pictures to these exhibitions, Michael Baxandall has written: "Once an Academician, he learned to speak also with the extreme, demanding quietness – small pictures one has to approach close to make out, banal subject-matters with little independent interest – of someone out to exact intense attention to himself in a different way. This . . . is how he catches and holds attention. Chardin's will to dominate, to insist on our attending to his performance, can be disquieting: there is a sinister aspect to exhibiting, at the Salon, an oil painting eight inches by seven."[2] Baxandall's observations are supported by the cautionary words of Chardin's friend Charles-Nicolas Cochin (1715–1790; son of the engraver of some of Chardin's works), who noted, "Although in general his touch was not very agreeable and in a way rough, there were few paintings which could sustain themselves next to his, and it was said of him that he was a dangerous neighbour."[3]

Chardin frequently made second or multiple versions of his paintings, as the reader of this catalogue will notice. This was not in itself an unusual practice in the eighteenth century. No stigma was attached to repeating a successful design, if the market demanded it. But Chardin replicated his works more often than his contemporaries. This may have been because he did not paint with great facility, and because invention came to him only with the greatest difficulty – as several contemporaries noted – and for him it was easier to copy himself, when circumstances allowed, than to invent a succession of new compositions.

We exhibit here for the first time a recently rediscovered version of *The Embroiderer*, painted on canvas. The composition

Fig. 100 Jean-Baptiste-Siméon Chardin, *The Embroiderer*, c. 1733. Nationalmuseum, Stockholm

is identical to the only other surviving version of the subject, in the Nationalmuseum, Stockholm (fig. 100), exhibited with its pendant *Young Student Drawing* at the Salon of 1738. A young woman is selecting a ball of blue wool from the workbasket beside her; a box of pins sits on the table, against which leans an ell for measuring cloth. She seems to pause for a moment, reflecting wistfully, which gives her an air of less concentrated urgency than her companion. The painting shares with the Stockholm version, and with both known examples of *Young Student Drawing*, a similar thickly impasted surface and grainy pigments.

The history of the exhibited version of *The Embroiderer* before 1920 is unknown, but probably it was once the pendant to a *Young Student Drawing* (but not the Kimbell Art Museum picture of this catalogue entry, which is painted on panel). In addition to the pair of paintings in Stockholm mentioned above, which were acquired for the Swedish royal collection at the sale of Antoine de La Roque in 1745, other pairs of *Young Student Drawing* and *The Embroiderer* passed through the Paris salerooms five times during the eighteenth century alone, but it is impossible to identify them positively with known paintings.[4] Two versions of *The Embroiderer* were destroyed in World War II (with their pendants), leaving the Stockholm picture and the exhibited picture as the only known examples. The present painting is on canvas, so it may possibly be identified with one or other *Embroiderer* that passed through the Paris salerooms (with pendants) in the eighteenth century: at the Lemoyne sale, 10 August 1778, no. 25; and at the Prince de Conti sale, 15 March 1779, no. 90.

Sources for Chardin's subject in *The Embroiderer* can be found in Dutch and Flemish seventeenth-century paintings, which were avidly collected in Paris in Chardin's day. *The Embroiderer* (Gemäldegalerie, Dresden) by Caspar Netscher (1635/36–1684) is a typical example. But Netscher's more precise – even prosaic – descriptive touch is quite different from the painterly manner of Chardin, where soft strokes of the brush and the enveloping atmosphere create a poetic, if indefinable, mood.

PC

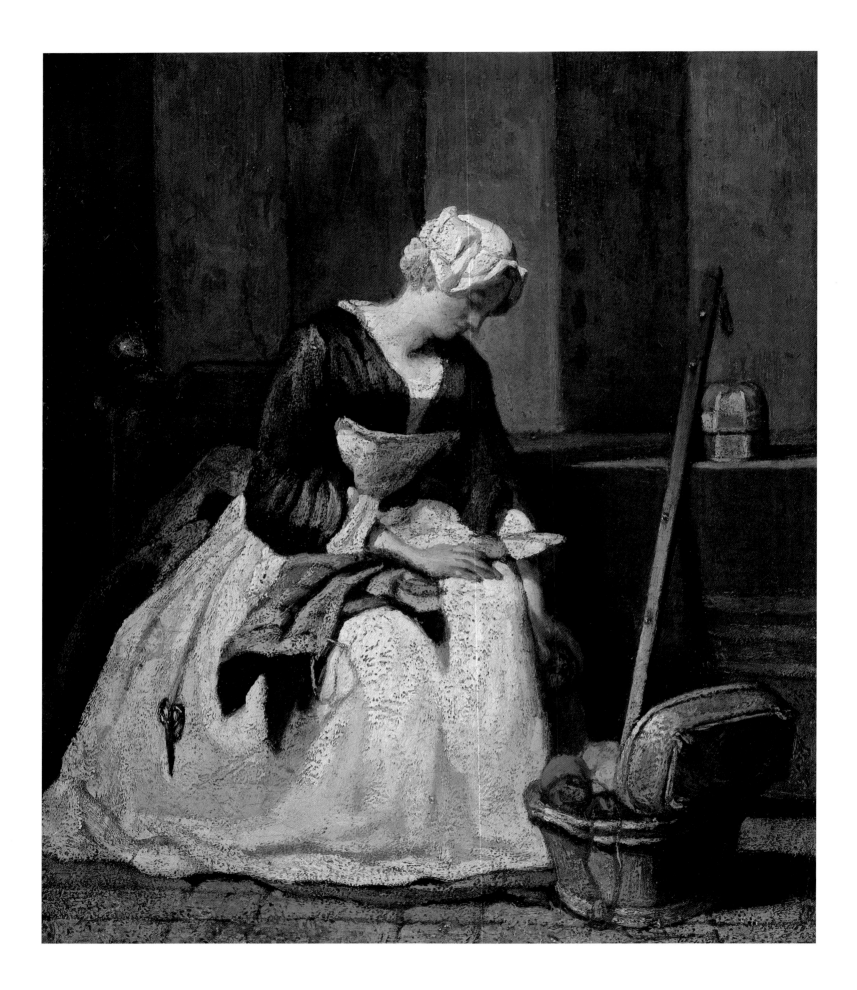

JEAN-BAPTISTE-SIMÉON CHARDIN (1699–1779)

33 *Soap Bubbles* c. 1735–40

93 × 74.5 cm

National Gallery of Art, Washington, D.C.

At the Paris Salon of 1739, Chardin exhibited (no. 8): "A small painting, representing the *Frivolous amusement of a young man making soap bubbles.*"[1] This was one of five genre subjects he showed that year,[2] which were enthusiastically received by the critics. An adolescent boy leans on a window ledge fringed with honeysuckle vines and blows through a straw, intensely concentrating on the large soap bubble at its tip. A young child strains over the ledge to watch. The image can be read in various ways: in the laconic Salon *livret* it is described as a "frivolous amusement;" did Chardin intend this title to have an admonitory ring? Is the youth wasting time and setting a bad example to the youngster? Ella Snoep-Reitsma convincingly places the subject within a long tradition of *vanitas* imagery, the bubble being an age-old emblem of the fragile and ephemeral nature of human life and endeavour. For Michael Fried, it is an "unmoralized vision of distraction as a vehicle of abstraction," mirroring "the absorption of the beholder before the finished work."[3] On their different levels, these readings are valid, and Chardin might not have argued with any of them. He was fascinated by images of children at play, and surely did not disapprove of the activity. His paintings suggest that he empathized with their innocent absorption in the task at hand. The spectator cannot resist joining in silent complicity and contemplation.

There are three known autograph versions of *Soap Bubbles*, all in American museums: horizontal formats in the Metropolitan Museum of Art[4] and in the Los Angeles County Museum of Art,[5] and the exhibited vertical one. The engraving by Pierre Filloeul (1696–after 1754) of *Soap Bubbles* (see fig. 61),[6] published with its pendant *Knucklebones* (fig. 101) shortly before December 1739, matches none of the three extant *Soap Bubbles* paintings precisely. It is most likely that Filloeul's print reproduces the painting shown in 1739. Only the National Gallery of Art's painting is vertically oriented and corresponds broadly in composition, but not in all details, to Filloeul's engraving. Missing in the Washington picture is the bas-relief beneath the windowsill shown in Filloeul's print, while missing in the print are the honeysuckle vines and encasement wall framing the Washington *Soap Bubbles* at the left and right sides. From this evidence alone, we believe that the painting exhibited in 1739 was a fourth version, now lost, but known from an early copy in a private collection in Paris.[7]

The Washington canvas was at some unknown date enlarged on all four sides. A description of what is most likely the Washington picture was given in the art journal *L'Artiste* in 1845, and is one of the first published references to Chardin at the time that his reputation was rising again in the mid-1800s: "We have just seen one of the most ravishing and best-preserved paintings of Chardin in the studio of M. Roehn. This signed painting depicts a very simple and charming young boy dressed in the style of Louis XIV, leaning out a window which is framed by vines and clusters of ivy leaves, amusing himself by blowing soap bubbles."[8] Thus we assume the extensions were made by 1845; but the question remains open as to whether they were added by Chardin himself soon after the central portion; by another hand at an early date (perhaps in Chardin's lifetime); or later, but before 1845.

According to Pierre-Jean Mariette (1694–1774),[9] the response of still-life painter Chardin to the challenge of the portrait painter Jacques-André-Joseph Aved – "If only painting a portrait were as easy as painting a sausage" – was to paint (a version of) *Soap Bubbles*.[10] But among Chardin's first figure subjects, dating to the early 1730s, were also small scullery and kitchen scenes, such as *The Washerwoman* and *The Water Urn* – extensions, as it were, of his kitchen still-lifes of the late 1720s and early 1730s (several versions of these two figure compositions exist; *The Water Urn* in the Nationalmuseum, Stockholm, is dated 1733). The large-scale *Lady Sealing a Letter* (fig. 3), also dated 1733, is in subject close to the work of Jean-François de Troy and in execution reminiscent of Aved, and is likely the earliest of Chardin's larger figure pieces. But we would date the concept and the execution of one or more of the four versions of *Soap Bubbles* to 1733 or 1734, and agree with Rosenberg that it is "the first of Chardin's pictures devoted to childhood or early adolescence."[11]

Chardin frequently made replicas of successful compositions, both still-lifes and figure subjects. X-radiography reveals no *pentimenti* in any of the three known versions of *Soap Bubbles*, suggesting that they derive from the lost prototype mentioned above: the painting engraved by Filloeul and the true pendant of the Baltimore *Knucklebones*.[12] Normally the "original" of such a series retains the trace of Chardin's compositional reworkings. As it happens, the Baltimore *Knucklebones* (one of the few figure compositions Chardin chose never to repeat) contains several adjustments to the face and hands, visible through x-radiography. In this context, we should note that Chardin retained a version of *Soap Bubbles* in his studio: could it have been the prototype for the later versions?[13]

PC

Fig. 101 Pierre Filloeul, after Chardin, *Knucklebones*, 1739. National Gallery of Art, Washington, D.C. Rosenwald Collection

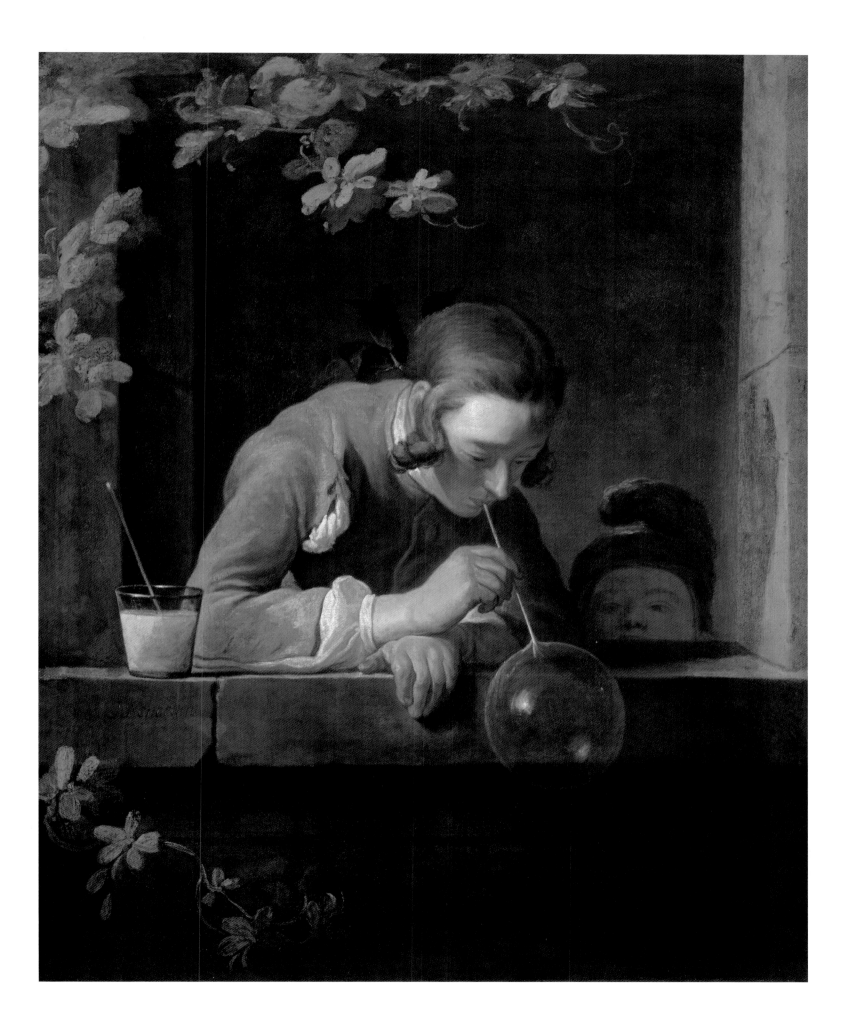

Jean-Baptiste-Siméon Chardin (1699–1779)

34 *The Young Draughtsman* 1737

81 × 67 cm

Staatliche Museen zu Berlin, Gemäldegalerie

An adolescent boy leans forward to support his left arm on the table in front of him, as he concentrates on sharpening with a knife the tip of a black crayon in a reed holder; a white crayon is inserted in the other end of the holder. Beneath his arm is a drawing, representing an old man's or a satyr's head, done in black crayon with white heightening on blue paper. The drawing sheet is supported by a portfolio, out of which a few other sheets of blue and white paper are projecting. The red ribbon of the portfolio, loosely looped, dangles down in front of the table, confirming the space between the edge of the table, set parallel to the picture plane, and the spectator. The youth, his hair carefully tied back with a bow, is rather elegantly dressed in a black tricorne hat and a cream tunic, which is protected by a blue apron attached to a button on his chest. As he leans forward on the drawing sheet, he risks smudging the drawing and blackening his sleeve. We cannot help noticing the simply jointed and pegged construction of the table, a reminder to us that Chardin's father was a cabinetmaker who specialized in the production of tables (see cat. 30).

The figure of the boy is placed in his pictorial space with the utmost care: the play of light and shade, the rhythms of horizontal, vertical, and above all diagonal lines being perfectly adjusted by the artist. All is balance, harmony, and careful regulation as he goes about his task in silent concentration. The contentment of the youth and his self-absorption are expressed not only through his avoidance of our gaze, but in the perfect equilibrium of the design, the subtle modulations of the impasted paint, rough and smooth, the delicate control of tonal values, and the muted harmonies of the palette. Paradoxically, Chardin engages the spectator's attention by the very reserve of his subject. The invitation is tacit, and Chardin, like his absorbed youth, conceals more than he chooses to reveal.

All indications are that Chardin himself was not a diligent draughtsman: only five drawings can be attributed to him with any certainty, and those date from very early in his career.[1] In his own practice, Chardin rejected the French academic tradition, deeply rooted as it was in the theory and practice of drawing. He seems not to have made drawings for his own pleasure or instruction, nor does his method of working seem to have required preparatory drawings. Rather, he painted in a somewhat intuitive way, directly applying his oils to the canvas or wood support, broadly speaking in the painterly, colouristic tradition begun in Venice in the sixteenth century.

Yet, for his subjects Chardin returned on numerous occasions to images of young draughtsmen, an academic theme *par excellence*,

almost as if he were seeking consolation for his own deficiency. Nor can we rule out the fact that his own son, Jean-Pierre Chardin (1731–1767/69) – a future prizewinner at the Academy in 1754 – was destined for a successful career as a painter (until his untimely death by suicide), and most likely had a crayon placed in his hand at an early date. One of Chardin's earliest genre paintings represents a *Young Student Drawing* (cat. 32), of which as many as seven versions from Chardin's hand are known or recorded. There are two versions of *The Young Draughtsman*: the present painting, exhibited at the Salon of 1737 and acquired ten years later for the collections of Frederick II of Prussia in Berlin and Potsdam, and a second version now in the Louvre, Paris, which was exported to England already by 1740.[2] These two examples alone illustrate how the demand for Chardin's pictures was an international one, even relatively early in his career. At the Salon of 1748, Chardin exhibited *The Study of Drawing* (see Le Bas's engraving, fig. 102), which, with its pendant *The Right Education*, was painted for Queen Luisa Ulrike of Sweden (the present whereabouts of the two original versions is unknown). He painted a second pair of these subjects for the great French collector Ange-Laurent de La Live de Jully (1725–1779), now respectively in the Fuji Art Museum, Japan, and the Museum of Fine Arts, Houston.

PC

Fig. 102 Jacques-Philippe Le Bas, after Chardin, *The Study of Drawing*, 1757. National Gallery of Art, Washington, D.C. Rosenwald Collection

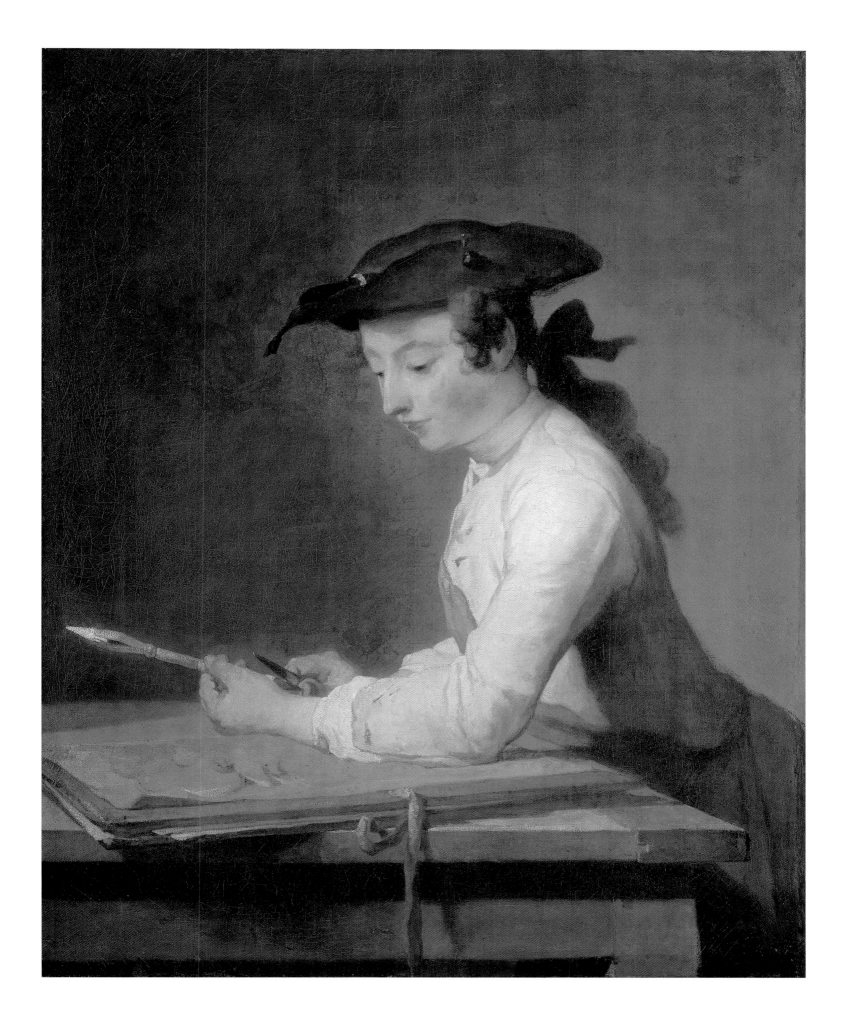

Jean-Baptiste-Siméon Chardin (1699–1779)

35 *The House of Cards* c. 1737

83 × 66 cm

National Gallery of Art, Washington, D.C.

Chardin made four variations on the theme of a boy building a house of cards, and all survive: at Nuneham Priory, Stanton Harcourt;[1] in the Louvre, Paris;[2] at the National Gallery, London (exhibited at the Salon of 1741);[3] and the present picture (exhibited at the Salon of 1737).[4] Of the four versions, only the Washington *House of Cards* is vertical in format, and it is arguably the most formally rigorous and fully realized of the group;[5] indeed it is one of the masterpieces of all Chardin's genre paintings. Surely, it was originally conceived as a pair with *Little Girl with a Shuttlecock* (fig. 103), dated 1737, of virtually identical dimensions and which also depicts a single three-quarters'-length figure.[6] They are both quite elegantly attired and coiffed, and they comport themselves with almost adult poise. The young boy is shown turned to our left, facing his equally youthful female counterpart, who is turned to our right. Both figures are positioned with arms slightly bent and extended: the boy as he delicately adjusts one more folded card in his v-shaped wall of cards; and the girl as she lets droop with her right hand a wooden battledore, while with her left hand she absently rests an unused shuttlecock on the raised knob of a wooden chairback. Chardin perfectly balances his carefully disposed forms – within each picture and reciprocally – with tenderly observant images of familiar childish demeanour.

The earliest history of these two masterpieces is not known, but they were almost certainly purchased together by Catherine the Great in the 1770s, as they are described in a catalogue of the Russian imperial collections compiled in 1774 or a few years thereafter;[7] they most likely hung together before *Little Girl with a Shuttlecock* was sold by Tsar Nicholas I in 1854. Replicas of both paintings are in the Uffizi, Florence, but scholarly consensus attributes them to a studio copyist, although they bear what appears to be Chardin's signature.[8]

The intricate psychological interplay between the Washington *House of Cards* and the private collection *Little Girl with a Shuttlecock* supports their pairing.[9] A subtle narrative links them. The gaze of the girl seems rather wistfully fixed on the same object as the boy's. It is as though Chardin has captured her resignation: she must wait patiently while her potential playmate finishes his solitary task; but she must also remain poised and ready to attract his attention with the racquet and shuttlecock she will at any moment wave before him by way of invitation. The boy wears a work apron: is he distracted from his proper business by this construction of cards? Are the coins on the table meant to suggest that a more adult game of gambling has taken place earlier, as the boy innocently and absorbedly bends the cards for his childish amusement? Chardin left nothing to chance, so the presence of a knave or jack (*valet* in French) of hearts facing us in the open drawer is unlikely to have been a random choice.

The verses appended to the engravings of *House of Cards* and *Little Girl with a Shuttlecock* add a moralizing note which may not have been intended by Chardin, but the lines were added perhaps to give the prints a wider popular appeal.[10] The engraver, Pierre Aveline (1702–1760?), lifted his quatrain from that on Nicolas-Bernard Lépicié's 1743 engraving after the London *House of Cards*: "Charming child, beguiled by pleasure, / We smile smugly at your frail *travaux*: / But, between us, which is the more solid / Our endeavours or your *châteaux*?"[11] This suggestion that no human undertaking is any more solid than the boy's house of cards can of course be applied to affairs of the heart. The legend on Lépicié's engraving after *Little Girl with a Shuttlecock* underlines her childish innocence: "Without cares, without sorrows, tranquil in my desires / A Racquet and a Shuttlecock provide all my pleasures."[12] The implication surely is that more adult desires and pleasures will bring her care and sorrow enough. Her tender look towards her companion, and the presence of the knave of hearts in his picture, perhaps also anticipate the first stirrings of adult desire – but her shuttlecock, so easily carried by the wind, is, like the house of cards, another emblem of the uncertainties and vagaries of love. Moreover, we are aware – just, discreetly – of the sexual difference between Chardin's two protagonists. There is almost a disconnection between their sexual potential (without, as yet, sexual awareness) and the childhood games they play.[13]

While the activity and objects depicted by Chardin can be read as emblematic of the *vanitas* theme,[14] unlike the captioned engraving, the painting itself does not necessarily demand such a moralizing reading. For Rosenberg, Chardin's concerns were formal and emotive, expressing the "latent poetry in the young man's diversion, not an allegory of vanity."[15] For Michael Fried, Chardin's concern was with the absorptive state of his young protagonist, "an unofficial morality according to which absorption emerges as good in and of itself."[16] Any significance we may project onto the image remains as legitimate as the next: or we may simply choose to share in the silent concentration of this young boy, whose intent gaze we cannot help but mimic with our own.

PC

Fig. 103 Jean-Baptiste-Siméon Chardin, *Little Girl with a Shuttlecock*, 1737. Private collection

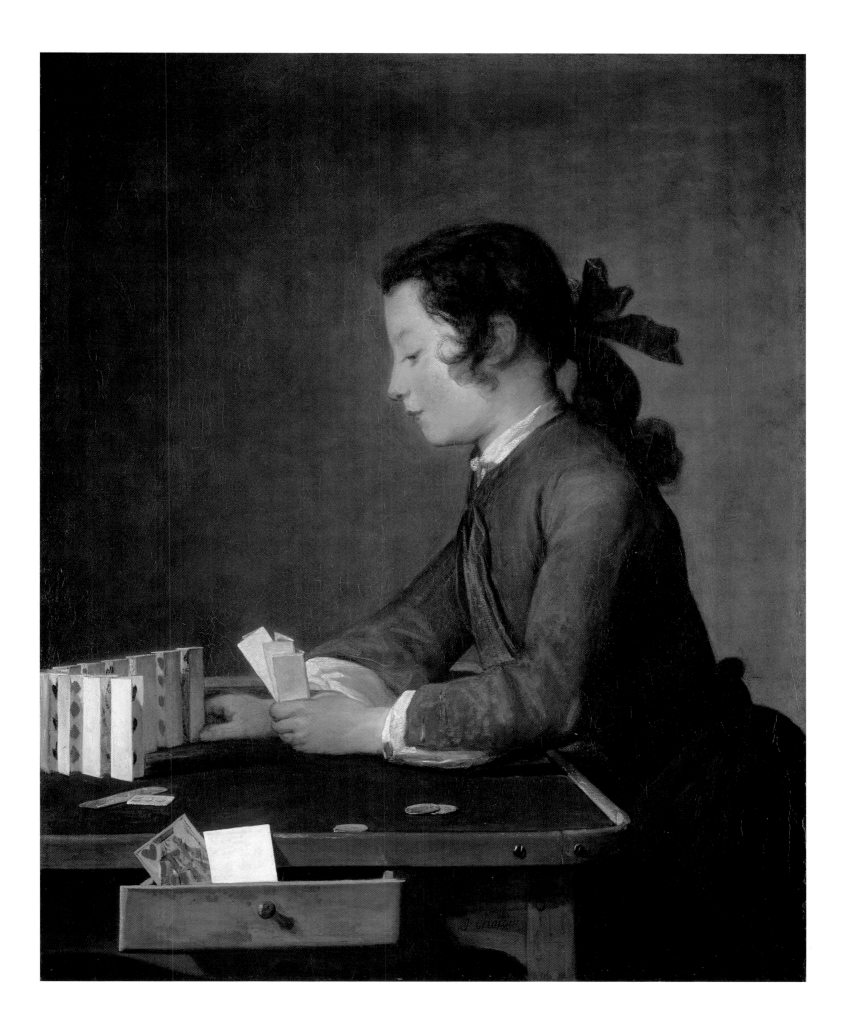

JEAN-BAPTISTE-SIMÉON CHARDIN (1699–1779)

36 *The Scullery Maid* 1738 (?)

47 × 38 cm

The Corcoran Gallery of Art, Washington, D.C.

Three versions of this subject are known: the present work; one destroyed with much of the Henri de Rothschild collection during World War II; and a third in the Hunterian Museum and Art Gallery, University of Glasgow, bequeathed by Dr. William Hunter (1718–1783) in 1783.[1] The former Rothschild picture, apparently undated, first belonged to the Comte de Vence in the eighteenth century – later to Madame de Pompadour, and then to her brother, the Marquis de Marigny – and was the version engraved by Charles-Nicolas Cochin (1688–1754) in 1740: therefore it was most likely the version exhibited at the Salon of 1738 (no. 23); it was exhibited again, as from the Vence collection, at the Salon of 1757 (no. 34). The Rothschild picture had a pendant, *The Cellar Boy*, also undated, which escaped destruction and has recently been rediscovered in a private collection in England.[2] The Glasgow picture is dated 1738 and was possibly acquired by Hunter on a trip to Paris in 1748, along with its pendant, another version of *The Cellar Boy* (fig. 104). It is not known if the Corcoran *Scullery Maid* ever had a pendant, but a single picture of this subject is recorded in a couple of eighteenth- and early-nineteenth-century sales.[3]

The exhibited *Scullery Maid* bears both a signature and date in the area between the woman's face and the top of the barrel, but they have sunk into the background and are very difficult to read in normal viewing conditions. The date is certainly *17*, followed by a *3* or a *5* (the lower loop of the digit is legible), the last digit is possibly an *8*: reason and logic suggest that this should read *1738*, the year the Vence picture was first exhibited and the date of the Glasgow version. The Glasgow and Washington paintings are identical: in the Vence version, engraved by Cochin, a flat dish and a knife are set on the floor at lower right, but these are replaced in the two dated pictures by a small casserole.

The Scullery Maid is one of Chardin's genre subjects of the 1730s which seem to grow out of his early still-lifes with familiar kitchen objects: it is as if the maid has walked into one of his assemblages of pots and pans. The composition is arranged with exquisite care; the maid is perfectly poised, looking out somewhat distractedly to our left. It is difficult to believe that Chardin conceived the Corcoran picture without a pendant *Cellar Boy*, because in the Hunterian and ex-Rothschild pairs the compositions, the leaning figures, and their gazes from one pictorial space into the other, so to speak, are so mutually complementary. The distinctively granular quality of Chardin's pigments, his employment of a characteristic thick impasto, and an almost laboured look to his handling, were noticed and appreciated – but sometimes criticized – by his contemporaries. A negative view comes from the great connoisseur – albeit with a conservative, classical taste – Pierre-Jean Mariette (1694–1774), who observed that, "The pictures of M. Chardin have too much feeling of

hard toil and difficulty. His touch is heavy and not at all varied. His brush has no facility."[4] We might say that "facility" was never the point, and that it is the very qualities of a forthright application and an intensely meditative type of execution that we, along with Chardin's contemporary admirers, find most engaging in subjects such as *The Scullery Maid*. These are qualities that set the work of Chardin apart from so much contemporary painting, as exemplified, for example, by the luscious, *léché* (licked) works of a de Troy (cat. 24–28) or a Boucher (cat. 50–55) in this exhibition. It was a more sympathetic critic (but not necessarily more perceptive than Mariette) who observed in 1738, when he saw versions of *The Scullery Maid* and *The Cellar Boy*, along with the Stockholm versions of *The Embroiderer* and *Young Student Drawing* (see cat. 31 and 32) exhibited at the Salon, that Chardin had a very expressive and individual way of painting these relatively unrefined subjects: "His manner of painting is all his own. It not a case of finished outlines, nor of a fluid touch; on the contrary, it is brutal and rough. It seems as if the strokes of his brush are exaggerated, and yet his figures are of a striking realism, and the singularity of his manner only makes them more natural and spirited."[5]

Chardin seems to have employed the same female model as in *The Scullery Maid* – perhaps a member of his own household – in several of his genre pictures of the mid-1730s, including *The Kitchen Maid* (cat. 37), *The Return from the Market* (cat. 38), and *The Governess* (cat. 39) in this exhibition. We know that he could not work without a model of some kind – still-life or figure – and it makes every sense that he should turn to those around him: Madame Chardin (for example, in *A Lady Taking Tea*, 1735; Hunterian Museum and Art Gallery, University of Glasgow), servants in his household, or the children of his friends (see *The Little Schoolmistress*, cat. 40).

PC

Fig. 104 Jean-Baptiste-Siméon Chardin, *The Cellar Boy*, 1735. Hunterian Museum and Art Gallery, University of Glasgow

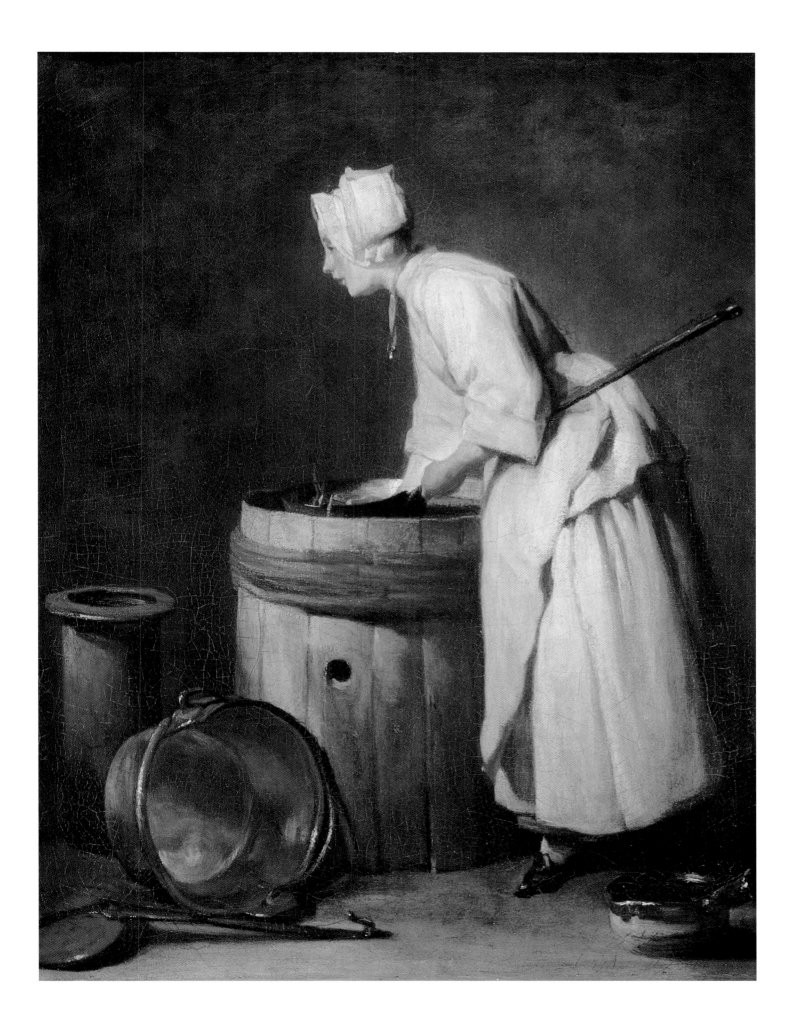

JEAN-BAPTISTE-SIMÉON CHARDIN (1699–1779)

37 *The Kitchen Maid* 1738

46.2 × 37.5 cm

National Gallery of Art, Washington, D.C.

Chardin exhibited this work at the Salon of 1739 as *La ratisseuse de navets* ("woman scraping turnips"); but among the various titles given the picture since then, we have retained the one currently employed by the National Gallery of Art. It shows a young kitchen maid seated on a low chair, pausing in her task to look abstractedly out of the picture to the viewer's right. On the floor are assorted vegetables, a pottery bowl of peeled turnips floating in water, two copper cooking pots, and a simple butcher's block fashioned from the trunk of a tree. A meat cleaver is lodged in the block, and a smear of blood beside it brings an unexpected suggestion of violence to this moment of reflection in a quiet domestic scene. As befits the humble subject and location "below stairs," Chardin's handling is thick, his pigments granular, his palette earthy. We have cited already (see *The Scullery Maid*, cat. 36) one contemporary critic who admired the singular technique of comparable works by Chardin exhibited at the Salon of 1738.

Chardin painted at least three versions of this composition. The Washington canvas is signed and dated 1738; a signed example is in the Alte Pinakothek, Munich; another, also signed, was acquired in 1746 by Count Friedrich Rudolf von Rothenburg for Frederick II of Prussia (lost since 1918); a fourth picture, in the collection of the Rijksdienst Beeldende Kunst in the Netherlands, is thought by Pierre Rosenberg to be a studio copy.[1] The existence of four known versions of the *Kitchen Maid* attests to the success of this image. The Washington canvas was almost certainly acquired by the Prince of Liechtenstein during his ambassadorship to Paris between 1737 and 1741, along with the versions we exhibit of *The Return from the Market* (cat. 38) and *The Governess* (cat. 39). In 1979 Rosenberg convincingly argued that the Munich example served as the model for the reproductive print engraved by François-Bernard Lépicié in 1742 and announced in January 1743; it was probably purchased for the picture gallery of Prince Karl August von Zweibrücken by the painter Johann Christian Mannlich (1741–1822) sometime between 1775 and 1793.[2] It is of a quality close to the Washington *Kitchen Maid*, although their exhibition side-by-side in Paris in 1999 revealed that the Munich picture has suffered from an overly enthusiastic cleaning at some point in its history.[3]

Chardin exhibited *The Kitchen Maid* along with five other figure subjects at the Salon of 1739, and it is likely that the three works acquired by Liechtenstein were those described in the Salon catalogue as, "un petit tableau en hauteur representant la *Gouvernante . . .* autre, representant la *Pourvoyeuse . . .* la *Ratisseuse de navets.*" *The Return from the Market* and *The Governess* were hung as pendants at the Salon (vertically, one above the other); *The Kitchen Maid* was hung on its own, above a work by Lancret.[4] The prince most likely acquired his version of *The Kitchen Maid* during the same Parisian sojourn

when he purchased the two other pictures, but we do not know from whom. When the Washington *Kitchen Maid* was exhibited in 1739, it drew little attention from the critics – who were far more seduced by *The Governess* – although it was included in a passing comment: "Each of his works exhibited this year merits particular praise; above all, *The Governess* and *The Kitchen Maid.*"[5]

It seems that Chardin did not necessarily conceive his genre paintings to be paired in strict combinations. For example, the painter Silvestre had a *Return from the Market* alongside a *Scullery Maid* (see cat. 38 and 36) from the 1760s until their sale in 1811,[6] while another *Return from the Market* was once paired in the Zweibrücken collection with *The Kitchen Maid* now in Munich.[7] We find listed in the estate sale of Chardin's effects on 6 March 1780 a version of *The Governess*, with a *Diligent Mother* (see fig. 22) as its pendant.[8] These examples would seem to point to flexibility in pairing, almost a mix-and-match approach. Thus it is difficult to be absolutely certain if, when the Prince of Liechtenstein commissioned *The Attentive Nurse* (cat. 42) in about 1747, it was originally intended as a pendant to *The Kitchen Maid* or *The Return from the Market* (as Rosenberg, following Colin Eisler, believes), or *The Governess*; but we lean strongly towards the former, and state our case in the catalogue entry for *The Attentive Nurse.*

François-Bernard Lépicié's 1742 print after the Munich *Kitchen Maid* was accompanied by moralizing verses: "When our ancestors took from Nature's hands / These vegetables, proof of their simple way, / The art of making food into poison / Had not yet seen the light of day."[9] This quatrain brings to mind the more obviously emblematic Dutch and Flemish seventeenth-century models with which Chardin was certainly familiar. His awareness of the northern tradition is well illustrated in Ella Snoep-Reitsma's comparison of *The Kitchen Maid* with the mezzotint by Wallerand Vaillant of a woman peeling a pear,[10] or Eisler's likening of the Washington picture to Nicolas Maes' *Woman Peeling,*[11] engraved in Chardin's day as *L'Éplucheuse*. But is hard to know how far Chardin intended a didactic message, if at all, in paintings such as this one. For all that he represents a servant who is low on the social scale of domestic help, she is quite well dressed, and there is every appearance of order in her corner of the kitchen: she does not fall within the category of idle servants, common in Dutch art of the seventeenth century and taken up by Greuze in works such as *Indolence* (cat. 66), for example. But nor is she a model of industry: she pauses in her humble task, and we are invited to speculate about what might be passing through her mind as she stares distractedly out of the picture. This ambiguity of mood and meaning is typical of Chardin, and was perhaps a deliberate strategy quietly to engage the attention of the Salon visitor, just as much as it still intrigues the modern one. There is a sensuous quality in Chardin's execution, in the elegance of his design, and in his judicious choice of colours. It could be said that the beautifully crafted aspect of such a picture places it still within a Rococo esthetic. Chardin seems to have employed the same model – perhaps a member of his own household – in several of his genre pictures of the mid-1730s, including *The Kitchen Maid, The Scullery Maid* (cat. 36), *The Return from the Market* (cat. 38), and *The Governess* (cat. 39), in this exhibition.

PC

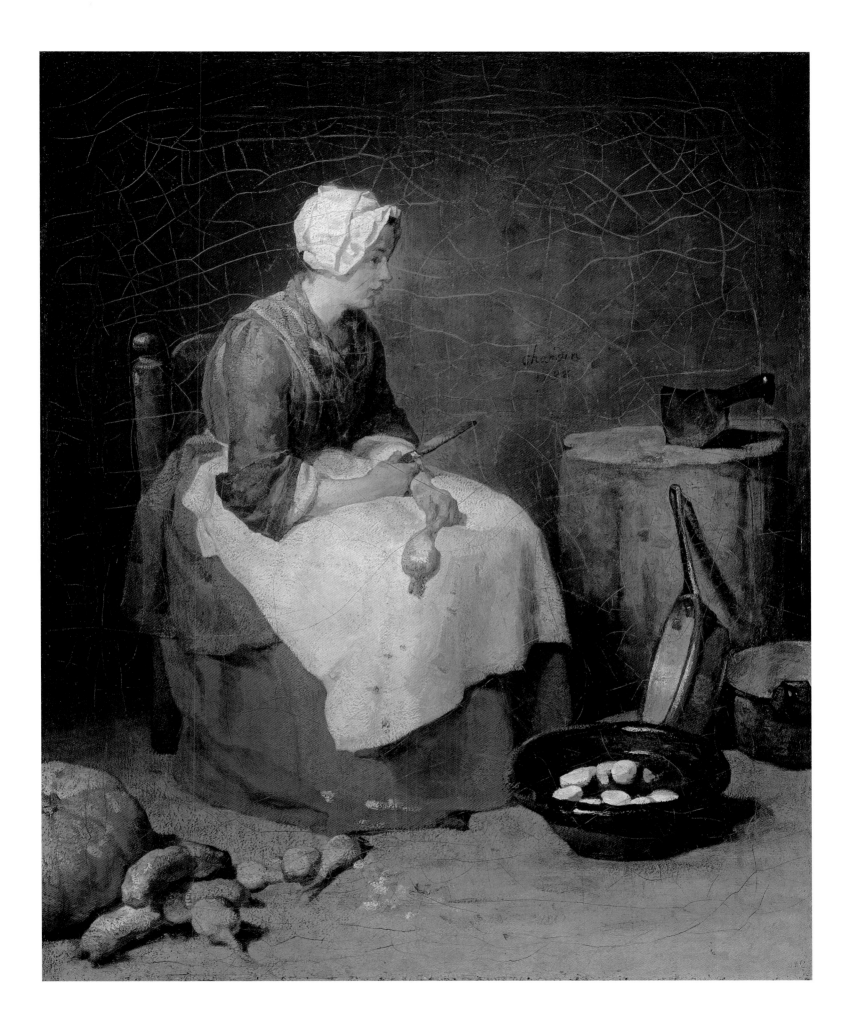

JEAN-BAPTISTE-SIMÉON CHARDIN (1699–1779)

38 *The Return from the Market* 1738

46.7 × 37.5 cm

National Gallery of Canada, Ottawa

A well-attired maid has returned from market to her clean and tidy pantry; she leans to place two large loaves of bread onto the dresser, while in her right hand she holds two bags, from one of which projects a leg of lamb. However, the turn of her head and her distracted expression indicate that her attention is drawn to the conversation taking place in the outer room, where a younger maid has opened a door to a male visitor: we can just see the corner of his hat, a glimpse of his face, and a small triangle of the blue sky outdoors. On a ribbon round her neck, the maid wears a portrait medallion or miniature, which dangles just over the top of her blue serge apron.

Most modern commentators have understandably focused on the formal qualities of this work: the monumentality of the figure of the maid, conferring on her a certain dignity; the perfect balance of the more-or-less pyramidal figure in relation to the space she occupies and to the familiar domestic objects around her; the dense, granular nature of the paint, so exactly matching the rude everyday utilitarian aspects of this workplace; the almost magical qualities of Chardin's execution, as he conjures up material substance, circulating in and around its tactile forms a marvellous ambience of air, light, and shadows.

When he exhibited this *The Return from the Market* at the Salon of 1739, Chardin was surely soliciting a double engagement of his audience: in both the manner and the matter of his art. His manner of painting is of the highest order for the paint-sniffing connoisseur, who will appreciate this artist's way with medium and pigment. For all that we are arrested by the simple power of the image from a distance – so necessary in the competitive clamour of the Salon exhibition – it is only up close that Chardin's touch yields its subtlest, most intimate pleasures. Then there is the matter, the narrative, often obliquely expressed, which we can only discern with another close look. It could be a vignette from Laurence Sterne, a practised follower of maids.[1] Has our maid been followed home? What is the nature of the inquiry at the door? Why is she so attentive to the incident in the next room? Is there a connection between the portrait miniature discreetly displayed – with an understated prominence, as it were – close to her heart? Thus Chardin solicited his public, with bold discretion, in the competitive arena of the Salon.

A measure of Chardin's success with this subject is the fact that he painted at least four versions of it: the exhibited painting; another, dated 1738 (Charlottenburg, Berlin); a third, dated 1739 (Musée du Louvre, Paris); the fourth known version was destroyed in World War II. The Ottawa painting, most likely the one exhibited in 1739, was in Liechtenstein by 1741; so it was probably the Louvre version that was engraved in 1742 by François-Bernard Lépicié (1698–1755; father of the painter of the same name, whose works are included in this exhibition, see cat. 96 and 97). Chardin's genre scenes were almost always engraved quite soon after they were shown at the Salon, which is another indication of their success with the public. Often the engravers added some verses to elucidate or to popularize the prints. On occasion these legends can aid the modern spectator in reading the period meaning of an image, but more often than not they can be misleading. In the case of Lépicié's verses appended to his engraving of *The Return from the Market*, it requires only common sense to see that they are not much help, indeed wide of the mark, as an interpretation of Chardin's image: "From your appearance, I note and conclude / My dear child, without calculation / That you take from the housekeeping / What you need to dress yourself."[2]

Michael Pantazzi[3] and Pierre Rosenberg[4] have established that the Ottawa version of *The Return from the Market*, exhibited in 1739, was first owned by a banker named variously "Despuech," "Despuechs," "Delpèche," and likely of the family Delpuech de la Loubière. It was acquired, perhaps directly from him, by Prince Joseph Wenzel of Liechtenstein, during the time he was Austrian Ambassador to Paris, from 1737 to 1741, along with its probable pendant, *The Governess* (cat. 39). The prince eventually owned four genre scenes by Chardin; he was but one member of the European royalty and nobility who had a passion for this artist, among others, such as Luisa Ulrike of Sweden (see cat. 41), Catherine the Great of Russia (see cat. 35), Frederick II of Prussia (see cat. 34), and Prince Karl August of Zweibrücken, as well as Louis XV and the Marquis de Marigny in France.

PC

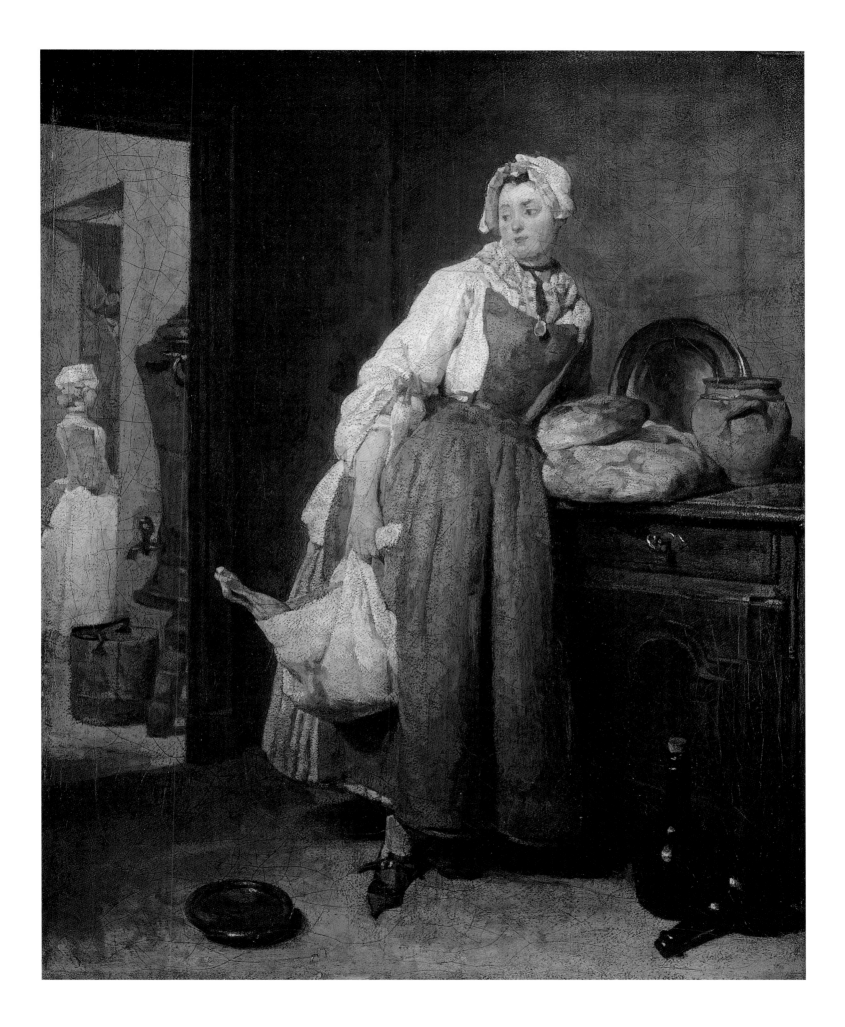

JEAN-BAPTISTE-SIMÉON CHARDIN (1699–1779)

39 *The Governess* 1739

46.7 × 37.5 cm

National Gallery of Canada, Ottawa

A nicely dressed young boy, lesson book tucked under his arm, stands before his seated governess, who pauses in brushing his tricorne hat to exchange words. From their expressions, the direct gaze of the governess and the downcast eyes of the boy, it seems she may be gently reprimanding him. Like generations before and after, the boy is perhaps reluctant to go off to his lessons, and would rather continue playing with his cards, or his racquet and shuttlecock, which lie prominently on the floor at the spectator's left. The contrast with the governess's workbasket at the right is deliberate: we have the choice to work or play. But, unlike his Dutch and Flemish predecessors of the seventeenth century, Chardin is not advocating a protestant work ethic, nor even moralizing too strongly. The emblematic details went unremarked by his contemporaries: they were certainly bearers of meaning, but a meaning somewhat tired by Chardin's time.[1] After all, we are witnessing a universal human confrontation, as accessible in its psychological tensions in our day as it was to the enthusiastic audience who appreciated this masterpiece at the Salon of 1739. Yet contemporary interpretations differed. For example, an anonymous critic writing in the *Mercure de France* with his own reading of the subject, noted the popularity of the picture: "The young schoolboy scolded by his governess for having soiled his hat is the piece which attracts the most praise."[2] Another described it as "*A Governess* listening to the lesson of a little boy, while brushing his hat, to send him off to class."[3]

We are in a spacious apartment, with rich but sober wall coverings in patterned silk or painted paper, and with a beautiful and characteristically French parquet floor; even the governess is quite well dressed. Chardin's friend Charles-Nicolas Cochin remarked of this painting that, in contrast with his earlier genre subjects (such as *The Scullery Maid*, cat. 36, or *The Kitchen Maid*, cat. 37), "His subjects are now more elevated by his choice of more refined persons."[4] The household is indeed affluent, but not ostentatious, and one senses it is well regulated: we do not see the conspicuous consumption represented in Boucher's pictorial world (cat. 52–54), nor the courtly opulence of the interiors inhabited by the characters of a Lancret (cat. 12) or a de Troy (cat. 25). The moral values discreetly expressed

in Chardin's work might be equally valued by the ordinary middle-class visitor to the Salon, by the affluent banker Delpuech (also named Despuech and Despuechs by contemporaries),[5] who was the painting's first owner, or by the foreign prince who took it home to Vienna in 1741. In other words, although it is difficult for us to be precise about the social standing of Chardin's cast of characters, the moral world they inhabit is a universal one.

According to Pierre-Jean Mariette (1694–1774), the painting was originally intended for the great collector and connoisseur – and guardian of Jean-Antoine Watteau's memory – Jean de Jullienne (1686–1766), before it was acquired by Delpuech. Mariette tells us also that it was *The Governess* "which made his reputation,"[6] and this is confirmed by the numerous favourable comments it drew from critics at the Salon, as well as the crowds of visitors it attracted.[7] An engraving by the elder François-Bernard Lépicié after *The Governess* was announced already in December 1739, only a few months after the Salon. In this case (unlike *The Kitchen Maid*, cat. 37), the legend appended to the print by Lépicié is close to Chardin's meaning: "His pretty face dissembles well / Obedience in all but name, / But I will bet his thoughts do dwell / On when he can resume his game."[8]

Both *The Governess* and *The Kitchen Maid* were exhibited at the Salon of 1739, and both passed rather soon thereafter from the collection of the banker Delpuech to that of the Prince of Liechtenstein. *Pace* Pierre Rosenberg,[9] it seems most likely to the present writer that these two paintings were paired by Chardin: the relation of the figures to the pictorial space, the spaces as defined by one room opening into another in the background, and the narrative involving more than one figure, all point in that direction. These words are chosen carefully, not to suggest that the two pictures were *conceived* as a pair, but to say that they were marketed as a pair. Chardin quite often paired the various versions of his genre paintings in different combinations – for more on this, see *The Kitchen Maid* (cat. 37).

PC

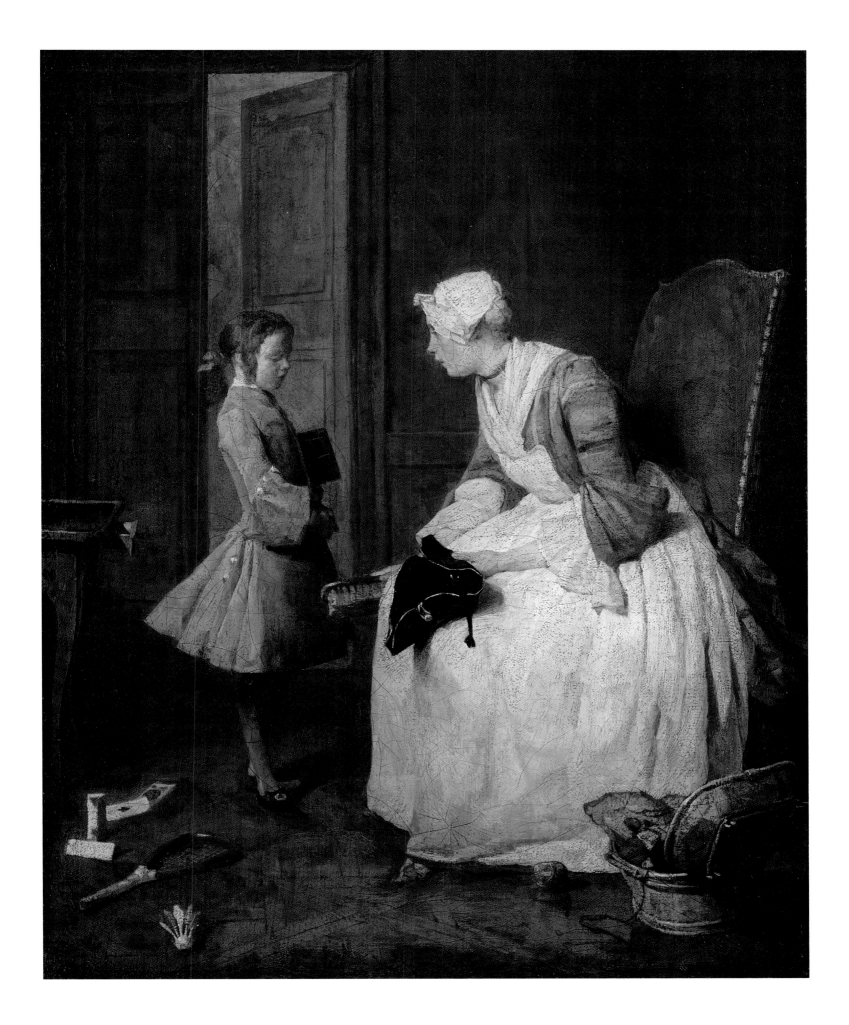

Jean-Baptiste-Siméon Chardin (1699–1779)

40 *The Little Schoolmistress* c. 1740

61.5 × 66.5 cm

The National Gallery, London

Chardin exhibited a version of *The Little Schoolmistress* at the Salon of 1740 (no. 62: *La petite maîtresse d'école*), along with two other moralizing genre scenes, *The Diligent Mother* (fig. 22)and *Saying Grace* (fig. 14), and a pair of long-lost satirical *singeries*. The broader dissemination of the image was assured through its engraved replication in a print released by François-Bernard Lépicié that same year. Subsequent demand for this composition is documented by the appearance of several versions in sale catalogues of the eighteenth century. There are three extant versions of *The Little Schoolmistress*: the present painting; an unsigned canvas in the National Gallery, Dublin;[1] and the signed painting in the National Gallery, Washington, D.C.[2] There are four references to versions of *The Little Schoolmistress* in eighteenth-century sale catalogues (which cannot be identified with any one of the three known paintings with certainty), but in all four sales a horizontal version of *Soap Bubbles* (cat. 33) was the pendant.[3]

In his 1979 exhibition catalogue, Pierre Rosenberg describes the London *Little Schoolmistress* as "by far the best and the only one whose attribution cannot be disputed." He then goes on to argue that it "is most likely the painting figuring at the Salon of 1740 and engraved by Lépicié that same year."[4] But is the London version indeed "most likely" the painting Chardin exhibited in 1740? While the London canvas is by far the superior surviving version of this subject, small discrepancies between it and Lépicié's print might give us pause. The painting does not appear to have been cut down, and yet it shows less of the image than is depicted in the print: notably, the print shows more of the woman's dress and the lower part of the cabinet.

As is true of some of Chardin's other figure paintings dating between 1737 and 1742, *The Little Schoolmistress* may depict specific individuals. Recent scholarly opinion tends to see this picture and *The House of Cards*, in the same collection, as pendants – not least because Lépicié engraved them as such.[5] The title given to *The House of Cards* exhibited at the Salon of 1741 was "The son of M. Le Noir, amusing himself by building a house of cards," which has led Marianne Roland Michel to suggest that the young girl may be another of the Le Noir children, an argument we find convincing.[6] Chardin was notoriously dependent on the model, whether still-life or figure. However, his conception of the subject invests *The Little Schoolmistress* with meanings broader than the limitations of portraiture, crossing pictorial categories, as it were, between portraiture and genre.

The theme, an understated moral exemplar, is reminiscent of the seventeenth-century Dutch and Flemish genre paintings much admired in Chardin's time, such as Gerard Terborch's *The Reading Lesson* (Musée du Louvre, Paris). Chardin's painting surely does not convey the kind of sly meaning insinuated by the verse appended by Lépicié to his engraved replication: "If this charming child puts on so well / The serious air and imposing demeanour of a schoolmarm / May one not think that such dissemblance and deception / Are granted to the fair sex at birth."[7]

Whichever version or versions of *The Little Schoolmistress* were paired with *Soap Bubbles* in the eighteenth century, it is quite possible that they were conceived as contrasting pendants representing "industry" and "idleness" respectively. The governess is usefully employed in teaching the younger child to read, while the youth blowing bubbles (or building a house of cards, see cat. 35) is squandering his time on a trivial pursuit. Moreover, in *Soap Bubbles*, the smaller child is watching an idle, time-wasting activity: his counterpart in *The Little Schoolmistress* is, by contrast, observing a virtuous example.

But Chardin wears his didacticism lightly. In *The Little Schoolmistress* he characteristically orchestrates the slightest details of dress and demeanor, gesture and expression, capturing perfectly a typical scene of sibling interaction. Chardin's choice of moment is also characteristic: the little boy struggles silently before attempting to pronounce the next letter in the alphabet, which his big sister so punctiliously indicates with her knitting needle. She waits with exaggerated patience, her eyes resting fixedly on her little brother's downcast face, as if willing him to utter the answer she can barely hold back from her own slightly parted lips. It is precisely the kind of still moment in a narrative that Chardin loved to paint. The text is that of everyday life. Relative visibility and scale are used for expressive ends. The slightly blurred and abbreviated handling of the boy's face offers a visual analogy to the vagaries of a young child's thinking, while the sharp and comparatively clean articulation of his sister's profile well communicates her clear comprehension. As always, Chardin's tender regard for his subject never strays into sentimentality. The correspondence of the pointing right hands of teacher and pupil is in itself enough to elicit the viewer's empathetic response.

PC

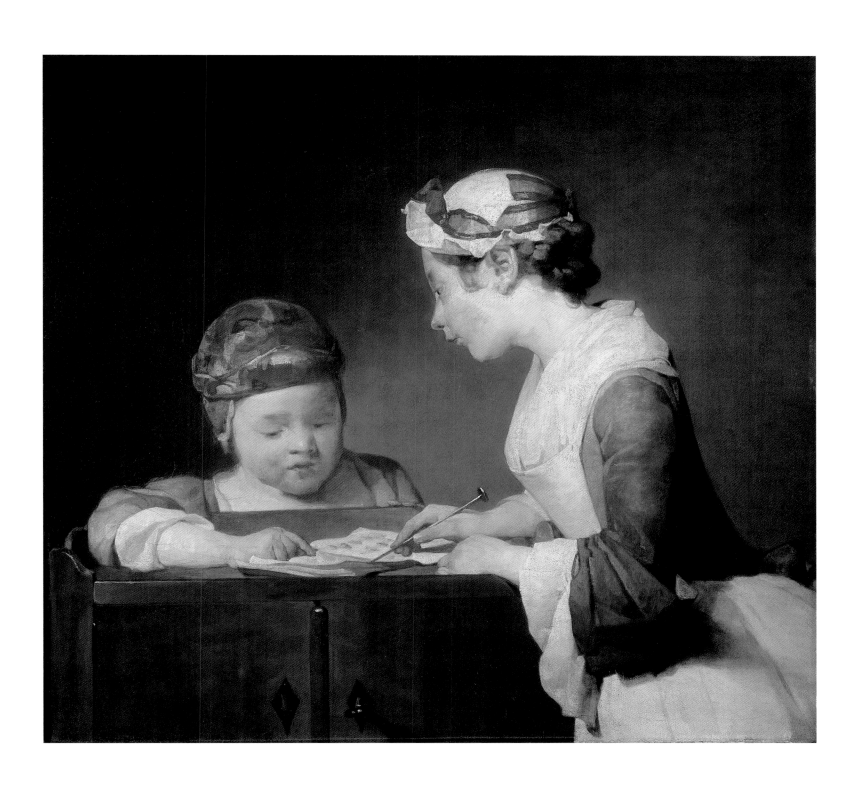

Jean-Baptiste-Siméon Chardin (1699–1779)

41 *The Morning Toilette* c. 1741

49 × 39 cm

Nationalmuseum, Stockholm

A mother and daughter stand before a dressing table as the mother slips a final pin into the ribbon on the little girl's bonnet. They are both elegantly and warmly dressed to go out, the mother already caped and hooded, with her red and white striped dress tucked up to reveal her underskirt. The girl clutches a fur-lined muff; the woman's muff lies on the red-covered stool to the left, next to a missal, which indicates that their destination is church: the clock in the background shows about five minutes to seven, so it is probably an early mass. Pierre Rosenberg has pointed out that this clock, standing on a rather fine cabinet, could be one owned by Chardin himself, and described in an inventory taken after the death of his first wife in 1737: "A clock with an enameled copper face in its marquetry frame, decorated in bronze, made in Paris by Fiacre Clément."[1] A pewter pot for hot water sits on the marquetry floor in the right foreground, as much as anything a means of marking the pictorial space – a device frequently employed by the artist.

Chardin shows a moment of tender parental solicitude suggested by the movement and delicate sloping form of the mother, but hints also at the girl's nascent vanity, as she glances coquettishly into the mirror on the dressing table. This was not missed by the critics, nor by the poet Charles-Étienne Pesselier (1712–1763), a friend of Chardin's, who added innocuous verses to the engraving by Jacques-Philippe Le Bas (1707–1783) published the same year: "Before Reason enlightens her, / She follows the mirror's seductive counsel. / In the desire to please and the art of pleasing, / The fair ones, I see, are never children."[2] The mirror, the extinguished candle with its faint trace of dying smoke, and the various silver boxes of a toilette service on the dressing table are gentle reminders of the *vanitas* tradition. As in *The Governess* (cat. 39) of 1739, Chardin has taken us "upstairs" into the elegant but well-regulated world of the Parisian bourgeoisie, where an exemplary mistress of the household tends with loving care to the interests of her growing child.

The Morning Toilette was lent to the Salon of 1741 by Carl Gustav Tessin (1695–1770), Swedish Ambassador to Paris and the picture's first owner. Tessin was a passionate amateur of contemporary French art, which he collected for himself, but he also acted as agent for Princess Luisa Ulrike, later Queen of Sweden, and for Crown Prince Adolphus Frederick. The fruits of much of their patronage of French painters can be enjoyed today in the Nationalmuseum and the surviving apartments in the royal palace in Stockholm. Their favoured artists were Nicolas Lancret (cat. 12), Jean-Baptiste Oudry (see cat. 43), François Desportes (1695–1774), François Boucher (cat. 54), and Chardin, who is represented by eight works in the Nationalmuseum (all genre scenes except for one still-life), along with a pair of studio copies ordered by Tessin, after *Saying Grace* (*Le Bénédicité*) and *The Diligent Mother* (*La Mère laborieuse*) in the collection of Louis XV.[3]

The Morning Toilette drew the praise of critics at the Salon, who admired above all the psychological niceties of the scene. One anonymous commentator made often-quoted but nonetheless intriguing observations about Chardin's audience: "In this same section there is one of the subjects of M. *Chardin*, in which he has painted a mother who is arranging the hair of her little daughter. It is always the *Bourgeoisie* whom he calls into play. . . . There is not a woman of the Third Estate who doesn't fancy that she is seeing an image of herself, her home life, her simple ways, her bearing, her daily occupations, her morals, the moods of her children, her furniture, her wardrobe."[4]

There is no reason to doubt that these observations do reflect the reality of at least some contemporary responses to Chardin's art. Surely, there was many a *bourgeoise* who joined the crowds at the Salon to admire such paintings by Chardin, and perhaps for the suggested reason of a certain self-recognition. Moreover, although she likely would never acquire a painting, she could always buy an impression of the engravings, which – with the exception of *The Attentive Nurse* (cat. 42) – were always made after Chardin's genre scenes. We might think at first that the socially rather elevated household depicted by Chardin in *The Morning Toilette* would appeal especially to the sophisticated Swedish courtier Tessin. For his crown prince back in Stockholm, Tessin also purchased, at the Antoine de La Roque sale in 1745, two of Chardin's most down-to-earth genre scenes, *The Washerwoman* and *The Water Urn* (both Nationalmuseum, Stockholm).

PC

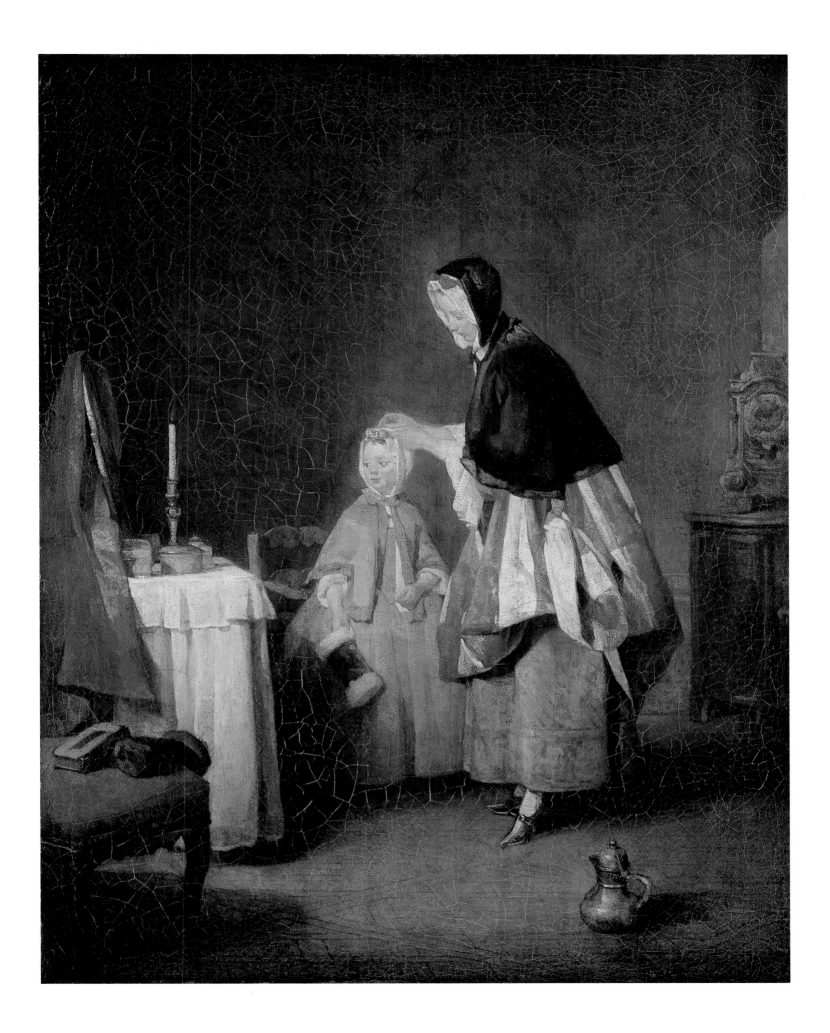

Jean-Baptiste-Siméon Chardin (1699–1779)

42 *The Attentive Nurse* 1747

46 × 37 cm

National Gallery of Art, Washington, D.C.

The Attentive Nurse or the Nourishment of Convalescence (*La Garde Attentive ou les Aliments de la Convalescence*), as it was exhibited in 1747, is one of Chardin's most refined and exquisitely finished paintings. A maid, performing the duties of a nurse, is shown at full length, peeling the shell from a boiled egg she will serve in the next moment to the unseen convalescent. Equal pictorial attention is given to the maid's delicate operation and the stunningly beautiful essay in white Chardin has presented to us in the prominent still-life at her side.

Among contemporaries, only the abbé Leblanc, in his review of the Salon of 1747, to which Chardin submitted just this one work, bothered to mention the painting, and then in rather general terms, admiring his "art of treating familiar subjects without commonness. . . . He has a manner that belongs only to himself and that is full of truth."[1] However, *The Attentive Nurse* was dispatched to Vienna, there to join the Prince of Liechtenstein's three other genre paintings by Chardin, immediately after its brief appearance at the Salon.[2] No time was allowed for the production of an engraving after *The Attentive Nurse*, perhaps because of the impatience of the prince to receive his new treasure.

In the *livret* of the 1747 Salon, we are told: "This painting forms the companion piece to another by the same artist which is in the collection of the prince of Liechtenstein and which he [Chardin] could not borrow along with the two others that left a short time ago for the Swedish court."[3] We know that during his 1737–41 stay in France as ambassador for the Austrian Emperor Charles VI, the prince had snapped up three versions of Chardin's well-known genre inventions: *The Kitchen Maid* (cat. 37), *The Return from the Market* (cat. 38), and *The Governess* (cat. 39). But for which of these three paintings did Chardin intend *The Attentive Nurse* as the "companion piece" mentioned in the *livret*? In 1979 Pierre Rosenberg asserted that "only *The Return from the Market* could pass for the companion piece to *The Attentive Nurse*," presumably because, of the three choices, only *The Return from the Market* features a full-length, standing woman. Rosenberg also dismissed as "impossible from the point of view of style," Eisler's suggestion that *The Attentive Nurse* must date from the same year as this supposed pendant, arguing instead that *The Attentive Nurse* must date from 1747.[4] We agree with Rosenberg's dating on stylistic grounds, but believe rather that it was painted as a companion to the 1738 *Kitchen Maid*.

Thematic and formal interplay abounds between the two images. Both women, in enclosed interiors, perform a quotidian kitchen task of food preparation. The more refined dress and type of activity in *The Attentive Nurse* contrast starkly with the coarser clothes and more humble chore of *The Kitchen Maid*. The engrossed expression of the nursemaid standing properly tall in her blouse sprigged with soft pink flowers and her striped skirt, beneath which peeks a pair of elegant blue mules, cannot be further from the turnip-scraper's evident lack of interest in the work at hand, as she sits awkwardly hunched forward in her serviceable maid's dress. The seated kitchen maid has paused in her chore, and looks distractedly out of the picture to our right. In both images, Chardin has left flecks of raw paint on the surface of the canvas to represent the unwanted waste of tiny bits of eggshell and turnip peel. In *The Kitchen Maid*, the paint is brushed broadly, at times roughly onto the canvas surface – which is characteristic of Chardin's handling in the 1730s. In *The Attentive Nurse*, his touch is more polished and softly blended, both attributes of his more refined style of the mid-to-late 1740s. The careful glazes Chardin applied in *The Attentive Nurse* seem to add to the woman's decorously controlled, more bourgeois demeanor, just as the coarser facture of the turnip-scraper's plain apron seems more appropriate to the woman's work-aday existence. While there are some inconsistencies in the artist's/spectator's viewpoints, we should remember that the two works were painted almost a decade apart, although Chardin could have had another version of *The Kitchen Maid* to hand in 1747. But the reader of our entry for this last picture (cat. 37) will see that there were no hard-and-fast rules for the pairing of Chardin's genre scenes, and it can be difficult to offer conclusive answers to such questions.

Chardin produced no replica of *The Attentive Nurse*, no doubt for the same reason it was not engraved: namely, its peremptory delivery to Vienna. There exists an oil sketch (fig. 105) – a rarity in Chardin's extant work – for the composition of *The Attentive Nurse*, which corresponds broadly to the Washington painting, but also differs in several fundamental respects. In the boldly executed sketch, the cropped fireplace is depicted at the other side of the canvas; a dark water jug sits at the woman's feet and not on the table; there is no earthenware boiling pot on the floor. What purpose did this sketch fulfil? Rather than the independent *ébauche* suggested by Rosenberg,[5] surely it is a preparatory *première pensée* as Marianne Roland Michel has proposed,[6] wherein Chardin has worked out the main elements of the composition and established the balance and contrasts of light and shade, the pale-toned figure and table setting, and the ambient shadows, which are so subtly modulated in the final work.

PC

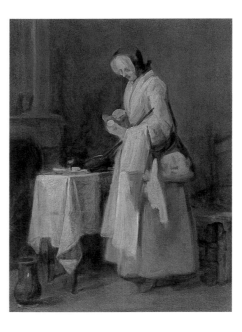

Fig. 105 Jean-Baptiste-Siméon Chardin, *Study for the Attentive Nurse*, 1747. Private collection

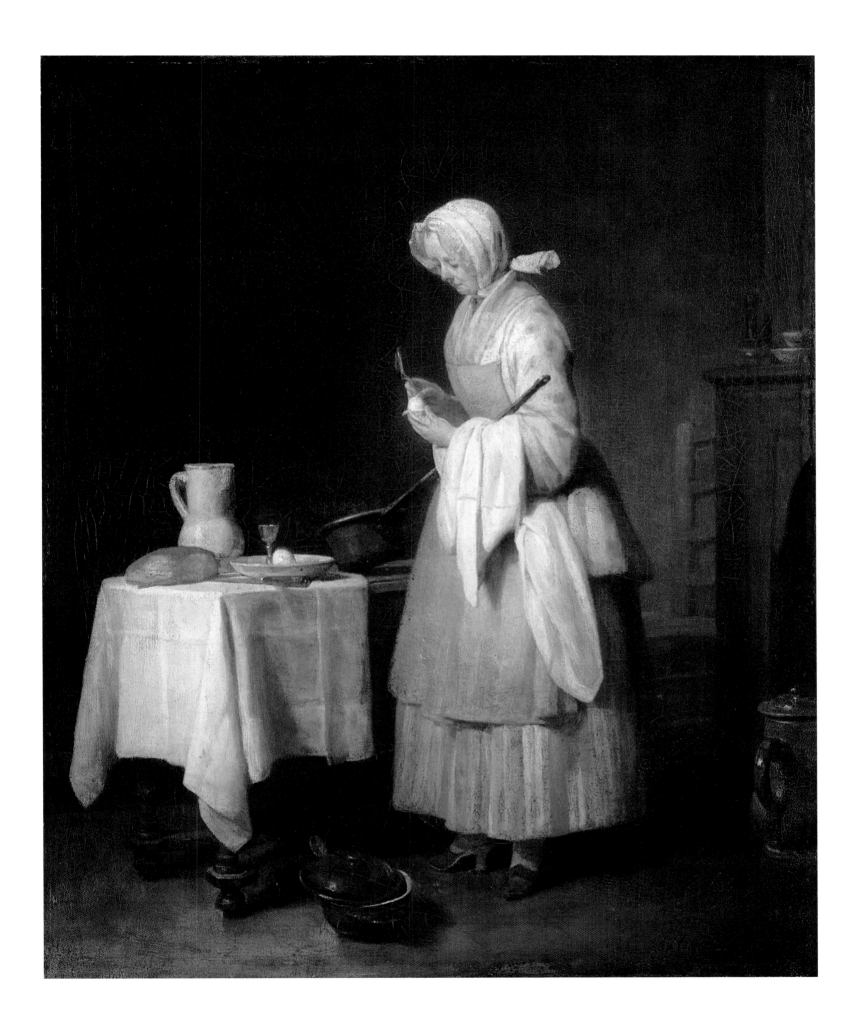

Jean-Baptiste Oudry (1686–1755)

43 *Lice Feeding her Pups* 1752

103 × 132 cm

Musée de la Chasse et de la Nature, Paris

During his five-year apprenticeship at the Académie de Saint-Luc under the tutelage of the renowned portraitist Nicolas de Largillière, Oudry once completed a painting of a hunter and his dog, upon which his teacher commented, "You will never be anything but a painter of dogs!"[1] Son of an artist and art dealer, Oudry had already made a name for himself by that time with his portraits. On a visit to Paris in 1717, Peter the Great had requested to be portrayed by the young artist. Delighted with the final product, the Tsar wanted to bring Oudry back to Saint Petersburg,[2] but this never came about. In 1719, Oudry was received into the Académie royale as a history painter.

Over the next two decades, he would replace Alexandre-François Desportes and earn the reputation as the foremost animal painter in France. Through his acquaintance with Louis Fagon, Intendant des Finances, and the Marquis de Beringhen, Premier Écuyer du Roi, Oudry secured a series of royal commissions. Louis XV was a passionate hunter, and as can be seen in his letter to the Comte de Toulouse in 1729, vigilantly saw to his hunting dogs with an almost paternal attention: "*Mascarade* having been mounted by *Polydore* on the 23rd of July, gave birth on the 21st of September to six pups: six *lices*.[3] *Noblesse* having been mounted on the same day, only gave birth on the 26th to one pup and two *lices*. . . . My little *Gredinet* is limping due to a chase yesterday after partridges, hares, rabbits, and deer in the *Parc de La Muette*."[4] Oudry became one of the King's preferred painters, and for the remainder of his career retained the monopoly on royal commissions for hunting scenes as well as portraits of the King's favourite hunting dogs, which served to decorate the royal palaces.

Lice Feeding her Pups, depicting a mother hound nursing her young, was not a royal commission, however. The work was exhibited in the Salon of 1753 when Oudry was nearing the end of his prolific and successful career. The painting was a favourite at the Salon, and was seen to exemplify a masterful reproduction of nature and consummate handling of perspective and chiaroscuro. In his review of the Salon, Pierre Estève wrote: "A ray of light shines onto the head of the mother bringing it forth. The rest of the body is in the shade and of a truly natural colour. The little pups do not yet appear properly licked, and still have that sort of coating that they wear at birth."[5] A second critic, possibly Charles-Nicolas Cochin, claimed that within the work "illusion is brought to the highest point that painting can reach, the effect is stunning and of a singular force, without us seeing any black, nor any total deprivation of light, through the science with which the lighting is treated."[6]

An interesting comparison has been made by Hal Opperman between this picture and Rembrandt's *Holy Family* of 1640, in which the holy mother sits breastfeeding her child, illuminated by a beam of light from a window. Although it is unlikely that the atheist *philosophe*, the Baron d'Holbach, author of *Système de la Nature* (1770) and *Le Christianisme dévoilé* (1767), who purchased *Lice Feeding her Pups* at the Salon of 1753, would have been aware of it, the anthropomorphic projection onto dogs was at the time quite common. While discussing the specific attributes of a dog in his *Histoire Naturelle* (1755), Buffon claims that it is not the exterior but rather the interior qualities of sentiment and spirit that elevate a being: "It is through them that he differs from the mechanical, is elevated above the vegetal, and draws nearer to us."[7] The female dog's feelings did not escape Salon goers, however: Estève comments, "We read in the eyes of the mother a maternal care, typified by the paw that she holds above one of her pups, for fear of hurting it."[8]

Oudry's painting had considerable sentimental appeal to the hearts of contemporary viewers. Today, it may appear at first glance to be little more than a pretty and well-crafted painting. But it can also be appreciated as an intriguing representation of motherhood, affording an insight into the elevated status and role of the hunting dog during the reign of Louis XV.

AF

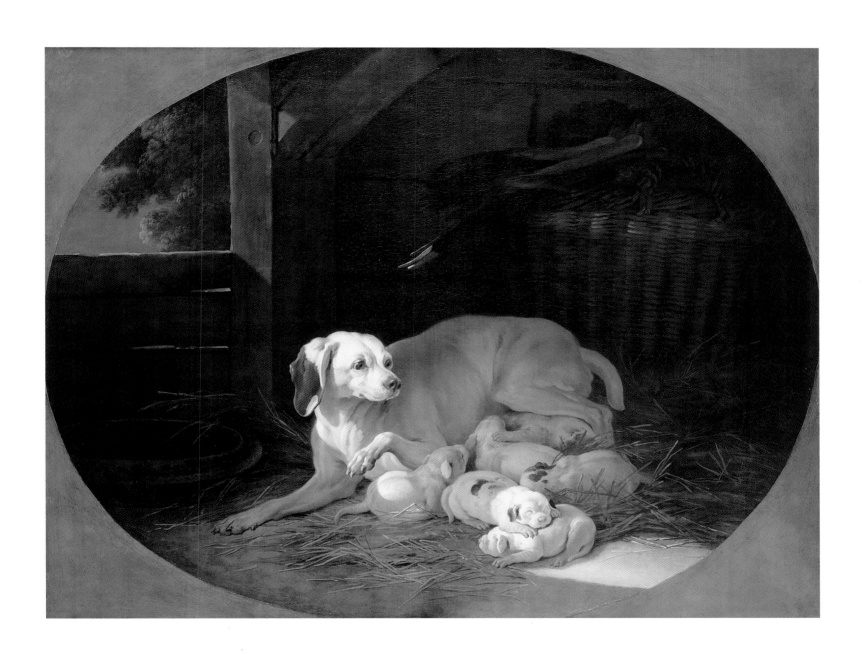

ÉTIENNE JEAURAT (1699–1789)

44 *Village Fair* 1748

59.5 × 107 cm

Galerie Didier Aaron, Paris

This painting is a preliminary study for one of four cartoons on the theme of "Village Festivals" prepared by Jeaurat for Michel Audran, a weaving contractor at the Royal Gobelins tapestry works. Jeaurat exhibited the sixteen-foot-wide cartoon for one of this series, *Noce de Village (Village Wedding)*, at the Salon of 1753, as well as a small sketch titled *Foire de Village (Village Fair)* that most likely was the work under discussion.[1] "Village Festivals" was a speculative venture that appears to have caused Audran some financial anxiety. In August 1754, he wrote to the Directeur des Bâtiments du roi, the Marquis de Marigny, claiming to have paid 6,000 livres for the four paintings and proposing that Marigny purchase them for the King. Marigny responded with a polite refusal, stating he only purchased work that he himself commissioned.[2]

The composition of *Village Fair* follows the model for such subjects provided by the seventeenth-century Flemish artist David Teniers the younger, whose paintings and the engravings after them were much sought after by eighteenth-century French collectors.[3] Like Teniers, Jeaurat depicts a range of festive pastimes at an outdoor fair within a setting of rustic architecture. At the far right, a merchant on horseback and wearing a turban offers a lit candle to a standing woman. In the full-scale cartoon recently discovered by Xavier Salmon, this turbanned figure holds a letter identifying him as a seller of medical remedies.[4] The right foreground of *Village Fair* contains a number of children marvelling over a primitive time-keeping device, possibly a sundial, and in the middle background a couple examine the wares of a ribbon seller – a group for which an independent cartoon exists (fig. 106).[5] A woman with a tray of pastries on her head walks toward four of her companions who link hands in a round dance, while a piper sits in the shade providing musical accompaniment. To the left, villagers sample wine in front of a tavern, and a seated woman is occupied cleaning lettuce. Jeaurat included this last figure in a separate painting also exhibited at the Salon of 1753.[6]

Such a teeming variety of activity is typical of a Teniers village festival scene, but Jeaurat reflects his own period and academic training in the eighteenth-century dress and the careful arrangement of figures, which lends balance to the composition. Perhaps it was a discrepancy between the spontaneous charm of Teniers and the classic tenor and decorative purpose of Jeaurat's *Village Wedding* that prompted a number of critics in 1753 to find it to be lacking in vitality. Père Laugier, for example, would complain: "The figures lack movement and agility. Their faces are neither sufficiently expressive nor kind. The tone of amusement and joy, that wild and boisterous joy that is specific to countryfolk, has been entirely neglected in this painting."[7] The same critic felt more favourably, however, toward *Village Fair*, exhibited together with a second small painting, *La Place Maubert*, suggesting that Jeaurat's genre scenes succeeded best on a small scale: "These sketches have an even more particular truth; the two subjects treated therein abound in burlesque scenes, from which the artist has been able to glean the spirit and character."[8]

Xavier Salmon has recently traced the history of Jeaurat's "Village Festival" series, and it should suffice here to summarize his findings regarding *Village Fair*. A woven version of the entire composition appeared at auction in 1923 with a number of minor changes.[9] Two versions of the left section including the tavern and salad cleaner have been identified with the title *The Recruiting Sergeant*, suggesting the cartoon had been cut by Audran in an effort to make the tapestries more marketable.[10] A woven version of the right section with the dancers and horseman is in the Städtische Kunstgewerbemuseum, Leipzig.[11] Salmon's discovery of the cartoon for the right section in a Paris private collection, signed and dated 1753, supports the conclusion that it was cut at an early date, and makes the present sketch all the more important for providing documentation of Jeaurat's initial concept.

JC

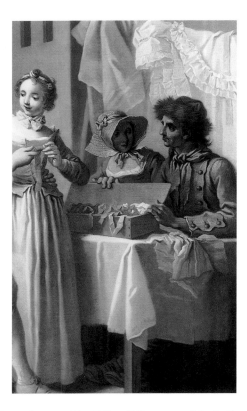

Fig. 106 Étienne Jeaurat, *The Ribbon Seller*, c. 1753. Musée Carnavalet, Paris

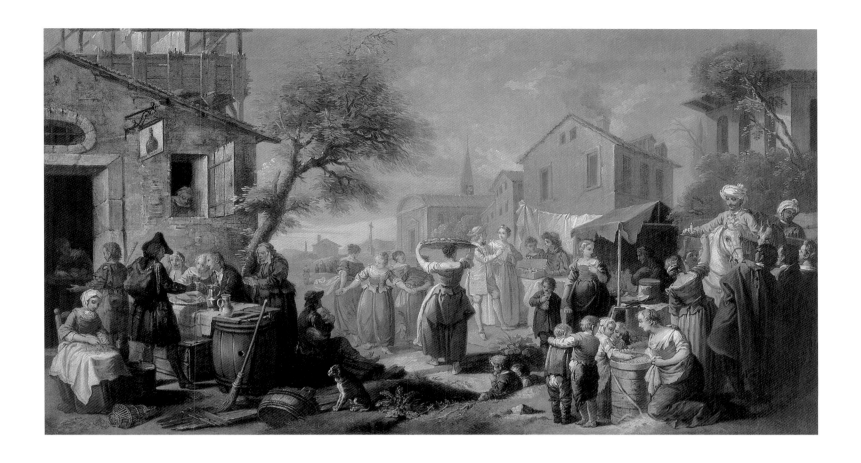

ÉTIENNE JEAURAT (1699–1789)

45 *Prostitutes Being Led Off to La Salpêtrière* 1757

65 × 82 cm

Musée Carnavalet–Histoire de Paris

This is one of four "scènes populaires," as the critic of the *Année Littéraire* described them, that Jeaurat exhibited at the Salon of 1757, including *Carnival in the Streets of Paris* (fig. 107).[2] With their shared theme of bustling urban activity, these two paintings have remained together as pendants from that time. While the actual location in Paris of *Carnival in the Streets* has never been determined, the Salon catalogue of 1757 identifies the arched gate in the background of *Prostitutes Being Led Off to La Salpêtrière* as the Porte Saint-Bernard. Constructed in 1670, the gate was situated on the south bank of the Seine where the Pont de la Tonnelle crosses from the Ile Saint-Louis. Jeaurat includes details of the allegorical relief sculpture by Jean-Baptiste Tuby on the facade that celebrates the benevolence of Louis XIV's reign.[3] A horizontal panel above the arches represents the seated king distributing wealth to his subjects, while the words *Ludovico Magnus. Abundantia Parta* (Louis the Great. Abundance Shared) are inscribed in the attic storey.

Such grandiose symbolism is at odds with the degree of civil disobedience implied by the act of law enforcement that Jeaurat has depicted. The procession occurred monthly, according to Louis Sébastien Mercier, who began his chronicle of city life, *Tableaux de Paris*, in 1781.[4] Mercier's account of the transport of prostitutes confirms that little had changed in the decades following the Salon of 1757: "They are made to climb into a long uncovered cart where they stand close together. Some cry, others moan or try to hide their face, the most insolent stare back at the crowds that shout at them; they answer back indecently and brave the jeers that they receive during their passage. This scandalous cart crosses the city in plain daylight, the language inspired by the procession is still an affront to public decency."[5] In Jeaurat's painting, the cart carrying the prostitutes,

known as "filles de joie," has just crossed the Pont de la Tonnelle on its way to take the women to serve their sentence at the prison quarters of the Salpêtrière Hospital on the eastern perimeter of the city, whose residents were frequently shipped off to America.[6] A covered wagon carrying the wealthier "madams" and "women of class," who have paid a levy to travel shielded from view, has already turned east to continue through the archway of the gate.[7] Almost an equal number of *police de moeurs* accompany the women, dressed in redingotes with tricorne hats and carrying the long canes they used to prod recalcitrants. Those on foot engage one another in conversation seemingly indifferent to the prostitutes' heckling, while at least four have the more difficult task of ensuring order among the women in the cart.

In a review of the Salon of 1757, Jeaurat's *Prostitutes* drew praise for the accuracy of its presentation of Parisian life from the anonymous critic of the *Mercure de France*: "There is much truth in the manner in which they are treated, this is a naïve and gracious painting of the events of popular life."[8] "Naïve" is an unusual word to describe the work of an artist with the rank of professor in the Academy. Its use in this context, to describe the charm of familiar sights of city life, suggests the author was making an allusion to the popular tradition of engravings of street occupations, known as the *Cris de Paris*. These *Cris* figures were known from the seventeenth century, and during the 1730s and 1740s such artists as Charles-Nicolas Cochin, François Boucher and Edme Bouchardon produced series of images for engravers who distributed them to a wide public.[9] The comment by another critic in 1757 that Jeaurat's paintings were more admired by the general public by than art lovers, indicates that his work had the same broad popular appeal as the *Cris*.[10]

With its depiction of crude street banter between the women in the cart and those market vendors who watch them pass, Jeaurat's *Prostitutes* can also be related to a type of theatre that flourished at the Opéra Comique of the Saint-Laurent fair, known as the "genre poissard" (fish market style). These plays were written primarily by Jean-Joseph Vadé (1719–1757), with dialogue derived from the slang idiom (*argot*) identified with the fish sellers in the markets of the Quartier Maubert.[11] The Porte Saint-Bernard is located just north-east of the Place Maubert, the title of another Jeaurat's popular street scenes exhibited in 1753.[12] Vadé's dialogue, like Jeaurat's genre painting, reveals a sympathetic observation of this area of Paris, and on two occasions at the Salon, 1757 and 1763, Jeaurat exhibited paintings with titles indicating they were inspired by Vadé's plays – prompting Diderot to describe him as the "Vadé of painting."[13]

JC

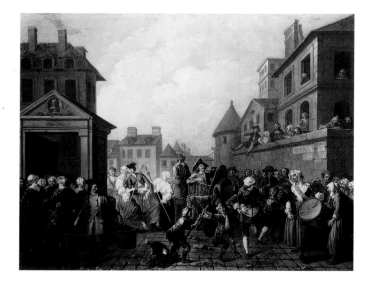

Fig. 107 Étienne Jeaurat, *Carnival in the Streets of Paris*, 1757. Musée Carnavalet, Paris. Gift of the Society of Friends of Carnavalet

PIERRE SUBLEYRAS (1699–1749)

46 *The Amorous Courtesan* c. 1735

30.5 × 23.5 cm

Musée du Louvre, Paris

Arriving in Rome in 1728 as a *pensionnaire* of the Académie de France, Subleyras lived in the Mancini Palace until 1735, thereafter taking up residence in the city and marrying an Italian, the miniaturist Maria Felice Tibaldi. Known as a portraitist and, above all, as a religious painter, Subleyras was one of those rare French artists able to win acclaim in this crowded field, although it is true that his style accorded remarkably well with contemporary Roman production. But in a playful mood that led him back to Parisian styles, Subleyras also ventured to illustrate the tales of La Fontaine. *Contes et nouvelles en vers* (*Tales and Novels in Verse*), repudiated by their author in the evening of his life, came back into favour under the Regency. All through the eighteenth century, they inspired brilliant images by many artists, from Boucher to Fragonard.

The setting of *The Amorous Courtesan* is Rome. Known among the courtesans of the city for her cold beauty and boundless ambition ("Even if the Pope fell for her, he wouldn't be good enough for her"),[2] Constance arouses in the young cavalier Camille the desire to humble her pride. His lack of response to her advances fuels the young woman's passion for this inaccessible being, and thus he obtains her utter submission; but soon, touched by the sincerity of her love, he proposes marriage. Subleyras illustrates the moment when, surrendering her dignity, Constance, who has found her way into Camille's bedroom, decides to act as a servant to undress him: "Grant her, as recompense / this honour. The young man consents. / She approaches; she unbuttons him; / touching the garments but not more, and not daring / to touch his person with a fingertip. / And that was not all: she took off his shoes. / With her own hands! Constance herself!"[3]

The space around the bed is suggested by a few draperies in the background, curtains and sheets mixed together, and pillows just visible to the right. The armchair is, of course, richly decorated, as is the young woman's apparel ("Her clothes reflect her pride / Diamonds sparkle on her dress / all richly trimmed and embroidered"),[4] but beyond the subtle harmonies of colour, Subleyras focuses on the characters and on the human sentiments: the yielding courtesan and the young man, satisfied, not haughty, and already prepared to forgive. Here, tenderness wins out over the description of the sensual disorder of the room, as drawn in detail by Boucher for the engraving,[5] or over the broad humour of Fragonard, who preferred to illustrate the outcome of the tale and the embrace of the reconciled lovers.[6]

The six tales of La Fontaine as painted by Subleyras were successful mainly in France. Four were engraved in Rome by Joseph-Marie Pierre, who based his print on a slightly different version of *The Amorous Courtesan*. The various replicas and copies of these small works appear to have enjoyed great success with French collectors. Only one of these has been identified with certainty: the Duc de Saint-Aignan, ambassador to Rome from 1730 to 1741, who also commissioned the artist to paint a large canvas of a totally different kind, celebrating the *Conferring of the Order of Saint-Esprit on Prince Vaini by the Duc de Saint-Aignan*. However, Subleyras's paintings based on La Fontaine could be found in all the major Parisian sales at the end of the eighteenth century (such as that of the abbé de Gevigney, Randon de Boisset, the Comte de Vaudreuil, Baillet de Saint-Julien, Boyer de Fonscolombe), while the preparatory drawings are shown in Mariette and the Comte d'Orsay. The names of their collectors remind us of the craze for these small compositions, which are marginal in the artist's production, but not without a certain charm.

CL

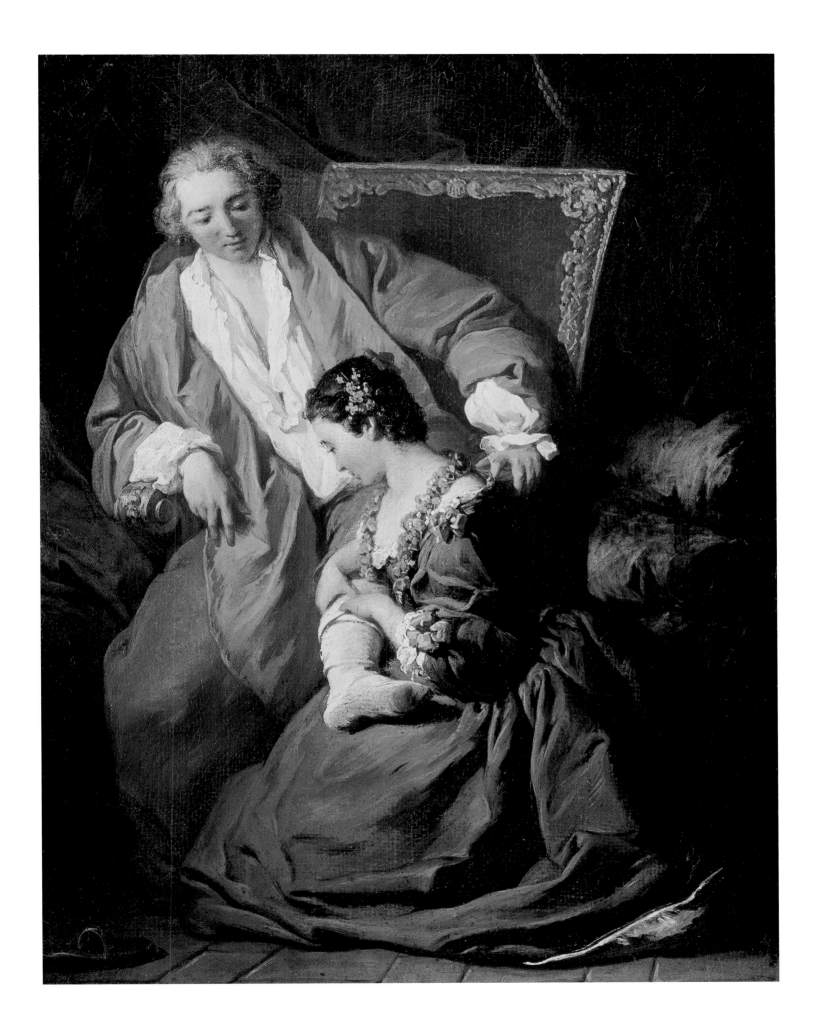

PIERRE SUBLEYRAS (1699–1749)

47 *The Packsaddle* c. 1735

30.5 × 23.5 cm

Private collection

By itself, *The Packsaddle* would not have been able to cause Subleyras to be labelled as a painter of licentious scenes. This image of the artists of the eighteenth century, which was cultivated to an exaggerated degree at the end of the nineteenth century, has long obscured the essential nature of their production at the time. Subleyras is, above all, still the celebrated maker of such canvases as the *Mass of Saint Basil*, 1747, intended, as a rare honour, for Saint Peter's in Rome (now at Santa Maria degli Angeli), or the official portrait of Pope Benedict XIV (Musée Condé, Chantilly, with numerous replicas in other collections).

The Packsaddle is drawn from one La Fontaine's most risqué tales. Before leaving on a trip, a jealous husband paints a donkey on his wife's stomach. But since the woman's lover is a painter himself, he easily sketches a new donkey to replace the one he has erased through congress with his his mistress. By mistake, however, the lover adds a detail that the husband notices on his return: a packsaddle (*bât*), a word that evokes innuendo and proverbs.

Another version of this small painting, in the Hermitage, Saint Petersburg, has some fairly major variations. In it, the artist's workshop is presented more succinctly, the easel, placed to the left, half disappears behind a drapery, while an oval canvas hangs on a wall. Most importantly, the young painter is copying the donkey from an album placed on the floor, while in La Fontaine's text he is supposed to execute it from memory, and here his mistress seems to show less interest in him. These elements are corrected in the version in the current exhibition, which indicates that the Hermitage painting is probably the earlier. The Hermitage owns its equally risqué pendant, the *Jument de compère Pierre* (fig. 108). Paralleling the preceding scene, a young woman presents her backside to a priest who has promised to transform her into a serviceable mare. The priest caresses her and looks ready to disrobe, but his gesture is stayed by the protestations of the husband, who is at last alarmed by these bold advances.

Both these scenes were also painted in Rome by Nicolas Vleughels. As Pierre Rosenberg has suggested, the difficult relations between the director of the Académie and his pensionnaire could lead us to suppose that Subleyras was driven to compete with Vleughels, even in the small-format works that had been his old master's specialty. Vleughels' *Gascon puni* dates from 1728,[1] but his versions of *Le Bât* and of the *Jument de compère Pierre* date only from 1735.[2] However,

precise dating of Subleyras's canvases before and after that date is not easy. Vleughels' small, accurately painted, and somewhat anecdotal pictures contrast with Subleyras's greater command of effect. In fact, Vleughels' compositions were intended to be engraved, which might explain their more conventional character.

Illustration of modern literary subjects certainly played a key role in the revival of genre painting in the eighteenth century. Moving beyond the simple representation of everyday life in the Northern tradition, this device offered the most inventive history painters, from Jean-François de Troy to Boucher and Fragonard (but also from Pater to Oudry and Charles Coypel), an opportunity to show off their narrative talent. At the same time, it left them the widest latitude in depicting a courtly world, often mixing the most recent fashions with memories of the seventeenth century – the age of Molière, Scarron, and La Fontaine.

CL

Fig. 108 Pierre Subleyras, *La jument de compère Pierre*. The State Hermitage Museum, Saint Petersburg

MICHEL-FRANÇOIS DANDRÉ-BARDON
(1700–1783)

48 *Childhood* 1743

37 × 29 cm

Musée Granet, Aix-en-Provence

49 *Youth* 1744

37 × 29 cm

Musée Granet, Aix-en-Provence

These paintings represent two of the Four Ages of Man, the others being *Birth* (*La Naissance*), 1743, and *Old Age* (*La Vieillesse*), 1744 (both also Musée Granet), commissioned by Dandré-Bardon's close friend, Jean-Baptiste-Laurent Boyer de Fonscolombe, a member of a noble family in Aix-en-Provence who would be remembered as a parliamentarian and art collector. The commission coincided with Boyer de Fonscolombe's move into the former home of the Marquis de la Barben, purchased by his father in 1743.[1] Dandré-Bardon, also a native of Aix, was on hand to carry out the commission, having returned from Paris in 1741 after the manager of his family's estate fell ill.[2] While in Aix, Dandré-Bardon continued to contribute to the Salon, sending *Birth* and *Childhood* in 1743. The Salon catalogue entries for these works indicated that the subjects were inspired by verse of the popular eighteenth-century poet Jean-Baptiste Rousseau, who died in 1741; and lines on the Ages of Man theme from Rousseau's *Stances* (*Stanzas*) were reprinted in the catalogue. Those that accompanied *Childhood*, for example, convey the painful trials of student life: "Childhood is a time of tears. / A schooling in sorrow, / Books of every colour, / And punishments of every kind."[3]

The moment of tearful drama captured in Dandré-Bardon's *Childhood* aptly illustrates Rousseau's verse. Judging by the look of grim resolve on the tutor's face, the unsatisfactory performance of the remorseful student approaching him merits a stern reprimand. The tutor has hastily set his own book on the floor and holds what looks like a wooden spoon in his left hand, while his right is extended in order to hold the boy's hand and administer the punishment. The look of indifference worn by second student suggests that such disruptions were not an unusual occurrence. The scene is set in the carpeted interior of a modestly furnished apartment, perhaps the tutor's own. A door of simple construction stands open, as if to beckon the students to leave, while bright sunlight falls upon the wall behind, illuminating their books rather than the games they could otherwise be enjoying. Suspended above the scene is a birdcage, a traditional metaphor of imprisonment.

In the second painting, *Youth*, we progess from the trials of student discipline to a young man's attempt at courtship. The gallantry of his kneeling entreaty to the woman recalls the pose of the male protaganist in *The Declaration of Love* (cat. 26) by Dandré-Bardon's teacher Jean-François de Troy. The soft, satiny surface of the woman's evening dress also suggests the influence of de Troy's *tableaux de mode*. Given the moralist theme that dominates Dandré-Bardon's Ages of Man paintings, the anecdotal elements of

Youth can be interpreted not as a proposal, but as an instance of love's disappointment. The woman holds a cameo in her hand, an item commonly exchanged at the time of betrothal. It is not offered to the suitor, however, but held away from him toward the newel post of an exterior stair of some *hôtel particulier*, which she nears with her parents. The young man raises his arms and draws back in a theatrical gesture of surprised alarm. The woman points upward to where her betrothed awaits, while the father, with a look of calm resignation, holds a folded piece of paper, possibly the notary's signed letter of engagement. His daughter has been promised to another, and the young man has arrived too late to change the course of events.

The commission for Dandré-Bardon's Ages of Man series can be viewed in the broader context of the mid-eighteenth-century fashion for portraying allegorical cycle with genre subject matter, such as the Seasons, the Elements, the Senses, or Parts of the World.[4] Dandré-Bardon's Ages of Man paintings were preceded between 1730 and 1735 by those of Nicolas Lancret, today in the National Gallery, London.[5] It is instructive to compare the two artists' treatment of the theme, as Dandré-Bardon envisioned his series as events in the life of one individual, while Lancret's groupings of vaguely identifiable figures in idealized pastoral settings retain the whimsical fantasy of the *fête galante* tradition. The more light-hearted approach taken by Lancret is suggested by the *Mercure de France*'s announcement of the engravings of the set by Nicolas de Larmessin IV in 1735 as "the four ages characterized by their pastimes."[6] The first of Lancret's paintings is *Children's Games* (*Jeux de l'Enfance*), but Dandré-Bardon begins with *Birth*, where a mother tries to calm a baby upset by his own phantom reflection in the mirror above the mantel, a quote from traditional *vanitas* imagery. Dandré-Bardon's presentation here, as with *Youth*, follows closely the pessimistic mood of the text by Jean-Baptiste Rousseau that accompanied the Salon catalogue entry: "What a perfect mirror of sadness / Is a man's life! / He no sooner draws breath, than he howls and cries, / As if foreseeing all his woes."[7] The last in Dandré-Bardon's series, *Old Age*, continues the moralist theme, with an infirm figure reflecting upon his past before a fireplace whose mantel design recalls that of *Birth*. The capped and seated figure in this painting was copied by Étienne Jeaurat for his version of *Old Age*, which was engraved by François-Bernard Lépicié.[8] This engraving was also accompanied by verse from Rousseau's *Stances* and exhibited at the Salon of 1745 with another engraving after Jeaurat on the theme of *Youth* (*l'Accouchée*), thus providing a follow-up to Dandré-Bardon's 1743 presentation of *Birth* and *Childhood*.[9]

This difference in approach to the Ages of Life theme by Lancret and Dandré-Bardon is accentuated by their contrasting painting styles. Lancret's multifigure compositions are rendered in the brighter Rococo palette of the lyrical *fête galante*; Dandré-Bardon's surfaces are suffused with muted interior colours derived from Chardin or the

Venetian genre painter Pietro Longhi, better suited to his more contemplative treatment of the subject.

The Ages of Man theme lends itself particularly well to genre painting. From medieval times, the quotidian provided meaningful settings for the allegorical representation of the progress of life.[10] That Dandré-Bardon was able to interpret this tradition with such originality is due to the breadth of his intellectual interests. He was among the most erudite and accomplished theoretical writers of his generation. His list of publications is extensive, and includes the *Traité de peinture*, an authoritative discussion of drawing, composition, and colour, in the tradition of Roger de Piles.[11] Also a gifted poet and musician, in 1754 he wrote *L'impartialité de la musique*, about the controversy surrounding Jean-Jacques Rousseau's opinions on French music.[12] In his eighteenth-century dictionary of artists, Pierre-Jean Mariette would describe Dandré-Bardon as a well-loved academician and professor: "His excellent character, his gentle ways, and a certain gaiety soon earned him the friendship of all those who knew him."[13]

JC

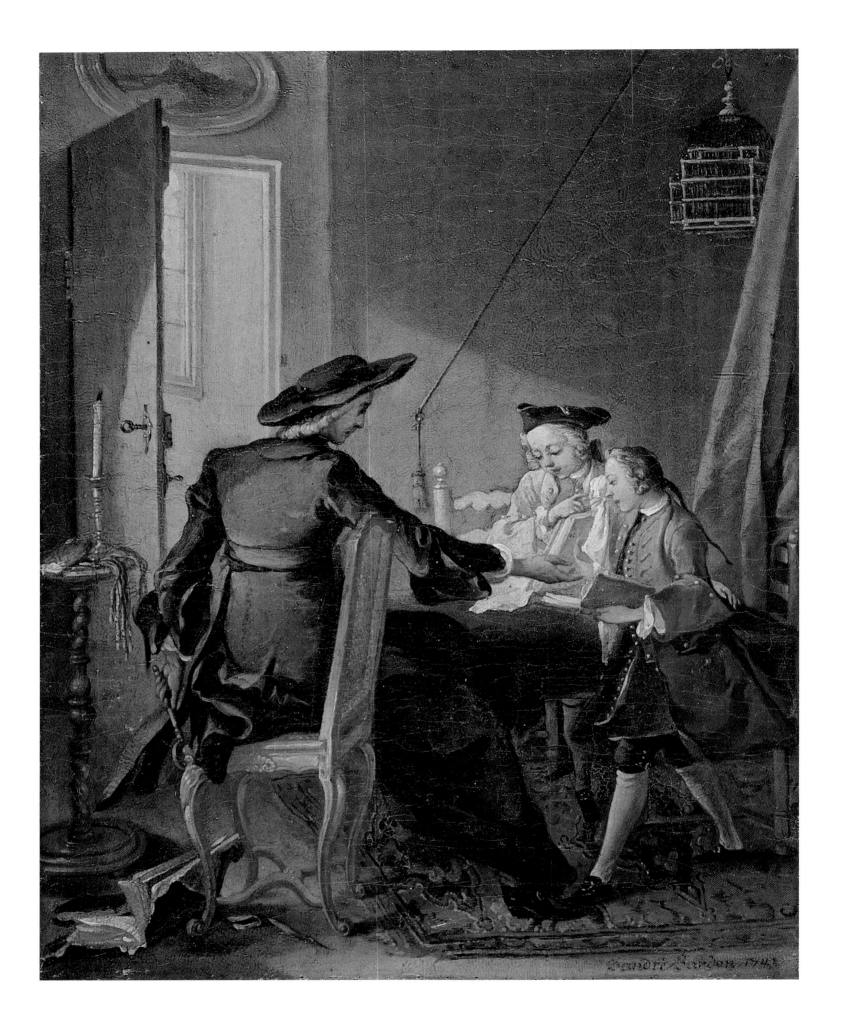

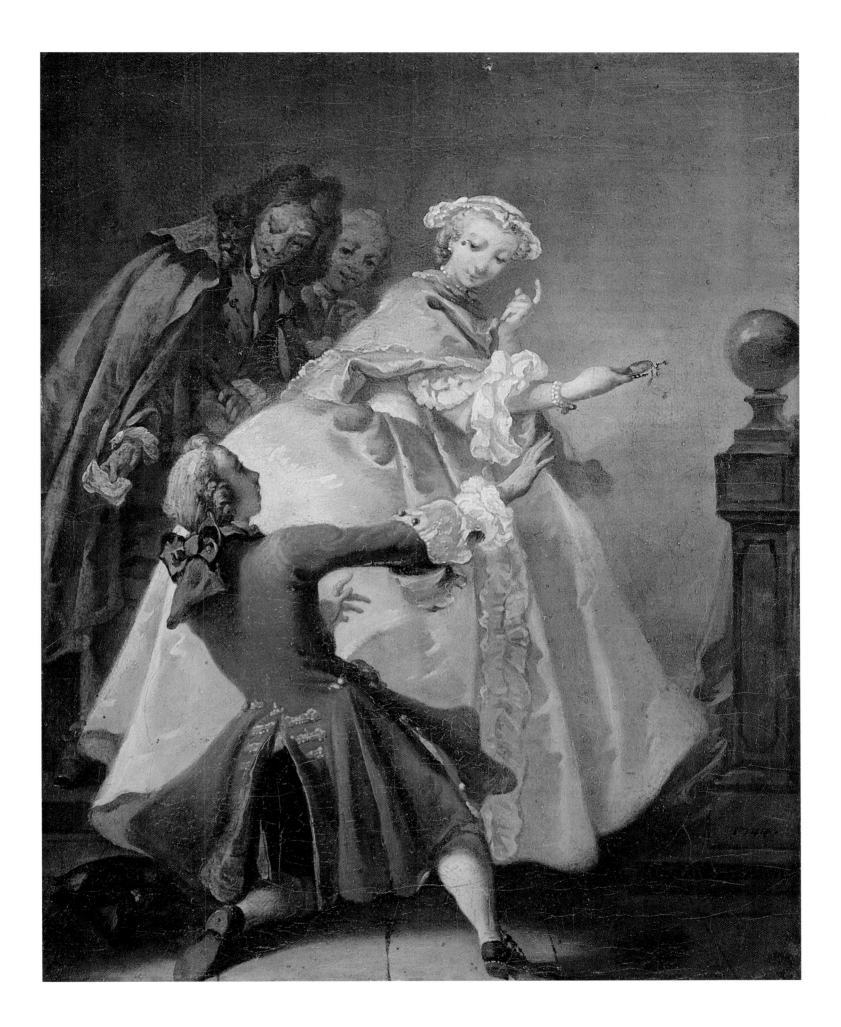

FRANÇOIS BOUCHER (1703–1770)

50 *"Of Three Things, Will You Do One For Me?"*: *The Game of Pied-de-Boeuf* c. 1733–34

105 × 85 cm

Fondation Ephrussi-de-Rothschild, Académie des Beaux-Arts, Saint-Jean-Cap-Ferrat

The puzzling title of Boucher's mildly flirtatious genre painting – which derives from Pasquier's engraving of 1768 – provides the clue to its subject.[1] We are witnessing the conclusion of *pied-de-boeuf*, a popular children's game, played also by adults, with distinctly sexual overtones. Initially, the players place their hands on top of one another's as quickly as they can, until the ninth round is called. The first player to reach nine grabs the hand of another (of the opposite sex), exclaiming "Nine! I've got my pied-de boeuf" ("Neuf! Je tiens mon pied-de-boeuf"). As a reward, the boy (or man) is allowed to claim a forfeit from his partner, whom he asks to do one of three things for him ("De trois choses en ferez-vous une?"). The first and second are likely to be impossible requests (flying to the moon, for example); but the third, the bestowing of a kiss, is within the captive girl's powers.[2] Boucher's expectant little boy holds the older girl's hand as he counts off his demands with his left forefinger; perfectly composed, she indulges him and offers no resistance.

No less than in his history paintings – and Laing has commented upon the similarity of the "broad, small-featured face" of the girl with that of the goddess Aurora from the contemporaneous *Aurora and Cephalus* (Musée des Beaux-Arts, Nancy)[3] – Boucher prepared this composition through drawings; and a sheet of studies for the figure of the boy suggests the deliberation with which he did so (fig. 109).[4] A rejected first idea on the verso of that drawing has the boy seated in an imposing armchair and viewed from behind (the game of *pied-de-boeuf* was usually played sitting down); in the studies on the recto, Boucher concentrates on the adolescent's ardent expression, the swagger of his coat, and the precise placement of hands. In the painting itself, Boucher made still further adjustments. Whereas in the drawing the boy secures the girl's hand between his own (perhaps suggesting the earlier part of the game), in the painting he holds it fast in his right hand only. The boy is younger in the painting than in the drawing, and is shown with a more innocent expression (he can hardly believe his luck!). Finally, it is possible that Boucher did not start out with an oval composition in mind – was the format perhaps imposed for decorative reasons? – since in the drawing he paid particular attention to the lower half of the boy's coat, which flares out as he turns towards his partner (this detail would be lost in the oval painting). In the final composition the boy's costume has undergone a radical change: instead of a fashionable coat with buttons, he now wears a somewhat theatrical jacket with ties that lace up, and a shirt with fanciful ribbons on its sleeves.

Such details are also suggestive of Boucher's allegiances at this point. The sheet of studies in Ottawa bears an (erroneous) inscription to Chardin, whose schoolboys, engaged in spinning tops and building houses of cards, are more or less contemporary in date.[5] In the transformation from drawing to painting, however, Boucher stays

aloof from Chardin's modernity, preferring to remain within an established pastoral mode. Hermann Voss's insight regarding his illustrations to Molière, that in them Boucher appears "an exact parallel to his older contemporaries Lancret and Pater,"[6] might usefully be applied to *The Game of Pied-de-Boeuf* as well, for here was a subject that Lancret treated more than any other genre painter of his generation.[7] Indeed, the pendant that Alastair Laing has proposed for this picture – the oval *Bird's-Nesters* (location unknown) – is of a theme similarly established in Lancret's repertory.[8] While the subject of Boucher's pastoral is second-hand, its broad, almost rugged handling – quite distinct from Lancret's meticulous finish – is typical of the "firm yet gracious" brush that Mariette (and Diderot) so admired in the artist's early production.[9]

CBB

Fig. 109 François Boucher, *Seated Boy and Studies of his Head and Hands*, c. 1733–34. National Gallery of Canada, Ottawa

FRANÇOIS BOUCHER (1703–1770)

51 *Pastoral: The Vegetable Vendor* c. 1735

241.3 × 170.2 cm

Chrysler Museum of Art, Norfolk, Virginia

A couple of years after the magisterial series of mythological paintings for the lawyer François Derbais (which Mariette claimed the artist would have painted for nothing, so eager was he to gain exposure), Boucher embarked upon an equally ambitious group of four pastoral decorations, only slightly less imposing in scale.[1] Comprising two vertical pendants and two pendants almost square in size (243 by 254 centimetres) – proportions reminiscent of the mythologies for Derbais – this series of rustic genre paintings deployed a panoply of still-life and landscape elements, while featuring amorous peasants of juvenile and sanitized appearance. Despite the best efforts of Alastair Laing (and the late Bruno Pons), we still have no idea who commissioned these expansive decorations, which are not referred to in any of the eighteenth-century literature.[2] The tradition that they were painted "expressly by Boucher for the Duc de Richelieu, the joyous companion of his pleasures," is a nineteenth-century fiction that cannot be substantiated:[3] neither by what is known of the taste (and resources) of the proposed patron, Louis-François-Armand de Vignerot du Plessis, Maréchal-Duc de Richelieu (1696–1788), nor by the documents that relate to the interior decoration of his Parisian residences.[4]

In *The Vegetable Vendor*, the young couple seem to be unloading provisions from the back of a jauntily caparisoned, but still heavily-laden horse: a family of dead sheep, trussed together in a wicker basket, hangs from its left side. With a tumbledown thatched hut in the background, and dead game and a basket of eggs resting on the stone ledge behind them, the adolescent protagonists, watched over by a rapt peasant girl, seem deeply engaged in scrutinizing vegetables. The boy holds a pair of oversize carrots in each hand; the girl cradles an enormous cabbage in her lap. Below them, on an impeccably white cloth, are two gleaming copper pans and a bunch of root vegetables – onions, parsnips, and carrots – in a suggestive grouping.

Although recently admitted as an Academician with his *Rinaldo and Armida* of 1734 (Musée du Louvre, Paris) – and the pose of the boy in *The Vegetable Vendor* repeats that of Rinaldo, but in reverse – Boucher was still experimenting with several idioms in the mid-1730s. As Laing has noted, "We find him trying his hand at pastoral themes, half-length *galant* subjects, quasi-Dutch interior scenes, and hybrid combinations of the last two."[5] Boucher seems to have had a particular fondness for kitchen scenes, where amorous dalliance between juvenile participants takes place to the accompaniment of pots, pans, and oversized vegetables. In *The Vegetable Vendor* he has taken his characters outside, extending his range as a painter of landscape and of still-life, ennobling his dramatis personae – the late Regina Slatkin identified the subject as "a farm boy offering his bountiful produce to a lady"[6] – while maintaining the unambiguously erotic portent of their banter. In her interpretation of Fragonard's early pastorals, Mary Sheriff has shown how rustic paraphernalia might also function as sexual puns and metaphors.[7] Boucher's

deployment of carrots, parsnips, and onions is unashamedly phallic; one can only speculate as to the significance of the oversized head of cabbage – which also appears in the lap of the seated woman in *Le repos des fermiers* (collection of Jeffrey E. Horvitz) and rolls from the apron of the leering maid in *Kitchen Maid and Young Boy* (private collection, Sainte-Adresse).[8]

Indebted to Castiglione's caravansaries, as well as to Abraham Bloemaert's rustic figures, with which Boucher had already a long-standing acquaintance, *The Vegetable Vendor* was also prepared through careful studies, not unlike those that Boucher made for his history paintings.[9] The title of this village pastoral, however, remains misleading, deriving as it does from the catalogue of the sale of 1852. It seems unlikely that Boucher would have undertaken such an ambitious (and carefully mediated) group of pictures without the armature of a unifying theme. While it is possible that a yet-to-be-discovered literary or theatrical source may be at the origin of this series, the four pictures can also be read as Allegories of the Elements. The larger pair in Munich, *Le bonheur au village* and *Le halte à la Fontaine*, represent Fire and Air respectively: in the former, the young woman holds a long-handled copper pan over the flames; in the latter, the wind blows over the stream and rushing waterfall in a composition of which fully half is sky. The pendant to the Chrysler picture, *Peasant Boy Fishing* (fig. 110), represents Water; and with its foreground of vegetables, plants, and hay, *The Vegetable Vendor* must surely symbolize Earth.

CBB

Fig. 110 François Boucher, *Pastoral: The Peasant Boy Fishing*, c. 1735. The Frick Art Museum, Pittsburgh

François Boucher (1703–1770)

52 *A Lady Fastening her Garter (La Toilette)* 1742

52.5 × 66.5 cm

Museo Thyssen-Bornemisza, Madrid

Midway between de Troy's mondaine ceremonials and Baudouin's fashion plates, *A Lady Fastening her Garter* presents an impossibly cluttered dressing room in which the lady of the house is assisted in her morning ritual by an elegant maid, who sports a *mouche* above her left eye.[2] We are witnessing the final stages of a fashionable toilette. The lady's face has been whitened with make-up, rouged, and provided with the requisite beauty spot; her hair, curled tightly in the current *tête de mouton* style, has also been powdered, and she still wears a powdering mantle to protect her dress. As the mistress attaches a pink garter to her stockinged leg, her servant hands her a white *commode* – a linen cap edged with lace – decorated with a matching pink ribbon.[3]

If the fashions are resolutely Parisian, the decor is impregnated with the Orient: as Alastair Laing has noted, the folding screen, fire-screen, tea set, and cassolette on the mantelpiece are all imports in the latest *chinoiserie* taste.[4] As in the *Presumed Portrait of Madame Boucher* (cat. 53), painted the following year, the mood created by so much fashionable bric-à-brac is faintly improper, even lascivious (one thinks of Diderot's comment, "What can you expect from a man who consorts with the lowest sort of prostitute?").[5] The playful kitten stretched out between his mistress's legs is a fairly obvious reference; the steaming teapot with its two cups suggests that a suitor is soon to arrive; most evocative of all, as Georges Brunel has noted, is the "tenderness of the little patch of pink flesh visible between the mistress's garter and her petticoat."[6]

Unlike the decorous *Luncheon* (see fig. 21), painted three years earlier, *Lady Fastening her Garter* evokes a disorder similar to one that literary historians have found in the worldly novels of Prévost, Marivaux, and Crébillon *fils*, in which for the first time the feminine toilette emerges as a primary motif.[7] "When the occasion permits, clothes, utensils, furnishings are described . . . with coquettish meticulousness and great delight in movement and colour": Erich Auerbach's analysis of *Manon Lescaut* could as easily introduce the setting of Boucher's *Lady Fastening her Garter*.[8]

With no hint of opprobrium and far removed from Rousseau's censuring of feminine fashion ("we force them to spend half of their lives at their toilette"),[9] Boucher attends to the vanities and coquetteries of this urban ritual with a celebratory brush. Yet if the details are rigorously contemporary, the genre itself retains links with an older, emblematic tradition, from which Boucher has not fully liberated himself. With Lancret as his model – and he was doubtless familiar with the latter's *Four Times of the Day* (National Gallery, London), exhibited at the Salon of 1737, in which Morning is represented by a woman offering tea to an abbé while her maid looks on (fig. 111)[10] – Boucher may well have conceived of his picture allegorically. The well-stoked fire, the candle on the mantelpiece, and the fur-lined wrap casually thrown over the chair at right all suggest that this toilette is taking place on a winter's morning; Boucher's delicately observed domestic idyll fits within the conventions for representing one of the Four Seasons.

A wintry toilette would also have appealed to the patron of this picture, the Swedish diplomat Carl Gustaf Tessin (1695–1770), who was approaching the end of a three-year mission in Paris as Extraordinary Envoy to the French court.[11] Two years earlier, Tessin had commissioned one of Boucher's masterpieces, *The Birth of Venus*, and he also owned *Leda and the Swan* (both Nationalmuseum, Stockholm), which was shipped back to Sweden on the same boat as *Lady Fastening her Garter*.[12] Whereas bankruptcy would oblige Tessin to sell most of his French paintings to his sovereign, Crown Princess Luisa Ulrike, in 1749, he appears to have had a particular affection for *Lady Fastening her Garter*, which remained with him in his estate at Åkerö until his death twenty-one years later.[13]

CBB

Fig. 111 Nicolas Lancret, *The Four Times of the Day (Morning)*, c. 1737. National Gallery, London

FRANÇOIS BOUCHER (1703–1770)

53 *Presumed Portrait of Madame Boucher* 1743

54 × 67 cm

The Frick Collection, New York

A sharp-faced, dark-eyed woman reclines on a daybed, revealing a fashionably stockinged foot shod in a pink mule. She is wearing a white taffeta dress with a ruched bodice, and a jacket with flounced sleeves. As was the custom for married women, she wears a cap to cover her hair; her only jewellery is a simple cameo bracelet.

Despite the *gemütlichkeit* of the setting – we are in the corner of a brocaded sitting room, with a chinoiserie screen at far right, a lacquered étagère with Chinese porcelain objects on the wall, and a *chatelaine* watch suspended next to it – there is something faintly improper in the way Boucher presents his model. Her right hand is cocked suggestively against her chin; her left rests languidly between her thighs. She has been interrupted both in her reading and in her needlework. Her workbag and material lie rumpled on the velvet footstool, a ball of yarn is on the floor, almost waiting for a cat to come in and play with it. The dramatic swag of the curtain as it inexplicably cascades onto the daybed at right adds a further note of disarray to the scene.

Traditionally considered to be a portrait of Marie-Jeanne Buzeau (1716–after 1786), Boucher's twenty-seven-year-old wife and the mother of his three children, this meticulously described genre scene is more likely to be one of those "fashionable figures, with the pretty little faces that he is so good at,"[1] made for an as yet unidentified collector's picture cabinet. Portraiture or genre painting? Sitter or model? These questions are of more than academic interest, and

might well have been answered had Boucher's picture been mentioned on even a single occasion during the eighteenth century.[2]

We know that between 1739 and 1746 Boucher made a small number of exquisite subject pictures showing pretty young women in routine occupations: eating breakfast (see fig. 21), doing their toilette (cat. 52), meeting their milliner (cat. 54). Jewel-like and delicate in colouring, revelling in the fashions and luxuries of the day, from Chinese porcelains to silk brocades, these genre paintings found a ready market among the high born (both at home and abroad), but Boucher soon tired of the care and finish that such work required. Despite his famed "universality," Boucher was primarily a history painter (and least of all a portraitist), and his talents were most engaged in public and private commissions of greater scale: from cartoons for tapestries to decorations for palaces. During the few years that the artist tried his hand at cabinet pictures – encouraged perhaps by the success of Chardin's genre scenes, which appeared at the Salon at exactly this time – he tended to portray the same dark-eyed beauty, with something of a doll's face, that we see in the Frick's *Madame Boucher*.[3]

That Marie-Jeanne Buzeau, a famed beauty, provided inspiration for her husband on more than one occasion is borne out by several contemporary accounts: "Having had the luck, like Albane, to find a companion capable of reminding him of the fleeting Graces," noted one of Boucher's obituary writers in 1771, "he knew how to make the best use of it in his art."[4] But it strains credibility to imagine Boucher employing such a diminutive format and casual pose for a portrait – to say nothing of the attention lavished on furniture and fabrics – however intimate his relationship with the sitter.[5] Rather, anticipating Goya's clothed and naked Majas, might the *Presumed Portrait of Madame Boucher*, better entitled *Woman on a Daybed*, have been conceived as a pendant of sorts to one of the many versions of *The Dark-Haired Odalisque* (fig. 112)?[6]

CBB

Fig. 112 François Boucher, *The Dark-Haired Odalisque*, 1745. Musée du Louvre, Paris

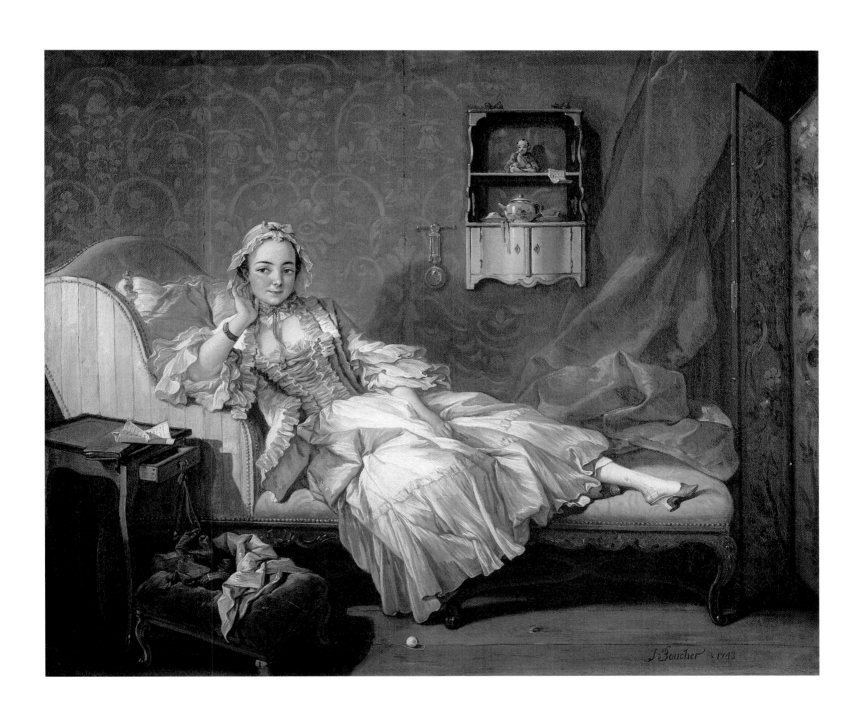

FRANÇOIS BOUCHER (1703–1770)

54 *The Milliner (Morning)* 1746

64 × 53 cm

Nationalmuseum, Stockholm

The story of Boucher's royal commission for a series of four genre paintings representing the Times of the Day – known to us from a remarkably complete diplomatic correspondence – has been admirably told by Alastair Laing.[2] Hoping, no doubt, for a set of pictures rather like *Lady Fastening her Garter* (cat. 52), the twenty-six-year-old Crown Princess Luisa Ulrike had Tessin supervise her commissions to Boucher, prescribing subjects with a confidence worthy of the younger sister of Frederick the Great.

In early October 1745, Tessin wrote to Carl Fredrik Scheffer (1715–1786), the Swedish Minister in Paris, that "Madame Royale would like four paintings by Boucher, a little larger than the one he did for me, in which a woman is tying her garter. The subjects are to be the Four Times of the Day – Morning, Midday, Evening, and Night – with those fashionable figures and pretty faces that he is so good at."[3] In order to save money, Scheffer was to tell Boucher that the pictures were for Tessin rather than for Luisa Ulrike: "That way I will be sure to have them for four hundred *livres* each."[4] An additional hundred *livres* was to be set aside for each frame, bringing the total cost to 2,000 *livres*.

As Laing noted, this letter was answered immediately, not by Scheffer but by the outgoing secretary to the Swedish legation in Paris, Carl Reinhold Berch (1706–1777): "I have communicated to Monsieur Boucher my ideas concerning the subjects he is to paint; he has not disapproved of any of them, and indeed seems to be most pleased. *Morning* will be a woman who has just finished with her hairdresser, still wearing her dressing gown, and amusing herself in examining the baubles presented to her by her milliner."[5] Berch also listed the subjects of the remaining three times of the day. *Midday* was to show an encounter at the Palais Royal between a lady and a "bel esprit;" *Evening* (which gave him and Boucher the most difficulty) would be represented either by letters brought to arrange a rendezvous, or a lady's maid helping her mistress with gloves and cape as she leaves to make calls. *Night* would be portrayed by a group of "giddy women about to depart for a masked ball."[6]

It is well known that Boucher reneged on the lion's share of this commission. He seems to have waited almost ten months, until August 1746, before beginning work on *The Milliner*, the only picture in the series he would complete, and it was delivered to Scheffer in early October 1746 ("he has never painted anything more gallant and finely executed").[7] Scheffer informed Tessin that Boucher was currently at work on its pendant ("he is now occupied in finishing *Evening*"), but that the remaining pair was unlikely to be ready before the following spring.[8] Because of the difficulty of shipping works home during winter, Scheffer had to wait until February 1747 to send back "ces eternels ouvrages de peinture."[9] Only one painting by Boucher would be included in this consignment. The promised *Midday* would not be ready for another six weeks; nothing more was

said about *Evening*. Once again, Boucher excused himself by citing his pressing commitments for the Bâtiments. Furthermore, Tessin was informed, "the weakening of his eyesight makes it each day harder for him to apply himself."[10]

In fact, *The Milliner* would be the last genre interior that Boucher painted, despite the growing demand for pictures "quand il y a du fini" (the Baron de Thiers had offered him twice the asking price for Luisa Ulrike's picture).[11] As I have noted in my introduction, Boucher remained faithful to the detailed brief given to him by Berch in October 1745 and seems to have been in no way constrained by it. The powdering mantle worn by the mistress of the household and her tightly curled coiffure are evidence of her hairdresser's recent handiwork, and she is indeed shown "examining the baubles presented to her by her milliner."[12]

While *The Milliner* has many elements in common with Tessin's *Lady Fastening her Garter* – the mistress wears the same dress and has the same hairstyle; her knotting bag, mirror, and cat appear in both compositions – its mood is altogether more dignified and stately (there are no beauty spots in sight!). A fashionably dressed (and gloved) milliner is making her morning call on a well-to-do client; holding a linen cap, edged with lace, in her right hand, she is seated on the floor next to an open box of ribbons, her measuring stick resting on the upper case.[13] As light streams in through the bedroom window (it is likely that *The Milliner* would also have represented Spring, in keeping with Berch's earlier requirement that the Four Times of Day also "yield the Four Seasons"),[14] the mistress attentively examines a piece of green ribbon. An unopened letter with a red seal, in shadow on the floor in the left foreground, is the only sign of gallantry.

Although, once started, Boucher seems to have completed *The Milliner* quite quickly (it may have been done in less than a month), he appears to have diverged from his practice of preparing the composition through drawings. No figure studies are known, and various *pentimenti* suggest that he had some difficulty with the seated figure (her head and foot have been reworked).[15] This is the only hint of any onerousness the artist may have experienced during the creation of this exquisite genre painting.

Boucher's refusal to provide a companion to *The Milliner* left Tessin in something of a quandary. As he noted in his letter of June 1747 acknowledging the safe arrival of the pictures, "Boucher's is very good, but it has been given less of a welcome here than it deserves, because it came alone."[16] So entrenched was the convention of presenting cabinet pictures in pairs, that Tessin finally had recourse to the art market to remedy Boucher's delinquency. After waiting another two and a half years for the promised pendant, he had Scheffer inform Boucher that if he did not produce the painting, he would have Gersaint "or another connoisseur" find him "a Flemish work in good taste" as a companion piece.[17] Such a threat galvanized Boucher into

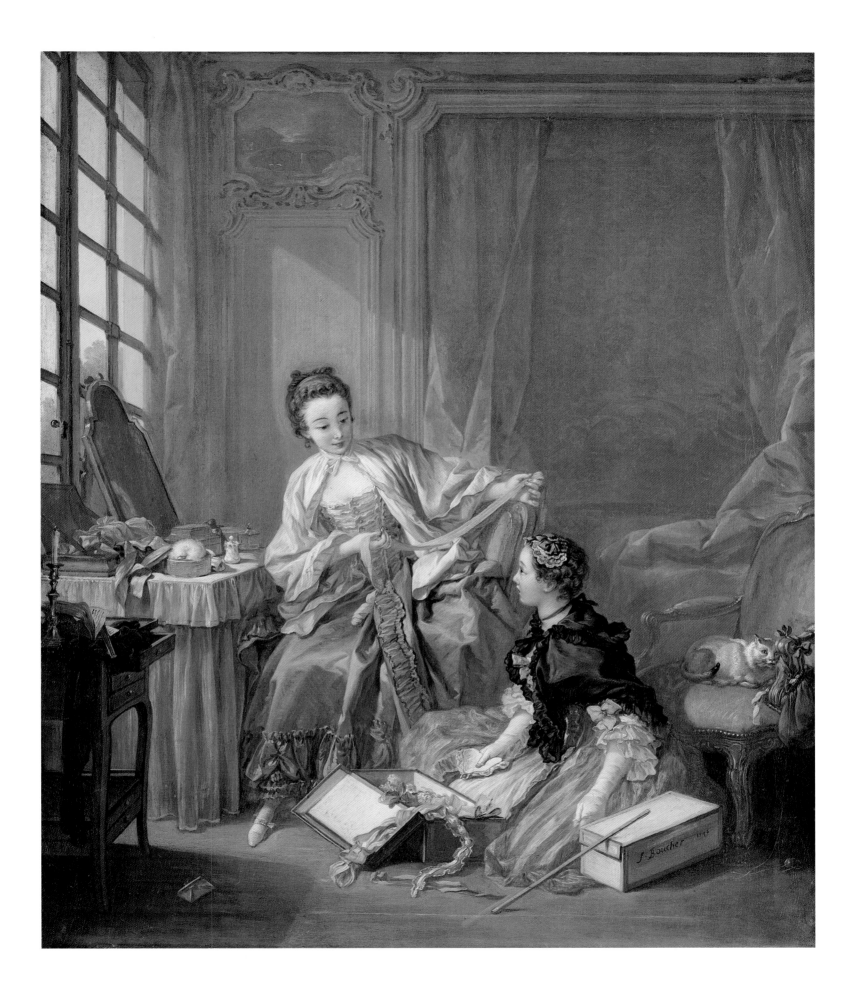

producing in August 1750 a sketch of "a painter occupied in finishing the portrait of Madame Royale, in her chamber, observed by a well-dressed lady;" but this idea never progressed beyond the stage of a rapid doodle.[18]

Tessin seems to have been determined to provide *The Milliner* with a pendant, however. Listed among the French pictures in Luisa Ulrike's Study Chamber was Pieter de Hooch's *Interior with Young Woman Reading a Letter* (fig. 113), a work slightly smaller than Boucher's, but to which it responds in subject and formal disposition.[19] As the single Northern genre picture among the thirty works that hung in this room, the majority of which were by eighteenth-century French and Italian artists, might the de Hooch have been acquired to compensate for Boucher's *libertinage*, "which has to be seen to be believed"?[20]

CBB

Fig. 113 Pieter de Hooch, *Interior with Young Woman Reading a Letter*, c. 1668–70. Nationalmuseum, Stockholm

FRANÇOIS BOUCHER (1703–1770)

55 *Is He Thinking about Grapes?* 1747

80 × 68 cm

The Art Institute of Chicago

"Pense-t-il aux raisins" was the title that appeared on Le Bas's engraving after a rectangular version of this composition (fig. 114), acquired by Crown Princess Luisa Ulrike of Sweden.[1] The primary, oval version of Boucher's pastoral, possibly exhibited at the Salon of 1747 with its pendant, *Le joueur de flageolet*, dated 1746 (private collection, Belgium), was inspired by Charles-Simon Favart's pantomime, *Les vendanges de Tempé*, first performed at the Foire Saint-Laurent on 29 August 1745. Favart's plot concerned the blossoming love affair of the unnamed Little Shepherd and a shepherdess, Lisette, which would gradually prevail over the opposition of rivals and disapproving family. The sixth scene opened with Lisette and the Little Shepherd feeding grapes to one another; in the previous scene, the Little Shepherd had played the flute for her (the subject of the pendant).[2] The addition of a young child in each of the pendants was the painter's invention.[3]

The novelty and topicality of Boucher's new genre – riding on the coattails of Favart's wildly successful theatrical revolution – has been thoroughly documented by Alastair Laing. In the painted pastoral, which Laing considers "Boucher's single most influential contribution to French eighteenth-century painting,"[4] the artist parted company with his earlier, Dutch-inspired peasant subjects, as well as those *sujets champêtres* indebted to the literary pastoral, in which the protagonists were dressed in the elaborate costumes of the *fête galante*. It had been Favart's signal innovation to create a new type of popular theatre that explored the naive emotions of country folk (rather than presenting them as coarse and ribald peasants) and chronicled their tender and sentimental love affairs. Under the energetic impresario Jean Monnet (1703–1785), Favart's repertory became the staple of the Opéra Comique, and, like the *commedia dell'arte* for an earlier generation, also infiltrated the diversions and entertainments of elite sociability as well.[5]

Despite Boucher's failing eyesight and his reported aversion to the requirements of finish – especially in interior genre subjects – he seems to have experienced no such constraints in the production of the painted pastoral (inspired, perhaps, by the novelty of the genre).[6] Attired in silks and satins of unblemished hue; their bare feet admittedly "of a scarcely credible cleanliness and delicacy;"[7] seated

in a verdant landscape where even the goats and sheep seem to be shampooed (as Théophile Gautier was the first to remark): Boucher's "rustics" seem both improbable and artificial, and it is not altogether easy for a twenty-first century audience to be moved by the "realism" of his painted pastorals. For Boucher's contempories, however, the greater naturalism of his shepherds and shepherdesses (no longer in "hooped skirts as at the Opéra"),[8] and above all, the innocent and trusting nature of their romances (with all licentiousness and innuendo removed), endowed these pastorals with a charm and authenticity that can still be recovered, but perhaps only after the suspension of a certain disbelief.

CBB

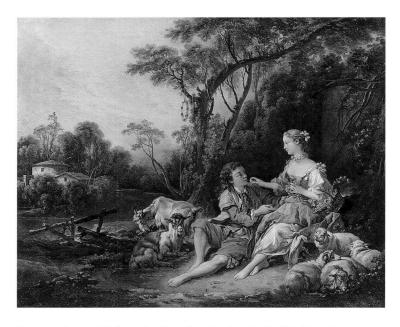

Fig. 114 Jacques-Philippe Le Bas, after Boucher, *Is He Thinking about Grapes?* Nationalmuseum, Stockholm

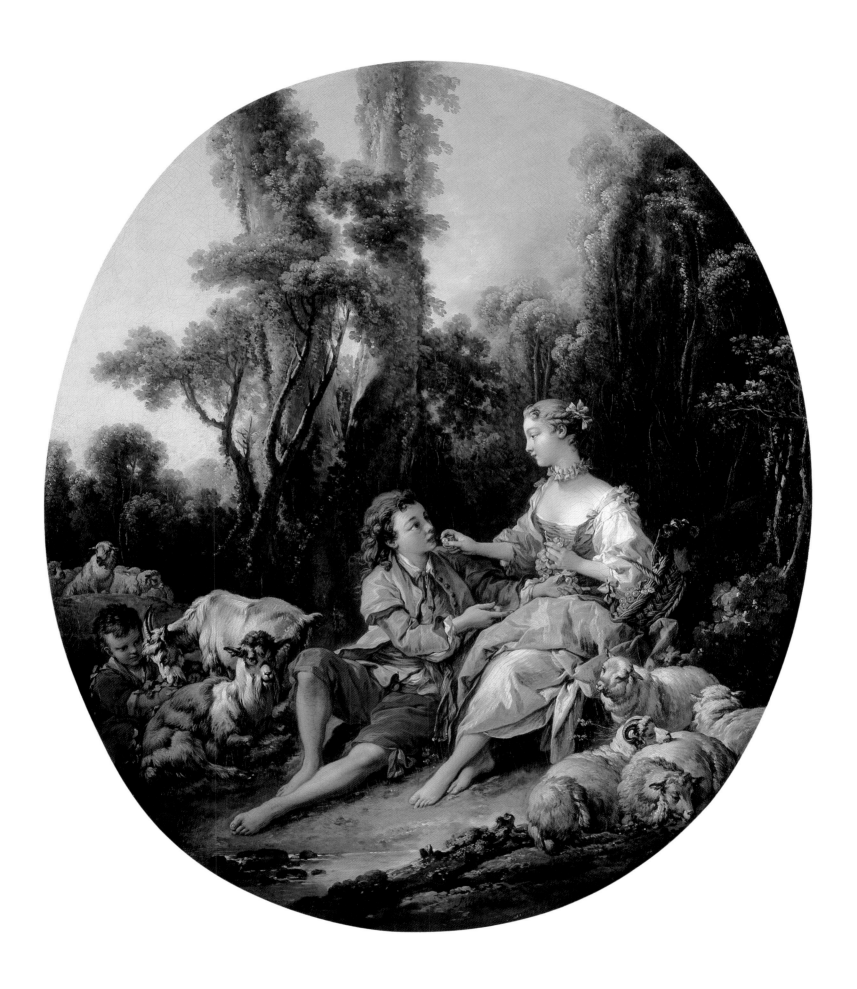

CARLE VAN LOO (1705–1765)

56 *A Pasha Having his Mistress' Portrait Painted* 1737

66 × 76 cm

Virginia Museum of Fine Arts, Richmond

This painting was shown at the Salon of 1737, the first of the newly re-established annual exhibitions of work by members of the French Academy. On 6 July, just a month prior to the opening of the Salon, Van Loo was appointed full professor of the Academy. His submission in 1737 also included *The Hunt Luncheon* (Musée du Louvre, Paris), *Jupiter and Juno* (Archives nationales, Paris), and a pendant to the present work, *The Grand Turk Giving a Concert to his Mistress* (fig. 115). According to Van Loo's first biographer, Michel-François Dandré-Bardon, the two works were painted for different clients. *The Concert* was for a M. Fagon, possibly Louis Fagon, Louis XV's Intendant des Finances, and the *Mistress' Portrait* was for the collector Jean de Jullienne.[1] The turbanned and grey-bearded Pasha appears in both paintings, as does the young man by his side and the male figure with a fur-trimmed hat and a cane.

In *A Pasha Having his Mistress' Portrait Painted*, Van Loo clouds the distinction between fantasy and contemporary life by placing himself in the role of the artist standing before his easel, dressed in a painting smock. With her blonde hair, pale complexion, and fashionable lace fan collar *à la Medici*, it has been suggested that the model for the mistress was the artist's wife, Cristina Antonia Somis, a native of Turin and a talented singer.[2] Van Loo peers over his shoulder to engage the viewer during a moment of exchange between the Pasha and his mistress. The modest setting appears to be the artist's studio. Watching attentively are two young students, one holding a drawing portfolio. On the far wall, two large battle scenes demonstrate Van

Loo's ability in this genre, at a time when he was being considered as the principal French contributor for a major commission from the King of Spain depicting the life of Alexander the Great.[3] A framed mirror on the far left wall reflects a copy of the Greek sculptor Doidalsas's *Venus Bathing*, which is on the table beside the Pasha.

This costume piece and its pendant in the Wallace Collection reflect a taste for exotic themes then prevalent in France.[4] This predilection is demonstrated by the eight hunting scenes of foreign lands that Louis XV commissioned for the Petite Galerie of his apartments at Versailles, and for which Van Loo contributed the *Bear Hunt* of 1736 and *Ostrich Hunt* of 1738.[5] *A Pasha Having his Mistress' Portrait Painted* can be placed within a more specific tradition of genre painting known as the "turquerie," a term applied to Turkish or Islamic costume or decor. "Pasha" (derived from the Arabic *bâchâ*) originally described a provincial governor of the early Ottoman Empire. The "Grand Seigneur" of Van Loo's original title was another way of referring to Islamic dignitaries, used notably by Montesquieu in his epistolary novel *Lettres Persanes* of 1721.[6] Montesquieu was inspired by the ceremonial visit to Versailles in 1715 of the Envoy of the Grand Sufi of Persia, Mehemet Riza Bey.[7] Van Loo's reputation as a painter of the "turquerie" later led to a commission from Madame de Pompadour for three paintings of "Sultanas" (the Sultan's wife), for her Turkish Room at the Château de Bellevue, completed in 1754.[8]

In the picture under discussion, Van Loo portrays himself with the status of court painter, modelled after the celebrated Greek Apelles who served Alexander the Great. Indeed Van Loo fulfilled such a role for the King of Sardinia in Turin from 1732 until 1734, during which time he met his wife.[9] As Pinkney Near has pointed out, *A Pasha Having his Mistress' Portrait Painted* reflects the popularity among eighteenth-century artists of *Apelles Painting the Portrait of Alexander's Mistress Campaspe*.[10] This romantic tale, in which Alexander gives up Campaspe to the painter, was an apt allusion for Van Loo's introduction of an autobiographical reference.

JC

Fig. 115 Carle Van Loo, *The Grand Turk Giving a Concert to his Mistress*, 1737. The Wallace Collection, London

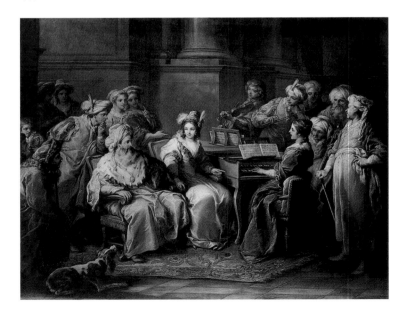

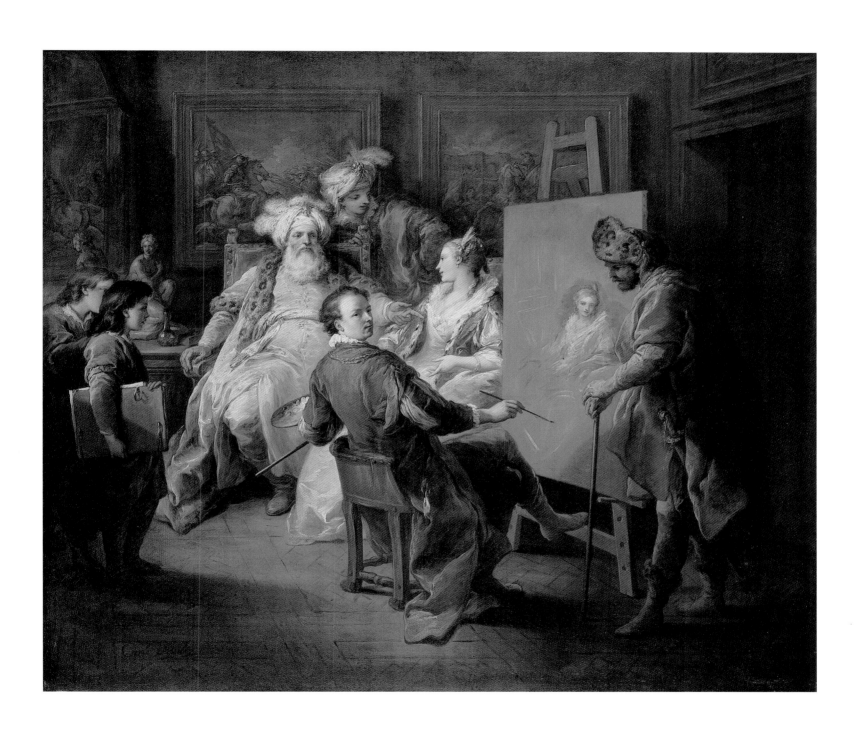

Noël Hallé (1711–1781)

57 *Portrait of Françoise-Geneviève Lorry and of her Son Jean-Noël* 1758

73 × 60.8 cm

Private collection

On 11 January 1751, Noël Hallé, an adjunct professor of the Académie royale in Paris since 1748,[2] married a ravishing eighteen-year-old, Françoise-Geneviève Lorry, the daughter of a wealthy Parisian bourgeois family. Through her mother, Marie-Madeleine de La Fosse, Hallé's bride was related to well-known artists: the grandniece of painter Charles de La Fosse and the cousin of Nicolas de Largillièrre. Her father, François Lorry, was advisor to the King, Regent of the Paris Faculty of Law, and a former parliamentary lawyer.[3] Noël Hallé painted the portrait of her eldest brother, Paul-Charles Lorry (1719–1766), a lawyer for the Parliament of Paris, doctor-in-law, and professor at the Faculty of Law. Although the painting has disappeared, it was commemorated in an engraving by François-Robert Ingouf le Jeune.[4] Her other brother, Anne-Charles Lorry (1726–1783), was Regent of the Paris Faculty of Medicine and physician to Louis XV, whom he attended during his final illness.[5]

Françoise-Geneviève Lorry posed constantly for her husband; we recognize her fine features in the Virgins of his many Holy Families, and in his female characters in genre painting. In this delightful portrait dated 1758, Hallé, by this time a professor at the Academy,[6] shows his wife at the age of twenty-five engaged in drawing *La fillette aux nattes* (*The Girl with Braids*), a sculpture by Jacques-François Saly; her son, Jean-Noël, born in 1754, snuggles at her side. Displayed at the Salon of 1750, this bust has been copied numerous times; as an engraving – and known as *La Boudeuse* (*The Pouter*) – it was one of a series of plates intended as models for students.[7]

Drawing was a very fashionable activity, practised by numerous amateurs who met in "private academies." Gabriel de Saint-Aubin captured it in an engraving entitled *L'Académie particulière*: a young man draws a female model who is stretched out on a couch at the home of the Comte and Comtesse de Rohan-Chabot. Françoise-Geneviève Lorry liked to draw; in 1775, she accompanied her husband to Rome, where he took up the post of director of the Académie de France for an *ad interim* mission.[8] There she did a charcoal drawing of *The Blessed Sacrament Procession on Corpus Christi Day* (École nationale supérieure des Beaux-Arts, Paris).

Jean-Noël Hallé, who was four years old when this portrait was painted, was destined to become one of the leading French physicians of his time: a member of the Institute, a member of the Academy of Science, professor of the Collége de France, personal physician to Princess Élisa, Bonaparte's sister, and physician in ordinary to Napoléon. He, too, liked to draw, and wrote numerous medical treatises and articles, which he illustrated with engravings from his drawings; he liked to sketch his colleagues during meetings at the Institute. He was also a courageous man. When the Revolution came, Jean-Noël showed his courage: he defended Lavoisier before the Convention during the Reign of Terror, but could not protect him from the guillotine.[9]

The work evokes the charm and refinement of the eighteenth century through its intimate nature, its freshness and grace, and its subtle cameo of golden-brown tones heightened with green, white, and golden yellow with touches of red and pink. The room in which the young woman is sitting is depicted soberly: a Louis XV *trumeau*-topped hearth, a small kidney-shaped table of natural wood used to prop up the drawing board. Paint pots on the table and the gold-edged fluted glass half-filled with water serve as a pretext for a beautiful piece of still-life. The rays of light on the faces of the models and the head of the bust animate the composition, allowing the delicate play of shadow from the *collarette* on the throat of the young woman. In his portrait, Noël Hallé has combined the symbols of the arts: as evidence of the significance the artist attached to his initial education, on the mantel a treatise on Architecture lies open; the bust of Saly represents Sculpture; the large portfolio, the wash drawing, the brush, inkwell, paints, and mechanical pencil, all evoke Painting and Drawing.

The painter's profound love for his family, like that uniting mother and son, are rendered with infinite sensitivity: the young woman's hand rests elegantly on the portfolio, the fineness of her profile is in contrast to the dark background, her torso inclined slightly to emphasize her attentiveness; but the most fascinating aspect is the enchanting portrait of the small boy, his face pressed against his mother, his hand on her arm; the vivacity of his expression and his interest in the drawing are expressed admirably. Here, Noël Hallé has executed one of his most successful easel paintings; he has left a lively witness to his family that fills us with joy. A drawing of his young wife playing with Jean-Noël and pregnant with the couple's second child (Catherine-Charlotte-Geneviève, born in 1755), is touching proof of his emotions (fig. 116).

The work was shown at the Salon of 1761, as *Une dame qui dessine à l'encre de la Chine* (*A Lady Drawing in China Ink*): Saint-Aubin sketched it in the margin of his Salon guide.[10] Critics, however, made no comment on this picture, reserving their remarks for the artist's larger historical works.

NW-B

Fig. 116 Noël Hallé, *Françoise-Geneviève Lorry, Pregnant, Playing with her First-born Child*, 1758. Private collection

NOËL HALLÉ (1711–1781)

58 *The Education of the Rich* 1765

35.8 × 45.1 cm
Private collection

59 *The Education of the Poor* 1765

35.9 × 45.1 cm
Private collection

Soon after his return from the Mancini Palace where he boarded from 1737 until 1744,[1] Noël Hallé was accredited by the Academy; he advanced through the hierarchy of the institution, was an esteemed and popular professor to his many students, and became treasurer in 1777; he held the top post of Rector at the time of his death. He exhibited regularly at all of the Salons from 1746 until 1779. In 1765, Hallé presented his masterpiece, *Atalanta and Hippomenes*, an immense tapestry designed for the Gobelins (Musée du Louvre, Paris), *La Clémence de Trajan*, a history painting for the Château de Choisy (Musée des Beaux-Arts, Marseille), and two sketches, *The Education of the Rich* and *The Education of the Poor* (private collection) which, despite their small size and the significance of this salon, were accepted and acclaimed by several critics. Abbé Bridard de La Garde in the *Mercure de France* deemed "these two small sketches remarkable in the ingenious placement of the subjects and the master's praiseworthy execution;"[2] they gave a "great deal of pleasure" to Mathon de La Cour, who found them "ingenious . . . [and having] perhaps a more solid moral foundation than most educational treatises."[3]

Painted three years after the publication of Jean-Jacques Rousseau's *Émile ou de L'Éducation* (1762), the philosophical and pedagogical interest of these two sketches was noted by critics, who considered them not only charming scenes of their genre but also understood

their profound meaning in an age when the problems associated with the education of children were the focus of lively debate. Noël Hallé had already shown his interest in this theme when he exhibited *The Schoolmaster*[4] (a work that no doubt was important to him because he engraved it himself) at the Salon of 1751; remember that in 1765 he was the father of two children, Jean-Noël and Catherine-Charlotte-Geneviève, respectively eleven and ten years old. Diderot bitterly criticized these works as unfinished drafts: "It's miserable. We sometimes see neglected feet or hands, sketchy heads . . . nothing here is complete, nothing at all; in fact, this is artistic license in the extreme;"[5] he did not choose to inquire into their meaning, or to notice a renowned painter's satirical view of his own social class.

Noël Hallé's critical perspective compares the unresponsive theoretical education dispensed by the tutor of an obstinate adolescent from a wealthy family to the vibrant practical education given by artisans to their children. In *The Education of the Rich*, the type of study is indicated by a globe and a city plan leaning against the table leg; the decor is opulent, as shown by the panelling and the abundance of gilding: heavy Louis XIV furniture and a Louis XV giltwood settee, ormulu wall clock, andirons and fireplace tongs, a broad giltwood frame on a painting. All of our attention is focused on an adolescent whose backward movement betrays his boredom; he refuses to understand what his professor is explaining, despite the exhortations of the abbot – his tutor – standing behind him; his mother and father are motionless, watching the scene; the young boy is alone, closed off from the adults; there is no understanding, no

Figs. 117 and 118 (BELOW AND RIGHT) Noël Hallé, *Sketch for the Education of the Rich*, 1764 and *Study for the Dog's Head in the Education of the Rich*, c. 1764. Private collection

discussion between them. The silence is barely interrupted by signs of life: the running dog, the little boy, also alone, thumbing through a scrapbook of drawings that is too big for him; a guitar, of no use, is abandoned on the floor. The office is dark, barely lit by an open door to another room. This is an enclosed space with a stifling atmosphere; the servant is seen from behind, as he leaves.

In stark contrast is the interior of a carpenter's home, built of wood, filled with liveliness and affection; the characters are enthralled with their activity: the father, behind his bench, shows a plan to his son, and they discuss it; the mother fondly counsels a small seamstress on her embroidery; a young woman teaches an attentive girl to read; a big sister helps a baby to climb the steps of a staircase. The space is airy; light enters the house through an open window and a door that allows a glimpse of the landscape – a door through which a man enters, hat in hand.

In these two swiftly executed works Hallé demonstrated his skill; he opposed the decor of the two corresponding scenes: giltwood with fruitwood; the rich Louis XIV table with rustic furniture; the shimmering evening ensembles – the trappings of wealth – with the simple woven garments of the poor. His touch is rapid, with heavy impastos and white for heightening; the palette is clear; vivid notes of reds, blues, and whites are well balanced. The artist's talent is easily recognizable in the ease of composition, the motion of his characters, their harmonious gestures, the silhouettes of the rosy-cheeked young women, their chignons high atop their heads. One must admire the treatment of the pale pink dress on the blue divan, the embroidered vest of the inattentive student, the wood chips on the floor. A preliminary sketch for *The Education of the Rich*, dated 1764, shows little variation from the final composition; its even freer and broader touch accentuates the oppressive nature of the scene (fig. 117).

In these scenes Noël Hallé expresses his personal opinion: he praises the warmth of family ties and the value of passing on the craftsman's knowledge, from which he had benefited personally; his earlier works show the influence of his father, Claude-Guy Hallé (1652–1736), a professor at the Academy since 1702 and from whom he learned his art. Claude-Guy Hallé had learned in turn from his father, Daniel Hallé (1614–1675), master painter at Rouen before taking up residence in Paris.

One detail of the works is significant, and with it the artist emphasizes the contrast between behaviours. A man – a pilgrim? a beggar? – opens the door and is welcomed by the humble carpenter; whereas the wealthy family's servant leaves through the door, turning his back on these people, who are strangers to him.

NW-B

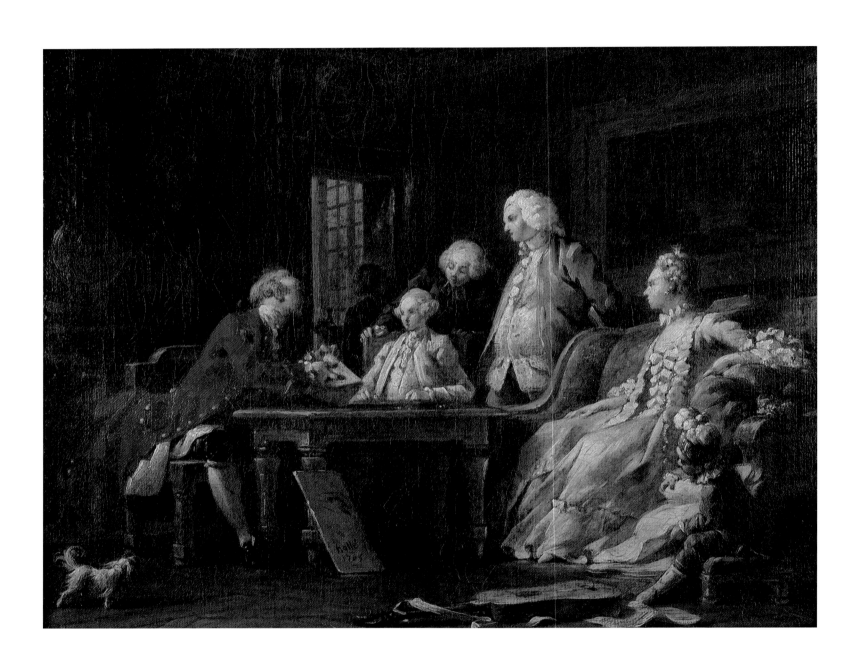

PIERRE-ANTOINE BAUDOUIN (1723–1769)

60 *The Honest Model* 1769

40.6 × 35.7 cm

National Gallery of Art, Washington, D.C.

The son of a little-known engraver, Baudouin studied with François Boucher, whose younger daughter he married in 1758. He devoted himself primarily to the production of miniatures and highly finished drawings in gouache. *Agréé* by the Académie royale in 1761 and elected to full membership in 1763, he exhibited at all the Salons in the 1760s. Baudouin acquired his reputation with mildly erotic boudoir scenes, which were popular with the court and the public and were often engraved. Critics like Diderot and Grimm, however, roundly criticized his work as too licentious and lacking in the moral message of the works of his near contemporary, Jean-Baptiste Greuze. Baudouin was only forty-six when he died, reportedly because of his libertine lifestyle.

Baudouin's highly finished gouache of *The Honest Model* was the subject of considerable commentary and discussion when it was exhibited at the Salon in 1769.[1] The theme of the drawing was clearly set out in a carved legend attached to the top of the original frame (now lost): *Quid non cogit Egestas?* ("What does not Poverty compel one to do?"). Yet Baudouin left some of the details of his scene sufficiently ambiguous to allow wide differences of interpretation. Most discussion and controversy centred on the identity of the older woman – whether the model's mother or a ruthless procuress – and the meaning of the moment depicted. The model has been posing for some time, as the well-advanced painting on the easel indicates, so why has she suddenly collapsed? Has her mother just arrived on the scene, unaware until now of what her daughter was willing to do to earn money for her family? Or did the mother, driven to poverty, allow her daughter to pose nude, with herself serving as chaperone, until finally overcome by shame? The expressions of both women seem to belie Diderot's notion (shared by others) that the older woman is "an ignoble creature who engages in some vile business."[2] But regardless of *their* relationship and emotional state, the artist is clearly unhappy with the turn of events and vehemently protests the imminent departure of his model.

One of the most interesting, and now perhaps somewhat entertaining criticisms that was levelled at Baudouin in response to *The Honest Model* was Baron Grimm's assertion that the painter was as "libertine with his brush as he [was] in his morals."[3] Certainly Baudouin's interpretation of the scene is caught up more in the actions of the figures – and especially the nude model – than in their psychological states; and the moral lesson is obscured by the attention lavished on the details of the studio interior and the corresponding lack of emphasis on facial expressions. But even though Baudouin was focused on the anecdotal aspects and mild eroticism of the scene and paid as much attention to the furniture as to the figures, he did not entirely lose sight of its moral purpose, and created a lively yet tender image that was much admired by most of his contemporaries. Diderot, however, thought that such moralizing subjects were better left to his own favourite painter, Jean-Baptiste Greuze, who would certainly have produced a more solemnly edifying work in which the moral message would have been clearly and forcefully conveyed.[4]

An earlier, sketchier version of the Woodner picture was reproduced quite faithfully in a print published in 1772 by Jean-Michel Moreau and Jean-Baptiste Simonet, which included one significant change in the position of the older woman's head. The Woodner drawing bears impressive witness to Baudouin's position as one of the great *gouachistes* of the eighteenth century and underlines his strong debt to his teacher and father-in-law, François Boucher. Indeed the paintings hanging on the studio walls of Baudouin's young artist and the unfinished work on the easel reflect his intimate knowledge of Boucher's art.[5] Baudouin was one of the last and best of Boucher's followers, but within less than a year of the exhibition of *The Honest Model* in the Salon of 1769, both he and his father-in-law were dead, and the high Rococo style was already falling out of favour.

MMG

GABRIEL DE SAINT-AUBIN (1724–1780)

61 *A Street Show in Paris* 1760

81 × 63 cm

The National Gallery, London

62 *The Meeting on the Boulevard* 1760

80 × 64 cm

Musée Hyacinthe-Rigaud, Perpignan

Around 1760, perhaps inspired by his younger brother Augustin's views of newly fashionable sites of Parisian recreation, Gabriel de Saint-Aubin produced a corpus of images in various media that treated citizens of the capital at their leisure.[2] Of this group, his most ambitious works were two multifigured genre paintings, *A Street Show in Paris* and *The Meeting on the Boulevard*, generally considered to be pendants even though the compositions do not relate to one other in any conventional way.[3] Little is known of the eighteenth-century history of these paintings,[4] which soon lost their attribution to Saint-Aubin: *A Street Show in Paris* was sold in the Baring sale as by Gillot; *The Meeting on the Boulevard* entered the Musée de Perpignan as a Lancret.[5] And if Gabriel had hoped to capitalize on the growing market for prints of Parisian social life, he was doubtless disappointed. A.-J. Duclos's etchings of *A Street Show* and *Meeting on the Boulevard* (fig. 119) – the latter, which differs from the painting in several details, was possibly based on an intermediary composition (see below) – were never published, and exist in only a handful of preliminary states.[6]

Fig. 119 A.-J. Duclos, after Saint-Aubin, *The Meeting on the Boulevard*. Bibliothèque nationale, Cabinet des Estampes, Paris

With its canopy of overarching elms offering shade from the afternoon sun, *A Street Show in Paris* presents a motley assortment of strollers and passers-by who stop to watch Arlequin and Crispin duelling on the raised wooden platform. As indicated by the painting's nineteenth-century title – *La Parade du Boulevard* – Saint-Aubin is portraying a *parade*, defined in a theatrical dictionary of 1763 as "a farce or little comedy with no rules whatsoever . . . very free and very satirical, that the buffoons stage on scaffolding above the entrance to their plays in order to attract the public."[7] Nurtured in the fairs of Saint-Laurent and Saint-Germain during the Regency, this sort of alternative theatre provided ubiquitous open-air entertainment that was dominated by the characters of the *commedia dell'arte* long after the demise of the *fête galante*. Indeed, with the growth of Paris and the opening up of the city to the north, the *parade* would become the form of entertainment intimately associated with the new boulevards.[8] As Louis-Sébastien Mercier complained in the *Tableau de Paris*, "The parades that are performed on the balcony in the open air to entice the public are extremely prejudicial in that they draw a crowd of workers who arrive open-mouthed, with their tools under their arms, thereby wasting the most precious hours of the day."[9]

Saint-Aubin's lyrical valediction to the *fête galante* contains no such hint of disapproval. At lower right we see a drummer boy who is napping before the next performance; his job is to sound a drum roll to draw the crowd's attention to the act. Observers of various ages are portrayed, equally enraptured by the mock duel: from the portly cleric who stands directly underneath the elegant lady with the parasol, to the child dragging at the hand of his mother (or sister) who is chaperoned by an amorous waiter (or *garçon limonadier*), with his flowing apron and rakish braid. In a splendid sheet of studies (fig. 120) formerly in the Goncourt collection, Saint-Aubin prepared several of these figures: the mother and child seated on the makeshift fence, the standing behatted man seen from behind, the afore-mentioned cleric, and the importuning boy with raised arm and leg, studied twice.[10] In the manner of Watteau and his followers, these drawings served as precise blueprints for the cluster of figures that are effortlessly integrated into the gently receding diagonals of Saint-Aubin's composition.

Unlike the humble protagonists of *A Street Show in Paris*, the dramatis personae of the *Meeting on the Boulevard* are distinctly patrician. Clad in red velvet, his tricorn tucked under his left arm, an elegant gallant escorts his fan-holding companion, resplendent in a mountainous hooped skirt of formal appearance and hue. Savoyard children provide musical entertainment, to which the couple remains oblivious, in contrast to the barking dog at right. At left, an equally stylish group of three women and a man, seated around a table and taking refreshment, is approached by an aged beggar. In the background at right can be seen a double row of carriages, arriving and departing.

Variously entitled the *Promenade aux Champs-Élysées*, *Promenade de Saint-Cloud*, and *Promenade à Longchamp*,[11] Saint-Aubin's *Meeting on the Boulevard* distils a minimum of topographical information, in keeping with the conventions of the *fête galante*. Yet its morphology is somewhat hesitant and additive, and historians have drawn attention to a certain strain in the composition, overpowered as it appears to be by the bower of trees in the upper quadrant.[12] As noted above, in contrast to *A Street Show in Paris*, its presumed pendant, *Meeting*

on the Boulevard was not engraved by Duclos. The etching by the latter must have been based on a very similar composition: it recasts the central couple, eliminates the Savoyard children, and enhances the proportions of the seated figures at left (see fig. 119).[13] Indeed, the seated quartet, courting couple, and music-making children of the final painting are based on figures from two different drawings altogether: the more populous (and urban) *Les Boulevards* (Fondation Custodia, Institut Néerlandais, Paris) and the virtuoso *Street Scene* (location unknown), which both date from around 1760.[14] That Saint-Aubin may have been working on two parallel compositions at the same time is further suggested by the reappearance of *Society Promenade* (The Hermitage, Saint Petersburg), a meticulously finished watercolour virtually identical to Duclos's etching (and in the same direction), with certain foreground details omitted.[15]

Dacier was the first to propose that *The Meeting on the Boulevard* may have been inspired by Augustin de Saint-Aubin's compositions of fashionable promenades on the outskirts of Paris, notably the leafy *Promenade des remparts* engraved by Courtois in 1760.[16] Such newly developed boulevards offered both public walks and ample pedestrian side paths, "dotted with cafés and variety shows of the sort commonly seen at fairs."[17] However, unlike his graphic work which is startling in its immediacy, Gabriel de Saint-Aubin's paintings are mediated by prior conventions and traditions. Here, the principal influences are the market scenes of Jeaurat, one of the artist's mentors at the Académie, and, above all, the moribund genre of the *fête galante* (it is not surprising that these paintings were once attributed to Watteau's master Claude Gillot and his most gifted follower, Nicolas Lancret).

For Dacier, both pendants represented different aspects of the *same* boulevard,[18] something that is not apparent to a twenty-first-century viewer, who is struck rather by the rustic or suburban appearance of the sites: *A Street Show in Paris* has none of the bustle of Saint-Aubin's Tuileries scenes; and *Meeting on the Boulevard* evokes the entertainments at Saint-Cloud or Auteuil, pared of their rowdiness. It may be merely coincidence that in 1759 the Boulevard du Temple was officially authorized to host popular entertainments, and the impresario Jean-Baptiste Nicolet transformed the Salle de spectacles at the Barrière du Temple into a fully-fledged popular theatre.[19]

Fig. 120 Gabriel de Saint-Aubin, *Study for A Street Show in Paris*, c. 1760. Location unknown

Very soon, the Boulevard du Temple, with its rows of trees, regularly watered promenades, and abundant seating, would become a favourite haunt of Parisians: "There, one saw the most beautiful women of the City and the Court, in their splendid carriages with seven-paned windows."[20] Few details of this burgeoning actuality are rendered in Saint-Aubin's pendants, but both paintings may be said to herald public life on the new boulevard – recently described as "both aristocratic and rustic in origin."[21]

CBB

Jean-Baptiste Greuze (1725–1805)

63 *The Sleeping Schoolboy* 1755

63 × 52 cm

Musée Fabre, Montpellier

One of the three paintings that Greuze presented in support of his associate membership of the Académie royale in June 1755 – all of which were owned by Ange-Laurent de La Live de Jully[2] – *The Sleeping Schoolboy* shows a young lad, in rustic attire, who has fallen asleep while studying his lessons (he appears to be leaning against the table). Despite the tenderness and lack of sentimentality of the composition, Greuze's somewhat laboured handling and thick impasto (the letters in the book are inscribed with the tip of the brush) were considered by certain critics of the Salon of 1755 to be inappropriate for a cabinet picture: "I do not know whether it would be advisable to continue in such a manner which will lose its effect in the collector's cabinet, where one likes to look at pictures close to, and where such slick brushstrokes, if you'll forgive the expression, are hardly flattering to the eye."[3] As Edgar Munhall has noted, here, perhaps for the first and last time, Greuze paid heed to a critic's advice.[4] In *The Young Knitter Asleep* (fig. 121) – the pendant to this painting, commissioned by La Live de Jully after the artist returned from Rome, and shown at the Salon of 1759 – Greuze's handling is far more delicate and controlled, and his technique more assured. Like Chardin, Greuze assigns his young protagonists activities appropriate to their gender, even if they are both quietly delinquent: the boy is taught to exercise the mind, while the girl learns a useful domestic skill.

Greuze's debt to seventeenth-century Dutch painting (and especially Rembrandt) was immediately remarked upon. He had been "nourished" by his study of "les peintres flamands," who were so skilled in "capturing Nature."[5] As Mariette noted a decade later, in both paintings, "Nature is rendered with the greatest truthfulness; the works are painted broadly and owe much to Rembrandt in their colouring and intelligent light effects, especially that of the little boy."[6] The device of a figure seen through a ledge or parapet, which Greuze employs with considerable subtlety, would further have been recognized as "in the manner of Girardou [Gerrit Dou]."[7] Although La Live de Jully gradually divested himself of his seventeenth-century Northern cabinet pictures, this was the school to which he had been initially attracted: in the mid-1750s he had owned a pair of pendants by Rembrandt.[8]

As Locke had noted in *Some Thoughts Concerning Education* (1693), learning need not be burdensome, and he discouraged parents and teachers from forcing books on children at too early an age, preferring instead various games and playthings to help teach them the alphabet:

A lasting continued attention is one of the hardest tasks [that] can be imposed on them. . . . Inadvertancy, forgetfulness, unsteadiness, and wandering of thought are the natural faults of childhood, and therefore when they are not observed to be wilful, are to be mentioned softly and gained upon by time.[9]

Greuze would seem to concur with such enlightened opinion. He is certainly less extreme than Rousseau, who advocated the abolition of all book learning, "the child's greatest misery."[10] "Reading is the scourge of childhood," Rousseau noted in *Émile ou de L'Éducation*, published in 1762, "and yet it is practically the only activity one imposes on them."[11] Émile will be given a book for the first time when he reaches the age of twelve; he will learn to read when it is of use to him; "until then, reading is good only to annoy him."[12]

Taking a stand midway between the English and French philosophers, Greuze's sympathetic, if rough-hewn portrayal of a boy at his lessons doubtless found a sympathetic response in the more moderate La Live de Jully, whose sister, the Comtesse d'Houdetot, and sister-in-law, Madame d'Épinay, were fervent supporters of Rousseau.[13] But it would be unwise to attach too programmatic a meaning to Greuze's precocious neo-Dutch genre painting. If anything, his sleeping schoolboy might be said to subvert the "absorptive activities of reading and study" that Michael Fried considered of such significance for French painting of the 1750s.[14]

CBB

Fig. 121 Jean-Baptiste Greuze, *The Young Knitter Asleep*, c. 1758. The Huntington Art Collection, San Marino, California

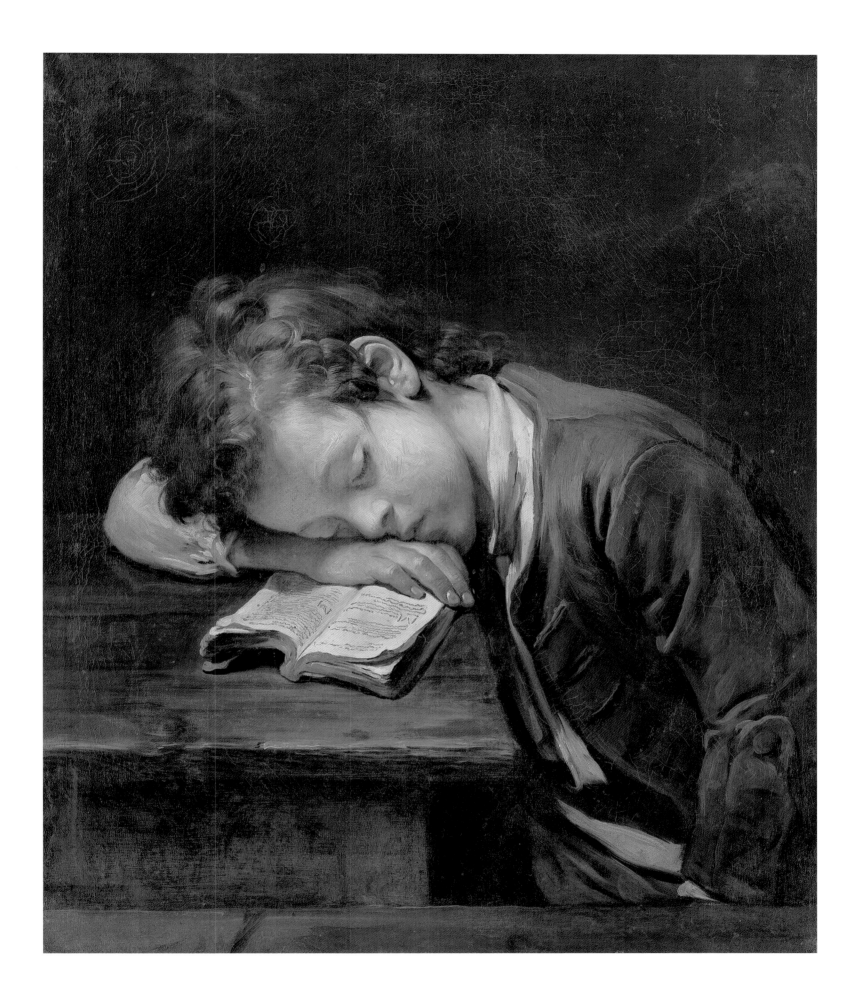

JEAN-BAPTISTE GREUZE (1725–1805)

64 *The Broken Eggs* 1756

73 × 94 cm

The Metropolitan Museum of Art, New York

65 *The Neapolitan Gesture* 1757

73 × 94.3 cm

Worcester Art Museum, Worcester, Massachusetts

This pair of pendants was painted in Rome, in two separate campaigns, for Louis Gougenot, abbé de Chezal-Benoît (1719–1767), who in October 1755 had invited Greuze to accompany him on a Grand Tour of Italy (and during that trip, proved a keen observer of local costumes). The two men travelled to Turin, Genoa, Parma, Modena, Bologna, Florence, and Naples before arriving in Rome in January 1756. Gougenot underwrote the costs of the journey, as well as those associated with the paintings upon which Greuze embarked, for which the hiring of models may have been the most significant expense.[3]

Gougenot returned to Paris in May 1756, probably taking *The Broken Eggs* with him (it was completed just before he left). Greuze would remain in Rome until April of the following year, and for the last six months of his sojourn was given lodgings at the Academy's quarters in the Palazzo Mancini on the Corso. It was doubtless in his studio there, two months before his own departure, that he completed *The Neapolitan Gesture*. On 22 February 1757, Natoire informed the Marquis de Marigny that this was probably the last work Greuze would paint in Rome. It had "great merit," but he wished that the artist "had added the element of landscape to his genre, which would lend more variety to his pictures."[4] As Edgar Munhall has pointed out, *The Neapolitan Gesture* has "about as much of a landscape as Greuze ever painted in his early years."[5]

Greuze's Roman genre paintings were already known to prominent Parisian collectors before their public unveiling at the Salon of 1757. The abbé Jean-Jacques Barthélemy had described them both in his dispatches to the Comte de Caylus (to whom, he noted, Greuze and Gougenot were "bien attachés"); and it was after having seen *The Broken Eggs* in the autumn of 1756, that Marigny commissioned Greuze to paint a pair of oval decorations for his sister's apartment at Versailles (see cat. 68).[6] As Barthélemy had predicted, *The Broken Eggs* and *The Neapolitan Gesture* received admiring and enthusiastic reviews from all critics of the Salon of 1757, where Greuze's pictures were hung next to Chardin's, "pour faciliter la comparaison" (a considerable honour for the thirty-two-year-old associate member of the Academy).[7] By including the portraits of Gougenot (Musée des Beaux-Arts, Dijon) and his good friend the sculptor Jean-Baptiste Pigalle in this Roman *envoi*, Greuze publicly acknowledged the generosity of his Maecenas, whom he seems largely to have shunned thereafter.[8]

Capitalizing perhaps on the vogue for Italianate costume scenes made for Parisian consumption – in November 1751 the *pensionnaire* Jean Barbault had been commissioned to paint a series of "costumes d'Italie" for the returning Marquis de Vandières (the future Marquis de Marigny)[9] – Greuze painted his most fluent and colourful genre pictures to date. The earliest description of *The Broken Eggs* is found in Barthélemy's letter to Caylus of 12 May 1756:

> A young girl had a basket of eggs; a young man has toyed with her, the basket has fallen and the eggs have broken. The girl's mother arrives, grabs the young man by the arm, and demands to be compensated for the eggs. The disconsolate girl is seated on the ground; the embarrassed young man makes the most feeble excuses in the world; the old woman is in a fury. In the corner of the canvas, a little child takes one of the broken eggs and tries to repair it.[10]

Greuze may have conceived of his characters somewhat differently. In the description that appeared in the *livret* of the Salon of 1757, the old crone is described as a mother who is scolding the young man for having upset the basket of eggs that her servant has just brought back from market.[11]

Curiously, in no contemporary account is there any allusion to the salacious meaning of the picture (Diderot would only begin writing salon criticism in 1759). Barthélemy considered the figure of the young girl so noble "that she could grace a history painting;"[12] Fréron, in *L'Année littéraire*, praised the "charm, beautiful softness, and lively expression" with which she was portrayed.[13] There is little question that Greuze was showing the consequences of the loss of virginity, for which broken eggs were a well-known symbol: the theme would interest him thoughout his career. Despite the propriety of girl's attire – her skirts are settled, her corset is tied – her red eyes and sorrowful expression suggest that she is crying over something more important than a basketful of broken eggs. And Greuze transforms the child at right, with his makeshift bow and arrow precariously balanced on the barrel, into a "solemn, plainclothes Cupid, silently commenting on the irreparable consequences of erotic abandon."[14]

As befitted even an unofficial *pensionnaire* of the Académie de France in Rome, Greuze more or less seamlessly incorporated a range of sources into this exquisitely painted costume drama. Willibald Sauerländer noted the affinity between the pose of the tricorne-doffing roué and the antique statue of the *Hercules Farnese*.[15] The figure of the seated girl that so impressed Barthélemy derives from van Mieris's *Broken Egg* (The Hermitage, Saint Petersburg), which Greuze could have known from Pierre-Étienne Moitte's engraving, published in 1754.[16] For his forlorn maiden, Greuze might also have been inspired by Caravaggio's *Penitent Magdalen*, with her lowered head and clasped hands, in the Doria-Pamphili collection. On a less elevated register, popular engravings showing the loss of virginity routinely employed the symbolism of broken eggs and admonishing crones: a crude print such as *Les plaisirs interrompus* suggests the sophistication of Greuze's interpretation of a well-established rustic theme.[17] Boucher had treated a slightly earlier episode of this predictable story in *La belle cuisinère* (fig. 122); and Greuze may well have been familiar with Aveline's engraving of it.[18]

Without *The Broken Eggs* in front of him (which left Rome for Paris with the abbé Gougenot), it is not altogether surprising that Greuze did not succeed in maintaining the same proportions for the figures in its pendant. While not identical, the dramatis personae of *The Neapolitan Gesture* loom somewhat larger than in the earlier

work. Once again, the first discussion of the painting comes from the abbé Barthélemy's letter to Caylus of 22 February 1757:

Greuze has just brought us a painting that is striking in its colour. It shows a Portuguese disguised as a seller of matches, who tries to make his way into a house to see a young lady. The servant suspects that there is some treachery afoot, pulls his cloak and discovers the Order of Christ (which Greuze calls his *dignity*). The Portuguese is abashed, and the girl, who is present, mocks him in the Neapolitan manner, by placing her fingers under her chin. It was in order to emphasize this gesture, which is very pretty, that Greuze conceived of his picture.[19]

Making use of the abbé Gougenot's unpublished travel diaries for his own, much-used *Voyage d'un françois en Italie* (1769), Jean-Jacques François de Lalande explained that the Neapolitan gesture of saying no by "passing the back of fingers rapidly under the chin," rather like "our gesture of turning the head to right and left," was in current usage in Rome as well as in Naples.[20] He noted furthermore that Greuze had done two pictures of the subject for the abbé Gougenot: *The Neapolitan Gesture* and one representing "a Roman woman in half-length, with her headdress lowered over her eyes." (Of the latter work, there is no trace.)[21]

Critics were also sensitive to Greuze's attempt – not altogether successful in their opinion – to elevate the social standing of the protagonists in *The Neapolitan Gesture*. The Portuguese suitor, disguised as a pedlar, is a chevalier of the Order of Christ, whose double cross hangs above his basket of wares.[22] Barthélemy claimed that he was not sufficiently noble in mien: "He looks too much like a match vendor."[23] Renou compared him to a thief on the run: "The artist should have ennobled his face."[24] The old woman, surely the same model whom Greuze had used for the angry crone in *The Broken Eggs*, appears now with the distinction befitting the duenna of the bejewelled young mistress. As to the latter, Barthélemy took exception to her expression, which should have been both more lively and more refined: "In a history painting, she would have been the most beautiful creature in the world."[25] Such microscopic scrutiny of Greuze's figures would become a commonplace of Salon criticism – at its most probing in discussions of *The Marriage Contract* (cat. 71).

As was increasingly his custom, Greuze made preparatory drawings (fig. 123) for several of the figures in *The Neapolitan Gesture*.[26] The motif of the child restraining the barking dog at lower right would later serve as the basis for his immensely successful *Child Playing with a Dog* (cat. 73) exhibited at the Salon of 1769, as James Thompson has noted.[27] Finally, such was the fashion for a paired reading of genre paintings, that Moitte's engraving of *The Neapolitan Gesture* was announced in June 1763 as a pendant to P.-F. Martinasi's print of *The Father Reading the Bible to his Family* in La Live de Jully's collection, first published four years earlier.[28]

CBB

Fig. 122 François Boucher, *La belle cuisinière*, 1732–34. Musée Cognacq-Jay, Paris

Fig. 123 Jean-Baptiste Greuze, *Drawing of an Old Woman with Arms Outstretched*, 1756. Collection of Joseph F. McCridle

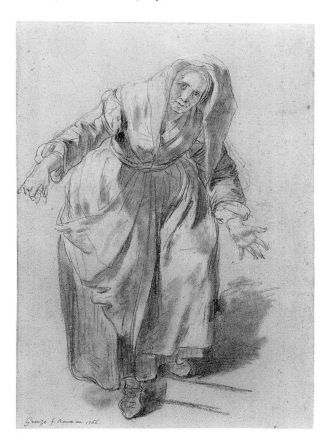

249

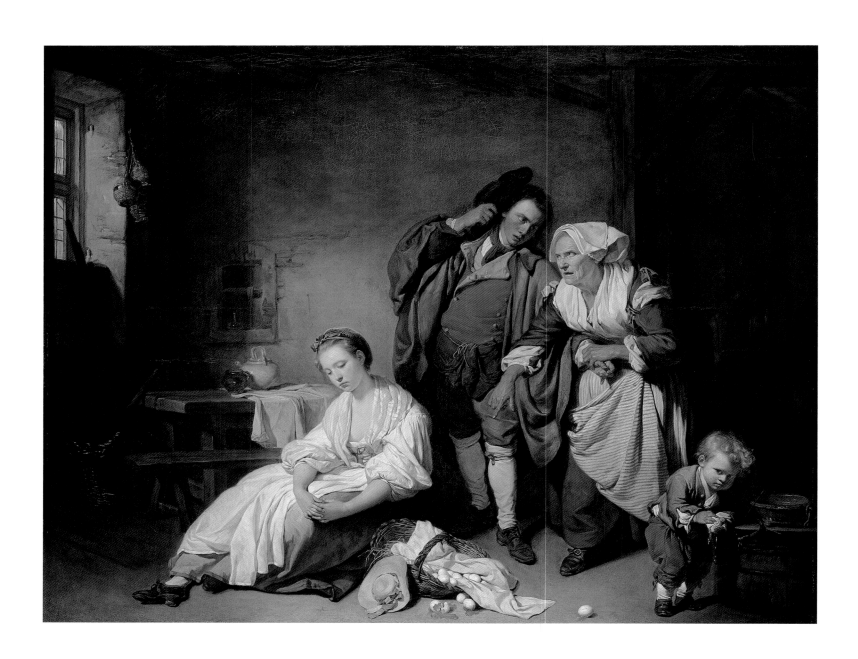

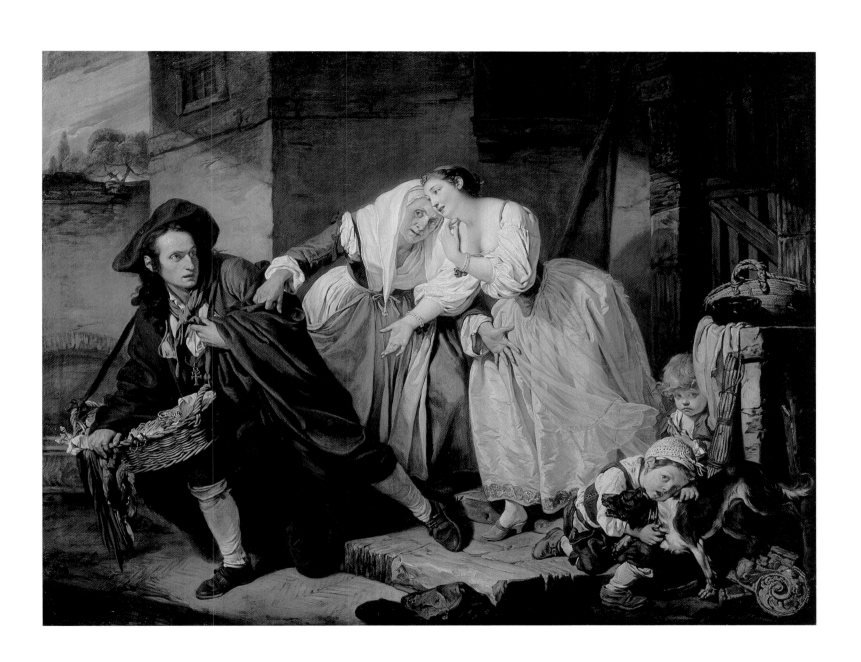

Jean-Baptiste Greuze (1725–1805)

66 *Indolence* 1756–57

64.8 × 48.8 cm

Wadsworth Atheneum Museum of Art, Hartford, Connecticut

Slovenly and slipshod, Greuze's "lazy Italian girl" presides over a kitchen of utter disarray, in which the lowly household objects – from the copper pot and *fiaschi di Chianti* on the upper right, to the trifoliate washstand, basin, and kettle below – are painted with the most extraordinary refinement. Rich brown tresses hang over her left breast; the nipple of the right breast is just visible; her right foot is bare, each toenail daintily painted (Greuze was something of a foot fetishist). Yet, despite this battery of erotic signifiers, Anita Brookner was surely right to stress that, for once, Greuze indulges in no "undertone of sexuality reprimanded; there is enough sensuality in the picture . . . to render it wholesome."[1] And the wedding band on the girl's plump finger serves almost to corroborate this insight.

Indolence was painted in Rome as a companion piece to *The Fowler* (fig. 124), whose dynamic arching composition it more gently mirrors (one imagines that *The Fowler* would have hung to the right). Just as the wide-eyed model for *The Fowler* had in all likelihood also

Fig. 124 Jean-Baptiste Greuze, *The Fowler*, 1756. National Museum, Warsaw

served for that of the Portuguese chevalier in *The Neapolitan Gesture* (cat. 65), so Greuze may have used the same raven-haired woman who modelled for the mistress in that composition as his slatternly kitchen maid.[2]

The two paintings relate to each other for reasons beyond the purely formal. As Edgar Munhall noted, they provide a contrast in states of mind: the extreme lethargy of the woman, the almost pathological brutality of the man.[3] Might Greuze have conceived of them as elements in a connecting narrative as well? The fowler, having returned from his hunt for birds (note the trap on the wall, the cage and decoy bird on the table), is now preparing to ensnare a human victim with his music; Moitte's print after the painting was entitled *Le donneur de sérénade*. In this reading, the dimwitted subject of *Indolence* assumes a certain poignancy as an unwilling Papagena. Indeed, it has recently been suggested that her doubled-over pose, with arms about her stomach, might have signalled that she was not only lazy but pregnant.[4]

Alone among Greuze's submissions to the Salon of 1757, this pair of pendants was listed in the *livret* with the name of their owner: "They belong to M. Boyer de Fonscolombe and are taken from his Picture Cabinet in Aix-en-Provence."[5] The discerning collector in question was Jean-Baptiste-Laurent Boyer de Fonscolombe (1716–1788), *conseiller au Parlement de Provence*, whose mansion on the Rue de la Grande Horloge housed a large collection of seventeenth-century Northern cabinet pictures and eighteenth-century French paintings and drawings.[6] Boyer de Fonscolombe was devoted to artists from his native town. He commissioned several works from Dandré-Bardon, including his genre series *The Four Ages of Man* (see cat. 48 and 49), and would later support the history painters Pierre Peyron and Esprit-Antoine Gibelin.[7] However, such early interest in Greuze – and Hubert Robert, his favourite artist – was most likely encouraged by his younger brother, the diplomat Joseph-Roch Boyer de Fonscolombe (1721–1799), who served as secretary to the Duc de Choiseul, newly appointed French Ambassador to Rome (and later the owner of several masterpieces by Greuze, including *Child Playing with a Dog*, cat. 73).[8] Joseph-Roch may also have acted as his brother's conduit to other French painters working in Rome during Greuze's sojourn. Among Boyer de Fonscolombe's modern French pictures were six small works by Jean Barbault, done in 1756, and representing "several different Roman and Neapolitan Costumes."[9]

CBB

Jean-Baptiste Greuze (1725–1805)

67 *Boy with a Lesson Book* 1757

61.8 × 48 cm

National Gallery of Scotland, Edinburgh

According to the dealer Pierre Remy, *Boy with a Lesson Book* was painted in Italy.[1] It was included among the "Roman paintings" shown at the Salon of 1757, although it parts company with these colourful costume pieces (see cat. 64–66) while sharing their subtlety of execution and mastery of technique. Wearing a plain, rustic jacket, his long locks swept back from his forehead in a braid, Greuze's diffident schoolboy, with immaculately clean hands and spotless fingernails, is shown committing his lesson to memory. Less ambitious as a composition, *Boy with a Lesson Book* may have nonetheless appealed to critics at the Salon of 1757 for its harmonious handling and tonal transitions, all the more impressive since Greuze's pictures had been hung next to Chardin's, whose "magie des tons" made him a redoubtable neighbour.[2]

Clearly, Dutch seventeenth-century painting remained a powerful inspiration for Greuze, despite the riches of the Eternal City; and Edgar Munhall has noted the influence of a work such as Rembrandt's *Titus at his Desk* (fig. 125) on Greuze's young scholar.[3] Such qualities would also have appealed to the first owner of this painting (who kept it for no more than seven years), Jean-Antoine de Guélis, Chevalier de Damery (1723–1803), *lieutenant de grenadiers aux gardes françaises* – a voracious collector of Dutch cabinet pictures and contemporary French art, both paintings and drawings, who would be the godfather to Greuze's second daughter, Anne-Geneviève. To the Salon of 1757, Damery had lent Chardin's *Still-life with Game, Gamebag, and Powder Horn* (location unknown) and Jeaurat's *Carnival in the Streets of Paris* and *Prostitutes Being Led Off to La Salpêtrière* (cat. 45).[4]

For the schoolboy's unexpected coiffure, Greuze may have looked to Jacques Saly's *Bust of a Young Girl* (marble in the Victoria and Albert Museum, London), commissioned by Jean-François de Troy and exhibited at the Salon of 1750, a version of which he could also have seen during his fourteen-month stay in Rome.[5] The renown of Saly's bust as a model for artists is attested to by its inclusion in Noel Hallé's *Portrait of Françoise-Geneviève Lorry and of her Son Jean-Noël* of 1758 (cat. 57).[6]

As Michael Fried has observed, "The student in Greuze's picture has partly covered with his hands the page of his book, and seems inwardly to rehearse its contents; his downward gaze conveys an impression of unseeing abstraction."[7] John Smith, who imported the picture into England in 1816, noted that the boy is "conning over his lesson."[8] Advanced opinion was beginning to question the usefulness of this sort of instruction, however. The *Encyclopédie* considered it unnatural that schoolmasters "give lessons that tire both understanding and memory without nourishing or perfecting either of them."[9] Words and writing were insufficient to impart ideas to young minds: "It is through his organs that man receives ideas, and only his feeling is capable of committing them to memory."[10] Rousseau insisted that Émile, living free of all constraints, would never learn anything by heart – not even La Fontaine's fables.[11]

Once again, Greuze seems more in sympathy with the measured advice in Locke's *Some Thoughts Concerning Education*. The training of memory is unquestionably "necessary to all parts and conditions of life;" strength of memory results from a happy constitution, rather than "any habitual improvement got by exercise;" but "learning by heart great parcels of the authors" is stringently discouraged. Careful selection of "wise and useful sentences" to be committed to memory – similar perhaps to the excerpts inscribed in Greuze's schoolboy's well-thumbed primer – provides the proper exercise for children: "The custom of frequent reflection will keep their minds from running adrift and call their thoughts home from useless, unattentive roving; and therefore I think it may do well to give them something every day to remember, but something that is in itself worth the remembering."[12]

CBB

Fig. 125 Rembrandt van Rijn, *Titus at his Desk*, 1655. Museum Boijmans Van Beuningen, Rotterdam

Jean-Baptiste Greuze (1725–1805)

68 *Simplicity* 1759

71.7 × 59.7 cm

Kimbell Art Museum, Fort Worth, Texas

Fig. 126 Jean-Baptiste Greuze, *The Young Shepherd Holding a Flower*, 1761. Musée du Petit Palais, Paris

Simplicity and its pendant, *The Young Shepherd Holding a Flower* (fig. 126), represent Greuze's brief incursion into Boucher's terrain of the pastoral. The pictures were commissioned in November 1756 by the Marquis de Marigny for the ground-floor apartments at Versailles that his sister, Madame de Pompadour, had occupied since October 1751.[4] Greuze did not begin work on the pair until after he returned to Paris, and even then, took four years to complete them: a rare case of "writer's block" perhaps, although Natoire had commented that "he is a boy who works with difficulty."[5]

Dressed in an elaborate peasant costume of the purest white, the young girl picks the petals from a daisy to answer the question, "He loves me, he loves me not." Her companion, a red-haired shepherd with immaculate curls, is about to blow on a dandelion to see whether his love is reciprocated. Given the cessation of carnal relations between Madame de Pompadour and the King – since 1751, their "friendship" was a matter of public knowledge – Greuze might have chosen a more tactful subject for his pendants.[6]

The genesis of this commission is well documented. Having seen Greuze's recent paintings, brought back from Rome by the abbé Gougenot (see cat. 64), the Marquis de Marigny, in a letter from Versailles dated 28 November 1756, informed Natoire that he wanted the "young man" (Greuze was thirty-one) to paint a pair of ovals for Madame de Pompadour's apartments in the château. This somewhat impulsive commission may have been inspired by the recent redecoration of Pompadour's state rooms, whose boiseries by Verberckt had been rewhitewashed in the summer of 1756.[7] Marigny enclosed a paper cut-out indicating the exact size and format of Greuze's paintings, but noted to Natoire, "I leave him the liberty of letting his own genius choose whatever subject he wishes."[8] Although Marigny did not indicate in which of the five magnificent rooms that comprised *l'appartement d'en bas* Greuze's ovals were to hang, he pointed out that "they will be seen by all the court, and could lead to great advantages for him if they are considered good."[9] Indeed, in January 1757 the Duc de Luynes noted that the Court and all the foreign ministers had assembled in Madame de Pompadour's apartments for the first time.[10]

Via Natoire, in January 1757 Greuze wisely requested that Marigny allow him to begin work on the oval pendants *after* he had returned to France.[11] Marigny graciously agreed, believing the artist's departure to be imminent: in fact, Greuze did not leave Rome until late April and, once home, his immediate concern was for the Salon of 1757. It is to be presumed that Greuze would then have sought more information as to the location and placement of his ovals, although there is no record that the Maison du Roi enlightened him on the subject. At least one preparatory drawing shows that he experimented with the position of the young girl, whom he initially portrayed turning to the left.[12]

What does seem likely, however, is that *Simplicity* and *The Young Shepherd* would have assumed a decorative function in whichever room they were installed (Pompadour did not have a picture cabinet in her official residence at Versailles), and may well have been placed at some distance from the viewer, although this did not prevent Greuze from scrupulously attending to details of fabric and flesh. For models, he may have looked to Charles-Antoine Coypel's ovals, *A Girl Playing with her Doll* and *A Boy Reading* (location unknown), commissioned in 1751 to decorate mirrors affixed to the upper section of two of Verberckt's panels in Pompadour's *Grand Cabinet*.[13]

Diderot's frosty reception of the two paintings is well known. *Simplicity* he dismissed, with Greuze's entire *envoi* to the Salon of 1759, "as insipid and off-white [*blanchâtre*] in colour."[14] *The Young Shepherd*, which finally appeared at the Salon of 1761, was "a thing of no great significance. One could almost take it for a Boucher, such is the elegance of the dress and the brilliance of the colours."[15] Given Pompadour's patronage of the latter, it is not altogether surprising that Greuze chose to work in Boucher's idiom. Furthermore, Greuze may also have been obliged to use a predominantly white palette – recognized as "one of the greatest difficulties for a painter"[16] – to harmonize with the panelling of Pompadour's refurbished apartment. But as one critic pointed out, having been reproached for his excessive use of black in his submissions to the previous Salon, Greuze had perhaps overcompensated by "going to the opposite extreme."[17]

CBB

JEAN-BAPTISTE GREUZE (1725–1805)

69 *Silence!* 1759

62.8 × 50.8 cm

Lent by Her Majesty Queen Elizabeth II

Of the twenty works that Greuze exhibited at the Salon of 1759, the most carefully scrutinized by far was *Silence!*, number 103 in the *livret*: "A Painting representing Rest, characterized by a Woman who obliges her son to be silent by pointing to her other sleeping children."[1] Assisted by Cochin perhaps, the "*anti-philosophe*" Élie-Catherine Fréron narrated the modest family drama that Greuze had so punctilliously inscribed in paint:

> The mother has just placed her youngest son on her knees, who has fallen asleep while suckling at the breast, which is still exposed. So attentive has she been to her breastfeeding, that she has not noticed what was happening elsewhere. One senses that the boy whom she has silenced has only half taken his little wooden trumpet from his mouth, and that he will play it again as soon as he can. On the other side of the composition, one sees a child who has fallen fast asleep in his chair. So fond is he of his broken drum that it hangs from the side of the chair, and he must have insisted that it be placed there for safekeeping before he would go to sleep. The household objects are in disarray, since the nurse was obliged to

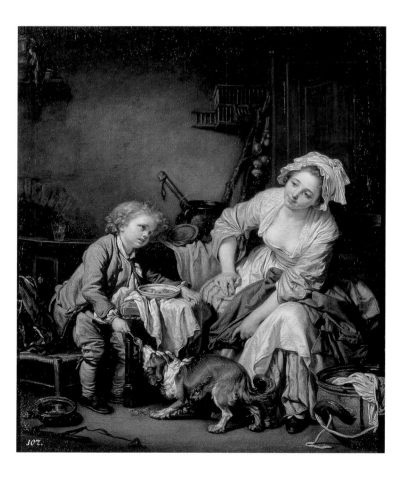

put them down in order to feed the crying infant: one cannot attend to everything at the same time.[2]

Continuing in this vein of *sensibilité*, Edgar Munhall noted that the eldest child was probably responsible for breaking his brother's toy drum.[3]

This painting was lent to the Salon by Jean de Jullienne (1686–1766), the *Amateur-honoraire* of the Academy who had been Watteau's great friend and promoter, but whose large collection was renowned for its Dutch and Flemish cabinet pictures. Indeed, Anita Brookner pointed out that Nicolaes Maes' *Young Mother Giving her Child the Breast* of 1655 (location unknown) may have offered Greuze his point of departure for *Silence!*[4] The beleaguered mother is posed as a rustic Madonna; as was his custom, Greuze also elaborated this genre scene through several preparatory drawings from various live models.[5]

In *Silence!* Greuze proves an unlikely advocate for maternal breastfeeding (his own children were farmed out to the wet-nurse); and on the subject of infant upbringing, he aligns himself with advanced opinion. "We are fully aware," wrote Jean-Charles Desessartz in his *Traité de l'éducation corporelle des enfants en bas âge* of 1760 (published two years before Rousseau's *Émile*), "that in our century a woman who breastfeeds her own child is a phenomenon one does not hesitate to associate with madness."[6] Not only is the youngest child in Greuze's painting suckled at the breast, he is also spared the constrictions of swaddling clothes: his dress has risen above the knees, exposing tiny genitals, and he is wearing shoes and socks at a remarkably early age. Wet-nurses were notorious for wrapping their charges tightly in the *maillot*, and letting them move as little as possible.[7]

For Rousseau, a return to maternal breastfeeding was a moral imperative: "Once mothers deign to feed their own children, our manners will reform themselves, a feeling for nature will awaken in everyone's hearts, and the State will be repopulated."[8] Extolling the figure of the "worthy mother," Rousseau nonetheless cautioned against the opposite extreme: the excessive mother, "who idolizes her child, who indulges and augments his weaknesses."[9] Greuze may have had such admonitions in mind when he painted *The Spoiled Child* (fig. 127). The picture's size and proportions render it a pendant of sorts to *Silence!*: it was shown at the Salon of 1765 and acquired immediately thereafter by the Duc de Choiseul-Praslin.[10] By allowing the little boy to spoon his meal to the dog, the delinquent mother is unwittingly cruel: "In letting their children wallow in such feebleness, they are preparing them for a life of suffering."[11]

CBB

Fig. 127 Jean-Baptiste Greuze, *The Spoiled Child*, 1765. The State Hermitage Museum, Saint Petersburg

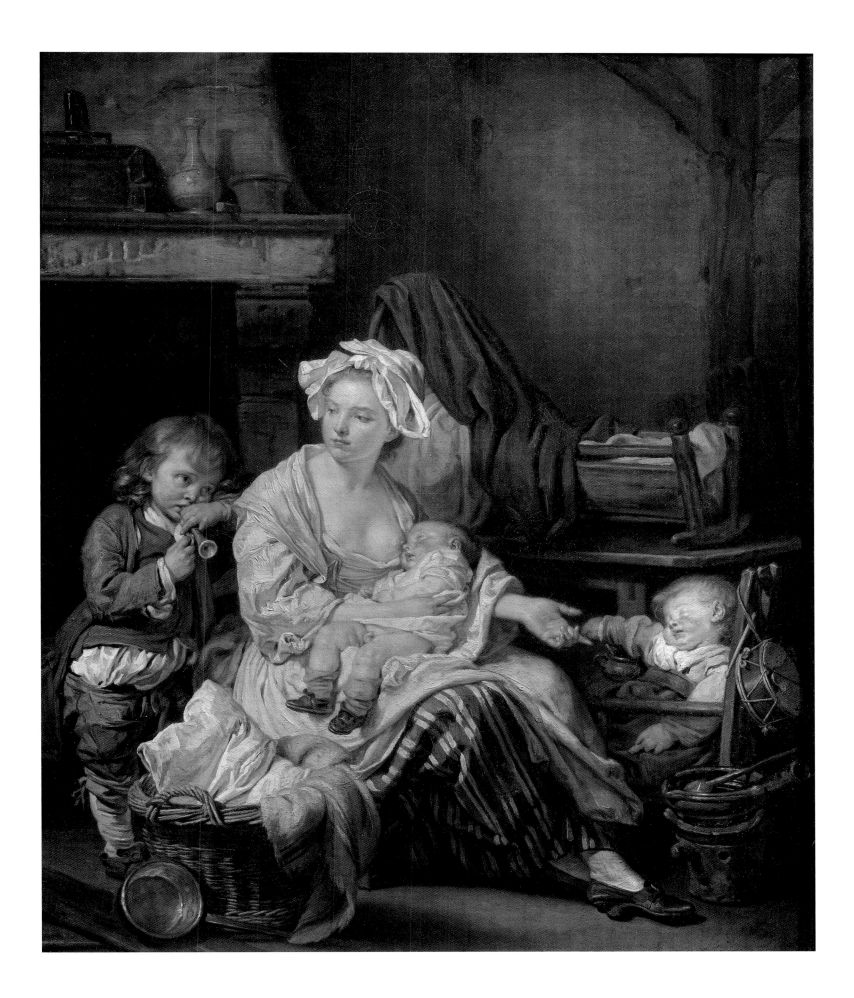

JEAN-BAPTISTE GREUZE (1725–1805)

70 *The Laundress* 1761

40.6 × 31.7 cm

The J. Paul Getty Museum, Los Angeles

"The little Laundress, who, seated on her tub, squeezes washing between her hands, is charming; but she's a rascal I wouldn't trust an inch. I'm too fond of my health."[1] Like all the critics of the Salon of 1761, Diderot responded enthusiastically to Greuze's lively representation of a maidservant doing the wash. Reviewers praised the painting's colour and handling, its truth to life, and the pert expression of the protagonist who casts a glance "as flirtatious as it is cheeky."[2] They also scrutinized the composition with the attention that might be reserved for a history painting. The abbé de la Garde questioned the decision to show linen hanging in the background, since it detracted from the brightness of the laundress's cap;[3] Diderot chided Greuze for not placing the girl more solidly on her wooden plank: "I'd be tempted to move that trestle forward a little, so that she'd be seated more comfortably."[4]

One of fourteen paintings, drawings, and pastels that Greuze exhibited that year – all soon to be eclipsed by *The Marriage Contract* (cat. 71), which arrived three weeks late – *The Laundress* was lent to the Salon of 1761 by Ange-Laurent de La Live de Jully (1725–1779), the *Introducteur des Ambassadeurs*, who was one of the artist's most prominent patrons. La Live de Jully paid six hundred *livres* for the canvas – more than Tessin had offered Boucher and Chardin for their cabinet pictures for Queen Luisa Ulrike fifteen years earlier – and he also framed it in a distinctive way.[5] As recorded by Gabriel de Saint-Aubin in a thumbnail sketch (fig. 128), a cartouche with the artist's name was placed on the upper section of the frame – as was the case for all the paintings in La Live de Jully's "patriotic collection" – since "it was perfectly possible to be a fine connoisseur and yet not know the name of the artist."[6]

With her lily-white hands, stockinged feet, and immaculate white cap and pink ribbon, Greuze's maidservant is an unlikely laundress, despite the appropriately humble setting in which she works (Saint-Aubin identified her as a "mlle du Lieu," a professional model well known to artists, no doubt).[7] Surrounded by almost spotless linen – hanging from the line, thrown across the little table at lower left, placed in a bundle behind her right sleeve – she is portrayed as a "blanchisseuse de gros linge," responsible for the larger household items. The distinctive tool of her trade – the beech beetle, or battledore, with which she would beat the linen to get rid of dirt – is shown only partially, almost as an afterthought, at the lower left-hand corner of the canvas. Far more prominence is given to an exotic pear-shaped pewter jug, or *marabout*, on the wooden table above the basin, which holds the hot water for the wash. Included as an homage to Chardin perhaps – who had used this vessel as an unlikely *repoussoir* in his *Morning Toilette* (see cat. 41) – the gleaming pot, no less than the laundress's Moroccan leather mule and spotless clothes, are unexpected accoutrements in these shabby servant's quarters.[8]

Diderot might well praise Greuze's vigorous naturalism, but the artist's world was selective and artfully constructed: a feminized *theatrum mundi* populated by maidservants and young mothers in varying states of decency and disarray. Greuze's *Laundress* is one of his more subtle (and restrained) inventions. Despite the provocative manner in which she handles the soapy wash – with the water oozing through her fingers – the young woman is not only remarkably animated and self-possessed, she is also properly attired, with no décolletage in view.

In fact, Greuze is less concerned to document the verities of washing linen in mid-eighteenth-century Paris – the job was carried out on the banks of the Seine by hardworking professionals (laundry was a site-specific undertaking)[9] – than to give visual form to a type of robust female character inspired by the popular theatre. The *genre poissard* (or fish-market style), which flourished at the Opéra Comique during the 1750s, took as its subject the fishwives and boatmen who worked along the Seine, as well as the stallholders of Paris's markets at Les Halles.[10] The leading exponent of the genre, Jean-Joseph Vadé (1719–1757), created the character of Nanette Dubut, a spirited laundress, as the heroine of his immensely popular epistolary novel, *Lettres de la Grenouillère*, published five times between 1755 and 1760.[11]

Greuze's *Laundress* is a seamless amalgam of various traditions, indebted to Dutch seventeenth-century cabinet painting, to Chardin's vacant servants washing linen, and to the fictional denizens of Les Halles and La Grenouillère. Despite the decorousness of her appearance, however, his laundress is unashamedly sensual; Greuze exploits the well-established literary trope of the maidservant-as-seductress with remarkable aplomb. *Pace* Diderot, Greuze had more in common with Boucher than his champion cared to admit.

CBB

Fig. 128 Gabriel de Saint-Aubin, illustration of Greuze's *Laundress* on a page (top left) from the *livret* of the Salon of 1761. Bibliothèque nationale, Cabinet des Estampes, Paris

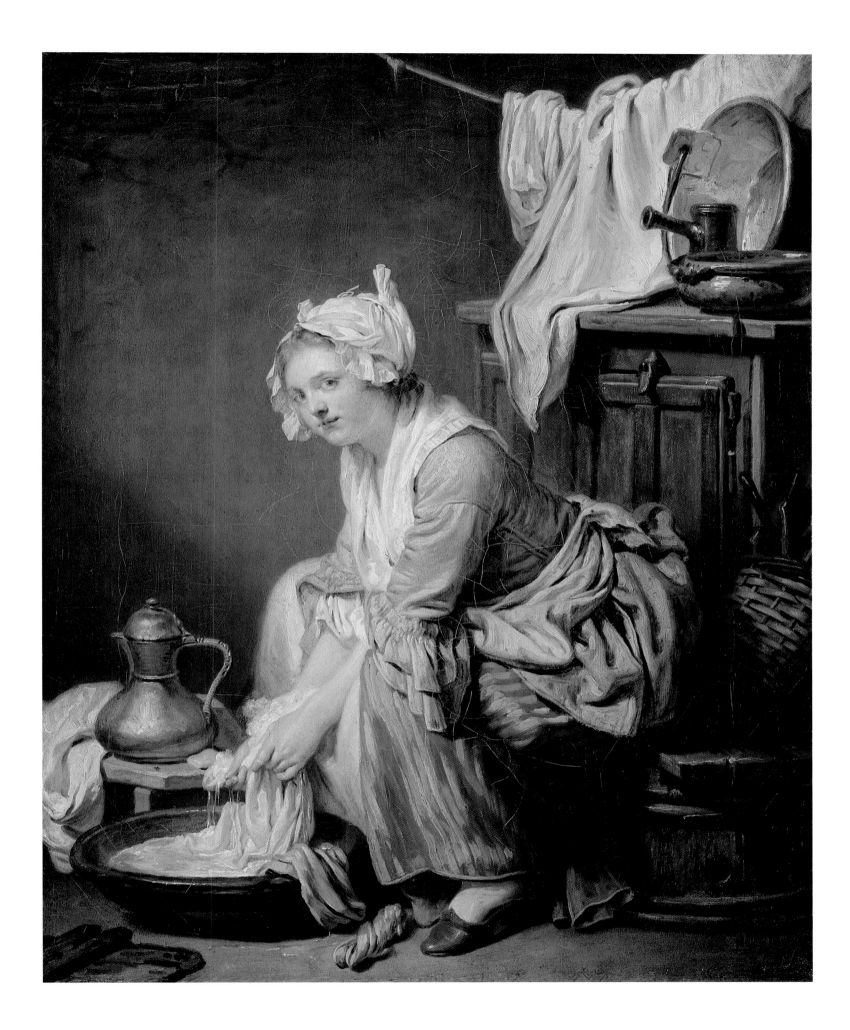

Jean-Baptiste Greuze (1725–1805)

71 *The Marriage Contract* 1761

92 × 117 cm

Musée du Louvre, Paris

Commissioned for his private collection by the Marquis de Marigny – for the princely sum of 3,000 *livres*, as both Grimm and Mariette confirmed[3] – *The Marriage Contract* was a spectacularly late arrival at the Salon of 1761, where it appeared three weeks after the opening. Greuze had been hard at work on the painting since July (at least),[4] and it was clearly Marigny's intention that it appear at the Salon on time. The marquis's name was published in the *livret* after the description of the work; Madame de Pompadour and La Live de Jully, both of whom also lent paintings by Greuze to the Salon of 1761, had preferred to remain anonymous.[5] As Cochin informed the impatient owner, "The picture that Greuze is doing for your cabinet" was completed on 17 September, would remain in the artist's studio for two days so that the paint could dry, and would be removed to the Salon immediately thereafter.[6] Thanks to Chardin, the new *tapissier* of the Salon (and also to the exalted status of Greuze's patron), *The Marriage Contract* must have been prominently displayed: it became the sensation of the year, "the painting that has *le tout Paris* returning to the Salon."[7] Diderot, and other critics, complained that it was hard to see "our friend Greuze's painting, which continues to attract great crowds."[8]

By far Greuze's most ambitious and carefully prepared genre painting to date – Edgar Munhall has identified over twenty preparatory drawings (and there were doubtless many more)[9] – *The Marriage Contract* depicts the ceremony of the *promesses de mariage*, the registration of a civil marriage by the notary, prior to the celebration in church.[10] As Emma Barker has pointed out, we are witnessing a betrothal, not a wedding. The signing of the contract and

the handing over of the dowry that formalized the young couple's union "were standard practice in France among all but the very poor."[11] Greuze's protagonists are members of a prosperous farming family: the patriarch is a *laboureur*, or tenant-farmer, whose house, while austere, boasts fine glass and metalware in the open cupboard and is well-stocked with bread (note the loaves on the upper shelf).[12] Two young maidservants in the background at left, as well as the figure of a worker climbing the stairs – more prominent in Greuze's final compositional study (fig. 129) – are suggestive of the hierarchy that exists within this rural household, as is the superiority of the notary, who has not removed his hat and is seated in the best armchair in
the house.

In the inspired ekphrasis that formed the "Récapitulation" to his Salon of 1761, Diderot marvelled at the role that each of Greuze's figures played so well. The curly-haired infant at right, too young to understand the momentous event, who interferes with the notary's papers; the elder sister behind him, "dying of sadness and jealousy," for whom it is a day of mourning (she ought to have married first);[13] the exemplary patriarch, whose hands are ruddied by hard work; the attentive son-in-law-to-be, "dressed to perfection, as befits his rank" (a dig at Boucher's "chimerical peasants").[14] Most affecting of all was the figure of the fiancée (*l'Accordée*), "charming, decent, and demure,"[15] whose left arm is slipped tenderly under that of her husband-to-be, and whose fingers touch his hand ("a delicate idea of the painter's").[16] Next to her, a younger sister, saddened to be separated from the bride (but whose tears do not dampen the event), and the robust mother – "a good peasant approaching her sixtieth birthday" – holding her daughter's arm for the last time.[17] Behind the matriarch are two of the younger children: a boy, standing on tiptoes so that he can see all that is happening, and a girl who is feeding the family of chicks with breadcrumbs from her apron. The mother hen and her brood, delicately illuminated in the foreground of the composition, discreetly symbolize the natural order.

As the critical response to it made clear, *The Marriage Contract*'s affective and dramatic unities satisfied the rampant sentimentality of the Parisian elites, while pictorializing many of the concerns dear to Enlightenment thought: the primacy of agriculture, the bonds of family, the importance of population, the legitimacy of the civil contract.[18] Applauded by Diderot, for whom such multifigured genre paintings were "just as much history paintings as Poussin's *Seven Sacraments* or Le Brun's *Family of Darius*,"[19] Greuze's masterpiece (as Mariette grudgingly admitted it to be) was received with similar enthusiasm by critics of all persuasions. Such was *The Marriage Contract*'s fame that on 3 April 1782, with Marigny's posthumous sale entering its third week, his successor at the Bâtiments authorized a bid of up to 24,000 *livres* so that the painting would remain in

Fig. 129 Jean-Baptiste Greuze, *Study for the Marriage Contract*, c. 1761. Musée du Petit Palais, Paris

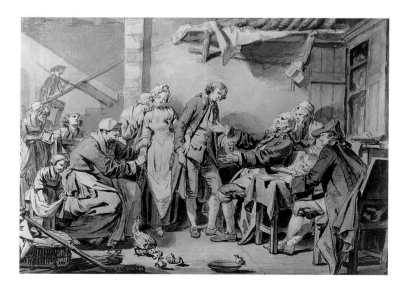

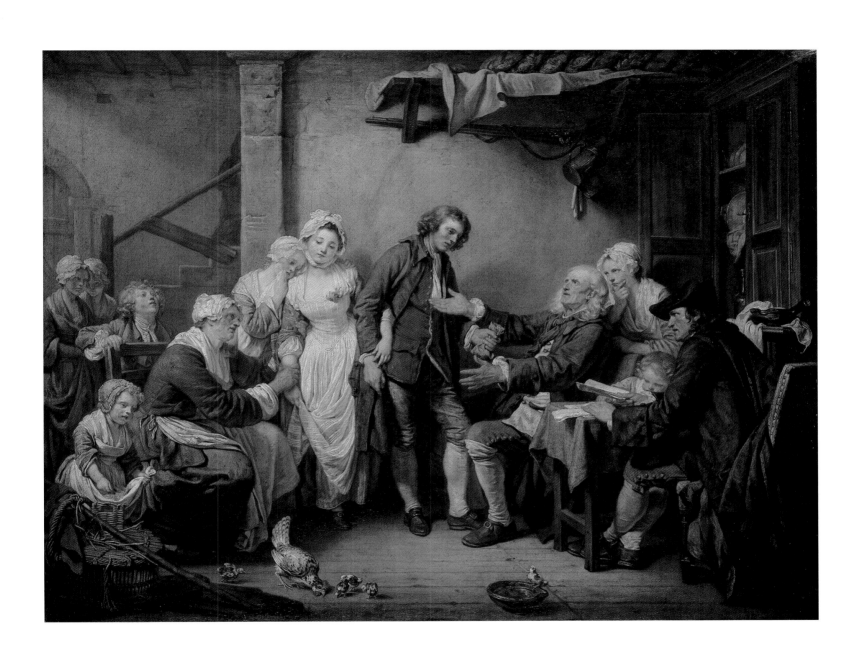

France.[20] D'Angiviller acquired *The Marriage Contract* for the royal collection for 16,500 *livres*; Boucher's masterpieces, *The Rising of the Sun* and *The Setting of the Sun* (The Wallace Collection, London), had been sold at Madame de Pompadour's sale in April 1766 for considerably less (9,800 *livres*).[21]

With Teniers as his starting point (as Diderot observed), Greuze created a hybrid that was unprecedented in French genre painting, and which seems to have appeared phoenix-like from his imagination (admittedly, after many preparatory studies). Emma Barker has noted that Le Bas' engraving of *La Fiancée normande* after a painting then attributed to Mathieu Le Nain, which appeared in 1760, might have provided a source for this rarely treated subject.[22] Greuze's debts to the contemporary theatre have also been remarked upon. Diderot's *Père de Famille*, published in 1758 and performed by the Comédie Française between February and April 1761, concludes with the father (a widower) blessing his children's marriages.[23] As Mark Ledbury pointed out, the final vaudevilles of "innumerable opéra-comiques" often ended with a marriage scene;[24] and indeed, it is well known that

Greuze's painting would inspire a *tableau vivant* in the Comédie Italienne, *Les Noces d'Arlequin*, performed before the year was out.[25]

Given that certain observers considered the female protagonists of *The Marriage Contract* to be *poissard* types – "the mother is a robust fruitseller or fishwife; the daughter, a pretty flower girl"[26] – it is worth noting another possible source for Greuze's composition. While Diderot's *Père de Famille* was playing at the Comédie Française, *Les Caquets* – a broad farce, inspired by Goldoni and written primarily by Marie-Jeanne de Mézières, Madame Riccoboni (1714–1792) – was being performed with greater success at the Comédie Italienne. Set among the denizens of Les Halles, the female characters are second-hand dealers of fine clothes (*revendeuses à la toilette*) and, as such, far removed from Greuze's prosperous peasantry. The play opens, however, in the paternal house of a Monsieur Adrien, where the company has assembled "to sign the marriage contract of Babet, who passes for his daughter."[27]

CBB

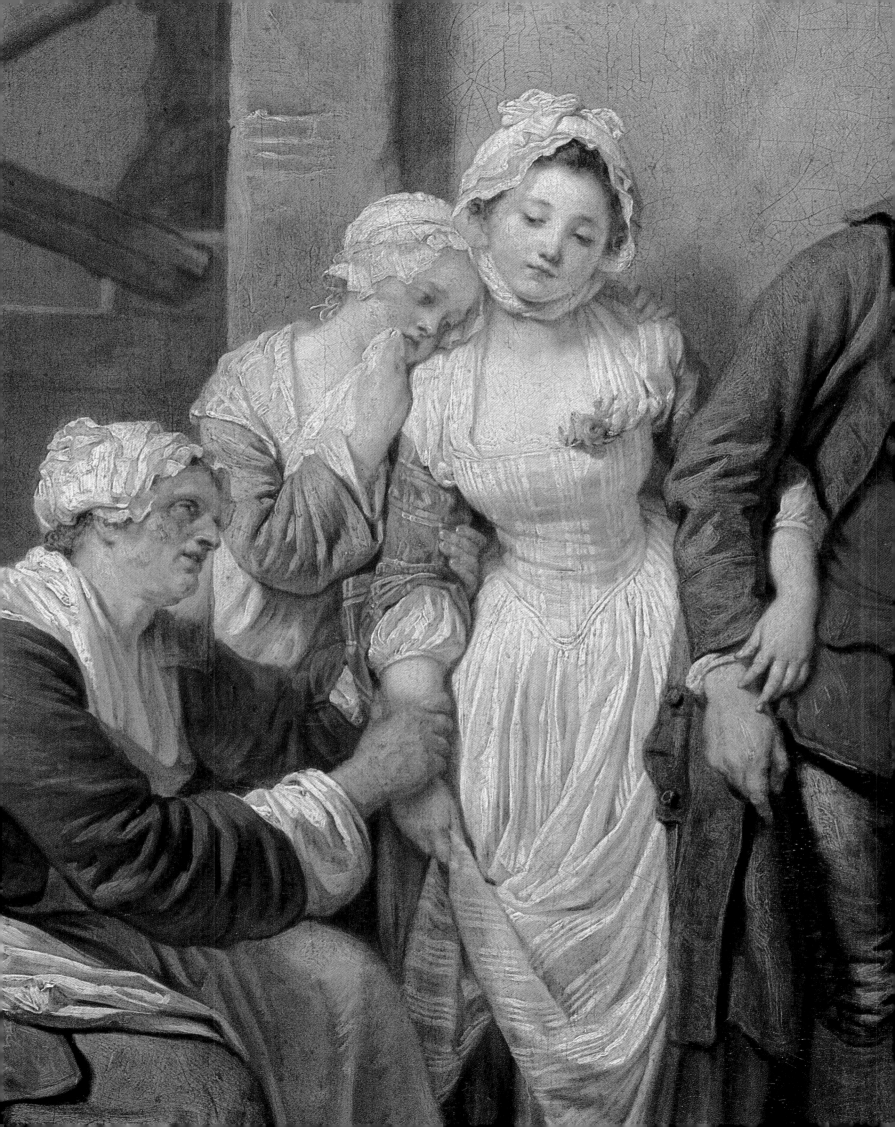

Jean-Baptiste Greuze (1725–1805)

72 *Filial Piety* 1763

115 × 146 cm

The Hermitage State Museum, Saint Petersburg

Conceived and executed over a period of three years – the earliest drawing for it is dated 1760, and a compositional study was exhibited at the Salon of 1761 (fig. 130)[1] – *Filial Piety* was Greuze's first neo-Poussinist genre painting. It was also an extremely expensive speculation, since, by the opening of the Salon of 1763, a buyer had yet to step forward (hence the announcement in the *livret* that the painting still belonged to Greuze: "Il appartient à l'auteur"); and Grimm would later remark that the artist had spent 4,800 *livres* on models ("ce tableau . . . lui a coûté 200 louis en études").[2] Understandably, therefore, *Filial Piety* appeared on time at the Salon of 1763, where it received the same acclaim as had *The Marriage Contract* (with certain critics assuming that it showed the same family two years hence).[3] For Diderot, Greuze's most enthusiastic champion at this point, here was "moral painting" at its most high-minded: a genre which, like dramatic poetry, was capable of "touching us, instructing us, improving us, and leading us to virtue."[4] Greuze's meticulously calibrated representation of a stroke victim surrounded by various members of his loving family, who bring him food and ensure his comfort, was a spectacle almost too moving for a contemporary audience to bear. Diderot and his daughter both "had tears ready to fall from [their] eyes;"[5] Grimm witnessed a female visitor to the Salon bursting into tears in front of the painting (something that apparently happened on more than one occasion);[6] even irreligious *philosophes* had been "converted by such a touching scene."[7]

Fig. 130 Jean-Baptiste Greuze, *Study for Filial Piety*, 1761. Musée des Beaux-Arts, Le Havre

Despite the many impassioned retellings of Greuze's drama – of which Diderot's was the most ecstatic – there was no consensus among the critics as to what exactly was taking place in *Filial Piety*.[8] For Diderot, the "pathetic and eloquent paralytic" surrounded by his children and grandchildren was being fed by his son-in-law. With the greatest effort, the patriarch addresses the young man ("he is not eating, he is talking"), and the women are enraptured by his words. His wife, at far left, puts down her sewing and leans forward, the better to hear him (she is somewhat deaf); his daughter suspends her reading aloud from the Bible "to listen with joy to what her father is saying to her husband."[9] The other children and grandchildren assist as best they can. At far right, a diffident grandson brings the old man something to drink (Mathon de la Cour assumed that this was a cup of old wine, saved for special occasions);[10] another emerges from behind the paralytic's chair; the eldest covers his feet with a blanket; and the youngest offers him a goldfinch ("he thinks this will cure his grandpa!").[11] Deferring to the son-in-law, the paralytic's other daughter arranges the bolster behind his head; while in the background at left, a servant setting the table for the family meal listens to the patriarch's words of wisdom.

As in *The Marriage Contract*, Greuze had once again shown impossibly aged parents with their remarkably young and vital progeny.[12] Writing in the *Mercure de France*, the abbé Bridard de la Garde (Pompadour's librarian) even assigned precise ages to Greuze's dramatis personae. The "venerable old man" was eighty years old, and was being served by his oldest *son*, whose wife – aged twenty-three – attended "with admiration" to her father-in-law's discourse. The matriarch of the family is aged about sixty; the grandchildren range from eighteen (the kneeling boy), to fifteen (the boy carrying the drink), to three years old (the boy with the bird). The diffident young girl adjusting the pillow is between fourteen and fifteen years of age. Which parents were responsible for which children seems not to have been a matter for concern, since Bridard de la Garde claimed to have gathered this information from Greuze himself. He assured his readers that "the description you have just read conforms precisely to the intentions of the Painter."[13]

In a composition that was "less jolly, but perhaps even more moral" than *The Marriage Contract*,[14] Greuze had once again given pictorial form to an ideal, but not obviously idealized, domesticity. It was, moreover, sufficiently rusticated for patrician tastes – all happy families resembling one another, as they are said to do. Once again, Greuze's much vaunted "naturalism" is filtered through a highly selective lens. Of the transformation from preparatory compositional drawing (fig. 130) to the final production, Emma Barker has noted that the "squat, shabby parents and young children have become long-limbed and open-faced adults and adolescents, whose neat clothes and more spacious surroundings, free of the picturesque squalor of scattered domestic utensils, demonstrate a certain social status."[15]

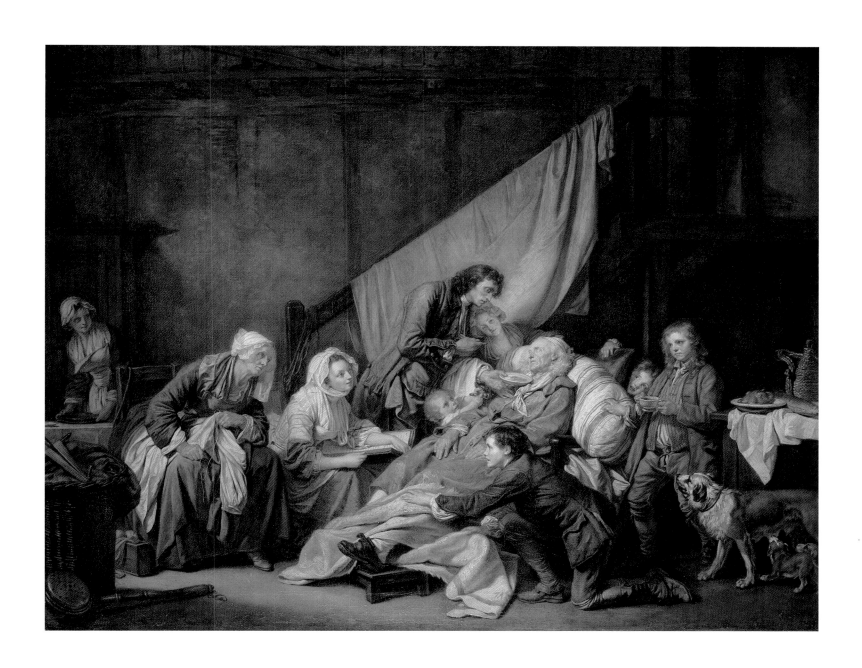

As Barker has shown in her exemplary commentary on this painting, Greuze was responding to a deeply nostalgic and utopian vision of the family as an all-embracing collectivity. The solidarity of his prosperous peasants, the respect of the young for the aging patriarch, the moral authority of the head of the household, unsullied, despite his paralysis, were potent myths for a highly-civilized urban audience, and among the Enlightenment's most cherished pieties.[16] How deep a chord Greuze's *Filial Piety* must have struck among progressive circles – one reason, perhaps, for the failure of his costly attempt to interest the Court in this painting[17] – is suggested by its affinities to a lengthy diatribe that appeared in the *Correspondance Littéraire* two months before the opening of the Salon of 1763. Railing against a crop of awful books devoted to the public good ("one of the disadvantages of our reasoning century"), Grimm had no hesitation in identifying the central issue for the reformers' consideration:

The bonds of family; filial love; paternal tenderness; domestic affection; the respect due to the head of the house and the father of the family; the love, goodness, and justice of this person towards all who are under his authority; respect for the rights of kinship; the common interest of the family inspiring all of its members: this is how the morals of a nation are formed.[18]

CBB

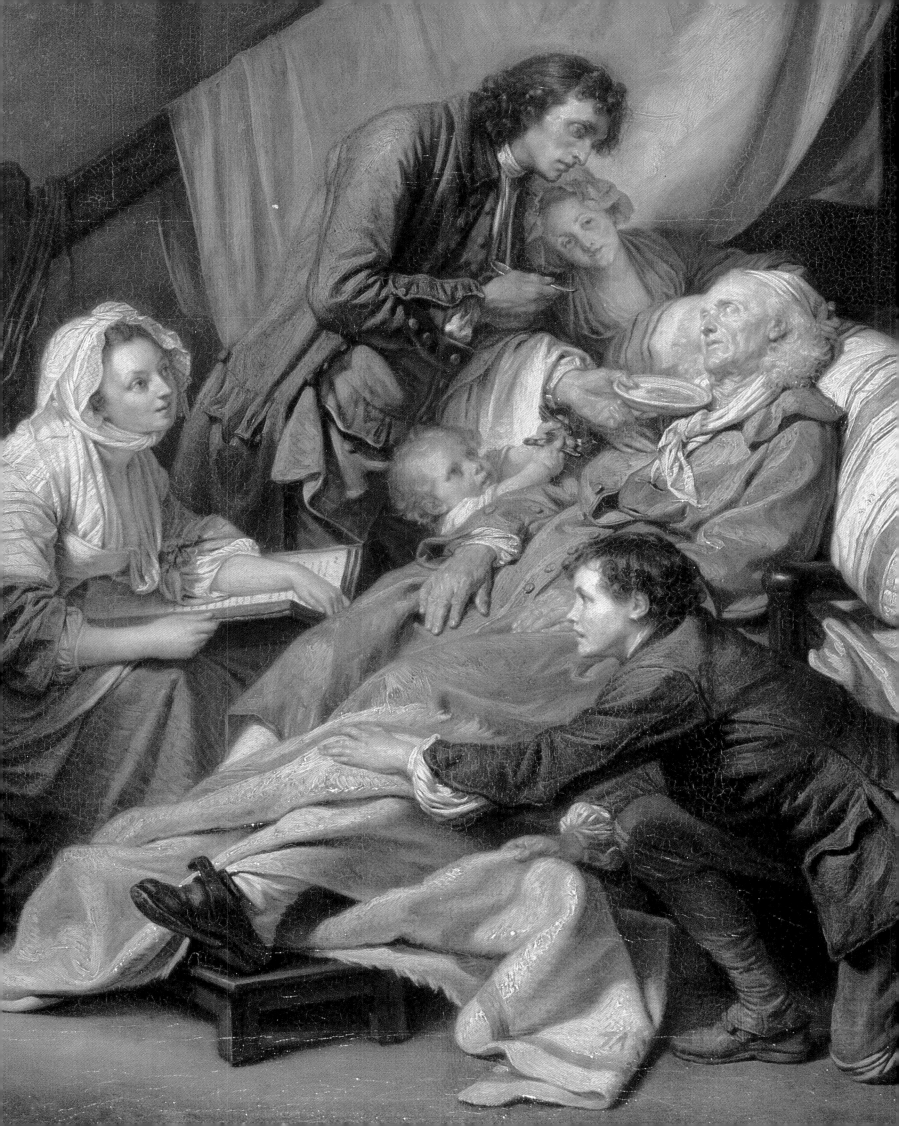

JEAN-BAPTISTE GREUZE (1725–1805)

73 *Child Playing with a Dog* 1767

62.9 × 52.7 cm

Private collection, England

Had Greuze been permitted to participate in the Salon of 1767 – he was now barred until he produced the *morceau de réception* that had been required since 1755 – he would doubtless have exhibited *Child Playing with a Dog*. For this was one of several pictures that Diderot saw in the artist's studio in the summer of 1767, and on which he reported to the sculptor Étienne Falconet in Saint Petersburg.[1] "The *Little Girl in a Nightshirt* grabbing hold of a little black dog who tries to free itself from her arms. It is beautiful, truly beautiful."[2] Greuze was currently engaged upon the ill-fated *Septimius Severus Reproaching Caracalla* (see fig. 41), which Diderot admired at the time, but would vilify, like every other critic, two years later at the Salon of 1769. It was perhaps with *Child Playing with a Dog* in mind, that Diderot confided to Falconet in August 1767, "Greuze has just done an amazing thing. He has suddenly, and successfully, made the leap from the *bambochade* to great painting."[3]

Discomfited by Greuze's grandiose emergence as a history painter at the Salon of 1769, critics turned with relief to this exceptionally vivid genre painting – "without question, the most perfect work in the Salon" (Diderot), and the "most universally applauded" (Fréron).[4] As Edgar Munhall noted, the best description of the subject would come from the English dealer John Smith, more than half a century later. "The child is attired in her nightclothes and cap, and appears to have just risen from her couch and seated herself in a chair in order to caress a pet dog, which she holds in her arms; the little animal, flattered by such notice, is excited by the presence of some stranger, towards whom the eyes of the child are also directed."[5] Diderot added that the dog, while frisky, was old.[6]

Greuze seems to have turned to family members for this intimate and affecting portrayal of a surprised child and her pet (although the

motif derives from his *Neapolitan Gesture* of a decade earlier, see cat. 65). In his Salon *livret*, Gabriel de Saint-Aubin noted that "this was the author's child," and Edgar Munhall reasonably assumed that Greuze's model was his third daughter, Louise-Gabrielle, born in May 1764.[7] Without wishing to quibble, I must note that the child in the picture looks to be about five years of age (Louise would have been three in August 1767), and so it may have been Greuze's elder daughter Anne-Geneviève (born April 1762) who obliged her father. Munhall has also identified the dog as a small-sized spaniel, known in the eighteenth century as an *épagneul de la petite espèce*, which appears in several paintings and drawings of the early 1760s, notably as Madame Greuze's lap dog (fig. 131).[8] The *Encyclopédie* sang the praises of these little spaniels: "Of all dogs, they have the most beautiful heads . . . and are faithful and affectionate."[9]

While Diderot considered the girl's flesh little short of miraculous – "since the rebirth of Painting, there has been nothing as beautiful as the head and knee of this child" – he was critical of Greuze's "mediocre imitation" of her costume.[10] Twice he noted that the folds of the nightdress above the child's right arm looked like "furrowed stone;" and parroting the complaints of the pastellist Maurice Quentin de La Tour, he also pointed out that the brim of the girl's nightcap should have been better illuminated.[11]

Diderot's conclusion, however, that *Child Playing with a Dog* was Greuze's "masterpiece," would be repeated in several of the catalogues of the prestigious collections in which this painting appeared during the artist's lifetime.[12] Its eighteenth-century provenance is of the bluest chip. Probably acquired *after* the Salon by Étienne-François de Choiseul-Stainville, Duc de Choiseul (1719–1785), it hung in the *premier Cabinet* of his mansion on the Rue de Richelieu, beside Rembrandt's *Self-portrait* of 1634 (Musée du Louvre, Paris) and in the company of cabinet pictures by Dou, Teniers, Terborch, and Potter.[13] Purchased for the record sum of 7,200 *livres* by Madame du Barry at the sale of her arch-enemy Choiseul in April 1772, *Child Playing with a Dog* entered the collections of Greuze's foremost patrons of the 1770s: the southern aristocrat Louis-Gabriel, Marquis de Véri (1722–1785), and the Parisian notary Charles-Nicolas Duclos-Dufresnoy (1733–1794).[14]

CBB

Fig. 131 Jean-Baptiste Greuze, *Madame Greuze on the Chaise Longue with the Dog*, c. 1765. Rijksmuseum, Amsterdam

JEAN-BAPTISTE GREUZE (1725–1805)

74 *The Woman of Good Deeds* 1775

112 × 146 cm

Musée des Beaux-Arts de Lyon

Critical of Lagrenée's bulimic showing at the Salon of 1767 (to which he had submitted seventeen paintings), Diderot remarked that "Greuze broods over his compositions for months, sometimes taking as long as a year to execute a single one."[1] The artist seems to have taken almost three years to produce *The Woman of Good Deeds*, which was finally shown to great acclaim in his studio in the summer of 1775 (since the disastrous reception of *Septimius Severus Reproaching Caracalla* (fig. 41), Greuze had boycotted the Salon).[2] Hailed by several commentators as Greuze's "chef d'oeuvre" – the term seems to have been routinely applied to his latest multifigured family drama – *The Woman of Good Deeds* was something of a media event, with one critic noting "that I had almost as much difficulty in forcing my way to his studio, as in seeing his work at the Salon."[3] The future Madame Roland went with a friend to see *The Woman of Good Deeds*: she told the artist that if she had not already loved virtue, his painting would have given her a taste for it.[4]

The Woman of Good Deeds shows an impoverished and bedridden nobleman and his wife, who are ministered to by a well-meaning matron and her daughter. The distinction of the old man, another stroke victim (*paralytique*),[5] was immediately apparent to a contemporary audience. Not only did his facial and gestural expressions conform to those of a gentleman, his noble status was indicated by the sword that hangs in the alcove above him (even more legible in Greuze's magnificent compositional drawing, fig. 132). Thus, unlike the grave (and prosperous) patriarchs familiar from earlier compositions (see cat. 71 and 72), Greuze's supplicant was identified as an *hobereau* – a distressed noble from the provinces. Indeed, one reviewer assumed that this was a Breton family, since suspending the

sword above the bed "was customary in the provinces, where there are many indigent nobility, as in Brittany, for example."[6]

The work was given an extended commentary by the marine painter and future regicide Gabriel Bouquier (1739–1810), who considered it the most touching picture he had ever seen ("it brought tears to my eyes").[7] With Bouquier as our guide – admittedly a pale surrogate for Diderot who by this date had broken with Greuze – it is possible to re-create the emotive force of *The Woman of Good Deeds*, a picture capable of moving "the hardest hearts to compassion, pity, and admiration."[8] Encouraged by her mother, the young daughter hands a purse full of money to the old couple. "Unaccustomed to such spectacles," she experiences a certain repugnance in so doing, but "her innate goodness" carries her through.[9] The gratitude of the recipients is appropriately conveyed: the "grandeur and strength" of the man contrasts with the eager vivacity of the woman "whose look seems to say, 'Without you we would have perished from destitution.'"[10] In the background at right stands a nun, the *introductrice* responsible for bringing the couple's plight to the attention of the charitable lady.[11] "Her character is one of indifference, which reminds us that familiarity with such wretched situations dulls the senses."[12] At far left, a young boy (elsewhere identified as a "little Savoyard"), who is the couple's sole resource, "appears intimidated by the presence of the young lady."[13]

For Bouquier, it was not just the dramatis personae who conveyed the moral message of Greuze's painting: meaning was also in the accessories. The sword hanging from a nail "is the unequivocal mark of the man's quality."[14] Next to the sword "one sees a shelf on which are placed several books of philosophy;" reading provides consolation for his impoverishment, while helping to preserve "the nobility of his feelings."[15] On the table by the bed are a bowl and a little bottle, "whose shape reveals that it is for medicine."[16] On the floor is a small stove (*réchaud*); sticks for the fire are shown under the chair at the right-hand corner of the composition. Details such as these "fortuitously convey the poverty of the conditions in which this invalid couple lives."[17] Curiously, however, when this picture was exhibited at Pahin de La Blancherie's Salon de la Correspondance on 18 December 1783, its subject was described as "A gentleman, in Paris to pursue a lawsuit, who is taken ill and shown in the greatest indigence."[18]

The Woman of Good Deeds was lent to the above-mentioned exhibition by the notary Charles-Nicolas Duclos-Dufresnoy, a voracious collector of modern painting, with a penchant for Greuze.[19] As I have noted elsewhere, while it is most unlikely that Duclos-Dufresnoy had anything to do with Greuze's choice of subject in this instance, the spectacle of charity accorded indigent nobility was a theme close to his heart. His well-born mistress had been ruined by her profligate husband, and in 1780 Duclos-Dufresnoy would be one of the founders of the Écoles nationales – a philanthropic venture designed to offer a decent education to the sons of impoverished nobles.[20]

CBB

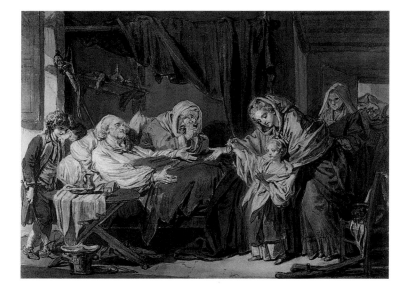

Fig. 132　Jean-Baptiste Greuze, *Drawing for the Woman of Good Deeds*, c. 1775. The J. Paul Getty Museum, Los Angeles

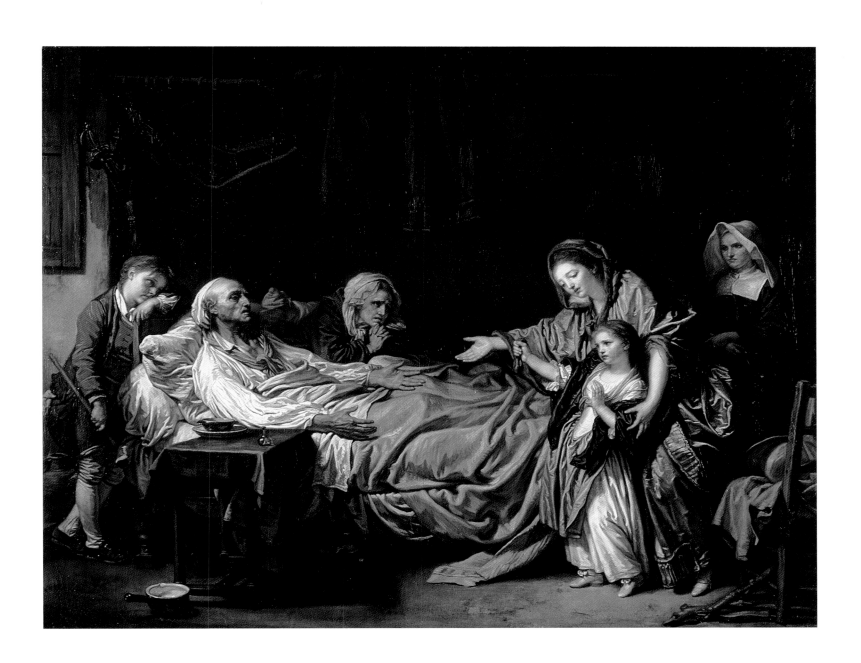

Jean-Honoré Fragonard (1732–1806)

75 *Blindman's Buff* c. 1750–55

117 × 91.5 cm

Toledo Museum of Art, Ohio

Fragonard's *Blindman's Buff* was created with its pendant *The Seesaw* (Museo Thyssen-Bornemisza, Madrid) either while he was studying under François Boucher or, more likely, in his first years of painting on his own, after he had completed his apprenticeship and was attending the *École des Élèves protégés*.[1] Contemporaries found the style of both paintings so similar to Boucher's that they could be taken for the work of Fragonard's mentor. Beauvarlet did in fact make engravings of them in 1760 under Boucher's name; however, a second edition of the engravings rectified this error.[2]

There is a captivating verve and joyful colour to these large-format decorative works. In *Blindman's Buff*, a young woman is carefully feeling her way forward, blindfolded, although she can peek out from underneath. Her arms are stretched out at her sides. A young man is walking along behind her and tickling her face with a blade of grass. Two children lie on the ground to the left; one holds a slingshot that is touching the girl's hand and distracting her. The scene takes place outdoors: on the right is a wall with a kettle and a large cloth on top of it, behind it is a wooden partition.[3] To the left is a lofty tree with flowers next to it, and the corner of a house is just visible behind it. Nothing is known about the intended purpose of the pendants. The engravings indicate that some of the canvas has been trimmed off the top.

The wide range of artistic expression that Fragonard displayed in these years is still astonishing and to some extent puzzling. In 1752, he received the Grand Prix de l'Académie for his painting *Jeroboam Sacrificing to the Idols* (École des Beaux-Arts, Paris). Only shortly thereafter, he completed his large *Psyche Showing her Sisters her Gifts from Cupid* (National Gallery, London). Whether the Toledo and Madrid pendants were created immediately beforehand or afterward is uncertain.[4]

The pictures still exhibit parallels with the Arcadian world that were a highlight of Boucher's Rococo artistry. However, the lovers depicted in Fragonard's pictures are farther removed from this ideal world than are Boucher's, and they demonstrate the artist's intention to make his subjects more immediate and natural. A comparison of the paintings of the two artists reveals how each evokes a lighthearted dreamworld that suited the lavish appointments of the elegant palaces of the aristocracy or the salons of the prosperous bourgeoisie. Nonetheless, these works are by no means superficial decorative pieces; instead, they represent the longings and wishful notions of a class of society at a time of radical change. The differences between Fragonard and Boucher are typically generational ones, arising from a changed view of artistic expression but also from a different idea and interpretation of Arcadia.

Boucher's paintings portray mostly high-society types placed in an imaginative theatrical decor.[5] The plush contemporary garments worn by his shepherds and shepherdesses speak of a worldly society artificially transposed to an imaginary Arcadia. Following in Watteau's wake with these *pastorales* in fictional surroundings, Boucher was creating a new genre, perhaps influenced by Fontenelle's poetry but certainly finding its counterpart in the plays written by his friend Favart.[6] This allegorical quality characterizes Fragonard's paintings as well, although they do strike a different tone. The figures seem more natural, livelier. His shepherdesses and gardeners are no longer role-playing, but are conceived of as genre figures, performing everyday tasks. It is not lavishness and gallantry that are the hallmarks of Fragonard's work but affection and happiness in love, admittedly still imagined, idealized. One senses not so much a different view of art as a different view of life. The bucolically literary genre has been transformed into a youthful and playful world, imagined, yes, but exhibiting definite traits of contemporary life.

Unlike Boucher's figures, Fragonard's are designed for movement; their gestures take them in all directions. The artist also endeavoured to add a sensuality to his paintings, eliminating the distance Boucher's works maintained from their audience. We share in a new narrative quality, wondering whether the blindfolded girl will notice the step or whether she will slip. Viewers practically see and feel themselves in the role of those portrayed. We are drawn into the scene at its transitory climax. Her lover will catch her any minute now. The spirited painting style matches this new light and exuberant setting of the scenes. There is a delicacy to the colouration that was previously unknown in French painting, not only in the figures and apparel, but also in the fashioning of trees, sky, and leaves. Colour is applied more thinly and therefore seems more transparent. Three-dimensionality is no longer evoked by the arrangement of the individual motifs but chiefly by the interpenetrating areas of colour. Here is a new way of conveying atmosphere, distinguished by a sensual quality.

It would be wrong to see *Blindman's Buff* and *The Seesaw* as merely a continuation of Boucher's bucolic genre scenes. In fact, Fragonard breaks with this genre and replaces an artistic ideal with an experience for the senses. This shift can scarcely be explained as merely a difference in artistic temperament. It was probably also keeping pace with the radical change sweeping down upon French society and aesthetics in the mid-eighteenth century. Boucher's Arcadia was that of Madame de Pompadour, a courtly society where emotional life was governed by the rules of a subtle ceremonial. The shepherds and shepherdesses in salon and boudoir behave in ways society would not allow. Boucher's dreamworld therefore satisfied a longing that could be realized only in an artist-created image. Despite the similar repertoire of figures and motifs in Fragonard, a painting undergoes a different genesis in his hands. He seeks to involve his audience, and portrays not fiction but a reality that has actually been experienced and observed, even though it remains couched in an art that radiates harmony, sensuality, and merriment.

TG

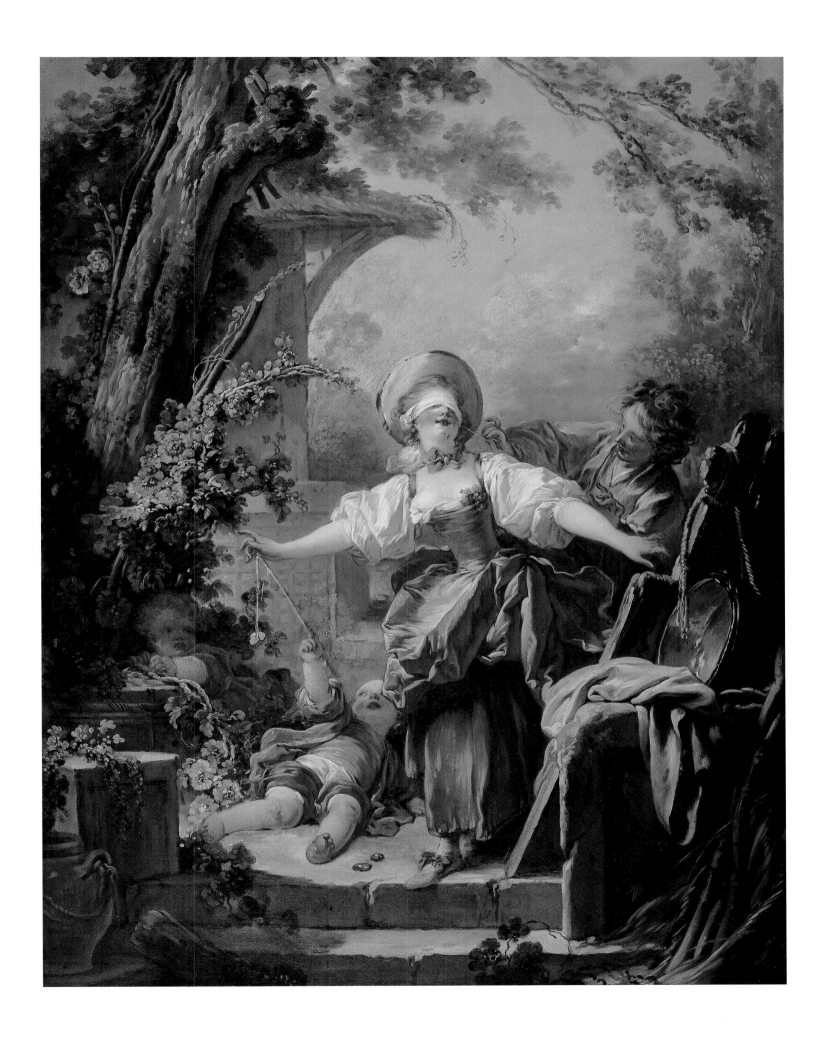

JEAN-HONORÉ FRAGONARD (1732–1806)

76 *The Washerwomen* c. 1759–60

61.5 × 73 cm

The Saint Louis Art Museum, Missouri

The painting in Saint Louis corresponds in theme and artistic style to the one in Rouen (cat. 77). There can be no doubt that the present work must have been painted around the same time, although the assumption that it is a pendant is unlikely. The composition is similar; but in our example two figures, viewed from the back, form the brightly lit central section. In the foreground a man lies playing with a baby; to his right is a dog, which a boy is teasing from the balustrade. On the left, a woman carrying a large basket descends the steps. Here, as well, Fragonard has concentrated entirely on the picturesque effects created by light and colour. Light falls from a not quite clearly visible opening in the ceiling onto the two women in the centre of the composition, who are at the same time illuminated by the fire beside the pillar. The kneeling figure, in a white blouse and yellow skirt, is turning to the obviously younger one, perhaps her daughter. An additional, undetermined source of light is located in the right foreground. The artist painted a whole series of works similar in style, featuring not only washerwomen but also family scenes with children. One especially fine example is *The Cradle* (Musée de Picardie, Amiens).[1]

Fragonard's understanding of genre painting differs fundamentally in these paintings from that displayed in Chardin's works, which, as in the case of *The Laundress*, 1733 (see fig. 67), focus more on the portrayal of individual figures. In contrast to Chardin's balanced and calm approach to figures in the manner of a still-life, Fragonard sought to recall the movement and activity of the situation as it was experienced. In Fragonard's sketchlike paintings, the expansive gestures, dramatic lighting, and lively brushstrokes convey the actual moment, while Chardin endowed the apparently lowly subject with a classically balanced composition and harmoniously coordinated colours. In Fragonard's work, even sounds and smells seem to be captured in an almost synesthetic manner, whereas Chardin's pictures provide a quiet pause for contemplation within the hustle and bustle of daily life.

These paintings form a distinct group within Fragonard's oeuvre and transmit the impression of the picturesque quality of the scenes that a visitor to the city would have encountered in the ruins that were bustling with activity. Like his friend Hubert Robert, he was evidently fascinated by these scenes, and both artists very likely also found buyers among the tourists passing through Rome as one of the stops on their Grand Tour. The director of the Académie de France à Rome, Natoire, complained in his reports to Paris that Fragonard, despite his great talent, could only with difficulty be persuaded to create copies of Italian masterpieces of the Renaissance and Baroque periods or to produce preliminary drawings for historical paintings. The large number of paintings made by him of city life in Rome that have come down to us evidently more closely reflected his artistic aim, which was to capture real life as it was experienced. Fragonard was not at ease with the heroic themes demanded by history painting, even though in 1765, after his return to Paris, he was to create *Coresus and Callirhoë* (Musée du Louvre, Paris), a masterpiece of French painting in this genre.

Fragonard's painting style during those years was characterized by soft, impasted brushstrokes. However, the feeling that the scenes were hastily rendered, or that there is a sketchlike quality about his work, is deceptive. One privately owned drawing, probably dating from a later period judging from its style, confirms the fact that the artist apparently made a series of studies using more or less the same repertoire of figures and motifs.[2] We can assume that he made drawings of subjects in their real-life settings and then combined them in different ways in his oil paintings.

TG

Jean-Honoré Fragonard (1732–1806)

77 *The Laundresses* c. 1759–60

59.5 × 73.5 cm

Musée des Beaux-Arts, Rouen

During, and possibly also immediately following, his stay as a *pensionnaire* at the French Academy in Rome from 1756 to 1761, Fragonard painted a series of genre scenes of simple city life. They consistently demonstrate a sketchlike style. The artist did not seek to give an exact reproduction of the individual details of figures and objects; instead, he concentrated on creating an impression full of atmosphere. Often the scene is set in modest cottages or buildings with the appearance of ruins, into which light penetrates through an opening, like a spotlight. The Rouen painting is a typical example of this group. At its brightest central point, a young woman is fastening a sheet to a pillar to dry. Only vague outlines of other figures are visible to her left, gathered around a fire. In the right foreground, a black dog is lying down, and a boy in a red cap is trying to climb onto a resting donkey. Other figures can be discerned in the background on the right. Large portions have been executed in a dark-brown tone through which one can only indistinctly make out details.

Fragonard created a series of paintings on similar themes and with comparable compositions, such as the one in the Saint Louis Art Museum (cat. 76). Colin B. Bailey, in an important study of Jean-Baptiste Greuze's *The Laundress* (see his entry for cat. 70), pointed out the importance of the role played by washerwomen as an occupational class in the eighteenth century.[1] He also described their living conditions, emphasizing the erotic allusions that point to the fact that laundresses were often forced, out of economic necessity, to earn their living by prostitution. However, in the case of the paintings in Rouen and Saint Louis, any such informative social-historical context is virtually lacking. Nor is Fragonard interested in making any moralizing statements of the kind for which Greuze is known.

The genre scenes painted in the early years of his career are, for the most part, small in size and do not seek to record social conditions; instead, Fragonard's intention is to give artistic form to picturesque impressions. Nevertheless, the artist felt a rapport with the world of the ordinary people whom he met on his walks through Rome, accompanied by his friend Hubert Robert. While Robert, who was a painter of landscapes and *veduta*, used the genre motifs taken from Roman city life mainly as foreground staffage to enliven his paintings, and only rarely took them as a theme (see cat. 91), Fragonard raised them to the level of the actual subject matter of his painting. In his choice of scenes, especially those featuring laundresses, it was presumably the picturesque aspect that was decisive. It is not just by chance that in the painting in Rouen, the play of light is centred on the white sheet. However, Fragonard is still a long way from engaging in the kind of socio-critical or moralizing interpretation of this occupational class – regarded as one of the lowest – that came later, in the nineteenth century. In Rome's streets and squares he sought the inspiration that would enable him to paint in a manner quite new and free for his time.

The rapid, sketchy style, executed with arresting vitality and incorporating bold contrasts of light and dark, was possibly inspired by his trip to Naples, accompanied by his patron the abbé de Saint-Non. However, this light, airy style of painting, which is also reminiscent of the Venetian masters, is entirely Fragonard's invention. The images are complete works in themselves, even if they have often been regarded as sketches. Only a few collectors, for whom Fragonard primarily painted, recognized their unique artistic power of expression.

TG

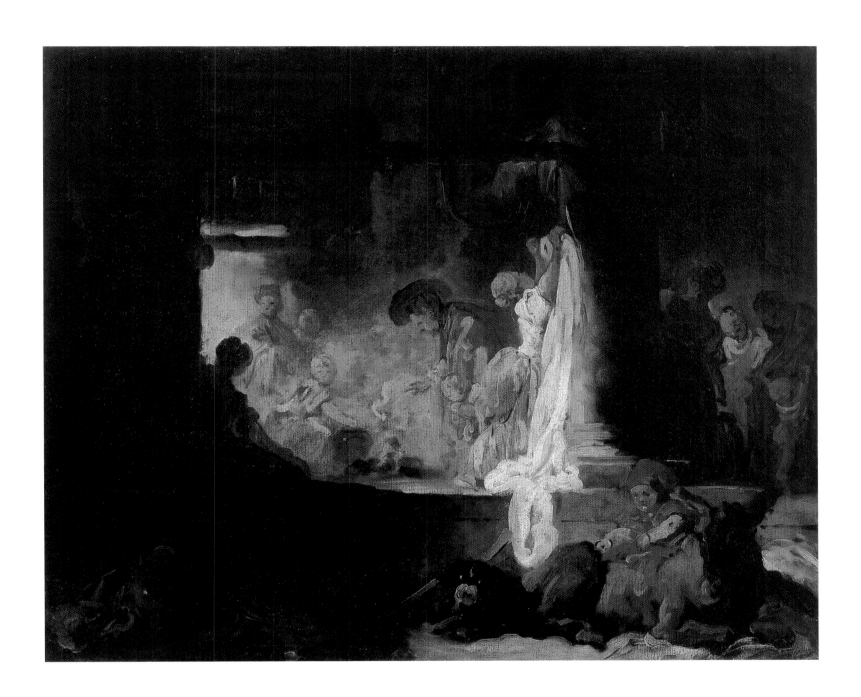

Jean-Honoré Fragonard (1732–1806)

78 *The Lost Forfeit or Captured Kiss* c. 1759–61

48.3 × 63.5 cm

The Metropolitan Museum of Art, New York

In a simple hut, as intimated by a few accessories in the background, two young women and a young man have been playing cards. The young man is embracing the woman seated on the left, trying to give her a kiss, which is obviously the prize for the winner of the game. For her part, she is turning away to evade his ardent overtures, but the girl on the right holds onto her hands, keeping her there.

The harmless subject matter typifies the work Fragonard produced during his first period in Rome (1756–61) as a *pensionnaire* at France's Royal Academy, above all through its refined use of light and sumptuous painterly style. Against a background shrouded in dark brown, the artist bathes the central image in a pool of glistening light, brightly illuminating the white, golden, and red fabrics. This spotlighting increases the luminosity of the colours and accentuates the central action and the movement of the figures. The erotic subject and Rococo elements of the motifs, such as the rich drapery of the garments and the intensity of the colours, recall the years Fragonard spent as a student and colleague of Boucher before going to Italy. His paintings *The Seesaw* (Museo Thyssen-Bornemisza, Madrid) and *Blindman's Buff* (cat. 75) were painted only shortly before.[1] Still, the nature of the genre theme has changed slightly. Instead of the larger panels probably intended to decorate a Parisian palace, there is just one scene, taking place in an ordinary, perhaps even peasant interior. In fact, the subjects' expensive costumes contrast oddly with the plain surroundings merely hinted at schematically in the background, all of which underscores Fragonard's creative, playful, and far from realistic style. However, compared to his earlier works, where draped materials functioned as an ornamental element, his more three-dimensional treatment of fabrics here does indicate an artistic development.

This development was apparently shaped by Fragonard's study of Italian Renaissance and Baroque paintings, which was meant to be the purpose of his stay in Rome. While Fragonard did not entirely shirk the task of studying and copying these masterpieces, he did spend a lot of time with his friend Hubert Robert wandering through the city and the Campagna, drawing genre and landscape motifs. Nor were the Academy's *pensionnaires* allowed to accept commissions for paintings that were not destined to be added to the collections of the royal house. *The Lost Forfeit* was purchased by Jacques-Laure Le Tonnelier, Bailli de Breteuil (1723–1785), who had been living in Rome since 1759 as Ambassador of the Order of the Knights of Malta, which provides a *terminus post quem* for dating the work.

Aside from the picture in New York, the Hermitage has an oil sketch (fig. 133) – rapidly made, as were a number of similar works from Fragonard's Roman sojourn.[2] The New York example differs from this sketch in its careful execution. Fragonard's foremost collector and patron, the abbé de Saint-Non, was a guest of Le Tonnelier in Rome in 1759. It is not impossible that Saint-Non commissioned the painting from the artist.

Collectors of this type of art appreciated the decorative aspect of the erotic and intimate subject matter; but Fragonard was undoubtedly also starting to make a name for himself with the boldness of his painting style. Dutch and Flemish genre scenes were much admired and sought after by French collectors. Artists thus took these works as their stimulus, to accommodate the buyers' tastes. The refined brushstrokes and bright colouration, as well as the anecdotal narrative also point to work produced sometime after the middle of the eighteenth century in France, a period when the work of Dutch "fine-painters" – Dou, Terborch, Netscher, and van der Werff – were fetching ever higher prices. If in Rome Fragonard was not easily convinced to devote himself to the great historical legacy of Italian art, as Academy director Natoire regularly reported to Paris, genre scenes permitted him to develop a client base in that city, too. In some sense, with their Roman genre scenes, Fragonard and Robert were continuing, while also re-invigorating, the tradition of the Dutch *bamboccianti*, who had captured motifs of daily life in Rome in the seventeenth century.

TG

Fig. 133 Jean-Honoré Fragonard, *Sketch for the Lost Forfeit or Captured Kiss*, c. 1759–60. The State Hermitage Museum, Saint Petersburg

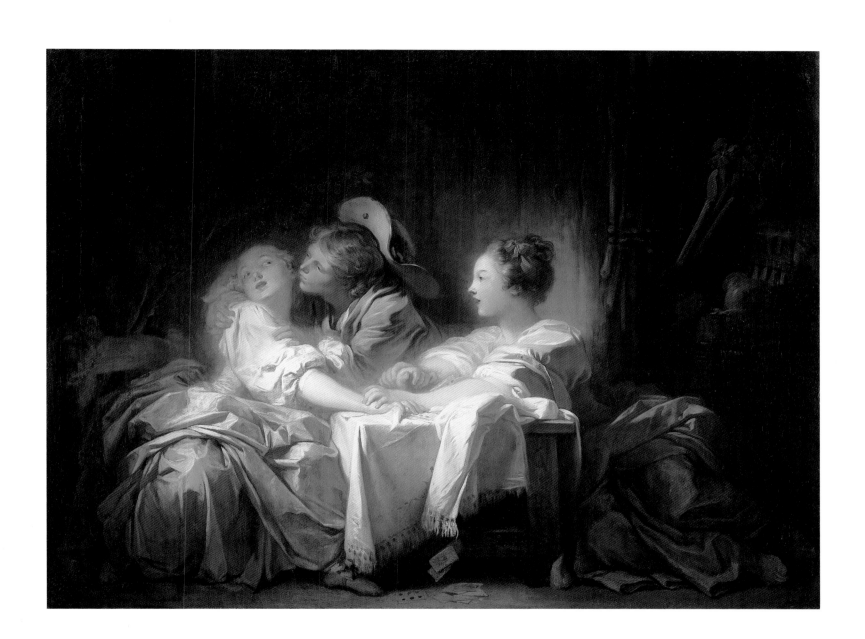

JEAN-HONORÉ FRAGONARD (1732–1806)

79 *The Happy Family* after 1769

53.9 × 65.1 cm

National Gallery of Art, Washington, D.C.

In February 1777, when the Comtesse Du Barry's art collection was sold at auction, the goldsmith Aubert, for the price of 1500 *livres*, acquired "a painting touched with much fire and of excellent effect, depicting the interior of a chamber in which sits a woman surrounded by several children; leaning in at the window is a man who appears to have surprised them."[1] The picture in question was probably *The Happy Family*, which today hangs in the National Gallery of Art in Washington. It is one of numerous family scenes that Jean-Honoré Fragonard painted from the mid-1760s on: sleeping infants, chubby toddlers taking their first steps, swarms of droll children embracing their parents, running about, or learning the alphabet. These are no mawkish pieces with a double moral standard *à la Greuze*, no hermetic close-ups *à la Chardin*, no sentimental scenes *à l'Aubry*, but rather small, always light-hearted stories of the simple but contented life. Since Fragonard habitually brings the action to the very front of the picture and shows it from a slightly dropped perspective, and since his subjects at the same time seem completely unaware of being observed, the viewer becomes a voyeur of notions of happiness – not least his own. For this reason, the artist's works have also been linked to the social ideals of the Enlightenment, a period when the social function of the family, and especially the mother's role in child-rearing, were examined in countless pedagogical and philosophical treatises, as well as literary and dramatic works, with Rousseau's widely-read novel *Émile* (1762) setting the programmatic framework.[2]

Nevertheless, one must guard against taking the sociological interpretation of Fragonard's work too far. The social ideals of Rousseau were a less important influence on his art than were the artist's own inventiveness and creative power. Few of the artist's colleagues could match the richness of his imagination and the breadth of his iconographic repertoire. Moreover, at the same time that he was painting happy families, he was also producing erotic paintings like *Young Girl Playing with her Dog* (cat. 80) or *The Bolt* (cat. 84), whose frivolity and *libertinage* were very much in contrast to the feminine or familial ideal of the *encyclopédistes*. The note in the Du Barry sale catalogue reminds us that for the eighteenth-century *connaisseur*, the quality of a picture depended less on its subject matter than on its form, less on the moral lesson it conveyed than on the painter's technique and the effect produced. Fragonard's *Happy Family* was successful on several levels inasmuch as it satisfied the desire for a characteristic *manière* and afforded an aesthetic experience.

Underlying the painting is a complex compositional structure, at the centre of which is the head of the child who sits on his mother's lap. Because it forms the visual midpoint of the entire picture as well as the tip of the pyramidal group of mother and children, the viewer's gaze returns to it again and again. All of the figures are lit by the sunlight flooding in through the open window. The dramatic chiaroscuro creates the illusion of depth and demarcates the boundary between internal and external. The masterful play of light culminates in the principal figures: while the mother and child are brilliantly lit against a sombre background, the dark silhouette of the man in the window appears, inversely, against a light backdrop. It is obvious here that Fragonard took as the point of departure for his lighting effects the capacity of the human eye. At the same time, the light reflecting on the classical plinth on the right side of the picture, the depictions of fabrics, furs, and skin, as well as the sfumato of the background attest to Fragonard's colour sense and virtuosity. He juxtaposes dazzlingly fine painting effects and light brushstrokes, impasted areas and sketchy, seemingly unfinished renderings with a skill reminiscent of Rembrandt, Rubens, Titian, and the other great masters of the Dutch and Italian schools. Hence Fragonard could be assured of success and acclaim, even from those who regretted that he had not chosen a career as a history painter: "Fragonard, endowed with a keen imagination and great technical skill . . . abandoned noble compositions and serious studies to devote himself to subjects of an inferior order, serving solely to dazzle with their lightness of invention, the diverting play of light and shadows, and the charm of a subtle and spiritual touch."[3]

Yet it was only outside of public discourse and the academic context that Fragonard was able to create for a cultured private clientele pictures in which established iconographic traditions and artistic dogma were either ignored or creatively reflected. Playing with established genres was one of his favourite devices. *The Happy Family*, for example, exhibits definite parallels with the iconography of the *Holy Family*, while *The Rest on the Flight into Egypt* (Musée des Beaux-Arts, Troyes), one of his religious paintings, shows Mary not in a state of otherworldly detachment but rather as a happy mother taking an intimate and entirely worldly pleasure in her child. Her loving adoration of the infant Jesus is in no way different from the tenderness of the young mother in *The Happy Family*. The boundaries between the two genres appear to have been obliterated.

MS

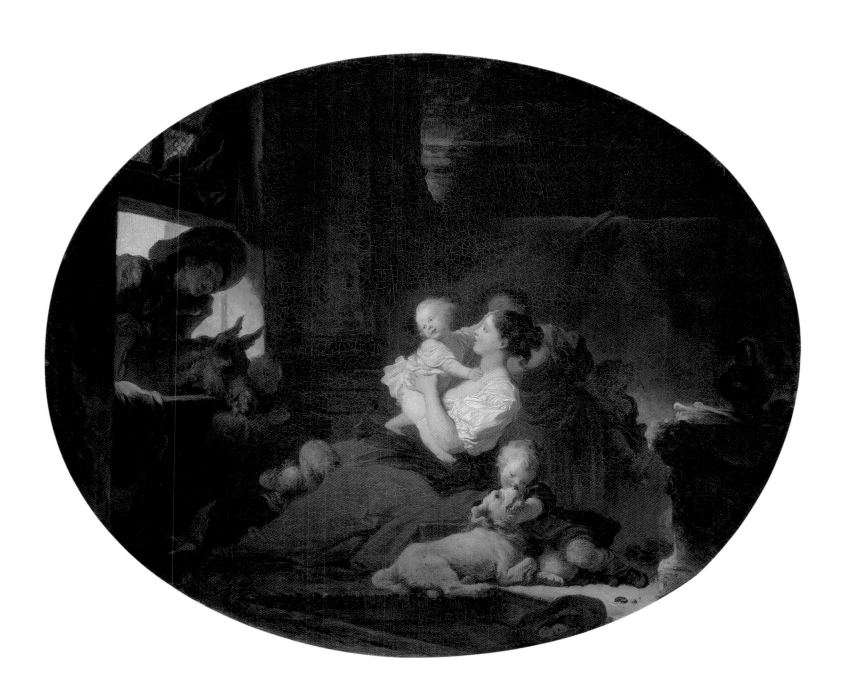

Jean-Honoré Fragonard (1732–1806)

80 *Young Girl Playing with her Dog ("La Gimblette")*

c. 1770–75

89 × 70 cm

Alte Pinakothek, Munich

Over several decades, Fragonard depicted erotic scenes in drawings, sketches, and oil paintings. They must have pleased a circle of well-paying patrons and collectors. A famous quotation from Madame d'Épinay presumably refers to these subjects: "M. Fragonard? He's wasting his time and talent: he makes money."[1] Many of these works were engraved and enjoyed widespread distribution on into the nineteenth century. *Young Girl Playing with her Dog* is a quintessential example of the erotic genre in Fragonard's work. A partially undressed young woman is shown lying on her back on a canopy bed, playing with her little dog; and the viewer catches a glimpse of this intimate scene. The loose, apparently rapid brushwork matches the animated and spontaneous scene. Bright, lustrous colours, which let the canvas base show through in several places, characterize the light-hearted and sensuous atmosphere, meant to draw the observer into a voyeuristic situation.

The aspect of erotic provocation of such paintings, *Useless Resistance* among them (Nationalmuseum, Stockholm), was certainly a lightning-rod for criticism.[2] An engraved copy of *Young Girl Playing with her Dog* by F.-A. Haméry was not allowed to be publicly displayed. On the other hand, illustrations of libertine literature or La Fontaine's tales were widely circulated.[3] This picture, however, exhibits no recognizable reference to a literary source, which means that it is more likely an autonomous work offering a look at a seemingly natural ambience. Erotic scenes had been reaching a wide audience since the Regency, although artists did generally try to endow them with a mythological theme. Boucher, Fragonard's teacher, was a master at presenting erotic subject matter in mythological guise,

and was harshly criticized for this practice by Diderot himself. In his discussion of the Salon of 1761, Diderot described the painter as a seducer: "His debauchery – it doubtless beguiles fops, women of easy virtue, young people, and men and women of the world, in short: the whole mass of those who are strangers to good taste, to truth, to right ideas, and to the seriousness of art. How could they resist the obviousness of it all, the trashiness, the nudity, the licentiousness . . . the impudent mockery coming from Boucher."[4]

Boucher also painted a number of nudes and erotic genre scenes not based in mythology. However, they were not as voyeuristically and sensually seductive for viewers as the sketches and drawings of Fragonard. Still, the various versions of his so-called "odalisques" (see fig. 112) did pave the way for Fragonard's erotic paintings.[5] Unlike Boucher's highly detailed canvases, most of Fragonard's erotic works are sketchlike. This apparently rapid execution mimics the spontaneous glance a viewer might cast at the intimate scene. Sketch-like painting methods were demonstrably a topic of discussion among mid-eighteenth century art theorists in France. Such writers as the Comte de Caylus tried to promote *facilité* and *légèreté* as painting techniques along the same lines as the Italian concept of *sprezzatura*, seeing them as the suitable means of expression for certain themes, and believing them to be pleasing to viewers.[6]

Fragonard evidently catered to a select group of enthusiasts for this kind of painting, such as Louis Varanchan, Trésorier-général de la Dauphine.[7] Varanchan owned a now lost variant or a second version of *Young Girl Playing with her Dog*.[8]

TG

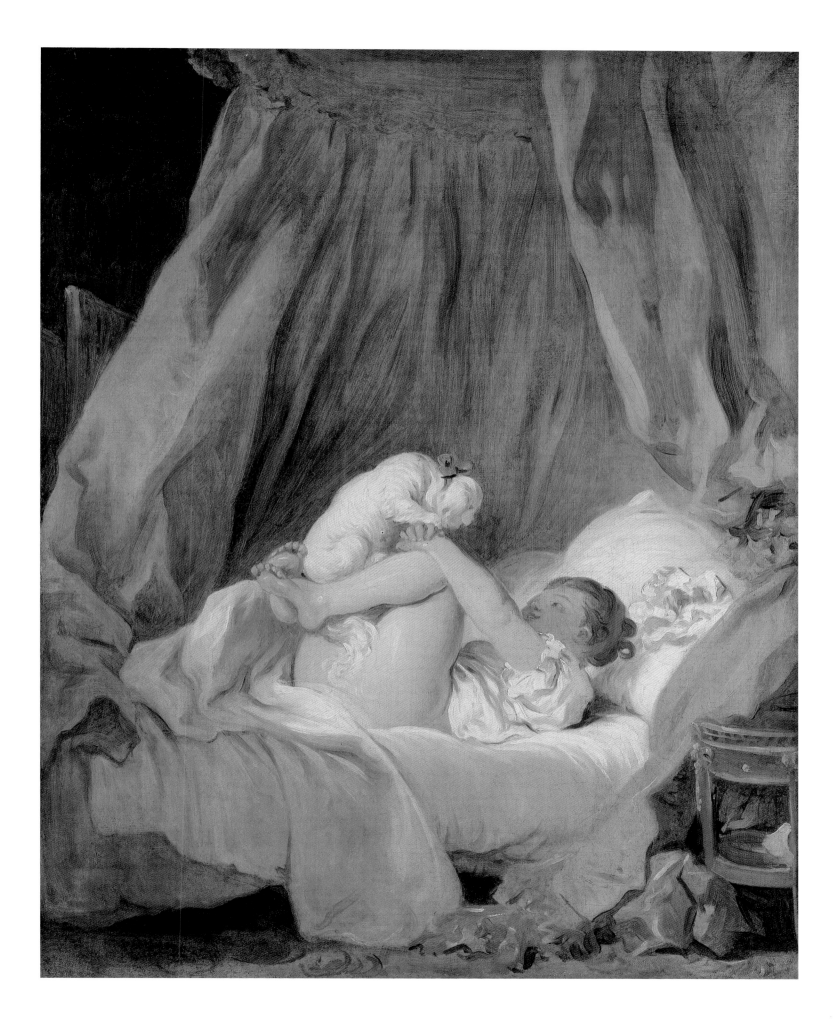

JEAN-HONORÉ FRAGONARD (1732–1806)

81 *A Young Girl Reading* 1771–73

81 × 65 cm

National Gallery of Art, Washington, D.C.

This calmly attentive girl wearing a brilliant saffron yellow dress accented with lilac ribbon is one of the most beguiling of a series of quickly painted, upper-torso, single figures, dubbed *portraits de fantaisie*.[2] Numbering approximately fifteen, most are of the same canvas size (80 by 65 centimetres) and portray the sitters with attributes that identify them as engaged in the arts. While the word "fantasy" suggests that the models are drawn from imagination, the facial features of these subjects tend to be highly individualized within Fragonard's oeuvre, and indeed many are recognized as costumed portraits, including that of the *philosophe* Denis Diderot.

The model for *Young Girl Reading* has not been identified, and given her youth and gender is unlikely ever to be. As x-rays have revealed, initially this canvas held a figure whose masculine features gazed directly out at the viewer, and indeed the large biceps of the young girl hints at an awkward transition to the painting's final appearance.[3] Nonetheless, Fragonard was well attuned to contemporary female fashion. The model's ribboned hair and corsage, white ruff, and dress design are features shared with the triumphal female figure in Fragonard's *The Lover Crowned*, 1771–73 (The Frick Collection, New York). As Richard Rand has proposed, *Young Girl Reading* functions as a kind of allegorical representation of reading, rather than as a portrait, here rendered in the everyday setting and costume usually associated with genre painting.[4] The contrasted lighting enhances the sense of verisimilitude. Strong light from above, perhaps daylight from a window, heightens the yellow tone of her dress, softens the pink of her cheeks, and casts a distinct shadow over the plush pillow that supports her back.

Reading was a common theme among French genre painters in the eighteenth century (see cat. 67), who drew upon a seventeenth-century Dutch tradition. It was not unusual to see pictures at the Salon featuring an individual or a group reading. One example by Chardin is particularly instructive as a comparison, *Portrait of the Painter Aved*, shown on two occasions, in 1737, and again in 1753, when it was titled simply *Un Philosophe occupé de sa lecture*.[5] Here the contrast with *Young Girl Reading* is as much in its portrayal of a gendered stereotype as it is in styles of reading. Leaning intently over the hefty folio volume resting on his desk, a page lifted between the fingers of his left hand, Chardin's philosopher bears an expression of fervid intellectual engagement with the text. Fragonard's model, on the other hand, sits demurely, displaying the utmost decorum as she holds her book in four fingers of her right hand, as one might hold a teacup; the content provokes a look of meditative reflection. *Young Girl Reading* reflects a vogue for the portable, personal, and lightweight volumes that flourished in the late eighteenth century.[6] Although our young reader is solitary in her occupation, Fragonard treated the subject of a female figure reading aloud to an audience in a number of drawings.[7]

The painting is first recorded in an anonymous sale of 11 March 1776, annotated as that of the Comte du Barry (though which brother, Jean or Guillaume, is not specified).[8] If correct, *Young Girl Reading* belonged to the same family as Fragonard's most important, yet notorious patron, the Comtesse du Barry, wife of Guillaume and mistress to the King. It was she who commissioned the *Progress of Love* paintings for her château in Louveciennes in 1771, only to abandon them in 1773 when tastes and fortunes began to change in the final year of Louis XV's reign.

JC

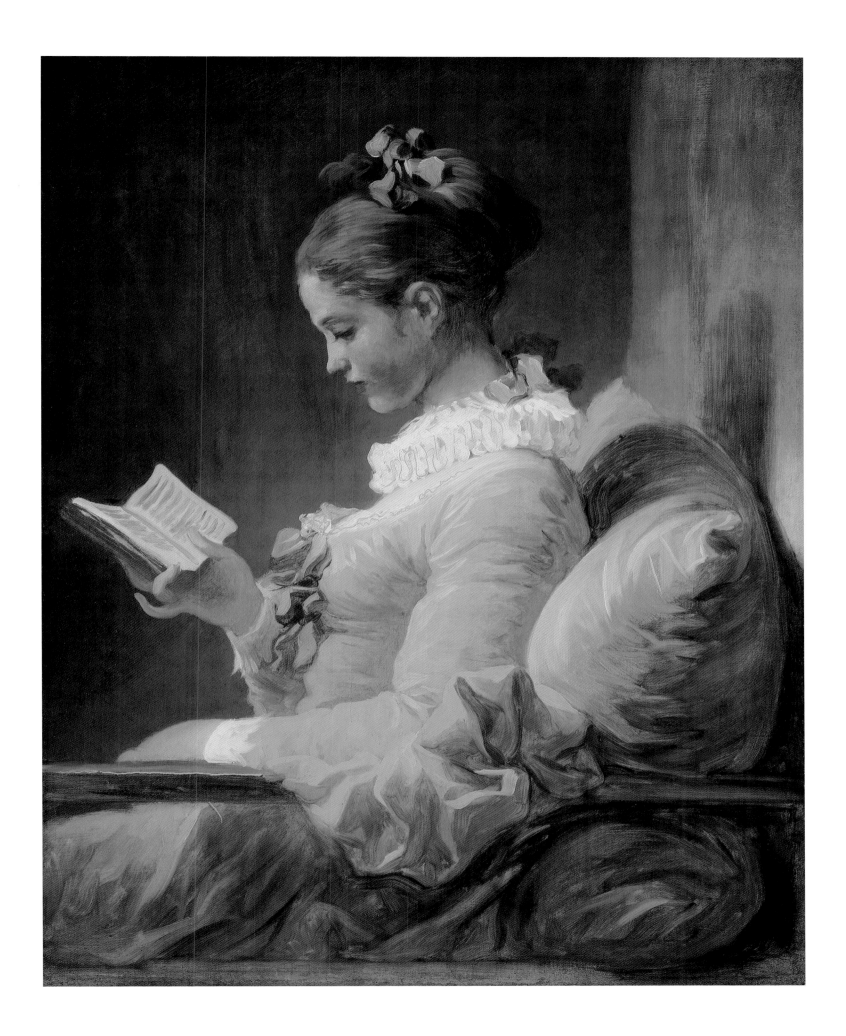

JEAN-HONORÉ FRAGONARD (1732–1806)

82 *The Charlatans* c. 1775–80

49.5 × 38.7 cm

Private collection

Despite the sketchiness that distinguishes much of Fragonard's oeuvre, this painting can be seen as a work of art that is complete in and of itself. The composition largely corresponds to the left-hand side of Fragonard's *Fête at Saint-Cloud* (fig. 134), which the artist painted between 1775 and 1780, that is, after his second trip to Italy, possibly for the Duc de Penthièvre's residence, the hôtel de Toulouse, although there is no record of a commission. Still housed in that same palatial edifice, which is now the Banque de France, this masterpiece combines genre motifs and landscape painting in one magnificent and entirely new kind of panorama in nature.[1] It shows motifs taken from the public festival held in the latter weeks of September each year, in the park of Saint-Cloud Palace. Fragonard did studies at Saint-Cloud that he used for his large-format work. Yet the finished painting is not a *veduta*, but rather a landscape vision into which he has integrated genre scenes.

In a way complementing Watteau's *Embarkation from Cythera* (fig. 55), Fragonard takes up the *fête galante* tradition, but at the same time transcends it, in the second half of the eighteenth century. In his works, nature is no more the *belle nature* arranged by the hand of landscape architect Le Nôtre and modelled on the aesthetic canon of the Grand Siècle; it is a creation that dwarfs human beings. The figures are introduced into this natural spectacle as tiny living extras. Like the viewer looking at the picture, their experience of this natural scenery is sublime, in the spirit of the theories expounded in Burke's highly influential treatise *A Philosophical Inquiry into the Origin of our Ideas of the Sublime and the Beautiful* of 1759.[2]

This is the same impression conveyed in the much smaller-scale picture known in the nineteenth century somewhat inaccurately as *Les Charlatans* or the *Le Marchand d'Orviétan (Charlatans)*. Showmen are

entertaining the people out-of-doors. A man in a pointed hat, posed against the backdrop of a large hanging tapestry, has a staff in his raised right hand. Below him, a woman holding an unidentifiable object is addressing the crowd. A little monkey perches between the two actors. The spectators have gathered at the base of the platform, while two women and a child are following the action from behind a balustrade. The performance itself has not been a topic of interest for scholars; however, it would certainly seem that Fragonard was assimilating impressions he might have gained on visiting Saint-Cloud park. Monkeys did perform occasionally at markets in Fragonard's lifetime, to entertain and amuse the population. In 1772, at the Saint-Germain market, a person could marvel at a monkey playing a hurdy-gurdy, accompanied by its master's mandolin.[3]

With only slight changes, the scene here matches that shown in the large painting today at the Banque de France. In this latter, though, the standing man is minus his pointed hat and has turned to face the spectators off to his side. A third figure has been inserted between the two performers; the little monkey is still there, perhaps intended to jump through the hoop leaning against the front of the platform. Balancing out this scene on the right-hand side of the Banque de France's *Fête at Saint-Cloud* is a puppet show, a *guignol*. The artist has juxtaposed two different theatrical traditions in his image, doubtless as an allusion to their different audiences and artistic merits.

Less easily understood is whether the current small-format, sketch-like, privately owned work should be considered a study for the large painting or whether it was created afterwards. Compared to the monumental Banque de France canvas, the dramatis personae have been simplified, and the two sparse trees at the left-hand edge are lacking. It would not seem unlikely for the sketch to have been done after the large-format painting, because compositional clarification is evident in the characters' movements. However, aside from the variations in motifs, a completely different artistic expression is noticeable. The sketch further exaggerates the proportions; the showmen seem to be entreating the audience from their platform, which is raised higher than the one in the large canvas. Fragonard has concentrated the colour contrasts and the use of light more dramatically, making the scene almost ghostly, reminiscent of Goya. Distinct from the playful mood of the Banque de France piece, with its delicate and glazed painting style, the action in the work under discussion transpires in an almost menacing magical world, where the audience is in thrall to the performers. Also, there is a conspicuous blue-grey spot to the right, beside the red flag, recalling the large group of trees in the larger image. It is not impossible that Fragonard initially extended the composition a little farther to the right, but then cut it off at the side, thereby leaving the picture looking incomplete.

Another sketch, showing a toy seller, possibly part of an originally larger painting in the same sketchlike technique, is held privately in New York.[4] A somewhat larger painting corresponding to the right-hand part of the composition at the Banque de France is in a private collection in Paris.[5]

TG

Fig. 134 Jean-Honoré Fragonard, *Fête at Saint-Cloud*, c. 1778–80. Banque de France, Paris

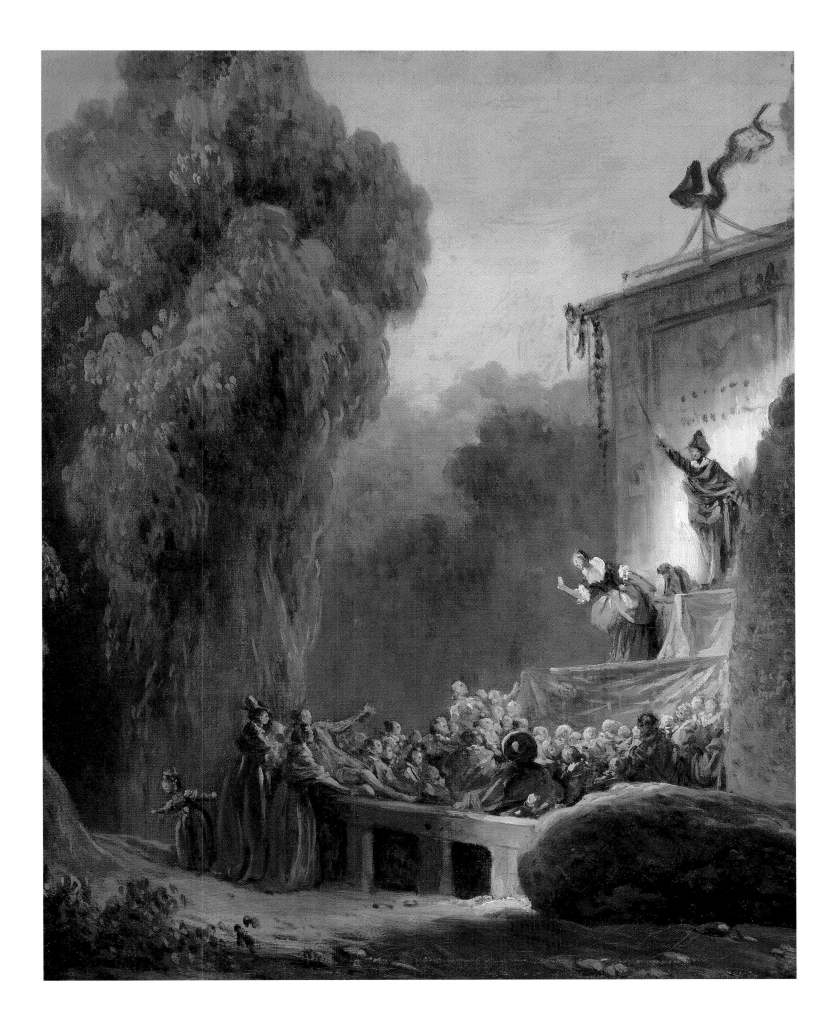

JEAN-HONORÉ FRAGONARD (1732–1806)

83 *Sketch for "The Bolt"* c. 1778

26 × 32.5 cm

Private collection

84 *The Bolt* 1776–79

73 × 93 cm

Musée du Louvre, Paris

Thanks to the dramatic treatment of its subject matter, its unusual genesis, and its widespread dissemination in the form of reproductive engravings, Jean-Honoré Fragonard's *The Bolt* is an epitome of eighteenth-century French painting. The scene is a bedroom in disarray: a dishevelled bed, a chair fallen on its side with pieces of clothing tossed across it, a vase that has been knocked over and a bouquet of roses lying on the floor. Voluminous draperies and an intense light falling diagonally into the room heighten the drama taking place on the small stage: clad only in a shirt and underbreeches, a young man is straining to bolt the door with his right hand, while with his other arm he clasps a girl around the waist and pulls her toward him. Apparently trying to escape from his passionate embrace, she turns her head aside and uses her hands to defend herself against his physical advances while at the same time trying to stop him from locking the door. Is this, as one contemporary put it, a naughty tête-à-tête, "next to a bed, the disorder of which tells the rest of the story."?[1] It certainly appears so at first glance. But then again, perhaps the viewer is not simply the voyeur of a passionate seduction, but witness to an unbridled *volupté* from which the girl finds herself unable to escape?[2] Or perhaps the two of them have just got out of bed, and the girl does not want to let her lover go quite yet.[3] Fragonard leaves that decision to our imaginations.

No less interesting than the picture itself is the story behind its creation. Three wash drawings (see fig. 135) and an oil sketch (cat. 83), all undated, are extant. In the drawings, the area of the picture to the right of the door is wider. Pieces of clothing and a *tricorne* lie scattered about the floor, a rapier leans against the wall that is decorated with pictures and medallions and before which stands a second chair. The bed appears to be still untouched; in any case, there is a clear spatial separation between it and the girl. Both the girl and the boy, judging from their facial expressions and physical proportions, look to be considerably younger than in the painting. These preliminary works are still very much in the tradition of Watteau and Boucher. In the painting, by contrast, Fragonard has not only cropped the scene but also cut the accessories to a minimum and altered the narrative perspective: as in a history painting, the story is now reduced to the critical moment, the *peripeteia*. The apple on the table, the subjects' faces and hands, and the lock now lie on a diagonal axis that corresponds to the angle of the light falling into the room. Next to the apple, as an ironic reference to original sin, two other erotic symbols in the tradition of seventeenth-century Dutch painting have been added: the overturned vase, symbolizing

the vagina, and the roses on the floor, as a sign of love and stolen innocence. The oil sketch is much closer to the painting in composition, but what distinguishes the painting from both is the artist's style. In place of painterly brushwork still very much in the Rococo style, we now find a fine-painting technique with which Fragonard reflects the latest developments in Neo-Classicism.

Stylistically, therefore, there is much to suggest that the drawings were created in the second half of the 1760s. Looking more closely, one notes that the chairs in them are still in the curving Louis XV style, while the overturned chair in the painting is characterized by a simple medallion on the back and, like the *tabouret* at the door, is in the early Louis XVI style. In their *manière* and iconography, the drawings also have much in common with those that Fragonard made as illustrations for La Fontaine's *Contes et Nouvelles*, which are also believed to date from between 1765 and 1770.[4] The series includes a number of drawings depicting gallant seductions, passionate embraces, and kisses. In particular, the drawing for *The Inhabitants of Reims* (fig. 136) exhibits notable similarities with *The Bolt* – from the motif of the tumultuous embrace to the bed and the overturned chair. In this case, however, the lover has failed to lock the door, with the result that the couple is surprised by the cuckolded husband: "He leads her with beguiling lies / . . . / Then, in a thrice, the ruff removed / He steals a kiss before her husband's eyes."[5]

These analogies do not, however, answer the question of why the painting was not completed until several years after the drawings – the probable date of its creation is believed to be between 1776 and 1779 –

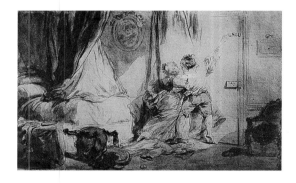

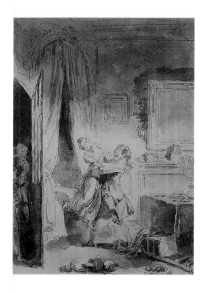

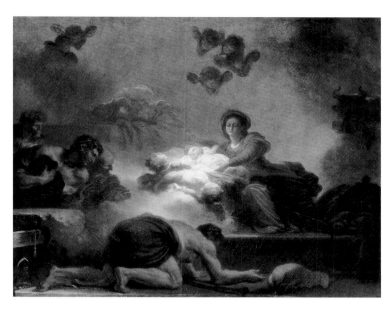

Fig. 137 Jean-Honoré Fragonard, *The Adoration of the Shepherds*, c. 1775–77. Musée du Louvre, Paris

and why Fragonard introduced such profound narrative and stylistic changes. The painting's commissioning by the Marquis de Véri provides some possible answers. The Marquis was among the most forward-looking collectors of contemporary French painting in the 1770s and 1780s.[6] He owned several pictures by Fragonard, including *The Adoration of the Shepherds* (fig. 137).[7] In the Marquis's auction catalogue, the art dealer Paillet described it as a "masterpiece upon which Monsieur Fragonard appears to have sought to lavish all the riches of a lively and learned imagination."[8] And indeed, Fragonard in this painting practically reinvented a central motif of Christian iconography that had been depicted over and over again by the great masters of the past but also by French painters of the eighteenth century from Lemoyne to Ménageot. Inspired by Le Brun's *Adoration of the Shepherds* in the collection of Louis XIV, by Castiglione's painting on the same theme in Genoa, which he had copied on his first trip to Italy, and also by Poussin's *Adoration of the Shepherds*, which he had seen in Dresden, Fragonard prepared a pastiche remarkable for its bold abstraction of the subject matter and formal stylization. Véri is said to have been so impressed that he asked Fragonard to produce a second painting to serve as a companion piece to the first. Thereupon Fragonard, "in what he felt was a stroke of genius, in a bizarre contrast, painted a picture that was unrestrained and full of passion, known under the name *The Bolt*."[9]

Even if it cannot be stated with absolute certainty whether *The Adoration* and *The Bolt* were in fact conceived of as pendants, it is undeniable that, beyond their identical format, they do exhibit typical characteristics of companion pieces despite, or perhaps even because of, their differences.[10] Both works are composed on the diagonal, but these are diametrically opposed to one another. Much the same is true for the use of colour. While there are tonal similarities between the two pictures, the overall effect is antithetical: in one image the colours are of a cool brilliance, in the other, they glow with a warm radiance. Moreover, in *The Bolt* the light source that creates the dramatic chiaroscuro is located outside the picture, whereas in *The Adoration* the source of the harmonious sfumato effects is the Christ child himself as *lux mundi*. In these two pastiches, Fragonard contrasted a genre scene of earthly passion with a religious cabinet painting of otherworldly humility, but his aim was principally to demonstrate two very different artistic concepts, behind which the subject matter was secondary: *expression* and *sentiment*, fine painting in the *goût hollandais* and painterly brushwork *à l'italienne*, delicate *non-finito* and the formal rigidity of the *beau idéal*.

Thus it is that the two pictures resist categorization according to the classic hierarchy of genres, as illustrated by a debate sparked by the appearance of Blot's engraving after *The Bolt* in 1784. While one critic complained that Blot had failed to render precisely the fabrics and materials, the other stressed that Fragonard had painted the picture in the style of a history painting, and noted that, "painters of this genre are not restricted in varying their draperies, like those whose talents demand a detailed rendering." His colleague, however, refused to let this argument stand: "The distinction between history painter and painter of *bambocciades* rests solely on the nature of their productions. Since the author of *Le Verrou* was not portraying a subject from history, he ought to have entered into all the details essential to tableaux of this inferior genre."[11]

In 1772 Fragonard had suffered a painful rejection of his art when the comtesse du Barry sent back his nearly completed cycle entitled *The Progress of Love* (*La Poursuite de l'Amour*), intended for her pavilion at Louveciennes, and gave the commission instead to Vien, who promised her a more modern work transcending the *petit goût* of the Rococo. With *The Bolt* and *The Adoration*, executed for one of the most renowned collectors of the last years of the Ancien Régime and auctioned in 1785 for record-breaking prices, Fragonard once again demonstrated his artistic virtuosity and intellectual mastery.

MS

Fig. 135 (FACING PAGE TOP) Jean-Honoré Fragonard, *Drawing for The Bolt*, c. 1765–68. Location unknown

Fig. 136 (FACING PAGE BOTTOM) Jean-Honoré Fragonard, *The Inhabitants of Reims*, c. 1765–70. Musée du Petit Palais, Paris

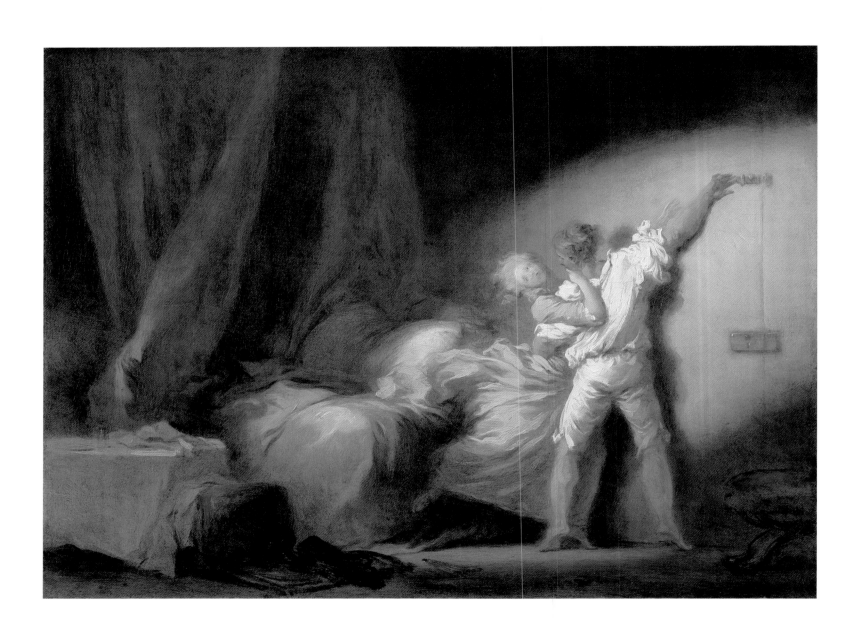

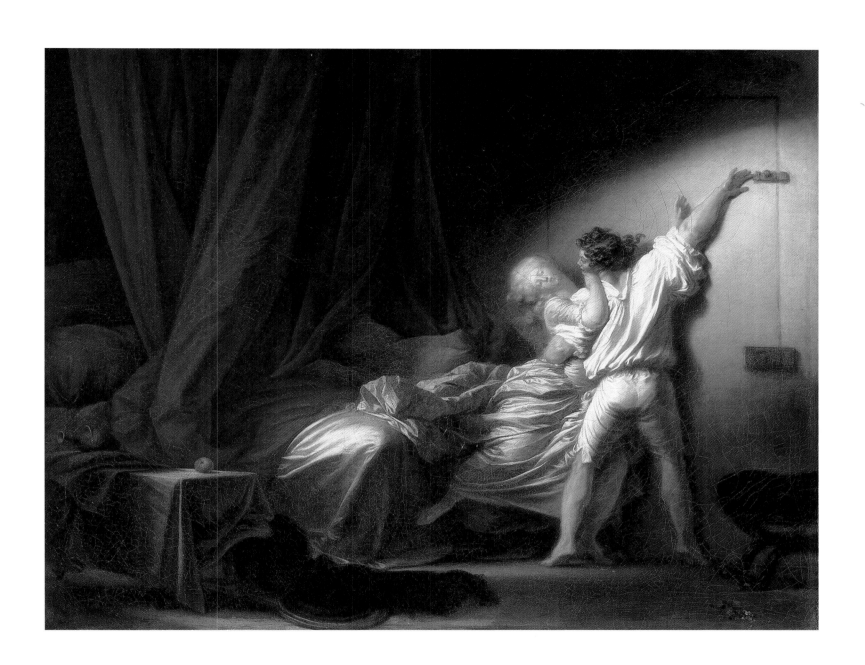

JEAN-HONORÉ FRAGONARD (1732–1806)

85 *The New Model* c. 1778

65 × 54 cm

Musée Jacquemart-André, Paris

Jean-Honoré Fragonard's lighthearted and risqué erotic paintings such as *Useless Resistance* and *Young Girl Playing with her Dog* (cat. 80) enjoyed great popularity in the eighteenth century and were widely distributed in the form of reproductive engravings. This is true also of *The New Model*, which leaves little to the imagination as regards the explicit nature of its subject matter. The picture, in a transverse oval format, shows a sparsely furnished artist's studio with three figures before an empty canvas on an easel. On the sofa to the left sits a young model whose breasts are being bared by her scarcely older companion for the inspection of the smartly dressed artist. The latter, however, is indicating that the model's state of undress is not yet satisfactory, as he brazenly lifts her petticoat with his painter's stick.

This painting, however, was not meant only to titillate the viewer by dint of its erotic subject matter and voyeuristic depiction. To the *connaisseur* it also revealed the refinement of Fragonard's artistic composition. A subtle interplay of form and colour underscores the spatial separation between the women and the painter. Lines of sight, lighting, as well as looks and gestures, all lead the viewer through the picture. Again and again, though, our eyes return to the model, who is using her direct gaze and physical charms to coquettish effect. The lighthearted atmosphere is enhanced by the artist's use of colour. The varying tones of white, yellowish-orange, and pink lend warmth and an almost pastel-like transparency to the scene. Corresponding to the play of colour is the light brushwork, in keeping with the prevailing contemporary taste for the incomplete, the *non finito*. Referring to Fragonard's loose, sketchlike style, the art dealer Paillet wrote in the catalogue of a collector who owned several of the artist's erotic pictures: "While scrupulously rendered paintings may please the more vulgar taste, there is a certain class of amateurs who take supreme pleasure in a single sketch; always in search of the soul and the ideas of the man of genius whom they discern and recognize."[1]

Another aspect also confirms that the painting did not spring from a spontaneous idea of Fragonard's, but was actually carefully thought out. The work is in fact a reference to a debate on the subject of the unclothed female model. In 1767, in response to Greuze's remark, "I would like to paint an entirely naked woman, without violating her modesty," Diderot had suggested, "Make the model modest." Greuze, proposed Diderot, should depict a girl shedding tears of shame after

having removed her humble garments – "Let her expression be one of innocence, shame and modesty." The mother, on whom the model would be leaning in the picture, should also be overcome by shame, so that the artist, "stirred and touched by the scene, lowers his palette."[2] Yet ultimately, it was not Greuze but Baudouin who exhibited *The Honest Model* at the Salon of 1769 (see cat. 60 for a discussion of this work). Baudouin created a particular stir in the Paris art scene, however, because the depiction of the naked female form was normally reserved for history painters. Students at the Academy were taught only from the male model; artists were permitted to work from unclothed female models only in the privacy of their own studios. In his *Mémoires*, the painter Mannlich describes the episode in which Boucher's favourite model posed for him as Venus: "I immediately began to sketch the upper portion. For the head I was obliged to substitute Greek forms, the features of a delectable Parisienne not being those of Venus; but for the bosom and the rest of the body I had no choice but to slavishly copy what was before me."[3]

Greuze and Diderot had believed that even in a genre picture, a naked woman could be depicted in such a way that the sight would not offend good taste. Behind the aim of elevating the moral tone of the painting by portraying the woman as modest and virtuous is of course concealed a double moral standard that is typical of many pictures by Greuze. Fragonard, on the other hand, was known for his virtuoso handling of the academic principles of *convenance*. The exchange of ideas between Greuze and Diderot challenged him to create a programmatic counterpart. Instead of a genteel salon he shows a sparsely furnished atelier. Modesty is replaced by coquetry, his model is not being covered up but rather exposed, and pathetic gestures are avoided in favour of signs of tacit complicity. Something else is notable as well: the artist's easel bears an empty canvas, the colour of which matches the model's alabaster complexion. It seems almost as though Fragonard in this painting wanted to turn the Pygmalion story upside down. His work of art will not give birth to a human being, but rather, through the magic of the artist's *inventio*, the model will become a work of art – the very painting at which the viewer is looking.

MS

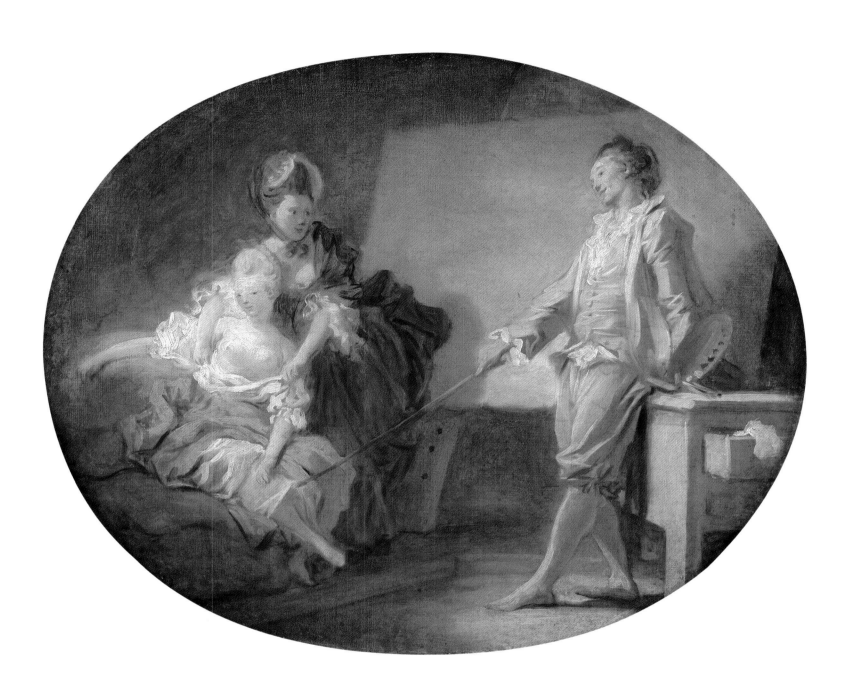

JEAN-HONORÉ FRAGONARD (1732–1806)

86 *The Stolen Kiss* c. 1786–88

45 × 55 cm

The State Hermitage Museum, Saint Petersburg

The Stolen Kiss (*Le baiser à la dérobée*) is considered one of the best-known works of Jean-Honoré Fragonard, even though it is not certain that he himself actually painted it. The painting shows a young woman wearing a sumptuous dress of Peking silk and a blue and brown striped *manteau*, standing in a small salon. It looks as though she has just been searching in the little gueridon table for a hair ribbon, and is about to put on a silk shawl when she is surprised by a young man who draws her toward him through an open side door to "steal" a kiss. Although the two evidently know each other, she tries to pull away from his embrace. It is unlikely that she will succeed, however, for the young man has set his foot on the hem of her dress. Her eyes, wide open in dismay, and her parted lips betray a justified fear: through the door on the right edge of the picture the viewer catches a glimpse of two women playing cards in front of a large fireplace, while a man kibitzes behind them. The girl has probably stepped out of the adjoining room for only a moment to fetch the shawl. Thus the young man's audacious display of affection threatens to end in a small drama if the pair is discovered in this compromising attitude. Only the viewer knows that the older folk are not (yet) aware of what is going on in the adjoining room.

The sudden entrance of the young man, the girl's slightly affected pose, the two half-open doors, the set-piece furnishings, the lighting and the movement of the draperies – the entire scene is suggestive of a play unfolding on a stage. And indeed, amorous adventure and forbidden love were central themes in the literature and painting of the Rococo period, themes that Fragonard too depicted again and again, from *The Lost Forfeit or Captured Kiss*, 1759–61 (cat. 78), through the cycle *The Progress of Love*, 1771–73, to *The Bolt* (cat. 84). Nonetheless, the cool elegance of the costumes, the Aubusson tapestry, the Louis XVI armchair and table in this picture set it

apart from the lighthearted scenes and renderings seen in his earlier works.

While the subject matter of this picture thus lies very much in the eighteenth-century French iconographic tradition, its artistic roots are to be found in the seventeenth-century Dutch style from which many artists drew their inspiration toward the end of the Ancien Régime. Fragonard too enjoyed great success with his pastiches of Dutch paintings that he studied in private collections and from engravings. Collectors who could not afford the costly originals would buy one of his landscapes in the *goût hollandais*, while others would hang a Fragonard next to a Ruisdael or Rembrandt and challenge the *connaisseur* to demonstrate his knowledge by naming the differences between them.[1] In the decade preceding the French Revolution, interest was concentrated more specifically on the Dutch fine-painting style. The acuity of the painterly execution, especially the illusionistic renderings of fabrics and materials in the *fijnschilder* of Dou, van Mieris, Metsu, or Terborch, inspired a number of later painters and thus contributed significantly to the rise of Neo-Classicism – David's *Portrait Lavoisier*, 1788, created almost contemporaneously with *The Stolen Kiss*, being a well-known example.[2] Fragonard's painting has much in common with the elegant genre scenes of upper-class society by Terborch, such as *The Paternal Admonition* or *The Suitor's Visit* (fig. 138), pictures in which we find again the sparsely furnished stage-like setting, the illusionistic depiction of the female figure's satin dress drawing all of the viewer's attention toward her, and the narrative element receding into the background. The spatial situation of *The Stolen Kiss* – only a portion of the room is shown, a figure enters from outside, the viewer sees through an open door into an adjoining room – also appears to be influenced by Dutch painters like Metsu and de Hooch.

The attribution of the painting to Fragonard is based on a mention in various gazettes in June 1788 that Regnault had produced an engraving of *Kiss*, "d'après H. Fragonard," intended as a companion piece to the one made by Blot after Fragonard's *Bolt* (cat. 84) four years earlier.[3] Yet even though the two paintings are similar with regard to their subject matter and composition, they differ significantly in their artistic execution. This is why many art historians believe that *The Stolen Kiss* was painted by Marguerite Gérard (1761–1837), Fragonard's sister-in-law and student. Gérard worked very closely with her teacher in the 1780s and 1790s, and there is much to suggest that while the composition of this work is his, the execution is hers.[4] For it was Gérard who, along with Boilly and Drolling, was a major exponent of the neo-Dutch style around 1800 (see cat. 87). In the gallery of her dealer Lebrun, who supplied the art market with works of Dutch fine painting and who in 1792 edited a three-volume *Galerie des peintres flamands, hollandais, et allemands*, Gérard would have been able to study the Dutch paintings in the original.

MS

Fig. 138 Gerard Terborch, *The Suitor's Visit*, c. 1658. National Gallery of Art, Washington, D.C. Andrew W. Mellon Collection

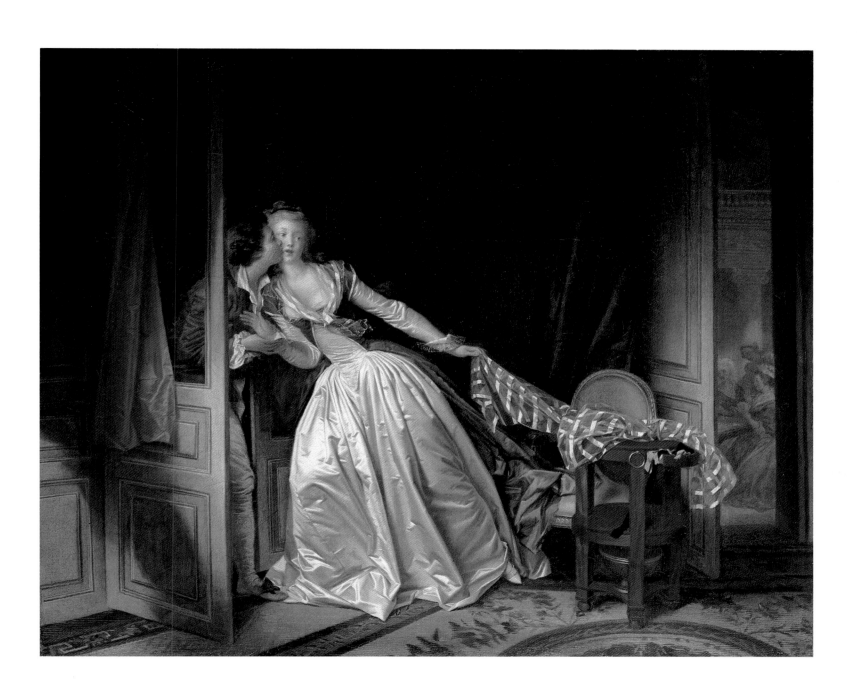

Jean-Honoré Fragonard (1732–1806) and Marguerite Gérard (1761–1837)

87 *The First Steps* c. 1780–85

44.45 × 55.25 cm

Fogg Art Museum, Harvard University Art Museums, Cambridge, Massachusetts

In a grove surrounded by a tangled growth of trees and climbing roses, the viewer is witness to a child taking his first steps. A little boy with blonde hair, dressed only in a shirt, runs towards his mother with arms outstretched; sitting on a stone bench, she waits for him, her arms open, her look both grave and tender. A young governess has taken him from his little wicker bed and placed him on this first difficult path – although it has been covered with a soft red fabric. Two other figures complete the scene: a young girl (possibly the older sister) sitting on the grass in the background, and an older woman leaning over the fence. In the right foreground a tabby cat has come to join the group and is also observing the event.

In this, one of her best-known and best-documented works, Gérard has given full rein to her young talent to reproduce this moment of maternal happiness. In addition to the touching subject, the delicate colours that bathe the scene in bright light create an emotional atmosphere. The image can be understood in the context of the growing public discussion about women's role as mothers, and clearly illustrates how this theme had made its way into genre painting.[1] The ideal of a woman devoting herself to the upbringing of her children, and thus becoming the guarantor of family happiness and a morally sound society, as propounded in the writings of Jean-Jacques Rousseau (1712–1778), was at odds with social reality. Children from a prosperous urban aristocratic or bourgeois background were still given to wet nurses at birth, after which they remained for a long time in the care of governesses.[2] Gérard takes this social reality into account by including servants in her painting. The image of the

elegantly dressed mother, with her carefully coiffed hair and gown of shimmering pale pink and yellow silk and lace-trimmed décolletage, is complemented by two female servants who, in neat but much simpler clothes, are there to care for the children.[3] Gérard takes us into an innocent ideal world, far away from everyday material worries. This is also reflected in the way in which the scene is set in a place borrowed from the *fêtes galantes* – rose branches reach into the child's cradle and wind themselves around the figures. Thus Gérard's interpretation of what is, strictly speaking, a domestic scene is nonetheless influenced by the court's view of the world.

In the latter half of the century, the relationship between mother and child was a very frequent theme in painting. Between around 1789 and 1798 Jacques-Henri Sablet (1749–1803), entirely in keeping with the contemporary philosophical debate on children, places the first steps of a child in an idealized Roman countryside (fig. 139). Whereas Gérard depicts an exclusively female group, Sablet's scene is a family event that includes several generations and both sexes. Although in Sablet's picture all the figures are also looking at the child, the theme of maternal happiness is expanded to represent pure and ideal humanity. His harmonious integration of the characters into a landscape with ruins, and the distant view of the Roman Campagna evoke the idea of a Golden Age.[4] For her part, Gérard, in her static and classical compositions, always retains her preference for the courtly setting.

Previous studies of *The First Steps* have examined in detail the question of whether and to what extent Gérard and her famous teacher Fragonard collaborated on this painting. In view of a chalk drawing by Fragonard (Fogg Art Museum, Cambridge) showing the basic features of this composition, and based on current knowledge, the major part of the composition must be attributed to him. As well, individual sections of the painting – for instance, the boy and the older woman – are certainly Fragonard's work.[5] In her paintings, Gérard focused especially on reproducing the appearance of materials and the details of fashion. For example, the highly modish (Medici) lace collar on the mother's gown is reminiscent of historical models dating from the late sixteenth and early seventeenth century, and was extremely popular among the aristocracy in the 1780s.[6] In addition to the topicality of the theme selected, such a composition was able to excite the interest of contemporary collectors on several levels at once. Both in format and in the fine-painting technique employed it is similar to seventeenth-century Dutch genre works, which were then highly regarded. The fact that the picture was intended as a pendant to *The Beloved Child* (Fogg Art Museum, Cambridge) is in keeping with the popular practice of hanging genre paintings in matching pairs. In this second composition, Gérard also shows a young mother together with another young woman, pulling a little boy through a park landscape in a little carriage. The birth of her nephew Alexandre-Évarist Fragonard, on 26 October 1780, also may have contributed to the fact that Gérard, who remained childless, in subsequent years favoured motifs featuring the intimate relationship between mother and child, thereby establishing herself as the best-known painter of this type of genre scene.

JE

Fig. 139 Jacques Sablet, *The First Steps*, c. 1789–98. Private collection, Rome

JEAN-HONORÉ FRAGONARD (1732–1806) and MARGUERITE GÉRARD (1761–1837)

88 *The Reader* c. 1783–85

64.8 × 53.8 cm

Lent by the Syndics of the Fitzwilliam Museum, Cambridge

Two young women have come together to read in a luxuriously decorated room. The one seated in an armchair wears a red jacket with ermine trim and a straw hat decorated with black ostrich feathers; she is reading to the other from a thin volume. This second woman, whose décolletage is decorated with pink roses, leans against a window niche while she listens attentively, her head turned towards the reader.

The painting, given jointly to Marguerite Gérard and her brother-in-law Jean-Honoré Fragonard – because of similarities in style to the figure in *The Stolen Kiss* (cat. 86), the standing woman is attributed to Fragonard – contains no narrative element beyond the depiction of two people enjoying a private moment together, reading. The characters' very reserved facial expressions and gestures offer no clues as to the possible reason for the meeting or on the relationship between the two. The reader makes a restrained declamatory movement with her left hand and extended arm, but this does not reveal to the viewer what is being read: is the book a heart-breaking novel or an amusing play? Besides making it possible to situate the women in a higher, cultured social class, the act of reading provides a thematic pretext for uniting in the painting all the individual objects and the women in silk gowns. An assortment of books lying scattered on a table, a portfolio with engravings standing on the floor, a lavishly decorated jewellery box in the background, a painting of an interior scene – probably Dutch – hanging on the wall, and a chandelier are the accessories in this composition, but they are of no relevance to the actual subject.

The Reader, painted around 1783–85, illustrates in form and style the strong influence that the seventeenth-century Dutch genre painters, such as Gabriel Metsu (1629–1667), Gerard Terborch (1617–1681), Caspar Netscher (c. 1639–1684), Adrian van der Werff (1659–1722), or Jan Verkolje (1650–1693), had on Marguerite Gérard's work. On the other hand, we do not find in her compositions the symbolism associated with individual objects so often seen in the works of those painters, nor is there any hidden eroticism, such as that encountered, for example, in the *tableaux de mode* painted by Jean-François de Troy. Often the elements that recall the Dutch models are restricted mainly to the small format and the meticulous finish of the *fijnmaler* style (see cat. 87). In the present painting, the furniture and the chandelier of polished brass, as well as the leaded glass window and the light-coloured parquet floor are unambiguous references to various Dutch paintings, which were meant to be recognized by the viewer of the time. By adopting a familiar compositional design from the Dutch works she had studied – the stage-like view into the room, with the window and jewellery box cut off at the edges of the canvas – Gérard increased the market value of

her paintings, but not by merely creating simple copies of other works (see fig. 140).

Gérard gives the illusion of historical authenticity by reproducing the fabrics and materials with incomparable precision, while at the same time playing with references to contemporary dress, so as to charm the viewer with things that he or she will recognize. A close analysis of the two women's apparel reveals a combination of Dutch clothing from the mid-seventeenth century, the historical costume style popular in France in the 1780s, and modern styles. In the cream-coloured gown *à l'anglaise* worn by the standing woman, the carefully reproduced pleats above the hips on both sides and the long bodice are taken from Dutch genre paintings. On the other hand, the long sleeves, embroidered *fichu menteur*, and fresh flowers at the neckline, are from the late eighteenth century.

We know little today about the circumstances or the manner in which Gérard studied the Dutch genre paintings then in many Parisian collections; however, she undoubtedly made use of the wide variety of prints circulating in Paris in her time. It is clear from her works that Gérard consciously studied historical images and laboriously acquired a repertoire of seventeenth-century forms and styles that she employed and recombined in her own compositions – the characteristic method of the subsequent generation of artists who painted in the *style troubadour*.[1]

Often a soft light spreads over Gérard's paintings, enhancing every detail, including each individual fold in the clothing. This *fini précieux*, well-known in the Dutch originals and sought after by collectors, is one of the reasons for the great success, also in financial terms, the artist enjoyed throughout her life, primarily among bourgeois collectors. The characters in her images are always taken from this prosperous milieu, whose own lifestyle was reflected in Gérard's courtly themes. At the time of the Ancien Régime, the number of female members of the Academy was limited. This explains why the painter only started to participate in the Salon in 1799, then went on to exhibit her genre paintings there regularly until 1824.[2] Marguerite Gérard was the first successful female genre painter in France.

JE

Fig. 140 Gerard Terborch, *Curiosity*, 1660. The Metropolitan Museum of Art, New York. The Jules Bache Collection, 1949

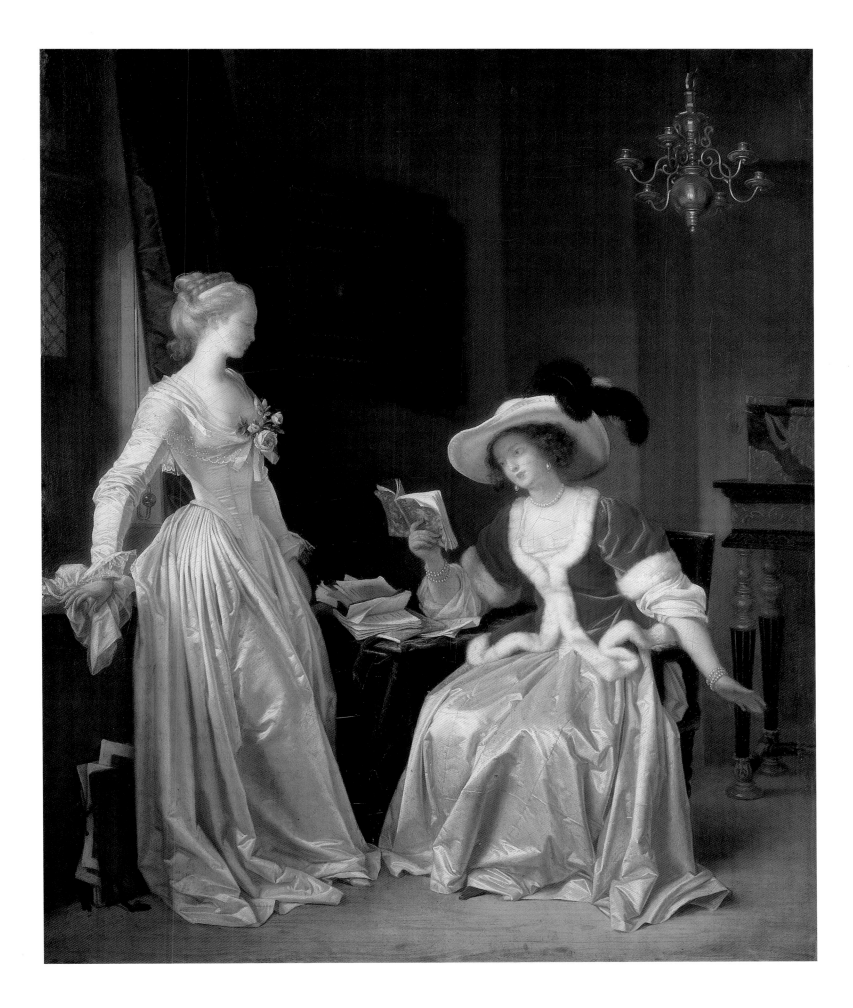

CLAUDE-JOSEPH VERNET (1714–1789)

89 *Constructing a Main Road* 1774

97 × 162 cm

Musée du Louvre, Paris

90 *The Approach to a Fair* 1774

97 × 162 cm

Musée Fabre, Montpellier

This pair of grand landscapes was commissioned from Vernet by the abbé Joseph-Marie Terray (1715–1778), Contrôleur-général des Finances from 1769 and simultaneously Directeur des Bâtiments for a brief term, from July 1773 until he was forced from office in August 1774. In the former capacity, Terray would have been indirectly responsible for road building schemes such as the imaginary one depicted in *Constructing a Main Road*, for the maintenance of France's waterways, and for the fairs intended to promote trade and commerce, as represented in *The Approach to a Fair*. There were tremendous efforts in mid-eighteenth-century France to develop these systems of communication throughout the country, both to encourage prosperity and commerce and to facilitate more efficient centralized social control. Terray commissioned a number of artists to execute works of painting and sculpture with similar didactic purposes. Nicolas-Bernard Lépicié's *Interior of a Customs House* (cat. 96) was another of Terray's commissions intended not only to entertain but also to instruct the spectator.[1] What is interesting about the commissions to Lépicié and Vernet in our context is that, while these two painters enjoyed considerable success in the relatively lowly categories of their chosen specialities (genre for Lépicié, landscape and marine painting for Vernet), this very success with the Salon-visiting public and with collectors ran counter to the official policy of the Academy. On the basis of a time-honoured humanistic tradition dating back to the Renaissance, the Academy promoted the more morally elevated class of history painting. Terray, who during his short-lived term as Directeur des Bâtiments had oversight of royal artistic policy, may have intended to play an active role in stimulating art of a more serious kind, by embodying within his commissioned genre and landscape pictures messages of an improving nature: pointing these types of painting towards the condition of history painting, so to speak.

The critic writing about the Salon of 1775 in the *Mémoires secrets* identified the principal figure on horseback in *Constructing a Main Road* as Jean-Rodolphe Perronet (1708–1794), the most celebrated bridge-builder and engineer of eighteenth-century France.[2] His features can be compared with those in his portrait drawn by Charles-Nicolas Cochin, which graces the engraved frontispiece to the first volume of Perronet's own lavish folio publication of 1782, *Description des projets et de la construction des Ponts de Neuilly, de Mantes, d'Orléans, & autres*. The young Perronet began his career in 1735 as *sous-ingénieur* in the Corps des Ponts et Chaussées, rising by 1747 to Premier Ingénieur; in this year he was also made director of the Bureau Central des Dessignateurs (later known as the École des

Ponts et Chaussées); he became Premier Ingénieur du Roi in 1763. Perronet made important improvements to the roads and bridges in and around Paris, and was responsible for such famous bridges as the one linking Paris with Neuilly (constructed 1768–72), and others listed in the title of his celebratory volume mentioned above. At the Salon of 1775, Hubert Robert exhibited the large (over two meters in width) *Decentring of the Pont de Neuilly* (lost; preparatory study, Musée Carnavalet, Paris), a panoramic scene, wherein the wooden centrings used to support the masonry construction of the bridge are removed, crashing into the river to dramatic effect. This was a major public event, and Robert depicted all levels of society, including Louis XV and members of his court, the abbé Terray, the engineer Perronet himself, and a great crowd of ordinary citizens, all of whom gathered along the banks of the Seine to witness the spectacle.

Constructing a Main Road, with its scenes of road and bridge building, is a tribute to the skills of Perronet, although the landscape depicted by Vernet is not topographical, but an imaginary one. The post at the left of the picture indicates that we are 280 leagues away from Paris. A specific invention of Perronet was the small cart with a triangular body seen to the right: his *camion prysmatique*. When filled, the body would be top heavy, and on release of a catch would pivot on the axle and automatically discharge its load. It was considered more efficacious than a cart tipping to the rear; it was lower, and hence easier to fill; and it involved less manoeuvring of the horse when emptying. Plate XII of Perronet's *Description* shows the *camion prysmatique* at work, and plate XIV has complete analytical diagrams. Perronet was also proud of the wooden centrings of his bridges – as in plate V, for example – and of the wooden construction of his cranes – as in plates VIII and XIX – and these are all reflected in the carefully observed details of Vernet's painting.

Constructing a Main Road is one of Vernet's most heroic landscapes, and comparable to his sublime *Mountain Landscape, with the Beginning of a Storm* (Dallas Museum of Art), exhibited at the same Salon of 1775 (no. 30). These images bear comparison with the heroic landscapes of Nicolas Poussin in the seventeenth century, and it is likely that such an allusion would have been appreciated by Vernet, at this period in the mid-1770s when critical and academic reaction to the decorative nature of Rococo art was at its strongest. The narrative structure is also suggestive of Poussin and the academic tradition, although it does not trace a lofty moral theme, but, typically of the Age of Enlightenment, is rather a step-by-step demonstration of how modern man can by design and labour overcome and improve brute nature.

The designer, on horseback, looks over a plan with a site foreman. In a series of delightful and instructive vignettes – as if brought to life from the dry illustrative engravings of the *Encyclopédie* (1751–65), which advocated the building of roads and bridges – we are shown just how such a road was constructed in the eighteenth century. On the right, labourers are digging into the hillside, widening the road and providing rubble for the embankment at the left. Here and in the foreground, larger pieces of rock are separated and shaped into blocks to pave the surface; to the left, the ground is being prepared, the blocks laid and then pounded into a solid and level pavement. In the background, the upper stages of a bridge are nearly complete; the wooden centring of the arches has not yet been removed, and a pair of Perronet's ingenious wooden cranes hoists blocks of masonry into

place. The windmill on the hill would have served to grind rocks and other matter to a granular consistency for construction purposes. All these details are rendered by Vernet with an exquisite, painterly touch.

Colin Bailey has recently pointed to the fact that many of the workers represented by Vernet would have belonged to the rural population, obliged to give up several days' labour as part of the *corvée* (a hated feudal exaction, which was to be abolished in 1776).[3] Although they were in effect forced labour, in Vernet's painting the men are shown as a dedicated workforce, happy with their lot and their place in the social order, supervised by Perronet, representative of the King. Needless to say, roads were not constructed with the concentrated simultaneity of activity we see in Vernet's idealized view: they took years to complete.

The companion painting *The Approach to a Fair* also depicts an imaginary landscape, although when it was sold from the Clos collection in 1812, it was said to represent Beaucaire. The provençal town of Beaucaire, on the Rhone, was a busy river port in Vernet's day, and a famous commercial fair was held there. The location depicted in his picture, along the banks of a broad river, almost certainly alludes to this place and event: they would have been familiar memories to Vernet, who was born and spent his youth in Avignon, only fifteen miles upstream. But it is rather due to Vernet's powers as an artist, in creating for us an illusion so convincing, that we feel this might be a real place. The bustling movement in the foreground, with laden barges and wagons, prosperous-looking travellers, and various craft plying the river, gives every indication of a busy commercial centre. One bale waiting on the riverbank is stencilled with the name of the abbé Terray, while another bears the name of Clos, doubtless added after he acquired the painting at or just after the Terray sale in 1779. The outer stalls and booths of the fair itself can be seen on the far bank of the river: they seem to be mainly selling such things as toys and candies, and there is a tented stage for performances of some kind. Overall, it is a scene of intense activity, with a sense of prosperity and well-being, and of time and opportunity for lighthearted pleasures. The child in the right foreground, playfully waving the pinwheel purchased for him at the fair, is a reminder that Vernet's notebooks record his own visits to fairgrounds, with their sideshows and marionettes, in the company of his children. *The Approach to a Fair* is less overtly didactic in conception than its pendant, but such well-maintained waterways and regulated commercial events were considered essential to a sound economy in eighteenth-century France, and it was surely Terray's intention that viewers of Vernet's work should be both delighted and gently instructed.

PC

HUBERT ROBERT (1733–1808)

91 *Laundress and Child* 1761

35.1 × 31.6 cm

Sterling and Francine Clark Art Institute, Williamstown, Massachusetts

Near a fountain, a young woman, seen from the back, is hanging a heavy wet linen sheet on a clothesline. At the same time, she looks down at the young boy at her feet, who holds up his shirt with both hands. He is relieving himself in cherubically innocent fashion, thereby complementing the jet of water from the fountain in a comic way that was no doubt intended by the artist. A large dog is huddled at the boy's feet. A wicker laundry basket, a bundle of washing, and a straw hat with a blue ribbon complete the picture.

We do not need the artist's two inscriptions in order to place this imaginary scene in Italy: a fountain with a statue and an antique-looking lion's mask, a wall made of fired bricks, the typical vegetation, and the bright light – all evoke memories of a warm summer day in Rome. The successful re-creation of the atmosphere, together with an Italian-style artist's signature carved with a chisel in the stone of the fountain, appealed to collectors on tour, who could take such an image home with them as a souvenir of Italy.[1]

The young Robert moved to Rome in 1754 as part of the retinue of the French ambassador, the Comte de Stainville, the future Duc de Choiseul (1719–1785). Robert was to spend altogether eleven years of his life in Rome, first as a guest of the Académie royale de France, then from 1759 to 1763 as a *pensionnaire* (scholarship holder). He was influenced by his friendship with Jean-Honoré Fragonard, who had been awarded the *Prix de Rome* in 1756. Both artists shared a predilection for subjects taken from the daily life of the Italian people, which they transferred to canvas in a similar delicate and rapid way.

Fig. 141 Hubert Robert, *Cuisine italienne*, c. 1767. National Museum, Warsaw

Therefore, during this phase, it was hard to distinguish stylistically between the two painters. Hubert Robert's sketchbooks and watercolours from this period contain numerous studies done in the manner of Watteau, in which he captures with swift brushstrokes the movements of women carrying water, peasant women, street scenes with children, and also laundresses. He used these studies to build up a repertoire of images and shapes with which he later populated his numerous paintings of ruins.[2] For example, Robert takes the laundress from the present work and includes her in the lower-right section of the painting *Vue du Pont des Sphinx*, which was engraved by P.-A. Martini (1738–1797).[3] Sketches of this type were popular with collectors and, as the signature suggests, were regarded as paintings in their own right.

Although they appear with regularity, genre scenes are an exception in the work of this painter of architectural subjects who was known as "Robert des Ruines." At the time when *Laundress and Child* was made, critics and artists in Paris were ardently discussing the moralizing subject matter of Jean-Baptiste Greuze's *Marriage Contract* (cat. 71), on display in the Salon of 1761. A new theoretical and aesthetic chapter in the evolution of genre painting was thus opening up.[4] Robert, by contrast, embraced a picturesque naturalism in his works. It was not least his gallant and emotional perception of reality that guaranteed his success with a public drawn largely from aristocratic circles, whose lives still resembled a *fête galante*.[5] The tenderness and sweetness with which Robert here describes the intimate scene between mother and son, and also the sense of cheerfulness that is conveyed to the observer through the delicate yellow and blue dabs of colour and the brilliant light, make for an Arcadian scene that stands in contrast to the laundresses' harsh occupation. Moreover, the erotic connotation associated with serving girls and laundresses is here merely hinted at through the gathered-up skirt and the elegant turn of the body.[6]

Cuisine italienne (fig. 141), which was shown at the Salon of 1767, is an example of the kind of genre painting in which Robert was engaged in the early stage of his career. Diderot praised this composition for its accurate rendering of the material world and the lighting, as well as for the carefully detailed, sensitive, atmosphere-laden kitchen scene *à la Chardin*: "Everything is soft, easy, harmonious, warm, and robust in this painting, which the artist seems to have created effortlessly This piece was not done to attract the attention of the masses. The vulgar eye seeks something more powerful, more strongly felt. This work attracts only individuals who are sensitive to true talent."[7] But even here, Robert remains committed to the anecdotal and the picturesque, two elements that characterize all his works.

JE

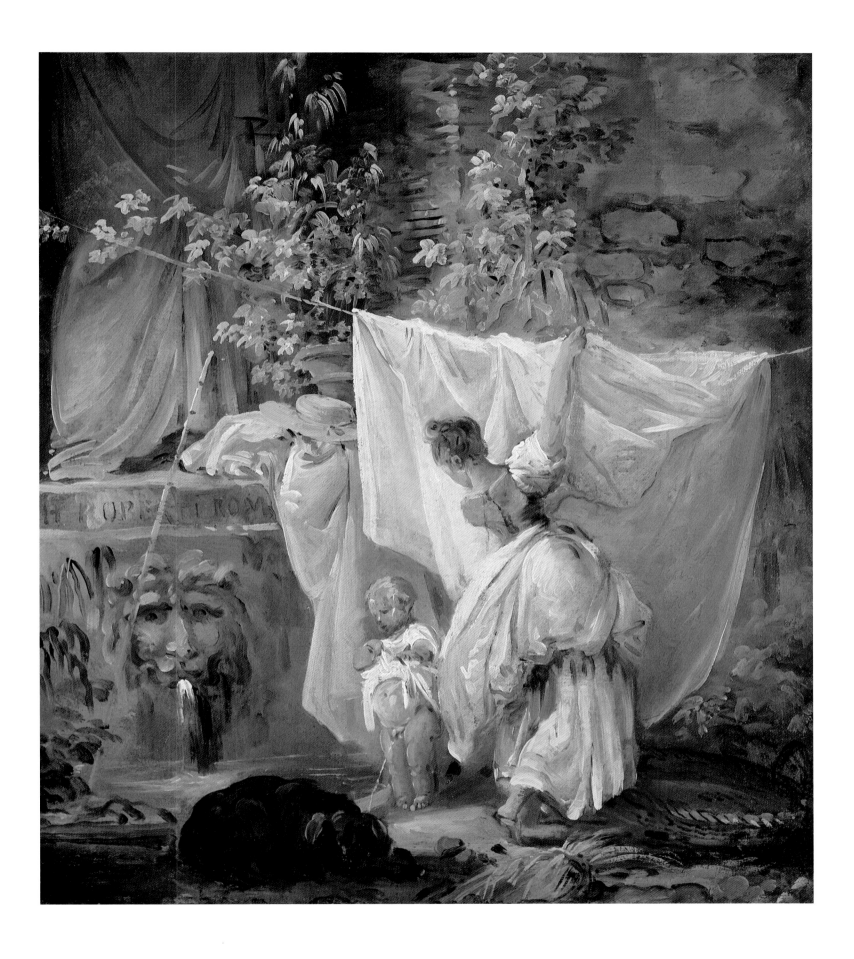

HUBERT ROBERT (1733–1808)

92 *The Artist in his Studio* c. 1763–65

37 × 46 cm

Museum Boijmans Van Beuningen, Rotterdam

In a room brightly illuminated by the light from a window, a young man is drawing the antique bust of a woman, which is positioned in front of him on a table. The artist sits forward on a simple chair, with his back to the window; a large sheet of drawing paper is before him, and he holds a pencil in his right hand. The two sizable art portfolios at his feet, the painting utensils on a side table, the rolled-up sheet of drawing paper, and an antique male statue all identify the room as an artist's studio. Freely arranged on the wall are an oil sketch, drawings, engravings, and a painting that cannot be further identified (or is it a mirror?).

The convention of depicting the artist working in his studio has a long tradition,[1] although in Robert's picture this theme is given emotional overtones. He does not yet show the artist as a creative genius working in seclusion, which is a frequent nineteenth-century interpretation; nor does he continue to portray him in the lofty manner of the seventeenth and early eighteenth centuries: instead, Robert shows the artist in the act of creating. His upper body is inclined slightly forward and his thoughtful gaze is fixed on the bust, giving the overall impression that he is studying his subject with great intensity, almost passionately. The untidy and casual way in which the young man is dressed – his jacket, cravat, and hat have been thrown aside, his waistcoat is unbuttoned, and his stockings hang loosely – indicates that he surrendered to inspiration and spontaneously sat down at the table to draw. He is so deeply absorbed that he does not notice the small greyhound at his side, playing with his red-heeled slippers.

Recent research dates Robert's studio scene to the last segment of his long stay in Italy, namely around 1763 to 1765. At that time, the young artist was living as the guest of his patron and sponsor, the Ambassador of the Order of Malta to the Holy See, the Bailli de Breteuil (1723–1785), in his Palazzo di Malta in the Via dei Condotti. A drawing of the *Salon du bailli de Breteuil à Rome* (Musée du Louvre, Paris) shows the same arrangement of window, curtains, ceiling, and table near the window. One can only speculate whether Robert used this salon as a model for the present painting, or whether he was assigned a similar room in the palace to use as his studio.[2] However, the arrangement of objects in the image, which merely appears random but is in fact very carefully composed, cannot be understood as depicting an existing studio. The statue at far left acts as a compositional counterweight to the axis of the window, and in addition, thematically reinforces the importance of antiquity as the source of the artist's inspiration. This is the famous statue of *Germanicus*, now in the Louvre, which had stood in the Galerie des Glaces in Versailles ever since its purchase by Louis XIV, and Robert was familiar with it from a cast in the Academy in Rome.[3]

In many of his canvases, Robert returns to the theme of the artist at work, either from nature or in the studio, and he also incorporates this motif into his architectural capriccios. Scholars have often looked for self-portraits of the artist in these pictures, and it is possible in this present work to believe that the man with the high forehead, slightly receding hairline, and high black eyebrows is Hubert Robert himself.[4] But, the portrait aspect is so downplayed here that the work has in fact become a genre painting. A drawing done in red chalk by Robert, which was recently on the art market (fig. 142), copies the central scene of the painting exactly, save for a few details: an artist, this time with a full head of hair, has his foot on an open portfolio and is also copying an antique bust. In this case, Robert has placed the bust of a woman on the table opposite a drawing or engraving of the bust of a bearded man hanging on the wall, in such a way that they appear to be in playful eye contact with one another.[5] However, the drawing does not reproduce so convincingly the atmosphere of the intimate dialogue with antiquity that the artist conducts in the painting. Here, through his rapid method of painting and a rather "mysterious" use of light,[6] Robert manages to convey to the viewer his personal fascination with remnants of antiquity; these he discovered – for himself and for his art – during his journeys through Italy.

JE

Fig. 142 Hubert Robert, *An Artist Drawing from an Antique Bust*. Location unknown

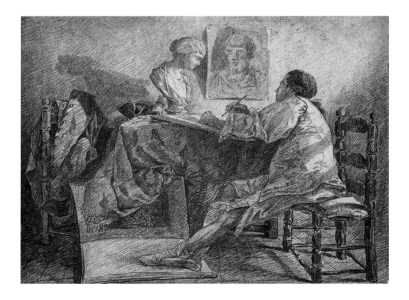

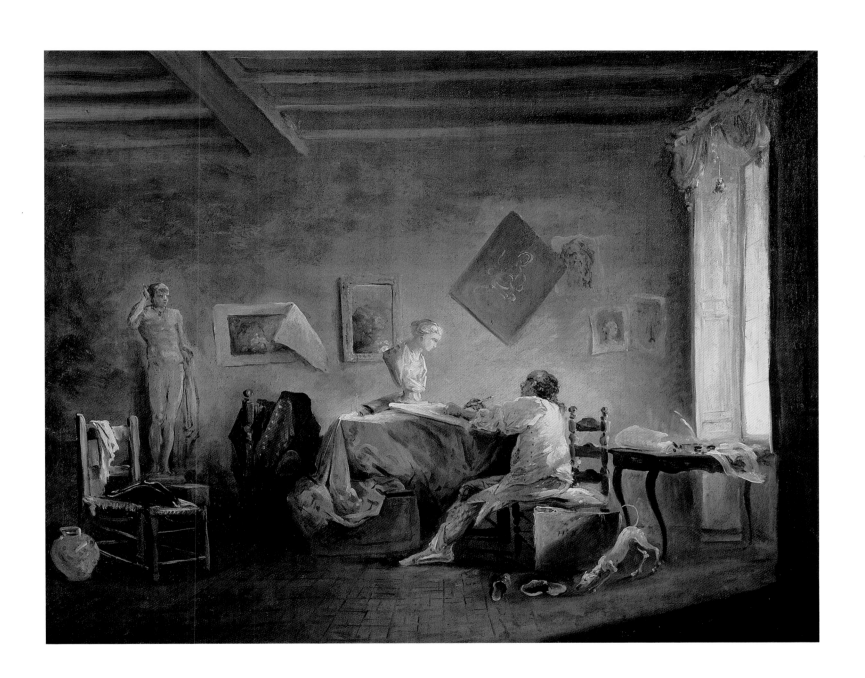

HUBERT ROBERT (1733–1808)

93 *The Demolition of Houses on the Pont Notre-Dame in 1786* 1787

81 × 154 cm

Staatliche Kunsthalle Karlsruhe

94 *The Demolition of Houses on the Pont-au-Change in 1788* 1788

86.5 × 159.5 cm

Musée Carnavalet–Histoire de Paris, dépôt du Musée de Versailles

The two paintings here presented and discussed together, as if a pair, in fact come from two different sets of pendants: the true companion, identical in size, to the Karlsruhe *Demolition of Houses on the Pont Notre-Dame in 1786* was acquired by the Alte Pinakothek, Munich, in 1957; we exhibit a second, very slightly larger version of the Munich *Demolition of Houses on the Pont-au-Change in 1788,* from the Musée Carnavalet, whose own true pendant, also in the Paris museum and with the same provenance, is a similarly slightly larger version of the Karlsruhe picture. It is not known who was the original patron, or even an early owner of either pair of highly original paintings.[1]

Bridges in Paris, like those in most European cities, had been built up with houses since medieval times. The wood-frame houses on the Pont Notre-Dame were erected between 1500 and 1512, while the adjacent Pont-au-Change, with its five-storeyed stone houses, was built between 1639 and 1647. In the reign of Louis XIV, however, the advisability of this type of construction began to be questioned. In his proposal for the embellishment of Paris in the 1670s, Pierre Bullet (1639–1716) advocated the clearing of houses from the bridges: densely packed together, they presented a fire risk (for example, there was to be a serious fire on the Petit-Pont in 1718, depicted in a painting by Jean-Baptiste Oudry);[2] they were a threat to health and hygiene, because they hampered the circulation of fresh air and contributed to the pollution of the river; they also interrupted vistas within the great metropolis. Discussions on these issues continued on-and-off for a century, and were given a new impetus with the publication of Pierre Patte's *Monumens érigés en France à la gloire de Louis XV* (1765), wherein he proposed the amelioration and rationalization of the still cramped and crowded street-plan of Paris, with the opening up of more squares, broad avenues, long vistas, and unobstructed quays and bridges. At the request of the Prévôt des Marchands de Paris, the matter was taken up again when the architect Pierre-Louis Moreau-Desproux (1727–1793), Maître-général des Bâtiments de la Ville, who was responsible for the roads, quays, and drainage of Paris, was asked to draw up a survey of the banks of the Seine. Again, the clearing of the bridges was recommended, but it took another twenty years to overcome the many financial and legal obstacles to the procedure. The houses packed onto the Pont Notre-Dame and the adjacent Pont-au-Change, both leading from the north (right) bank of the Seine to the Ile de la Cité, were viewed as particularly problematic. Only when the Crown undertook to indemnify property owners for loss of income

did the first demolitions begin on the Pont Notre-Dame, in January 1786. The year 1787 saw the demolition of houses above the Quai de Gesvres, linking the two bridges along the north bank, and the beginning of work on the Pont-au-Change. Robert's paintings document and celebrate these important town planning initiatives.

Robert's view of the Pont Notre-Dame is taken from the riverbank on the north side of the Seine, below the embankment of the Quai Pelletier, designed by Pierre Bullet in the 1670s. The artist himself can be seen – a tiny figure in red, busily at work – in the centre foreground of the Karlsruhe picture. He is seated on a pile of masonry and timbers, likely salvaged from the demolition above; other fragments are stacked or scattered along the riverbank, and men are loading some onto a barge. The salvaged building materials were sold off by the city.[3] The life of the river goes on as usual: at the left, men are fishing; various craft ply up- and downstream; and professional laundresses are at work on their floating laundry boats moored just off the bank. Here, we see about two dozen of the nearly two thousand washerwomen who washed the linens of Paris in the mid-eighteenth century, and who were themselves frequently the subjects of genre paintings (see the works by Greuze, cat. 70, Fragonard, cat. 76 and 77, Boilly, cat. 111, and Robert himself, cat. 91).[4]

Under the second left arch of the bridge can be seen a floating watermill. The wooden substructures under the third and central arch are frameworks for the pumping equipment – the Pompe Notre-Dame, installed in 1670 – which was driven by bladed wheels visible here, and drew water up from the river onto the bridge. On the bridge, to left of centre, we see the remains of a classical portico in masonry, marking the public entry to the water pump.

On the bridge itself, the houses along the east side have been torn down and are being cleared, revealing the partially demolished west terrace. The vaulted spaces visible at the lowest level housed the shops and other commercial premises that lined the street. On this bridge there were mainly dealers in luxury goods: works of art, books, embroidery, and lingerie. It was into such a vaulted space that the shopsign painted by Watteau for his friend the art dealer Edme Gersaint was inserted in 1721, which explains why its top was originally curved in shape (see fig. 1). The tiny figures of labourers are busy among the dusty remains of the houses, clambering up ladders and scaffolding, or filling and conducting away wagonloads of debris.

Beyond the Pont Notre-Dame we see the Pont-au-Change, with its very tall houses, still intact in 1786; further is the Pont Neuf, which was free of houses; and, barely discernible in the distance, the Pont Royal. Just above the gabled roofs to the left of the Pont Notre-Dame, we can see the top of the *flèche* (spire) of the Sainte-Chapelle and, beyond the pump gate on the near bridge, the greyish form of the Tour de l'Horloge. These are features of the old royal palace on the Ile de la Cité, situated at the end of the Pont-au-Change, which appear again in the background of Robert's companion picture, *The Demolition of Houses on the Pont-au-Change in 1788.*

In this second painting, the Tour de l'Horloge is quite prominent in the right background; behind and next to it is the spire of the chapel; and further to the right, the two round towers of the Conciergerie. These medieval structures on the Ile de la Cité rise defiantly above the scene of devastation on the bridge before them. Robert has taken a slightly elevated position in the middle of the street, creating a dramatic perspective view. He seems to be located at

a point near the north end of the bridge, where the street widened and divided into a Y-shape, with two streets leading onto the right bank. Here, we are looking south towards the Rue Saint Barthélemy, which continued southwards alongside the royal palace. The houses have been reduced to rubble, and with them have been obliterated the premises of the goldsmiths and money-changers who plied their trades along this thoroughfare. Gangs of labourers are busy salvaging blocks of masonry and lengths of timber; a soldier on guard duty appears to be ushering a passing woman and child away from the work site.

Robert's two pairs of large paintings are fascinating social and historical documents, charting with considerable topographical and human detail major developments in the urban renewal of Paris in the Age of Reason. The city appears in its dual identity of social space and human construction – or, rather, destruction. This infuses the works with an undeniable melancholy. For all that we are witnessing the first steps in a worthy programme of urban improvement, it is the sense of chaos and the temporality of human endeavour that prevail. Robert seems to exaggerate this effect by reducing the stature of his human participants, making them puny in relation to the scale of the destruction around them. This is a device he likely learned from the art of his great Italian contemporary Giovanni Battista Piranesi (1720–1778), who populated his etched views of Roman ruins with figures deliberately diminutive in scale, the more to evoke a sense of the grandeur of the ancient remains. Robert's vision is unheroic, however, and noticeably against the grain of the celebratory urban topography of an Antonio Canaletto (1697–1768) in Venice and London, or a Claude-Joseph Vernet patriotically depicting the major seaports of France.

Ambitious in size and didactic in intent, Robert's urban scenes nevertheless bear some comparison to Vernet's *Constructing a Main Road* and *The Approach to a Fair* (cat. 89 and 90), or Lépicié's *Interior of a Customs House* (cat. 96) and its pendant, painted in the middle of the preceding decade. They can be compared, too, with Robert's pair of equally monumental views depicting the *Cutting Down of Trees in the Gardens at Versailles*, 1776–77 (Musée national du Château, Versailles), showing modifications to the royal grounds at Versailles, witnessed by a social cross-section of spectators. All these paintings merge the observation of contemporary life, idealized to various degrees, with an improving and didactic element, which in combination with their large scale elevates them towards the condition of history painting. It is surely no accident that the works we exhibit were conceived at a time when critics and royal officials were calling for a return to the Grand Manner of the seventeenth century. This was even more the case with the set of four paintings, *Monuments de la France* (Musée du Louvre, Paris) – truly monumental in every sense – representing the major antiquities of Languedoc, which Robert painted on commission at just this same time for the dining room of Louis XVI at Fontainebleau, and exhibited at the Salon of 1787 (nos. 46–49).[5] These scenes of ancient rather than modern ruins were populated by Robert – somewhat anomalously, as the monuments were already in ruins – by figures wearing classical dress: ancient genre, as it were, but giving the scenes a quasi-historical dimension. Here, the borderlines of the different categories of painting become quite blurred, between decoration, landscape painting, ruin painting (Robert's signature speciality), genre, and even history.

PC

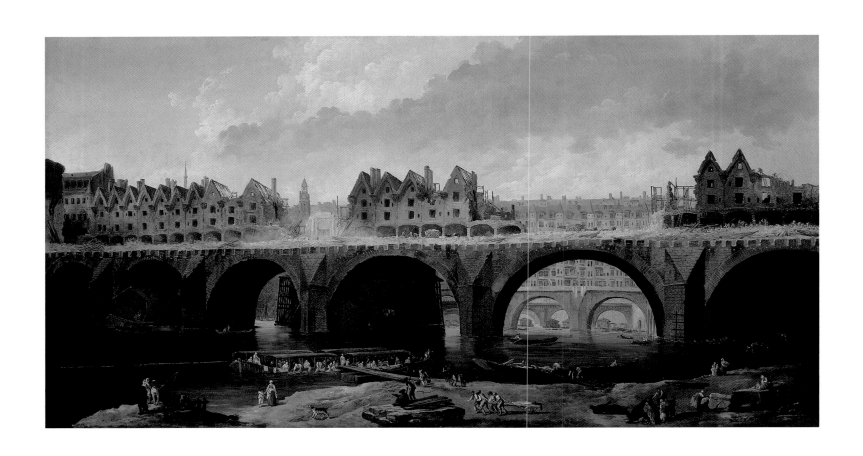

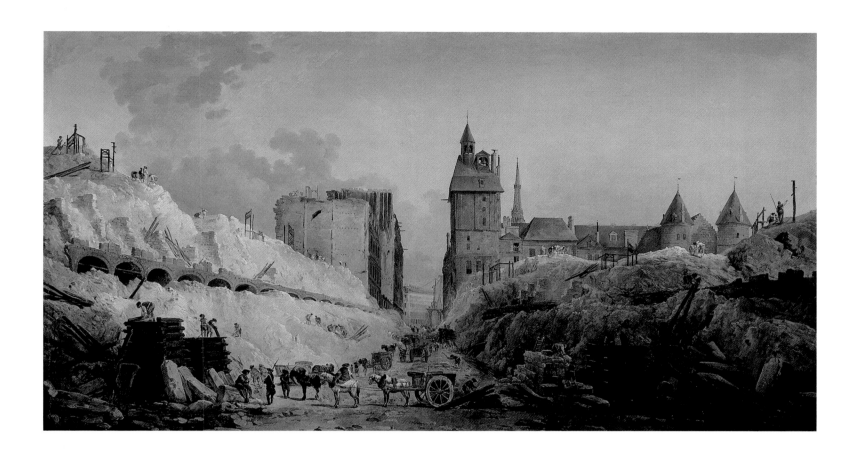

HUBERT ROBERT (1733–1808)

95 *Jean-Antoine Roucher (1745–1794) as he Prepares to be Transferred from Sainte-Pélagie to Saint-Lazare*
c. 1794

32 × 40 cm

Wadsworth Atheneum Museum of Art, Hartford, Connecticut

A well-dressed, middle-aged man stands in a prison cell containing plain furniture and sundry utensils of daily life. In his right hand he holds a book, and his gaze rests on the oval portrait of a young woman, on a writing desk before him. The packed travelling bag at his feet signals that this is a moment of departure. The assemblage of an inkwell, pen, and sheets of paper with writing on them provides a clue to the occupation of the person depicted here: current research indicates that this is the poet and journalist Jean-Antoine Roucher (1745–1794), who was incarcerated along with Robert in the Sainte-Pélagie prison. Three months later, the two were transferred to Saint-Lazare, where Robert remained until his release on 4 August 1794. Roucher, however, lost his life on the guillotine just a short while before the Reign of Terror ended. In his letters from prison, Roucher had described in detail the habits of the jailed artist, who used to paint until midday and then liked to play ball in the courtyard.[1]

The numerous biographies of the painter contain different versions of the reasons for Robert's arrest on "8 Brumaire An II" (29 October 1793): likely, he was denounced. Even at the height of the Revolution, the artist still maintained contact with former clients and patrons in the circles of the high nobility and the financial aristocracy. The revolutionaries also discovered rooms that had been decorated by Robert in many of the urban palaces and country houses that had been confiscated. There were, therefore, sufficient reasons for him to appear suspicious to the Comité de surveillance révolutionnaire.[2]

Hubert Robert's small scene from the period of the *Terreur* is one of a series in which the famous painter of ruins and landscapes delineated, in his own inimitable manner, not only important events but also the everyday face of the French Revolution. To judge these genre scenes, we must consider them in the context of the paintings produced during the revolutionary period: their quality stands in crass contrast to the artistically inferior, sometimes naive, engravings that

the Revolution issued in great numbers for propaganda purposes. However, Robert lacked the necessary analytical and artistic skills that would have enabled him, like the history painter Jacques-Louis David (1748–1825), to symbolize the ideas of the Revolution and to glorify its heroes by means of allegory. The painting *La Bastille dans les premiers jours de sa démolition* (Musée Carnavalet, Paris) from 1789 is an eloquent example of the approach taken by Robert, who was admitted to the Académie royale in 1766 as a "peintre d'architecture." Although he was an eyewitness to the incident, Robert seems to be preoccupied here with questions of composition and perspective, as well as with the subtle rendering of the light conditions, rather than with giving the viewer a sense of the emotions and scope of this epoch-making event.[3]

The situation is similar for the work under discussion; its subject matter cannot be understood unless one is familiar with the historical circumstances surrounding its creation. The composition gives no information about the tragic fates endured under the Reign of Terror, nor does one gain any impression of the fears and doubts suffered by the prisoner. This type of genre painting, as practised by Robert, is almost documentary in its manner of depiction, but is it capable at all of conveying feelings and emotions without making use of the tools commonly employed by a history painter – namely theatricality and the *expression des passions*? Even during this momentous period in his life, Robert retains the almost neutral descriptive style of the *chroniqueur* from his sojourn in Italy, where he captured the daily life of the population in his art (see cat. 91).[4]

The historical and political significance of the painting in Hartford was appreciated for a long time because it was thought that the person shown was Camille Desmoulins (1760–1794), a member of the radical faction and thus one of the Revolution's major protagonists.[5] During the revolutionary period, Robert often tried his hand at depicting contemporary personalities, but he invariably rendered them in an undramatic manner and in the style of genre painting. The watercolour *Marat Asleep on his Bed* (fig. 143) is, on first examination, a personal and perhaps spontaneous commentary on the circumstances of the artist's own imprisonment. The words "*dénunciat[ion] de Robert par Baudouin*" can be clearly read on the piece of paper lying on the table, illuminated by a candle. However, individual, carefully selected elements in the composition, such as the bust of the Republican Michel LePeletier de Saint-Fargeau (1760–1793), who was murdered in 1793, or the crude club at the foot of the bed, can be seen as political barbs against the revolutionary methods employed by Marat (1743–1793), by whom Robert felt he had been victimized.[6] The question arises as to the identifiability of the figures, and as to the aims and function of such genre scenes.[7] If the person depicted is actually the artist's fellow prisoner Roucher – as scholars have assumed so far – then the present painting could be seen as a token of personal friendship.

JE

Fig. 143 Hubert Robert, *Marat Asleep on his Bed*. Graphische Sammlung Albertina, Vienna

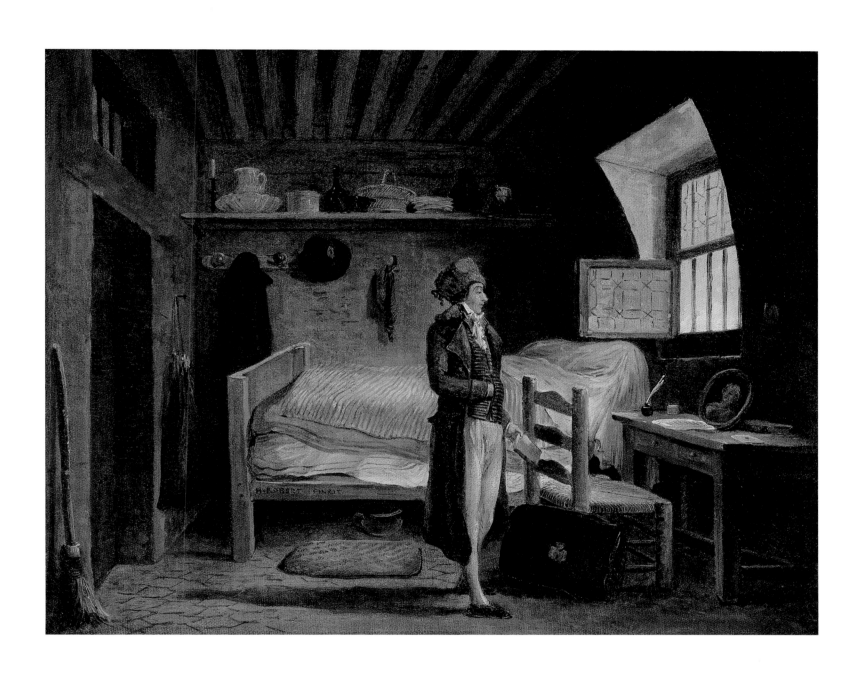

NICOLAS-BERNARD LÉPICIÉ (1735–1784)

96 *Interior of a Customs House* 1775

98 × 164 cm

Museo Thyssen-Bornemisza, Madrid

Interior of a Customs House, along with its pendant *Interior of a Market* (fig. 144), was commissioned by the abbé Terray (1715–1778), Contrôleur-général des Finances and Directeur des Bâtiments, during his brief tenure in the latter post from July 1773 to his dismissal from office in August 1774. Lépicié's pictures were two of several works in painting and sculpture commissioned by Terray from various artists, which evidently had didactic purposes and were intended to reflect directly and indirectly the abbé's diverse royally ordained responsibilities for commerce, communications, agriculture, and their infrastructures throughout the realm. The two didactic landscapes by Claude-Joseph Vernet in this exhibition (cat. 89 and 90) were among these commissions. From the history painter Nicolas-Guy Brenet (1728–1792), Terray ordered *The Roman Farmer* (Salon of 1775, no. 28, lost; another version, Musée des Augustins, Toulouse), depicting Caius Furius Cressinus wrongly accused of sorcery on account of the abundance of his crops; and *Cincinnatus Made Dictator* (Salon of 1779, no. 72, lost), representing the celebrated Roman summoned from his plough to take up the sword, and who was, happily, to return to his fields.[1]

Lépicié began his career during the 1760s with aspirations to be a history painter. But in the 1770s he turned increasingly to portraiture and genre painting, because these types of painting were more in demand and more lucrative. In its large scale and its moralizing overtones, *Interior of a Customs House* may be seen as an attempt by Lépicié to elevate genre painting – here a scene of daily commercial life in Paris – from its relatively low status towards the intellectual level of history painting. We are shown an ideal urban space and the complementary human activities that bring it to life. The choice of subject, as with the companion picture representing the *Interior of a Market* – emanating surely from Terray's office and not from a proposal by the artist – is clearly a didactic one, extolling the virtues of trade and agriculture, and the royal system of customs and excise. As the *Encyclopédie* noted: "In France, the customs relate to trade in the same way that a man's pulse relates to his health: it is the means by which we are able to judge the vigour of commerce."[2]

The artist has synchronized several places in the city which would have been more-or-less recognizable to his contemporaries, notably the arcaded curved gallery that evokes the Halle au Blé (Corn Exchange), built between 1762 and 1766 by the architect Le Camus de Mézières, and much admired in its day. The artist has represented himself in the central figure with a green vest, facing us: he is pulling back a cover on a bale to check the seals against a customs declaration held by the officer next to him. To the right, the abbé Terray is identifiable, in his soberest ecclesiastical garb. Both men are delineated as merchants or travellers having their goods and papers inspected. In the right foreground, a crate of books is opened, while a curious porter waits to pick up his load. To our left, wagons are being inspected or are waiting their turn; various groups linger and converse; in the background, a large load drawn by six horses is inspected by an official, who is checking the marks stamped on the packages at their point of origin. A weighing shed is over at the extreme right side, where barrels of wine are being assessed.

The picture was admired by public and critics alike at the Salon of 1775. In contrast with other works exhibited by Lépicié, the critic of the *Mémoires secrets* observed, "His *Customs House*, grander in design, drew in the crowd, presenting them with a great variety of objects. . . . The connoisseurs found there that calm, that accord, that harmony, which are absent from his other creations."[3] Lépicié's painting, full of engaging incident, skilfully orchestrated, represents a well-ordered and policed society. Bailey has pointed out that this scene of compliant travellers and polite customs officials was far from the reality experienced by eighteenth-century voyagers, however.[4] But Lépicié shows us that commerce is thriving; and the various grades of society take their place in the scheme of things, overseen by Terray himself, here discreetly presented as a representative of the Crown.

Lépicié's companion picture, *Interior of a Market*, equally admired when it was later exhibited at the Salon of 1779, shows a bustling produce market. It is an idealized view of Les Halles in Paris: the artist's contemporaries would have recognized the central fountain and, across the rooftops, the top of the astrological column of the nearby Halle au Blé. It is a scene of natural abundance and busy commerce, telling us, as does *Interior of a Customs House*, that in the realm of Louis XV and Louis XVI, all is well in the best of all possible worlds.

PC

Fig. 144 Nicolas-Bernard Lépicié, *Interior of a Market*, 1779. Private collection

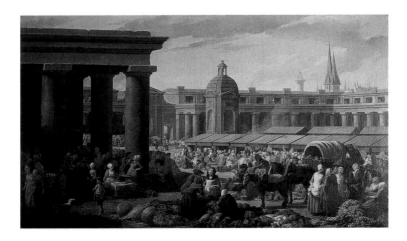

Nicolas-Bernard Lépicié (1735–1784)

97 *The Departure of the Poacher* 1780

81 × 65 cm

Musée des Beaux-Arts et d'Archéologie J. Déchelette,
Roanne

This masterpiece by Lépicié was exhibited in the Salon of 1781 along with a number of other genre paintings. In the recent literature, this work is generally interpreted as embodying a Rousseauesque theme that denounces the deplorable pre-revolutionary social conditions of the Ancien Régime. As early as 1762, in his *Émile ou de L'Éducation*, Jean-Jacques Rousseau (1712–1778) recommended hunting as a virtue, a "plaisir innocent," that improves the mind and strengthens the body; in the early stages of the French Revolution the aristocracy was stripped of its hunting privileges. The negative and subversive image of the poacher in a feudal society is converted into something positive by the Enlightenment: he is now a new man, proud and free, close to nature and god-fearing (observe the small cross in his buttonhole), who attempts to improve his family's diet by hunting, even though it is against the law.[1]

On the other hand, Diderot (1713–1784), in his salon criticism, does not mention this socio-critical aspect; but rather, judges the painting solely according to artistic criteria: "The poacher's face has character, but the manner of depiction does not please me. The colour of his clothing is the same from head to toe, and his clogs are of the same material as his clothes. The little boy whose hand he is holding has the same shortcoming. There is liveliness in the face of this child. The dog next to him is completely unnatural, in tone and form. However, this little painting has impact and draws the eye."[2] Diderot points out some small problems of draughtsmanship (the poacher's left hand, for example), but he criticizes above all the monochrome colour scheme of the painting, which is executed in harmonious shades of brown and grey. Beyond subject matter and realistic style, it was Lépicié's palette, akin to that used by seventeenth-century Dutch painters, that made him popular with collectors who inclined to the *goût hollandais* in the late eighteenth century.[3]

In 1782, Lépicié painted the return of the wife of the poacher and their daughter, and exhibited this composition under the title *Peasant Woman Returning from the Forest* at the 1783 Salon.[4] In terms of subject matter and composition, the austere-looking woman and her charming daughter form an ideal counterpart to the present picture. Furthermore, the fact that the works are of the same size and thus could have been purchased by collectors as a desirable matching pair, supports the assumption that Lépicié's primary intent was not the expression of a social concern. As a trained history painter and initially as a member, then, as of 1777, a professor of the Académie royale, Lépicié devoted himself increasingly to genre painting from the 1770s onwards, in the wake of the growing success of the genre scenes of Jean-Baptiste Greuze (1725–1805). By creating a pendant to the painting that he successfully showed at the Salon of 1781, and also by making numerous copies of his works, Lépicié, who was compared by his contemporaries with David Teniers (1610–1690), was satisfying the demands of an affluent clientele – collectors who did not feel that their social status or hereditary privileges were in any way threatened by the innocuous depiction of a poacher, a marginal figure in society. It was in this spirit that Mouffle d'Angerville (c. 1729–c. 1794) commented on Lépicié's genre scenes at the Salon of 1783: "M. L'Epicier [*sic*] always gives us something to savour when he does not want to rise to the level of the historical genre; he has truth, a precious naïveté that renders his grotesqueries pleasant, without provoking laughter."[5]

The man in the image is about to go out the door of his humble but solid dwelling; he gazes out of the painting with an earnest and thoughtful expression on his face; with his right hand he firmly grasps his gun. With his left, he gently holds the hand of his son, who is smiling happily, while playfully putting his father's hat on the dog's head, as the animal waits, ready to set off, at far right. The pair are framed in a rudimentary manner by a few simple, homely things: a basket, a wooden block, the straw-covered floor of the hut. Despite the tattered clothing, pieced together from scraps, the viewer is not quite convinced of the family's serious economic plight, which the title of the painting suggests. Probably for this reason, at the start of the nineteenth century, a smaller version of the image was given the more honourable title of *The Gamekeeper*.[6] The intimacy of the father-son relationship shown, also the sweet-looking, well-nourished face of the son that puts him on a par with the contemporary series of child figurines produced in biscuit porcelain by the Sèvres factory, which were popular with the aristocracy,[7] all convey an idealized and fictional image of the peasant world. In academic circles, even in the late eighteenth century, the depiction of social reality was still influenced by the way the court viewed the world.[8] The current image is evidence that the rules governing the subjects that formed the hierarchy of the genres had been opened up. The life of the lower orders was now also considered a fit topic for a painting, and *The Departure of the Poacher* is a prime example of this phenomenon. Lépicié was described as devout by his contemporaries, and in the literature, scholars repeatedly mention that he was close to the mainstream philosophical ideas of his day. Yet despite this, the artist was very timid about displaying any moralizing tendencies of the kind manifest in Greuze, who invested his figures with gestures and facial expressions borrowed from the field of history painting.

JE

ÉTIENNE AUBRY (1745–1781)

98 *The Shepherdess of the Alps* 1775

50.8 × 62.2 cm

The Detroit Institute of Arts

Étienne Aubry studied under the historical painter Joseph-Marie Vien (1716–1809), although he chose not to adopt the same themes. His interest lay more in portraiture and genre painting. Chardin, Greuze, and Fragonard had made the latter a recognized pictorial form preferred by collectors around the middle of the century. Aubry followed in their wake, and his pictures were praised by art critics of the Salon in the 1770s. Like Chardin and Greuze, he incorporated moralistic content in his work. Nevertheless, he hoped to be admitted to France's Royal Academy as a history painter. Like Greuze, however, he was refused that designation, and had to content himself with being known as a portraitist. Sponsored by d'Angiviller and encouraged by Vien, Aubry did turn to history painting and moved to Rome in 1778; he returned to Paris in 1780 and died shortly thereafter.

The Shepherdess of the Alps was seen in the Salon of 1775. The scene is derived from a literary source, a story by Jean-François Marmontel published in the *Mercure de France* in 1759. It illustrates the well-to-do Marquis de Fonrose and his wife seeking shelter at a farm in the Alps. The Marquise realizes that the bearing and character of Adelaide, a shepherdess and allegedly the daughter of the peasant couple, are those of a young noblewoman. And it does in fact emerge that Adelaide had withdrawn to the country to live near the grave of her husband, who had fallen in the war. Once the Fonroses

tell their son of the young woman's beauty, he wins her affection and marries her.

In the painting, Aubry captures the moment when the Marquise perceives not only Adelaide's natural beauty but also, through it, the same social background as her own. The moment of recognition is rendered by the outstretched left arm of the Marquise who, in her surprise, grasps her husband's arm with her right hand, and by Adelaide's state of suspended animation. The honest peasant couple is consigned to the centre background. Reflecting the social reality of the time, the work shows that there is a natural common bond between the social classes. Yet even in the garb of an Alpine shepherdess, Adelaide's aristocratic status is evident. The image came into being at a time when Marie-Antoinette was having a miniature farm ("The Hamlet") built in the park of the Petit Trianon at Versailles, where she played at leading a life she felt was natural and remote from court etiquette.

Unlike Greuze's paintings that combine social subject matter with a high moral stance, Aubry delineates the encounter inside the farmhouse that shelters the elegant city-dwellers as an anecdotal picturesque scene that is hardly comprehensible without knowing the original literary source. It conveys no dramatic impression, but rather seeks to emphasize the refined painting effects. And the social differences are evident in the radiant colours of the aristocrats' clothing in contrast to the grey and brown worn by the older peasant couple. Critics praised Aubry's painting as "true, sensitive and expressive."[1] The painterly, flowing, impasto style exemplifies Aubry, who was likewise indebted to Dutch models. Using sumptuous, fine brushwork, he sought to imitate the Dutch "fine painters" at a time when the works of artists such as Netscher, Terborch, Dou, Schalcken, and van der Werff were commanding top prices in the French art market. Pictures such as *The Shepherdess of the Alps* were added to the collections of the aristocracy of the fading Ancien Régime, where Dutch and French paintings were not infrequently paired as companion pieces on the walls.

Marmontel's story became exceptionally popular, not least thanks to the version Desfontaine brought to the stage, and it repeatedly inspired artists to create their own paintings and book illustrations. However, the scene usually depicted is of the young couple meeting, as in the portrayal by Joseph Vernet (fig. 145).[2] A sketch of Aubry's painting, deviating little from the finished work, is located in Vienna, in the Graphische Sammlung at the Albertina.

TG

Fig. 145 Joseph Vernet, *Shepherdess of the Alps.* Musée des Beaux-Arts, Tours

ÉTIENNE AUBRY (1745–1781)

99 *Paternal Love* c. 1775

78.7 × 101.5 cm

The Trustees of the Barber Institute of Fine Arts,
The University of Birmingham

Aubry was recognized in the Salon of 1775 for his portrayal of *Paternal Love*. No less a person than Diderot expressed his appreciation of the painting. He praised its natural authenticity and its colouration. However, the critic was particularly impressed that the artist had succeeded so well at representing the "moral genre" – which meant that, in the spirit of Greuze's genre painting, Aubry had also incorporated an ethical standard in his picture. The seemingly straightforward work does indeed harbour a moral sensibility. In the middle of the composition, set in simple surroundings, a man embraces his small son who happily reaches out his arms, while the mother looks on at the warm welcome. To her left are two more children, one of them busy playing with a drum. The group is flanked on the left by an older man leaning on a chair for support – the grandfather surveying this scene of happy family life. At the right in this interior is a hearth, and in the foreground, a barrel with a cloth spread over it and a large pot. These objects may indicate that the woman is a laundress, but this is not conclusive.

Aubry's painting only appears to show an everyday scene. By no means was it a matter of course for devoted marriages and love of children to be the underpinnings of social life. As of the mid-eighteenth century, though, these virtues were being propagated by Enlightenment-minded writers and philosophers and were also being integrated into paintings, especially by Greuze. His painting *The Beloved Mother* (fig. 23) had been an overwhelming success at the Salon of 1765.[1] Diderot praised it effusively: "It is excellent, in respect of talent but also of morality. It is a kind of sermon for the people and depicts, most dramatically, domestic peace as priceless good fortune and an inestimable treasure."[2]

Aubry's painting is a pendant, as it were, to Greuze's. It shows familial felicity with the father in the pivotal role. It is no accident that the scene takes place in a simple bourgeois milieu, far from the social circumstances of the upper classes or nobility, who would usually leave the children's upbringing to governesses. Enlightenment philosophers idealized rural life, making it a model for a Community of Nature, where fathers assumed the role of lovingly raising their children. Rousseau in particular extolled paternal love as requisite to a social order for which the Enlightenment set the tone. Carol Duncan has vividly described these socio-political contexts and pointed to the function of painting and literature as a medium for conveying the concepts of the Enlightenment.

Aubry did not limit himself to peasant or bourgeois scenes, however. In *First Lesson in Love* (private collection), his aim was to depict the importance of developing human relationships even in childhood, and this in the more affluent of families as well.[3] Like others of its kind, this work was modelled somewhat on seventeenth-century Dutch and Flemish paintings, which were greatly prized in France when it was created. However, in his art and especially in this picture, Aubry did more than just satisfy collectors' craving for picturesque works executed in the Dutch *fijnmaler* style. He sought to embody in his work a moral message, one that was also disseminated beyond the scope of the painting itself in an engraved copy produced by J.-C. Le Vasseur. It is indicative that a painting such as this was acquired by the Comte d'Angiviller, who was the king's Director General of Royal Buildings and thus the minister responsible for policy governing the arts under Louis XVI. The fact that D'Angiviller was one of Aubry's patrons serves to corroborate that moral messages were expected not only from history painting in this era, but from genre painting, too.

TG

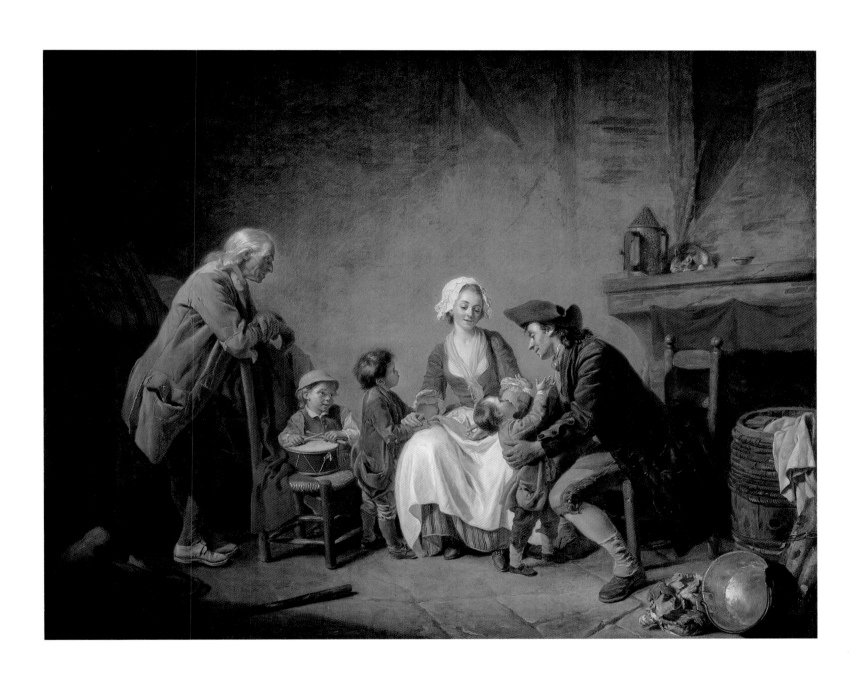

LOUIS-ROLAND TRINQUESSE (c. 1746–c. 1800)

100 *The Music Party* 1774

194 × 133 cm

Alte Pinakothek, Munich

Trinquesse began his studies at the Académie royale in Paris and completed his training in The Hague. After returning to the French capital, he was awarded two medals by the Académie royale, yet despite all his efforts was never admitted to that institution. He exhibited at the Salon de la Correspondance from 1779 to 1787 and at the official Salon in 1791 and 1793. Aside from his better-known genre pictures, which were much inspired by Dutch painting, Trinquesse produced many portraits of a remarkable quality, startling in their realistic depiction and artistic brilliance. The artist's superbly executed red-chalk and charcoal drawings won praise from his contemporaries.

This previously unpublished painting is one of a number of large-format pictures that Trinquesse painted for the aristocracy and a well-to-do bourgeois clientele in the 1770s and 1780s. Almost all were commissions that called for portrayals of individuals in Neo-Classical interiors. In *The Music Party*, however, the artist merged the concert-type picture, heavily influenced by Dutch genre painting, with the intimate and sentimental group portrait of late-eighteenth-century French art. Such artists as Jean Raoux, François de Troy, Jean-Antoine Watteau, and Nicolas Lancret had often embraced this thematic, creating intimate concert scenes akin to *The Music Party*.[1] But Trinquesse's image owes more to the tradition of full-length portraits, of which Jean-Marc Nattier's *Madame Henriette in Court Dress Playing the Bass Viol* is an exemplar.[2]

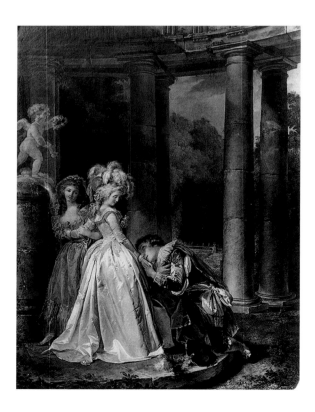

The artist's enthusiasm for his first important commission in Paris is obvious from the extensive group of red-chalk and charcoal drawings, some titled, he made for the individual figures. Many of the studies show the current painting's principals – the young man and the woman seated at centre. The man is captured in various poses: frontal or side view, or even taking a step. His expression is invariably pensive and directed towards someone opposite him.[3] Jean Cailleux has compiled and analyzed the drawings of Louis-Roland Trinquesse:[4] in them, the woman is mainly viewed seated or standing; one study concentrates on rendering her attire, which is considerably simpler in these preliminary drawings than in the final painting; in most of them, she appears to be wearing an unostentatious at-home dress.[5]

The figure is said to be Marianne Franméry, young wife of the composer François Étienne Franméry (1745–1810), perhaps even depicted here as a bride. In the finished work she is shown from the side, seated charmingly on a Louis XVI armchair. The emphasis is on rendering the lustrous white taffeta and ruched trim edging the front of the *manteau* of her *robe à la française*. The actual subject matter – namely, the act of playing a musical duet – is relegated entirely to the background in favour of another, equally popular genre theme, *la visite imprévue* or *le retour de l'amant*. But with a crucial difference: in Rococo art there would almost always be some element of a disreputable tone to the scene, whereas here, in Neo-Classicism, clearly aided by the furnishings, the wall decoration, and the statue in the background, it is the sentimental aspect that comes to the fore. Propriety (*convenance*) is further underscored by the sculpture in a niche: it is *Pudicitia*, described in *Meyers Konversationslexikon* as, "Modesty, personified as a matron or woman who is demurely wrapped in her garment, but who is about to veil herself."[6]

A painting owned privately in Paris, which we know only from a poor reproduction, possibly entitled *The Pledge of Love* (*Le Serment d'amour*, fig. 146), can be regarded as a direct iconographical complement.[7] In the same ambience and with the same characters, a genre scene unfolds: an oath of love is sworn in the presence of a woman-friend (and is thus entirely in keeping with *convenance*). Both themes had been very much in vogue since the publication of Jean-Jacques Rousseau's *La Nouvelle Héloïse* (1761), and may have influenced the artist's thematic choice in these sentimentalized pictures;[8] a third painting features the same threesome (see cat. 101). All three works may have originally been made to decorate the residence of a single client. In these paintings, Trinquesse has created a new type of pictorial work that fuses genre and portrait; they may may also attest to contemporary bourgeois musical taste, as Franméry was an enthusiastic admirer of Niccolò Piccini (1728–1827), then Italy's most celebrated composer (and creator of 150 operas in fifteen years). Piccini went to Paris in 1776 and became one of Christoph Willibald Gluck's fiercest rivals.[9] Franméry and Piccini were thus completely at odds with official court taste, for the Dauphine fervently admired the reformist Gluck.

HS

Fig. 146 Louis-Roland Trinquesse, *The Pledge of Love*, 1786. Musée des Beaux-Arts, Dijon

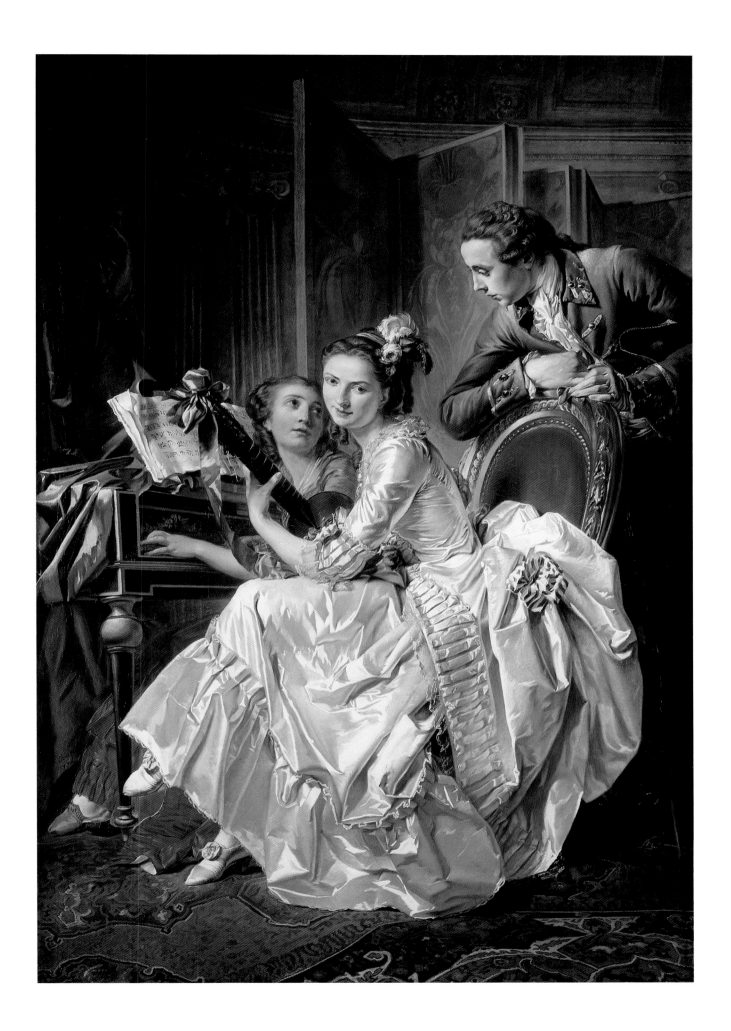

LOUIS-ROLAND TRINQUESSE (c. 1746–c. 1800)

101 *Interior Scene with Two Women and a Gentleman* 1776

96.5 × 122 cm

Maurice Segoura Collection

One of the *petits maîtres* who operated outside the academic establishment during the reign of Louis XVI, Trinquesse was known for his portraits and genre paintings that drew on the tradition of the *tableau de mode*. As a student at the Academy, he won two medals in 1770, but failed to achieve acceptance as an *agréé*, which would have qualified him to exhibit at the Salon.[1] He opted instead to send portraits and genre scenes to the *Salon de la Correspondance*, an independent learned society devoted to the encouragement of arts and sciences, organized by Mammès Claude Pahin de la Blancherie (1752–1811) and supported through subscriptions.[2] During his lifetime, Trinquesse earned a respected position as a portraitist, counting among his patrons such French aristocrats as the Vicomtesse de Laval and the governor of Paris, the Duc de Cossé-Brissac, as well as numerous artists, architects, and men of letters, of whom Trinquesse prepared designs for engraved medallion portraits.[3] In the nineteenth century, Edmond de Goncourt collected Trinquesse's costume drawings (fig. 147), which, ironically, he described in *La Maison d'un Artiste* (1881) as "too academic."[4]

One suspects that it was not a lack of talent but rather Trinquesse's preference for the *tableau de mode* and *sujets galants* that caused his break with the Academy at a time when a taste for the noble principles embodied in Neo-Classicism and history painting predominated among official circles. Such works as *Interior Scene*

privilege everyday life, and owe much to the portrayals of intrigues among the fashionable bourgeoisie by the earlier generation of French artists, such as de Troy, Watteau, and Boucher. But rather than being regressive in outlook, Trinquesse's painting anticipates the highly polished "Metsu Manner" of the genre scenes of Marguerite Gérard and Louis-Léopold Boilly.[5]

With its intimate grouping of figures in a woman's boudoir, *Interior Scene* recalls the views of such dressing rituals as de Troy's *Before the Ball*, 1735 (cat. 27), or Boucher's *Lady Fastening her Garter (La Toilette)*, 1742 (cat. 52). In contrast to de Troy, Trinquesse portrays the scene during daylight, and the presence of the male visitor cannot be explained by his role as escort to a masked ball. While the man may represent a husband or fiancé, a certain coldness, even scepticism, in the woman's demeanor implies she is a courtesan entertaining a client. There is a charming spontaneity of action as she listens while undertaking the intricate task of removing pins from a cushion and pinning them to a hat before leaving her apartment. In typical *toilette* costume, she wears a transparent peignoir over a pink satin dress, with every detail of its folds and texture carefully rendered. On the table before her is a *miroir de toilette*, draped with a luxurious blue fabric and thus hidden from view. A maid stands patiently behind the chair ready to help when needed, though she appears less a servant than shrewd collaborator. The hat is ornamented with ostrich plumes "à la Henri IV," a style popularized by Marie-Antoinette.[6] Furnishings in the apartment are also of the latest fashion, including the Louis XVI style chairs distinguished by their classical design of turned, fluted legs; and a smoking *brûle parfum* – a freestanding incense burner – can be seen to the right. Adding to the mundanity of the scene is an open book on the mantelpiece with fanned pages, beside which stands a vase filled with a fresh flower arrangement.

As a portraitist, Trinquesse would have been attuned to the ability of facial expression to inflect meaning; and those of the models of *Interior Scene* project an unusual suggestiveness. Dramatic tension is created by the knowing exchanges among the protagonists, small gestures that enrich the erotic subtext: the way the male figure leans forward and smiles, the woman's hesitant response, and the maid's furtive eavesdropping. What is being said and why is a matter of conjecture. The female models of *Interior Scene* bear a resemblance to two frequently portrayed by Trinquesse in his costume drawings of the 1770s, Marianne Franméry and Louise-Élisabeth Bain.[7] As fine examples of Trinquesse's images of romantic intrigue, *The Music Party* (cat. 100) and *Interior Scene* both rely on realism and technical brilliance for effect, while sharing the immediacy and individuality of portraits.

JC

Fig. 147 Louis-Roland Trinquesse, *Woman in a Plumed Hat*, c. 1777–79. National Gallery of Canada, Ottawa

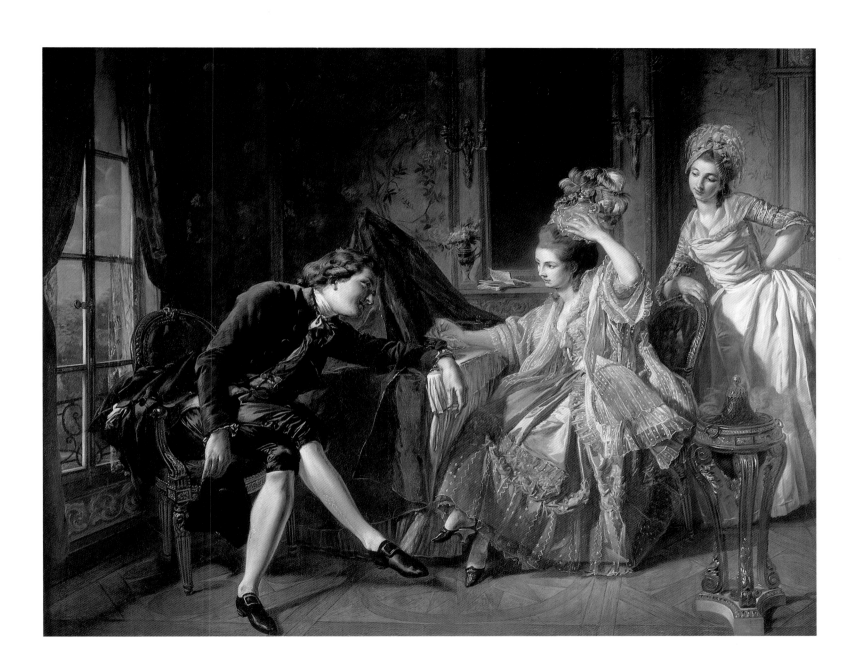

Jacques Sablet (1749–1803)

102 *Blindman's Buff* 1790

104 × 115 cm

Musée Cantonal des Beaux-Arts, Lausanne

In his account of his *Italian Journey*, Goethe wrote enthusiastically about the picturesque life he observed in Naples: "One has only to wander the streets and have eyes in one's head to see the most inimitable scenes. . . . There are still many original entertainments to be enjoyed when one lives among the people; they are so natural that one might well become natural in their company."[1] Jacques Sablet, who worked in Rome from 1775 to 1793 and was in touch with the German colony of artists and academics there, may well have met Goethe.[2] Sablet too observed scenes of simple everyday life in the cities and in the Campagna and recorded what he saw in numerous drawings and paintings. In 1781–82 he and Ducros together published a series of engravings showing street scenes, inns, and processions.[3] Such idealized depictions of the life of the ordinary people, the *popolino*, in the tradition of the *bambocciades* of Lingelbach (fig. 148), Asselijn, and other seventeenth-century Dutch painters were extremely popular among artists and collectors in the last quarter of the eighteenth century. Collections of engravings like the abbé de Saint-Non's *Le Voyage pittoresque ou Description des royaumes de Sicile et de Naples* (1779–86) or Houël's *Le Voyage dans les Isles de Sicile, de Malte et de Lipari* (1788) are typical examples. Sablet was familiar with the poetic *Idylls* (1756) of his friend Salomon Gessner, in which the latter advocated the perfect homogeneity of man and nature; for Sablet, the representation of popular customs and simple mores also served a didactic purpose. In the words of one of his contemporaries, the artist sought to "uplift [the genre of the Flemish school] by his choice of subjects . . . ; he intended each of his pictures to represent a moral action; he endeavoured to express only decent, honest and sentimental passions; he painted people engaged only in innocent games or acts of charity."[4]

Sablet's best-known depiction of an "innocent game" was produced in 1790: *Blindman's Buff* shows a large rural dancing party in the park of a feudal villa, against a background of ornate arcades, terraces, and flights of steps. At the centre of the painting is a young man

fashionably dressed in a red and white ensemble, with a blindfold covering his eyes. Urged on by his friends, he is trying to catch three female dancers. At the far left are two statues that appear to be commenting on the merry-making: Paris handing an apple to the *Venus Medici*, the most beautiful of all the goddesses. Like the hero of antiquity, the "blind" dancer must choose among three beauties. In his portraits and genre paintings, Sablet frequently used columns, sarcophagi, statues, and other classical relicts. Surrounded by enthusiastic connoisseurs like Vien, Reiffenstein, and Percier, he intensively studied the art of the classical period; already in 1781–82 he produced a series of drawings of antiquities he had examined in private collections.[5] In *Blindman's Buff*, the artist depicts an ideal, harmonious society: here the upper classes, for whose amusement the classical ornaments are intended, strolling among arcades; there the originality and naturalness of the country folk.[6]

Sablet exhibited his painting at the Paris Salons of 1796 and 1798, to great acclaim. French art critics were agreed that no other painter was as accomplished in the genre *à l'italienne* as Sablet, displayed as much sensitivity and realism, or the same mastery of colour and light: "In all of his pictures the costumes and the settings are Italian and I know of no other artist who achieves such verisimilitude in painting both the one and the other. . . . Sablet is without doubt one of our finest colourists and I know of no one else who is as skilled in painting light," wrote Amaury-Duval, for instance.[7] This positive response may have helped induce Cardinal Fesch, the most important collector of Sablet's work after Lucien Bonaparte, to buy the picture. Noteworthy from an art-historical perspective is a comparison made by Chaussard. The critic, who described Sablet's painting as "one of the artist's masterpieces," wrote that the artist was "superior to Vateau [*sic*]. Vateau's manner was monotonous and conventional; Sablet's is always brilliant and true to life."[8]

The theme of the game of blindman's buff indeed stands in an iconographic tradition of the Ancien Régime that had its origins at least in part in the *fêtes galantes* of Watteau or Lancret (cat. 12) and Fragonard (cat. 75). Sablet, however, removed the subject from the fantasy world of the French aristocracy to place it in the no less idealized context of the daily life of the Italian *popolino*. As a result, his genre paintings show many similarities with what is known in France as the *genre poissard*, in which the life of the ordinary French city dwellers and country folk was raised to a subject for painting; a look at Jeaurat's *Village Fair* (cat. 44), for example, illustrates this parallel.

MS

Fig. 148 Jan Lingelbach, *Village Scene with Peasants Merrymaking*, 1650–55. Castle Museum and Art Gallery, Nottingham

JACQUES SABLET (1749–1803)

103 *Family Group before a Seaport* c. 1800

65 × 81 cm

The Montreal Museum of Fine Arts

Jacques Sablet enjoyed particular success with the popular, Italian-style street scenes and portraits he painted in Rome and Paris between the French Revolution and the Directoire. This picture of an aristocratic family of five was shown at the annual Paris Salon of 1800, in the newly opened Musée Central; it can be seen in the bottom row on the left in a contemporary view of the Salon by Monsaldy.[1] The image shows a mother and father watching attentively as their son invites his older sister to dance to the music of a violinist. The grandfather too is turned toward the activity in the centre of the picture, though his eyes are closed, the better to listen to the melody of the violin. The scene takes place on a terrace; beyond it in the distance lies a Mediterranean-looking port city, with the outline of a mountain chain rising above. Since the image lacks a middle ground as such, the picturesque view has a scenery-like quality, and the subjects look like actors scattered about a stage. The great distance between the foreground and background is further emphasized by the tiny size of the people on the distant shore.

Sablet has placed the members of the family nearly parallel to the edges of the picture, and distributed them, slightly staggered, across the width of the painting, as in a classical relief or frieze. Although the dancers in the centre are the focal point, the figures nevertheless appear isolated and dispirited in their stiff poses. The violin player in particular exudes a certain melancholy that appears to have settled over the whole group. Before Sablet was forced to flee Rome and return to Paris in 1793 as a result of the anti-French revolts in the ecclesial state, he had indeed frequented artistic circles "in which the subject of melancholy was explored in depth."[2] In much the same way as Sablet's *First Steps of Childhood*, c. 1789–98 (see cat. 87 for Fragonard and Gérard's treatment of the theme), this image too can be read as a coded representation of the three stages of life: to the left stands the aged grandfather, above whose head a dead branch points skyward, while across from him, at far right, stands the violin player,

dressed in black and also symbolizing death, the two of them framing the parents and the young people. In several of his *conversations funèbres* – for example, the *Elegia romana* (fig. 149), a self-portrait of the brothers Jacques and François Sablet at the grave of a friend near the Pyramid of Cestius in Rome – such proto-romantic symbols of death are even more starkly evident.

Attempts have been made to identify both the port city and the people portrayed in the picture. Although the city in question could be, for instance, Palermo or Naples, it is thought that Sablet's subjects were an aristocratic émigré family forced to flee the anti-French uprisings and take refuge in the Kingdom of Sicily, ruled by Ferdinand I of the House of Bourbon. As evidence of this, critics point out that the two older men are still turned out in the style of the Ancien Régime – in wigs, *cravate lâche*, English-style breeches reaching below the knee, and shoes with silver buckles – all of which had fallen out of fashion by the Directoire period. The women, meanwhile, in their short-sleeved, high-waisted pale muslin gowns, as well as the boy and the violin player, are dressed and coiffed in the contemporary fashion.

Inspired by Flemish painters like Van Dyck and especially the English portraitists who were well known in cosmopolitan Rome, French painters from the 1780s onward had increasingly been placing their subjects out-of-doors.[3] Sablet specialized in small-scale portraits of one or more subjects, "against landscape backgrounds or settings that appeal to the eye through their piquant effect; these as well as other larger-scale compositions with figures in the costume of the common Roman people all have the merit of delicate brushwork and pleasing colouring."[4] At the Salon of 1800, however, his painting met with little interest and in a few cases with downright rejection. Critics pointed to the lack of depth in the landscape: "It is a cold composition; the landscape that forms the backdrop is grey and unmodulated, with the result that the figures resemble paper cut-outs."[5] Another critic praised the colouration and the "tasteful execution," but complained that Sablet always followed the same formula: "The subjects are always set against these clear and transparent skies! Surely the painter must become bored with this."[6] As a result, the painting is difficult to categorize from an art-historical viewpoint. Doubtless it still stands in the tradition of the eighteenth-century "conversation pieces," even though Sablet places his family on the stage-like terrace rather than directly in the landscape. Moreover, he has reduced the communicative action to a minimum by setting the figures apart from one another, eliminating anecdotal detail, and downplaying gestures. The melancholy mood thus created, which is further heightened by the Mediterranean light, presages the artistic movements of the nineteenth century.

MS

Fig. 149 Jacques Sablet, *Elegia romana*, 1791. Musée des Beaux-Arts, Brest

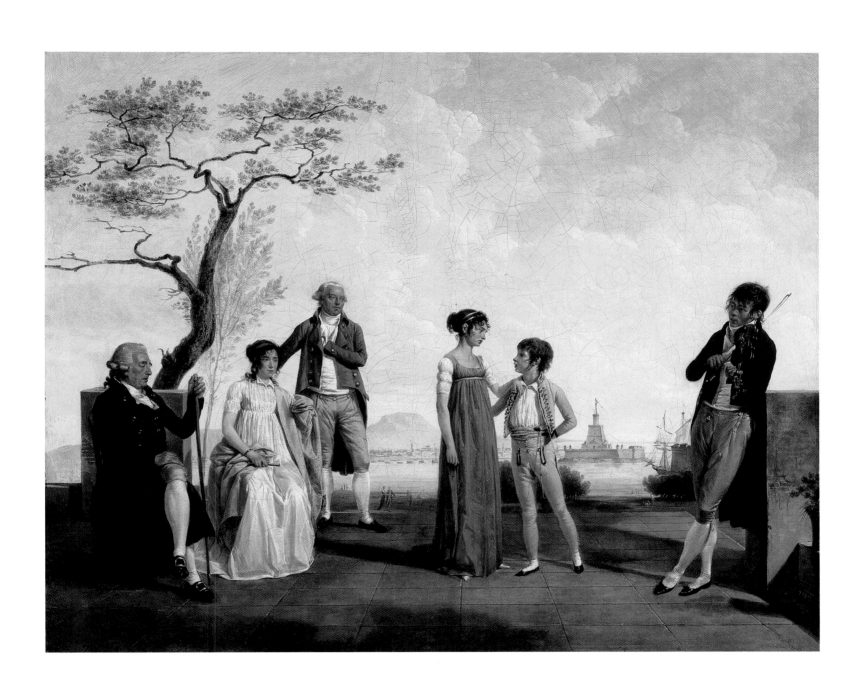

MARTIN DROLLING (1752–1817)

104 *Peasants in a Rustic Interior* c. 1800

66 × 93 cm

Private collection

Eighteenth-century French genre painters rarely chose to depict the misery of the rural population in such a drastic and accusing manner as Martin Drolling did in this image dating from the turn of the century. Long before the Revolution, the scholar Valentin Jamery-Duval (1695–1775), from a humble background himself, had pointed out in his memoirs the great discrepancy between the dire conditions of countryfolk, crushed under the burden of high taxes, and the ideal of gallant life propagated through works of art.[1] In the present work, this playful, courtly perspective has given way to harsh realism. Crude, rough-hewn wooden beams and boards, a dusty floor of clay tiles, and coarse, simple furnishings characterize the meagre dwelling of a family gathered around the cradle of their dying child.

Drolling divides his composition into three starkly defined areas delineated by vertical supporting beams, each showing a separate scene, but linked by the way the light is cast. In the centre, the mother is depicted from behind, bending over a wicker cradle, her garment slipping off her shoulder. A piece of cloth hung over a cord creates a frame for the mother and her sleeping child. Bright light enters the room from a window at the left, clearly emphasizing the fleshtones of the mother's body. In the partial shadow on the floor in front of her lies a sleeping dog. Framed by the wooden arch of the ceiling, the father leans against the table at the left, his hardened gaze fixed on some distant point outside the picture. To the right, the elder son sits on a stool; he rests his left arm on a worn chair and has turned away from his brother with a hopeless gaze.

The subdued colour scheme, reduced to shades of brown and grey, accentuated only by the green in the curtain and the red in the seated boy's vest, illustrates the influence of seventeenth-century Dutch and Flemish paintings on Drolling's palette. He had studied these works during his training at the École des Beaux-Arts and copied them at the Louvre. The peasant milieu is also related to the *bambochades*, but here it is intensified to tragic dimensions unknown in the models of the previous century. The carefully balanced composition also contains forms from the repertoire of historical paintings, thereby adding a touch of grandeur to the family's fate. For example, the mother's gesture of despair resembles that of the young woman in Jacques-Louis David's *Oath of the Horatians*, 1785 (Musée du Louvre, Paris) who, grief-stricken, is leaning over the back of a chair at the right-hand edge of the painting.[2] Also unusual is the introduction of the extremely costly green silk damask into the peasant interior, which draws the viewer's attention to the Mother and Child theme. Here the artist may have included a motif from the Marian iconography, which appears in Raphael's *Sistine Madonna* and later also in Rembrandt's representations of the Holy Family.

The close relationship with the work of Jean-Baptiste Greuze (1725–1805) was signalled early on because of the similarly moralizing subject matter: "He [Drolling] and Greuze share the honour of having ennobled genre painting, of having furthered its aspirations to the moral, the sentimental."[3] In the work under discussion, however, Drolling creates a setting that contrasts with Greuze's dramatic compositions (see fig. 39). He does not render hopelessness by intensifying gestures and facial expressions, but formally, through the strict linearity of the composition and a static, relieflike disposition of the self-contained figures. Their capitulation to inescapable fate is conveyed by the spatial separation of the family members, each suffering in isolation.

Drolling made his reputation as both a portraitist and a genre painter, and exhibited at the Salon from 1793 to 1817. Around 1800 he started to devote himself to rural subjects; however, his work is generally dominated by amusing anecdotes and the detailed description of objects, as illustrated in *Kitchen Interior* of 1798 (Musée des Beaux-Arts, Orléans), which shows a little kitchen-boy playing with a dog.[4] Like his contemporary Louis Boilly (1761–1845), Drolling became known for his naturalistic representation of interiors in which the subject matter is, to some extent, secondary in importance to the individual object. A prime example of this is *The Messenger or "The Good News"* of 1806 (fig. 150), in which, moreover, the narrative takes an optimistic turn, as the title of the work intimates.

The treatment of the themes of despair and poverty and the large format of *Peasants in a Rustic Interior* seem unusual, even exceptional, in the overall context of Drolling's work, about which our current knowledge is no more than fragmentary. Also, the facts surrounding the picture's origins and the person for whom it was intended are still unknown. One cannot help wondering under what circumstances this masterly, yet disturbing depiction of a haggard man and his family in the act of submitting to their fate was exhibited.[5]

JE

Fig. 150 Martin Drolling, *The Messenger or "The Good News,"* 1806. Private collection

HENRI-PIERRE DANLOUX (1753–1809)

105 *The Baron de Besenval in his Salon de Compagnie*

1791

46 × 37 cm

Private collection

Painted in 1791, the seventieth and last year of Besenval's life, Danloux's most accomplished Parisian portrait shows this Swiss aristocrat seated by the fireplace of his elegant *salon de compagnie*, surrounded by pictures and various *objets de luxe*, including a small snuffbox which he holds in his left hand. Besenval's studied calm gives no hint of the recent collapse of the establishment to which he was intimately connected. In July 1789, he had abandoned the Swiss Guards (of which he was Commander-in-Chief), in the face of the insurgents who were storming the Bastille; he had attempted to escape to his native Switzerland, was arrested, and then incarcerated in the Châtelet prison on charges of *lèse-nation*. Acquitted and freed at the end of January 1790, Besenval prudently remained outside of active military and political circles for the rest of the year.[1]

Pierre-Victor de Besenval (14 October 1721–2 June 1791) ("an extremely amiable man, of great wit, even though Swiss" [Madame de Genlis]) came from a noble family whose prominence rested largely on the military achievements of his father, Jean-Victor (1671–1736), who had distinguished himself in the late wars of Louis XIV's reign and served as Extraordinary Ambassador at Warsaw until 1721. There, in 1718, he married Catherine, Countess Bielinska, daughter of a Grand Marshal of Poland and a distant relative of the future Queen Marie Leczinska, who became a protector of Rousseau and Voltaire and a patron of Meissonier.[2]

Having taken up arms at the tender age of nine and a half – he was enlisted as a cadet in the First Company of the First Battalion of the Swiss Guards – Pierre-Victor was awarded the Cross of Saint-Louis at the age of twenty-two; appropriately, it was as a dashing warrior that he was represented by Nattier, in a bravura portrait exhibited at the Salon of 1746.[3] A brigadier by the age of twenty-six, Besenval's military career flourished during the Seven Years War, by the end of which he was made Inspector-General of the Swiss Guards.

Formerly part of Choiseul's circle, in the 1770s Besenval gained the confidence of the new queen, Marie-Antoinette, and in the early years of Louis XVI's reign was considered among the most influential of her favourites.[4] But Besenval was far from aspiring to the role of *éminence grise*. His years in retirement from campaigning were spent largely in Paris (and not Versailles), where from the mid-1760s he resided at the hôtel Chanac de Pompadour on the Rue de Grenelle, designed in 1704 by Pierre-Alexis Delamaire. In 1767 Besenval acquired the property – today the residence of the Swiss Ambassador to France – and in 1782 he commissioned Alexandre Brogniart to add an enormous underground *salle de bains* "in the antique style," decorated with twelve Tuscan columns and with vases, statues, and friezes by Clodion.[5]

As a collector, Besenval achieved a certain fame during his later years. He was elected *Associé-libre* of the Académie royale de peinture et de sculpture in March 1769 (promoted to *Amateur-honoraire* in February 1784); nine years earlier he had rendered that institution a great service by allowing one of the splendid Swiss Guards to quit the regiment and serve as the model for the Academy's life-class.[6] Characteristic of his taste were Monnot's near life-size marble, *Love Firing his Arrows* (acquired in 1769), and Fragonard's *Young Girl Playing with her Dog ("La Gimblette")* (cat. 80), of which he owned an autograph version.[7] But he favoured no style or school exclusively, and in this he was typical of many aristocratic collectors in Paris during the 1770s and 1780s. Thiéry's invaluable *Guide des Amateurs* (both the 1784 and 1787 editions) noted that Besenval's collection was composed "de morceaux choisis des meilleurs maîtres de trois écoles."[8]

In Danloux's portrait, the sitter is portrayed in front of seven cabinet paintings hung against green damask – the material of choice for picture hanging in eighteenth-century France – each of which is reproduced in miniature with great fidelity (even the artists' names seem to be inscribed on the cartouches).[9] Thanks to the scrupulous listing in Thiéry's *Guide* of 1787, it is possible to identify each work, although the eighteenth-century attributions are to be treated with some caution. Reading from left to right (and top to bottom), we see: the oval frame of Maratta's *Leda* (or its pendant, *Danaë*); van de Velde's *Seascape*; Cuyp's *Landscape with Two Horsemen*. The square picture at left in the middle row is one of Polembourg's *Italian Landscapes*; next to it, Teniers' *Rustic Interior*; and to its right, a *Sunset* attributed to Pynacker. Finally, on the bottom row, next to Besenval's head, is Polembourg's *Self-portrait*.[10] On the mantel we see three pieces of pale-blue celadon porcelain in eighteenth-century gilt bronze mounts. The ewer in the middle – a porcelain carp set in a richly scrolled mount – is very similar to a pair of ewers in the Fine Arts Museum of San Francisco.[11]

CBB

HENRI-PIERRE DANLOUX (1753–1809)

106 *Mademoiselle Duthé* 1792

81 × 65 cm

Staatliche Kunsthalle Karlsruhe

The French Revolution at times brought artists and their patrons together by roundabout routes. Certainly this was true of Henri-Pierre Danloux, who painted this portrait of Catherine-Rosalie Gérard, known as Mademoiselle Duthé, in 1792 while in exile in London. Danloux had worked under Lepicié before accompanying Vien to Rome in 1775. He returned to Lyon in 1780, and five years later moved to Paris, where he quickly became much in demand as a portrait painter (see cat. 105). In 1792 Danloux, like many of his aristocratic and royal patrons, was forced to flee France and seek refuge in England. Within the London *émigré* community, the clientele for whom he painted genre scenes and especially portraits was partly the same as it had been in Paris. Mademoiselle Duthé, a former dancer and singer at the Paris Opéra, and said to have been "one of the most famous courtesans of the day in Paris,"[1] frequented the same circles; the Comte d'Artois, the later King Charles X, was one of her lovers. Mademoiselle Duthé had gone to England in October 1786, three years before the outbreak of the Revolution, but when the revolutionary expropriations began, not only did the sums of money she received from her French admirers dry up, but her own property in Paris was confiscated.

Mademoiselle Duthé had already been portrayed by artists like Perrin and Houdon when the picture now in Karlsruhe was created in 1792. Danloux recorded the story of the painting's genesis in the journal he kept during his years in exile. Perrégaux, a Paris banker who did business with émigrés and revolutionaries alike, wished to have a portrait of the object of his affection and referred her to Danloux. "She is to come to be painted as soon as she has recovered from an affliction of the heart from which she is suffering," wrote the artist in his journal.[2] On 2 July 1792, she appeared for the first sitting: "She made an appointment for the small preparatory drawing, and decided to pose in the attitude of a woman hanging a painting representing a *Sacrifice to Friendship* above the sofa in her Boudoir."[3] Three months later the portrait was completed, and a satisfied Danloux noted in his journal that "It is quite handsome, and above all a good likeness of the sitter."[4] The artist had devoted great care to the reproduction of furnishings, accessories, and fabrics, and noted that, as he wished to place the actress against a blue background – "la couleur des blondes" – he had borrowed from a seller of dress goods the lengths of taffeta intended to serve as the curtains and upholstery.[5]

Against the blue-green of the canapé and the curtained alcove, Duthé's white muslin dress fairly glows. The dress is of the same understated elegance as her lilac-trimmed bodice, the delicate scarf about her shoulders, and the light-coloured ribbon in her unbound hair, as was the fashion in 1790. On the desk of fine English marquetry stands a vase, and next to it a statuette of *Threatening Cupid*. The sheets of music on the sofa point to the subject's profession, while the two books are flattering accessories: "It pleases

her to think of herself as a *philosophe sans le savoir*."[6] Contrary to the original idea, the painting she holds in her hands is an allegory not of friendship but of hope: a woman seated in an attitude of melancholy, gazing sorrowfully out to sea and grasping with her left hand an anchor, symbol of hope. Duthé, the actress, may have been alluding to Iphigenia, whose fate she shared: separated from her native land by water and politics. The picture could also contain a hidden allusion to the political hopes of all *émigrés*, a suggestion that is supported by the white of the dress. Of course, the simple gown with its classic elegance is a reference to antiquity – one can compare it to portraits by David, such as that of *Madame Récamier* – but given the subject's social milieu, a monarchist interpretation seems plausible as well, since white was the colour of the Bourbons.

In theme and composition, the painting draws on the motif of the Sacrifice to Love that was popular in the last third of the eighteenth century and that was often used in portraiture as well (see fig. 151). Here Danloux was also following a trend that had been widespread in French genre painting since about 1770, based on seventeenth-century Dutch works. Painters like Boilly (cat. 109), Fragonard (cat. 84), and Marguerite Gérard (cat. 88) enlivened their interiors with narrative elements and sought to show their subjects in motion. This emphasis on the narrative and the temporal was picked up by French portrait painters, with the result that the boundaries between the two genres become fluid. Danloux had made use of his years in exile to familiarize himself with the latest developments by English portraitists. Romney and Reynolds in particular inspired Danloux to portray his models in more spontaneous poses: "I have become very English," he once wrote in his journal.[7]

MS

Fig. 151 Alexander Roslin, *Girl Placing a Garland on the Statue of Amor*, 1785. Musée du Louvre, Paris

MICHEL GARNIER (1753–1819)

107 *In the Artist's Studio* c. 1792–95

58.5 × 73.5 cm

Musée d'Art Moderne, Saint-Étienne

Standing on a carpeted podium in the middle of a studio cluttered with artefacts, casts, and painting utensils, a young woman is posing for an artist. As she playfully holds a guitar, the artist kneels at her feet, facing her, in the act of capturing her image on a large canvas. She wears a shimmering, pale bluish-grey silk gown, and has adorned herself especially for the portrait sitting by putting roses in her décolletage and a white ostrich feather in her hair, as well as pearls. Her gaze is on a fashionably dressed young man in a striking red cape, who sits and observes the artist's work approvingly. Behind him to his left, an older woman in a straw hat is seated, glasses in her hand, glancing up at another young woman, standing there.

Even if the finely interwoven relationships of the figures can no longer be elucidated today – for instance, how should we interpret the looks being exchanged by the older woman and the younger one? – Garnier, in creating the composition, based himself on traditional models in such a way as to guarantee that the contemporary public would easily understand the scene. Art historians are correct in seeing parallels here to the ancient myth of the artist *Apelles* and his model *Campaspe*; however, such parallels are confined to the constellation of the characters. In the story as told by Pliny, Alexander the Great gives his own mistress to his highly esteemed court artist, who had fallen in love with his model;[1] the king retains only her portrait for himself. One can probably rule out a direct correspondence in the case of the current painting. Moreover, it would appear that Garnier was inspired by the large-scale painting *Zeuxis Choosing his Models for the Image of Helen from among the Girls of Crotona* (Musée du Louvre, Paris) by François-André Vincent (1746–1816) when deciding on the placement and depiction of his figures, and for the lines of the composition as well. Vincent's painting was exhibited at the Salon in 1789 at a time when Garnier, after experimenting with portraits, was turning to genre painting.

The present studio scene is a notable example of the way genre painters frequently borrowed familiar themes from ancient history and gave them a contemporary look. It also demonstrates that genre scenes were only seemingly painted from nature; in actuality, they were extremely well thought out, and often composed according to the rules of history painting. The stage-like foreground is a floor covered with Versailles parquet, on which Garnier arranges his figures, like a relief, in a classical triangular composition that is slightly offset to the left and culminates in the plaster cast of the *Apollo Belvedere*. A similar example of an artist transposing the designs of historical paintings into his *tableaux de mode* can also be found in the early eighteenth century in the works of Jean-François de Troy (1679–1752), such as *The Declaration of Love* (cat. 26). In our scene it is the arms that hold the composition together; the outstretched arm of the statue and that of the person commissioning the painting, both shown in profile, and the arms of the model and of the artist form a rhythmic arrangement of vertical and horizontal lines. Thematically, the fact that the client, the artist, and the muse are making the same gesture as Apollo, the god of the fine arts and Lord of the Muses, can give rise to numerous intellectual associations in the mind of the educated viewer. On the other hand, a glove slowly slipping off a footstool and the raised right foot of the painter, who seems about to lose his slipper, emphasize the transitory nature of the scene, and are intended to draw our attention away from the effort the artist has made in creating the picture.

It was thanks to his position as the court painter of the Duc de Chartres (1747–1793), the future Philippe-Egalité, that Garnier was accepted as a pupil by the historical painter and Premier peintre du roi, Jean-Baptiste-Marie Pierre (1714–1789), although he himself had not had any academic training. Not until 1793, that is, after the Salon had been opened up in 1791 to artists who were not members of the Academy, was Garnier able to exhibit his genre paintings there.[2] His dramatis personae in these scenes are drawn from aristocratic or upper-class circles. Garnier is always *à la mode* and he documents the changes in styles of dress and interior decor from the end of the Ancien Régime up to the Empire.[3] This enables us to understand the social connotations, but also to date his works – in this case, the fashion points to around 1792–95. Garnier was strongly influenced in his fine-painting technique not only by seventeenth-century Dutch genre, but also by his contemporaries Louis-Léopold Boilly (1761–1845) and Marguerite Gérard (1761–1837). Indeed, for a long time *In the Artist's Studio* was attributed to Gérard.

Garnier's gallant, slightly erotic, not highly moralizing, and never socio-critical themes, and his clear accentuation of fashionable accessories, carried the *tableau de mode* into the chaos of the Revolution. However, he encountered the harsh criticism that condemned this type of painting as "smutty jokes in the French style that do not even have the quality of art," and, in view of the intellectual, political, and social upheaval of the times, as anachronistic: "Those subjects were once in vogue, as can be seen in Diderot's description of the Salon of 1765. It seems to me that tastes have changed a lot on this point, and for that I congratulate my compatriots."[4] In an era in which it was demanded that even genre painting should convey moral and republican values, an image that was devoted entirely to fashion, such as *The Artist in his Studio*, was considered as *démodé* and already obsolete.[5]

JE

LOUIS-LÉOPOLD BOILLY (1761–1845)

108 *Woman Showing her Portrait* c. 1790

45.7 × 54.5 cm

The Michael L. Rosenberg Collection, Dallas, Texas

The nineteenth-century title of this painting, *Woman Showing her Portrait*, is less misleading than the recent *A Family Admiring a Portrait of a Lady in an Interior*, since nothing in the scene necessarily identifies the characters as members of a family.[3] More radically, Dr. Babin has proposed identifying the painting with the long-lost *The Four Ages of Life, or the Moralist* (*Les quatres âges de la vie, ou Le moraliste*), one of the subjects invented by Alexander Tulle, Marquis de Villefranche, and commissioned from Boilly for his friend Calvet de Lapalun, an Avignon lawyer and art collector.[4] This title, unfortunately without a description of the scene but dated 1790, figured as no. 3 in Calvet de Lapalun's inventory of eleven paintings by Boilly that he acquired through gifts or commissions between 1789 and 1792.[5] There is much to support this thesis and we accept it provisionally, though questions remain.[6]

The focus of the scene is an appreciation of the young woman's beauty, which is captured in the portrait she points to and holds. The gentleman peering at her through a pince-nez enacts the evaluation, squinting in an unattractive way that makes him less like a lover than a connoisseur. He is presumably the Moralist, taking into account the masculine designation of this variably gendered French term, who will pass judgement: will she, or the portrait, pass the test?[7] The ephemeral nature of her beauty is accentuated by the other characters, especially the old woman and child to whom she presents the portrait. Of the "four ages," they represent the extremes of childhood and old age. It is less clear which of the remaining three characters (or four, including the subject of the portrait) represent youth and maturity.

The subject is thematically linked to Boilly's pendants in the Wallace Collection, London. Their subjects were also invented by the Marquis de Villefranche and appear as numbers 2 and 4 in Calvet de Lapalun's inventory.[8] *The Sorrows of Love*, 1790 (no. 4), spells out the

consequences of failing the test of beauty when a gentleman's servant returns a lady's portrait, signalling the end of the affair (fig. 152). In *The Visit Returned*, 1789, a lady effectively brings her portrait to life when she pays an unexpected visit to her lover and finds him writing to her under the inspiration of her painted likeness. The portrait travels between lovers as a vehicle of communication, rather like the *billet doux* of the period, although the image made claims to being a surrogate presence. Boilly, a skilled portraitist, often accorded portraits a narrative role in his *galant* scenes: delivered, returned, admired, hidden, and crushed, they virtually suffer the travails of a character. This is especially true of portraits of women, which are physically larger objects – like these bust-length oval canvases – than the miniatures of men he represented in other paintings.[9]

The portrait has a common role in these three paintings, as a barometer of romance, although the same object is not depicted in all of them: the oval portraits were adjusted to match the lady's different costume and orientation in each scene, as if responding to her presence in the room. The paintings form a loosely structured thematic group along with a fourth, *The Visit Received*, 1789 (Musée Sandelin, Saint-Omer), a subject invented by Boilly and bought by the Marquis de Villefranche, which was no. 1 in his friend's inventory. The group can be flexibly ordered into narrative or chronological sequences, subdivided into pendants or a trio and individual painting, or increased by the addition of other scenes. Such flexibility accommodated patronage practices of the period.

It would also have accommodated other interpretations of this intriguing subject, such as a political one that has been proposed. According to this reading, the oval portrait represents the old woman in her youth and symbolizes the Ancien Régime. The sympathetic portrayal of the old woman in the painting suggests that the Moralist, who compares the two women, prefers the old one, or Ancien Régime, to the young one, or new order.[10] This interpretation depends upon a projection of the patron's known royalist political sympathies at the time of the French Revolution.

If the painting is *The Four Ages of Life, or the Moralist*, Prince Nikolai Borisovich Yusupov would have acquired it from Calvet de Lapalun's estate, a speculation based upon his apparent acquisition of other works from the same collection, rather than directly from the artist in 1789, as previously supposed.[11] Yusupov owned nine paintings by Boilly. As Heinrich von Reimers remarked à propos of three Boilly paintings in Yusupov's collection in 1805, "Boilly is nowadays the fashionable French artist; his brush is full of expression and truth, good colour, the work is very finished."[12] Yusupov may well have acquired his remaining Boilly paintings in 1806–10 when he returned to Paris and concentrated on building up his collection (see cat. 113).[13]

ss

Fig. 152 Louis-Léopold Boilly, *The Sorrows of Love*, 1790. The Wallace Collection, London

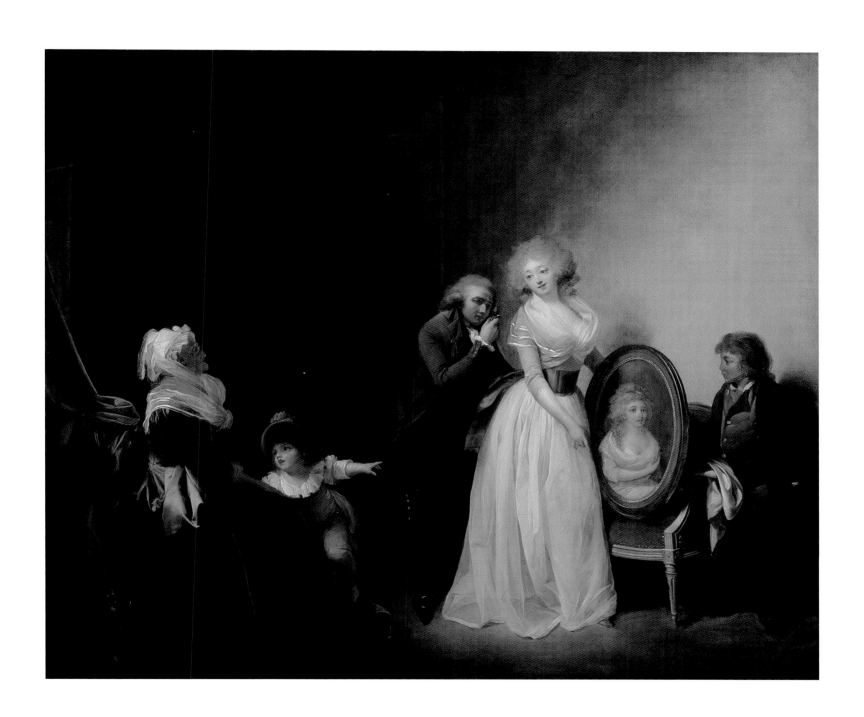

LOUIS-LÉOPOLD BOILLY (1761–1845)

109 *The Electric Spark* c. 1791

46.1 × 55.3 cm

Virginia Museum of Fine Arts, Richmond

An inventive *galant* subject, *The Electric Spark* combined themes of romance, alchemy, and popular science in an original way. The scene shows a pair of lovers who have come to an alchemist's studio to have an "experience of electricity," as this subject was once called.[2] They lean forward, careful not to overstep a magic circle inscribed on the floor, as the young man guides his lady's arm forward to touch the tip of Cupid's arrow. She will receive an electric spark from this point of contact with the statue, which is attached to an electric plate generator that is operated by an alchemist. Electricity was believed to have magical properties at the time, ranging from healing to stimulating fertility; in this case, the experience has been sought as an aphrodisiac, symbolically conveyed by Aphrodite's son Cupid.

The painting focuses on the young lady's experience of love's spark. The smoking fire in the brazier behind her, which makes her white dress and pale skin loom out of the nighttime shadows, dramatically lights her. Her face is the most expressive one in the picture, with staring eyes and parted lips that betray excitement and trepidation. This treatment of the woman as the emotive centrepiece is typical of Boilly's work, as seen in other night pieces such as *The Improvised Concert* (fig. 153) and *The Prelude to Nina* (The State Hermitage Museum, Saint Petersburg). In contrast to the musical pretext of those flirtations, which was a conventional idea, Boilly transposed the couple in the *Electric Spark* to an exotic setting, an alchemist's laboratory, which opened up certain narrative and thematic possibilities.

He contrasted the young couple with an old one and played the anticipation of love against its frustrations. The young man and a dog in the foreground fix their eyes on Cupid and wait to see what will happen when the spark flies. But the old alchemist has his eyes on the young lady, as we do, voyeuristically watching her thrill to the

electric surge produced by his turning the crank, which must have been understood at the time as a surrogate for orgasm. Meanwhile, the alchemist's wife looks at him, frowning and preparing to drink from a beaker that one assumes has been filled at the still in the background. Liquor is the old woman's palliative for the loss of love, just as mechanically assisted voyeurism is her husband's substitute for the real thing. The young apprentice in the background rounds off this thematic of age by remaining oblivious to the follies of the adult world. This moralizing reflection on age was an elaboration by Boilly, since the old woman and young boy do not appear in his preparatory drawing (Virginia Museum of Fine Arts, Richmond) or in the other painted version of this subject (private collection, Paris).[3]

The magical atmosphere of alchemy is conveyed by the "night effect," as Boilly originally described this scene, and also by incongruities such as the presence of chic pieces of furniture and a well-dressed couple in a humble laboratory.[4] The setting was pure fiction, an imaginary stage-set one step removed from the electrical experiences that could be had for a song on the Boulevard du Temple as part of the regular street fair of pseudo-scientific entertainments:

> From one end to the other were crowded tight-rope walkers, fortune-tellers, astrologers and astronomers, physicians in the open air, making electrical machines turn and giving people a shock for two pennies, showing *chambres noirs* or miraculous telescopes that let one see perfectly any object placed at their extremity, even when they were blocked by a hat or a board.[5]

These "scientific mountebanks," as Victor Fournel called them in his well-read books on French literature and history, were part and parcel of the popularization of scientific discoveries in the Age of Enlightenment. Boilly capitalized on the interest in such subjects by exhibiting *The Electric Spark* at the Salon de la Jeunesse in 1791.[6] He emphasized the charlatanism of modern science over and above its claims to rationality, which other artists stressed.[7] He situated a new-fangled electrical contraption in an alchemist's laboratory, the traditional setting of the scholar-fool, where it was predictably put to dubious use. The alchemist encourages love's false hopes with his electrified Cupid, in much the same way that he searched fruitlessly for the philosopher's stone that would transform base metals into gold and provide the key to health, youth, and immortality.[8]

SS

Fig. 153 Louis-Léopold Boilly, *The Improvised Concert*, 1790. Musée Sandelin, Saint-Omer

Louis-Léopold Boilly (1761–1845)

110 *The Painter in her Studio* 1796

49.9 × 60.5 cm

Staatliches Museum Schwerin

The Painter in her Studio, exhibited at the Salon of 1796, took Boilly's treatment of this favourite subject in new directions. He reversed the gender roles traditionally assigned artist and model by depicting a woman artist studying a male model. The professionalism of the woman's status is underscored by the representation of her doing serious work, surrounded by the paraphernalia of studio equipment. A little boy seated before her is the object of visual delectation – both women in the painting look at him, as we do – and he also assumes the female role of looking out and engaging the viewer (see cat. 111). The woman artist is also the object of our gaze, however. Beautifully lit from above, she dominates the scene in her flowing white dress; and her absorption in her work leaves the viewer free to look her over. Her status as an object of the gaze is delineated by the blank canvas behind her, which frames her head and shoulders as though she, and not the child, were the subject of a portrait. Through this clever juxtaposition Boilly recalled his presence as the male artist who was in fact in control of this fiction.

The painting depicts the making of a portrait, which Boilly illustrated by reference to his own work. The boy model is related to a portrait drawing of one of his sons (fig. 154), which he adapted to this genre subject: the poses are similar but not identical, and the facial features have been generalized.[1] The borrowing indicates the free use that he made of preparatory drawings for other works in his imaginative subjects, as if he had pulled the sheet out of one of the portfolios depicted in this studio. We are invited to compare the woman's sketch with her model, since her drawing is clearly visible, and the square and callipers resting on the stool in the foreground may allude to the accuracy of her imitation. The painting's original title drew attention to the portrait process: *The Interior of a Painter's Studio. A Seated Woman Draws the Portrait of a Child.*[2] An accomplished portraitist, Boilly treated portraiture as a genre subject in other works as well, such as his genre-portrait of Houdon sculpting Laplace (Musée des Arts Décoratifs, Paris) and scenes that represent the social uses made of portraits (see cat. 108).

The sedate tone of the painting departed from the flirtatious studio scenes he produced in the 1780s, doubtless in response to the changed circumstances of artists after the French Revolution. In this respect Boilly demonstrated a certain sympathy with the situation of women artists, which was analogous to his own, or perhaps used the figure of the woman artist in *The Painter in her Studio* as a way of referring to his own situation. Like most women artists and like many other genre painters, Boilly had been prevented from exhibiting at the state-sponsored exhibitions held in the Louvre before 1791 because he was not a member of the Royal Academy of Painting and Sculpture. And like these artists, he took advantage of the new opportunities for public exhibition that opened up in the 1790s when restrictions on exhibitors were lifted. The sharp increase in the number of women presenting at the Salon drew comment from critics, especially those against the trend, which indicates that women artists became the figurehead of a broader democratic tendency. Boilly's showing of this painting at the Salon was another manifestation of that change, and the picture commented on it through its subject matter as well, at the level of its manifest content. At the same time, by representing a woman drawing the portrait of a child, rather than painting or drawing an imaginative subject, he conformed to prejudices about the media and subjects deemed appropriate for women artists.

It is not known how *The Painter in her Studio* came into the hands of the French government by 1815, if the traditional report of its provenance is believed. The painting was apparently sent to Schwerin as part of the reparations for artworks confiscated by Napoleon: "According to the verbal testimony of Prosch, it first entered the collection [of the Duke of Mecklenburg-Schwerin] in 1815, sent there from Paris by mistake instead of a picture that had earlier been taken from Ludwigslust [*sic*: Schwerin Castle]."[3]

Boilly evidently executed a study for this composition.[4] One copy of *The Painter in her Studio* is known (Minneapolis art market, 2002), which may possibly have been made in view of an engraving by J.F. Cazenave entitled *L'Étude du Dessin* (Bibliothèque nationale, Paris).[5]

SS

Fig. 154 Louis-Léopold Boilly, *Portrait of One of the Sons of the Artist.* Location unknown

344

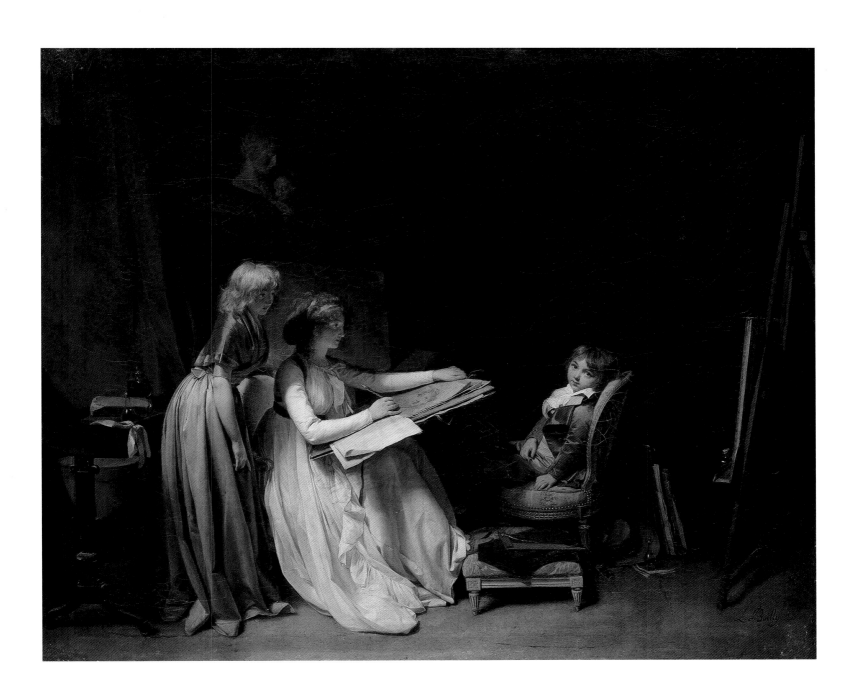

LOUIS-LÉOPOLD BOILLY (1761–1845)

III *Young Woman Ironing* c. 1800–03

40.7 × 32.4 cm

The Museum of Fine Arts, Boston

Young Woman Ironing is the type of intimate, mildly erotic picture for which Boilly was noted. He brought these to a high degree of sophistication in the aftermath of the French Revolution, in the context of new strictures on morality. *Young Woman Ironing* is closely related to a somewhat larger painting he exhibited at the Salon of 1800, *A Woman Seated near a Stove, Occupied with her Housework* (fig. 155), which can be tentatively identified with a painting formerly known as *La cuisinière*.[2] Both works place an unusual emphasis on their surroundings, in which an abundance of objects vies with the women for attention. The calculated arrangement of articles around the woman ironing introduces us to her work: a glass dampening bottle rests on the chair beside her; a stove with its red-hot coals sits on a table, a pair of tongs below, heating the irons so hot she must wrap them to hold them; and bolts of cloth (and undergarments?) are stacked on the table before her. The subtlety of Boilly's observations of textures and the virtuosity of his technique are on display in the painting as much as its ostensible subject: for example, the translucency of the fine muslin she works on is caught in the fire's glow.

The refinement of some items, such as the scalloped porcelain bowl, crimson satin drape, and pile of striped silks, introduces a note of luxury that seems at odds with the activity of manual domestic labour. This discrepancy bothered one critic who reviewed the related kitchen scene: "The young girl is placed with too much studied elegance and taste for her state."[3] The exquisiteness of Boilly's descriptions and of certain objects in the scene obscured the social status of these women. It still remains unclear whether they were housewives, servants or, in the case of the *repasseuse*, someone who took in piecework.[4] Boilly's other scenes of working women are characterized by the same social ambiguity and refinements.[5] This was part of a broader trend toward prettifying the representation of work, evident in Bouchardon's prints of street vendors, and which Boilly accentuated, as compared with the earlier kitchen scenes of Chardin, Greuze, and Aubry.[6]

The tidiness and serious propriety of the woman ironing undercuts her availability as a sexual object. Laundresses were notorious for their sexual favours, being obliged by wretched conditions of work to supplement their income with occasional prostitution, and were represented as morally loose in prints, paintings, and novels of the period. The woman in Boilly's painting looks out at the viewer, but her gaze is difficult to interpret: is she flirting, as suggested by her décolleté, or simply distracted from her work, as suggested by her slightly averted, blank eyes? The viewer cannot be certain that she has engaged his or her attention. The teasing uncertainty of her status and her attitude contributes to the intriguing qualities of the painting. Either way, by offering herself to our gaze the woman becomes an object of delectation, equivalent to the still-lifes that surround her. The eroticism hovering over her has been largely displaced onto the textures and shapes of the objects – onto the suggestive juxtaposition of clear liquids and fiery heat, for example, or onto the insistent repetition of the rounded forms and openings of pots, pitchers, and bottles. It is as if Boilly diffused the sexual symbolism that was once more explicitly coded in the emblematic objects of seventeenth-century Dutch genre painting into the sensuality of material description.

Boilly often executed highly finished drawings after subjects like this one, possibly in preparation for engravings, though none after this work is known.[7]

SS

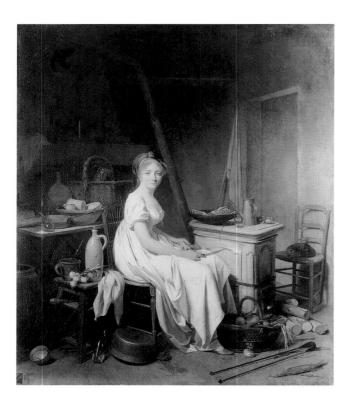

Fig. 155 Louis-Léopold Boilly, *A Woman Seated near a Stove, Occupied with her Housework*. Location unknown

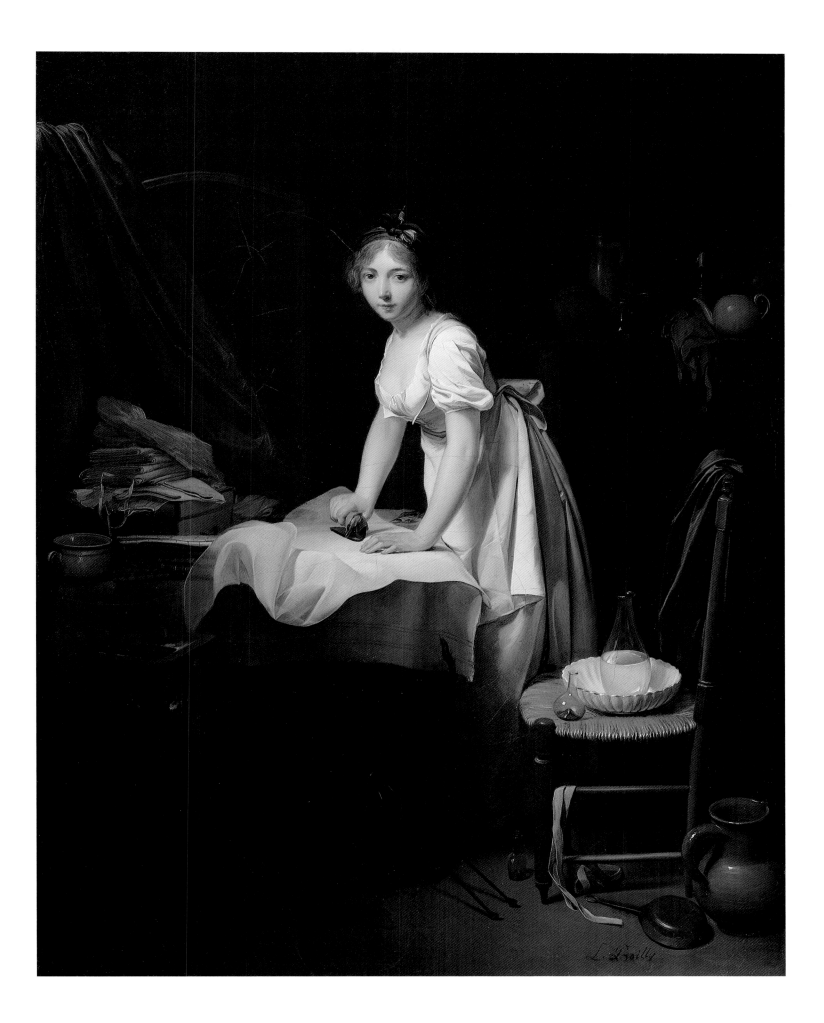

LOUIS-LÉOPOLD BOILLY (1761–1845)

112 *The Cardsharp on the Boulevard* 1806

24 × 33 cm

National Gallery of Art, Washington, D.C.

Boilly exhibited the *Cardsharp on the Boulevard* at the Salon of 1808, along with its pendant *The Little Savoyards Showing a Marmot* (fig. 156). The paintings are remarkable for their small scale and high degree of finish, and recall coloured engravings such as Louis Philibert Debucourt's scenes of the promenading public.[1] The close relation between printmaking and genre painting is further attested to by Édouard Wattier's lithograph of *Cardsharp on the Boulevard* (1822), which replicated it almost exactly in size;[2] but lithographs lacked the colour of eighteenth-century genre prints. The small format of Boilly's paintings showed off his virtuoso oil technique to advantage, perhaps in a calculated appeal to connoisseurs. None came forward in 1808, however. The artist took advantage of a retrospective exhibition of French painting organized to greet the returning Bourbon monarchy in 1814 by re-exhibiting his pendants at the Salon. They must have been bought from that exhibition by the Duchesse de Berry, a returning *émigrée*, who built up a collection of modern French pictures, especially genre paintings, through purchases made from the Salons.[3]

Boilly reconnected with a rich eighteenth-century tradition of images of Paris in these works, yet they also mark a transition toward nineteenth-century notions of the city. The painter Féréol Bonnemaison, who catalogued the Duchesse de Berry's collection in 1822, understood them as groundbreaking in their modern outlook.[4] Boilly's paintings departed from the caricatural element in Debucourt through the realism of their descriptions, and his close-up, fragmentary view of the crowd was also quite new. He devised a pictorial format that approximated the pedestrian's view of the street, a compressed, shallow frieze of figures that is cropped at the sides.[5] The flattened space creates a sense of being close in to the crowd, not enveloped by it, as in Gabriel de Saint-Aubin's paintings of the boulevard, or distanced from it, like the outside observer posited by many eighteenth-century views. The pedestrian's vantage point had already been represented in literature by writers such as Louis

Sébastien Mercier, in his influential *Tableau de Paris* (1781–89) and *Le Nouveau Paris* (1798).[6] Mercier set his narrator in motion and made him pause from time to time to contemplate a *tableau*, or morally enlightening scene of human activity. This was a distinctively French idea, with roots in Greuze's genre paintings and Diderot's dramas. Boilly's street scenes can be understood as visual equivalents of Mercier's urban *tableaux*.

Boilly picked up on the moral conventions of eighteenth-century urban genre painting and literature by bringing out a contrast of social classes on the boulevard. He redeployed a number of figures from earlier paintings to create this mix, and some may have retained their previous connotations.[7] Boilly derived the cardsharp from his figure of the speculator, who symbolized the fraud and deception of the Directory period. The proper gentleman at left was based on his portrait of Christophe-Philippe Oberkampf, a successful textile manufacturer, whom he recast as a generic embodiment of bourgeois morality and order. Boilly contrasted this stolid, black-clad pillar of respectability to the twisting figure of the shyster, and built his two main figure groups around that opposition. It underscored a familiar moral about the gullibility of human nature, regardless of social class.[8] The women and children, who enter into the cardsharp's tricks, represent the naivety of the common people clustering around him. The smartly dressed gentleman and lady keep their distance from this vulgar entertainment, but there is an implication that the gentleman is just as easy to fleece: the poor boy behind him appears to be picking his pocket; and it has even been suggested, less credibly perhaps but indicative of this moral convention, that the fashionable lady is a courtesan who attracts him.[9]

More topical political and social references may have overlaid these conventional topoi. The popular audience watching an *escamoteur* in Marlet's lithograph of the 1820s was seen in much the same way that Bonnemaison described Boilly's crowd in 1822, through the lens of analogy with the rich, who were evoked as equally gullible in their own way:

> Worldly people pass disdainfully by this circle where all eyes are ardently fixed on the magic goblet and fail to notice, when they raise their shoulders in pity, that the same attraction has conducted them a thousand times to the conjuror (*l'escamoteur*) Olivier, to the physician Comte, where the result of the same phenomena is simply disguised under a great elegance of forms.[10]

Just as the little people could be seen to represent the foibles of the rich, so the conjuror could be taken as a figure of high-level financial and political deception. The commentators of Marlet expanded their definition of *escamoteurs* to include famous swindlers such as Scot, who introduced credit to France, and "the conqueror [Napoleon], who suppressed even the appearance of our liberties."[11]

SS

Fig. 156 Louis-Léopold Boilly, *The Little Savoyards Showing a Marmot*, 1807. Private collection

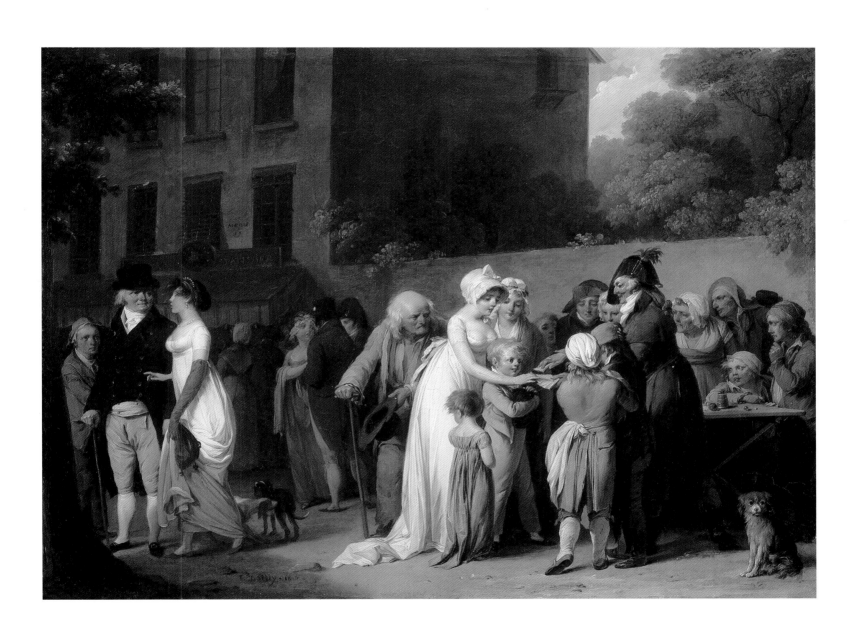

LOUIS-LÉOPOLD BOILLY (1761–1845)

113 *The Game of Billiards* 1807

56 × 81 cm

The State Hermitage Museum, Saint Petersburg

The Game of Billiards has become Boilly's most celebrated genre painting. It presents a highly complex picture of urban sociability in the early nineteenth century. While it belonged to the broader exploration of different forms of urban leisure that genre painters had begun to represent in the eighteenth century, the subject Boilly chose – a mixed game of billiards – is extremely rare in art.

The Game of Billiards is a disarmingly racy painting. A family element is emphasized through the presence of mob-capped nursemaids, young and old people and pets, and a noisy informality pervades the room, as casual conversations take place and children play. But the sexual innuendoes are also very strong, beginning with the woman taking the shot whose curvy buttock and breast are outlined by her clinging Empire dress. Flooded with light, she is the sensational, eye-catching centre of the composition and leads us in, as it were, from the rear. The effect was highly calculated, since Boilly changed her pose from an earlier profile view to this rear angle. Flirtations crop up everywhere. The nursemaid looking up at us from the corner, eerily lit from below, seems to suggest that the goings-on are less innocent than they appear.

The type of billiard room depicted is uncertain, owing largely to the mixed company portrayed. It does not appear to be a commercial establishment of the type illustrated in odd images and billiard manuals of the period, which were frequented by men.[1] These stark environments were filled only with equipment such as cue racks, scoreboards, and rules of the game, and had none of the homey touches of Boilly's setting, such as wall paintings and a refreshment table. He subdued the masculine associations of the decor when modifying his first sketch, by replacing hunting scenes with land- and seascapes, shifting a rack of billiard cues to an obscure position, and eliminating a hanging lamp.[2] On the other hand, there are too many people in his scene (with some wearing hats) for it to be a private residence, as is traditionally supposed.[3] More likely Boilly evoked the type of commercial establishment that welcomed women and children, such as lemonade parlors that had billiard rooms.[4] Certain male establishments also reserved "ladies' nights" for mixed card games and dancing, which may have provided the setting for Boilly's later variant of this subject and its pendant, *The Game of Cards* (1827 or 1828, private collection).[5] The evidence that respectable women (not prostitutes, as recently assumed)[6] socialized in these kinds of bourgeois leisure establishments flies in the face of received wisdom about middle-class women being confined to the home in the male-dominated public spaces of the modern metropolis.

The Game of Billiards was a key acquisition of the Russian prince and former diplomat Nikolai Borisovitch Yusupov (1751–1831) from the Salon of 1808, as recorded in the following receipt:

> I sold one of my paintings depicting a Game of Billiards, which is currently in the Salon, to Prince Youssoupoff [*sic*] for the sum of 2700 *livres*, of which I received 1200 livres in payment. When [the bankers] monsieurs Perigaux and Lafitte send for the painting they will pay me the remainder, that is, 1500 *livres*. 3 November 1808. Le Boilly.[7]

Yusupov was a great admirer of Boilly's work, apparently attracted by its erotic undertones and contemporary subject matter. He already owned several paintings by Boilly (see cat. 108) and listed him, along with Taunay (one of only two genre painters in the Institut de France), Demarne, and Vigée-Lebrun, as artists he wished to patronize during his 1806–10 visit to Paris.[8] He acquired major works by all of them and other artists besides, and gave commissions to the leading history painters in a concerted effort to build up a collection of modern French pictures. *The Game of Billiards* was installed in a privileged location, the Salon of Psyche, at Archangelskoe, Yusupov's pleasure-palace near Moscow that he purchased in 1810, and where until 1837 it formed part of an ensemble with Canova's *Cupid and Psyche*, David's *Sappho and Phaon*, Guérin's *Aurora and Cephalus* and *Iris and Morpheus*, and paintings by Prud'hon, Van Gorp, Demarne, and Kobelya.[9]

The popularity of the subject is indicated by two early copies of the painting (Chrysler Museum, Norfolk, Virginia, and unknown collection).[10] It is surprising that no oil studies for the painting survive, as they do for Boilly's other elaborate genre scenes, but he evidently did the preparatory work on paper. He studied the disposition of the figures and the dark atmosphere of the room,

Fig. 157 Louis-Léopold Boilly, *Study for the Game of Billiards*. Location unknown

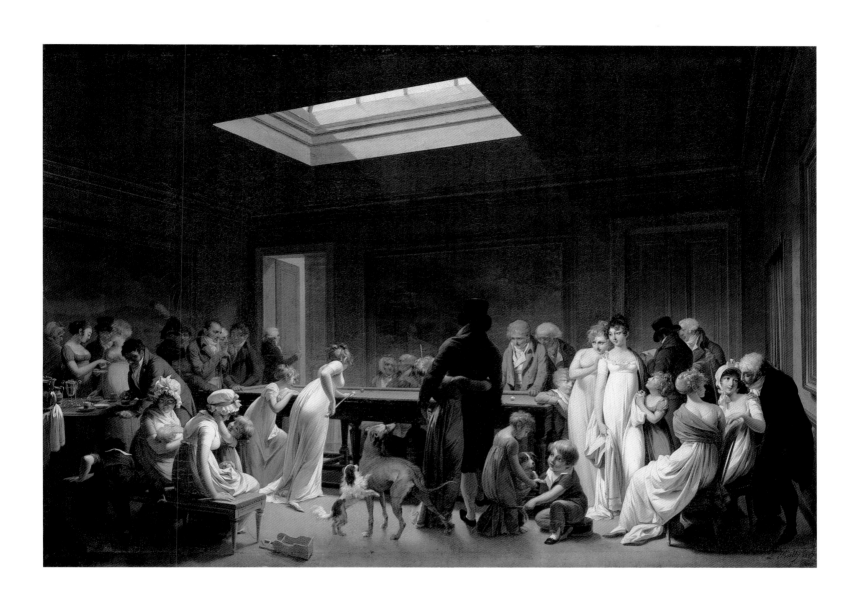

dramatically lit by a skylight, in a large black wash drawing of
the whole composition (fig. 157).[11] Following his additive approach
to composition, this drawing pulled together the figures that
were studied individually or in groups, for which five drawings
are known.[12]

SS

Fig. 158 Louis-Léopold Boilly, *Studies of a Mother and Children.*
Private collection

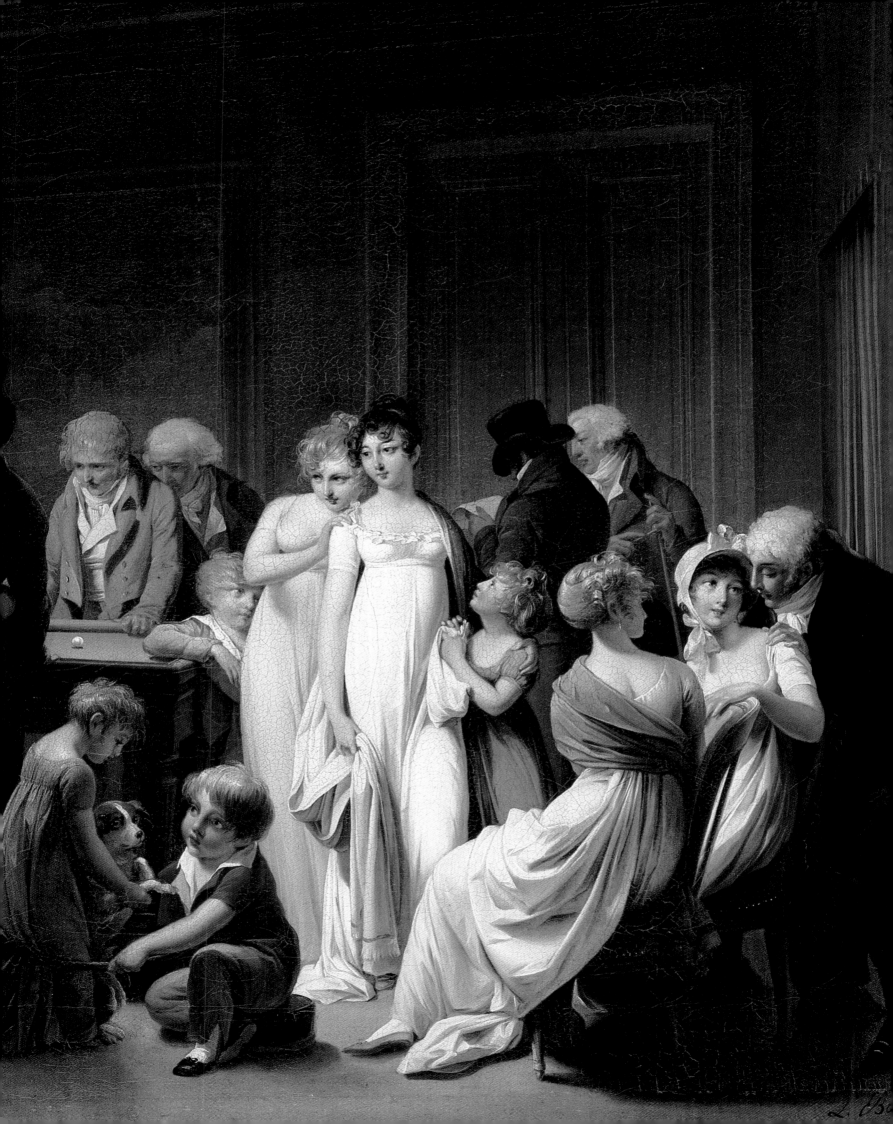

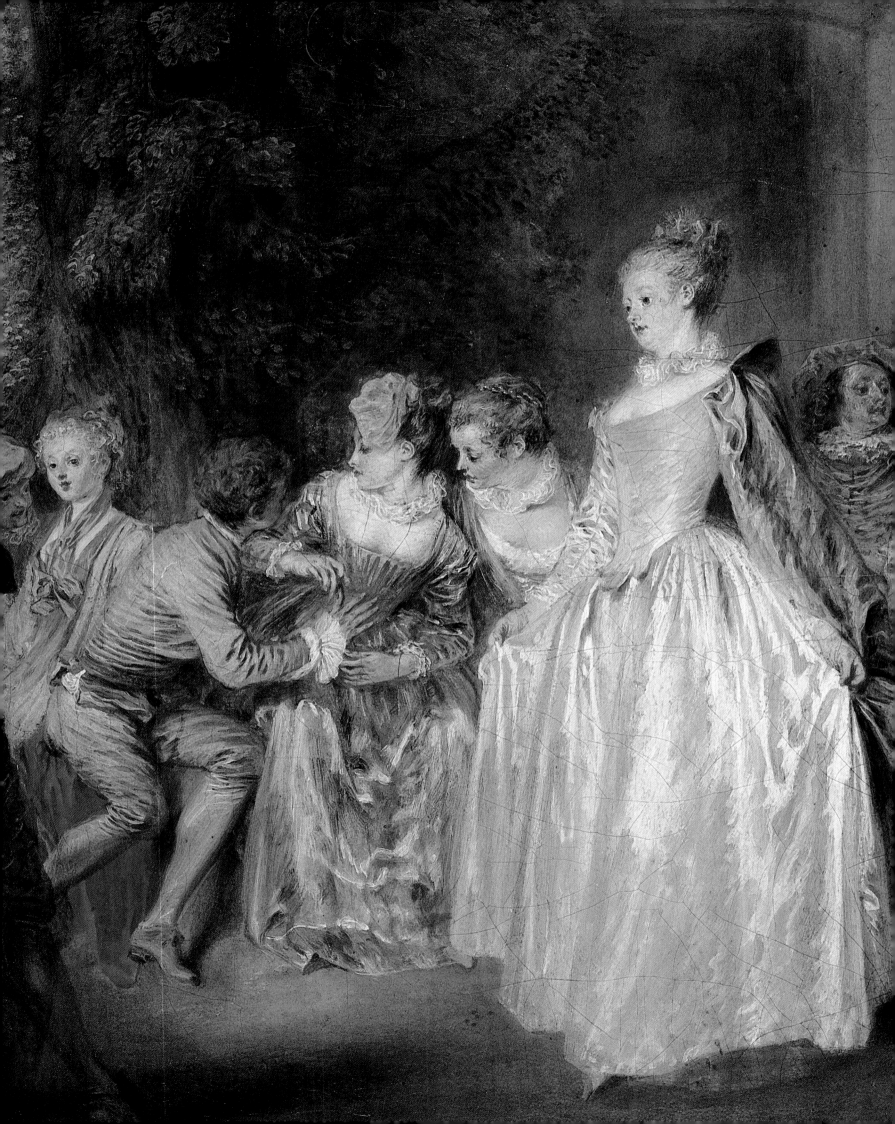

Notes to the Catalogue

Cat. 1

Jean-Antoine Watteau (1684–1721)
The Portal of Valenciennes
La porte de Valenciennes
c. 1710
Oil on canvas, 32.5 × 40.5 cm
The Frick Collection, New York
Purchased with funds from the bequest of Arthemise
Redpath, 1991

Provenance: Théophile-Étienne-Joseph Thoré (1807–1869),
Paris, probably after 1859; sale, Paris, 5 December 1892, lot
39, as by J.-B. Pater; Jacques Doucet (1853–1929), Paris; his
sale, Paris, 6 June 1912, lot 192, as by Watteau; Albert
Lehmann, Paris; sale, Paris, 8 June 1925, lot 222, as by
Watteau; Otto Bemberg, Paris, as of 1961; Luis Bemberg,
and by descent; sold, Sotheby's, London, 12 December 1990,
lot 7, as by Watteau; Colnaghi USA, Ltd., New York; pur-
chased by The Frick Collection, 1991.

Selected References: Mathey 1959, pp. 18, 47, 67, 78; Munhall
1992a; Munhall 1992b; Plax 2000, pp. 100–01, 160.

Notes

1 For Watteau's military drawings of this period, see
 Rosenberg and Prat 1996, nos. 25, 26, 58, 61, 66, 67, 94,
 124; nos. 57, 59 and 60 are studies for *The Portal of
 Valenciennes*. See also Wintermute 1999, nos. 3, 4.
2 This entry is based closely on Munhall 1992b, which is
 by far the most thorough study yet made of the Frick
 painting. On the fortifications of Valenciennes, see
 Munhall 1992b, pp. 20–21.
3 Rosenberg and Prat 1996, nos. 57, 59, 60; see also
 Munhall 1992b, pp. 14–16.
4 Munhall 1992b, pp. 23–25.
5 Watteau's original military paintings, or prints after
 them, are reproduced in Camesasca and Rosenberg
 1970, nos. 40, 41, 42, 43, 44, 55, 57, 59, 96, 97, 5–C (*The
 Portal of Valenciennes*).
6 Munhall 1992b, p. 27.
7 Opperman, in Moureau and Grasselli 1987, p. 28.
8 Reproduced in Munhall 1992b, pp. 17–18, fig. 8–10.
9 Munhall 1992b, p. 18. Allen Rosenbaum had previous-
 ly suggested the possibility that *La halte* had formed
 part of a decorative ensemble; see Rosenbaum 1979, p.
 143.
10 The prints are discussed in Dacier and Vuaflart
 1921–29, III, nos. 222 (*La halte*) and 223 (*Défilé*).
11 Munhall 1992b, p. 22.

Cat. 2

Jean-Antoine Watteau (1684–1721)
The Marmot
La marmotte
c. 1715–16
Oil on canvas, 40.5 × 32.5 cm
The State Hermitage Museum, Saint Petersburg

Provenance: Claude III Audran (1658–1734), as of 1732; prob-
ably to his brother, Jean Audran, in 1734; to his son, Benoit
II Audran; listed in an inventory of works intended for the
Comtesse de Redern, wife of the Grand Marshal of the
Russian Court, after 1768; Empress Catherine the Great of
Russia, the Hermitage, Saint Petersburg, from 1774.

Selected References: Dacier and Vuaflart 1921–29, III, under
no. 122; Munhall 1968; Camesasca and Rosenberg 1970, no.
142; Posner 1975; Grasselli and Rosenberg 1984, no. 32.

Notes

1 The most thorough discussion of the subject of
 Savoyards in art is found in Munhall 1968.
2 Rosenberg and Prat 1996, nos. 290–303; see also
 Wintermute 1999, no. 14.
3 Rosenberg and Prat 1996, no. 294.
4 The counterproof is previously unpublished. Parker
 and Mathey (1957, under no. 490) had proposed that
 the painting was based on a lost counterproof of
 the Petit Palais drawing (red and black chalks coun-
 terproof with light brown wash, 31.3 × 17.0 cm,
 numbered "3057" and "No. 8" on the mount). Sold
 at Christie's, South Kensington, 12 December 1998,
 lot 160 (repr.).
5 The Teylers drawing is in Rosenberg and Prat 1996, no.
 135.
6 Dacier and Vuaflart 1921–29, III, no. 123.
7 Posner 1975, p. 282.
8 Dacier and Vuaflart 1921–29, III, nos. 122 (*La mar-
 motte*) and 123 (*La fileuse*).
9 Posner 1984, p. 27.
10 Ibid.

Cat. 3

Jean-Antoine Watteau (1684–1721)
The Perspective
La perspective
c. 1716–17
Oil on canvas, 46.7 × 55.3 cm
The Museum of Fine Arts, Boston
Maria Antoinette Evans Fund

Provenance: M. Guenon, Paris, by 1729; Daniel Saint, Paris;
sale, Paris, 4 May 1846, lot 56; Richard, 4th Marquis of
Hertford (d. 1870), London; to his illegitimate son, Sir
Richard Wallace (d. 1890), London; to Lady Wallace (d.
1897), London; to Sir Richard's secretary, Sir John Murray
Scott (d. 1912), London; sale, London, 27 June 1913, lot 138;
Thomas Agnew and Sons, London; Walter Burns, from
1919; Durlacher Brothers, New York and London; acquired
by the museum in 1923.

Selected References: Dacier and Vuaflart 1921–29, III, under
no. 172; Junecke 1960, pp. 66–73; Camesasca and Rosenberg
1970, no. 117; Grasselli and Rosenberg 1984, no. 25;
Wintermute 1990, no. 20; Zafran 1998, no. 30.

Notes

1 X-rays reveal that Watteau had originally included
 another couple to the right of the seated guitarist and
 his lady. This couple was reclining on the grass in an
 embrace, in poses quite similar to those employed in
 Watteau's painting *The Family* (*La famille*; private
 collection, Switzerland); see Camesasca and Rosenberg
 1970, no. 153. Watteau himself painted the couple out
 of the present composition. Could it have been
 because, as Rosenberg has suggested (in Moureau and
 Grasselli 1987, p. 108), these active poses upset the calm
 harmoniousness of the composition?
2 Posner 1984, p. 176.
3 Three figures that Watteau had originally painted to
 the right of the standing women – a man seated on the
 balustrade with his feet crossed and two other figures
 seen from behind leaning against the balustrade – have
 been completely lost to abrasion: only the raw reddish
 ground is evidence of where they once were located.
 However, their original disposition is evident in Louis
 Crépy's engraving of the painting made for the *Recueil
 Jullienne* and announced in December 1729 in the
 Mercure de France (Dacier and Vuaflart 1921–29, III, no.
 172), and in an old copy of the painting. See Zafran
 1998, under no. 30, pp. 83–84, figs. 30a and 30b. The
 loss of these figures undoubtedly heightens the sense of
 isolated longing projected by the surviving figures.
4 See *Rubenism*, exhib. cat., Rhode Island School of
 Design, Providence, 1975, under no. 45, p. 145.
5 Mariette cited Crépy's engraving in his handwritten
 Notes manuscrites (Note mss., X, folio 192 [58], in the
 Bibliothèque nationale, Paris), noting that "the back-
 ground of this painting represents a view of M. Crozat's
 garden at Montmorency." Caylus's etching after a lost
 drawing by Watteau that depicted the gardens and
 château at Montmorency (fig. 82) survives in the
 Bibliothèque nationale, Paris; it clearly represents the
 same site depicted in *The Perspective*. The etching car-
 ries Caylus's handwritten inscription identifying the
 site as the "Maison de M. Le Brun P.P. du Roi L.XIV."

See M. Roux, *Inventaire du Fonds Français. Graveurs du XVIII^e siècle* (Paris: Bibliothèque nationale, 1940), IV, p. 140, under no. 486.

6 For the most thorough analysis of Montmorency during Crozat's occupancy, see Junecke 1960, pp. 66–73; see also Dacier and Vuaflart 1921–29, III, under no. 172. For Crozat as an art collector, see M. Stuffman, "Les Tableaux de la collection de Pierre Crozat," *Gazette des Beaux-Arts*, 6th series, LXXII (1968), pp. 1–44; for a brief life of Crozat, see B. Scott, "Pierre Crozat, a Maecenas of the Régence," *Apollo* XCVII:131 (January 1973), pp. 11–19.

7 Only one of the *Seasons* survives, the *Allegory of Summer* (*L'Esté*), in the National Gallery of Art, Washington, D.C. (Camesasca and Rosenberg 1970, no. 107b). For engravings of the other three, see Dacier and Vuaflart 1921–29, III, nos. 105, 107, 108. On Watteau's study of Crozat's drawings collection, see Wintermute 1999, pp. 21–24.

8 Watteau is recorded in the 1718 *Almanach Royal* as living in Crozat's house; see Grasselli and Rosenberg 1984, p. 23. Curiously, the first recorded owner of *The Perspective* was a M. Guenon, one of a family of cabinet-makers who worked for the King; there is no reason to believe that Pierre Crozat ever owned Watteau's depiction of his estate.

9 Rosenberg and Prat 1996, nos. 182, 199, 222, 324, 444, 475, 479, 542.

10 See Crow 1985, pp. 55–57.

Cat. 4

Jean-Antoine Watteau (1684–1721)
Pleasures of the Dance
Les plaisirs du bal
c. 1717
Oil on canvas, 52.6 × 65.4 cm
The Governors of the Dulwich Picture Gallery, London

Provenance: according to Caylus (1748), painted for François II de Boyer de Bandol (1673–1748), Aix-en-Provence, president of the Parlement de Provence; Claude Glucq (after 1674–1742), conseiller au Parlement, cousin of Jean de Jullienne; according to Dezallier d'Argenville, with Louis Pasquier, royal counselor of trade for Normandy, as of 1752; by descent to Pasquier's executor, Vincent de Gournay, Paris, intendant of trade and commerce for Lyon and Burgundy, in 1754; with Jean de Jullienne, Paris, by c. 1756; bequeathed in 1764 to Jullienne's cousin Jean-Baptiste-François de Montullé (1721–1787); his sale, Paris, 22 December 1783, lot 55, to the dealer Le Brun; Vaudreuil sale, Paris, 26 November 1787, lot 6, to the dealer Le Brun; Marquis de Montesquiou sale, Paris, 9 December 1788, lot 212, to the dealer Le Brun; Le Brun sale, Paris, 11 April 1791, lot 197 (unsold); passed to his friend and partner Noel Desenfans (174?–1807); traded by Desenfans in 1792 to Sir Abraham Hume (1749–1838); traded back to Desenfans in 1797, and recorded in his possession in 1802, 1803 and 1804; bequeathed to Sir Francis Bourgeois (1756–1811); Bourgeois's gift to Dulwich College in 1811.

Selected References: Dacier and Vuaflart 1921–29, III, under no. 114; Watson 1953, pp. 238–42; Camesasca and Rosenberg 1970, no. 164; Grasselli and Rosenberg 1984, no. 51; Vidal 1992, pp. 11–16, 20, 36, 127, 134, 136, 145–46.

Notes

1 Caylus (1748), in Rosenberg 1984, pp. 79–80. "Cette façon de composer, qui n'est assurément pas à suivre, est la véritable cause de cette uniformité qu'on peut reprocher aux tableaux de Watteau. Indépendamment de ce que, sans s'en apercevoir, il répétait très souvent la même figure, ou parce qu'elle lui plaisait, ou parce qu'en cherchant ç'avait été la première qui s'était présentée à lui. C'est encore ce qui donne aux estampes gravées d'après lui une espèce de monotonie et de rapport général qui n'en permettent nullement la quantité. En un mot, à la réserve de quelques-uns de ses tableaux tels que l'Accordée ou la Noce de village, le Bal, l'Enseigne

faite pour le sieur Gersaint, l'Embarquement de Cythère qu'il a peint pour sa réception dans votre Académie et qu'il a répétée, ses compositions n'ont aucun objet. Elles n'expriment le concours d'aucune passion et sont, par conséquent, dépourvues d'une des plus piquantes parties de la peinture, je veux dire l'action."

2 The studies are found in Rosenberg and Prat 1996, nos. 123, 229, 405, 460, 482, 495, 501, 505, 543, 555, 607, 635.

3 The radiographs are reproduced in Watson 1953, p. 239, fig. 12, and in Posner 1984, p. 164, fig. 125.

4 First posited in Watson 1953, p. 241. Watteau might also have been inspired by the colonnade in Veronese's *Feast in the House of Simon* (Musée national du Château de Versailles et de Trianon, Versailles), a painting in the French royal collections since 1664.

5 Parker 1932, p. 7, n. 5.

6 The drawing (Musée du Louvre, Paris) is discussed in Rosenberg and Prat 1996, no. 420. Veronese's painting is reproduced and fully analyzed in Rowlands 1996, no. 24.

7 C.R. Leslie, *Memoirs of the Life of John Constable*, London, 1938; quoted in Grasselli and Rosenberg 1984, under no. 51, p. 368.

8 Camesasca and Rosenberg 1970, under no. 164. Watteau employed the identical columns again in *Les charmes de la vie* (Wallace Collection, London), a work generally dated to 1718–19, perhaps more than a year later than *Pleasures of the Dance*.

9 François Moureau in Grasselli and Rosenberg 1984, p. 482. A regulation of the Regent permitting the Opéra to hold balls was signed in December 1715. The same privilege was granted the Comédie-Française exactly one year later; however, the Opéra succeeded in having its competition quickly suppressed. On the balls, see also Cohen 2000, pp. 218–26, and Plax 2000, pp. 117–42.

Cat. 5 and 6

Jean-Antoine Watteau (1684–1721)
Love in the French Theatre
L'amour au Théâtre-Français
c. 1716
Oil on canvas, 37 × 48 cm
Staatliche Museen zu Berlin, Gemäldegalerie

Love in the Italian Theatre
L'amour au Théâtre-Italien
c. 1718
Oil on canvas, 37 × 48 cm
Staatliche Museen zu Berlin, Gemäldegalerie

Provenance: Henri de Rosnel, Paris, 1734;[1] King Frederick the Great of Prussia, picture gallery in park of Sanssouci Palace near Potsdam, 1766;[2] Königliches Museum, Berlin, 1830;[3] Kaiser Friedrich Museum, Berlin, 1904;[4] (American) Art Collecting Point, Wiesbaden, 1945;[5] Gemäldegalerie, Berlin-Dahlem, 1956;[6] gallery of Berlin Kulturforum, 1996.[7]

Selected References: Goncourt 1875, pp. 64–68, no. 65; Macchia 1968, p. 118, nos. 187 and 188; Börsch-Supan 2000, pp. 53–55.

Notes

1 Mentioned on the engraving by Charles-Nicolas Cochin for the *Recueil Jullienne*, which was advertised in May 1734 in the *Mercure de France*.

2 Display plan by gallery curator Matthias Oesterreich is given in Bartoschek 1986, pp. 40–41. Noted as still in the Sanssouci gallery in 1769 (Nicolai 1769, p. 522).

3 Waagen 1830, p. 120, nos. I/477 and I/479 (*Ein nächtlicher Maskenzug* [A Night-time Carnival Procession]); Vogtherr 1991, pp. 162–63.

4 *Verzeichnis* 1904, pp. 420–21.

5 Archival records, Gemäldegalerie, Berlin.

6 *Verzeichnis* 1956, pp. 79–80.

7 *Gesamtverzeichnis* 1996, p. 128.

8 Pierre Rosenberg, in Grasselli and Rosenberg 1984 (French ed.), p. 338.

9 Oil on canvas; Bartoschek 1983, p. 33, nos. 271–275 (inv.

GKI 8127–8131). The Marquis d'Argens was a close confidant of the Prussian king from about 1758.

10 In Grasselli and Rosenberg 1984; see p. 336, n. 7.

11 As of late 1718, Watteau was living in Paris at the home of Flemish compatriot and fellow painter Nicolas Vleughels (1668–1737).

Cat. 7

Jean-Antoine Watteau (1684–1721)
The Shepherds
Les bergers
c. 1717–19
Oil on canvas, 55.9 × 81 cm
Stiftung Preussische Schlösser und Gärten Berlin-Brandenburg, Charlottenburg Palace, Berlin

Provenance: most likely in the Prussian royal collection since the eighteenth century (not clearly identifiable with a painting in the Royal Palace, Potsdam, in 1773);[1] possibly Royal Palace, Potsdam, 1822; Royal Palace, Berlin, 1876; Neues Palais von Sanssouci, Potsdam; Berlin, Charlottenburg Palace, 1937; (American) Art Collecting Point, Wiesbaden, 1956; Gemäldegalerie, Berlin, 1962; transferred to Charlottenburg Palace.

Selected References: Paris 1963, no. 34; Posner 1982, pp. 75–88; Grasselli and Rosenberg 1984, pp. 375–78; Baticle 1985; Garnier-Pelle 1995, pp. 149–52; Rosenberg and Prat 1996.

Notes

1 As was suggested by Pierre Rosenberg in Grasselli and Rosenberg 1984, p. 376.

2 *Le plaisir pastoral*, 1714–16, oil on panel, 31 × 44 cm, Musée Condé, Chantilly (inv. 370).

3 As listed in Grasselli and Rosenberg 1984 and also in Rosenberg and Prat 1996.

4 For example, no. 28 is described as "Un tableau peint sur toille représentant une bergerie."

Cat. 8

Jean-Antoine Watteau (1684–1721)
Peaceful Love
L'amour paisible
c. 1718
Oil on canvas, 53.5 × 81 cm
Stiftung Preussische Schlösser und Gärten Berlin-Brandenburg, Charlottenburg Palace, Berlin

Provenance: Prussian royal collection since the eighteenth century;[1] Royal Palace, Berlin, 1876; Neues Palais von Sanssouci, Potsdam; Charlottenburg Palace, Berlin, 1937; (American) Art Collecting Point, Wiesbaden, 1956; Gemäldegalerie, Berlin, 1962; transferred to Charlottenburg Palace.

Selected References: Paris 1963, no. 37; Grasselli and Rosenberg 1984, pp. 422–25; Rosenberg and Prat 1996.

Notes

1 The identification with a painting recorded in the Neues Palais in 1773, as suggested in Grasselli and Rosenberg 1984 (wrongly as in Sanssouci Palace), appears doubtful, as the work is described as "oil on panel."

2 Stiftung Preussische Schlösser und Gärten Berlin-Brandenburg, Charlottenburg Palace (inv. GK I 1198).

3 As listed in Grasselli and Rosenberg 1984 and also in Rosenberg and Prat 1996.

Cat. 9

Jean-Antoine Watteau (1684–1721)
Venetian Pleasures
Fêtes vénitiennes
c. 1718–19
Oil on canvas, 55.9 × 45.7 cm
National Gallery of Scotland, Edinburgh

Provenance: Jean de Jullienne (1686–1766), Paris; his sale, Paris, 30 March 1767, lot 250; Randon de Boisset (d. 1776), Paris; sale, Paris, 27 February 1777, lot 178, where acquired by Allan Ramsay (1713–1784); by descent to his son, General

John Ramsay; by descent to Lady Murray of Henderland; her bequest to the National Gallery of Scotland, 1861.

Selected References: Bouvy 1921, p. 65; Dacier and Vuaflart 1921–29, III, under no. 6; Camesasca and Rosenberg 1970, no. 180; Schmierer 1995, pp. 203–39; Cohen 2000, pp. 247–50.

Notes

1 Dacier and Vuaflart 1921–29, III, no. 6.
2 Bouvy 1921, p. 65.
3 See Schmierer 1995, and Cohen 2000, p. 248.
4 On the technical examinations, see Colin Thompson and Hugh Brigstocke, *National Gallery of Scotland Shorter Catalogue*, Edinburgh, 1978, no. 439, p. 114, and Levey 1966, p. 71.
5 Rosenberg and Prat 1996, nos. 460 and 505. The drawings are in the Musée du Louvre, Paris, and the Musée du Petit Palais, Paris, respectively.
6 All modern scholars agree that the male dancer represents Vleughels, by comparison to verified portraits of the artist that depict the same fleshy jaw, prominent nose, and cleft chin. Levey (1966, p. 74) and Posner (1984, p. 240) both express the belief that the musette-player represents Watteau himself, as can be confirmed by comparison with Watteau's engraved self-portrait and his engraved self-portrait with Jullienne.
7 Hercenberg 1975. Vleughels was appointed director of the French Academy in Rome in 1724, and served in this role when Allan Ramsay, the Scottish portraitist who was an early owner of the *Fêtes vénetiennes*, studied there in 1734. Might the presence of portraits of Vleughels and Watteau in the painting have recommended it to Ramsay?
8 Grasselli and Rosenberg 1984, pp. 24, 189–90.
9 The drawings are found in Rosenberg and Prat 1996, nos. 338 and 600.
10 Posner 1984, p. 240.
11 Levey 1966, p. 72.
12 Ibid., p. 76; "agréable, tendre et peut-être un peu berger," quoted in Rosenberg 1984, pp. 71–72.

Cat. 10

JEAN-ANTOINE WATTEAU (1684–1721)
Mezzetin
Mezzetin
c. 1718–20
Oil on canvas, 55.2 × 43.2 cm
The Metropolitan Museum of Art, New York
Munsey Fund, 1934

Provenance: Jean de Jullienne (1686–1766), Paris, before 1735; sale, Paris, 30 March 1767, lot 253; Rémy, Paris, probably acquired for Empress Catherine the Great of Russia (1729–1796); in the State Hermitage, Saint Petersburg until 1931; sold to Wildenstein and Co., New York; acquired by the museum in 1934.

Selected References: Dacier and Vuaflart 1921–29, III, under no. 215; Sterling 1955, pp. 105–08; Mirimonde 1961, p. 253; Camesasca and Rosenberg 1970, no. 193; Grasselli and Rosenberg 1984, no. 49.

Notes

1 Sterling 1955, p. 105; François Moureau, in Grasselli and Rosenberg 1984, pp. 508–10.
2 Ibid., p. 509.
3 "Il est valet intrigant et . . . toujours employé dans les fourberries et dans les déquisements." From Luigi Riccoboni, *Histoire du théâtre italien* (Paris, 1931, II, p. 316); quoted by Moureau in Grasselli and Rosenberg 1984, p. 509.
4 Adhémar 1950, p. 100. The association of Constantini or Riccoboni with Watteau's picture can be easily dismissed. Constantini was absent from Paris throughout Watteau's entire career, having left the city in 1697 to return only in 1729; likewise, Riccoboni (who was a member of Crozat's circle) is not recorded as playing Mezzetin between 1716, the year he established his com-

pany in Paris, and 1721, the year of Watteau's death.
5 For an analysis of Mezzetin's traditional costume see Moureau, in Grasselli and Rosenberg 1984, p. 509.
6 Rosenberg and Prat 1996, II, no. 615.
7 A scratchy chalk drawing of a guitar-playing Mezzetin in a landscape, in the Ashmolean Museum, Oxford, has been proposed by Eidelberg (1977a, pp. 22–24) as Watteau's compositional study for *Mezzetin*. Despite recent support for its attribution from Jon Whiteley (*Catalogue of the Collection of Drawings in the Ashmolean Museum, Volume VII, French School*, Oxford, 2000, no. 833), Rosenberg and Prat (1996, no. R488) reject the drawing, and we concur with this rejection. Huyghe first drew the connection between *Mezzetin* and Titian's *Concert champêtre*, then attributed to Giorgione. See Huyghe in Adhémar 1950, pp. 14–16, and 54, n. 25. See also Rosenberg, in Grasselli and Rosenberg 1984, p. 362.
8 Dacier and Vuaflart 1921–29, III, no. 215.
9 Rosenberg, in Grasselli and Rosenberg 1984, p. 364.

Cat. 11

JEAN-ANTOINE WATTEAU (1684–1721)
Iris (The Dance)
Iris (La danse)
c. 1719
Oil on canvas, 97.5 × 116 cm
Staatliche Museen zu Berlin, Gemäldegalerie,
on loan from the German Federal Government

Provenance: auction of Gerrit Braamcamp collection, Amsterdam, 4 June 1766, no. 55 (likely purchased there for King Frederick the Great of Prussia); presumably purchased of the King's brother, Prince Heinrich (Ludwig), on Unter den Linden, Berlin, 1769;[1] in room 57 ("Iris") at Rheinsberg Castle (Prince Heinrich's residence from 1763), 1802;[2] Stadtschloss, Berlin, 1862[3] and 1875;[4] in the study of the King's apartments in the Neues Palais, Potsdam, before 1918; still in possession of former ruling house of Hohenzollern, 1926; Schloss Oels in Silesia, 1927; Kunsthandel Hugo Moser, Berlin, to Switzerland, then auctioned in New York, 1928; purchased for the "Führer Museum" that Adolf Hitler was planning for Linz, Austria, 1942; Treuhandverwaltung für Kulturgut, Munich, 1945; Gemäldegalerie, Berlin, on loan from the Federal Republic of Germany, 1952; Gemäldegalerie, Berlin-Dahlem, 1956;[5] gallery of Berlin Kulturforum, 1996.[6]

Selected References: Goncourt 1875, p. 151, no. 175; Macchia 1968, p. 120, no. 200; Börsch-Supan 2000, pp. 119–21.

Notes

1 Nicolai 1769, pp. 369–70 ("42 Eine Gesellschaft auf dem Lande" ["42 Gathering in the Country"]).
2 As *Ländliche Scene* ("Rural Scene") in the castle inventory of 1802, artist not named; also in 1802 on the list of paintings at Rheinsberg Castle as recorded by Count La Roche-Aymon: "Antoine Watteau . . . une petite fille dansant, des Enfants faisant de la Musique." After Bartoschek 1985, p. 81.
3 Ibid.
4 Goncourt 1875, p. 151, no. 175 ("Chambre de parade. Salon vert").
5 *Verzeichnis* 1956, p. 81.
6 *Gesamtverzeichnis* 1996, p. 128.
7 "Iris c'est de bonne heure avoir l'air à la danse, / Vous exprimez déja les tendres mouvemens, / Qui nous font tous les jours conoitre à la Cadance, / Le goust que vôtre Sexe a pour les instrumens?" In Grasselli and Rosenberg 1984 (French ed.), p. 447.
8 Research report (p. 9) by Dr. Hermann Kühn, Munich, 19 August 1987. Typewritten manuscript in the archives of the Gemäldegalerie.

Cat. 12

NICOLAS LANCRET (1690–1743)
Blindman's Buff
Le colin-maillard
c. 1728
Oil on canvas, 37 × 47 cm
Nationalmuseum, Stockholm

Provenance: Count Gustav Tessin, 1729; Queen Louisa Ulrike by 1760.

Selected References: Wildenstein 1924, no. 229; Holmes 1991a, no. 7; Grate 1994, no. 164.

Notes

1 Holmes 1991a, p. 72, quoting Charles Sorel's treatise *The House of Games* of 1642.
2 Grate 1994, no. 164.

Cat. 13

NICOLAS LANCRET (1690–1743)
Luncheon Party in the Park
Déjeuner dans un parc
c. 1735
Oil on canvas, 55.7 × 46 cm
The Museum of Fine Arts, Boston
The Forsyth Wickes Collection

Provenance: Ange-Laurent de La Live de Jully sale, 5 March 1770, lot 79; Marquis de la Rochefoucauld-Bayers; David Weil, Paris, by 1926; Wildenstein and Co., New York, by 1937; Jacques Helft and Co., New York; Forsyth Wickes Collection, by 1945; entered the museum, 1965.

Selected References: Wildenstein 1924, nos. 73–74; Holmes 1991a, pp. 78–79; Munger 1992, no. 15; Garnier-Pelle 1995, pp. 87–89; Zafran 1998, pp. 87–89.

Notes

1 "Un Tableau de Lancret, représentant un Repas champêtre." See Bailey 1988, p. 37; Holmes 1991a, p. 78; Garnier-Pelle 1995, p. 87.
2 Ibid., p. 88; Holmes 1991a, p, 14.
3 Ibid., p. 78.
4 Marie 1984, p. 251.
5 "Un tableau représentant une partie de jeunes gens à table, faisant la débauche," Garnier-Pelle 1995, p. 88.

Cat. 14

NICOLAS LANCRET (1690–1743)
The Bourbon-Conti Family
La famille Bourbon-Conti
c. 1737
Oil on canvas, 49.3 × 66.7 cm
Krannert Art Museum and Kinkead Pavilion,
University of Illinois, Urbana-Champaign
Gift of Ellnora D. Krannert

Provenance: Comtesse d'Hautpol (a descendant of the Bourbon-Conti family, according to Duveen Brothers); her sale, Hôtel Drouot, Paris, 29 June 1905, lot 44, as *Les Plaisirs Champêtres*; Duveen Brothers, London, 1906; Galerie Cailleux, Paris, by 1930; Timary de Binkum; sale, Palais Galliera, Paris, 16 March 1967, lot 28; Galerie Cailleux, Paris; acquired by the museum in 1967.

Selected References: Wildenstein 1924, no. 562; Wintermute 1990, p. 24; Holmes 1991a, no. 12.

Notes

1 New York 1990, p. 155. Although *The Bourbon-Conti Family* appeared in the 1930 catalogue *Les Artistes du Salon de 1737*, there is no eighteenth-century evidence that this painting was ever actually exhibited at the Salon. As Alan Wintermute demonstrates, the exhibition presented works appearing in the Salon of that year together with works from that era that had not been exhibited.
2 Holmes 1991a, p. 82.
3 New York 1990, p. 153.
4 Holmes 1991a, p. 82.

5 Posner 1984, p. 169.
6 Wildenstein 1924, no. 32.
7 Bartoschek 1986, no. VII.20.
8 New York 1990, p. 154, fig. 3.
9 Vidal 1992, p. 115.
10 Ibid., pp. 115–118.
11 Holmes 1991a, p. 84.

Cat. 15
NICOLAS LANCRET (1690–1743)
A Hunter and his Servant
Un chasseur et son domestique
c. 1737–40
Oil on canvas, 82.5 × 65 cm
Private collection

Provenance: collection of a nobleman, Great Britain.

Selected References: Holmes 1991a, no. 15.

Notes
1 Wildenstein 1924, no. 442.
2 Ibid., no. 446.
3 Holmes 1991a, no. 15.
4 New York 1990, p. 155; Grasselli and Rosenberg 1984, p. 191.

Cat. 16
NICOLAS LANCRET (1690–1743)
Picnic after the Hunt
Le retour de chasse
c. 1738
Oil on canvas, 61.5 × 74.8 cm
National Gallery of Art, Washington, D.C.
Samuel H. Kress Collection

Provenance: possibly Prince August Wilhelm; possibly by inheritance to, or acquired directly by his brother, Friedrich II, King of Prussia; by inheritance to the imperial Hohenzollern, Potsdam; Kaiser Wilhelm II, Berlin; sold to Wildenstein, New York, 1923; sold to the Samuel H. Kress Foundation, New York, 1946; gift to the museum, 1952.

Selected References: Wildenstein 1924, no. 444; Holmes 1991a, no. 9; Grasselli and McCullagh 1994, p. 171.

Notes
1 Holmes 1991a, p. 76.
2 Grasselli and McCullagh 1994, p. 171.

Cat. 17
NICOLAS LANCRET (1690–1743)
A Lady in a Garden Taking Coffee with Some Children
Une dame dans un jardin, prenant du café avec des enfants
c. 1742
Oil on canvas, 88.9 × 97.8 cm
The National Gallery, London

Salon of 1742, no. 50.

Provenance: Lady Wantage, London.

Selected References: Wildenstein 1924, no. 621; Holmes 1991a, no. 18.

Notes
1 "Une Dame dans un Jardin, prenant du Caffé avec des Enfans." Laing 1986a, pp. 179–81, quoting the 1749 *Catalogue d'une grande Collection de Tableaux des meilleurs Maistres. . . .*
2 Dilke 1899, p. 109.
3 London 1914, no. 14, *La tasse de chocolat.*
4 Wilson 1985, no. 34; Holmes 1991a, p. 96.
5 Holmes (ibid.) asserts that this is a coffee pot.
6 *Catalogue d'une grande Collection . . .* (26 March 1749), see n. 1 above.

Cat. 18, 19, and 20
JEAN-BAPTISTE PATER (1695–1736)
The Pyramid of Chicken Wings and Thighs Elevated on a Plate of Destiny by Madame Bouvillon
Pyramide d'ailes et de cuisses de poulet élevée sur l'assiette du Destin par Madame Bouvillon
before 1733
Oil on canvas, 29 × 38 cm
Stiftung Preussische Schlösser und Gärten Berlin-Brandenburg, Neues Palais, Potsdam

Madame Bouvillon Opens the Door to Ragotin Who Hits Her in the Face
Madame Bouvillon ouvre la porte à Ragotin qui lui fait une bosse au front
before 1735
Oil on canvas, 29 × 38 cm
Stiftung Preussische Schlösser und Gärten Berlin-Brandenburg, Neues Palais, Potsdam

Madame Bouvillon Who, in order to Tempt Destiny, Asks Him to Look for Lice
Madame Bouvillon pour tenter le Destin le prie de lui chercher une puce
before 1733
Oil on canvas, 29 × 38 cm
Stiftung Preussische Schlösser und Gärten Berlin-Brandenburg,Neues Palais, Potsdam

Provenance: acquired by Frederick II of Prussia through the Berlin bank of Girard et Michelet, in 1766; Neues Palais von Sanssouci, Potsdam; (American) Art Collecting Point, Wiesbaden; Charlottenburg Palace, Berlin, before 1961; Neues Palais von Sanssouci, Potsdam, 1994.

Selected References: Matthias Oesterreich, "Beschreibung aller Gemählde, Antiquitäten . . . in Sans-Souci, wie auch in dem Schlosse zu Potsdam und Charlottenburg. . . ." Berlin, 1773 (reprint Potsdam, 1990), p. 25, nos. 58–71; Ingersoll-Smouse 1928, pp. 76–77, nos. 489–502; Paris 1963, no. 18; Foucart-Walter 1982, pp. 51–68; Opperman 1982, pp. 110–25; Vogtherr and Evers 2004.

Cat. 21
JEAN-BAPTISTE PATER (1695–1736)
The Fair at Bezons
La foire à Bezons
c. 1733–36
Oil on canvas, 106.7 × 142.2 cm
The Metropolitan Museum of Art, New York
The Jules Bache Collection, 1949

Provenance: Espagnac or Tricot collection; Le Brun sale, 22 May 1793 and following days, no. 101; Alfred Charles de Rothschild, Paris; Almina, Lady Carnavon, London; Duveen Brothers, New York; Jules S. Bache, New York, 1925; gift to the museum, 1949.

Selected References: Ingersoll-Smouse 1928, p. 42, no. 55; Sterling 1955, pp. 112–14; Rosenberg 1975, pp. 62–63, pl. 49; Conisbee 1981, pp. 154–55.

Note
1 Stiftung Preussische Schlösser und Gärten Berlin-Brandenburg, Sanssouci Palace, Potsdam (inv. GK I 5292).

Cat. 22
FRANÇOIS LEMOYNE (1688–1737)
A Hunting Party
Déjeuner de chasse
1723
Oil on canvas, 211 × 186 cm
Signed lower left: *F. Lem(o)ine*
Bayerische Staatsgemäldesammlungen, Alte Pinakothek, Munich
Collection of the Bayerische Hypotheken- und Wechsel-Bank

Provenance: from the collection of the Dukes von Zweibrücken.

Selected References: Hirth and Muther 1888, p. 204; Valabrège 1895, pp. 7–8; Brieger 1922, pp. 147–48 (repr. p. 82); Saunier 1928, no. 52; Wilhelm 1951; Bordeaux 1984, p. 56 (São Paulo picture), pp. 88–89, no. 38 (São Paulo; Munich picture mentioned in passing), pp. 178–84, fig. 34.[1]

Notes
1 Further sources: Zweibrücken inventory 1801, no. 55; 1822, no. 387; 1856, no. 126; Mannlich 1805, I, no. 646; *Notice des Tableaux de la galerie Royale de Munich*, Munich, 1818, p. 63, no. 646; Carl Thienemann, *Die Königliche Gemälde-Galerie in München*, no. 286; Georg von Dillis, *Verzeichnis der Gemälde in der königlichen Pinakothek zu München*, Munich, 1838, p. 103, no. 409; 1853, p. 95, no. 404; *Königlich Bayerische Pinakothek zu München und Gemälde-Gallerie zu Schleissheim*, published as lithographic reproductions by Piloty und Löhle, Munich, 1837ff., I, no. 73, *Refreshment after the Hunt (Le repas après la chasse)*, lithograph by J. Wölffle, c. 1837; Rudolf Marggraf, *Verzeichnis der Gemälde in der Älteren königlichen Pinakothek zu München*, Munich, 1865, p. 80, no. 404; *Katalog der Gemäldeausstellung der Königlichen Älteren Pinakothek in München* (illustrated ed.), Munich, 1884, p. 265, no. 1362; *Katalog der Älteren Pinakothek*, Munich, 1920, p. 75; 18th ed., Munich, 1936, pp. 128, 135–36.
2 Bordeaux 1984, pp. 90–92, no. 44, *Perseus and Andromeda* (Wallace Collection, London, and copy in Musée Boucher de Perthes, Abbeville); pp. 93–95, no. 47, fig. 43, *Hercules and Omphale* (Musée du Louvre, Paris), and fig. 43b (private collection, New York); pp. 95–97, no. 48, fig. 44, *The Bather* (location unknown), and p. 97, no. 49, fig. 45 (The Hermitage, Saint Petersburg); pp. 111–12, no. 72, fig. 75, *Narcissus* (Louvre), and pp. 112–13, no. 73, fig. 76 (Hamburger Kunsthalle).
3 The 1987 restoration was executed with great sensitivity by Veronika Poll-Frommel.
4 Bordeaux 1984, pp. 88–89, no. 38, fig. 34. The author discusses only the painting in São Paulo and, without having ever seen it, labels the Munich painting a mere copy.
5 Wilhelm 1951, pp. 216–30, no. 219, fig. 4–6, studies for the servant (private collection, Paris; Nationalmuseum, Stockholm; and Metropolitan Museum of Art, New York); p. 219, fig. 7, *Seated Hunter* (M. De Lens collection, Paris); p. 219, fig. 8, *Seated Hunter* (private collection, Paris). Other drawings are discussed in Bordeaux 1984, pp. 151–53, nos. 50–56, fig. 178–184.
6 See Ingamells 1989, pp. 366–70, no. 416 (repr.).

Cat. 23
JEAN-FRANÇOIS DE TROY (1679–1752)
The Game of Pied-de-Boeuf
Le jeu de pied-de-bœuf
1725
Oil on canvas, 68.5 × 56 cm
Private collection

Salon of 1725.

Provenance: Marquis de Fontaine et L'Espinasse, according to an inscription on the back; Galerie Germain Seligmann, Paris, 1931–32; Mrs. Lushington, Mahrurangi Head, New Zealand, 1932; private collection; Hall & Knight Ltd., London, 1999.

Selected References: Mercure de France (September 1725), II, p. 2257; *Mercure de France* (April 1736), p. 767; *Extrait . . .* 1854, II, p. 275; Dezallier d'Argenville 1762, IV, p. 373; Brière 1930, II, pp. 6, 39, no. 76 (repr.); Leribault 2002, pp. 277–79 (pl. 124).

Notes

1 "L'entente & le goût galant & vrai dont il est composé. C'est un jeune cavalier en habit de velours, dont l'étoffe est véritablement moelleuse, auprès d'une dame, assise sur un canapé." *Mercure de France* (June 1724), II, p. 1391.

2 Wildenstein 1924, pp. 87–88, nos. 246–250. One of Lancret's paintings was engraved by Larmessin; for one in the collection of Frederick II, see Paris 1963, no. 13 (repr.); for another in a private collection, see Holmes 1985, p. 27 (repr.), and Holmes 1991a, no. 20a, pp. 100–02 (repr.).

3 "En vain je voudrois m'en deffendre / Vous m'aprenez trop, jeune Iris / Qu'à ce jeu lorsqu'on croit vous prendre / On ne manque pas d'estre pris."

Cat. 24

Jean-François de Troy (1679–1752)
The Rendezvous at the Fountain (or The Alarm)
Le rendez-vous à la fontaine (ou L'alarme]
c. 1727
Oil on canvas, 69.5 × 64 cm
Signed at base of fountain: *J F DE TROY 172*[.]
The Victoria and Albert Museum, London
Jones Bequest

Provenance: John Jones, London; bequeathed to the museum in 1882, as a Watteau (on the basis of a false signature removed before 1893).

Selected References: Extrait . . . 1854, II, p. 275; Long 1923, pp. 41–42, no. 531 (pl. 26); Brière 1930, II, pp. 6, 39, no. 75 (repr.); Kauffmann 1973, pp. 275–76 (repr.); Leribault 2002, pp. 62, 64, 290–91 (pl. 135).

Note

1 "Fuyez, Iris, fuyez: ce sejour est à craindre / Tandis que dans ces eaux vous cherchez la fraîcheur, / Des discours d'un amant déffendez vôtre cœur, / Ils allument un feu difficile à s'éteindre."

Cat. 25

Jean-François de Troy (1679–1752)
The Reading from Molière
La lecture de Molière
c. 1730
Oil on canvas, 74 × 93 cm
Signed on bottom of left armchair: *DTROY 1710*
Private collection

Provenance: Frederick II of Prussia, Sanssouci Palace, Potsdam, 1768; seized by Napoleon 1806; William, 2nd Earl of Lonsdale and his descendants; sale of Emily, widow of the 3rd Earl of Lonsdale, Christie's, London, 21 February 1919, no. 105; Agnew's Gallery, London; Sir Philip Sassoon, London; his sister, Sybile, wife of the 5th Marquis of Cholmondeley at Houghton Hall and his descendants; sale, Christie's, London, 8 December 1994, no. 147 (repr.); Dickinson Gallery, London and New York.

Selected References: Boyer d'Argens 1768, pp. 122–23; Oesterreich 1773, p. 77, no. 278–14; Brière 1930, II, p. 39, no. 74; Winkler 1932, pp. 183–84 (repr.); Cailleux 1960 (repr.); Faton 1982, pp. 20–21 (repr.); Leribault 2002, pp. 72–77, 322 (pl. 203).

Notes

1 Vivant Denon, *Monuments des arts du dessin*, IV, 1829, pls. CCXCII–CCXCIII.

2 Lefrançois 1994, pp. 428–29 (repr.).

Cat. 26

Jean-François de Troy (1679–1752)
The Declaration of Love
La déclaration d'amour
1731
Oil on canvas, 71 × 91 cm
Signed lower left, on leg of bench: *DETROY / 1731*.
Stiftung Preussische Schlösser und Gärten Berlin-
 Brandenburg, Sanssouci Palace, Potsdam

Provenance: Frederick II of Prussia, Potsdam (described by Oesterreich in 1773 in the audience chamber of Sanssouci Palace, as a pendant to *The Reading from Molière*), until 1806; transferred to Charlottenburg Palace, Berlin, after World War II; returned to Sanssouci in 1993.

Selected References: Boyer d'Argens 1768, pp. 122–23; Seidel 1900a, p. 139 (pl. 139); Brière 1930, II, pp. 39–40, no. 77; Starobinski 1964, p. 64 (repr. p. 69); Braunschweig 1983, pp. 86–88 (repr.); Krause 1997, pp. 148–49 (fig. 6); Leribault 2002, pp. 72–77, 321 (pl. 202).

Note

1 "[de Troy] a beaucoup plu à Paris par ses petits tableaux de modes, qui sont en effet plus soignés que ses grands tableaux d'histoire; mais je ne pense pas que ce soit sur ces ouvrages qu'il fonde sa réputation." Mariette 1851–60, II, p. 101.

Cat. 27

Jean-François de Troy (1679–1752)
Before the Ball
La toilette pour le bal
1735
Oil on canvas, 82 × 65 cm
Signed lower right, in a figure on the carpet: *DETROY 1735*
The J. Paul Getty Museum, Los Angeles

Salon of 1737.

Provenance: commissioned by Germain-Louis de Chauvelin; sale, Paris, 26 March 1749, no. 48; Salomon-Pierre Prousteau, Paris; Prousteau sale, Paris, 5 June 1769, no. 46 (sold with pendant to Langlier for 240 *livres*); private collection, Shropshire, England, until 1948; Wildenstein Gallery, New York; acquired by the museum in 1984.

Selected References: Mercure de France (September 1737), p. 2017; Extrait . . . 1854, II, pp. 276–77; Goncourt 1862, pp. 117–18; Fredericksen 1988, no. 34 (repr.); Leribault 2002, pp. 68, 342–44 (pl. 234).

Notes

1 "Deux tableaux, l'un une préparation de bal ou mascarade, et l'autre un retour de bal, tous deux peints à la lumière. Ces deux tableaux avoient été faits pour M. Chauvelin, ministre, mais sa disgrâce empêcha de lui faire parvenir." Extrait . . . 1854, II, pp. 276–77.

2 Maurepas and Boulant 1996, pp. 134–37.

Cat. 28

Jean-François de Troy (1679–1752)
The Hunt Luncheon
Le déjeuner de chasse
1737
Oil on canvas, 241 × 170 cm
Signed bottom centre, on a stone: *De Troy / 1737*
Musée du Louvre, Paris

Salon of 1737.

Provenance: commissioned, with its pendant, *Le Cerf aux abois* (*Death of a Stag*), for the great dining room of the small apartments of Louis XV at Fontainebleau, 1737; reinstalled in the new dining room of the palace, 1748; transferred to the warehouses of the Bâtiments du roi, 1785; reclaimed by the Musées royaux during the Restoration, by Louis-Philippe, then Duc d'Orléans, as originating with his family; King Louis-Philippe, Château d'Eu; sale of Louis-Philippe's collection, Christie's, London, June 1857, p. 23, no. 486 (purchased by Nieuwenhuys for £163 10s); Galerie Wildenstein, Paris, 1926; purchased by Baron Maurice de Rothschild before 1932; his son, Baron Edmond de Rothschild, Paris; acquired by the Louvre as payment in kind of inheritance tax, 1990.

Selected References: Extrait . . . 1854, II, p. 277; Brière 1931, p. 166; Ingamells 1989, pp. 335–37; Cuzin 1991 (repr.); Cuzin in *Nouvelles Acquisitions* 1991, pp. 124–26 (repr.); Garnier-Pelle 1995, pp. 136, 138; Leribault 2002, pp. 91, 355–56 (pl. 257).

Cat. 29

Charles-Antoine Coypel (1694–1752)
Children's Games
Jeux d'enfants à la toilette
1728
Oil on canvas, 64 × 80 cm
Martin L. Cohen, M.D., and Sharleen Cooper Cohen

Provenance: modello painted 1728, perhaps for Louis Fagon, owner 1730–31; possibly in the collection of Claude-Jacques Hebert, economist, after 1758; Marquise de Pompadour (d. 1764), in inventory of the painting and drawing collection at the Hôtel de Pompadour, Paris, 1764; her brother, the Marquis de Marigny (d. 1782); Thiéry, sale, Paris, 18 March 1782, no. 31; Barre, Oger de Bréart sale, Paris, 17 May 1886, no. 10; Hôtel Drouot, Paris, 18 February 1930, no. 89; Galerie Charpentier, Paris, 24 March 1952, no. 110; Hôtel du Lion d'Or, Bernay, 21 February 1882.

Selected References: Blanc 1860–77; Ingersoll-Smouse 1920; Lefrançois 1994; Salmon 2002.

Notes

1 Lefrançois 1994, p. 85.

2 See ibid., pp. 217–18.

3 Montesquieu 1964, p. 183.

4 A short jacket. According to *Le Grand Robert*, the term's first recorded use was in 1726. For French eighteenth-century fashion, see Delpierre 1997.

5 Blanc 1860–77, p. 4.

6 A piece of black taffeta that women applied to the skin to heighten its whiteness.

7 The most popular wig in France in the early 1700s. The style was originated by Louis XIII in 1624; see Corson 1965.

8 See Ingersoll-Smouse 1920, pp. 143–54.

Cat. 30

Jean-Baptiste-Siméon Chardin (1699–1779)
The Game of Billiards
La partie de billard
c. 1725
Oil on canvas, 55 × 82.5 cm
Musée Carnavalet–Histoire de Paris

Provenance: Paris art market, c. 1964; Heim Gallery, London (*French Paintings & Sculptures of the 18th Century*, no. 13, as by Étienne Jeaurat), 1968; acquired by the museum in 1968.

Selected References: Wilhelm 1969; Rosenberg 1979, no. 3; Conisbee 1986, pp. 57–58; Roland Michel 1994, p. 13; Rosenberg and Temperini 1999, no. 2.

Notes

1 "Le tableau n'étoit que heurté, mais traité avec goût. L'effet en étoit singulièrement piquant. . . . On juge bien que le tableau fit bruit, on s'empressa d'aller en juger: toute l'Académie connut les talents du jeune Chardin." Haillet de la Couronne, *Éloge de M. Chardin*, 1780, in Wildenstein 1933, p. 41; a slightly variant ms. of this biography is quoted in Rosenberg 1979, p. 102.

2 See Roland Michel 1994, p. 15, repr.

Cat. 31 and 32

Jean-Baptiste-Siméon Chardin (1699–1779)
The Embroiderer
L'ouvrière en tapisserie
c. 1733–38
Oil on canvas, 19 × 16.5 cm
Private collection

Provenance: Christie's, London, 19 November 1920, without lot no.; acquired by an ancestor of the present owner.

Selected References: Rosenberg and Temperini 1999, no. 85C.

Young Student Drawing
Le jeune écolier qui dessine
c. 1733–38
Oil on panel, 21 × 17 cm
Kimbell Art Museum, Fort Worth, Texas

Provenance: acquired in Paris in 1848 by Isambard Kingdom Brunel (1806–59); by descent; sold Christie's, London, 23 April 1982, no. 96; David Carritt; acquired by the museum in 1982.

Selected References: Rosenberg 1979, no. 69 (under Stockholm version); Conisbee 1986, pp. 19–23; Pillsbury 1987, pp. 226–27; Baxandall 1995, pp. 139–43; Rosenberg 1999, no. 37; Rosenberg and Temperini 1999, no. 86D.

Notes

1 Rosenberg and Temperini 1999, nos. 86–86F. X-radiography has revealed that the Fort Worth panel originally displayed a portrait head (by Chardin?), subsequently painted over with the present image; I would like to thank Charles Stuckey, formerly curator at the Kimbell Art Museum, for bringing this to my attention in 2000. Comparison with two panels in the Louvre (see Rosenberg 1979, nos. 51 and 53), where Chardin also painted over fragments of a figure composition, may reveal a common origin for the support.

2 Baxandall 1995, pp. 141–42.

3 Charles-Nicolas Cochin, *Essai sur la vie de Chardin,* 1780, in Wildenstein 1933, p. 38.

4 See Rosenberg 1979, p. 226, under no. 68, for a listing of the relevant sales, and a discussion of the difficulty of positively identifying such works.

Cat. 33

Jean-Baptiste-Siméon Chardin (1699–1779)
Soap Bubbles
Les bulles de savon
c. 1735–40
Oil on canvas, 93 × 74.5 cm
National Gallery of Art, Washington, D.C.
Gift of Mrs. John W. Simpson

Provenance: probably Adolphe Eugène Gabriel Roehn (1780–1867), Paris, by 1845; Laurent Laperlier, Paris, by 1860; his sale, Paris, 11–13 April 1867, no. 10; purchased by Biesta; Gimpel and Wildenstein, New York and Paris; acquired 1905 by John Woodruff Simpson (d. 1920), New York; Mrs. John Woodruff Simpson, née Seney (d. 1943), New York; gift to the museum in 1942.

Selected References: Snoep-Reitsma 1973, pp. 217–19; Rosenberg 1979, no. 59; Fried 1980, pp. 46–51; Conisbee 1990; Rosenberg and Temperini 1999, no. 98A.

Notes

1 "Un petit tableau representant *l'Amusement frivole d'un jeune homme faisant des bouteilles de savon,*" according to the *livret* of the Salon of 1739, n.p.

2 The other works exhibited were *A Lady Taking Tea* (Rosenberg and Temperini 1999, no. 102); *The Kitchen Maid* (cat. 37); *The Return from the Market* (cat. 38); *The Governess* (cat. 39).

3 Fried 1980, p. 51.

4 Rosenberg and Temperini 1999, no. 98.

5 Ibid., 98B.

6 Ibid., 98C.

7 Sold at the Hôtel Drouot, Paris, 17 December 1980, no. 51; then at Versailles, Palais des Congrès, 24 May 1981, no. 30: Rosenberg and Temperini 1999, no. 98D. However, Conisbee and Rosenberg agree that the picture is a good studio copy and not by the hand of Chardin. See Conisbee 1990, p. 22, n. 5; Rosenberg and Temperini 1999, no. 98D.

8 *L'Artiste,* 5 August 1845, p. 72; the full quotation is given in Rosenberg 1979, p. 205.

9 Mariette 1851–60, I, pp. 355–60.

10 Ibid., p. 357.

11 Rosenberg and Temperini 1999, no. 107.

12 See Conisbee 1990, p. 17; thus it is likely that the Baltimore *Knucklebones* and the lost *Soap Bubbles* are the pictures that appeared in the estate sale of the architect Pierre Boscry (d. 1781), Paris, 19 March 1781, no. 17, and subsequently in the Gruel Sale, 16–18

April 1811, no. 5; at an unknown subsequent date they were separated, with only *Knucklebones* reappearing in 1905. National Gallery of Art curatorial records wrongly associate the Washington picture with these sales.

13 A painting described as "a boy making soap bubbles, valued at twenty-four *livres*" is mentioned in Chardin's estate inventory, which was prepared on 18 December 1779; cited in Rosenberg 1979, p. 206.

Cat. 34

Jean-Baptiste-Siméon Chardin (1699–1779)
The Young Draughtsman
Le jeune dessinateur
1737
Oil on canvas, 81 × 67 cm
Staatliche Museen zu Berlin, Gemäldegalerie

Possibly Salon of 1738, no. 117.

Provenance: probably acquired in Paris in 1747 by Count Frederick-Rudolph of Rothenburg (1710–1751), on behalf of Frederick II of Prussia; by descent; acquired by the Kaiser-Friedrich Museum, Berlin, in 1931.

Selected References: Carritt 1974, p. 509; Rosenberg 1979, no. 77; Roland Michel 1994, pp. 204–05, p. 233, n. 31; Karlsruhe 1999, no. 18; Rosenberg and Temperini 1999, no. 113A.

Notes

1 For the most recent discussion and illustration of Chardin's drawings, see Roland Michel 1994, pp. 12–15.

2 Rosenberg and Temperini 1999, no. 113.

Cat. 35

Jean-Baptiste-Siméon Chardin (1699–1779)
The House of Cards
Le château de cartes
c. 1737
Oil on canvas, 83 × 66 cm
National Gallery of Art, Washington, D.C.
Andrew W. Mellon Collection

Salon of 1737.

Provenance: Catherine II of Russia, Saint Petersburg, by 1774; by descent; sold from the Hermitage (then Leningrad), to Andrew W. Mellon, Washington, D.C., 1932; gift to the museum in 1937.

Selected References: Rosenberg 1979, no. 73; Fried 1980, pp. 46–51; Conisbee 1986, pp. 140–42; Rosenberg and Temperini 1999, no. 110.

Notes

1 Rosenberg and Temperini 1999, pp. 237–38, no. 103.

2 Ibid., no. 104.

3 Ibid., no. 106.

4 Ibid., no. 110.

5 For example, see Roland Michel 1994, p. 201.

6 Rosenberg and Temperini 1999, no. 109, where Rosenberg confirms a reading of the 1737 date.

7 See Rosenberg 1979, under no. 72.

8 Rosenberg and Temperini 1999, nos. 109A and 110A, acquired by the Uffizi in 1951 from the Pallavicino collection.

9 Conisbee 1986, p. 123.

10 For a fairly extreme position on the moralizing intent of Chardin's art, and discussions of the verses and legends appended to engravings after Chardin, see Snoep-Reitsma 1973, pp. 147–243; for more moderate views, see Conisbee 1986, pp. 133–49, Roland Michel 1994, p. 242, and the essay by Katie Scott in this catalogue.

11 "Aimable enfant que le plaisir décide, / Nous badinons de vos frêles travaux: / Mais entre nous, quel est le plus solide / De nos projets ou bien de vos châteaux?" "Travaux" can be translated as "constructions," but it is retained in French here to complete the rhyme. See Roland Michel 1994, p. 277, nos. XXIV, XXV.

12 "Sans souci, sans chagrin, tranquille en mes désirs / Une Raquette, et un Volant forment tous mes plaisirs." Ibid., p. 275, no. XVI.

13 See the nuanced readings in Démoris 1991, pp. 85–88.

14 For earlier and contemporary treatments of the subject matter of the house of cards as a *vanitas* theme, see Snoep-Reitsma 1973, pp. 207–09.

15 Rosenberg and Temperini 1999, no. 108.

16 Fried 1980, p. 51.

Cat. 36

Jean-Baptiste-Siméon Chardin (1699–1779)
The Scullery Maid
L'écureuse
1738 (?)
Oil on canvas, 47 × 38 cm
The Corcoran Gallery of Art, Washington, D.C.
Gift of William A. Clark

Provenance: perhaps Sylvestre sale, Paris, 28 February–25 March 1811, no. 13; Godfrey von Preyer, Vienna; William A. Clark (1838–1925), Washington, D.C.; his bequest to the museum in 1926.

Selected References: Glasgow version: Kemp 1976; Rosenberg 1979, no. 79. Exhibited version: Rosenberg 1999, no. 53; Rosenberg and Temperini 1999, no. 115B.

Notes

1 Rosenberg and Temperini 1999, no. 115, Glasgow version; no. 115A, ex-Rothschild version.

2 Ibid., no. 114A; the ex-Rothschild *Cellar Boy* was first exhibited in Rosenberg 1999, no. 52.

3 See Rosenberg and Temperini 1999, no. 115B; the sales were Geminiani, London, 1743, no. 67, and Sylvestre, Paris, 28 February–25 March 1811, no. 3.

4 In Mariette 1851–60, I, p. 359. "Les tableaux de M. Chardin sentent trop la fatigue et la peine. Sa touche est lourde et n'est point variée. Son pinceau n'a rien de facile . . ."

5 Le Chevalier de Neufville de Brunaubois-Montador, *Lettre à la Marquise de S.P.R,* 1738, cited in Wildenstein 1933, p. 68. "Son goût de peinture est à lui seul. Ce ne sont pas des traits finis, ce n'est pas une touche fondue, c'est au contraire du brut et du raboteux. Il semble que ses coups de pinceaux soient appuyées et néanmoins ses figures sont d'une variété frappante et la singularité de sa façon ne leur donne que plus de naturel et d'âme."

Cat. 37

Jean-Baptiste-Siméon Chardin (1699–1779)
The Kitchen Maid
La ratisseuse de navets
1738
Oil on canvas, 46.2 × 37.5 cm
National Gallery of Art, Washington, D.C.
Samuel H. Kress Collection

Salon of 1739 (without number).

Provenance: acquired in Paris by Prince Joseph Wenzel of Liechtenstein (1696–1772), Austrian ambassador to Paris, 1737–41; by descent in Vienna and Vaduz; Samuel H. Kress, New York, 1951; gift to the museum in 1952.

Selected References: Snoep-Reitsma 1973, pp. 182–85; Eisler 1977, pp. 311–13; Rosenberg 1979, no. 82 (under Munich version); Conisbee 1986, pp. 128–31; Rosenberg 1999, no. 57; Rosenberg and Temperini 1999, no. 117.

Notes

1 For the four versions, see Rosenberg and Temperini 1999, nos. 117, 117A, 117B, and 117C (copy); see also Rosenberg 1979, no. 82, for more detailed discussion of the versions.

2 Rosenberg 1979, p. 258; Rosenberg 1983, p. 97, no. 116A; it had as its pendant a version of *The Return from the Market* (lost); see also Laskin and Pantazzi 1987, p. 72.

3 See Conisbee 2000, p. 56.

4 The hang can be deduced from descriptions in the the Salon *livret*, *Explication des Peintures, Sculptures, et Autres Ouvrages de Messieurs de l'Académie Royale . . . de la Présente Année 1739*, p. 8; *The Governess* is described as hanging "above" and *The Return from the Market* as hanging "below." François Stiémart (d. 1740), that year's *tapissier* (responsible for installing the exhibition), hung these two works by Chardin between a landscape by Oudry and a *House of Cards* by Chardin.

5 "Chacun de ses ouvrages exposés cette année mérite en particulier des louanges et surtout La gouvernante et La ratiseuse." Abbé Desfontaines, *Observations sur les écrits modernes*, 3 October 1739, p. 116; this commentary could suggest that they were a pair, but the Despuech provenance for *The Return from the Market* and *The Governess* is more convincing (see cats. 38 and 39).

6 The Sylvestre paintings are discussed in Rosenberg 1979, p. 253.

7 See n. 2 above. The version of *The Return from the Market* at Charlottenburg, Berlin, formerly in the collection of Frederick II of Prussia, was also paired with a version of *The Kitchen Maid* (lost).

8 Rosenberg 1979, under no. 83.

9 "Quand nos ayeux tenoient des mains de la nature, / Ces legumes, garants de leur simplicité / L'art de faire un poison de notre nourriture / N'étoit point encore inventé." Roland Michel 1994, p. 276, no. XIX.

10 Snoep-Reitsma 1973, p. 183, fig. 25.

11 Eisler 1977, p. 312.

Cat. 38

JEAN-BAPTISTE-SIMÉON CHARDIN (1699–1779)
The Return from the Market
La pourvoyeuse
1738
Oil on canvas, 46.7 × 37.5 cm
National Gallery of Canada, Ottawa
Purchased 1956

Salon of 1739 (without number).

Provenance: Delpuech de la Loubière, Paris; acquired in Paris by Prince Joseph Wenzel of Liechtenstein (1696–1772) while Austrian ambassador to Paris, 1737–41; by descent, in Vienna and Vaduz; acquired by the museum in 1956.

Selected References: Rosenberg 1979, no. 81 (under Paris version). Exhibited version: Laskin and Pantazzi 1987, pp. 70–74; Rosenberg 1999, no. 54; Rosenberg and Temperini 1999, no. 116.

Notes

1 As in *A Sentimental Journey through France and Italy*, 1768.

2 "A vôtre air j'estime et je pense / Ma chère enfant, sans calculer, / Que vous prenez sur la dépense / Ce qu'il faut pour vous habiller." Roland Michel 1994, p. 275, no. XVII.

3 Laskin and Pantazzi 1987, pp. 71–72.

4 Rosenberg 1979, under nos. 81 and 83.

Cat. 39

JEAN-BAPTISTE-SIMÉON CHARDIN (1699–1779)
The Governess
La gouvernante
1739
Oil on canvas, 46.7 × 37.5 cm
National Gallery of Canada, Ottawa
Purchased 1956

Salon of 1739 (without number).

Provenance: Delpuech de la Loubière, Paris; Prince Joseph Wenzel of Liechtenstein (1696–1772), Austrian ambassador to Paris, 1737–41; by descent in Vienna and Vaduz; acquired by the museum in 1956.

Selected References: Snoep-Reitsma 1973, pp. 186–88; Rosenberg 1979, no. 83; Conisbee 1986, p. 162; Laskin and Pantazzi 1987, pp. 74–79; Rosenberg 1999, no. 59; Rosenberg and Temperini 1999, no. 118.

Notes

1 See Démoris 1991, p. 84.

2 *Mercure de France* (September 1739), p. 2217, cited in Wildenstein 1933, p. 69. "Le jeune écolier grondé par sa gouvernante pour avoir sali son chapeau est le morceau qui attire le plus de suffrages."

3 Neufville de Brunaubois-Montador, *Description raisonnée des tableaux exposés au Salon du Louvre, Lettre à Madame la Marquise de S.P.R.*, 1739, cited in Wildenstein 1933, p. 69. "Une gouvernante qui faire dire la leçon à un petit garçon pendant qu'elle lui vergète son chapeau pour l'envoyer en classe."

4 Charles-Nicolas Cochin, "Essai sur la vie de Chardin," reprinted in Wildenstein 1933, pp. 35–40, cited on p. 38. "Les sujets se sont ensuite annoblis par un choix plus élevé dans les personnages."

5 Pierre Rosenberg identified the name of this collector's family, if not the specific collector, in Rosenberg 1979, nos. 81 and 83.

6 Mariette 1851–1860, I, p. 358.

7 Most of these are cited in Rosenberg 1979, no. 83.

8 "Malgré le Minois hypocrite / Et l'air soumis de cet enfant / Je gagerois qu'il prémédite / De retourner à son Volant." Roland Michel 1994, p. 274, no. IX.

9 In Rosenberg 1979, p. 285, and Rosenberg 1999, p. 254.

Cat. 40

JEAN-BAPTISTE-SIMÉON CHARDIN (1699–1779)
The Little Schoolmistress
La maîtresse d'école
c. 1740
Oil on canvas, 61.5 × 66.5 cm
National Gallery, London

Provenance: James Stuart sale, Christie's, London, 18–19 April 1850, no. 185; Fuller; John Webb; gift to the museum of Mrs. Edith Cragg (née Webb) in memory of her father John Webb in 1925.

Selected References: Snoep-Reitsma 1973, pp. 192, 219; Rosenberg 1979, no. 70; Conisbee 1986, pp. 147–49; Rosenberg and Temperini 1999, no. 105.

Notes

1 Rosenberg and Temperini 1999, no. 105A.

2 Ibid., no. 105B, where Rosenberg does not accept the attribution to Chardin; but a recent (2000) cleaning confirms the attribution to Chardin in our opinion, although the picture is in poor condition, as a result of abrasion and heavy-handed relining in the past.

3 For the other three eighteenth-century sales references, see Rosenberg 1979, no. 70, under "Related Works."

4 Rosenberg 1979, p. 230.

5 Conisbee 1986, pp. 147–49; Roland Michel 1994, p. 204; Rosenberg 1999, no. 47.

6 Roland Michel 1994, p. 204; less convincing is Roland Michel's suggestion that the same young person is represented in the 1737 *Girl with a Shuttlecock* (private collection, Paris). However, there are other examples of Chardin's mixing the portrait with moralizing genre, such as *Boy with a Top* (*L'Enfant au toton*), exhibited at the Salon of 1738 as *Le Portrait du fils de M. Godefroy, joaillier, appliqué à voir tourner un toton* (Musée du Louvre, Paris).

7 "Si cet aimable enfant, rend bien d'une maîtresse / L'air sérieux, le dehors imposant, / Ne peut-on pas penser que la feinte et l'adresse / Viennent au sexe, au plus tard en naissant." Roland Michel 1994, p. 274, no. XIII.

Cat. 41

JEAN-BAPTISTE-SIMÉON CHARDIN (1699–1779)
The Morning Toilette
La toilette du matin
c. 1741
Oil on canvas, 49 × 39 cm
Nationalmuseum, Stockholm

Salon of 1741.

Provenance: Count Carl Gustav Tessin (1695–1770), Swedish ambassador to Paris, 1741; sold by him in 1749 to King Frederick I of Sweden, as a gift for Princess Luisa Ulrike (1720–1782); transferred to the museum in 1865.

Selected References: Snoep-Reitsma 1973, p. 191; Rosenberg 1979, no. 88; Conisbee 1986, pp. 166–68; Grate 1994, no. 107; Rosenberg 1999, no. 63; Rosenberg and Temperini 1999, no. 122.

Notes

1 "Une pendule à cadran de cuivre émaillé dans sa boîte de marqueterie ornée de bronze fait à Paris par Fiacre Clément." Noted in Rosenberg 1979, p. 276.

2 "Avant que la Raison l'éclaire, / Elle prend du Miroir les avis séduisans / Dans le désir et l'art de plaire, / Les Belles, je le vois, ne sont jamais enfans." Roland Michel 1994, p. 275, no. XV.

3 For the Stockholm collections, see Grate 1994.

4 "Dans ce même canton est un des petits sujets de M. Chardin, dans lequel il a peint une mère qui ajuste la coefe de sa petite fille. C'est toujours de la *Bourgeoisie* qu'il met en jeu. . . . Il ne vient pas là une Femme du Tiers-État, qui ne croye que c'est une idée de sa figure, qui n'y voye son train domestique, ses manières rondes, sa contenance, ses occupations journalières, sa morale, l'humeur de ses enfants, son ameublement, sa garde-robe." [Anon.], *Lettre à Monsieur de Poiresson-Chamarande . . . au sujet des tableaux exposés au Salon de 1741*, Paris, 1741, pp. 33–34; quoted in Wildenstein 1933, p. 72.

Cat. 42

JEAN-BAPTISTE-SIMÉON CHARDIN (1699–1779)
The Attentive Nurse
La garde attentive
1747
Oil on canvas, 46 × 37 cm
National Gallery of Art, Washington, D.C.
Samuel H. Kress Collection

Salon of 1747, no. 60.

Provenance: Prince Joseph Wenzel of Liechtenstein (1696–1772); by descent, in Vienna and Vaduz; Samuel H. Kress, New York, 1950; given to the museum in 1951.

Selected References: Eisler 1977, pp. 313–14; Rosenberg 1979, no. 92; Rosenberg 1999, no. 65; Rosenberg and Temperini 1999, no. 126.

Notes

1 "L'art de traiter des sujets familiers sans être bas. . . . Il s'est fait une manière qui n'appartient qu'à lui et qui est pleine de vérité." Abbé Leblanc, *Lettre sur l'Exposition des ouvrages de peinture, sculpture, etc., de l'année 1747*, 1747, p. 95, cited in Wildenstein 1933, p. 81.

2 See Rosenberg 1979, no. 92.

3 See Rosenberg 1979, p. 285, citing the 1747 *livret*: "Ce tableau fait pendant à un autre du même auteur qui est dans le cabinet du prince de Leichtenstein [*sic*] et dont il n'a pu disposer ainsi que de deux autres qui sont partis depuis pour la Cour de Suède." The Swedish pictures are *Domestic Pleasures* (*Amusements de la vie privée*) and *The Housekeeper* (*L'Économe*), both Nationalmuseum, Stockholm.

4 Eisler 1977, p. 313; Rosenberg 1979, p. 285.

5 Rosenberg 1983, p. 39.

6 Roland Michel 1994, p. 221, where the sketch is reproduced in colour, facing a colour plate of the Washington picture.

Cat. 43

JEAN-BAPTISTE OUDRY (1686–1755)
Lice Feeding her Pups
Lice allaitant ses petits
1752
Oil on canvas, 103 × 132 cm
Musée de la Chasse et de la Nature, Paris

Salon of 1753, no. 22.

Provenance: purchased by Baron d'Holbach at the Salon of 1753 for 100 *pistoles*; his sale, Paris, 16 March 1789, no. 27; acquired by the museum in 1971.

Selected References: Opperman 1982.

Notes

1 "Mémoire pour servir à l'éloge de M. Oudry," in *Revue Universelle des Arts*, 1858, pp. 234–37. This eulogy, found among the papers of the French writer Louis Petit de Bachaumont (1690–1771), was presumably written by one of Oudry's friends.
2 Blanc 1860–77, p. 2.
3 *Lice*, as defined by the *Petit Robert*: "Femelle de chien de chasse."
4 Antoine 1989, p. 407.
5 Pierre Estève, "Lettre à un ami sur l'exposition des tableaux, faite dans le grand Salon du Louvre le 25 août 1753," cited in McWilliam 1990, p. 9 (Salon of 1753: 0076).
6 Charles-Nicolas Cochin, "Lettre à un amateur en réponse aux critiques qui ont paru sur l'exposition des tableaux," cited in ibid., p. 23 (Salon of 1753: 0075).
7 Buffon 1928, p. 223.
8 Pierre Estève (see note 5).

Cat. 44

ÉTIENNE JEAURAT (1699–1789)
Village Fair
Foire de village
1748
Oil on canvas, 59.5 × 107 cm
Galerie Didier Aaron, Paris

Possibly Salon of 1753, no. 20, as *Foire de Village*.

Provenance: Jean de Jullienne; sale after his death, Paris, 20 March–22 May 1767, no. 285; M. de Nanteuil; sale after his death, Paris, 1 March 1792, no. 19; Ph. Sichel; sale after his death, Paris, Galerie Georges Petit, 22–28 June 1899, no. 25; Galerie Pardo, Paris, 1956; Sotheby's, London, 7 December 1994, no. 47; Didier Aaron, Ltd.

Selected References: Salmon 1996; Didier Aaron, no. 8.

Notes

1 Another of the themes was identified by Fenaille (1903–23, IV, p. 171) as *Départ pour le marché* (sale Hôtel Drouot, Paris, salle no. 1, 8 April 1893, no. 2). A sketch for the fourth is possibly the "Scène Champêtre," depicting a ball game, in the Musée des Beaux-Arts, Mâcon; see Dautzenberg 1959.
2 Salmon (1996, pp. 187–88) publishes Audran's letter and Marigny's response.
3 The *Mercure de France* published notification of dozens of engravings of Teniers's paintings from 1735 to 1777, most from French collections. An engraving of the painting *Fête de Village* belonging to the Comtesse de Verruë was announced in August 1737, and was among three Teniers genre scenes inventoried after her husband's death with a total value of 8,500 livres. See inventory published in Rambaud 1971, II, pp. 890–92.
4 Salmon 1996, p. 192.
5 Ibid., pp. 192–93. This scene was replaced by musicians in the cartoon shown at the Salon of 1753, and then restored before the completion of the tapestry with the specially prepared detail.
6 *Une femme qui épluche de la salade*, engraved by J.-F. Beauvarlet, reproduced in Salmon 1996, p. 194.
7 "Les figures manquent de mouvement et d'agilité. Les airs de tête n'ont ni assez d'expression ni assez de gen-

tillesse. Le ton du divertissement et de la joie, de cette joie folle et bruyante qui est le propre des gens de la campagne, a été entièrement négligé dans ce tableau." [Père Laugier], *Jugement d'un amateur sur l'exposition des tableaux. Lettre à M. le Marquis de V*** [Villette]*, 1753, p. 36. See also Élie Fréron, *Lettres sur quelques écrits de ce temps. Au sujet des Tableaux qui ont été exposés dans le grand salon du Louvre en 1753*, 1753, pp. 328–29: "Je lui reproche [Jeaurat] tout seul que dans ce Tableau représentant une noce de Village, la joie n'anime pas assez les Paysans."
8 "Ces esquisses ont une vérité plus particulière encore; les deux sujets qui y sont traités abondent en scènes burlesques, dont l'Auteur a sçu bien prendre l'esprit et le caractère." [Père Laugier] (see n. 7 above), p. 37.
9 Galerie Georges Petit, Paris, 16 February 1923, lot 85.
10 *Le Sergent Recruter*, formerly of the Lord Addington Collection, appeared 13 November 1925, Knight, Frank and Rutley, London, lot 63, and another version of the same subject, with an ornamental border, in the Charles M. Ffoulke Collection was offered by Parke-Bernet, New York, 6 November 1943, lot 209.
11 *Führer durch das Städtische Kunstgewerbemuseum zu Leipzig*, 1931, fig. 65 (inv. 1364).

Cat. 45

ÉTIENNE JEAURAT (1699–1789)
Prostitutes Being Led Off to La Salpêtrière
La conduite des filles de joie à la Salpêtrière
1757
Oil on canvas, 65 × 82 cm
Musée Carnavalet–Histoire de Paris

Salon of 1757, no. 16, as *La Conduite des Filles de Joye à la Salpêtrière, lorsqu'elles passent par la Porte S. Bernard.*

Provenance: collection of the artist; Jean-Antoine Levaillant de Guélis, chevalier de Damery, by 1771;[1] Prosper Talma; Henri Dabot; with A. Perrault-Dabot in 1928; gift of La Société des amis de Carnavalet, 1939.

Selected References: Boucher 1928, p. 198; Wescher 1969, p. 162; Bruson and Leribault 1999, p. 244.

Notes

1 Engraved in 1771 by Charles Levasseur, as *Cabinet de Monsieur Damery*. Puychevrier (1863, pp. 171–72) cites Jeaurat's testament stating that the paintings of *La Conduite des Filles de Joie à la Salpêtrière* and *Le Carnaval des Rues de Paris* were left to his executor and great-nephew Henri-Gabriel Duchesne. I have not been able to confirm this by means of the original document. No autograph copies of either painting are known. I would like to thank Sonya Herring for her assistance in preparing this entry.
2 A fifth, mythological painting, *Prometheus*, is lost; the other two genre paintings exhibited in 1757 were *L'Inventaire du Pont S. Michel, tiré du Poème de "la Pipe Cassée" de feu M. Vadé*, now lost, and *Les Écosseuses de pois de la Halle*, possibly one of the works in the collection of Earl Beauchamp; see Sutton 1968, nos. 345–49. Described as "scènes populaires" in *L'Année Littéraire* (31 August 1757), p. 349.
3 Brice 1971, pp. 355–57.
4 Louis-Sebastien Mercier's description of the procession in "Filles publiques," in *Le Tableau de Paris*, edited by J. Kaplow (Paris: François Maspero, 1979), p. 241.
5 Ibid.: "On les fait monter dans un long chariot, qui n'est pas couvert. Elles sont toutes debout et pressées. L'une pleure, l'autre gémit; celle-ci se cache le visage; les plus effrontées soutiennent les regards de la populace qui les apostrophe; elles riposent indécemment et bravent les huées qui s'élèvent sur leur passage. Ce char scandaleux traverse une partie de la ville en plein jour; les propos que cette marche occasionne sont encore une atteinte à l'honnêteté publique."
6 Benabou 1987, pp. 79ff.
7 Mercier (see note 4).

8 "Il y a beaucoup de verité dans la manière dont ils sont traités, c'est une peinture naïve et gracieuse des événements de la vie populaire." *Mercure de France* (October 1757), Part II, pp. 159–60.
9 Milliot 1995, pp. 171, 177, 199.
10 "Quatre petits tableaux de M. Jeaurat . . . sont plus admirés du gros Public, que des Amateurs; ils ne sont cependant pas sans mérite; on y trouve quelquefois la nature, et plus souvent la pratique." Anonymous critic of the *Journal Encyclopédique*, 1 October 1757, pp. 102–03.
11 Ledbury (2000, p. 73) describes the relationship as a "mutually inspiring partnership."
12 Salon of 1753, as part of no. 20. Collection Earl Beauchamp; see Sutton 1968, no. 345.
13 See n. 2 above. In 1763 he exhibited *Les Citrons de Javotte. Sujet tiré d'un petit ouvrage en vers de M. Vadé, qui porte ce même titre* (no. 11). Diderot's comment is in Seznec and Adhémar 1957–67, I, p. 206.

Cat. 46

PIERRE SUBLEYRAS (1699–1749)
The Amorous Courtesan
La courtisane amoureuse
c. 1735
Oil on canvas, 30.5 × 23.5 cm
Musée du Louvre, Paris

Provenance: as traced by Pierre Rosenberg,[1] Rome then Paris, Duc de Saint-Aignan; Saint-Aignan sale, Paris, 17 June 1776, no. 42; Randon de Boisset sale, 27 February 1777, no. 182; Trouard sale, 22 February 1779, no. 23; M. de Saint-Julien, 1783; sale of Comte de Vaudreuil, 26 November 1787, no. 67; Marquis de Saint-Marc sale, 23 February 1859, no. 15; Jules Burat sale, 28 April 1885, no. 168; Léon Michel-Lévy sale, 17 June 1925, no. 154; Galerie Paul Cailleux, Paris; Comte Niel; Beets sale at Fr. Muller, Amsterdam, 9–11 April 1940, no. 343 (repr.); J. de Monchy sale; sale 29–31 October 1969, Rotterdam, no. 89 (repr.); Galerie Hoogsteder; Colnaghi Gallery, London; Antenor Patino; gift of Madame Patino to the Musée du Louvre with right of usufruct, 1985.

Selected References: Le Moël and Rosenberg 1969, pp. 61–62 (repr.); Michel and Rosenberg 1987, no. 28 (repr.); Rosenberg, in *Nouvelles Acquisitions* 1987, pp. 138–39 (repr.).

Notes

1 The difficult problem of the provenances of such scenes, of which several examples are known, was examined by Pierre Rosenberg in the catalogue of the monographic exhibition of 1987: Michel and Rosenberg 1987, pp. 173–74.
2 "Le Pape enfin, s'il se fût piqué d'elle, / N'aurait été trop bon pour la donzelle."
3 "Accordez-lui pour toute récompense / Cet honneur-là. Le jeune homme y consent. / Elle s'approche; elle le déboutonne; / Touchant sans plus à l'habit, et n'osant / Du bout du doigt toucher à la personne; / Ce ne fut tout; elle le déchaussa. / Quoi de sa main ! quoi Constance elle-même!"
4 "De son orgueil ses habits se sentaient / Force brillants sur sa robe éclatante, / La chamarrure avec la broderie."
5 Drawing preserved at Waddesdon Manor, Aylesbury, U.K.; for the print, see Jean-Richard 1978, no. 1252 (repr.).
6 For the brown wash drawing in the Musée du Petit Palais, see Paris 1992, p. 242 (repr.).

Cat. 47

PIERRE SUBLEYRAS (1699–1749)
The Packsaddle
Le bât
c. 1735
Oil on canvas, 30.5 × 23.5 cm
Private collection, New York

Provenance: sale, Hôtel Drouot, Paris, 3 December 1985, no. 25 (repr.), "attributed to Subleyras."

Selected References: Michel and Rosenberg 1987, p. 192 (repr.).

Notes

1 Musée La Fontaine, Château-Thierry; see Hercenberg 1975, p. 97, no. 113, and Paris 1992, p. 197 (repr.). A painting by Lancret of the same subject, exhibited in the Salon of 1738, is preserved in the Louvre.
2 Hercenberg 1975, pp. 106–08, nos. 132–135 (repr.).

Cat. 48 and 49
Michel-François Dandré-Bardon (1700–1783)
Childhood
L'enfance
1743
Oil on canvas, 37 × 29 cm
Musée Granet, Aix-en-Provence

Salon of 1743, no. 36.

Youth
La jeunesse
1744
Oil on canvas, 37 × 29 cm
Musée Granet, Aix-en-Provence

Provenance: Jean-Baptiste-Laurent Boyer de Fonscolombe, Aix-en-Provence; passed to A. de Saporta from Irène Boyer de Fonscolombe by 1821; restored and put back into the Salon of the Hôtel d'Aix, 1870; private collection, Aix-en-Provence; acquired by the museum, 1997.

Selected References: D'Ageville, *Éloge historique de Michel-François D'André-Bardon*, 1765, catalogued as "Les Misères de la Vie," reprinted in Rosenberg 2001, p. 98; Chol 1987, pp. 52–57, 86–87.

Notes

1 Chol 1987, p. 131, n. 154.
2 Ibid., p. 38.
3 "Dans l'Enfance toujours des pleurs. / Un Pédant porteur de tristesse, / Des Livres de toutes couleurs, / Des châtimens de toute espèce" (our translation). Identified in the *Inventaire du Fonds Français. Graveurs du XVIIIᵉ siècle* (Paris: Bibliothèque nationale, 1930), I, p. 416.
4 See discussion in Holmes 1986, ch. 2, p. 1ff.
5 Nicolas Lancret, *The Four Ages of Man*, 1730–35, 33 × 44.5 cm (each), National Gallery, London (NG 101–104).
6 "Les quatre âges caractérisez par leurs amusemens." *Mercure de France* (July 1735), pp. 1612–13.
7 "Que l'homme est bien durant sa vie / Un parfait miroir de douleurs! / Dès qu'il respire, il pleure, il crie, / Et semble prévoir ses malheurs" (our translation). J.B. Rousseau, *Oeuvres*, London, 1748, p. 340.
8 Engravings by François-Bernard Lépicié, Bibliothèque nationale, Ee 7, in-fol., *Inventaire du Fonds Français. Graveurs du XVIIIᵉ siècle* (Paris: Bibliothèque nationale, 1977), XIV, pp. 411–12.
9 Rousseau (see note 7), p. 341.
10 The severe tutor was a notable medieval theme; see discussion of a thirteenth-century illustrated manuscript from Picardy, "Tree of Wisdom" (Bibliothèque nationale, ms. Fr. 9220), in Elizabeth Sears, *The Ages of Man: Medieval Interpretations of the Life Cycle*, Princeton University Press, 1986, pp. 142–43.
11 "Peindre la Nature sans choix, comme un Élève de Teniers dessineroit un Apollon d'après un Paysan d'Anvers, c'est faire des tableaux peu capables d'attirer les suffrages des Connoisseurs." Michel-François Dandré-Bardon, *Traité de peinture suivi d'un essai sur la sculpture* (Paris: Chez Saillant, 1765), p. 180. Cited from Dandré-Bardon 1972.
12 He would merit an entry in the *Biographie universelle des musiciens*, 1881–89, by F.J. Fetis.
13 "Son excellente caractère ses moeurs douces, et un certain enjouement lui gagnerent bientôt l'amitié de tous ceux qui le connurent." Mariette 1851–60, II, p. 57.

Cat. 50
François Boucher (1703–1770)
"Of Three Things, Will You Do One for Me?": The Game of Pied-de-Boeuf
"De trois choses en ferez-vous une?": Le jeu du pied-de-bœuf
c. 1733–34
Oil on canvas, 105 × 85 cm
Fondation Ephrussi-de-Rothschild, Académie des Beaux-Arts, Saint-Jean-Cap-Ferrat

Provenance: Lecomte and Escudero sale, Paris, 12 December 1854, no. 36; sale, Paris, 22 January 1874, no. 1; sale, Paris, 14 May 1877, no. 7; collection of Mme C. Lelong, Paris; sale of Mme X., Paris, 26 June 1924, no. 70; Madame Ephrussi, Saint-Jean-Cap-Ferrat; donated in 1938, with the foundation established in honour of her parents.

Selected References: Voss 1953, pp. 90–93; Laing 1986a, pp. 139–41; Wintermute 1999, pp. 186–87.

Notes

1 It should be noted that Boucher's autograph variant of this composition recently appeared at auction; see Sotheby's, New York, 24 January 2002, no. 194.
2 See the description of the game in Holmes 1991a, p. 100.
3 Laing 1986a, p. 141.
4 Wintermute 1999, pp. 186–87, who notes that "despite their apparent spontaneity, each of the Ottawa sketches was conceived and adjusted with an eye to its final destination, and it was Boucher's particular gift to be able to imbue his drawings with a freshness belying his many calculations."
5 Bailey 2000a, p. 91, for the commonality between Boucher and Chardin in this type of subject.
6 Voss 1953, p. 82.
7 Holmes 1986, ch. 4, pp. 3–5; Holmes 1991a, pp. 100–02.
8 Laing 1986a, p. 140, fig. 103 (rightly rejecting the candidacy of the *Marchande d'Oeufs* [Wadsworth Atheneum, Hartford, Conn.], with which *The Pied-de-Boeuf* was paired in the late nineteenth century). For the theme of bird's-nesters in Lancret's and Boucher's pastorals and genre paintings, see Goodman (E.) 1995.
9 "Surtout un pinceau aussi ferme qu'il est gracieux." Mariette 1851–60, I, p. 165.

Cat. 51
François Boucher (1703–1770)
Pastoral: The Vegetable Vendor
Le retour du marché
c. 1735
Oil on canvas, 241.3 × 170.2 cm
Chrysler Museum of Art, Norfolk, Virginia
Gift of Walter P. Chrysler, Jr.

Provenance: sale (*Catalogue de Quatre Tableaux . . . provenant de l'Hôtel du duc de Richelieu, dont ils décoraient le salon de réception*, Paris, 18 May 1852, no. 2 (as "Le retour du marché"); Baron de Rothschild, Paris; Alphonse de Rothschild, Paris, 1954; Robert Lebel, Paris, 1954; Walter P. Chrysler Jr., by 1956; his gift to the museum in 1971.

Selected References: Slatkin 1973, pp. 41–42; Laing 1986a, pp. 163–68; Harrison 1986, pp. 22–24.

Notes

1 On the commissions for Derbais, see Laing 1986a, pp. 133–38, and Bailey 1992, pp. 380–89.
2 Laing 1986a, pp. 163–64.
3 "[Ils] ont été peints expressément par Boucher pour le duc de Richelieu, le joyeux compagnon de ses plaisirs." *Catalogue de Quatre Tableaux . . .*, cited in Laing 1986a, p. 163; and see Provenance above.
4 Laing (1986a, pp. 165–66) summarizes the history of the hôtel de Richelieu on the rue Louis-le-Grand, acquired by the maréchal only in 1756 – but formerly the hôtel de Travers (and residence of the Duc d'Antin, Directeur-Général des Bâtiments from 1708 to 1736) – noting that

"there is no trace of any set of pictures such as these in the inventories taken on the deaths of either the duc d'Antin or the maréchal de Richelieu."
5 Laing 1986a, p. 168, in his discussion of *Kitchen Maid and Young Boy* (private collection, Sainte-Adresse).
6 Slatkin 1973, p. 41; it should be noted that this same young woman reappears as the figure holding the pan over the fire in *Le bonheur au village* (Bayerische Landesbank, on deposit in the Alte Pinakothek, Munich).
7 Sheriff 1990, p. 103. For the relevance of this argument to Boucher's pastorals, see Hyde 1996, p. 32.
8 For these pictures, see Laing 1986a, pp. 141–45, 168–70.
9 The *Sheet of Studies* (location unknown) preparatory for the young man is reproduced in Slatkin 1973, p. 42; the red chalk *Standing Servant Girl*, acquired by Tessin during his sojourn of 1739–42, is reproduced in Laing 1986a, p. 167.

Cat. 52
François Boucher (1703–1770)
A Lady Fastening her Garter (La Toilette)
Femme ajustant sa jarretière (La toilette)
1742
Oil on canvas, 52.5 × 66.5 cm
Museo Thyssen-Bornemisza, Madrid

Provenance: acquired from the artist for 648 *livres* by Count Carl Gustaf Tessin (1695–1770), Paris; sent to Stockholm in June 1742; recorded in Tessin's post-mortem inventory as "A woman near a fireplace who ties her garter while her chambermaid arranges her nightcap [*sic*]";[1] Tessin's posthumous sale, Åkerö, 4–16 February 1771; L. Masreliez, Stockholm; Baron E. Cederström, Löfsta; Baron Nathaniel de Rothschild, Vienna, by 1903; Baron Alphonse de Rothschild, Vienna; Rosenberg & Stiebel, New York; acquired by H.H. Thyssen-Bornemisza in 1967.

Selected References: Rosenbaum 1979, no. 46; Brunel 1986, pp. 116–17; Marandel 1986; Laing 1986a, pp. 195–97; Rand 1997, pp. 112–13.

Notes

1 Marandel 1986, p. 75.
2 Preparatory drawings in "trois crayons" exist for both the mistress and her maid. *Seated Woman Attaching her Garter* is in the Musée des Beaux-Arts, Orléans; *Standing Girl Seen from Behind*, for the Watteau-inspired servant, is in the Institut Néerlandais, Paris; see Laing 1986a, p. 195.
3 Ribeiro 2002, pp. 178–79; Brunel 1986, p. 116.
4 Laing 1986a, pp. 195–96.
5 "Un homme qui passe sa vie avec les prostituées du plus bas étage." Diderot 1984, *Salon de 1765*, p. 54.
6 Brunel 1986, p. 116.
7 Roberts 1974, pp. 18–20.
8 Auerbach 1968, p. 399.
9 "Leur fait-on malgré elles passer la moitié de leur vie à leur toilette." Rousseau 1966, p. 453.
10 The connection was first made in Rand 1997, p. 112.
11 See Proschwitz 1983, pp. 24–28.
12 Laing 1986a, p. 200.
13 Marandel (1986, pp. 75–76) lists six paintings by Boucher that remained in Tessin's possession after the sale of his collection in 1749.

Cat. 53
François Boucher (1703–1770)
Presumed Portrait of Madame Boucher
Portrait présumé de Madame Boucher
1743
Oil on canvas, 54 × 67 cm
The Frick Collection, New York

Provenance: Joseph Bardac, Paris; David David-Weill, Paris; Wildenstein and Co., New York; acquired by The Frick Collection in 1937.

Selected References: Davidson and Munhall 1968, II, pp. 3–6; Brunel 1986, pp. 41–44.

Notes

1 "En figures de mode, avec les jolis minois qu'il sait peindre." Heidner 1982, p. 104, n. 9; the quote comes from Tessin's letter to Scheffer of 6 October 1745, in connection with the abortive *Times of the Day* for Luisa Ulrike (see cat. 54).

2 A cursory reference in the posthumous sale of a certain "M. Davoust" (27 April 1772) to "Une Dame sur un canapé, par Boucher" – apparently withdrawn at 80 *livres* – cannot be confidently associated with the Frick picture, *pace* Ananoff 1976, I, no. 263.

3 Boucher most likely used his wife as a model in the same way that Chardin did his own in *The Serinette* of 1751 (Musée du Louvre, Paris, and The Frick Collection, New York); see Rosenberg 1999, pp. 264–67. And while it is always hazardous to expect eighteenth-century portraits to serve as surrogate photographs, comparison with Roslin's admittedly later portrait of Madame Boucher (Schloss Nymphenburg, Munich), exhibited at the Salon of 1761, reinforces the argument that Boucher was not attempting to reproduce his wife's features in his genre paintings; see Lundberg 1957, II, p. 30.

4 "Ayant eu comme l'Albâne le bonheur de se choisir une compagne qui pût sans cesse lui retracer l'idée de ces Graces fugitives, il sut . . . en faire le plus heureux usage pour son Art." *Nécrologe des Hommes célèbres*, VI, 1771, p. 56.

5 Laing (1986a, p. 218) reached a similar conclusion, while reserving final judgement: "It would, however, be carrying pyrrhonism too far to doubt the traditional identification."

6 See Laing 1986a, pp. 217–18.

Cat. 54

François Boucher (1703–1770)
The Milliner (Morning)
La marchande de modes (Le matin)
1746
Oil on canvas, 64 × 53 cm
Nationalmuseum, Stockholm

Provenance: commissioned in October 1745 for 500 *livres* (including the frame) by Princess Luisa Ulrike of Sweden (1720–1782); delivered to the Swedish envoy in Paris in October 1746, and shipped to Stockholm in February 1747; hanging in the Queen's Study Chamber, Drottningholm Castle, by 1777;[1] Drottningholm Castle, until 1865, when it was transferred to the Nationalmuseum, Stockholm.

Selected References: Heidner 1982, pp. 103–04, 124–25, 144, 153–56, 200, 209, 212–15, 253–54; Laing 1986a, pp. 224–29; Grate 1994, pp. 65–66; Rand 1997, pp. 114–16.

Notes

1 M. Lane, "A Minerva for the North: Queen Lovisa Ulrika, Her Collections, and Commissions of Art and Architecture," unpublished dissertation (in Swedish), Uppsala, 1998, p. 219.

2 Laing 1986a, pp. 224–29.

3 "Madame Royale desireroit Quatre tableaux de Boucher, un peu plus grands que celuy qu'il m'a livré, et où il y a une femme qui noue sa jarretiere. Les sujets seront les Quatre heures du jour, Matin, Midi, soir et nuit, en figures de mode, avec les jolis minois qu'il sait peindre." Heidner 1982, p. 104, Tessin to Scheffer, 6 October 1745.

4 "Si vous les commandes pour moi, je suis seur de les avoir à raison de 400 # la piece." Ibid., p. 104.

5 "J'ai communiqué à M. Boucher mes idées sur la disposition des sujets: il ne les a pas désapprouvés et a paru en être fort content. Le matin sera une femme qui a fini avec son friseur, gardant encore son peignoir, et s'amusant à regarder des brinborions qu'une

marchande de modes étale." Ananoff 1976, I, p. 27, Berch to Tessin, 17/27 October 1745; for the full letter, and the most scholarly edition of it, see Heidner 1997, pp. 145–47.

6 "La Nuit . . . par les folles qui vont en habit de bal." Ananoff 1976, I, p. 27; Heidner 1997, p. 146.

7 "Il n'a peut etre jamais fait rien d'aussi galant et d'aussi heureusement executé." Heidner 1982, p. 144, Scheffer to Tessin, 7 October 1746.

8 "Il est actuellement occupé à achever le soir. . . . J'ai eu beau gronder ou solliciter, je n'ai pû obtenir l'esperance certaine des deux autres, que pour le printems prochain." Ibid., p. 144.

9 Ibid., pp. 153–55, Scheffer to Tessin, 16/27 February 1747. Chardin's *Domestic Pleasures* and *The Housekeeper* and Oudry's pastel *Entrance to City of Beauvais* were also on board.

10 "Et l'affoiblissement de sa vue le rend tous les jours moins capable d'aplication." Ibid., p. 154.

11 Ananoff 1976, I, p. 27; Heidner 1982, p. 144: "M. Crozat de Thiers, qui lui en a offert 50 pistoles de plus que ce qu'il coutera à la Princesse."

12 "S'amusant à regarder des brinborions qu'une marchande de modes étale." Ananoff 1976, I, p. 27; Heidner 1997, p. 146.

13 As Mercier (1990, p. 216) noted of milliners, "Plusieurs vont le matin aux toilettes avec des pompons dans leurs corbeilles. Il faut parer le front des belles, leurs rivales; il faut qu'elles fassent taire la secrète jalousie de leur sexe, et que par état, elles embellissent toutes celles qui les paient et qui les traitent avec hauteur."

14 "On tâchera de caractériser les sujets, de manière qu'avec les Quatres Points du Jour, cela fasse aussi les Quatres Saisons." Ananoff 1976, I, p. 27; Heidner 1997, p. 146.

15 Laing (1986a, p. 227) discusses the differences between Boucher's treatment of the primary version of *The Toilette* and the autograph replica now in The Wallace Collection, London, made for the wine-merchant and Capitaine des Gardes de la Ville, Salomon-Pierre Prousteau, a keen collector of Boucher's genre painting; he also owned *The Luncheon* (fig. 21).

16 "Celui de Boucher est tres bien; mais on luy a fait moins d'accueil qu'il ne merite, puisqu'il est venu seul." Heidner 1982, pp. 155–56, Tessin to Scheffer, 6 June 1747.

17 "Je ne balancerai plus une minute d'employer le remede que Vre Exce m'indique, et d'acheter pour les 600 # payés d'avance . . . quelques tableaux Flamands de bon gout, que je ferai choisir par Gersaint ou par quelqu'autre connoisseur." Heidner 1982, p. 200, Scheffer to Tessin, 12 December 1749.

18 "Un peintre sera occupé à finir un portrait, et ce portrait sera celui de Madame Royale. Une dame bien mise viendra regarder par derriere l'ouvrage du Peintre." Ibid., p. 214, Scheffer to Tessin, 21 August 1750. Boucher's sketch, with Scheffer's annotations, is reproduced on p. 215.

19 Sutton (1980, p. 101) notes that the de Hooch is first recorded as in Luisa Ulrike's collection in an inventory of 1760, and that this painting was initially on canvas. For providing me with a list of the pictures displayed in Luisa Ulrike's Study Chamber (or Green Cabinet), taken from an inventory drawn up in 1777, I am most grateful to Mikael Ahlund and Merit Laine.

20 "Le libertinage de Boucher dont il faut etre temoin pour le croire." Heidner 1982, pp. 124–25, Scheffer to Tessin, June 1746.

Cat. 55

François Boucher (1703–1770)
Is He Thinking about Grapes?
Pense-t-il aux raisins?
1747
Oil on canvas, 80 × 68 cm
The Art Institute of Chicago
Martha E. Leverone Endowment

Possibly Salon of 1747, no. 33 *bis*, as *Deux Pastorales, aussi en forme ovale*.

Provenance: possibly Jean-Baptiste Machault d'Arnouville (1701–1794), Contrôleur-général des finances; Comte de Rohan-Chabot, Paris; from whom acquired by Wildenstein in 1959; sold to the museum in 1973.

Selected References: Laing 1986a, pp. 67–72, 233–37; Laing 1986b; Scott 1995, pp. 161–66; Hyde 1996.

Notes

1 Grate 1994, pp. 67–69.

2 Laing 1986a, p. 235; the Little Shepherd instructing Lisette on how to play the flute is also the subject of *The Enjoyable Lesson* (The National Gallery of Victoria, Melbourne), exhibited at the Salon of 1748.

3 Scott (1995, p. 161) has noted succinctly that "the relationship between Boucher's pastorals and Charles-Simon Favart's plays was one of illustration, and the transformation of the Opéra-Comique's repertoire in the late 1730s and 1740s." That Boucher and Favart may have inspired one another – their collaboration dates from as early as 1744 – is noted by Laing 1986a, p. 71, and Hyde 1996, pp. 35, 54, n. 46.

4 Laing 1986a, p. 68; the same observation was made by the abbé Leblanc in 1753 when he noted that the pastoral was "un genre dont M. Boucher est le créateur."

5 As Melissa Hyde (1996, pp. 35–36) has pointed out, Favart was also "commissioned to produce prodigious numbers of divertissements for fashionable social gatherings"; similarly, the earliest patrons of Boucher's painted pastorals were prominent government officials and *fermiers généraux*.

6 For Boucher's refusal to complete the series of the Four Times of the Day, commissioned in 1745 by Luisa Ulrike, see cat. 54 in this volume.

7 Laing 1986a, p. 233.

8 Dufort de Cheverny's fillip, "des bergères à pieds nus avec des paniers comme à l'Opéra," is quoted in Laing 1986a, p. 233.

Cat. 56

Carle Van Loo (1705–1765)
A Pasha Having his Mistress' Portrait Painted
Le Grand Seigneur qui fait peindre sa maîtresse
1737
Oil on canvas, 66 × 76 cm
Virginia Museum of Fine Arts, Richmond
The Adolph D. and Wilkins C. Williams Fund

Salon of 1737, as *Le Grand Seigneur qui fait peindre sa Maîtresse*.

Provenance: painted for Jean de Julienne; sale after his death, Paris, 20 March–22 May 1767, no. 266; collection de Presle; sale Robit, Paris, 11–18 May 1801, no. 54; Empress Joséphine Beauharnais, Château de Malmaison, until her death in 1814; her son, Prince Eugène de Beauharnais, Graf von Leuchtenberg, Munich; still with Leuchtenberg family in 1851; sale George C. Thomas, Philadelphia, Samuel Freeman Galleries, 12 November 1924, no. 29; acquired by the museum in 1959.

Selected References: Dandré-Bardon 1972, pp. 24, 62; Sahut 1977, no. 53; Near 1983.

Notes

1 Dandré-Bardon 1972, p. 24. For Fagon, see the entry

for *The Grand Turk Giving a Concert to his Mistress*, catalogued in Ingamells 1989, p. 257, n. 7.

2 Near 1983, p. 23.
3 *Porus defeated by Alexander*, Sahut 1977, no. 63.
4 For more on exoticism and genre painting, see Marianne Roland Michel's article in this catalogue.
5 Salmon 1995; Sahut 1977, nos. 43, 62. See also Thomson 1981.
6 Montesquieu, *Lettres Persanes*, Lausanne, 1960, p. 156.
7 For a discussion of the imagery generated by this visit, see Bouret 1982.
8 Sahut 1977, nos. 148, 149, 159.
9 Dandré-Bardon 1972, pp. 21–23.
10 Near 1983, pp. 26–27. The subject was painted in 1716 by Nicolas Vleughels (Musée du Louvre) and again in 1730 by Giovanni Battista Tiepolo (Montreal Museum of Fine Arts). Diderot discussed at length Falconet's sculptural relief version exhibited at the Salon of 1765 (Seznec and Adhémar 1957–67, II, pp. 216–18).

Cat. 57

NOËL HALLÉ (1711–1781)
Portrait of Françoise-Geneviève Lorry and of her Son Jean-Noël
Portrait de Françoise-Geneviève Lorry et de son fils Jean-Noël
1758
Oil on canvas, 73 × 60.8 cm
Signed bottom right: *hallé 1758*
Private collection

Salon of 1761, no. 19, as *Une dame qui dessine à l'encre de la Chine.*

Provenance: collection of the artist; Noël Hallé's widow gave it to their son, Jean-Noël, as a wedding gift, 7 April 1785;[1] remained with the artist's descendants.

Selected References: Estournet 1905, pp. 159–60, no. 169 (repr. p. 158); Beaulieu 1956, p. 65; Willk-Brocard 1995, pp. 393–94 (repr. p. 174).

Notes
1 Archives nationales, Paris, Minutier central, C, 882, "Marriage contract of Jean-Noël Hallé."
2 *Procès-verbaux*, VI, pp. 112, 122–23.
3 Archives nationales, Paris, Minutier central, LXXIII, 764, "Marriage contract between Noël Hallé and Françoise-Geneviève Lorry." A sister of the painter Charles de La Fosse had married painter Jean Forest; their daughter, Marie-Élisabeth, married Nicolas de Largillière. Marguerite-Madeleine, granddaughter of another La Fosse brother, Antoine, a jeweller, married François Lorry, Françoise-Geneviève's father.
4 *Galerie françoise*, fascicle devoted to Paul-Charles Lorry.
5 Michaud 1811–28, XXV, p. 132.
6 *Procès-verbaux*, VI, p. 419.
7 The notoriety of this sculpture prompted various authors to attempt to identify the young girl. The names of Alexandrine d'Étiolles, daughter of Madame de Pompadour, Noël Hallé's own daughter, Catherine-Geneviève (who was not born in 1750), and, lastly, the only child of de Troy have been cited without proof (cf. Beaulieu 1956, pp. 62–66, and Leribault 2002, p. 127).
8 *Correspondance des directeurs*, XIII, pp. 72–73.
9 Dubois 1853.
10 Dacier 1909–21, III, catalogue no. 6, p. 55 (repr.).

Cat. 58 and 59

NOËL HALLÉ (1711–1781)
The Education of the Rich
L'éducation des riches
1765
Oil on canvas, laminated on wood, 35.8 × 45.1 cm
Signed on the plan leaning against table leg: *hallé 1765*
Private collection

The Education of the Poor
L'éducation des pauvres
1765
Oil on canvas, laminated on wood, 35.9 × 45.1 cm
Private collection

Salon of 1765, no. 17.

Provenance: collection of the artist; bequeathed to his daughter, and remained with his descendants.

Selected References: Estournet 1905, pp. 122, 149 (*L'éducation des pauvres* repr. p. 150); Seznec and Adhémar 1957–67, II, pp. 7, 9, 20–21, 86–87; Willk-Brocard 1984, pp. 272–74 (repr.); Willk-Brocard 1995, pp. 417–20 (repr.); Scott 1995, p. 44 (*L'éducation des pauvres* repr.).

Notes
1 *Correspondance des directeurs*, IX, pp. 295, 327; X, p. 70.
2 "Observations sur les ouvrages de peinture et sculpture exposés au Louvre en 1765." *Mercure de France* (October 1765), I, pp. 156–58.
3 *Lettres à monsieur ˟˟. sur les Peintures, les Sculptures & les Gravures exposées au Sallon du Louvre en 1765. Première lettre.* 8 September 1765 (Collection Deloynes, VIII, no. 108, pp. 437–41).
4 Location unknown. The numerous versions of this work attest to the interest that it aroused.
5 Seznec and Adhémar 1957–67, II, pp. 86–87.

Cat. 60

PIERRE-ANTOINE BAUDOUIN (1723–1769)
The Honest Model
Le modèle honnête
1769
Gouache with touches of graphite on vellum, 40.6 × 35.7 cm
National Gallery of Art, Washington, D.C.
Gift of Ian Woodner

Salon of 1769, no. 68.

Provenance: Mlle Testard sale, Paris, 22 January 1776, no. 30; M. Prault sale, Paris, 27 November 1780, no. 41; M. Groult; Mrs. George Blumenthal, New York; Baroness Wrangell, Sotheby's, London, 26 November 1970, no. 93; William H. Schab Gallery, New York; purchased by Ian Woodner; gift to the museum in 1983.

Selected References: Washington 1999, no. 92.

Notes
1 See Washington 1999.
2 "Une ignoble créature qui fait quelque vilain commerce." Seznec and Adhémar 1957–67, IV, p. 95.
3 "Libertin dans son pinceau comme dans ses moeurs." Ibid.
4 After Baudouin's picture appeared in the Salon of 1769, Greuze claimed that Baudouin had stolen his subject (Grimm; ibid., p. 94).
5 Diderot tried – unsuccessfully – to steer Baudouin away from the influence of his father-in-law (whom Diderot loathed) and continued to harp on the subject even as late as 1769. Writing specifically in relation to the Salon of 1769, Diderot critized Baudouin for following too closely the example of "le plus dangereux des modèles. . . . À votre place, j'aimerais mieux être un pauvre petit original qu'un grand copiste" ("this most dangerous of models. . . . In your place, I would prefer to be a poor little original than a great copyist"). Ibid.

Cat. 61 and 62

GABRIEL DE SAINT-AUBIN (1724–1780)
A Street Show in Paris
La parade du Boulevard
1760
Oil on canvas, 81 × 63 cm
The National Gallery, London

Provenance: probably in the collection of Charles Baring-Wall at the beginning of nineteenth century; by inheritance to Francis Baring, Norman Court, Salisbury; Francis Baring sale, Christie, Mansons & Woods, London, 4 May 1907, lot 24, as Gillot, *A Street scene with figures watching mountebanks fencing*; acquired by Agnew's for £99 for the National Gallery.

Selected References: Lebel 1926; Dacier 1929–31, I, pp. 16–17, 34–35; II, pp. 90–92; Davies 1946, p. 86; de Beaumont 1998, I, pp. 280–305; II, pp. 684–96; Toulouse 2001, pp. 184–86.

The Meeting on the Boulevard
La réunion du Boulevard
1760
Oil on canvas, 80 × 64 cm
Musée Hyacinthe-Rigaud, Perpignan

Possibly in the Académie royale de peinture, sculpture et architecture de Toulouse, Salon de 1783, no. 156, as *Promenade aux Champs-Élisées.*[1]

Provenance: possibly in the collection of Jean-Louis-Gabriel de Bécarie de Pavie, Marquis de Fourquevaux, in 1783; entered the Musée Rigaud with the rest of the Pelegry collection in September 1840.

Notes
1 Mesuret 1972, p. 416, no. 4653; Toulouse 2001, p. 184.
2 The group includes *The Rendez-vous at the Tuileries* (c. 1760; whereabouts unknown), *The Country Fair* (c. 1762; J. Paul Getty Museum, Los Angeles), the etchings *The Spectacle of the Tuileries* and *The Bal d'Auteuil*, and the drawings of boulevard scenes in the Musée Carnavalet and the Institut Néerlandais, Paris; see de Beaumont 1998, I, p. 281.
3 For discussions of the pair, and speculations as to which was painted first, see Dacier 1929–31, I, pp. 34–35, and de Beaumont 1998, I, pp. 286–88.
4 See Mesuret 1972, p. 416, and Christophe de France's entry in Toulouse 2001, pp. 184–86, for the intriguing possibility that *Meeting on the Boulevard* was posthumously exhibited (as a single work) at the Toulouse Salon of 1783.
5 Wildenstein (1924, pp. 74–75, no. 45) rejected the attribution to Lancret, but without proposing an alternative candidate.
6 Dacier 1929–31, II, nos. 527, 531. It was the engraver's annotations on a rare proof of the *Street Scene in Paris* – "G. de St. Aubin pinxit . . . J. Duclos aquaf." – that led Dacier to revise his prior attribution of the London National Gallery's painting to Augustin de Saint-Aubin. De Beaumont (1998, I, p. 303) provides the context for this "aborted publication."
7 Crow 1985, p. 53, quoting from Antoine de Léris's *Dictionnaire portatif, historique et littéraire des Théatres* (Paris, 1763).
8 Massin 1981, pp. 111–19.
9 "Les parades qu'on représente extérieurement sur le balcon comme une espèce d'invitation publique, sont très préjudiciables aux travaux journaliers, en ce qu'elles ameutent une foule d'ouvriers qui, avec les instruments de leur profession sous le bras, demeurent là la bouche béante, et perdent les heures les plus précieuses de la journée." Mercier 1990, p. 118, *Spectacles des boulevards* (Mercier's compendium was first published between 1782 and 1788).
10 Launay 1991, p. 451.
11 Lebel 1926, p. 54.
12 Dacier 1929–31, I, p. 35; de Beaumont 1998, I, pp. 287–88.

13 Dacier 1929–31, II, no. 527, pl. XX.

14 For *The Boulevards*, which replicates the seated group at left and the waiter bringing drinks on a tray, see Toulouse 2001, p. 184; the central couple and the Savoyard children appear in the *Street Scene* (formerly in collection of Pierre Verdé-Delisle), repr. in Lebel 1926, p. 53.

15 Novoselskaya in London 2001, p. 116 (repr. in colour). This watercolour was unknown to both Dacier and de Beaumont.

16 Dacier 1929–31, I, p. 34; Augustin's print is also discussed (and reproduced) in de Beaumont 1998, I, pp. 285–86; II, fig. 121.

17 De Beaumont 1998, I, p. 282.

18 Dacier 1929–31, I, p. 17.

19 Paris 1985, p. 89; Trott 2000, pp. 160–62.

20 "On voyait-là, dans de superbes voitures à sept glaces, les plus jolies femmes de la Cour et de la Ville." Madame de Genlis, cited in Paris 1985, p. 89.

21 Ibid.

Cat. 63

JEAN-BAPTISTE GREUZE (1725–1805)
The Sleeping Schoolboy
Un enfant qui s'est endormi sur son livre
1755
Oil on canvas, 63 × 52 cm
Musée Fabre, Montpellier

Salon of 1755, no. 147, as *Un Enfant qui s'est endormi sur son Livre*.

Provenance: Ange-Laurent de La Live de Jully (1725–1779), Paris, 1755; recorded in the "Salon sur le Jardin" of his hôtel on the rue de Richelieu in 1764;[1] his sale, Paris, 2–14 May 1770, no. 111, sold for 730 *livres* to the Marquis de Roquefort; Thomas de Pange, Paris; his sale, Paris, 5 February 1781, no. 46; Choiseul-Praslin, Paris; his sale, 18 February 1793, sold 630 *livres* to Desmarest; acquired in 1836 by the Baron François-Xavier Fabre, Montpellier, for 1,600 francs; donated by him to the museum in 1837.

Selected References: Brookner 1972, p. 95; Munhall 1977, pp. 32–33; Fried 1980, pp. 32–35.

Notes

1 *Catalogue historique de Cabinet de . . . M. de Lalive*, Paris, 1764, pp. 76–77.

2 Munhall 1976, p. 18; Bailey 2002, pp. 46–47.

3 "Je ne sçais pas s'il seroit aussi avantageux d'employer continuellement cette manière, elle perdroit au cabinet où l'on aime à voir les Tableaux de près, & où ce pinceau torché, si j'ose me servir de cette expression, ne flatteroit gueres l'œil." [Anon.], *Lettre sur le Salon de 1755, adressée à ceux qui la liront*, Amsterdam, 1755, p. 39.

4 Munhall 1977, p. 32.

5 "M. Greuze, nourri par l'étude des peintres flamands, ces hommes si habiles à saisir la nature," [Anon.]; "Réflexions sommaires sur les ouvrages exposés au Louvre," *Mercure de France* (September 1755), Collection Deloynes, no. 1246.

6 "Ils sont largement peints, & tiennent beaucoup de RIMBRANT [*sic*] pour la couleur, & la belle intelligence de lumière, surtout celui du petit garçon." Mariette in La Live de Jully 1764, p. 77. Comparison to Rembrandt was made rather freely in Salon criticism: François-Hubert Drouais had also been welcomed at the Salon of 1755 as a "nouveau Rembrandt"; see Anonymous [Pierre Baillet de Saint-Julien], *Lettre à un partisan du bon goût sur l'exposition des tableaux faite dans le grand Sallon du Louvre*, n.d. [1755], p. 10.

7 Brookner 1972, p. 95.

8 Descamps 1753–64, II, p. 97.

9 Locke 1964, pp. 175–77.

10 "L'instrument de leur plus grand misère." Rousseau 1966, p. 115 (book 2).

11 "La lecture est le fléau de l'enfance, et presque la seule occupation qu'on lui sait donner." Ibid., p. 115.

12 "Jusqu'alors elle n'est bonne qu'à l'ennuyer." Ibid., p. 116.

13 On this circle, see Steegmuller 1991.

14 Fried 1980, p. 33.

Cat. 64 and 65

JEAN-BAPTISTE GREUZE (1725–1805)
The Broken Eggs
Les œufs cassés
1756
Oil on canvas, 73 × 94 cm
The Metropolitan Museum of Art, New York
Bequest of William K. Vanderbilt, 1920

Salon of 1757, no. 112, as *Une Mère grondant un jeune Homme pour avoir renversé un Panier d'Oeufs que sa Servante apportoit du Marché. Un Enfant tente de raccommoder un Oeuf cassé.*

Provenance: Louis Gougenot, abbé de Chezal-Benoît (1719–1767), Paris, with pendant; at his death, inventoried as hanging in an "antichambre au premier ayant vu sur le jardin et sur la rue," in his hôtel on the rue Notre-Dame des Champs, and estimated at 80 *livres*;[1] by inheritance to his brother, George Gougenot de Croissy (1721–1784); sale, *Catalogue de Tableaux Formant une Réunion imposante d'Articles*, Paris, 18–25 April 1803, no. 90, 3,000 francs to Tessier (with pendant); Prince Nicolas Nikitich Demidoff (d. 1828), with pendant; his son Prince Anatole Demidoff, San Donato Palace, near Florence, with pendant; his sale, Paris, 21–22 February 1870, lot 107, sold for 12,600 francs to the 4th Marquess of Hertford; his son, Richard Wallace, London and Paris; sold by him in April 1875 for £5,292 to Lord Dudley; William K. Vanderbilt, New York, after 1914; bequeathed by him to the museum in 1920.

The Neapolitan Gesture
Le geste napolitain
1757
Oil on canvas, 73 × 94.3 cm
Worcester Art Museum, Worcester, Massachusetts
Charlotte E.W. Buffington Fund

Salon of 1757, no. 113, as *Une jeune Italienne congédiant (avec le Geste Napolitain) un Cavalier Portugais travesti, & reconnu par sa Suivante: deux Enfans ornent ce sujet, l'un retient un Chien qui abboye.*

Provenance: Louis Gougenot, abbé de Chezal-Benoît (1719–1767), Paris, with pendant; at his death, inventoried as hanging in an "antichambre au premier ayant vu sur le jardin et sur la rue," in his hôtel on the rue Notre-Dames des Champs, and estimated at 80 *livres*;[2] by inheritance to his brother, George Gougenot de Croissy (1721–1784); sale, *Catalogue de Tableaux Formant une Réunion imposante d'Articles*, Paris, 18–25 April 1803, no. 90, 3,000 francs to Tessier (with pendant); Prince Nicolas Nikitich Demidoff (d. 1828), with pendant; his son Prince Anatole Demidoff, San Donato Palace, near Florence, with pendant; his sale, Paris, 21–22 February 1870, lot 108, sold for 5,300 francs to Philips, probably for William, first Earl of Dudley (d. 1885); acquired by Agnew, London, in the 1890s for Lord Masham (d. 1924); Viscountess Swinton; David Koetser Gallery, New York, 1956; Acquavella Galleries, New York; Alberto Reyna, Caracas; purchased by the museum from French and Co., New York, 1964.

Selected References: Barthélemy 1802, pp. 138–39, 218–19; Munhall 1976, pp. 40–41, 49–50; Thompson 1989–90, pp. 12–17; Guicharnaud 1999, pp. 52–53; Munhall 2002, pp. 50–53.

Notes

1 "No. 86, Deux tableaux pendants peint par M. Greuze, l'un representant les oeufs cassés." Archives nationales, Paris, Minutier central, XCII/711, "Inventaire après décès," 23 October 1767; cited in Guicharnaud 1999, p. 46.

2 "No. 86, Deux tableaux pendants peint par M. Greuze . . . l'autre le geste napolitain." Ibid.

3 Especially since, according to Gougenot's great-nephew, "it was necessary to assemble in the greatest haste the characters required for the composition of the picture he was working on. Then, once they were all brought together, his verve, he would say, had died out; he no longer felt in a creative state, and he would dismiss his models, who nevertheless received the payment agreed upon for the session." Chevalier G. des Mousseaux, "Notice sur l'abbé Gougenot," *R.U.A.* I (1855), p. 441, cited (and translated) in Munhall 2002, p. 52. On Gougenot and Greuze in Italy, see Guicharnaud 1999.

4 "Il vient de finir le pendant d'un tableau pour M. l'abbé Gougenot, où il y a beaucoup de méritte. Se sera presque son dernier ouvrage de Rome. Je souhaitterois que, dans son jenre, il y joignit la partie du paysage; cela donneroit de la variété dans ses tableau." *Correspondance des Directeurs*, XI, pp. 174–75.

5 Munhall 1976, p. 50.

6 In his letter of 12 May 1756, Barthélemy politely requested that Caylus support Greuze's decision to remain in Rome with Marigny and his circle: "Si vous l'approuvez, vous êtes priés de la justifier aux yeux de M. le marquis de Marigni et de tous ceux qui peuvent s'intéresser aux progrès de ce jeune homme qui paroît avoir un grand talent." Barthélemy 1802, p. 138.

7 Renou 1757, p. 15; "On a placé sur la même ligne comme faciliter la comparaison de ce peintre avec M. Greuze . . . les ouvrages de l'un & de l'autre."

8 Bailey 2000b, p. 4.

9 On Barbault's commissions for Vandières, supervised by Jean-François de Troy, see Leribault 2002, p. 154.

10 "Une jeune fille avoit un panier d'oeufs; un jeune homme a joué avec elle; le panier est tombé et les oeufs se sont cassés. La mère de la fille arrive, saisit le jeune homme par le bras et demande réparation des oeufs: la fille interdite est assise par terre; le jeune homme embarrassé donne les plus mauvaises excuses du monde, et la vieille est en fureur: un petit enfant jeté sur le coin du tableau, prend un de ces oeufs cassés, et tâche de le rajuster." Barthélemy 1802, p. 138.

11 "Une Mere grondant un jeune Homme pour avoir renversé un Panier d'Oeufs que sa Servante apportoit du Marché." *Explication des peintures, sculptures et gravures de Messieurs de l'Académie royale . . . pour l'année 1757*, pp. 25–26.

12 "La figure de la jeune fille a une position si noble, qu'elle pourroit orner un tableau d'histoire." Barthélemy 1802, p. 138.

13 "Sa tête est charmante; elle est peinte avec une belle douceur, & pleine d'expression." Fréron 1757, pp. 347–48.

14 Thompson 1989–90, p. 14.

15 Sauerländer 1965, p. 149.

16 Naumann 1981, II, pp. 19–20. Moitte's engraving appeared as one of the fifty prints in the *Cabinet de S.E. Mr. le Comte de Brühl* (Count Heinrich von Brühl [1700–1763], Prime Minister to Augustus III, King of Poland), published in Dresden in 1754, and which Greuze might have seen in Paris before setting off for Italy; see Atwater 1988, I, pp. 182–83.

17 See other such images in Flandrin 1993, "La virginité."

18 Laing 1986a, pp. 145–47.

19 "Greuze nous a aporté un tableau surprenant pour la couleur. C'est un Portugais déguisé en marchand d'allumettes, qui veut s'introduire dans une maison pour voir une jeune demoiselle. La servante soupçonne quelque fourberie, tire son manteau et découvre l'ordre de Christ (que Greuze appelle sa dignité). Le Portugais est confus, et la fille qui est présente, se moque de lui à la napolitaine, c'est-à-dire en mettant ses doigts sous son menton. C'étoit pour mettre en valeur ce geste qui est très-joli, que Greuze a fait son tableau." Barthélemy 1802, pp. 218–19.

20 "Il se fait en passant le revers des doigts avec vitesse sous le menton; il exprime la négation, comme notre geste de tourner la tête à droite et à gauche." Lalande,

Voyage d'un françois en Italie (1769), cited in Munhall 1976, p. 50.

21 "Une Romaine à mi-corps. sa coëffe rebattue sur les yeux." Lalande, ibid.

22 A figure familiar to fashionable Parisians. The future directeur of the Opéra-Comique, Jean Monnet (1909, p. 69), recalled a nocturnal intrigue in which he gained access to a masked ball by dressing as a chevalier of the Order of Christ, "[qui] avait à cette époque un costume distinctif et portait le grand manteau avec la croix brodée."

23 "Le Portugais ressemble trop pour le visage au marchand d'allumettes." Barthélemy 1802, p. 219.

24 "Il auroit dû ennoblir sa tête." Renou 1757, p. 16.

25 "Elle n'est pas assez vive, assez fine. Dans un tableau d'histoire, ce seroit la plus belle créature du monde." Barthélemy 1802, p. 219.

26 See Monod and Hautecoeur 1922, nos. 17, 52; Munhall 2002, pp. 52–53.

27 Thompson 1989–90, p. 13.

28 "Cette nouvelle Estampe . . . fait *pendant* avec *le Père de famille* que l'on revoit toujours avec tant de plaisir." *Mercure de France* (June 1763), pp. 180–81; see Portalis and Béraldi 1880–82, III, p. 23.

Cat. 66

Jean-Baptiste Greuze (1725–1805)
Indolence
La paresseuse italienne
1756–57
Oil on canvas, 64.8 × 48.8 cm
Wadsworth Atheneum Museum of Art, Hartford, Connecticut
The Ella Gallup Sumner and Mary Catlin Sumner Collection Fund

Salon of 1757, no. 114, as *La Paresseuse Italienne*.

Provenance: Jean-Baptiste-Laurent Boyer de Fonscolombe (1716–1788), Aix-en-Provence, 1757, with pendant; his sale, Paris, 18 January 1790, lot 101, 877 *livres* to Constantin, with pendant; Prince Radziwill Branicki, Rome, Paris, and Warsaw, with pendant, before 1874; acquired by the museum from Wildenstein and Co., New York, 1934.

Selected References: Brookner 1972, pp. 59, 97; Munhall 1976, pp. 42–43; Rand 1997, pp. 147–49.

Notes
1 Brookner 1972, p. 97.
2 Munhall 1976, pp. 46–47.
3 Ibid., p. 47.
4 Rand 1997, p. 148.
5 "Ces deux tableaux appartiennent à M. Boyer de Fonscolombe, & sont tirés de son Cabinet à Aix en Provence." *Explication des peintures, sculptures et gravures de Messieurs de l'Académie royale . . . pour l'année 1757*, p. 26.
6 *Dictionnaire de biographie française*, VII, p. 113; Chol 1987, p. 52.
7 Chol 1987, pp. 86–87; Wine 1997, p. 249.
8 Munhall 1976, p. 42; Butler 1980, pp. 1047–50.
9 *Catalogue d'une collection de Tableaux d'Italie, de Flandre, de Hollande et de France . . . formant le cabinet de feu M. Boyer de Fonscolombe, d'Aix en Provence*, Paris, 18 January 1790, p. 28: "Barbault, 1756: Six Tableaux représentant plusieurs Costumes Romains & Napolitains."

Cat. 67

Jean-Baptiste Greuze (1725–1805)
Boy with a Lesson Book
Un écolier qui étudie sa leçon
1757
Oil on canvas, 61.8 × 48 cm
National Gallery of Scotland, Edinburgh

Salon of 1757, no. 119, as *Un Ecolier qui étudie sa leçon*.

Provenance: Jean-Antoine de Guélis, chevalier de Damery (1723–1803); sale of the estate of Jean-François de Troy, Paris,

9 April 1764, lot 154; Clos sale, Paris, 18–19 November 1812, lot 13, sold for 754 francs; John Smith, London, 1816; Allen Ramsey, London; his son, Major-General Ramsey, London, 1837; his cousin, Lord Murray of Henderland; Lady Murray; bequeathed by her to the museum in 1861.

Selected References: Brookner 1972, pp. 60, 98; Munhall 1976, p. 51; Fried 1980, pp. 16–17.

Notes
1 *Catalogue d'une collection de très beaux tableaux, desseins et estampes*, Paris, 9 April 1764, p. 43.
2 Renou 1757, p. 16. Antoine Renou (and others) criticized Greuze's larger compositions for their heavy-handed use of black, while finding his smaller studies much more harmonious: "N'ayant qu'un objet à rendre, il a considéré & dévoré toute l'union & la participation de tons de cet objet en lui-même, il n'a pas pu y fourrer aucun noir sans se contredire avec la nature."
3 Munhall 1976, p. 51. During Greuze's lifetime, *Titus at his Desk* was in the possession of Thomas Barnard, Bishop of Limerick (1728–1806), and so it is most unlikely that he was familiar with the original; see Lloyd Williams 1992, pp. 126–27.
4 On Damery, see Munhall 1976, pp. 96–97, and Bailey 2000b, p. 36.
5 Levey 1965.
6 Willk-Brocard 1995, pp. 393–95.
7 Fried 1980, p. 17.
8 Smith 1829–42, VIII, p. 435.
9 "Les maîtres de la jeunesse . . . donnent des leçons qui fatiguent l'entendement & la mémoire sans les enrichir & sans les perfectionner." Diderot and d'Alembert 1751–76, IX, p. 332, article "Leçon."
10 "C'est par ses organes qu'il reçoit ses idées, & que le sentiment seul les fixe dans sa mémoire." Ibid.
11 "Émile n'apprendra jamais rien par coeur, pas même des fables, pas même celles de la Fontaine, toutes naïves, toutes charmantes qu'elles sont." Rousseau 1966, p. 110.
12 Locke 1964, pp. 180–82.

Cat. 68

Jean-Baptiste Greuze (1725–1805)
Simplicity
La simplicité
1759
Oil on canvas, 71.7 × 59.7 cm
Kimbell Art Museum, Fort Worth, Texas

Salon of 1759, no. 104, as *La Simplicité représentée par une jeune Fille*.

Provenance: painted for the state apartments of Jeanne Antoinette Poisson, Marquise de Pompadour (1721–1764), at Versailles (until 1764); inventoried in the hôtel de Pompadour, Paris, among "les tableaux rapportés de Versailles aud. hôtel," and valued, with its pendant, at 900 *livres*;[1] her brother, Abel François Poisson, Marquis de Marigny (1727–1781); recorded as hanging in the Salon of his hôtel on the rue Saint-Thomas-du-Louvre;[2] estimated, with its pendant, at 1,500 *livres* in the posthumous inventory of his estate on 21 July 1781;[3] Marigny sale, Paris, 18 March–6 April 1782, no. 43, sold with pendant for 2,399 *livres* 19 sols, "à Robit, pour le roi de France [*sic*]"; Comte Hyacinthe-François-Joseph d'Espinoy, Paris; his sale, 14–19 January and 4–9 February 1850, lot 935, sold with pendant for 615 francs to Ward; Édouard de Rothschild, Paris; Edmond de Rothschild, Château de Prégny, Switzerland; acquired by the museum in 1985.

Selected References: Munhall, in Diderot 1984a, pp. 227–30; Rand 1997, pp. 152–54; Salmon 2002, pp. 139–40, 188–90.

Notes
1 Cordey 1939, p. 91.
2 Bibliothèque historique de la ville de Paris, N.A. 102, fol. 92: "Mémoire des tableaux rentoilés et nettoyés par Hooghstoel, pour le marquis de Marigny, pour l'année 1777."

3 Archives nationales, Paris, Minutier central, XCIX/657, "Procès-verbaux d'inventaire," 1 June 1781, no. 892: "Jeune femme et un jeune garçon, chacun [tenant] une fleur, 1,500 livres."
4 Hans, in Salmon 2002, pp. 78–84.
5 *Correspondance des directeurs*, XI, p. 168: "C'est un garçon qui travaille difficilement."
6 On Madame de Pompadour and the iconography of friendship, see Gordon 1968.
7 Hans, in Salmon 2002, p. 82. On 30 July 1756 it was reported that "l'appartement est entièrement achevé à quelques bagatelles près, et l'on pourra le meubler."
8 *Correspondance des directeurs*, XI, p. 165, Marigny to Natoire, 28 November 1756: "Je luy laisse la liberté de son génie pour choisir le sujet qu'il voudra."
9 Ibid., XI, p. 165: "Ils seront vus de toutte la cour et il pourroit en naître de gros avantages pour luy s'ils sont trouvés bons."
10 Cited by Hans, in Salmon 2002, p. 82.
11 "Après avoir bien réfléchy, il me prie de vous dire, Monsieur, que sa santé ne luy permettant pas de faire un lon séjour à Rome, il s'étoit déterminé à en partir dans deux mois environ, et que, si vous vouliés bien luy continuer vos mêmes bontés qu'il sera arrivé, il travaillera à les mériter en fesant les deux morceaux que vous luy demandés." *Correspondance des directeurs*, XI, p. 168, Natoire to Marigny, 22 December 1756.
12 Rand 1997, p. 152; might this drawing, or one like it, have been presented to the Bâtiments for approval?
13 Lefrançois 1994, pp. 374–75; Baulez 1975, pp. 84–85, illustrating Frédéric Nepveu's cross-section of the *Grand Cabinet*, taken in 1834 before the room was dismantled, in which two ovals are shown almost at ceiling height.
14 "Les Greuze ne sont pas merveilleux cet année. Le faire en est roide, et la couleur fade et blanchâtre." Diderot 1984b (*Salon de 1759*), p. 101.
15 "A l'élégance du vêtement, à l'éclat des couleurs, on le prendrait presque pour un morceau de Boucher." Ibid., p. 157 (*Salon de 1761*).
16 "Mr. Greuze paroit préférer de revêtir ses figures de blanc; c'est une des plus grandes difficultés en peinture." *Mercure de France* (October 1759), Collection Deloynes, no. 1259.
17 "On lui reproche cependant qu'en voulant éviter les tons noirs, il est tombé dans un excès contraire." *Lettre critique à un ami sur les ouvrages de Messieurs de l'Académie exposés au Sallon du Louvre*, Paris, 1759, p. 27.

Cat. 69

Jean-Baptiste Greuze (1725–1805)
Silence!
Silence !
1759
Oil on canvas, 62.8 × 50.8 cm
Lent by Her Majesty Queen Elizabeth II

Salon of 1759, no. 103, as *Un Tableau représentant le Repos, caractérisé par une Femme qui impose silence à son fils, en lui montrant ses autres enfants qui dorment*.

Provenance: Jean de Jullienne (1686–1766), Paris; by inheritance to Jean-Baptiste-François de Montullé (1721–1787); his sale, Paris, 20–23 December 1783, lot 81, sold for 2,400 *livres* to Verrier; Joseph-Hyacinthe-François de Paule de Rigaud, Comte de Vaudreuil (1740–1817); his sale, Paris, 26 November 1787, lot 96, sold for 2,001 *livres* to Verrier; Stanley sale, London, 7 June 1815; acquired in 1817 in Paris by Lord Yarmouth, 3rd Marquess of Hertford, for George IV; at Buckingham Palace since 1843.

Selected References: Brookner 1972, pp. 98, 100; Munhall 1976, pp. 66–67; Lloyd 1994, pp. 76–77.

Notes
1 "L'instant de l'action est celui ou cette mère vient de poser sur ses genoux le plus jeune de ses fils qui vient de s'endormir en tetant. Son sein est encore découvert: on apperçoit que l'attention qu'elle a donné jusque là à

l'enfant qu'elle allaitait ne lui a pas permis de prendre garde à ce qui se passait ailleurs. On sent que celui qu'elle fait taire, retire à demi de sa bouche une petite trompette de bois, qu'il est bien dans l'intention d'y remettre le plutôt qu'il le pourra. On voit d'un autre côté un enfant endormi sur sa chaise. Son sommeil est profond; son tambour cassé attaché à sa chaise, indique de sa part un grand attachement pour le jouet, et l'on devine aisément qu'il a exigé, avant de s'endormir, qu'on le mit dans la plus grand sureté. Les utensiles de ménage sont arrangés sans ordre dans la chambre; la nourrice a été obligée de les abandonner subitement pour allaiter l'enfant qui criait. On ne peut pas tout faire à la fois." *Explication des peintures, sculptures et gravures de Messieurs de l'Académie royale . . . pour l'année 1759*, p. 21.

2 [É.-C. Fréron], "Exposition des peintures, sculptures et gravures," *L'Année littéraire* (September 1759) (Collection Deloynes, no. 1257).

3 Munhall 1976, p. 66.

4 Brookner 1972, p. 100. For the painting in question, see Krempel 2000, p. 335, in which two versions of the composition are noted, neither of which the author considers to be by Maes, and one of which circulated in France during Greuze's lifetime (it was recorded in Calonne's collection at the end of the eighteenth century).

5 Monod and Hautecoeur 1922, nos. 28, 29, 41, 71. *A Little Boy Standing* (drawing no. 41) was most recently sold at Christie's, London, 4 July 1984, no. 120.

6 "Nous n'ignorons pas qu'une Dame qui allaite son enfant, est pour notre siècle un phénomène, qu'on ne rougit pas de taxer de folie." Cited in Senior 1983, p. 380.

7 Morel 1980, pp. 53–54; Senior 1983, pp. 377–78.

8 "Mais que les mères daignent nourrir leurs enfans, les moeurs vont se réformer d'elles-mêmes, les sentiments de la nature se réveillent dans tous les coeurs; l'État va se repeupler." Rousseau 1966, p. 18 (book 1).

9 "Lorsqu'elle fait de son enfant son idole, qu'elle augmente et nourrit sa faiblesse pour l'empêcher de la sentir." Ibid., p. 19 (book 1).

10 Munhall 2002, p. 112.

11 "A force de plonger leurs enfants dans la mollesse, elles les préparent à la souffrance." Rousseau 1966, p. 19 (book 1).

Cat. 70
Jean-Baptiste Greuze (1725–1805)
The Laundress
La blanchisseuse
1761
Oil on canvas, 40.6 × 31.7 cm
The J. Paul Getty Museum, Los Angeles

Salon of 1761, Paris, no. 102, as *Une jeune Blanchisseuse*.

Provenance: sold by Greuze to Ange-Laurent de La Live de Jully (1725–1779) for 600 *livres*; La Live de Jully sale, Paris, 2–14 May 1770, lot 115, sold for 2,399 *livres* to Langlier, on behalf of Count Gustaf Adolph Sparre (1746–1794), Kulia Gunnarstorp, Sweden; by inheritance to Count C. de Geer, Leufsta, Wånas, Sweden, c. 1837; Countess Elizabeth Wachtmeister, Sweden, by inheritance from grandfather, Count C. de Geer, 1855; Count Axel Wachtmeister, Wånas, Sweden, by inheritance, by 1886; Count Gustav Wachtmeister, Wånas, Sweden, by inheritance, by 1958; Count Axel Wachtmeister, Wånas, Sweden, by inheritance; acquired by the museum in 1983.

Selected References: Rand 1997, pp. 157–59; Bailey 2000b.

Notes
1 "Cette petite Blanchisseuse qui, penchée sur sa terrine, presse du linge entre ses mains est charmante; mais c'est une coquine à qui je ne fierais pas. J'aime ma santé." Diderot 1984b (*Salon de 1761*), p. 156.

2 "Une jeune blanchisseuse . . . [qui] lance un coup

d'oeil aussi coquet que malin." [Anon.], "Les Tableaux de l'Académie de peinture, exposés dans le Sallon du Louvre," *Journal Encyclopédique* (September 1761), Collection Deloynes, no. 1273.

3 In the *Observations d'une société d'amateurs sur les tableaux exposés au Sallon de cette Année 1761*, p. 46.

4 "Je serais seulement tenté d'avancer son tréteau un peu plus sous ses fesses, afin qu'elle fût mieux assise." Diderot 1984b (*Salon de 1761*), p. 156.

5 On La Live de Jully, see Bailey 2000b, pp. 14–18, and Bailey 2002, pp. 32–69.

6 La Live de Jully 1764, p. viii: "J'ai mis à chaque morceau le nom de l'Auteur, parce qu'il est très possible de se connoître fort bien aux arts, et d'ignorer le nom de l'artiste."

7 Dacier 1909–21, III, part 6, p. 64.

8 Bailey 2000b, pp. 47–49.

9 Ibid., pp. 46–58, "The Brutal Business of Laundering Linen."

10 Ledbury 1997; Bailey 2000b, pp. 59–70, "Greuze's Naturalism and the *Genre Poissard*."

11 Bailey 2000b, p. 66.

Cat. 71
Jean-Baptiste Greuze (1725–1805)
The Marriage Contract
L'accordée de village
1761
Oil on canvas, 92 × 117 cm
Musée du Louvre, Paris

Salon of 1761, no. 100, as *Un Mariage, & l'instant où le père de l'Accordée délivre la dot à son Gendre.*

Provenance: Acquired by Abel Poisson, Marquis de Marigny (1727–1781), from the artist for 3,000 *livres*; recorded as hanging in the Salon of Marigny's hôtel on the rue Saint-Thomas-du-Louvre;[1] estimated at 5,600 *livres* in the posthumous inventory of his estate on 21 July 1781;[2] Marigny sale, Paris, 18 March–6 April, no. 42, sold to Joullain for King Louis XVI for 16,500 *livres*; Musée du Louvre, Paris.

Selected References: Munhall, in Diderot 1984a, pp. 222–27; Crow 1985, pp. 142–53; Barker 1994, I, pp. 49–81; Rand 1996; Barker 1997; Ledbury 2000, pp. 143–53; Munhall 2002, pp. 70–83.

Notes
1 Bibliothèque historique de la ville de Paris, N.A. 102, fol. 92, "Mémoire des tableaux rentoilés et nettoyés par Hooghstoel, pour le marquis de Marigny, pour l'année 1777."

2 Archives nationales, Paris, Minutier central, XCIX/657, "Procès-verbaux d'inventaire," 1 June 1781, no. 905, "L'Accordée de village peint par Greuze et connu par l'estampe qu'en a gravé Flipart: 5,600 livres."

3 At the Salon of 1763, Grimm noted that Marigny had paid Greuze "mille écus pour le tableau des Fiançailles du dernier Salon" (cited in Diderot 1984b, p. 225); Mariette (1851–60, II, p. 330) praised the painting "que M. de Marigny a mis dans son cabinet et payé 3,000 liv. [*sic*]."

4 On 17 July 1761, the engraver Wille noted in his diary that he had just acquired one of Greuze's drawings for the head of the father in *The Marriage Contract*, "tableau qu'il fait actuellement." Wille 1857, I, p. 173.

5 *Explication des peintures, sculptures et gravures de Messieurs de l'Académie royale . . . pour l'année 1761*, p. 24, no. 100: "Ce Tableau appartient à M. le Marquis de Marigny."

6 "M. Greuze achève aujourd'huy le tableau qu'il fait pour votre cabinet; il l'aura encore chés lui demain et après-demain. . . . Aussitôt qu'il sera seché il le fera porter au Salon." Furcy-Reynaud 1903–04, I, p. 203, Cochin to Marigny, 17 September 1761.

7 *Mercure de France* (October 1761), pp. 114–15.

8 "Ce tableau de notre ami Greuze . . . il continue d'attirer la foule." Diderot 1984b (*Salon de 1761*), p. 164.

9 See the listing in Diderot 1984b, p. 227, to which might be added a drawing, "dessiné à l'encre de la Chine & au bistre," noted to be "la première pensée de l'accordée de village," in the collection of Jean-Baptiste-Laurent Boyer de Fonscolombe, the first owner of *Indolence* (cat. 66); see *Catalogue d'une collection de Tableaux d'Italie, de Flandre, de Hollande et de France . . . formant le cabinet de feu M. Boyer de Fonscolombe, d'Aix en Provence*, Paris, 18 January 1790, p. 45, no. 189.

10 Munhall 2002, p. 70.

11 Barker 1997, pp. 43–44. The notion that Greuze is portraying a Protestant civil ceremony is no longer tenable.

12 Ibid., pp. 45–46.

13 "Elle crève de douleur et de jalousie, de ce qu'on a accordé le pas sur elle à sa cadette." Diderot 1984b (*Salon de 1761*), p. 166.

14 "Il est vêtu à merveille, sans sortir de son état." Ibid., p. 167.

15 "Une figure charmante, décente et réservée." Ibid.

16 "C'est une idée délicate du peintre." Ibid., p. 168.

17 "Une bonne paysanne qui touche à la soixantaine." Ibid.

18 See Barker 1997 and Rand 1996.

19 "Le Père qui fait la lecture à sa famille, le Fils ingrat, et les Fiançailles de Greuze . . . sont autant pour moi des tableaux d'histoire que les Sept Sacrements du Poussin, [ou] la Famille de Darius de Le Brun." Diderot 1984b, pp. 66–67.

20 "En balançant donc, d'un côté le désagrément de le laisser échapper et peut-être en pays étranger . . . je crois devoir m'en tenir à vingt ou 24,000 en plus." D'Angiviller à Pierre, 3 April 1782 (cited by Munhall, in Diderot 1984a, p. 226). (D'Angiviller perhaps had in mind Greuze's sale of *Filial Piety* to Catherine the Great in 1766.)

21 See ibid.; Ingamells 1989, pp. 77–78.

22 Barker 1997, pp. 44, 50. Barker (1994, I, pp. 53–56) provides the most thorough survey of potential sources, noting also that Greuze was familiar with the engravings after Hogarth's *Marriage à la Mode* (even though he transforms "satire into sentiment").

23 Barker 1997, p. 45; Ledbury 2000, p. 150.

24 Ibid., p. 146.

25 Munhall, in Diderot 1984a, p. 226; Barker 1994, I, p. 52.

26 "Une femme de beaucoup d'esprit a remarqué que ce tableau était composé de deux natures . . . que la mère, la fiancée et toutes les autres figures sont de la halle de Paris. La mère est une grosse marchande de fruits ou de poissons; la fille est une jolie bouquetière." Diderot 1984b (*Salon de 1761*), pp. 169–70.

27 "Pour signer le contrat de mariage de Babet, qui passe pour sa fille"; see the detailed synopsis that appeared in the *Mercure de France* (April 1761), pp. 165–71. The *Correspondance Littéraire* (IV, pp. 368–69) commented in April 1761 that the play "est gaie et n'a aucune prétention, et cela l'a fait réussir au-delà de son mérite."

Cat. 72
Jean-Baptiste Greuze (1725–1805)
Filial Piety
La piété filiale
1763
Oil on canvas, 115 × 146 cm
The Hermitage State Museum, Saint Petersburg

Salon of 1763, no. 140, as *La Piété filiale.*

Provenance: sold by Greuze to Empress Catherine II in 1766.

Selected References: Munhall, in Diderot 1984a, pp. 232–37; Barker 1994, I, pp. 82–114; London 2001, pp. 118–30; Munhall 2002, pp. 91–95.

Notes

1 Munhall (in Diderot 1984a) cites a drawing last mentioned in the Revoil sale of 24 February 1845, apparently signed and dated "1760." He has proposed two candidates for the compositional drawing shown at the Salon of 1761 entitled "Un paralytique soigné par sa famille": the drawing in Le Havre (fig. 130) and the more elaborate, highly worked drawing in the Louvre, closer in conception to the final painting (see Munhall 2002, pp. 91–93). In the former drawing, only two generations of the family appear (with everyone shown slightly younger); since Diderot specified that the old man was being looked after by his *children* (and not his grandchildren as well), it may be prudent to retain Munhall's earlier identification of the Le Havre drawing as that exhibited in 1761.

2 Grimm and Mariette both noted that Greuze had turned down substantial offers for the painting. "Il a refusé un gros prix, et je crains qu'il ne s'en repente" (Mariette 1851–60, II, p. 330); Grimm specified the amount as four thousand *livres* ("On m'a assuré que l'auteur en avait refusé deux mille écus"): see Munhall, in Diderot 1984a, p. 235.

3 Not that the paintings were conceived as pendants, an error that has occasionally slipped into modern scholarship. As Mathon de La Cour noted, "Ils ne sont pas destinés à servir de pendant; ils ne sont pas seulement de la même grandeur" (*Lettres à Madame ** sur les Peintures, les Sculptures, et les Gravures exposées dans le Sallon du Louvre en 1763*, Paris, 1763, p. 69).

4 "A nous toucher, à nous instruire, à nous corriger et à nous inviter à la vertu." Diderot 1984b (*Salon de 1763*), p. 234.

5 "Je sentis, comme elle, mon âme s'attendrir et des pleurs prêts à tomber de mes yeux." Ibid.

6 "J'ai vu de mes yeux une femme approcher du tableau de Greuze, l'envisager, et fondre en larmes. On m'a dit que cela est arrivé plus d'une fois pendant le Salon; il n'y a point de critique que ces larmes n'effacent." Seznec and Adhémar 1957–67, I, p. 238.

7 "Un philosophe incroyant s'est converti devant une scène si touchante." *Affiches, annonces et avis divers* (September 1763), p. 152.

8 It is difficult to accept that *Filial Piety* illustrates a passage from Marco Girolamo Vida's *Parentum Manibus* – an obscure sixteenth-century Latin poem, which would be translated into French only in 1809, but which was claimed as Greuze's source by the critic of the *Affiches de Paris*; see Munhall, in Diderot 1984a, p. 235, and Barker 1994, pp. 89, 107. *Pace* Diderot, most critics assumed, reasonably enough, that the paralytic was being tended to by his *son*, to whom he was addressing words of wisdom. This was consistent with current medical opinion that stroke victims retained their mental faculties, even if their bodily functions were impaired: "Il est assez rare qu'elles se rencontrent ensemble, plus souvent le mouvement est aboli & le sentiment persiste" (*Encyclopédie*, XI, p. 910, article on "Paralysie").

9 "Elle a sur ses genoux l'Écriture sainte. Elle a suspendu la lecture qu'elle faisait au bonhomme." Diderot 1984b (*Salon de 1763*), p. 235.

10 "Un peu de vin vieux, qu'on réservoit pour les grandes occasions." *Lettres à Madame ** sur les Peintures, les Sculptures, et les Gravures exposées dans le Sallon du Louvre en 1763*, Paris 1763, p. 65.

11 "Comme il tient l'oiseau! Comme il l'offre! Il croit que cela va guérir le grand-papa." Diderot 1984b (*Salon de 1763*), p. 235.

12 A point first made by Crow (1985, p. 150).

13 "Nous croyons pouvoir assurer que la description qu'on vient de lire est exactement conforme à l'intention du Peintre." *Description des Tableaux exposés au Sallon du Louvre, avec des remarques. Par une société d'amateurs*, Paris, 1763, p. 57; this commentary was first published in the *Mercure de France* in November 1763.

14 "Moins riante, mais peut-être encore plus morale." Ibid., p. 55.

15 Barker 1994, I, p. 82. Responding to Greuze's drawing at the Salon of 1761, Grimm would have preferred a father afflicted with gout rather than paralysis, since "la goutte ordinaire n'ôte même pas la gaîté." Seznec and Adhémar 1957–67, I, p. 146. As Barker has shown, this was in line with conventional (and comic) depictions of "Old Age," from which Greuze studiously distanced himself.

16 Barker 1994, I, pp. 84–91.

17 "On en entendit parler à la Cour, on le fit venir, il fut regardé avec admiration, mais on ne le prit pas, et il en coûta une vingtaine d'écus à l'artiste pour avoir le bonheur inestimable." Diderot 1984b (*Salon de 1765*), p. 200.

18 "Le lien des familles, l'amour filial, la tendresse paternelle, l'attachement domestique, le respect qu'on porte au chef et au père de famille, la justice de celui-ci envers tout ce qui est soumis à son autorité, les droits de la parenté respecté, l'intérêt commun de la famille animant tous ceux qui la composent: voilà ce qui forme les moeurs publiques d'une nation." *Correspondance Littéraire*, V, pp. 301–02, June 1763 (following a review of Faignet's *L'Économe politique, projet pour enrichir et perfectionner l'espèce humaine*, which had appeared the previous winter).

Cat. 73
Jean-Baptiste Greuze (1725–1805)
Child Playing with a Dog
Un jeune enfant qui joue avec un chien
1767
Oil on canvas, 62.9 × 52.7 cm
Private collection, England

Salon of 1769, no. 155, as *Un jeune Enfant qui joue avec un Chien*.

Provenance: Étienne-François de Choiseul-Stainville, Duc de Choiseul (1719–1785), Paris, by 1769; his sale, Paris, 6–10 April 1772, lot 136, sold for 7,200 *livres*; Jeanne Bécu, Comtesse du Barry (1743–1793), Louveciennes; her sales, Paris, 22 December 1775, lot 20, unsold, and Paris, 17 February 1777, lot 51, sold for 7,201 *livres* to Paillet for the Marquis de Véri; Louis-Gabriel, Marquis de Véri (1722–1785), Paris; his sale, Paris, 12–14 December 1785, lot 24, sold for 7,200 *livres* to Duclos-Dufresnoy; Duclos-Dufresnoy, Paris; his sale, Paris, 28 August 1795, lot 11, sold for 140,500 *livres assignats*; Montaleau, Paris; his sale, Paris, 10 September 1802, lot 46, sold for 8,016 *livres*; Robert de Saint-Victor, Paris; his sale, Paris, 26 November 1822 and 7 January 1823, lot 529; George Watson Taylor, London, 1824; his sale, London, 24 July 1832, lot 70, sold for £703 10s; Richard Manley Foster, Clewer Manor; his sale, London, 3 June 1876, lot 16, sold for £6,720 to Lord Dudley; Lord Bearsted, Upton House, near Banbury, 1892.

Selected References: Munhall 1976, pp. 126–27; Munhall, in Diderot 1984a, pp. 259–62; Bailey 2002, pp. 115–17, 132.

Notes

1 The other pictures Diderot mentions are *The Votive Offering to Cupid* (The Wallace Collection, London) and *The Blown Kiss* (private collection), both shown at the Salon of 1769 as from the collection of the Duc de Choiseul (Diderot had commented upon the latter at the end of his review of the Salon of 1765).

2 "La petite fille en chemise qui s'est saisie d'un petit chien noir qui cherche à se débarrasser de ses bras. Cela est beau, vraiment beau." Diderot *Correspondance*, VII, pp. 103–04.

3 "Le Greuze vient de faire une tour de force. Il s'est tout à coup élancé de la bambochade dans la grande peinture." Ibid., p. 102.

4 "Sans contredit le morceau le plus parfait qu'il y eût au Salon" (Diderot 1984b [*Salon de 1769*], p. 92); "Le plus universellement applaudi est une jeune enfant qui joue

avec un chien" ([Fréron], "Exposition des Peintures, Sculptures & Gravures," *L'Année Littéraire* [September 1769], p. 310).

5 Munhall 1976, p. 126, quoting the entry from Smith's *Catalogue raisonné of the Works of the Most Eminent Dutch, Flemish and French Painters*, London, 1837.

6 "Il est vivant, il a les yeux éraillés de la vieillesse." Diderot 1984b (*Salon de 1769*), p. 92.

7 Munhall 1976, p. 126.

8 Ibid.; Munhall 2002, pp. 124–25.

9 "C'est de tous les chiens celui qui a la plus belle tête . . . il est fidèle et caressant." *Encyclopédie*, III, p. 329.

10 "On n'a rien fait de mieux que la tête et le genou de cet enfant depuis le rétablissement de la peinture." Diderot 1984b (*Salon de 1769*), p. 92.

11 "Le bout de chemise qui est sur le bras est un morceau de pierre sillonné. . . . La tête tournerait encore davantage si les bords du béguin étaient plus éclairés." Diderot 1984b (*Salon de 1769*), p. 93. See also his discussion with La Tour on Greuze's *Child Playing with a Dog*, earlier in his review of the Salon of 1769 (ibid., p. 48).

12 "Ce morceau [est] regardé comme le chef-d'oeuvre de ce célèbre Peintre" (*Catalogue de Tableaux Précieux . . . d'un Cabinet distingué* [Comtesse du Barry], Paris, 22 December 1775, p. 15); "Les Amateurs s'accordent à le regarder presque comme le chef d'oeuvre de M. Greuze dans ce genre" (*Catalogue des Tableaux . . . du Cabinet de feu M. le Marquis de VERI*, Paris, 12 December 1785, p. 19).

13 Watson, in Snowman 1990, Appendix B. He noted that it is also shown a second time in Van Blarenberghe's miniatures of the Choiseul box, hanging over the overmantel mirror in the *Cabinet à la Lanterne*.

14 Bailey 2002, pp. 115–16, 141.

Cat. 74
Jean-Baptiste Greuze (1725–1805)
The Woman of Good Deeds
La dame de charité
1775
Oil on canvas, 112 × 146 cm
Musée des Beaux-Arts de Lyon

Exhibited in Greuze's studio, August–October 1775, and in Pahin de La Blancherie's Salon de la Correspondance, Paris, 18 December 1783.

Provenance: Charles-Nicolas Duclos-Dufresnoy (1733–1794), Paris; his sale, Paris, 18–21 August 1795, no. 8, sold 74,000 *livres assignats*; de Montaleau, Paris; his sale, Paris, 19–29 July 1802, no. 44; Prince Anatole Demidoff, San Donato Palace, near Florence; his sale, Paris, 13–16 January 1863, no. 3, sold for 49,000 francs to Mannheim *fils*; acquired by the city of Lyons in 1897.

Selected References: Munhall 1964; Munhall 1977, pp. 168–71; Soubeyran and Vilain 1975; Bailey 2002, pp. 131–42.

Notes

1 Goodman 1995, p. 70; "Greuze couve pendant des mois entiers la composition d'un seul, et me quelquefois un an à l'exécuter" (Diderot 1995a [*Salon de 1767*], p. 158).

2 Munhall (1977, p. 170) has drawn attention to Massard's preliminary engraving entitled *Étude du tableau de la dame de charité*, which is dated 1772. For a listing of the many preparatory drawings for this painting, see Munhall 1977, pp. 168–71, and Munhall 2002, pp. 208–09; also Goldner 1988–2001, I, p. 166.

3 "Vous ne croiriez pas que j'ai eu autant de peine à percer chez lui, qu'au Salon?" *La Lanterne magique aux Champs-Elysées, ou Entretien des Grands Peintres Sur le Sallon de 1775*, Paris, 1775, p. 16.

4 "Ce que j'ai dit à M. Greuze de son tableau: Si je n'amois pas la vertu, il n'en donneroit le goût." Dauban 1867, I, pp. 303–04 (letter of 31 October 1775).

5 Greuze's red-chalk drawing *Head of a Man in Profile*, in

the Louvre, is inscribed "étude pour son paralytique"; see Munhall 2002, p. 208.

6 "Un bon gentilhomme designé par son épée suspendu à son chevet suivant l'usage des provinces, où il y a beaucoup de noblesse indigente, telle qu'en Bretagne." [Anon.], *Observations de Bachaumont sur la Dame de charité, tableau de Mr. Greuze*, Collection Deloynes, no. 221.

7 "Le tableau le plus pathétique que j'aie vu de ma vie, il me touche jusqu'aux larmes." Soubeyran and Vilain 1975, p. 98.

8 "Capable de faire naître dans les coeurs les moins sensibles des mouvements de compation [*sic*], de pitié et d'admiration." Ibid., p. 99.

9 "Cet enfant peu accoutumé à de pareils spectacles, éprouve une espèce de répugnance qui lui fait reculer le corps, en même tems que son heureux naturel la part à tendre la main." Ibid., p. 98.

10 "Elle regarde la jeune dame et semble lui dire, Sans vous nous allions périr de misère." Ibid., p. 98.

11 Munhall 1964, p. 10. In discussing the role of this figure, Brookner (1972, pp. 120–21) noted that she was "a sour-faced nun of the order of St Vincent de Paul."

12 "Le caractère de cette figure est un carctère d'indifférence . . . qui nous montre en même tems que l'habitude de voir des malheureux émousse la sensibilité." Soubeyran and Vilain 1975, p. 98.

13 "Un petit garçon, seul secours des deux malades . . . paroit intimidé par la présence de la jeune dame." Ibid. See Munhall 1977, p. 170, for a discussion of this figure as a Savoyard.

14 "C'est la marque non équivoque de sa qualité." Soubeyran and Vilain 1975, p. 98.

15 "On voit une planche sur laquelle sont rangés quelques livres de philosophie, dont la lecture, en consolant le gentilhomme de son infortune, entretient en lui la grandeur de ses sentiments." Ibid.

16 "Une petite bouteille vuide dont la forme anonce qu'elle contenoit une médecine." Ibid.

17 "Tous ces accessoires contribuent on ne peut plus heureusement à faire connoître l'indigente situation des deux malades." Ibid.

18 "Un gentilhomme qu'un procès attire à Paris s'y trouve malade et dans la plus grande indigence." *Nouvelles de la République des lettres et des arts*, 18 December 1783. The *Dame de charité* was exhibited with five other paintings from Duclos-Dufresnoy's collection.

19 The *Woman of Good Deeds* was first published as in his collection by the abbé Lebrun in 1777: "Parmi les tableaux modernes qu'on y voit, sont des Vernet, la *Dame de Charité* & le *Gâteau des Rois* de M. Greuze &c" (Lebrun 1776–77, II, p. 183).

20 Bailey 2002, pp. 139–40.

Cat. 75
Jean-Honoré Fragonard (1732–1806)
Blindman's Buff
Le colin-maillard
c. 1750–55
Oil on canvas, 117 × 91.5 cm
Toledo Museum of Art, Ohio
Purchased with funds from the Libbey Endowment
Gift of Edward Drummond Libbey

Provenance: sale, Baron Baillet de Saint-Julien, Paris, 21 June 1784, no. 75; sale, Morel (or Morelle), Paris, 3 May 1786, no. 177; sale, Ferlet, Paris, 18 April 1792, no. 25; Comte de Sinéty, Paris, 1889; Baron Nathaniel de Rothschild, Vienna, probably before 1902; Baron Maurice de Rothschild, Château de Prégny, Switzerland (purchased by Rosenberg & Stiebel, New York); acquired by the museum, 1954.

Selected References: Wildenstein 1960, p. 202, no. 47; Rosenberg 1987a, pp. 46–48, no. 5; Cuzin 1987, p. 268, no. 44; Rand 1997, pp. 138–39, no. 22; Milam 1998, pp. 1–25.

Notes

1 On this topic, see especially Cuzin 1986, p. 59; also Posner 1982, pp. 75–88.
2 See Rosenberg 1987a, p. 46.
3 Bailey 2000b (p. 86, n. 153) has recently suggested that the young woman was a laundress.
4 Around the same period as the four paintings in the Detroit Institute of Art and the *Seasons* in the Hôtel Matignon and the Los Angeles County Museum, Rosenberg 1987a, pp. 40–45, nos. 1–4; p. 50, no. 7.
5 See Laing 1986a (pp. 176–79, nos. 30–31) for the paintings in the Hôtel Soubise.
6 Ibid., p. 177.

Cat. 76
Jean-Honoré Fragonard (1732–1806)
The Washerwomen
Les blanchisseuses ou La lessive
c. 1759–60
Oil on canvas, 61.5 × 73 cm
The Saint Louis Art Museum, Saint Louis, Missouri
Purchase

Provenance: Bachstitz Gallery; Benedict Cathabard, Lyon; private collection, New York; private collection, Moscow; Arnold Seligmann, Rey & Co.; acquired by the museum in 1937.

Selected References: Wildenstein 1960, p. 279, no. 361; Thuillier 1967, p. 49; Cuzin 1986, p. 61; Cuzin 1987, p. 273, no. 72; Rosenberg 1987a, pp. 88–89, no. 21; Cuzin and Rosenberg 1990.

Notes

1 Cuzin 1987, p. 53, fig. 62.
2 Rosenberg 1987a, p. 89, fig. 2.

Cat. 77
Jean-Honoré Fragonard (1732–1806)
The Laundresses
Les blanchisseuses ou L'étendage
c. 1759–60
Oil on canvas, 59.5 × 73.5 cm
Musée des Beaux-Arts, Rouen

Provenance: Hippolyte Walferdin (1795–1880); his sale, Paris, 12–16 April 1880, no. 22; purchased by the museum, 1880.

Selected References: Wildenstein 1960, p. 279, no. 362; Cuzin 1986, p. 61; Cuzin 1987, p. 273, no. 71; Rosenberg 1987a, pp. 90–91, no. 22; Cuzin and Rosenberg 1990.

Note

1 Bailey 2000b.

Cat. 78
Jean-Honoré Fragonard (1732–1806)
The Lost Forfeit or Captured Kiss
L'enjeu perdu ou Le baiser gagné
c. 1759–61
Oil on canvas, 48.3 × 63.5 cm
The Metropolitan Museum of Art, New York
Gift of Jessie Woolworth Donahue, 1956

Provenance: Jacques-Laure Le Tonnelier, Bailli de Breteuil (1723–1785); his sale, Paris, 1786, no. 49 (purchased by Guérin for 500 *livres*); Marquis de Chamgrand (de Proth, Saint-Maurice) sale, Paris, 1787, no. 224; Dr. Aussant, Rennes; his sale, Paris, 1863, no. 31; Comte Duchâtel collection, 1863–89; Morton F. Plant (?); Mrs. William Hayward, New York, 1933–44; (M. Knoedler and Co.), 1944; Mrs. James P. (Jessie Woolworth) Donahue, New York; her gift to the museum, 1956.

Selected References: Wildenstein 1960, p. 224, no. 119; Cuzin 1987, pp. 49–50, 274, no. 76; Rosenberg 1987a, pp. 82–83, no. 18; Rand 1997, pp. 138–39, no. 22.

Notes

1 Wildenstein 1960, pp. 202–03, nos. 47–48; Cuzin 1987, pp. 267–68, nos. 43–44; Rosenberg 1987a, pp. 46–59, nos. 5–6; Rand 1997, pp. 138–39, no. 21.
2 Wildenstein 1960, p. 224, no. 118; Cuzin 1987, p. 24, no. 77; Rosenberg 1987a, pp. 79–81, no. 16. A sketch of similar composition, in the same format, with the theme of the "Poor Family," is in Moscow's Pushkin Museum.

Cat. 79
Jean-Honoré Fragonard (1732–1806)
The Happy Family
La famille heureuse
after 1769
Oil on canvas, 53.9 × 65.1 cm
National Gallery of Art, Washington, D.C.
Timken Collection

Provenance: probably sale of Comtesse du Barry, Radix de Sainte Foy, 17 February 1777, Paris, no. 55; Duc de La Rochefoucauld-Liancourt; Poilleux; Eduardo Guinle, Rio de Janeiro; Nicolas Ambatielos, London; William R. Timken; Lillian Guyer Timken, bequest to the museum, 1936.

Selected References: Cuzin 1987, p. 188, no. 311; Rosenberg 1987a, pp. 456–58, no. 222; Sheriff 1991.

Notes

1 Auction catalogue Du Barry and Radix de Sainte Foy, 17 February 1777, no. 55. "Un tableau touché avec beaucoup de feu et d'un effet excellent, il représente l'intérieur d'une chambre dans laquelle est une femme avec plusieurs enfants; on voit paroître à une croisée un homme qui semble les surprendre"; quoted in Rosenberg 1987a, p. 456, no. 222.
2 See Duncan 1973; *Greuze & Diderot. Vie familiale et éducation dans la seconde moitié du XVIIIᵉᵐᵉ siècle*, exhib. cat., Clermont-Ferrand, 1984; Swain 1997.
3 C.-P. Landon, *Salon de 1808*, 2 vols., Paris, 1808 Salon, I, p. 8. "Fragonard, doué d'une imagination vive et d'une grande facilité d'exécution . . . abandonna les compositions nobles et les études sérieuses pour se vouer à des sujets d'un ordre inférieur, destinés seulement à faire briller la légèreté d'invention, le jeu piquant des ombres et des lumières, et la grâce d'une touche fine et spirituelle"; quoted in Rosenberg 1987b, p. 89.

Cat. 80
Jean-Honoré Fragonard (1732–1806)
Young Girl Playing with her Dog ("La Gimblette")
Jeune fille faisant danser son chien (La gimblette)
c. 1770–75
Oil on canvas, 89 × 70 cm
Bayerische Staatsgemäldesammlungen, Alte Pinakothek, Munich
Collection of the Bayerische Hypotheken- und Wechsel-Bank

Provenance: widow of Lebas de Courmont, sale, 26 May 1795, no. 40; Demidoff Père sale, 8–13 April 1839, no. 88 (?); sale, 10–11 December 1847, no. 38 (?); sale, 14 March 1868, no. 8 (?); Hippolyte Walferdin (1795–1880) sale, 12–16 April 1880, no. 61; Poidatz, 1889; Arthur Veil-Picard; Jeannette Veil-Picard; purchased by the Bayerische Hypotheken- und Wechsel-Bank for the museum, 1977.

Selected References: Wildenstein 1960, p. 262, no. 280; *Münchener Jahrbuch der bildenden Kunst*, III:29 (1978), pp. 242–44; Cuzin 1987, pp. 182–84, 313, no. 282; Rosenberg 1987a, pp. 232–34, no. 110.

Notes

1 "M. Fragonard? Il perd son temps et son talent: il gagne de l'argent." Cited in Rosenberg 1987a, p. 300.
2 See Rand 1997, pp. 142–43, no. 24.
3 See Paris 1992, pp. 191–273.
4 "Sa débauche, doivent captiver les petit-maîtres, les

petites femmes, les jeunes gens, les gens du monde, la foule de ceux qui sont étrangers au vrai goût, à la vérité, aux idées justes, à la sévérité de l'art; comment résisteraient-ils au saillant, au libertinage, à l'éclat, aux pompons, aux tétons, aux fesses, à l'épigramme de Boucher." Diderot 1984b, p. 120.

5 Cf. the *Odalisque blonde* (Bayerische Staatsgemälde-sammlungen, Alte Pinakothek, Munich), in Laing 1986a, pp. 259–64, no. 61.

6 See, in this regard, A.-C.-P. Comte de Caylus, "De la légèreté de l'outil," in *Vie d'artistes du XVIIIᵉ siècle, Discours sur la peinture*, edited by A. Fontaine, Paris, 1910, pp. 150–57; see also Sheriff 1990, particularly pp. 122–32.

7 Roger Portalis (1889, p. 65) described the collection as follows: "Varanchan aimait les études, les choses librement faites. Il avait réuni chez lui de ces notes intimes, des gouaches pleines de ragoût de Baudouin, des académies de jeunes filles de Boucher, aux chairs délicieusement fraîches, égayées par de piquants rehauts de crayons de couleur, et quelques-unes des plus libres productions de Fragonard."

8 Cuzin 1987, p. 341, no. D4. Concerning a number of engravings, copies, and variants incorporating Fragonard's creation, see Rosenberg 1987a, pp. 232, 234.

Cat. 81

JEAN-HONORÉ FRAGONARD (1732–1806)
A Young Girl Reading
Jeune fille lisant
1771–73
Oil on canvas, 81 × 65 cm
National Gallery of Art, Washington, D.C.
Gift of Mrs. Mellon Bruce in memory of her father, Andrew W. Mellon

Provenance: likely Comte du Barry, Paris; sale (inscribed as Comte du Barry), Paris, 11 March 1776, no. 80 (purchased by Mailly); sale, Paris, 7 February 1777, no. 15; Leroy de Senneville, Paris; his sale, Paris, 5 April 1780, no. 59 (purchased by Duquesnoy); Duquesnoy sale, Paris, 10 March 1803, no. 19; sale, Alliance des Arts, Paris, 26 April 1844, no. 14; Marquis de Cypierre; his sale, Paris, 10 March 1845, no. 55; catalogued by Portalis as Comte de Kergolay collection in 1889; Wildenstein; sold by Gimpel in 1899 to Ernest Cronier, Paris; Cronier sale, Paris, 4 December 1905, no. 8, purchased by Ducrey; Théodore Tuffier, Paris, by 1910, still in his collection, 1921; Wildenstein; Alfred Erickson, New York, by 1930, and upon his death in 1936 to his wife, Anna Erickson, New York; Erickson sale, Parke-Bernet Galleries, New York, 15 November 1961, no. 16, purchased by Ailsa Mellon Bruce, New York; gift to the museum, 1961.[1]

Selected References: Portalis 1889, II, pp. 202, 282; Wildenstein 1960, no. 39; Gimpel 1963, pp. 310, 415; Rosenberg 1987a, no. 136; Rand 2004.

Notes

1 Adapted from Richard Rand's thorough catalogue entry for this work in Conisbee 2004, forthcoming.

2 For a discussion of Fragonard's *portraits de fantaisie*, see Wildenstein 1960, pp. 14–15; Rosenberg 1987a, pp. 255–93; Sheriff 1990, pp. 153–84.

3 Reproduced in Rosenberg 1987a, p. 282.

4 Rand 2004.

5 Jacques-André-Joseph Aved (1702–1766) was a fellow artist. Chardin's portrait was exhibited in 1737 as *Chimiste dans son Laboratoire*. Other paintings at the Salon that treat the subject of reading include Carle Van Loo, *Une Lecture*, 1761; Jean-Baptiste Le Prince, *Une Femme qui . . . écoute une vieille qui fait une lecture* and *Une Femme asiatique méditant sur sa lecture*, both of 1773; and Jean Laurent Mosnier, *Une jeune Personne méditant sur une lecture*, 1789.

6 A 16-cm binding was not uncommon. For a discussion of publishing in the eighteenth century, see Martin and Chartier 1984.

7 See Ananoff 1961–70, I: *Le Concours*, no. 26; *La Lecture*, no. 64; II: *La Lecture à la ferme*, no. 43.

8 *Catalogue de tableaux et marbres dont la vente sera le Lundi 11 March 1776*, Chez Paillet, Paris, 1776, no. 80. Gabriel de Saint-Aubin drew a sketch of the work in a copy of the catalogue now in the Philadelphia Museum of Art, reproduced in Rosenberg 1987a, p. 282.

Cat. 82

JEAN-HONORÉ FRAGONARD (1732–1806)
The Charlatans
Les charlatans
c. 1775–80
Oil on canvas, 49.5 × 38.7 cm
Private collection

Provenance: Hippolyte Walferdin; his sale, Paris, 12–16 April 1880, no. 11; Brame (?) sale, 20 March 1883, lot 11; A. Courtin sale, 29 March 1886, lot. 5; P. Watel; his widow, Mme. Watel, 1889; C. Marcille (according to Wildenstein 1960); C. Groult; Wildenstein, New York; Emil Bührle, Zurich; Mme. C. Bührle, Zürich; private collection, USA.

Selected References: Wildenstein 1960, p. 294, no. 433; Cuzin 1987, pp. 200, 326, no. 344; Rosenberg 1987a, p. 340, fig. 3.

Notes

1 Gaehtgens 1983; Tavernier 1990, pp. 165–200.

2 Edmund Burke, *A Philosophical Inquiry into the Origin of our Ideas of the Sublime and the Beautiful*, London, 1759.

3 Émile Campardon, *Les spectacles de la foire: Théâtres, acteurs, sauteurs et danseurs de corde, monstres, géants, nains, animaux curieux ou savants, marionettes, automates, figures de cire et jeux mécaniques des foires Saint-German et Saint-Laurent, des boulevards et du Palais-Royal depuis 1595 jusqu'à 1791*, Documents inédits aux Archives nationales, reprint of the Paris 1877 edition, Geneva, 1970, p. 400. A reference kindly passed on by Pierre Frantz, Paris.

4 Wildenstein 1960, p. 294, no. 434; Gaehtgens 1983, p. 30; Cuzin 1987, pp. 200, 326, no. 344; Rosenberg 1987a, p. 340, fig. 2.

5 Wildenstein 1960, p. 294, no. 435; Gaehtgens 1983, p. 31; Cuzin 1987, pp. 200, 326, no. 344; Rosenberg 1987a, p. 340, fig. 1.

Cat. 83 and 84

JEAN-HONORÉ FRAGONARD (1732–1806)
Sketch for "The Bolt"
Étude pour "Le verrou"
c. 1778
Oil on wood, 26 × 32.5 cm
Private collection

Provenance: seizure of Duc de Coigny collection, 1794; Jourdan sale, 4 April 1803, no. 13; B.G. Sage sale, 8 February 1827, no. 43; Abel Remusat sale, 22–23 April 1833, no. 17 or 11; first Bertrand sale, 17 March 1854, Saint-Germain-en-Laye, no. 7; second Bertrand sale, 16–17 November 1855, no. 387 (acquired by H.D.); Adrien Fauchier Magnan, Paris; Wildenstein, New York; Baronness von Cramm, New York, 1960; her sale, Sotheby's, London, 24 June 1964, no. 41; private collection; sale, Sotheby's, Monte Carlo, 14 February 1983, no. 645; private collection.

The Bolt
Le verrou
1776–79
Oil on canvas, 73 × 93 cm
Musée du Louvre, Paris

Provenance: Marquis de Véri sale, Paris, 12 December 1785, no. 37 (purchased by art dealer Lebrun for 3950 *livres*); Laurent Grimod de La Reynière sale, Paris, 3 April 1793, no. 28 (purchased by art dealer Lebrun for 3010 *livres*); Gabriel d'Arjuzon (offered to the Louvre in 1817?); Marquis A. de Bailleul, 1887; Madame de La Potterie, 1921 (offered to the

Louvre by G. Sortais in 1922); Madame Le Pelletier, 1927; André Vincent sale, Galerie Charpentier, Paris, 26 May 1933, no. 21; Lebaron-Cotnareanu sale, Paris, Palais Galliéra, 21 March 1969, no. 166; acquired by the museum, 1974.

Selected References: Rosenberg and Compin 1974b; Wildenstein 1975; Cuzin 1987, pp. 179–82; Rosenberg 1987a, pp. 481–85, nos. 236, 237.

Notes

1 "Auprès d'un lit, dont le désordre indique le reste du sujet." Paillet 1785, p. 26, no. 37.

2 On the concept of "volupté" in the eighteenth century see Mauzi 1979, ch. 10.

3 Such a scene is depicted in Boilly's *L'Amant favorisé*; see Duncan 1973, especially p. 574, fig. 7.

4 See Paris 1992, pp. 191–274.

5 "La conduisit de fleurette en fleurette / . . . / Puis, tout à coup levant la colerette, / Prit un baiser dont l'époux fut témoin." La Fontaine, "Les Rémois," *Contes et Nouvelles*, III, in *Oeuvres complètes* (I. Fables, contes et nouvelles), Jean-Pierre Collinet, ed., Paris, 1991, p. 717.

6 See Bailey 1985.

7 See Cuzin 1987, pp. 178–79; Rosenberg 1987a, pp. 478–79, no. 234; Rosenberg 1988.

8 "Chef-d'œuvre, dans lequel M. Fragonard semble avoir voulu prodiguer toutes les richesses d'une imagination vive & savante." Paillet 1785, p. 25.

9 "Croyant faire preuve de génie, par un contraste bizarre lui fit un tableau libre et rempli de passion, connu sous le nom du *Verrou*." Lenoir 1816.

10 Paillet (1785, p. 26) listed the two pictures one after the other but under separate numbers, and described *Le Verrou* as "un sujet tout opposé."

11 "Nous admettons la distinction de Peintre d'Histoire et de Bambochade seulement par leurs productions. Or comme l'Auteur du *Verrou* ne traitait pas un sujet d'Histoire, il aurait dû entrer dans tous les détails essentiels aux tableaux du genre inférieur." Abbé de Fontenai and M. de Saint-Félix, "Affiches, Annonces et Avis divers, 8 and 22 May 1784," p. 272, quoted in Rosenberg and Compin 1974b, pp. 272–73.

Cat. 85

JEAN-HONORÉ FRAGONARD (1732–1806)
The New Model
Les débuts du modèle
c. 1778
Oil on canvas, 65 × 54 cm
Musée Jacquemart-André, Paris

Provenance: J. Folliot sale, Paris, 15–16 April 1793, no. 49; Barroilhet sale, 10 March 1856, Paris, no. 27; sale, 19 March 1857, Paris, no. 16; Hippolyte Walferdin, 1860; his sale, Paris, 12–16 April 1880, no. 31; Jacquemart-André collection; bequest of Mme André to museum, 1912.

Selected References: Sheriff 1986; Rosenberg 1987a, pp. 316–17, no. 150; Sheriff 1990; Clements 1992.

Notes

1 "Si les Tableaux soigneusement finis plaisent plus vulgairement, il est une certaine classe d'Amateurs qui jouissent suprêmement sur un seul croquis; ils recherchent l'âme et les pensées de l'homme de génie qu'ils savent voir et reconnoître." Varanchan de Saint-Geniès, auction catalogue, 1777, quoted in Rosenberg 1987a, p. 421.

2 "Je voudrais bien peindre une femme toute nue, sans blesser la pudeur"; "Faites le modèle honnête"; "que son expression soit celle de l'innocence, de la pudeur et de la modestie"; "témoin de cette scène, attendri, touché, laisse tomber sa palette." Denis Diderot, *Salon de 1767*, quoted in Versini 1996, pp. 574–75.

3 "Je me mis aussitôt à ébaucher la partie superieur. A la tête il falloit substituer des formes grecques, les traits de Venus n'étant pas ceux d'une appetisante Parisienne; mais pour la gorge et le reste du corps je ne pouvois rien

fair de mieux que de m'attacher servilement." Mannlich 1989–93, I, p. 198.

Cat. 86
JEAN-HONORÉ FRAGONARD (1732–1806)
The Stolen Kiss
Le baiser à la dérobée
c. 1786–88
Oil on canvas, 45 × 55 cm
The State Hermitage Museum, Saint Petersburg

Provenance: collection of King Stanislas Augustus Poniatowski of Poland; Lazienski Palace, Warsaw, 1851; acquired by Tsar Nicolas II in 1895.

Selected References: Rosenberg and Rosenblum 1974, pp. 415–16, no. 60; Cuzin 1987, pp. 224–25, no. 383; Rosenberg 1987a, no. 304; Talley 1992.

Notes

1 See the article by Thomas W. Gaehtgens in this catalogue.
2 See Eliel 1989.
3 *Mercure de France* (7 June 1788), p. 95. It is also believed that *The Stolen Kiss* may have been painted as a companion piece to the lost work *Le contrat* (Cuzin 1987, no. 376).
4 See Ananoff 1979. It is interesting to compare *The Stolen Kiss* with *Before the Masked Ball* (c. 1785), by Marguerite Gérard, which was recently exhibited for the first time; Rand 1997, pp. 184–86, no. 42.

Cat. 87
JEAN-HONORÉ FRAGONARD (1732–1806)
and **MARGUERITE GÉRARD** (1761–1837)
The First Steps
Les premiers pas de l'enfance
c. 1780–85
Oil on canvas, 44.45 × 55.25 cm
Fogg Art Museum, Harvard University Art Museums, Cambridge, Massachusetts
Gift of Charles E. Dunlap, 1961

Provenance: "O" collection, sale, Paris, 16–17 December 1839, no. 89; de Rigny sale, Paris, 2 June 1857, no. 40; Pillot sale, Paris, 6–8 December 1858, no. 43; de la Roncière sale, Paris, 28 March 1859, no. 25, attr. to Fragonard; Lord Rosebery, Mentmore, England; Wildenstein and Co., New York; Charles E. Dunlap, Saint-Louis, 1952; his gift to the museum, 1961.

Selected References: Rosenberg and Rosenblum 1975, pp. 441–43, no. 71; Wells-Robertson 1978, pp. 732–34, no. 6; Rosenberg 1987a, pp. 573–75, no. 303; Williams 1993, n.p., fig. 22; Rand 1997, pp. 182–84, no. 41.

Notes

1 See in detail Duncan 1973.
2 See Hilberath 1993, especially pp. 63–66 and 90–91 (fig. 5).
3 For identification of the characters in the painting, see Rosenberg 1987a, p. 574; Pierre Rosenberg believes the older woman to be the grandmother.
4 Milan and Florence 2002, pp. 42, 414, no. I.25
5 See the discussion in Rosenberg 1987a, pp. 573–75, no. 303.
6 Ribeiro 1995, p. 169.

Cat. 88
JEAN-HONORÉ FRAGONARD (1732–1806)
and **MARGUERITE GÉRARD** (1761–1837)
The Reader
La liseuse
c. 1783–85
Oil on canvas, 64.8 × 53.8 cm
Lent by the Syndics of the Fitzwilliam Museum, Cambridge

Provenance: [Champgrand] collection, sale, Paris, 20 March 1787, no. 229 (together with pendant, *Young Woman Playing*

the *Lute Accompanied by an Officer*), as *Mlle Gérard, pupil of M. Fragonard*; sale 9–11 February 1813, no. 310; Bouillac collection, sale, Paris, 29 May 1827, no. 32; Charles Brinsley Marlay collection; gift to the museum, 1912.

Selected References: Winter 1958, p. 375, fig. 94; Goodison and Sutton 1960, p. 177, fig. 92; Wells-Robertson 1978, p. 741, no. 10; Ribeiro 1995, pp. 169–70, fig. 173.

Notes

1 Ribeiro 1995, pp. 169–70.
2 Eliel 1989, pp. 54–56.

Cat. 89 and 90
CLAUDE-JOSEPH VERNET (1714–1789)
Constructing a Main Road
La construction d'un grand chemin
1774
Oil on canvas, 97 × 162 cm
Musée du Louvre, Paris

Salon of 1775, no. 31.

Provenance: Abbé Terray, Paris; Terray sale, Paris, 20 January 1779, no. 2; de Cotte; acquired by the Chambre des Pairs for the Vernet Gallery in the Luxembourg Museum, 1814; transferred to the Louvre, 1816.

Selected References: Lagrange 1864, pp. 198, 368, 466, 481; Ingersoll-Smouse 1926b, II, no. 981; London 1976, no. 46; Conisbee 1977, no. 59; Bailey 2002, pp. 90–91.

The Approach to a Fair
Les abords d'une foire
1774
Oil on canvas, 97 × 162 cm
Musée Fabre, Montpellier

Salon of 1775, no. 31.

Provenance: Abbé Terray, Paris; Terray sale, Paris, 20 January 1779, no. 3; Claude-Joseph Clos sale, Paris, 18–19 November 1812, no. 43 (acquired by Roland); de Sorilène sale, Paris, 5 May 1829, no. 127; acquired from the dealer Roger *fils aîné* by François-Xavier Fabre, 28 July 1829; Fabre bequest, 1837.

Selected References: Lagrange 1864, pp. 198, 368, 466, 476, 481–82; Ingersoll-Smouse 1926b, II, no. 982; Conisbee 1977, no. 60; Bailey 2002, p. 91.

Notes

1 For a very thorough account of Terray as a patron, see the chapter devoted to him in Bailey 2002, pp. 71–100.
2 Fort 1999, p. 143.
3 Bailey 2002, p. 91.

Cat. 91
HUBERT ROBERT (1733–1808)
Laundress and Child
La blanchisseuse avec son enfant
1761
Oil on canvas, 35.1 × 31.6 cm
Signed centre left: *H. ROBERTI ROM / 1761*; centre right, on sheet: *Roberti / Roma / 1761*
Sterling and Francine Clark Art Institute, Williamstown, Massachusetts

Provenance: Adrien Fauchier-Magnan, Neuilly-sur-Seine; sale, Sotheby's, London, 4 December 1935, no. 90 (repr.), as *La Blanchisseuse avec son enfant*; purchased by Knoedler & Co., London; sold, 18 December 1935, to Robert Sterling Clark; acquired by the Clark Art Institute in 1955.

Selected References: Wildenstein and Co., New York 1978, no. 56; Zafran 1983, p. 116, no. 50; Wildenstein and Co., New York 1988, pp. 4, 82; Rand 1997, pp. 162–63, no. 32.

Notes

1 Rand 1997, pp. 162–63, no. 32.
2 An example of this is the painting entitled *Laundresses in the Ruins* (The Hermitage, Saint Petersburg), dated to 1760, in which the laundresses are reduced to simple staffage figures; see Karlsruhe 1996, pp. 108–09, fig. 24.

3 See *Oeuvre de P.A. Martini*, Bibliothèque nationale, Cabinet des Estampes, no. 22 (*Eau-forte d'après Robert par Martini*).
4 Rand 1996, pp. 221–34.
5 On this topic, see Burda 1991.
6 Bailey 2000b, pp. 46–57, 71–75.
7 "Tout est doux, facile, harmonieux, chaud et vigoureux dans ce tableau, que l'artiste paraît avoir exécuté en se jouant. . . . Ce morceau n'est pas fait pour arrêter le commun des spectateurs. Il faut à l'oeil vulgaire quelque chose de plus fort et de plus ressenti. Ceci n'arrête que l'homme sensible au vrai talent." Hubert Robert, *La cuisine italienne* (oil on canvas, 60 × 74 cm, National Museum, Warsaw, inv. 211650); on this topic, see May 1984, pp. 126–29.

Cat. 92
HUBERT ROBERT (1733–1808)
The Artist in his Studio
L'atelier du peintre
c. 1763–65
Oil on canvas, 37 × 46 cm
Signed bottom right, on portfolio: *H.R. / 17*
Museum Boijmans Van Beuningen, Rotterdam

Provenance: Princesse Pascal de Bourbon; Jules M. Féral, Paris, 1932; J. Goudstikker Gallery, Amsterdam; purchased from Goudstikker by D.G. Van Beuningen, 11 September 1937; acquired with the Van Beuningen Collection in 1958.

Selected References: Cuzin and Rosenberg 1990, pp. 190–91, no. 135; Rosenberg 1992, pp. 167–69, no. 38; Wilton and Bignamini 1996, pp. 70–71, no. 30; Beck, Bol and Bückling 1999, pp. 146–47, no. 86; Friedel 2001, p. 160, no. 51; Mai and Wettengl 2002, pp. 347–48, no. 136.

Notes

1 For a detailed analysis of this topic, see Andrea Beate Kleffmann, *Atelierdarstellungen im 18. und 19. Jahrhundert*, Essen, 2000; and Esther Straub-Fischer, "Blick in Ateliers," *Speculum Artis* XVII:4 (1965), pp. 9–16;
2 Rosenberg 1992, pp. 167–69, no. 38, fig. 1.
3 See Haskell and Penny 1994, pp. 219–20, no. 42, fig. 114.
4 The features of the face resemble the famous portrait of Robert painted in 1788 by Elisabeth Vigée-Lebrun (1755–1842), now in the Musée du Louvre, Paris. See the discussion in Rosenberg 1992, pp. 167–69, no. 38, and Wilton and Bignamini 1996, pp. 70–71, no. 30.
5 *Un dessinateur assis à une table, de profil à gauche, dessinant un buste de femme, un dessin d'un buste antique accroché au mur* (red chalk, 32.9 × 43.9 cm; sale Christie's, Paris, 21 March 2002, no. 317).
6 Beck, Bol and Bückling 1999, p. 147; see also Mai and Wettengl 2002, pp. 347–48, no. 136.

Cat. 93 and 94
HUBERT ROBERT (1733–1808)
The Demolition of Houses on the Pont Notre-Dame in 1786
La démolition des maisons du pont Notre-Dame en 1786
1787
Oil on canvas, 81 × 154 cm
Staatliche Kunsthalle Karlsruhe

Provenance: Duchesse de Beaufort, Paris, before 1921; Paul Cailleux, Paris, 1921; Humbert de Wendel, Paris; Madame P. de C., Paris, 1957; acquired by the museum from Galerie Cailleux, Paris, in 1982.

Selected References: Karlsruhe 1984; Held 1990, pp. 293–96; Karlsruhe 1991, pp. 15–17, 26–27; no. 2.

The Demolition of Houses on the Pont-au-Change in 1788
La démolition des maisons du Pont-au-Change en 1788
1788
Oil on canvas, 86.5 × 159.5 cm
Musée Carnavalet–Histoire de Paris, dépôt du Musée de Versailles

Provenance: entered Versailles during the reign (1830–48) of Louis-Philippe; deposited at the Musée Carnavalet in 1898.

Selected References: Held 1990, pp. 293–96; Karlsruhe 1991, pp. 19, 27–28, and under no. 3.

Notes

1 For a very thorough discussion of these paintings in context, see the excellent exhibition catalogue by Ditmar Lüdke, Karlsruhe 1991, from which much of the information in the present catalogue entry is derived.
2 See Karlsruhe 1991, no. 12.
3 See Ibid., no. 112, for a flyer issued by the city of Paris in January 1787 advertising the sale of salvage from the demolition of the houses on the Pont Notre-Dame.
4 For more on laundresses in eighteenth-century Paris, see Bailey 2000b, especially pp. 48–52.
5 For a recent discussion of these paintings, see Radisich 1998, pp. 97–114.

Cat. 95

HUBERT ROBERT (1733–1808)
Jean-Antoine Roucher (1745–1794) as he Prepares to be Transferred from Sainte-Pélagie to Saint-Lazare
Jean-Antoine Roucher (1745–1794) se préparant à son transfert de Sainte-Pélagie à Saint-Lazare
c. 1794
Oil on canvas, 32 × 40 cm
Signed on the bedframe: *H. Robert Pinxit*
Wadsworth Atheneum Museum of Art, Hartford, Connecticut
The Ella Gallup Sumner and Mary Catlin Sumner Collection Fund

Provenance: Baron du Thiel, Paris; Wildenstein and Co., New York; purchase by the Wadsworth Atheneum, 1937.

Selected References: Wildenstein and Co., New York 1943, no. 9; Sutton 1968, no. 594; Rosenthal 1987, pp. 148–49, no. 48 (as *Camille Desmoulins in Prison*).

Notes

1 On Robert's artistic output while imprisoned, see J. Nicolay, "Les assiettes de prison d'Hubert Robert," *Connaissance des Arts* (April 1958), pp. 36–41.
2 Jean de Cayeux gives an overview of the various discussions in *Hubert Robert*, Paris, 1989, pp. 278–82; with regard to the present painting, compare also the drawing *Hubert Robert dans sa cellule à Sainte-Pélagie* (1793; Musée Carnavalet, Paris), which is very similar in composition; see Garrigues 1982, no. 138.
3 Valencia 1989, pp. 62–63, no. 14.
4 At an early stage, Diderot was critical of Robert's figures, which he described as "peu soignées." Diderot 1995a (*Salon of 1767*), p. 336. Like the furniture, the somewhat awkward-looking poet shown in the painting is not very convincing.
5 Rosenthal 1987, pp. 148–49, no. 48, as *Camille Desmoulins in Prison.*
6 On this subject, see Gaborit 1989, II, pp. 455ff., no. 599.
7 See, most recently, Radisich 1998, pp. 117–39.

Cat. 96

NICOLAS-BERNARD LÉPICIÉ (1735–1784)
Interior of a Customs House
L'intérieur d'une douane
1775
Oil on canvas, 98 × 164 cm
Museo Thyssen-Bornemisza, Madrid

Salon of 1775, no. 23.

Provenance: Abbé Terray, Paris; Terray sale, Paris, 20 January 1779, no. 9 (acquired by Dubois); Marquis de Marigny sale, Paris, 18 March 1782, no. 54; Claude-Joseph Clos sale, Paris, 18–19 November 1812, no. 23; given by M. Tarade (d. 1880) to the city of Tours, 1874; the gift rescinded in 1880, the painting given to Tarade's widow, née Anne Limousin; Tarade sale, Paris, 6–9 October 1881, no. 365; Comte Daupias sale, Paris, 16–17 March 1892, no. 28; sale, Paris,

13–15 March 1893, no. 54; Mme C. Lelong sale, Paris, 27 April–1 May 1903, no. 36; Henri de Rothschild; James de Rothschild; James de Rothschild sale, 1 December 1966, no. 127; acquired for the Thyssen-Bornemisza collection, Lugano, 1966.

Selected References: Gaston-Dreyfus 1922, no. 182; Ingersoll-Smouse 1923, p. 132; 1926a, p. 293; 1927, p. 182; Rosenberg and Rosenblum 1975, no. 121; Bailey 2002, pp. 86–89.

Notes

1 For a thorough discussion of Terray as a patron, see the chapter in Bailey 2002, pp. 71–100.
2 "L'on peut dire que les Douanes sont en France, par rapport au commerce, comme le pouls dans le corps de l'homme par rapport à la santé, puisque c'est par elles que l'on peut juger de la vigueur du commerce." "Douane," in Diderot and d'Alembert 1751–76, V, p. 72.
3 "Sa Douane, d'un plus grand dessin, a rappelé la foule, en lui presentent une variété plus multipliée d'objets. . . . Les connaisseurs y trouvent ce repos, cet accord, cette harmonie, qui manquent à ses autres productions." Fort 1999, p. 140.
4 Bailey 2002, pp. 88–89.

Cat. 97

NICOLAS-BERNARD LÉPICIÉ (1735–1784)
The Departure of the Poacher
Le départ du braconnier
1780
Oil on canvas, 81 × 65 cm
Signed lower left, on stone: *N.B. Lépicié, 1780*
Musée des Beaux-Arts et d'Archéologie J. Déchelette, Roanne
Purchased with the help of the Fonds Régional d'Acquisition pour les Musées, 1984

Salon of 1781, no. 22.

Selected References: Diderot, 1995b, no. 22; Gaston-Dreyfus 1923, p. 83, no. 195; Roland Michel 1973, p. 357, no. 23; Moinet 1986; Langlois 2000, pp. 24–26, no. 9.

Notes

1 Moinet 1986, p. 297; Langlois 2000, p. 25.
2 "La tête du braconnier a du caractère, mais cette manière de faire ne me plaît pas. Les habillements sont du même ton de la tête aux pieds, les sabots dont il est chaussé sont de la même étoffe que l'habit; le petit garçon qu'il tient par la main a le même défaut. Il y a de l'esprit dans la tête de cette enfant. Le chien qui est auprès de lui n'est point naturel ni de ton, ni de forme. Cependant ce petit tableau a de l'effet et arrête les yeux." Seznec and Adhémar 1957–67, IV, p. 357.
3 On Lépicié in general, see Lille 1985, pp. 122–24.
4 "Par M. Lépicié, Professeur, 6. La Paysanne revenant du bois"; in Guiffrey 1990, p. 15. The painting is signed and dated *1782* and measures 80 × 63 cm; see Gaston-Dreyfus 1923, p. 84, no. 201.
5 "M. L'Epicier [*sic*] se fait toujours goûter, quand il ne veut pas s'élever au genre d'histoire; il a une vérité, une naïveté [*sic*] précieuse qui rendent ses grotesques aimables, sans exciter le rire." Fabric Faré, *Les Salons de Bachaumont* (*Chroniques esthétiques du XVIIIᵉ siècle*, 1), Nogent-le-Roi, 1995, p. 116.
6 Cf. *Catalogue des tableaux anciens composant la collection de M.P.M . . .* , Paris, Drouot, 8 May 1908, no. 99.
7 See the catalogue *Falconet à Sèvres ou l'art de plaire: 1757–1766*, Paris, 2001, pp. 115–31.
8 On this subject, see the discussion in Thomas Kirchner, "'Observons le monde,' La réalité sociale dans la peinture française du XVIIIᵉ siècle," in Gaehtgens 2001, pp. 367–81; see Langlois 2000, p. 25: "Son tableau à résonance sentimentale peut aussi considéré comme un témoignage ethnographique de la paysannerie française à la veille de la Révolution, qui semble avoir peu évolué depuis le dix-septième siècle."

Cat. 98

ÉTIENNE AUBRY (1745–1781)
The Shepherdess of the Alps
La bergère des Alpes
1775
Oil on canvas, 50.8 × 62.2 cm
Signed lower left: *Aubry 1775*
The Detroit Institute of Arts

Salon of 1775, no. 177.

Provenance: Le Chevalier Lambert sale, Paris, 27 March 1878, no. 206; Sir John Foley Grey, Baronet, Malvern, England; his sale, Christie's, London, 15 June 1928, no. 127; Horace Ayers Buttery, London, 1928; A.F. Mondschein Galleries, New York, 1947; acquired by the museum in 1948.

Selected References: Hautecoeur 1909, p. 166; Ingersoll-Smouse 1925, p. 79; Grigaut 1949; Seznec and Adhémar 1975, IV, pp. 261, 291; Bukdahl 1980–82, I, pp. 58, 127, 212; II, pp. 195–96, 301–02; Rand 1997, pp. 172–74, no. 36.

Notes

1 *Mercure de France* (1775), pp. 739–40: "Un pinceau large et plein de goût, des détails étudiés, un dessin correct et ce qui est encore plus precieux, de la vérité, du sentiment, de l'expression."
2 Musée des Beaux-Arts, Tours; exhibited in Salon of 1763, no. 92; Grigaut 1949, fig. 2; Seznec and Adhémar 1975, I, p. 175, no. 92, fig. 100; see also Dassas 2002, pp. 258–59.

Cat. 99

ÉTIENNE AUBRY (1745–1781)
Paternal Love
L'amour paternel
c. 1775
Oil on canvas, 78.7 × 101.5 cm
The Trustees of the Barber Institute of Fine Arts,
The University of Birmingham

Salon of 1775, no. 175.

Provenance: Comte d'Angiviller.

Selected References: Hautecoeur 1909; Ingersoll-Smouse 1925, p. 79; Seznec and Adhémar 1975, IV, pp. 261, 291; Bukdahl 1980–82, II, p. 302; Duncan 1973, p. 577, fig. 1.

Notes

1 *Salon de 1765*, no. 123. Seznec and Adhémar 1975, pp. 153–56, fig. 58; Duncan 1973, fig.
2 Seznec and Adhémar 1975, p. 155: "Cela est excellent, et par le talent, et pour les moeurs. Cela prêche la population, et peint très-pathétiquement le bonheur et le prix inestimables de la paix domestique."
3 Ingersoll-Smouse 1925, p. 79 (repr.); see also Williamstown 1998.

Cat. 100

LOUIS-ROLAND TRINQUESSE (c. 1746–c. 1800)
The Music Party
Divertissement musical
1774
Oil on canvas, 194 × 133 cm
Signed at left, on curtain: *L. Trinquesse 1774*
Bayerische Staatsgemäldesammlungen, Alte Pinakothek, Munich
Collection of the Bayerische Hypotheken- und Wechsel-Bank

Provenance: first recorded in 1870 in a private collection, Paris; Count Mora, Spain; private collection, USA; purchased by the museum on the London art market.

Selected References: *Katalog der Alten Pinakothek München: Erläuterungen zu den ausgestellten Werken*, Munich, 1986, II, pp. 587–88; *Münchner Jahrbuch der Bildenden Kunst*, dritte Folge, 36 (1986), pp. 253–54 (acquisitions report).

Notes

1 Mirimonde 1966; Mirimonde 1968.
2 Salmon 1999, pp. 251–55, no. 71.
3 École nationale supérieure des Beaux-Arts, Paris, inv. 1763–5, 1763–6 and 1763–7. No. 5: The young man, in simple dress (knee breeches, tailcoat, and waistcoat), stands lost in thought, a book in his hands. No. 6: He is shown from the side, wearing a frock coat. No. 7: Another side view, chin resting on his right hand, left hand on his hip.
4 Cailleux 1974, pp. 121ff.
5 Ibid., fig. 4.
6 *Meyers Konversationslexikon*, 3rd ed., Leipzig, 1877, XIII, p. 326.
7 The picture was documented in the archives of the Galerie Cailleux; it was apparently dated 1775 (private collection, Paris; 93 × 128 cm).
8 Jean-Jacques Rousseau, *Julie ou La Nouvelle Héloïse ou Lettres de deux amants d'une petite ville au pied des Alpes*, Paris, 1960 edition. Rousseau made suggestions for the novel's illustrations, describing the characters at the outset: "1. Julie est la figure principale. Blonde, une physionomie douce, tendre, modeste, enchanteresse. Des grâces naturelles sans la moindre affectation: une élégante simplicité . . . ; la gorge couverte en fille modeste" (p. liii); "2. Claire ou la cousine. Une brune piquante; l'air plus fin . . . Jamais de panier ni à l'une ni à l'autre. 3. Saint-Preux ou l'ami. Un jeune Homme d'une figure ordinaire; rien de distingué, seulement d'une physionomie sensible et intéressante . . . l'habillement est très simple" (p. liv). In Trinquesse's pictures, Julie, Claire, and St. Preux are gathered, and the novel's characteristic *sensibilité* is manifest in their looks and gestures. Rousseau also had a great love of music, and his epistolary novel repeatedly stresses the primacy of Italian music and song.
9 *Meyers Konversationslexikon*, 3rd ed., Leipzig, 1877, XII, pp. 938–39.

Cat. 101

Louis-Roland Trinquesse (c. 1746–c. 1800)
Interior Scene with Two Women and a Gentleman
Intérieur avec deux dames et un gentilhomme
1776
Oil on canvas, 96.5 × 122 cm
Maurice Segoura Collection

Provenance: Maurice Segoura Gallery, New York.

Selected References: Zafran 1983, no. 56.

Notes

1 The best sources on this artist remain Dijon 1969, Cailleux 1974, and Wilhelm 1974.
2 See Bellier and Auvray 1882–85, II, pp. 592–93, for a list of exhibited works, and Wrigley 1993, pp. 36–38, for the Salon de la Correspondance.
3 Wilhelm 1974 examines Trinquesse's considerable oeuvre of male portraits. Bellier and Auvray (1882–85, II, p. 592) list the Vicomtesse de Laval as owner of a portrait of a young girl, exhibited at the Salon de la Correspondance in 1782.
4 See Launay 1991, pp. 482–85, and Cailleux 1974.
5 See Hallam 1981, pp. 619–20, for the influence of the "Metsu Manner" on Marguerite Gérard and Louis-Léopold Boilly.
6 Ribeiro 1995, p. 169.
7 Their relationship to Trinquesse is discussed in Cailleux 1974.

Cat. 102

Jacques Sablet (1749–1803)
Blindman's Buff
Le colin-maillard
1790
Oil on canvas, 104 × 115 cm
Musée Cantonal des Beaux-Arts, Lausanne

Salon of 1796, no. 410; Salon of 1798, no. 355.

Provenance: Cardinal Fesch, Paris, 1839; his sale, Paris, 17–18 March 1845, no. 426 (purchased by Berardi); sale, Hôtel Drouot, Paris, 23 March 1966; Galerie Pardo, Paris, 1979; acquired by the Canton of Vaud with financial support from the Gottfried Keller Foundation.

Selected References: Vilain 1974; Van de Sandt 1977–80; Van de Sandt 1985, pp. 61–62, no. 21; Billeter 1989, p. 58.

Notes

1 "Man darf nur auf der Strasse wandeln und Augen haben, man sieht die unnachahmlichsten Bilder. . . . Und so gibt es noch manche originale Unterhaltung, wenn man mit dem Volke lebt, es ist so natürlich, dass man mit ihm natürlich werden könnte." Johann Wolfgang Goethe, "Italienische Reise, 19 March 1787," in Goethe 1985–98, XV, pp. 264–65.
2 Heinrich Meyer mentions Sablet in the book *Winckelmann und sein Jahrhundert*, which Goethe published in 1805; Goethe 1985–98, 6.2, pp. 320–21.
3 See Van de Sandt 1985, pp. 100–08, nos. 76–88.
4 "De le [le genre de l'école flamande] relever par le choix des sujets . . . ; il voulut que chacun de ses tableaux représentât une action morale; il ne s'appliqua qu'à exprimer des passions douces, honnêtes, sentimentales: s'il peignit le peuple, ce ne fut plus que dans ses jeux innocens, ou dans ses actes de bienfaisance." J.-L. Bridel, *Le Conservateur suisse, ou Recueil complet des Etrennes helvétiques*, 2 vols., Lausanne, 1813, as quoted in Van de Sandt 1985, p. 28.
5 See ibid., pp. 81–83, nos. 40–42.
6 Régis Michel, "L'art des Salons," even suggests that "the innocence of these rustic games stands in contrast to the corruption of aristocratic pastimes of dubious reputation." Michel and Bordes 1988, p. 71.
7 "Dans tous ses tableaux les costumes et les sites sont d'Italie et je ne connais personne qui peigne les uns et les autres avec plus de verité. . . . on doit compter Sablet parmi nos meilleurs coloristes. je n'en sais même aucun qui peigne aussi bien la lumière." [Amaury-Duval], *Observations de Polyscope sur le Salon de peinture et de sculpture de 1796* . . . , Paris, 1796 (Collection Deloynes, no. 493, pp. 1032 and 1034).
8 "[Sablet] est superieur à vateau [*sic*]. la maniere de vateau etait monotone et de convention; celle de Sablet est toujours brillante et vraie." Pierre Chaussard, "Exposition des ouvrages de peinture, sculpture . . . ," in *La Décade philosophique*, Paris, 1798 (Collection Deloynes, no. 539, p. 160); and Chaussard, "Exposition des ouvrages de peinture, sculpture . . . ," in *La Décade philosophique*, Paris, 1799 (Collection Deloynes, no. 580, p. 456).

Cat. 103

Jacques Sablet (1749–1803)
Family Group before a Seaport
Portrait de famille devant un port
c. 1800
Oil on canvas, 65 × 81 cm
The Montreal Museum of Fine Arts
Purchase, special replacement fund

Salon of 1800, no. 328.

Provenance: purchased by J. Veysset in 1941 as a work of Jean-Baptiste Isabey; sale, London, 1975; sale, Munich, 1975, acquired by the museum as by Louis-Léopold Boilly.

Selected References: Vilain 1974; Hould 1979–80; Van de Sandt 1985, pp. 78–79, no. 38.

Notes

1 The painting has at various times been attributed to Boilly, Isabey, and François Sablet. The identity of the painter has long been disputed, but the authorship of Jacques Sablet now seems assured.
2 "[Où] on traite a fond le chapitre de la melancholie." Beat de Hennezel, in *Journal littéraire de Lausanne* VI (November 1796), pp. 390–404, as quoted in Van de Sandt 1985, p. 176.

3 See the article by Martin Schieder in this catalogue.
4 "Mit teils landschaftlichen, teils andern Gründen und Nebenwerken, welche vornehmlich durch pikante Wirkung das Auge reizen; diese sowohl als verschiedene andere weitläufigere Kompositionen mit Figuren im Kostüm des gemeinen Römischen Volks, haben alle das Verdienst eines zarten gewandten Pinsels und gefälliger Farbengebung," Heinrich Meyer, "Entwurf einer Kunstgeschichte des 18. Jahrhunderts," in *Winckelmann und sein Jahrhundert*. "In Briefen und Aufsätzen herausgegeben von Goethe," Tübingen, 1805, in Goethe 1985–98, 6.2, pp. 320–21.
5 "Cette composition est froide; le paysage qui en fait le fond est d'un ton gris et sans dégradations; de sorte que les figures ressemblent assez à des découpures." *La Vérité au Musée ou l'oeil trompé* . . . , Paris, 1800, p. 18 (Collection Deloynes, no. 623).
6 "Exécution bien sentie." A.D.F., *Notice sur les ouvrages de peinture, de sculpture, d'architecture et de gravure. Exposés au Salon du Musée central des Arts* . . . , Paris, 1800, p. 29 (Collection Deloynes, no. 626).

Cat. 104

Martin Drolling (1752–1817)
Peasants in a Rustic Interior
Intérieur paysan
c. 1800
Oil on canvas, 66 × 93 cm
Private collection

Provenance: sale, Sotheby's, Monaco, 2 December 1988, no. 677; Colnaghi; private collection.

Selected References: Wintermute 1989, pp. 154–55, no. 17; Rand 1997, pp. 194–95, no. 47.

Notes

1 Valentin Jamerey-Duval, *Mémoires: Enfance et éducation d'un paysan au XVIIIe siècle* (Jean-Marie Goulement, ed., Paris, 1981); a small abstract is given in Arnaud de Maurepas and Florent Brayard, eds., *Les Français vus par eux-mêmes. Le XVIIIe siècle*, Paris, 1996, pp. 501–02.
2 Eliel 1989, p. 54.
3 "Il [Drolling] partage avec Greuze l'honneur d'avoir ennobli [*sic*] le genre, d'avoir favorisé ses aspirations vers le moral, le sentimental." E. Sainte-Maurice Cabany, *Michel-Martin Drölling, peintre d'histoire et de portraits*, extrait du *Nécrologe universel du XIXe siècle*, Paris, 1851, pp. 3–4 (a short study of Martin Drolling's son, also a painter, with some facts about the father).
4 See also *The Peasant in French XIX Century Art*, exhib. cat., Dublin, 1980, fig. 13.
5 Rand 1997 (p. 195) discusses the possible identification of the painting in the Salon of 1807 and the question of whether the painting was intended as a pendant.

Cat. 105

Henri-Pierre Danloux (1753–1809)
The Baron de Besenval in his Salon de Compagnie
Le baron de Besenval dans son salon de compagnie
1791
Oil on canvas, 46 × 37 cm
Private collection

Provenance: estate of Pierre-Joseph-Victor, Baron de Besenval (1721–1791); by inheritance to his natural son Joseph-Alexandre, Vicomte de Ségur (1756–1805); Charles-Louis, Marquis de Chérisey, by 1827; Comte de Chérisey, his sale, Paris, 16 June 1909, no. 4, sold for 27,000 francs to Prince François de Broglie; collection Prince François de Broglie until 1930; collection of Princess Amédée de Broglie until the mid-1980s; private collection since 1986.

Selected References: Portalis 1910, pp. 44–49; Bailey 1989b.

Notes

1 Schama 1989, pp. 383–400 and passim.
2 Vallière 1960.
3 Nattier's portrait of Besenval *en guerrier* was exhibited in the Salon of 1746 and was last recorded in the

family residence of the château de Waldegg; see Nolhac 1925, pp. 83, 275, and Vallière 1960, p. 20. A copy is in The Hermitage, Saint Petersburg; see Salmon 1999, p. 63.

4 D'Arneth and Geoffroy 1874, I, pp. 361, 363.

5 Poulet and Scherf 1992, pp. 228–51; Clodion's decorative frieze from Besenval's *salle de bains* has recently been acquired by the Louvre.

6 In thanks, the Academy offered him Louis-Michel Van Loo's Grand Prix of 1725, *Moses Stamping upon Pharaoh's Crown*; see *Procès-verbaux*, VII, p. 134. Such an austere picture – and by a student – may not have been to Besenval's taste, for it is not recorded in any of the listings of his collection.

7 Rosenberg 1987a, pp. 232–35.

8 Thiéry 1787, II, p. 574.

9 Bailey 1987, p. 440.

10 Thiéry 1787, II, p. 577. I have correlated Thiéry's listing with Paillet's fuller descriptions in the catalogue of the posthumous sale of Besenval's collection; see *Catalogue de tableaux précieux*, Paris, 29 Thermidor an III (1795). For a fuller discussion, see Bailey 1989b, p. III.

11 Noted in Watson and Wilson 1982, pp. 13–14.

Cat. 106

Henri-Pierre Danloux (1753–1809)
Mademoiselle Duthé
Mademoiselle Duthé
1792
Oil on canvas, 81 × 65 cm
Staatliche Kunsthalle Karlsruhe

Provenance: Raymond Danloux-Dumesnil, 1910; Roger Danloux-Dumesnil, 1929; sale, Sotheby Parke-Bernet, Monaco, 5 March 1984; sale, Colnaghi, London, 1984, acquired by the museum, 1984.

Selected References: Portalis 1910, pp. 128–63; Garstang 1984, p. 176, no. 55; Karlsruhe 1985, pp. 151–66, especially pp. 153–55; Beckmann 1995, pp. 25–27, no. 2755; Gooden 1999.

Notes

1 "Une des courtisanes les plus renommées aujourd'hui dans cette capitale," *Mémoires secrets pour servir à l'histoire de la République des Lettres en France depuis 1762 jusqu'à nos jours*, London, 1780, VI, p. 182 (5 September 1772).

2 "Aussitôt rétablie d'une affection du cœur dont elle souffre, elle fera appel à mes pinceaux," Portalis 1910, p. 130.

3 "Elle prend séance pour l'esquisse en petit de son portrait et se décide à poser dans l'attitude d'une femme qui attache dans son boudoir, au-dessus du canapé, un tableau représentant un *Sacrifice à l'Amitié*," Portalis 1910, p. 130.

4 "Il est assez bien, surtout fort ressemblant en beau," Portalis 1910, p. 133.

5 Portalis 1910, p. 131.

6 "Elle se trouve heureuse d'être *une philosophe sans le savoir*," Portalis 1910, p. 132.

7 "Je suis devenu très anglais," quoted from Rosenberg and Rosenblum 1974, p. 357. Danloux's portrait shows interesting affinities with Reynolds' *Lady Sarah Bunbury* (Chicago, The Art Institute of Chicago, Mr. and Mrs. W.W. Kimball Collection).

Cat. 107

Michel Garnier (1753–1819)
In the Artist's Studio
L'atelier du peintre
c. 1792–95
Oil on canvas, 58.5 × 73.5 cm
Musée d'Art Moderne, Saint-Étienne

Provenance: legs Bancel 1893.

Selected References: Exposition centennale de l'art français 1800–1889 / Exposition universelle de 1900, 1900, p. 4, no. 290

(repr.), as *Chez le peintre*, attr. to Jean-Honoré Fragonard and Marguerite Gérard; Mirimonde 1968, pp. 125–38, figs. 15, 16, attr. to Marguerite Gérard; *L'Atelier du peintre*, exhib. cat., Paris, 1976, no. 135; De Maintenant 2002, fig. 8.

Notes

1 Pliny, *Naturalis Historiae*, XXXV, p. 10.

2 For Garnier's paintings exhibited in the Salon, see Heim and Béraud 1989, p. 213.

3 See also Michel Gallet, "Deux scènes de moeurs parisiennes de la fin du XVIIIᵉ siècle, par Michel Garnier," in *Bulletin du Musée Carnavalet*, pp. 2–4.

4 "Polissonnerie à la française qui n'a même pas le mérite de l'art"; "Ces sujets-là étaient de mode comme on le voit par la description que Diderot fait du salon de 1765. Il me semble que sur ce point les goûts ont bien changé et j'en félicite mes compatriotes." [Amaury Duval], "Observations de Polyscope sur le salon de Peinture et de Sculpture de 1796 tirées de la *Décadaire*," pp. 1066–67 (Collections Deloynes), as quoted in De Maintenant 2002, p. 81, n. 14.

5 On this subject, see van de Sandt 1989, pp. 72–73.

Cat. 108

Louis-Léopold Boilly (1761–1845)
Woman Showing her Portrait
Femme montrant son portrait
c. 1790
Oil on canvas, 45.7 × 54.5 cm
Signed lower left, under footstool: *L. Boilly*
The Michael L. Rosenberg Collection, Dallas, Texas

Provenance: (?) Calvet de Lapalun, Avignon; Prince Nikolai Borisovich Yusupov, before 1812; kept at the Archangelskoe estate near Moscow, 1815–37; Yusupov palace on the Moika, Saint Petersburg, 1837–1919; Palace Museum (formerly Yusupov), Petrograd, 1919–24; State antiquarian sale, after 1924;[1] private collection, France (purchased before World War II); sale, Vichy, Maître Guy Laurent and expert Louis Ryaux, 13 June 1987 (purchased by Stair Sainty Matthiessen, New York, 1988); Nancy Richardson; her sale, Christie's, New York, 21 October 1997, no. 247; Michael Rosenberg.

Archival Sources: inv. 1812, p. 4rev., case 8, no. 15 (as *Dama pokazivaet portret / A lady shows a portrait* – Boilly [so cited in later inventories unless noted]); inv. 1815, p. 3, no. 55, and p. 16rev., no. 150; inv. 1822, p. 3rev., no. 55,–150, Galerie; "Galerie d'Archangelski 1827," I, p. 58, no. 8, Galerie; inv. 1833, p. 3rev., no. 150; inv. 1837 (shipping), p. 65, no. 150; inv. 1850 (Saint Petersburg), p. 128rev., no. 107, Anticheskaya [Antique Hall]; inv. 1877, p. 296, no. 132, Antikovaya [Antique Hall] inv. 1924, p. 25rev., no. 589 (Boilly. *Portret / Portrait*. For the Hermitage).[2]

Selected References: Lecointe de Laveau 1828, as *Jeune dame qui montre un portrait*; Harrisse 1898, p. 106, no. 251, as *Femme montrant son portrait*; Ernst 1924, repr. as *Novy Portret [A New Portrait]*; Babin 2001–02, p. 96, repr. as *Portrait*; Babin 2002–03.

Notes
The author wishes to thank Dr. Alexander Babin, Hermitage State Museum; Dr. Liubov Savinskaya, Pushkin State Museum of Fine Arts; Étienne Bréton, Paris; and Pascal Zuber, Paris, for their assistance.

1 A circular stamp "Douanes Françaises / Recette du Paris Nord" on the chassis may indicate the painting's shipment to France. The canvas was last recorded in the Russian State Archives in 1924. Louis Réau cited it in the Yusupov collection at the Hermitage in a 1928 catalogue (Réau 1928, p. 177, as *Le nouveau portrait*), but he may have relied on earlier publications.

2 The painting was never sent to the Hermitage. It may have been moved to the State Museum Foundation and thence to the State antiquarian sale.

3 On Boilly's conception of his characters as generic types representing conditions or states rather than kinship relations, see Siegfried 1995, pp. 2–5. The painting was

traditionally identified in the Yusupov archives as *Dama pokazivaet portret / A Lady Shows a Portrait* (see Archival Sources above), and in nineteenth-century French literature on Russian collections as *Jeune dame qui montre un portrait / A Young Lady Who Shows a Portrait* (Lecointe de Laveau 1828, p. 285; Lecointe de Laveau 1835, II, p. 283; *Musée du Prince Youssoupoff, contenant les tableaux, marbres, ivoires et porcelaines qui se trouvent dans l'hôtel de Son Excellence, à Saint Petersbourg*, Saint Petersbourg, 1838, p. 56, no. 268), or *Femme faisant voir son portrait / A Woman Having her Portrait Shown* (Dussieux 1856, p. 444, under no. 963). Harrisse stayed close to these sources in cataloguing the painting as *Femme montrant son portrait* (1898, p. 106, no. 251), as did Marmottan (1913, p. 245). Louis Ryaux slightly modified that title to *La présentation du portrait / The Presentation of the Portrait* (*Gazette de l'Hôtel Drouot*, no. 21–22 [May 1987], p. 11), and by 1997 it had changed to *A Family Admiring a Portrait of a Lady in an Interior* (Christie's, New York, 21 October 1997, no. 247). In his 1906 catalogue of the Yusupov collection, Prakhov (1901–07 [1906], p. 212, fig. 138) called the painting simply *Portret [Portrait]*, while Ernst catalogued it in 1924 (pp. 202–03, repr.) as *Novy Portret [A New Portrait]*.

4 Babin 2002–03; and Babin 2001–02, I, p. 96 (painting considered as lost).

5 Hallam 1984, p. 189.

6 The painting shares several motifs with others in Calvet de Lapalun's collection: the messenger boy appears in *La Visite reçue* (1789; Musée Sandelin, Saint-Omer), repr. Siegfried 1995, p. 3, fig. 5; the old woman in *La beauté comme une fleur ne dure qu'un jour, ou la mère philosophe / Beauty like a flower only lasts a day, or the philosophical mother* (1791; location unknown; Collection Dadvisard, 1930), repr. Hallam 1984, fig. 11; and the statue of cupid on the wardrobe in *L'Hymen ôte à l'amour son bandeau, ou Les avis maternels / Hymen removes the blindfold from love, or Motherly advice* (1791; location unknown; variant, private collection, Paris), repr. Hallam 1984, fig. 12, and Paris 1984, no. 3. Stylistic considerations pull the date of the painting toward 1789: Boilly favoured the complex style of the woman's costume in *The Young Artist* (1785–88; The Hermitage, Saint Petersburg) and *The Visit Returned* (1789), while her pose resembles one in the *Gohin Family* (1787; Musée des Arts Décoratifs, Paris). For questions outstanding on provenance see n. 9.

7 But for the gendering of the term and her pleased expression, the old woman might be "the moralist," in view of the moralizing role she plays in other Boilly paintings commissioned by Calvet de Lapalun, notably *La mère philosophe* and *Les avis maternels* (see n. 4).

8 Ingamells 1989, pp. 26–29, nos. P473 and P479.

9 Examples include *The Jealous Lover / Le Vieillard jaloux* (Musée Sandelin, St. Omer), *Le Portrait désiré* (location unknown), and *Lady with a Miniature* (Leeds Castle, Kent, on loan from a private collection, London). In *Le Cadeau délicat*, however, the miniature represents a woman (Christie's, London, 14 June 2002, no. 620, formerly called *The Miniature*, collection of the Marquess of Bath, Longleat House; the grisaille version is in the Musée des Arts Décoratifs, Paris).

10 Babin 2002–03.

11 Babin 2001–02, I, p. 96; Babin 2002, p. 11; and Babin 2002–03. Calvet de Lapalun's name does not appear in the Yusupov archives, although Yusupov purchased some old master paintings through dealers in Paris in 1809 (Savinskaia 1994, p. 212). Research remains to be done on the sale of the Calvet de Lapalun collection, which might help to clarify how Yusupov acquired these paintings. The previous thesis of acquisition was set out in *Arts of France*, Christie's, New York, 1997, no. 247.

12 Reimers 1805, II, p. 372, on Yusupov's collection at the Fontanka palace in Saint Petersburg: ". . . drei

[Gemälde] von Boilly vom Jahr 1800 u.s.w. Letztere ist der jetzige französische Modekünstler; sein Pinsel ist voll Ausdruck und Wahrheit, gutes Colorit, die Arbeit sehr beendigt." I am grateful to Dr. Liubov Savinskaia for drawing this to my attention.

13　Babin (2002–03) has proposed that Yusupov bought, in addition to *The Game of Billiards*, at least two other paintings by Boilly in 1808–10. (The attribution of three of Nikolai Yusupov's nine Boilly paintings has recently been questioned.) A tenth painting by Boilly, *On nous voit* (location unknown), was acquired before 1917 by Felix Felixovitch Yusupov (1887–1967).

Cat. 109
LOUIS-LÉOPOLD BOILLY (1761–1845)
The Electric Spark
L'étincelle électrique
c. 1791
Oil on canvas, 46.1 × 55.3 cm
Signed on base of cupid's pedestal: *L BOILLY*
Virginia Museum of Fine Arts, Richmond
The Arthur and Margaret Glasgow Fund

[Salon de la Jeunesse] Paris, 1791, as *Un tableau représentant deux amants se faisant électriser par l'Amour. Effet de nuit*. [Lebrun] *Catalogue des ouvrages . . . exposés le 30 juin jusqu'au 15 juillet [1791]* (Collection Deloynes no. 48), p. 14, no. 45. (It is not clear which version of the painting was exhibited in 1791.)

Provenance: sale, Hôtel Drouot, Paris, 28 November 1910, no. 17, repr., acquired by Lucien Cottreau; sale, Hôtel Drouot, Paris, 26 May 1972, no. 8, bought by H. Shickman Gallery, New York; acquired by the museum in 1973.[1]

Selected References: Harrisse 1898, no. 198 or 199; Marmottan 1913, pp. 35, 39, pl. 12; Mabille de Poncheville 1931, pp. 32–33; Hallam 1977; Eliel 1989, pp. 51–53, fig. 2; Rand 1997, pp. 198–200, no. 49.

Notes

1　The provenance of this painting has been confused with that of another, nearly identical version of the same subject (private collection, Paris). It is not clear (contrary to Rand 1997, no. 49) which of the two versions passed through the Lafontaine and de Livry sales in, respectively, January and April 1810 (Harrisse 1898, no. 199), or through the E. Vincent sale at Hôtel Drouot, Paris, 22 February 1872, no. 2, bought by Féral, or which was lent by Mr. Hodgkins of Paris to an exhibition held there in 1908, when Marmottan (1913, p. 39) saw it. The version owned by the duchesse de Cadore was exhibited at Seligmann's in 1930 (Paris 1930, pl. 12, no. 24). The catalogue identified the Marquis d'Estampes as the previous owner and further indicated that the painting was probably the one sold in 1810 from the Lafontaine and de Livry collections. While the latter claim cannot be confirmed, the Marquis d'Estampes was identified as the purchaser of this work in an annotated catalogue of a sale (Hôtel Drouot, Paris, 19–20 May 1876, no. 40), the precise description of which matches the Cadore version. Hallam (1977, p. 11, n. 4) identified the painting exhibited at Seligmann's with the version in a private collection, Paris.

2　Harrisse (1898, p. 102, no. 199) called the painting *L'Expérience d'électricité*, a title based on that of a reproductive engraving, probably following the description given in the 1810 Lafontaine sale catalogue: "Un tableau connu et gravé sous le titre de *l'expérience d'électricité*." (The engraving has never been located.) This listing may refer to the same or to a second painting of the subject, catalogued by Harrisse (1898, no. 198) as *L'Étincelle électrique*. The other version of the painting (in a private collection, Paris) is closer to the preparatory drawing (Hallam 1977, p. 5, fig. 2), and might therefore be assumed to be the earlier version.

3　Harrisse (1898, p. 168, no. 939) catalogued the drawing

as *L'Étincelle électrique*, based on the title under which it was published in the Julien Boilly sale (Paris, 4 May 1868, no. 91). The Richmond drawing was sold at Hôtel Drouot, Paris, 26 February 1900, no. 98, repr., attributed to Fr[ançois-Marie-]I[sidore] Queverdo as *L'Alchimiste consulté*, sepia on ink, 11 × 16 cm (annotated "P. – M.D. – [M. Delestre]" on the copy in the Louvre, Service de la Documentation); it then passed through a sale, Hôtel Drouot, Paris, 22 March 1995, no. 12, repr. (purchased by Kate de Rothschild, London), and was acquired by the Virginia Museum of Fine Arts in 1996 (pen, ink, and brown wash, 10.8 × 15.8 cm). See Hallam 1977, fig. 3; Rand 1997, fig. 76; and *Master Drawings 1996*, New York, Didier Aaron, Braume and Lorenceau, and Kate de Rothschild, 1996, no. 33, repr., n.p. A larger drawing (25.5 × 30.5 cm) of the same composition, with minor differences, executed in the same technique, was sold in a sale, Hôtel Drouot, Paris, 16 October 1998, no. 16, repr. The catalogue of the Seligmann (1930, p. 11, no. 24) *Boilly* exhibition identified two compositional studies – one in Julien Boilly's collection and the so-called Queverdo sold in 1900 – which it related to the two versions of the painting.

4　On the furniture, see Hallam 1977, and Émile Dacier, "L'Athénienne et son inventeur," *Gazette des beaux-arts*, 6th ser., VIII (July–December 1932), pp. 112–22.

5　Fournel 1887, p. 131.

6　The entry was transcribed by Marmottan (1913, p. 39) and Hallam (1979, p. 311).

7　On Charles-Amédée Van Loo's paintings of *A Pneumatic Experience* (1771), and *Electricity* (1777, Salon of 1788; Archangelskoe Museum, Moscow), see Turchin 2002, p. 35, and Hallam 1977, fig. 7. On Gravelot's engraving of *Electricity*, see Eliel 1989, p. 51, fig. 4. On Joseph Wright's exploration of the dark side of modern science, see Siegfried 1999, pp. 40–46.

8　See Hallam 1977. Joseph Wright represented the alchemist as a figure of irrational faith in *The Alchemist* (1771/95; Derby Museums and Art Gallery, Derby).

Cat. 110
LOUIS-LÉOPOLD BOILLY (1761–1845)
The Painter in her Studio
Atelier d'une jeune artiste
1796
Oil on canvas, 49.9 × 60.5 cm
Signed lower right: *L.Boilly*
Staatliches Museum Schwerin

Salon of 1796, no. 41, as *L'intérieur d'un attelier [sic] de peintre. Une femme assise dessine le portrait d'un enfant.*

Provenance: Sent by the French government from Paris in 1815 to Friedrich Franz II, Grand Duke of Mecklenburg-Schwerin, through his commissioners, in partial reparation for one of the 209 works removed by the French in 1807 from Schwerin Castle; kept at Ludwigslust Castle after 1815; dispatched to the Grossherzogliche Gemälde-galerie, Schwerin, in 1882, which was renamed Mecklenburgisches Landesmuseum in 1918 and the Staatliches Museum Schwerin in 1952.

Selected References: Lenthe 1821, no. 152, description and comment; Schlie 1884, no. 1154, as *Eine Malerin zeichnet das Bildnis eines kleinen Knaben*; Harrisse 1898, p. 74, no. 9, as *Atelier de peintre*, and p. 97, no. 152, as *La Dame artiste*; Marmottan 1913, p. 245, as *Scène d'intérieur* (with description following Lenthe 1821, Dussieux 1856); Siegfried 1995, pp. 174–80, figs. 132, 149, 153.

Notes

1　The drawing of Boilly's son is currently known only from the reproduction in the catalogue of the Marius Paulme sale, Paris, Galerie Georges Petit, 13 May 1929, no. 7, repr. It may be related to an oil portrait (73 × 59.7 cm; private collection, London). On Boilly's sons, see Siegfried 1995, pp. 202–03, n. 47.

2　Paris 1796 Salon, p. 16, no. 41.

3　Schlie 1884, p. 4, no. 1154: "Nach mündlicher Angabe von Prosch erst seit 1815 in der Sammlung, in welchem es aus Versehen statt eines anderen aus früher aus Ludwigslust mitgenommenen Bilder von Paris eingesandt wurde." The reverse of the Schwerin canvas is stamped "Grossherzogliche Galerie Ludwigslust." The painting that was supposed to have been returned to Schwerin is Oudry's *Bittern and Partridge, watched by a dog in sunlight* (Musée du Louvre, Paris), which was in Lyon in 1815 (communication, Staatliches Museum Schwerin, 7 June 2002).

4　The description of a drawing (location unknown) formerly in the Marquis de Biron sale closely matches *The Painter in her Studio*, Galerie Georges Petit, Paris, 9–11 June 1914, no. 4, as *Études pour "L'Atelier de peintre"* (38 × 24 cm).

5　Dr. Lutze, Bremen, reported a studio copy in the Kunsthalle, Bremen (note dated 23 February 1959, curatorial file, Staatliches Museum Schwerin). The painting was subsequently with Alexandre Popoff, Paris; sale, Christie's, London, 18 March 1960; private collection, Bogotá, Colombia, 1993; sale, Hôtel Drouot, Paris, 12 October 2001, no. 44, repr., attributed to "École française du 19e siècle, suiveur de L.L. Boilly"; sale, Minneapolis, Minnesota, 2002. Cazenave's engraving (48 × 58 cm) was noted by Harrisse 1898, p. 216.

Cat. 111
LOUIS-LÉOPOLD BOILLY (1761–1845)
Young Woman Ironing
Jeune femme repassant
c. 1800–03
Oil on canvas, 40.7 × 32.4 cm
Signed lower right: *L. LBoilly*
The Museum of Fine Arts, Boston
Charles H. Bayley Picture and Painting Fund

Provenance: private collection, Paris; Niklaus Reber (d. 1821), Basel; private collection, possibly Burchardt, Basel, c. 1810; by inheritance to Madame von der Muehl, Basel;[1] bought by Hazlitt, Gooden and Fox, London, at Sotheby's, London, 9 December 1981, lot 2; purchased by the museum in 1983.

Selected References: Sotheby's 1982, p. 28; Siegfried 1995, p. 167, pl. 142, 143; Stebbins 1986, p. 55; Zafran 1998, pp. 174–76.

Notes

1　See letter of 8 February 1983 in curatorial file, from David Fyfe-Jamieson of Sotheby's to John Walsh of the Museum of Fine Arts, Boston.

2　Paris 1800 Salon, p. 7, no. 36, as *Une femme assise près d'un poële, occupée de son ménage*; Harrisse 1898, p. 77, no. 20. According to notes in the files of the Museum of Fine Arts, Boston, the painting was last known as *La cuisinière* in 1939 through Nikolas Koenigsberg, New York. A copy of *La cuisinière*, bought by King Frederick William III in Paris in 1804, is in the Stiftung Preussische Schlösser und Gärten Berlin-Brandenburg, Charlottenburg Palace (oil on canvas, 63 × 56 cm, inv. GK I 5111, signed and dated lower left: *L.Boilly / an 7*).

3　*Notice des ouvrages de peinture exposés au Musée central des arts* (Paris, an VIII–IX [1800]), p. 16; quoted in Harrisse 1898, p. 77.

4　On the social and sexual status of laundresses, see Lipton 1980, and Lipton 1986, pp. 123–33.

5　*Girl Grinding Coffee*, oil on canvas, 40 × 31.5 cm (Sotheby's, London, 9 December 1981, no. 3; see Zafran 1998, fig. 78a); and *La Paresseuse* (facing right), oil on canvas, 40 × 32 cm (Vente Mis de . . . B, Hôtel Drouot, Paris, 14 June 1900, salle 6, no. 8), and a probable copy of *La Paresseuse* (facing left), doubtfully attributed to Boilly, oil on canvas, 41 × 32.5 cm, Sotheby's, Monaco, 3 December 1985, no. 503, the latter identified with Harrisse 1898, p. 94, no. 126, *Le Chien chéri*. More questionable attributions to Boilly include two paintings of laundresses and two kitchen scenes: *A Young*

376

Ironing Woman Engaged in Conversation by a Youth, oil on panel, 20.2 × 15 cm (Christie's, London, 22 May 1989); *The Laundress*, oil on canvas, 46 × 55.5 cm (Hôtel Drouot, Paris, 24 October 1983, no. 25, and 12 December 1989, no. 34, as *La Lessiveuse*, identified with Harrisse 1898, p. 116, no. 365); *La Belle Cuisinière*, 1788, oil on canvas, 61 × 54.5 cm (*Étude Couturier Nicolay*, Hôtel Drouot, Paris, 26 March 1984, identified with Harrisse 1898, p. 97, no. 149); and *La Malicieuse Cuisinière*, oil on panel, 27 × 19.5 cm (Sotheby's, London, 12 January 1989, identified with Harrisse 1898, p. 96, no. 148).

6 On the imagery of street vendors, see Roche 1981, pp. 73–74; for comparison of similar subjects by other genre painters see Rand 1997, nos. 16, 26, 30, 35.

7 Drawings after related paintings include *Woman Seated near a Stove* (location unknown, Harrisse 1898, p. 169, no. 967); *Girl Grinding Coffee* (Vente Cmte B . . . , Galerie Charpentier, Paris, 11–12 June 1959, as *La Jeune Ménagère*); and *La Paresseuse*, formerly also called *La Mansarde* (private collection, London).

Cat. 112
LOUIS-LÉOPOLD BOILLY (1761–1845)
The Cardsharp on the Boulevard
L'escamoteur sur les boulevards
1806
Oil on wood, 24 × 33 cm
Signed lower left: *L. Boilly. 1806.*
National Gallery of Art, Washington, D.C.
Gift of Roger and Vicki Sant

Salon of 1808, no. 55, as *Scènes de boulevart* [sic], with its pendant; Salon of 1814, no. 115, as *Scènes de boulevart* [sic], with its pendant.

Provenance: Marie-Caroline-Ferdinande-Louise de Naples, duchesse de Berry (1798–1870); her sale of works from the Château de Rosny, Hôtel (?), rue Caumartin, Maître Batailard and expert Charles Paillet, 22 February–15 March 1836, no. 14, as *L'escamoteur, scène de boulevards* (her coat of arms, with inv. no. 23, are on the reverse); her sale, Bellavoine and Margny, Paris, 28 January 1848, no. 80, as *Le Diseur de bonne aventure*; Forestier and Descharmes collection; their estate sale, Maître Perrot, Hôtel Drouot, Paris, 11–15 December 1871, no. 6, as *L'Escamoteur*; Duc de Persigny, Château de Chamarande; his sale, Hôtel Drouot, Paris, 15 March 1876, no. 4, as *Une scène de boulevard* (purchased by Gillet); sale, Hôtel Drouot, Paris, 13–14 December 1943, no. 68, as *Scènes des boulevards*; Sotheby's, Monaco, 23 February 1986, no. 310, as *Scène de Boulevard*; Christie, Manson & Woods, New York, 27 January 2000, no. 67; purchased by the museum through Agnew's Inc., London, February 2000.

Selected References: Bonnemaison 1822, n.p. and unnumbered repr., as *Une Scène des Boulevards*; Harrisse 1898, no. 33, and Harrisse 1898 BN, no. 33, noted as "signé et daté de 1806"; Marmottan 1913, pp. 117, 226, as *Tireur de cartes*; Mabille de Poncheville 1931, p. 123; Siegfried 2001, pp. 280–81.

Notes

1 For example, *The Palais-Royal Gallery's Walk* (28.5 × 55.2 cm, Metropolitan Museum of Art, New York). On the relation between genre prints and paintings in eighteenth-century France, see Schroder 1997.

2 *Une Scène des boulevards*, signed "Boilly pinxt / Bonnemaison dirext / É[douard] Wattier del." and "I. Lith. de Villain" in Bonnemaison 1822, unnumbered [15th plate]; image, 23.5 × 31.5 cm.

3 Bonnemaison (1822, n.p.) noted that *Une Scène des boulevards*, lithographed with the title *Savoyards montrant la marmotte*, had been exhibited at the Salon of 1814, and that *Une Scène des boulevards* [the *Cardsharp*] had been exhibited in 1808. The duchesse de Berry also bought Boilly's *Entrance to the Theatre Ambigu-Comique for a Free Performance* (Musée du Louvre, Paris) from the Salon of 1819; see Scott 1986,

pp. 347–48. Harrisse noted the rising prices of the *Cardsharp on the Boulevard*, as having sold for 300 francs at the Château de Rosny sale [1836], 4,450 francs (?) at the 1871 Forestier-Descharmes sale, 4,750 francs at the Château de Chamarande sale [1876], and 4,850 francs in the year he annotated his book (1898, no. 33, and 1898 BN, no. 33).

4 Bonnemaison 1822, n.p. [text on *Une scène des boulevards*, lithographed with the title *Savoyards montrant la marmotte*].

5 He developed this pictorial format on a larger scale in *The Entrance to the Turkish Garden Café* (1812; private collection, Australia); see Siegfried 1995, pp. 135–50.

6 On the relation of Mercier's texts to Boilly, see Siegfried 2001, pp. 282–83, and Siegfried 1995, chapters 3 and 6.

7 The cardsharp and the boy wearing a white cap and apron are variations on the figures of the speculator and the baker's apprentice in the *Speculators in the Palais-Royal* (c. 1796; private collection, Vancouver), probably mediated by a drawing (Hilliard Collection, Chicago; see Siegfried 1995, fig. 37). The man in the bicorn hat watching the card trick, the girl in the foreground, and the woman holding her dress were derived from the *Arrival of the Stagecoach in the Courtyard of the Messageries* (1803; Musée du Louvre, Paris), with the latter figure probably based on a drawing (Musée des Beaux-Arts, Arras; see Lille 1988, no. 32). The gentleman at left was based on Boilly's full-length portrait of *Monsieur Oberkampf and his Children* (1803; private collection; see Siegfried 1995, fig. 68). A drawing of the woman to the left of the young girl is known, with the figure reversed (black ink and white gouache, 16.8 × 11 cm; formerly Galerie Arnoldi-Livie, Munich). An oil study of *Le Jeune Savoyard* (Musée Picardie, Amiens) bears some resemblance to the poor boy at left, but the attribution to Boilly is problematic. Harrisse noted the Amiens sketch in his additions (1898 BN, p. 128, addition, as *Le Jeune Savoyard*) without relating it to his no. 290, *Garçon couvert de haillons*, a sketch that came from Julien Boilly's collection.

8 A classic representation of the theme of superstition cutting across the social classes is Mercier's description of the people who frequented a popular fortune-teller (Mercier [1798], I, ch. 63, pp. 165–80, "Le Tireur de cartes"). Bonnemaison brought this convention to bear on his seminal interpretation of Boilly's painting (1822, n.p.); it was this section that Marmottan eliminated when he virtually copied Bonnemaison's commentary on the painting (1913, p. 117).

9 The interpretation of the pickpocket comes from the catalogue of the 1876 Château de Chamarande sale, no. 4, and of the courtesan, from Bonnemaison 1822, n.p. [text accompanying *Une scène des boulevards*].

10 Marlet 1821–24, pl. 17, "L'Escamoteur du Château-d'Eu." For the plate, see also the reprint by Guillaume de Bertier de Sauvigny, Paris and Geneva, 1979, p. 36, pl. 18.

11 Marlet 1821–24, introduction, n.p.

Cat. 113
LOUIS-LÉOPOLD BOILLY (1761–1845)
The Game of Billiards
Un jeu de billard
1807
Oil on canvas, 56 × 81 cm
Signed lower right: *L. L. Boilly 1807*
The State Hermitage Museum, Saint Petersburg

Salon of 1808, no. 53, as *Un jeu de billard*.

Provenance: acquired by Prince Nikolai Borisovich Yusupov in Paris in 1808 from L.L. Boilly; kept at the Archangelskoe estate near Moscow after 1810; Yusupov palace on the Moika, Saint Petersburg, 1837; Palace Museum (formerly Yusupov), Petrograd, 1919–24; received by the museum in 1925.

Archival Sources: (Yusupov collections) Notebook 1808–1809, p. 15; Receipts 1808–1811, p. 152; inv. 1812, p. 1, case 4, no. 5; inv. 1815, p. 4, no. 99, p. 15, no. 46 (*A Parisian Inn*); inv. 1822, p. 2, no. 99.–46.; Amurovaya, "Galerie d'Archangelski 1827," I, p. 128, no. 4, Salon de Psyche; inv. 1833, p. 2, no. 46; inv. 1837 (shipping), p. 68, no. 46; inv. 1850 (Saint Petersburg), p. 135, no. 15, about the room; inv. 1877, part 2, p. 296, no. 131, Antikovaya [Antique Hall]; inv. 1924, p. 21, no. 497; inv. 1925, p. 806, no. 45.–71. (See Moscow and Saint Petersburg 2001–02.)

Selected References: Harrisse 1898, p. 91, no. 95; Harrisse 1898 BN, p. 81, no. 35, and p. 91, no. 95; Hallam 1981, pp. 628–29, n. 46; Siegfried 1995, pp. 150–57, figs. 126, 131; Moscow and Saint Petersburg 2001–02, I, no. 48, II, repr.; Savinskaia 1994. Provenance and archival sources compiled by Dr. Liubov Savinskaia, Pushkin Museum; entry by Dr. Alexander Babin, The Hermitage.

Notes

1 For example, as represented in Chardin's *The Game of Billiards* (cat. 30) and a lithographic plate entitled *The Interior of a Billiard Room, with Thurston's Table, Improved Revolving Lamp, and Furniture Complete*, in Kentfield 1839.

2 Duits 1964.

3 There is no evidence to support Mabille de Poncheville's claim (1931, p. 121) that Boilly depicted the billiard room in Christophe Philippe Oberkampf's residence, the Château de Montcel, Jouy. Boilly bought a country house on an estate that had a billiard hall, but it was not part of his purchase, and he completed the painting the year before he purchased that property (Siegfried 1990, pp. 530, 540, n. 53).

4 These are mentioned in an article on gaming houses probably written by Roederer in 1799.

5 Harrisse 1898, p. 113, no. 336, *Le Jeu de l'écarté*; p. 190, nos. 1226 and 1227, lithographs of the pendants done by Villain in 1828, with further notes on the lithographs of *Le Jeu de l'écarté* by Villain and of *La Partie de Billard* by Magnin in Harrisse 1898 BN, p. 81, no. 35. As Hallam first pointed out (1979, p. 97, n. 194, figs. 105, 165; and 1981, pp. 628–29, n. 46), Harrisse confused the 1827 variant of *La Partie de billard* with the painting exhibited in 1808 (Harrisse 1898, p. 81, no. 35, n. 3; p. 91, no. 95; p. 113, no. 336). However, Harrisse realized his error in his annotations to his book: "Je commence à croire que celui de Prince Youssoupoff est le tableau qui fut exposé en 1808 et dont je donne la photographie [identified as Braun no. 61931]; tandis que celui qui a été lithographié en 1828 est le tableau que possède Mme E. Gasnier-Guy, et se distingue de l'autre par l'homme au chapeau gris. Il aura fait le dernier (très différent du premier) pour servir de pendant à la *Partie d'écarté* [sic], dont les costumes sont ceux de la Restauration. Le chapeau dit Bolivar en l'honneur du héros américain de ce nom, date de 1824" (Harrisse 1898 BN, p. 81, no. 35); and "Coll. du Prince Youssoupoff. Photo par Braun no. 61921 [sic]. Pour le dessin voir le no. 881 et la photo . . . et *supra* p. 81 no. 35, pour le tableau sous sa première forme exposé au Louvre en 1808. Mais voir ma note à la page 81. Vendu à M. Cordonnier?" (Ibid., p. 91, no. 95).

6 By Dr. Alexandre Babin in Moscow and Saint Petersburg 2001–02, no. 48.

7 "J'ai vendu un de mes Tableaux representant un Jeu de billard qui se trouve au Salon actuellement pour le prix de deux mille sept cent Livres au Prince Youssoupoff dont j'ai Reçu en payement mille et deux cent Livres, quand [the bankers] Mrs Perigaux et Lafitte m'enverront chercher le tableau ils me payeront le restand c: a:d Mille cinq cent Livres. 3 Novembre 1808. Paris. Le Boilly." Savinskaia 1994, pp. 217–18, n. 56. The letter is in the Rossijskij Gosudartvennij Arkhiv Drevnikh Aktov (RGADA) [Russian State Archives of Ancient Acts], Moscow.

8 Savinskaia 1994, p. 206, n. 45.

9 Ibid., p. 213. The painting was illustrated by a drawing

in the two-volume manuscript catalogue "Galerie d'Archangelski 1827," I, no. 4 (reproduced by Savinskaia, p. 208).

10 On the Chrysler painting, considered a studio copy, see Harrison 1986, pp. 35–37, no. 18; the copy formerly in the Massoullard collection, France, in 1949, was sold in Versailles, 29 November 1970, no. 87, repr. One of these copies may be the painting formerly in the Paul Delaroff collection, sold Hôtel Drouot, Paris, 23–24 April 1914, no. 56.

11 Harrisse 1898, p. 163, no. 881; Paris 1964, pp. 112–13, no. 136.

12 The studies are for the shooter (in profile), black chalk heightened with white on blue paper (location unknown; Sotheby's, London, Heseltine sale, 10 April 1933, no. 17); the shooter (rear view), 31 × 26 cm, black and white chalk on blue paper (location unknown; Sotheby's, London, Heseltine sale, 28 May 1935, no. 220; probably catalogued with the previous drawing as Harrisse 1898, nos. 972 and 973); the men, called *Two Standing Figures (Study for "A Game of Billiards")*, 31.1 × 27.3 cm, black chalk on paper (Muriel Butkin collection, Cleveland; see Cleveland 2001, pp. 64–67, 136–37, no. 27); the nursemaids, called *Studies of Mothers and Children*, 24 × 24 cm, black and white chalks on ochre paper (private collection, London); arms, hands, and heads, 35.5 × 26.5 cm (location unknown); and Hôtel Drouot, Paris, Maître Lair-Dubreuil and expert Marius Paulme, Bourgarel sale, 16 June 1922, no. 7. The existence of a sixth drawing is indirectly indicated by the repetition of the figure group of two seated women and a man at right in Boilly's *The Magic Lantern* (private collection, Paris; see Siegfried 1995, fig. 134)

Bibliography

Aaron 2002 Olivier Aaron. "Le pendant d'une *turquerie* de Madame de Pompadour récemment identifié." *L'Objet d'art* (Jan. 2002).

Adhémar 1950 Hélène Adhémar and René Huyghe. *Watteau, sa vie, son oeuvre.* Paris, 1950.

Albaric 1987 Frère Michel Albaric. "Quelques bulles de savon d'Epicure à Manet." In *Jeux et Jouets Religieux.* Exhib. cat. Musée du Jouet, Poissy, 1987.

Altes 2000–01 Everhard Korthals Altes. "The Eighteenth-Century Gentleman Dealer Willem Lormier and the International Dispersal of Seventeenth-Century Dutch Paintings." *Simiolus* XXVIII: 4 (2000–01), pp. 251–311.

Ananoff 1961–70 Alexandre Ananoff. *L'oeuvre dessiné de Jean-Honoré Fragonard.* 4 vols. Paris, 1961–70.

Ananoff 1976 Alexandre Ananoff. *François Boucher.* 2 vols. Lausanne, 1976.

Ananoff 1979 Alexandre Ananoff. "Propos sur les peintures de Marguerite Gérard." *Gazette des Beaux-Arts* XCIV (Dec. 1979), pp. 211–18.

Anderman 2000 Barbara J. Anderman. "'Petits sujets, grandes machines': Critical Battles over Genre Painting in France, 1660–1780." Ph.D. diss., Rutgers, The State University of New Jersey, 2000.

[Anonymous 1858] "Mémoire pour servir à l'éloge de M. Oudry." *Revue Universelle des Arts* VIII (1858), pp. 234–37.

Antoine 1989 Michelle Antoine. *Louis XV.* Paris, 1989.

Ariès 1960 Philippe Ariès. *L'Enfant et la vie familiale sous l'Ancien Régime.* Paris, 1960.

Armogathe 1976 Jean-Robert Armogathe. "Jeux licites et jeux interdits." In *Le jeu au XVIIIᵉ siècle.* Centre Aixois d'Études et de Recherches sur le XVIIIᵉ siècle, 30 Apr.–2 May 1971 (Aix-en-Provence, 1976), pp. 23–27.

Atwater 1988 Vivien Lee Atwater. "A Catalogue and Analysis of Eighteenth-Century French Prints after Netherlandish Baroque Paintings." 3 vols. Ph.D. diss., University of Washington, Seattle, 1988.

Atwater 1995 Vivien Lee Atwater. "Les Graveurs et la vogue néerlandaise dans le Paris du XVIIIᵉ siècle. II. Le Bas, Teniers et l'idéalisation de la vie paysanne." *Nouvelles de l'Estampe* 142–43 (July 1995), pp. 3–12.

Auerbach 1968 Erich Auerbach. *Mimesis: The Representation of Reality in Western Culture.* Princeton, 1968.

Babeau 1886 Albert Babeau. *Les artisans et les domestiques d'autrefois.* Paris, 1886.

Babin 2001–02 Alexander Babin. "French Painters: The Contemporaries of Prince N.B. Yusupov." In *Sobiraniye Knyaza Nikolaia Borisovicha Yusupova: Uchenaia prikhet* [*The Collection of Prince Nikolai Borisovich Yusupov: A Learned Whim*]. Pushkin Museum of Fine Arts, Moscow, and The State Hermitage Museum, Saint Petersburg, 2001–02, I, pp. 86–106.

Babin 2002 Alexander Babin. "Prince Yusupov and his Collection of French Art." *Rossica: International Review of Russian Culture* 5 (Winter 2002), pp. 5–12 (condensed English summary of Babin 2001–02).

Babin 2002–03 Alexander Babin. "The Paintings of Louis-Léopold Boilly in the Collection of the Prince Nikolai Borisovich Yusupov." In *Materials of the Scientific Conference "The Prince Nikolai Borisovich Yusupov and the Collectors of the Epoch of Enlightenment"* [in Russian]. 15–17 October 2001, Pushkin Museum of Fine Arts, Moscow. Forthcoming, 2002–03.

Bachelier 1999 *Jean-Jacques Bachelier (1724–1806): peintre du Roi et de Madame de Pompadour.* Exhib. cat. Musée Lambinet, Versailles, 1999.

Bailey 1985 Colin B. Bailey. "Le marquis de Véri collectionneur." *Bulletin de la Société de l'Histoire de l'Art français. Année 1983* (1985), pp. 67–83.

Bailey 1987 Colin B. Bailey. "Conventions of the Eighteenth-Century *Cabinet de tableaux*: Blondel d'Azincourt's *La Première idée de curiosité*." *The Art Bulletin* LXIX:3 (Sept. 1987), pp. 431–47.

Bailey 1988 Colin B. Bailey, ed. *Ange-Laurent de La Live de Jully: A Facsimile Reprint of the Catalogue Historique (1764) and the Catalogue raisonné des tableaux (1770)*. New York, 1988.

Bailey 1989a Colin B. Bailey. "'Quel dommage qu'une telle dispersion': Collectors of French Painting and the French Revolution." In Wintermute 1989, pp. 10–26.

Bailey 1989b Colin B. Bailey. "Henri-Pierre Danloux. *The Baron de Besenval in his 'Salon de Compagnie'*." In Wintermute 1989, pp. 105–11.

Bailey 1991 *Les amours des dieux. La peinture mythologique de Watteau à David*. Exhib. cat. by Colin B. Bailey. Grand Palais, Paris, 1991.

Bailey 1992 *The Loves of the Gods: Mythological Painting from Watteau to David*. Exhib. cat. by Colin B. Bailey. Kimbell Art Museum, Fort Worth, Texas, 1992.

Bailey 1998 Colin B. Bailey. "François Berger, 1684–1747: Enlightened Patron, Benighted Impresario." In *Curiosité. Études d'histoire de l'art en l'honneur d'Antoine Schnapper*. Paris, 1998, pp. 389–405.

Bailey 2000a Colin B. Bailey. "Anglo-Saxon Attitudes: Recent Writings on Chardin." In Rosenberg 1999, pp. 77–97.

Bailey 2000b Colin B. Bailey. *Jean-Baptiste Greuze. The Laundress*. Getty Museum Studies on Art, Los Angeles, 2000.

Bailey 2002 Colin B. Bailey. *Patriotic Taste: Collecting Modern Art in Pre-Revolutionary Paris*. New Haven and London, 2002.

Banks 1977 Oliver T. Banks. "Watteau and the North: Studies in the Dutch and Flemish Baroque Influence on French Rococo Painting." Ph.D. diss., Princeton University, 1977.

Barker 1994 Emma Barker. "Greuze and the Painting of Sentiment: The Family in French Art 1755–1785." Ph.D. diss., London University, 1994.

Barker 1997 Emma Barker. "Painting and Reform in Eighteenth-Century France: Greuze's *L'Accordée de Village*." *Oxford Art Journal* XX:2 (1997), pp. 42–52.

Barthélemy 1802 Jean-Jacques Barthélemy. *Voyage en Italie. Imprimé sur ses lettres originales écrites au Comte de Caylus*. 2nd ed., with an introduction by the Duchess of Choiseul. Paris, 1802.

Bartoschek 1983 Gerd Bartoschek. *Die Gemälde im Neuen Palais*. Staatliche Schlösser und Gärten Potsdam-Sanssouci, 1983.

Bartoschek 1985 Gerd Bartoschek. In *Rheinsberg. Eine märkische Residenz des 18. Jahrhunderts*. Exhib. cat. Staatliche Schlösser und Gärten Potsdam-Sanssouci, 1985.

Bartoschek 1986 Gerd Bartoschek. "Friedrich II. als Sammler von Gemälden." In *Friedrich und die Kunst*. Staatliche Schlösser und Gärten, Potsdam-Sanssouci, 1986, pp. 86–99.

Baticle 1985 Jeannine Baticle. "Le chanoine Haranger, ami de Watteau." *Revue de l'Art* 69 (1985), pp. 55–68.

Baulez 1975 Christian Baulez. "Versailles, de quelques portes et cheminées." *Bulletin de la Société de l'Histoire de l'Art français. Année 1974* (1975), pp. 71–88.

Baxandall 1985 Michael Baxandall. *Patterns of Intention: On the Historical Explanation of Pictures*. New Haven and London, 1985.

Baxandall 1995 Michael Baxandall. *Shadows and Enlightenment*. New Haven and London, 1995. French ed.: *Ombres et lumières*. Paris, 1999.

Beaulieu 1956 Michèle Beaulieu. "La fillette aux nattes de Saly. Note rectificative." *Bulletin de la Société de l'Histoire de l'Art Français. Année 1955* (1956), pp. 62–66.

Beaurepaire 1876 Charles-Nicolas Cochin. "Essai sur la vie de Chardin (1780)." Published by Charles Beaurepaire in *Précis analytique des travaux de l'Académie des sciences, belles-lettres et arts de Rouen* LXXVIII (1875–76), pp. 417–41.

Beck, Bol and Bückling 1999 *Mehr Licht. Europa um 1770. Die Bildende Kunst der Aufklärung*. Exhib. cat. edited by Herbert Beck, Peter C. Bol and Maraike Bückling. Städelsches Kunstinstitut und Städtische Galerie, Frankfurt am Main. Munich, 1999.

Beckmann 1995 Angelika Beckmann, ed. *Staatliche Kunsthalle Karlsruhe. Neuerwerbungen für die Gemäldegalerie 1984–1994*. With contributions by Dietmar Lüdke. Karlsruhe, 1995.

Belevitch-Stankevitch 1910 H. Belevitch-Stankevitch. *Le goût chinois en France au temps de Louis XIV*. Paris, 1910.

Bellier and Auvray 1882–85 Émile Bellier de La Chavignerie and Louis Auvray. *Dictionnaire général des Artistes de l'École française depuis l'origine des arts du dessin jusqu'au nos jours. Architectes, peintres, sculpteurs, graveurs et lithographes*. 2 vols. Paris, 1882–85.

Benabou 1987 Erica-Marie Benabou. *La Prostitution et la Police des Moeurs au XVIII^e siècle*. Paris, 1987.

Berlin 1983 *Bilder vom Irdischen Glück*. Exhib. cat. edited by Thomas W. Gaehtgens and Karl-Ulrich Majer. Charlottenburg Palace, Berlin, 1983.

Bertrand 1991 Dominique Bertrand. "L'éducation selon Fénelon, ou l'enfant et le pédagogue à l'épreuve du rire et de la gaieté." *Littératures classiques* 14 (Jan. 1991), pp. 215–25.

Bettagno 1993 A. Bettagno. *Guardi, quadri tedeschi*. Exhib. cat. Fondation Cini, Venice, 1993.

Billeter 1989 Erika Billeter et al. *Chefs-d'oeuvre du Musée cantonal des Beaux-Arts Lausanne. Regard sur 150 tableaux*. Lausanne, 1989.

Blanc 1860–77 Charles Blanc. *Histoire des peintres de toutes les écoles*. 3 vols. Paris, 1860–77.

Bonfait 1986 Olivier Bonfait. "Les collections des parlementaires parisiens du XVIII^e siècle." *Revue de l'Art* 73 (1986), pp. 28–48.

Bonnaire 1937–43 Marcel Bonnaire, ed. *Procès-Verbaux de l'Académie des beaux-arts*. 3 vols. Paris, 1937–43.

Bonnemaison 1822 Féréol Bonnemaison. *Galerie de son Altesse Royale Madame la Duchesse de Berry. École française. Peintres modernes*. 2 vols. Paris, 1822.

Boppe 1989 André Boppe. *Les peintres du Bosphore au XVIII^e siècle, mis à jour par C. Boppe-Vigne*. Paris, 1989.

Bordeaux 1984 Jean-Luc Bordeaux. *François Le Moyne and his Generation, 1688–1737*. Neuilly-sur-Seine, 1984.

Börsch-Supan 1988 Helmut Börsch-Supan. "Friedrich des Grossen Umgang mit Bildern." *Zeitschrift des Deutschen Vereins für Kunstwissenschaft* XLI:1 (1988), pp. 23–32.

Börsch-Supan 2000 Helmut Börsch-Supan. *Meister der französischen Kunst. Antoine Watteau 1684–1721*. Cologne, 2000.

Boucher 1928 François Boucher. "L'Exposition de la vie Parisienne au XVIII^e siècle au Musée Carnavalet." *Gazette des Beaux-Arts* XVII: 786 (Apr. 1928), pp. 193–212.

Bouret 1982 Blandine Bouret. "L'Ambassade persane à Paris en 1715 et son image." *Gazette des Beaux-Arts* C:1365 (Oct. 1982), pp. 109–30.

Bouvet 1697 Joachim Bouvet. *L'estat présent de la Chine en figures*. Paris, 1697.

Bouvy 1921 Eugène Bouvy. "Fêtes vénitiennes." *Études italiennes* (Apr.–June 1921).

Boyer 1997 Jean-Claude Boyer, ed. *Pierre Mignard "le Romain". Actes du colloque organisé au musée du Louvre par le Service culturel, le 29 septembre 1995*. Paris, 1997.

Boyer d'Argens 1768 Jean-Baptiste de Boyer d'Argens. *Examen critique des différentes écoles de peinture*. Berlin, 1768.

Braunschweig 1983 *Französische Malerei von Watteau bis Renoir. Meisterwerke aus der Gemäldegalerie und Nationalgalerie der Staatlichen Museen Preussischer Kulturbesitz Berlin und anderen*

Sammlungen. Exhib. cat. Herzog Anton Ulrich-Museum, Braunschweig, 1983.

Brejon de Lavergné 1987 Arnauld Brejon de Lavergné. *L'Inventaire Le Brun de 1683. La collection des tableaux de Louis XIV.* Paris, 1987.

Brice 1971 Germain Brice. *Description de la ville de Paris et de tout ce qu'elle contient de plus remarquable.* 9th ed. Paris, 1752. Reprint: Geneva, 1971.

Brieger 1922 Lothar Brieger. *Das Genrebild. Die Entwicklung der bürgerlichen Malerei.* Munich, 1922.

Brieger 1931 Lothar Brieger. *Die grossen Kunstsammler.* Berlin, 1931.

Brière 1930 Gaston Brière. "Detroy, 1679–1752." In Louis Dimier. *Les peintres français du XVIIIᵉ siècle.* Paris and Brussels, 1930, II, pp. 1–48.

Brière 1931 Gaston Brière. "Jean-François De Troy, peintre de la société élégante, nouveaux renseignements sur l'oeuvre de l'artiste." *Bulletin de la Société de l'Histoire de l'Art Français. Année 1931* (1931), pp. 162–67.

Brookner 1972 Anita Brookner. *Greuze: The Rise and Fall of an Eighteenth-Century Phenomenon.* London, 1972.

Brunel 1986 Georges Brunel. *Boucher.* New York, 1986.

Bruson and Leribault 1999 Jean-Marie Bruson and Christophe Leribault. *Peintures du musée Carnavalet. Catalogue sommaire.* Paris, 1999.

Buffon 1928 Georges Louis Leclerc Buffon. "Histoire naturelle générale et particulière." In Montesquieu. *Considération sur les causes de la grandeur des Romains et de leur décadence.* Paris, 1928.

Bukdahl 1980–82 Else Marie Bukdahl. *Diderot, Critique d'art.* 2 vols. Copenhagen, 1980.

Burda 1991 Huberta Burda. *Vom Galanten zum Sublimen. Überlegungen zu einigen Bildern Hubert Roberts.* In *Aufsätze zur Kunstgeschichte. Festschrift für Hermann Bauer zum 60. Geburtstag.* Edited by Karl Mösender and Andreas Prater. Hildesheim, Zürich and New York, 1991, pp. 284–90.

Busch 1993 Werner Busch. *Das sentimentalische Bild. Die Krise der Kunst im 18. Jahrhundert und die Geburt der Moderne.* Munich, 1993.

Butler 1980 Rohan d'Olier Butler. *Choiseul.* Oxford and New York, 1980.

Cailleux 1960 Jean Cailleux. "The *Lecture de Molière* by Jean-François de Troy and its Date." *The Burlington Magazine* CII:683 (Feb. 1960) (supplement), pp. i–iv.

Cailleux 1974 Jean Cailleux. "L'Art du Dix-huitième Siècle: The Drawings of Louis-Roland Trinquesse." *The Burlington Magazine* 30 (1974).

Caillois 1996 Roger Caillois. *Les jeux et les hommes.* Paris, 1996.

Camesasca and Rosenberg 1970 Ettore Camesasca and Pierre Rosenberg. *Tout l'oeuvre peint de Watteau.* Paris, 1970.

Campan 1988 Jeanne-Louise-Henriette Campan. *Mémoires de Madame Campan; Première femme de chambre de Marie-Antoinette.* Edited by J. Chalon. Paris, 1988.

Carritt 1974 David Carritt. "Mr. Fauquier's Chardins." *The Burlington Magazine* CXVI:858 (Sept. 1974), pp. 502–09.

Caylus 1755 Anne-Claude-Philippe de Tubières-Grimoard, comte de Caylus. *Nouveaux Sujets de peinture et de sculpture.* Paris, 1755.

Chappey 2000 Frédéric Chappey. *Les Trésors des Princes de Bourbon-Conti.* Exhib. cat. Musée d'art et d'histoire Louis-Senlecq, L'Isle-Adam, 2000.

Cherel 1918 Albert Cherel. "La pédagogie Fénelonienne, son originalité, son influence au XVIIIᵉ siècle." *Revue d'histoire littéraire de la France* XXV (1918), pp. 505–31.

Chol 1987 Daniel Chol. *Michel François Dandré-Bardon ou l'apogée de la peinture en Provence au XVIIIᵉ siècle.* Aix-en-Provence, 1987.

Clements 1992 Candace Clements. "The Academy and the Other: *Les Grâces* and *Le Genre Galant.*" *Eighteenth-Century Studies* XXV:4 (Summer 1992), pp. 469–94.

Cleveland 2001 *French Master Drawings from the Collection of Muriel Butkin.* Exhib. cat. by Carter E. Foster, with Sylvain Bellenger and Patrick Shaw Cable. Cleveland Museum of Art, 2001.

Cochin 1880 Charles-Nicolas Cochin. *Mémoires inédits de Charles-Nicolas Cochin sur le comte de Caylus, Bouchardon, les Slodtz.* Paris, 1880.

Cohen 2000 Sarah R. Cohen. *Art, Dance and the Body in French Culture of the Ancien Régime.* Cambridge, 2000.

Collection Deloynes Georges Duplessis, ed. *Catalogue de la collection de pièces sur les beaux-arts, imprimées et manuscrites. Recueillie par Pierre-Jean Mariette, Charles-Nicolas Cochin et M. Deloynes, auditeur des comptes, et acquise récemment par le Département des estampes de la Bibliothèque nationale.* 63 vols. Paris, 1881.

Conisbee 1977 *Claude-Joseph Vernet, 1714–1789.* Exhib. cat. by Philip Conisbee. Musée de la Marine, Paris, 1977.

Conisbee 1981 Philip Conisbee. *Painting in Eighteenth-Century France.* Oxford, 1981.

Conisbee 1985 Philip Conisbee. *La vie et l'oeuvre de Jean-Siméon Chardin.* Translation of Yves Thoraval, *Chardin.* Paris, 1985.

Conisbee 1986 Philip Conisbee. *Chardin.* Oxford, 1986.

Conisbee 1990 *Soap Bubbles, by Jean-Siméon Chardin.* Exhib. cat. by Philip Conisbee. Los Angeles Museum of Art, 1990.

Conisbee 2000 Philip Conisbee. "Paris and Düsseldorf: Chardin." *The Burlington Magazine* CXLII:1162 (Jan. 2000), pp. 55–56.

Conisbee 2004 Philip Conisbee, ed. *French Paintings of the Fifteenth through Eighteenth Centuries.* National Gallery of Art, Washington, D.C., 2004. Forthcoming.

Cordey 1939 Jean Cordey. *Inventaire des biens de Madame de Pompadour rédigé après son décès.* Paris, 1939.

Cornelis 1998 Bart Cornelis. "Arnold Houbraken's *Groote schouburgh* and the Canon of Seventeenth-Century Dutch Painting." *Simiolus* XXVI:3 (1998), pp. 144–61.

Correspondance des directeurs Anatole de Montaiglon and Jules Guiffrey, eds. *Correspondance des directeurs de l'Académie de France à Rome avec les surintendants des bâtiments, 1666–1804.* 18 vols. Paris, 1887–1912.

Correspondance littéraire Maurice Tourneux, ed. *Correspondance littéraire, philosophique et critique par Grimm, Diderot, Raynal, Meister, etc.* 16 vols. Paris, 1877–82.

Corson 1965 Richard Corson. *Fashions in Hair: The First Five Thousand Years.* London, 1965.

Crow 1985 Thomas Crow. *Painters and Public Life in Eighteenth-Century Paris.* New Haven and London, 1985.

Cuzin 1986 Jean-Pierre Cuzin. "Fragonard dans les musées français: quelques tableaux reconsidérés ou discutés." *Revue du Louvre et des musées de France* XXXVI:1 (1986), pp. 58–66.

Cuzin 1987 Jean-Pierre Cuzin. *Jean-Honoré Fragonard, vie et oeuvre. Catalogue complet des peintures.* Fribourg, 1987.

Cuzin 1991 Jean-Pierre Cuzin. "Le *Déjeuner de Chasse* de Jean-François de Troy (1679–1752) peint pour Fontainebleau." *Revue du Louvre et des musées de France* XLI:1 (1991), pp. 43–48.

Cuzin and Rosenberg 1990 *J.H. Fragonard e H. Robert a Roma.* Exhib. cat. by Jean-Pierre Cuzin, Pierre Rosenberg and Catherine Boulot. Villa Medici, Rome, 1990.

Dacier 1909–21 Émile Dacier. *Catalogues de ventes et livrets de Salons illustrés par Gabriel de Saint-Aubin.* 6 vols. Paris, 1909–21.

Dacier 1929–31 Émile Dacier. *Gabriel de Saint-Aubin. Peintre, dessinateur et graveur (1724–1780).* 2 vols. Paris and Brussels, 1929–31.

Dacier 1949 Émile Dacier. "La curiosité au XVIIIᵉ siècle. Choiseul collectionneur." *Gazette des Beaux-Arts* XXXVI (July–Sept. 1949), pp. 47–74.

Dacier and Vuaflart 1921–29 Émile Dacier and Albert Vuaflart. *Jean de Julienne et les graveurs de Watteau au XVIIIᵉ siècle.* 4 vols. 1921–29.

Dandré-Bardon 1972 Michel François Dandré-Bardon. *Traité de peinture suivi d'un essai sur la sculpture.* Paris, 1765. Reprint: Geneva, 1972.

Dapper 1670 Olfert Dapper. *Gedenkweredig Bedryf der Nederlandsche Oostindische maetschappye.* Amsterdam, 1670.

D'Arneth and Geoffroy 1874 Alfred d'Arneth and Auguste Geoffroy, eds. *Correspondance secrète entre Marie-Thérèse et le Comte de Mercy-Argenteau. Avec les lettres de Marie-Thérèse et de Marie-Antoinette.* 3 vols. Paris, 1874.

Dassas 2002 *L'Invention du sentiment aux sources du Romantisme.* Exhib. cat. edited by Frédéric Dassas, Dominique de Font-Réaulx and Barthélémy Jobert. Musée de la musique, Paris, 2002.

Dauban 1867 Charles Aimé Dauban, ed. *Lettres en partie inédites de Madame Roland (Mlle. Plipon) aux demoiselles Cannet suivies des lettres de Madame Roland à Bosc, Servan, Lanthenas, Robespierre, etc., et de documents inédits.* 2 vols. Paris, 1867.

Dautzenberg 1959 Jean Dautzenberg. "Une tapisserie ancienne d'Aubusson d'après Étienne Jeaurat." *Bulletin de la Société de l'Histoire de l'Art Français. Année 1958* (1959), pp. 89–90.

Davidson and Munhall 1968 Bernice Davidson and Edgar Munhall. *The Frick Collection: An Illustrated Catalogue. Paintings,* vols. I and II. New York, 1968.

Davies 1946 Martin Davies. *National Gallery Catalogues: French School.* London, 1946.

De Beaumont 1998 Kim de Beaumont. "Reconsidering Gabriel de Saint-Aubin (1724–1780): The Background for his Scenes of Paris." 2 vols. Ph.D. diss., New York University, 1998.

De Brosses 1986 Charles de Brosses. *Lettres d'Italie.* 2 vols. Paris, 1986.

Delpierre 1997 Madeleine Delpierre. *Dress in France in the Eighteenth Century.* London, 1997.

De Maintenant 2002 Elvire de Maintenant. "Michel Garnier, peintre de genre sous la Révolution." *L'Estampille* 370 (June 2002), pp. 76–82.

Démoris 1969 René Démoris. "La nature morte chez Chardin." *Revue d'Esthétique* XXII:4 (1969), pp. 363–85.

Démoris 1987 André Félibien. *Entretiens sur les vies et les ouvrages des plus excellens peintres anciens et modernes.* Edited, with introduction, by René Démoris. Paris, 1987.

Démoris 1991 René Démoris. *Chardin, la chair et l'objet.* Paris, 1991.

De Piles 1699 Roger de Piles. *Abrégé de la vie des peintres, avec des reflexions sur leurs ouvrages, et un Traité du peintre parfait, de la connaissance des desseins et de l'utilité des estampes.* Paris, 1699.

De Piles 1989 Roger de Piles. *Cours de peinture par principes.* 1708. Reprint, with preface by Jacques Thuillier. Paris, 1989.

Descamps 1753–64 Jean-Baptiste Descamps. *La vie des peintres flamands, allemands et hollandois, avec des portraits gravés en taille-douce, une indication de leurs principaux ouvrages & des réflexions sur leurs différentes manières.* 4 vols. Paris, 1753–64.

Dezallier d'Argenville 1727 Antoine-Joseph Dezallier d'Argenville. "Lettre sur le choix et l'arrangement d'un Cabinet curieux, écrite par M. Dezallier d'Argenville, Secretaire du Roy en la Grande Chancellerie, à M. de Fougeroux, Tresorier-Payeur des Rentes de l'Hôtel de Ville." *Mercure de France* (June 1727), pp. 1295–1330.

Dezallier d'Argenville 1745–52 Antoine-Joseph Dezallier d'Argenville. *Abrégé de la vie des plus fameux peintres.* 3 vols. Paris, 1745–52.

Dezallier d'Argenville 1762 Antoine-Joseph Dezallier d'Argenville. *Abrégé de la vie des plus fameux peintres.* 4 vols. New ed. Paris, 1762. Reprint: Geneva, 1972.

Diderot *Correspondance* Denis Diderot. *Correspondance.* Edited by Georges Roth and J. Varloot. 16 vols. Paris, 1955–70.

Diderot 1984a *Diderot et l'art de Boucher à David.* Exhib. cat. Hôtel de la Monnaie, Paris, 1984.

Diderot 1984b Denis Diderot. *Essais sur la peinture. Salons de 1759, 1761, 1763.* Edited by G. May and J. Chouillet. Paris, 1984.

Diderot 1984, *Salon de 1765* Denis Diderot. *Salon de 1765. Essais sur la peinture. Oeuvres complètes.* XIV. Paris, 1984.

Diderot 1995a Denis Diderot. *Salon de 1767. Salon de 1769. Oeuvres complètes.* XVI. Paris, 1995.

Diderot 1995b Denis Diderot. *Salon de 1781.* Paris, 1995.

Diderot and d'Alembert 1751–76 Denis Diderot and Jean Le Rond d'Alembert. *Encyclopédie ou Dictionnaire raisonné des sciences, des arts et des métiers, par une société de gens de lettres.* 28 vols. in addition to supplement and index. Paris, 1751–76. Reprinted in 5 vols. New York, 1969.

Didier Aaron Didier Aaron Ltd. *Catalogue IV.* Paris, London, New York, n.d.

Dijon 1969 *Trois peintres bourguignons du XVIIIᵉ siècle: Colson, Vestier, Trinquesse.* Exhib. cat. Musée des Beaux-Arts, Dijon, 1969.

Dilke 1898 Lady Emilia Dilke. "L'art français au Guildhall de Londres en 1898." *Gazette des Beaux-Arts* XX:496 (Oct. 1898), pp. 321–36.

Dilke 1899 Lady Emilia Dilke. *French Painting of the XVIIIth Century.* London, 1899.

Doane and Hodges 1992 Janice Doane and Devon Hodges. *From Klein to Kristeva: Psychoanalytic Feminism and the Search for the "good enough" Mother.* Ann Arbor, 1992.

Dresdner 1915 Albert Dresdner. *Die Entstehung der Kunstkritik im Zusammenhang mit der Geschichte des europäischen Kunstlebens.* Munich, 1915.

Dubois 1853 François Dubois. "Éloge de M. Hallé." *Mémoires de l'Académie Impériale de Médecine* XVII (1853), pp. i–xxvii.

Dubois de Saint-Gelais 1727 Louis-François Dubois de Saint-Gelais. *Description des tableaux du Palais-Royal; avec la vie des peintres à la tête de leurs ouvrages.* Paris, 1727. Reprint: Geneva, 1972.

Dubos 1993 Abbé Jean-Baptiste Du Bos. *Réflexions critiques sur la poésie et sur la peinture.* 1755. Reprint: Paris, 1993.

Dufour 1685 Philippe Sylvestre Dufour. *The Manner of Making Coffee, Tea, and Chocolate: As It Is Used in Most Parts of Europe, Asia, Africa, and America with their Virtues.* London, 1685.

Du Halde 1735 Père Du Halde. *Description géographique, historique, chronologique, politique et physique de l'Empire de la Chine et de la Tartarie chinoise.* The Hague, 1735.

Duits 1964 Anonymous. "A Boilly Drawing: Does it Point to a Lost Snyders?" Clifford Duits, ed. *Duits Quarterly* I:3 (Spring 1964), pp. 6–9.

Duncan 1973 Carol Duncan. "Happy Mothers and Other New Ideas in French Art." *The Art Bulletin* LV:4 (Dec. 1973), pp. 570–83.

Duncan 1981 Carol Duncan. "Fallen Fathers: Images of Authority in Pre-Revolutionary French Art." *Art History* IV:2 (June 1981), pp. 186–202.

Dussieux 1854 Louis-Étienne Dussieux, Eudore Soulié et al. *Mémoires inédits sur la vie et les ouvrages des membres de l'Académie Royale de Peinture et de Sculpture.* 2 vols. Paris, 1854.

Dussieux 1856 Louis-Étienne Dussieux. *Les Artistes français à l'étranger.* Paris, 1856.

Duverger 1967 Erik Duverger. "Réflexions sur le commerce d'art au XVIIIᵉ siècle." In *Stil und Überlieferung in der Kunst des Abendlandes,* papers from the 21st International Congress of Art History (Bonn 1964). Berlin, 1967, III, pp. 65–88.

Edwards 1996 JoLynn Edwards. *Alexandre-Joseph Paillet. Expert et marchand de tableaux à la fin du XVIIIᵉ siècle.* Paris, 1996.

Ehrman 1968 J. Ehrman. "Homo Ludens Revisited." *Yale French Studies* XLI (1968), pp. 31–57.

Eidelberg 1977a Martin Eidelberg. "Watteau's Drawings: Their Use

and Significance." Ph.D. diss., Princeton University. New York and London, 1977.

Eidelberg 1977b Martin Eidelberg. "A Chinoiserie by Jacques Vigoureux-Duplessis." *The Journal of the Walters Art Gallery* XXXV (1977), pp. 62ff.

Eidelberg 1997 Martin Eidelberg. "'Dieu invenit, Watteau pinxit.' Un nouvel éclairage sur une ancienne relation." *Revue de l'Art* 115 (1997), pp. 25–29.

Eidelberg and Gopin 1997 Martin Eidelberg and Seth A. Gopin. "Watteau's Chinoiseries at La Muette." *Gazette des Beaux-Arts* CXXX (July–Aug. 1997), pp. 19–46.

Eisler 1977 Colin Eisler. *Complete Catalogue of the Kress Collection: European Paintings Excluding Italian.* London, 1977.

Eliel 1989 Carol Eliel. "Genre Painting during the Revolution and the *Goût Hollandais.*" In Wintermute 1989, pp. 47–61.

Encyclopédie *Encyclopédie ou Dictionnaire raisonné des sciences, des arts et metiers, par une société de gens de lettres, mis en ordre par Diderot, et quant à la partie mathématique par d'Alembert.* 28 vols. 1751–72.

Engerand 1899 Fernand Engerand, ed. *Inventaires des collections de la couronne. Inventaire des tableaux du roy, rédigé en 1709 et 1710 par Nicole Bailly.* Paris, 1899.

Engerand 1901 Fernand Engerand, ed. *Inventaires des collections de la couronne. Inventaire des tableaux commandés et achetés par la direction des bâtiments du roi (1709–1792).* Paris, 1901.

Ernst 1924 Sergei Ernst. *Gosudarstvennij musejnij fond. Yusupovskaya Galerya–Frantsuskaya Skola [State Museum Foundation. Yusupov Gallery. French School].* The Hermitage, Leningrad, 1924, pp. 196–97.

Estournet 1905 Octave Estournet. "La famille des Hallé." Excerpt from the *Réunion des Sociétés des Beaux-Arts des Départements* (1905), pp. 71–236.

Exposition 1900 *Exposition centennale de l'art français 1800–1889 – Exposition universelle de 1900.*

Extrait . . . 1854, II *Extrait de la vie de M. de Troy, peintre du roi et directeur de son Académie à Rome*, voir *Mémoires inédits. . . . 1854*, II, pp. 274–80.

Fahy and Watson 1973 Francis J. Watson, ed. *The Wrightsman Collection*, vol. 5: *Paintings and Drawings*, by Everett Fahy. The Metropolitan Museum of Art, New York, 1973.

Faton 1982 Louis Faton. "La bergère, reine des sièges: Le mystère du tableau de Jean-François de Troy." *L'Estampille* 150 (Oct. 1982), pp. 20–21.

Félibien 1660 André Félibien. *De l'origine de la peinture et des plus excellents peintres de l'Antiquité. Dialogue.* Paris, 1660.

Félibien 1668 André Félibien. *Conférences tenues à l'Académie royale de peinture et de sculpture en l'année 1667.* Paris, 1668.

Félibien 1705 André Félibien. *Entretiens sur les vies et les ouvrages des plus excellents peintres anciens et modernes.* New ed. 4 vols. London, 1705.

Félibien 1725 André Félibien. *Entretiens sur les vies et les ouvrages des plus excellents peintres anciens et modernes avec la vie des architectes.* New ed. Trévoux, 1725. Reprint, with an introduction by Anthony Blunt, Farnborough, 1967.

Fenaille 1903–23 Maurice Fenaille. *État général des tapisseries de la Manufacture des Gobelins depuis son origine jusqu'à nos jours, 1600–1900.* 4 vols. Paris, 1903–23.

Fénelon 1687 François Fénelon. *De l'éducation des filles.* 1687. Edited by J. Le Brun. Paris, 1983.

Flandrin 1979 Jean-Louis Flandrin. *Families in Former Times: Kinship, Household, and Sexuality.* Cambridge, 1979.

Flandrin 1993 Jean-Louis Flandrin. *Les amours paysannes, XVI^e–XIX^e siècles.* Paris, 1993.

Fleckner, Schieder and Zimmermann 2000 Uwe Fleckner, Martin Schieder and Michael Zimmermann, eds. *Jenseits der Grenzen. Französische und deutsche Kunst vom Ancien régime bis zur Gegenwart. Thomas W. Gaehtgens zum 60. Geburtstag.* 3 vols. Cologne, 2000.

Fontaine 1909 André Fontaine. *Les doctrines d'art en France. Peintres, amateurs, critiques de Poussin à Diderot.* Paris, 1909.

Fort 1999 Louis Petit de Bachaumont. *Les salons des "Mémoires secrets" 1767–1787.* Edited by Bernadette Fort. Paris, 1999.

Foucart-Walter 1982 Elisabeth Foucart-Walter. *Le Mans, musée de Tessé. Peintures françaises du XVII^e siècle.* Inventaire des collections publiques françaises, no. 26. Paris, 1982.

Fourcaud 1899 M. de Fourcaud. "Jean-Baptiste Siméon Chardin." *Revue de l'Art Ancien et Moderne* II (1899), pp. 383–418.

Fournel 1887 Victor Fournel. *Le Vieux Paris. Fêtes, jeux et spectacles.* Tours, 1887.

Franklin 1906 Alfred Franklin. *Dictionnaire historique des arts, métiers et professions exercés dans Paris depuis le treizième siècle.* Paris, 1906.

Fredericksen 1988 Burton B. Fredericksen. *Masterpieces of Painting in the J. Paul Getty Museum.* Malibu, 1988.

Fréron 1757 Élie-Catherine Fréron. "Lettre XV: Exposition des ouvrages de peinture, de sculpture et de gravure." *L'Année littéraire* (1757), pp. 347–48.

Fried 1980 Michael Fried. *Absorption and Theatricality: Painting and Beholder in the Age of Diderot.* Berkeley, Los Angeles, London, 1980.

Friedel 2001 *Pygmalions Werkstatt. Die Erschaffung des Menschen im Atelier von der Renaissance bis zum Surrealismus.* Exhib. cat. edited by H. Friedel. Munich, 2001.

Fumaroli 1996 Marc Fumaroli. "Une amité paradoxale: Antoine Watteau et le comte de Caylus (1712–1719)." *Revue de l'Art* 114 (1996), pp. 34–47.

Furcy-Raynaud 1903–04 Marc Furcy-Raynaud, ed. "Correspondance de M. de Marigny avec Coypel, Lépicié et Cochin [1751–1773]." *Nouvelles archives de l'art français* XIX [1751–1764] (1903) and XX [1765–1773] (1904).

Gaborit 1989 Jean-René Gaborit, ed. *La Révolution française et l'Europe. 1789–1799.* Exhib. cat. Paris 1989.

Gaehtgens 1980 Thomas W. Gaehtgens. "Chardin, 1699–1779" [Review]. *Kunstchronik* II:3 (Mar. 1980), pp. 89–95.

Gaehtgens 1983 Thomas W. Gaehtgens. "Fragonard: *Fest von Saint-Cloud.*" In Berlin 1983, pp. 27–35.

Gaehtgens 1987 Barbara Gaehtgens. *Adriaen van der Werff (1659–1722).* Munich, 1987.

Gaehtgens 2000 Thomas W. Gaehtgens. "Die Gestalt der Venus im 18. Jahrhundert in Frankreich." In *Faszination Venus. Bilder einer Göttin von Cranach bis Cabanel.* Exhib. cat. edited by Ekkehard Mai. Museum der Stadt, Cologne, and Koninklijk Museum, Antwerp, 2000, pp. 147–60.

Gaehtgens 2001 Thomas W. Gaehtgens et al., eds. *L'art et les normes sociales au XVIII^e siècle.* Paris, 2001.

Gaehtgens 2002 Barbara Gaehtgens. *Genremalerei: Geschichte der klassischen Bildgattungen in Quellentexten und Kommentaren.* Berlin, 2002.

Gaehtgens and Fleckner 1996 Thomas W. Gaehtgens and Uwe Fleckner, eds. *Historienmalerei: Geschichte der klassischen Bildgattungen in Quellentexten und Kommentaren.* Berlin, 1996.

Gaehtgens and Lugand 1988 Thomas W. Gaehtgens and Jacques Lugand. *Joseph-Marie Vien. peintre du Roi (1716–1809).* Paris, 1988.

Galerie françoise *Galerie françoise ou Portrait des hommes et des femmes célèbres qui ont paru en France.* 2 vols. Paris, 1771–72.

Garnier-Pelle 1995 Nicole Garnier-Pelle. *Chantilly, musée Condé. Peintures du XVIII^e siècle.* Paris, 1995.

Garrigues 1982 Martine Garrigues, ed. *La Révolution française. Le Premier Empire.* Exhib. cat. Paris, 1982.

Garstang 1984 *Art, Commerce, Scholarship: A Window onto the Art World. Colnaghi 1760 to 1984.* Exhib. cat. by Donald Garstang. Colnaghi, London, 1984.

Gaston-Dreyfus 1922 Philippe Gaston-Dreyfus. "Catalogue raisonné de l'oeuvre de Nicolas-Bernard Lépicié." *Bulletin de la Société de l'Histoire de l'Art Français. Année 1922* (1922), pp. 134–283.

Gaston-Dreyfus 1923 Philippe Gaston-Dreyfus. *Catalogue raisonné de l'oeuvre peint et dessiné de Nicolas-Bernard Lépicié (1735–1784).* Paris, 1923.

Gélis 1989 Jacques Gélis. "The Child: From Anonymity to Individuality." In *A History of Private Life,* vol. 3: *Passions of the Renaissance.* Edited by R. Chartier. Translated by A. Goldhammer. Cambridge, Mass., and London, 1989, pp. 309–25.

Germer 1997 Stefan Germer. *Kunst, Macht, Diskurs. Die Intellektuelle Karriere des André Félibien.* Munich, 1997.

Gerson 1983 Horst Gerson. *Ausbreitung und Nachwirkung der holländischen Malerei des 17. Jahrhunderts.* Amsterdam, 1983.

Gesamtverzeichnis 1996 Henning Bock, Jan Kelch, Rainer Michaelis et al. *Gemäldegalerie Berlin. Gesamtverzeichnis.* Staatliche Museen zu Berlin, Preussischer Kulturbesitz, Berlin, 1996.

Gimpel 1963 René Gimpel. *Journal d'un collectionneur, marchand de tableaux.* Paris, 1963.

Glorieux 1998 Guillaume Glorieux. "Edmé-François Gersaint 1694–1750: un marchand-mercier exemplaire au XVIIIᵉ siècle." *L'Estampille* 330 (Dec. 1998), pp. 46–57.

Goethe 1985–98 Johann Wolfgang von Goethe. *Sämtliche Werke nach Epochen seines Schaffens.* Edited by Karl Richter et al. 21 vols. Munich, 1985–98.

Goldner 1988–2001 George R. Goldner. *J. Paul Getty Museum. European Drawings. Catalogue of the Collections.* 4 vols. Los Angeles, 1988–2001.

Goncourt 1862 Edmond and Jules Goncourt. *La femme au dix-huitième siècle.* Paris, 1862.

Goncourt 1875 Edmond de Goncourt. *Catalogue raisonné de l'oeuvre peint, dessiné et gravé d'Antoine Watteau.* Paris, 1875.

Goncourt 1880–82 Edmond and Jules de Goncourt. *L'Art du dix-huitième siècle.* 3rd ed. 2 vols. Paris, 1880–82.

Goncourt 1981 Edmond and Jules de Goncourt. *French Painting in the Eighteenth Century.* Translated by Robin Ironside. 2nd ed. Oxford, 1981.

Gooden 1999 Angelica Gooden. "Danloux in England (1792–1802): An Émigré Artist." In *The French Émigrés in Europe and the Struggle against Revolution 1789–1814.* Edited by Kirsty Carpenter and Philip Mansel. London, 1999, pp. 165–83.

Goodison and Sutton 1960 J.W. Goodison and Denys Sutton. *Catalogue of Paintings in the Fitzwilliam Museum, Cambridge, Vol. I, French, German and Spanish.* Cambridge, 1960.

Goodman (E.) 1995 Elise Goodman. "'Les jeux innocents': French Rococo Birding and Fishing Scenes." *Simiolus* XXIII:4 (1995), pp. 251–67.

Goodman 1995 John Goodman, ed. and trans. *Diderot on Art.* 2 vols. New Haven and London, 1995.

Goodman-Soellner 1983 Elise Goodman-Soellner. "Nicolas Lancret's 'Le miroir ardent': An Emblematic Image of Love." *Simiolus* XIII: 3–4 (1983), pp. 218–24.

Gordon 1968 Katherine K. Gordon. "Madame de Pompadour, Pigalle, and the Iconography of Friendship." *The Art Bulletin* L:3 (Sept. 1968), pp. 249–62.

Gougenot 1749 Abbé Louis Gougenot. *Lettre sur la peinture, la sculpture et l'architecture à M***.* Amsterdam, 1749.

Grasselli and McCullagh 1994 Margaret Morgan Grasselli and Suzanne Folds McCullagh. "*Nicolas Lancret (1690–1743)*" [review of exhib. cat.]. *Master Drawings* XXXII:2 (Summer 1994), pp. 168–71.

Grasselli and Rosenberg 1984 *Watteau, 1684–1721.* Exhib. cat. by Margaret Morgan Grasselli and Pierre Rosenberg. National Gallery of Art, Washington, D.C., 1984. French ed.: Grand Palais, Paris, 1984.

Grate 1994 Pontus Grate. *Swedish National Art Museums. French Paintings II. Eighteenth Century.* Stockholm, 1994.

Grigaut 1949 Paul L. Grigaut. "Marmontel's *Shepherdess of the Alps* in Eighteenth-Century Art." *The Art Quarterly* XII:1 (1949), pp. 30–47.

Grosrichard 1979 A. Grosrichard. *Structure du sérail. La fiction du despotisme asiatique dans l'Occident classique.* Paris, 1979.

Gruber 1992 Alain Gruber. "Chinoiserie." In *L'art décoratif en Europe. Classique et baroque.* Paris, 1992.

Guicharnaud 1999 Hélène Guicharnaud. "Un Collectionneur Parisien, ami de Greuze et de Pigalle, l'abbé Louis Gougenot (1724–1767)." *Gazette des Beaux-Arts* CXXXI:1566–67 (July–Aug. 1999), pp. 1–74.

Guiffrey 1874 Jules J. Guiffrey, ed. *Éloge de Lancret peintre du roi, par Ballot de Sovot, accompagné de diverses notes sur Lancret, de pièces inédites et du catalogue des ses tableaux et de ses estampes.* Paris, [1874].

Guiffrey 1990 Jules J. Guiffrey, ed. *Collection des livrets des anciennes expositions depuis 1673 jusqu'en 1800.* Facsimile reprint of the 1869–72 ed. Nogent-le-Roi, 1990.

Guth 1956 Paul Guth. "Catalogue des Tableaux de Mr. de Jullienne." *Connaissance des Arts* I:50 (Apr. 1956), pp. 64–69.

Haillet de Couronne 1854 Jean-Baptiste-Guillaume Haillet de Couronne. "Éloge de M. Chardin sur les mémoires fournis par M. Cochin." In Dussieux 1854, II, pp. 428–41.

Hallam 1977 John S. Hallam. "The Alchemist Transformed: Boilly's *Electric Shock* in Richmond." *Arts in Virginia* XVII:3 (Spring 1977), pp. 2–11.

Hallam 1979 John S. Hallam. *The Genre Works of Louis-Léopold Boilly.* University Microfilms. Ann Arbor, 1979.

Hallam 1981 John S. Hallam. "The Two Manners of Louis-Léopold Boilly and French Genre Painting in Transition." *The Art Bulletin* LXIII:4 (Dec. 1981), pp. 618–33.

Hallam 1984 John S. Hallam. "Boilly et Calvet de Lapalun, ou la sensibilité chez le peintre et l'amateur." *Bulletin de la Société de l'art français* (1984), pp. 177–92.

Harrison 1986 Jefferson C. Harrison. *French Paintings from the Chrysler Museum.* Norfolk, Virginia, 1986.

Harrisse 1898 Henry Harrisse. *L.-L. Boilly, peintre, dessinateur et lithographe, sa vie et son oeuvre, 1761–1845.* Paris, 1898.

Harrisse 1898 BN Henry Harrisse. *L.-L. Boilly, peintre, dessinateur et lithographe, sa vie et son oeuvre, 1761–1845.* Copy owned by Harrisse with manuscript annotations and additions, bequeathed to the Bibliothèque nationale, Paris, Cabinet des estampes (D.c. 43.a+ pet. fol.).

Haskell 1984 Francis Haskell. "The Voyage of Watteau." *New York Review of Books* XX (Dec. 1984), pp. 25–30.

Haskell and Penny 1994 Francis Haskell and Nicholas Penny. *Taste and the Antique: The Lure of Classical Sculpture, 1500–1900.* 4th ed. New Haven, 1994.

Hautecoeur 1909 Louis Hautecoeur. "Le sentimentalisme dans la peinture française de Greuze à David." *Gazette des Beaux-Arts* (1909).

Heidner 1982 Jan Heidner, ed. *Carl Fredrik Scheffer. Lettres particulières à Carl Gustaf Tessin, 1744–1752.* Stockholm, 1982.

Heidner 1984 Jan Heidner. "Edme-François Gersaint. Neuf lettres au comte Carl Gustav Tessin, 1743–1748." *Archives de l'Art français* XXVI (1984), pp. 185–96.

Heidner 1997 Jan Heidner, ed. *Carl Reinhold Berch. Lettres Parisiennes adressées à ses amis, 1740–1746.* Stockholm, 1997.

Heim and Béraud 1989 Jean-François Heim, Claire Béraud and Philippe Heim. *Les salons de peinture de la révolution française 1789–1799*. Paris, 1989.

Held 1990 Jutta Held. *Monument und Volk. Vorrevolutionäre Wahrnehmung in Bildern des ausgehenden Ancien Régime*. Cologne and Vienna, 1990.

Hellegouarc'h 2000 Jacqueline Hellegouarc'h. *L'Esprit de société. Cercles et "salons" parisiens au XVIIIᵉ siècle*. Paris, 2000.

Hercenberg 1975 Bernard Hercenberg. *Nicolas Vleughels. Peintre et Directeur de l'Académie de France à Rome, 1663–1737*. Paris, 1975.

Hiesinger 1976 Kathryn B. Hiesinger. "The Sources of François Boucher's Psyche Tapestries." *Philadelphia Museum of Art Bulletin* (Nov. 1976), pp. 7–23.

Hilberath 1993 Ursula Hilberath. "'Ce sexe est sûr de nous trouver sensible.' Studien zu Weiblichkeitsentwürfen in der französischen Malerei der Aufklärungszeit (1733–1789)." Ph.D. diss., Bonn, 1993.

Hirth and Muther 1888 Georg Hirth and Richard Muther. *Der Cicerone in der Königlichen Älteren Pinakothek zu München*. Munich, 1888.

Hohenzollern 1992 *Friedrich der Grosse. Sammler und Mäzen*. Exhib. cat. edited by Johann Georg, Prince of Hohenzollern. Hypo-Kunsthalle, Munich, 1992.

Holmes 1985 Mary Tavener Holmes. "Lancret, décorateur des 'petits cabinets' de Louis XV à Versailles." *L'oeil* 356 (Mar. 1985), pp. 24–31.

Holmes 1986 Mary Tavener Holmes. "Nicolas Lancret and Genre Themes of the Eighteenth Century." Ph.D. diss., New York University, 1986.

Holmes 1991a *Nicolas Lancret 1690–1743*. Exhib. cat. by Mary Tavener Holmes. The Frick Collection, New York, 1991.

Holmes 1991b Mary Tavener Holmes. "Deux chefs-d'oeuvre de Nicolas Lancret (1690–1743)." *Revue du Louvre et des musées de France* 41 (1991), pp. 40–42.

Honour 1961 Hugh Honour. *Chinoiserie, the Vision of Cathay*. New York, 1961.

Hould 1979–80 Claudette Hould. "Un tableau de Jacques Sablet au Musée des beaux-arts de Montréal." *RACAR* VI:2 (1979–80), pp. 97–105.

Howells 2000 Robin Howells. "Marivaux's *Le Bilboquet* (1714): The Game as Subversive Principle." *Studies on Voltaire and the Eighteenth Century* (2000), pp. 175–78.

Huizinga 1970 Johan Huizinga. *Homo Ludens: A Study of the Play Element in Culture*. London, 1970.

Hyde 1996 Melissa Hyde. "Confounding Conventions: Gender Ambiguity and François Boucher's Painted Pastorals." *Eighteenth-Century Studies* XXX:1 (1996), pp. 25–57.

Ingamells 1989 John Ingamells. *The Wallace Collection. Catalogue of Pictures*, III: *French before 1815*. London, 1989.

Ingersoll-Smouse 1920 Florence Ingersoll-Smouse. "Charles-Antoine Coypel, 1694–1752." *Revue de l'Art Ancien et Moderne* XXXVII (Mar. 1920), pp. 143–54, and (May 1920), pp. 285–92.

Ingersoll-Smouse 1923 Florence Ingersoll-Smouse. "Nicolas-Bernard Lépicié." *Revue de l'Art Ancien et Moderne* XLIII (1923), pp. 39–43, 129–36, 365–78.

Ingersoll-Smouse 1924 Florence Ingersoll-Smouse. "Nicolas-Bernard Lépicié." *Revue de l'Art Ancien et Moderne* XLVI (1924), pp. 122–30, 217–28.

Ingersoll-Smouse 1925 Florence Ingersoll-Smouse. "Quelques tableaux de genre inédits par Étienne Aubry (1745–1781)." *Gazette des Beaux-Arts* II (1925).

Ingersoll-Smouse 1926a Florence Ingersoll-Smouse. "Nicolas-Bernard Lépicié." *Revue de l'Art Ancien et Moderne* L (1926), pp. 293–96.

Ingersoll-Smouse 1926b Florence Ingersoll-Smouse. *Joseph Vernet, 1714–1789. Peintre de Marine*. 2 vols. Paris, 1926.

Ingersoll-Smouse 1927 Florence Ingersoll-Smouse. "Nicolas-Bernard Lépicié." *Revue de l'Art Ancien et Moderne* LI (1927), pp. 179–86.

Ingersoll-Smouse 1928 Florence Ingersoll-Smouse. *Pater. Biographie et catalogue critiques, l'oeuvre complète de l'artiste reproduite en deux cent treize héliogravures*. Paris, 1928.

Jarry 1975 Madeleine Jarry. "Chinoiseries à la mode de Beauvais." *Plaisir de France* (May 1975), pp. 53–60.

Jean-Richard 1978 Pierrette Jean-Richard. *L'oeuvre gravé de François Boucher dans la collection Edmond de Rothschild*. Paris, 1978.

Johnson 1990 Dorothy Johnson. "Picturing Pedagogy: Education and the Child in the Paintings of Chardin." *Eighteenth-Century Studies* XXIV:1 (1990), pp. 47–68.

Jollet 2001 Étienne Jollet, ed. *La Font de Saint-Yenne. Oeuvre critique*. Paris, 2001.

Junecke 1960 Hans Junecke. *Montmorency, Der Landsitz Charles Le Brun's. Geschichte, Gestalt und die "Ile Enchantée."* Berlin, 1960.

Karlsruhe 1984 Staatliche Kunsthalle Karlsruhe. *Neuerwerbungen für die Gemäldegalerie, 1972–1984*. Karlsruhe, 1984.

Karlsruhe 1985 Anonymous. "Staatliche Kunsthalle Karlsruhe. Neuerwerbungen 1984." *Jahrbuch der Staatlichen Kunstsammlungen in Baden-Württemberg* XXII (1985), pp. 151–66.

Karlsruhe 1991 *Hubert Robert 1733–1808 und die Brücken von Paris*. Exhib. cat. Staatliche Kunsthalle Karlsruhe, 1991.

Karlsruhe 1996 *Vom Glück des Lebens. Französische Kunst des 18. Jahrhunderts aus der Staatlichen Eremitage St. Petersburg*. Exhib. cat. Karlsruhe, 1996.

Karlsruhe 1999 *Jean-Siméon Chardin. Werk, Herkunft, Wirkung*. Exhib. cat. Staatliche Kunsthalle Karlsruhe, 1999.

Kauffmann 1973 Claus Michael Kauffmann. *Victoria and Albert Museum. Catalogue of Foreign Paintings*. 2 vols. London, 1973.

Kavanagh 1993 Thomas M. Kavanagh. *Enlightenment and the Shadows of Chance: The Novel and the Culture of Gambling in Eighteenth-Century France*. Baltimore and London, 1993.

Kemmer 1998 Claus Kemmer. "In Search of Classical Form: Gérard de Lairesse's *Groot Schilderboek* and Seventeenth-Century Dutch Genre Painting." *Simiolus* XXVI:1–2 (1998), pp. 87–115.

Kemp 1976 Martin Kemp. "The Hunterian Chardin X-Rayed." *The Burlington Magazine* CXVIII:877 (Apr. 1976), pp. 228–31.

Kentfield 1839 Edwin Kentfield. *The Game of Billiards*. London, 1839.

Kircher 1667 Athanasius Kircher. *China Monumentis qua Sacris qua Profanis*. Amsterdam, 1667.

Kirchner 1990 Thomas Kirchner. "Neue Themen – neue Kunst? Zu einem Versuch, die französische Historienmalerei zu reformieren." In Ekkehard Mai and Anke Repp-Eckert, eds. *Historienmalerei in Europa. Paradigmen in Form, Funktion und Ideologie*. Mainz am Rhein, 1990, pp. 107–19.

Kirchner 1997 Thomas Kirchner. "La nécessité d'une hiérarchie des genres." *Revue de l'Esthétique* [issue title: *La naissance de la théorie de l'art en France 1640–1720*] 31–32 (1997), pp. 187–96.

Koch 1967 Georg Friedrich Koch. *Die Kunstausstellung. Ihre Geschichte von den Anfängen bis zum Ausgang des 18. Jahrhunderts*. Berlin, 1967.

Krause 1997 Katharina Krause. "Genrebilder: Mode und Gesellschaft der Aristokraten bei Jean-François de Troy." In *Festschrift für Johannes Langner zum 65. Geburtstag am 1. Februar 1997*. Münster, 1997, pp. 141–57.

Krempel 2000 Léon Krempel. *Studien zu den datierten Gemälden des Nicolaes Maes, 1634–1693*. Saint Petersburg, 2000.

Labbé and Bicart-Sée 1996 Jacqueline Labbé and Lise Bicart-Sée. *La collection de dessins d'Antoine-Joseph Dezallier d'Argenville, reconstituée d'après son* Abrégé de la vie des plus fameux peintres, *édition de 1762*. Paris, 1996.

La Bruyère 1965 Jean de La Bruyère. *Les caractères de Théophraste*

traduits du grec avec les caractères ou les moeurs de ce siècle. 1688. Reprint Paris, 1965.

Lacombe 1752 Jacques Lacombe. *Dictionnaire portatif des beaux-arts, ou Abrégé de ce qui concerne l'architecture, la sculpture, la peinture, la gravure, la poésie et la musique*. Paris, 1752.

La Font de Saint-Yenne 1747 Étienne La Font de Saint-Yenne. *Réflexions sur quelques causes de l'état présent de la peinture en France. Avec un examen des principaux ouvrages exposés au Louvre le mois d'août 1746*. The Hague, 1747. Reprint: Geneva, 1970.

La Font de Saint-Yenne 1752 Étienne La Font de Saint-Yenne. *L'ombre du grand Colbert, le Louvre, et la ville de Paris. Dialogue. Réflexions sur quelques causes de l'état présent de la peinture en France avec quelques lettres de l'auteur à ce sujet*. [Paris], 1752.

La Font de Saint-Yenne 1754 Étienne La Font de Saint-Yenne. *Sentimens sur quelques ouvrages de peinture, sculpture et gravure. Écrits à un Particulier en Province*. Paris, 1754.

La Gorce 1983 Jérôme de La Gorce. "Un peintre du XVIIIᵉ siècle au service de l'Opéra de Paris: Jacques Vigoureux-Duplessis." *Bulletin de la Société de l'Histoire de l'Art français. Année 1981* (1983), pp. 71–80.

Lagrange 1864 Léon Lagrange. *Les Vernet. Joseph Vernet et la peinture au XVIIIᵉ siècle*. Paris, 1864.

Laing 1986a *François Boucher, 1703–1770*. Exhib. cat. by Alastair Laing et al. Metropolitan Museum of Art, New York, 1986.

Laing 1986b Alastair Laing. "Boucher et la pastorale peinte." *Revue de l'Art* 73 (1986), pp. 55–64.

La Live de Jully 1764 Ange-Laurent de La Live de Jully. *Catalogue Historique*. 1764. Reprint in Bailey 1988.

Langlois 2000 Françoise Vieux-Pernon Langlois. *Catalogue des tableaux de l'école française, Roanne, Musée Déchelette*. Mémoire de maîtrise d'histoire de l'art. Université Lumière Lyon II, 2000.

Laskin and Pantazzi 1987 Myron Laskin and Michael Pantazzi. *Catalogue of the National Gallery of Canada, Ottawa. European and American Painting, Sculpture and Decorative Arts, 1300–1800*. Ottawa, 1987.

Laugier 1771 Marc-Antoine Laugier. *Manière de bien juger des ouvrages de peinture*. Paris, 1771.

Launay 1991 Élisabeth Launay. *Les frères Goncourt collectionneurs de dessins*. Paris, 1991.

Lavallet 1925 Mlle Lavallet. "Notes inédites sur la collection de Choiseul." *Bulletin de la Société de l'Histoire de l'art français. Année 1925* (1925), pp. 201–11.

Lawrence and Kasman 1997 Cynthia Lawrence and Magdalena Kasman. "Jeanne-Baptiste d'Albert de Luynes, Comtesse de Verrue (1670–1736)." In *Women and Art in Early Modern Europe: Patrons, Collectors, and Connoisseurs*. University Park, Pennsylvania, 1997, pp. 207–26.

Lebel 1926 Gustave Lebel. "Un Tableau de Gabriel de Saint-Aubin au musée de Perpignan." *Revue de l'Art Ancien et Moderne* XLIX (1926), pp. 48–54.

Lebrun 1776–77 Abbé Lebrun. *Almanach historique et raisonné des architectes, peintres, sculpteurs, graveurs, et ciseleurs*. 2 vols. Paris, 1776–77.

Lecointe de Laveau 1828 G. Lecointe de Laveau. "Archanguelski." *Bulletin du Nord* (3 March 1828), p. 285.

Lecointe de Laveau 1835 G. Lecointe de Laveau. *Description de Moscou*. 2nd ed. 2 vols. Moscow, 1835.

Le Comte 1696 Père Louis Le Comte. *Nouveau mémoire sur l'état présent de la Chine*. Paris, 1696.

Ledbury 1997 Mark Ledbury. "Intimate Dramas: Genre Painting and New Theater in Eighteenth-Century France." In Rand 1997, pp. 49–68.

Ledbury 2000 Mark Ledbury. *Sedaine, Greuze and the Boundaries of Genre*. Oxford, 2000.

Lefrançois 1994 Thierry Lefrançois. *Charles Coypel. Peintre du Roi, 1694–1752*. Paris, 1994.

Le Moël and Rosenberg 1969 Michel Le Moël and Pierre Rosenberg. "La collection de tableaux du duc de Saint-Aignan et le catalogue de sa vente illustré par Gabriel de Saint-Aubin." *Revue de l'Art* 6 (1969), pp. 51–67.

Lenoir 1816 Alexandre Lenoir. "Fragonard." In *Biographie universelle ancienne et moderne*. Edited by J. Fr. Michaud. Paris, 1816, XV, pp. 601–02.

Lenthe 1821 F.C.G. Lenthe. *Verzeichniss der Gemälde, welche sich in der Grossherzoglichen Gallerie zu Ludwigslust befinden*. Parchim, 1821.

Leribault 2002 Christophe Leribault. *Jean-François de Troy (1679–1752)*. Paris, 2002.

Levey 1965 Michael Levey. "A New Identity for Saly's 'Bust of a Young Girl.'" *The Burlington Magazine* (Feb. 1965), p. 91.

Levey 1966 Michael Levey. *Rococo to Revolution: Major Trends in Eighteenth-Century Painting*. New York and Toronto, 1966.

Lille 1985 *Au temps de Watteau, Fragonard et Chardin. Les Pays-Bas et les peintres français du XVIIIᵉ siècle*. Exhib. cat. Musée des Beaux-Arts, Lille, 1985.

Lille 1988 *Boilly 1761–1845. Un grand peintre français de la Révolution à la Restauration*. Exhib. cat. Musée des Beaux-Arts, Lille, 1988.

Lipton 1980 Eunice Lipton. "The Laundress in Late Nineteenth-Century French Culture: Imagery, Ideology and Edgar Degas." *Art History* III:3 (Sept. 1980), pp. 295–313.

Lipton 1986 Eunice Lipton. *Looking into Degas: Uneasy Images of Women and Modern Life*. Berkeley, 1986.

Lloyd 1994 *The Queen's Pictures. Old Masters from the Royal Collection*. Exhib. cat. by Christopher Lloyd. London, 1994.

Lloyd Williams 1992 Julia Lloyd Williams. *Dutch Art and Scotland: A Reflection of Taste*. Edinburgh, 1992.

Locke 1964 John Locke. *Some Thoughts Concerning Education*. 1693. New York, 1964.

Locquin 1978 Jean Locquin. *La Peinture d'histoire en France de 1747 à 1785, étude sur l'évolution des idées artistiques dans la seconde moitié du XVIIIᵉ siècle*. 1912. Paris, 1978.

London 1914 *French Art of the Eighteenth Century*. Exhib. cat. Burlington Fine Arts Club, London, 1914.

London 1976 *Claude-Joseph Vernet, 1714–1789*. Exhib. cat. by Philip Conisbee. The Iveagh Bequest, Kenwood, 1976.

London 2001 *French Drawings and Paintings from the Hermitage: Poussin to Picasso*. Exhib. cat. Somerset House, London, 2001.

Long 1923 Basil S. Long. *Catalogue of the Jones Collection. Part III – Paintings and Miniatures. Victoria and Albert Museum*. London, 1923.

Lundberg 1957 Gunnar W. Lundberg. *Roslin. Liv och Verk*. 3 vols. Malmö, 1957.

Lyons 1989 John D. Lyons. *Exemplum: The Rhetoric of Example in Early Modern France and Italy*. Princeton, 1989.

Mabille de Poncheville 1931 André Mabille de Poncheville. *Boilly*. Paris, 1931.

Macchia 1968 Giovanni Macchia. *L'opera completa di Watteau*. Milan, 1968.

Mai and Wettengl 2002 *Wettstreit der Künste. Malerei und Skulptur von Dürer bis Daumier*. Exhib. cat. by Ekkehard Mai and Kurt Wettengl. Munich and Cologne, 2002.

Mannlich 1805 Johann Christian von Mannlich. *Beschreibung der Churpfalzbaierischen Gemäldesammlungen zu München und Schleissheim*. 3 vols. Munich, 1805.

Mannlich 1989–93 Johann Christian von Mannlich. *Histoire de ma vie. Mémoires de Johann Christian von Mannlich, 1741–1822*. Edited by Karl-Heinz Bender and Hermann Kleber. 2 vols. Trier, 1989–93.

Manœuvre and Rieth 1994 Laurent Manœuvre and Erich Rieth. *Joseph Vernet, 1714–1789. Les ports de France.* Arcueil, France, 1994.

Marandel 1986 J. Patrice Marandel. "Boucher and Europe." In Laing 1986a, pp. 74–77.

Marandel 1991–92 J. Patrice Marandel. "Natoire aux appartements de Louis XV à Fontainebleau." *Antologia di belle arti* 39–42 (1991–92), pp. 129–34.

Mardrus 1993 Françoise Mardrus. "Le guide, la curiosité et la galerie du Palais Royal." *Histoire de l'art* 21–22 (1993), pp. 17–25.

Marie 1984 Alfred and Jeanne Marie. *Versailles au temps de Louis XV.* Paris, 1984.

Mariette 1851–60 Pierre Jean Mariette. *Abecedario de P.J. Mariette et autres notes inédites de cet amateur sur les arts et les artistes.* Edited by P. de Chennevières and A. de Montaiglon. 6 vols. Paris, 1851–60. Reprint: Paris, 1966.

Marlet 1821–24 Jean-Henri Marlet. *Tableaux de Paris* [72 plates with texts by V[?] and P.J.S. Duféy de l'Yonne]. Paris, 1821–24.

Marmottan 1913 Paul Marmottan. *Louis-Léopold Boilly.* Paris, 1913.

Martin and Chartier 1984 Henri-Jean Martin and Roger Chartier, eds. *Histoire de l'édition française.* II. *Le livre triomphant, 1660–1830.* Paris, 1984.

Massin 1981 Massin. *Les célébrités de la rue.* Paris, 1981.

Mathey 1939 Jacques Mathey. "Remarques sur la chronologie des peintures et dessins d'Antoine Watteau." *Bulletin de la Société de l'histoire de l'Art français* (1939), pp. 150–60.

Mathey 1959 Jacques Mathey. *Antoine Watteau. Peintures réapparues, inconnues ou négligées par les historiens.* Paris, 1959.

Maurepas and Boulant 1996 Arnaud de Maurepas and Antoine Boulant. *Les ministres et les ministères du siècle des Lumières (1715–1789). Étude et dictionnaire.* Paris, 1996.

Mauzi 1958 Robert Mauzi. "Écrivains et moralistes au XVIIIᵉ siècle devant le jeu de hasard." *Revue des sciences humaines* XC (1958), pp. 219–56.

Mauzi 1979 Robert Mauzi. *L'idée du bonheur dans la littérature et la pensée françaises au XVIIIᵉ siècle.* Paris, 1979. Reprinted 1994.

May 1984 Roland May, ed. *Diderot et la critique de Salon, 1759–1781.* Exhib. cat. Nouveau Musée d'Art et d'Histoire, Langres, 1984.

Maza 1983 Sarah Maza. *Servants and Masters in Eighteenth-Century France The Uses of Loyalty.* Princeton, 1983.

Maza 1997 Sarah Maza. "The 'Bourgeois' Family Revisited: Sentimentalism and Social Class in Pre-Revolutionary French Culture." In Rand 1997, pp. 39–47.

McAllister Johnson 1982 *French Royal Academy of Painting and Sculpture Engraved Reception Pieces, 1672–1789. Les morceaux de réception gravés de l'Académie royale de peinture et de sculpture, 1672–1789.* Exhib. publication by William McAllister Johnson. Agnes Etherington Art Centre, Kingston, 1982.

McClellan 1996 Andrew McClellan. "Watteau's Dealer: Gersaint and the Marketing of Art in Eighteenth-Century Paris." *The Art Bulletin* LXXVIII:3 (Sept. 1996), pp. 439–53.

McPherson 1982 Heather Ann McPherson. "Some Aspects of Genre Painting and its Popularity in Eighteenth-Century France." Ph.D. diss., University of Washington, 1982.

McWilliam 1990 Neil McWilliam, ed. *A Bibliography of Salon Criticism in Paris from the Ancien Régime to the Restoration, 1699–1827.* Cambridge, 1990.

Mehmet Effendi 1981 Mehmet Effendi. *Le paradis des Infidèles: Un ambassadeur ottoman en France sous la Régence.* Edited by G. Veinstein. Paris, 1981.

Mercier [1798] Louis-Sébastien Mercier. *Le Nouveau Paris.* 6 vols. Paris and Braunschweig, n.d. [1798].

Mercier 1990 Louis-Sébastien Mercier. *Tableau de Paris.* Paris, 1990.

Mérot 1996 Alain Mérot, ed. *Les conférences de l'Académie royale de peinture et de sculpture au XVIIᵉ siècle.* Paris, 1996.

Mesuret 1972 Robert Mesuret, ed. *Les expositions de l'Académie royale de Toulouse de 1751 à 1791. Livrets.* Toulouse, 1972.

Michaelis 1994 Rainer Michaelis. "Un dessin préparatoire pour Samson et Dalila: morceau de réception d'Antoine Pesne, 1683–1737, à l'Académie en 1720." *Revue du Louvre et des Musées de France* XLIII:4 (1994), pp. 41–42.

Michaud 1811–28 Louis-Gabriel Michaud. *Biographie universelle, ancienne et moderne.* 85 vols. Paris, 1811–28.

Michel 1985 Régis Michel. "Diderot and Modernity." *Oxford Art Journal* VIII:2 (1985), pp. 36–51.

Michel 1987a Christian Michel. "Les Fêtes galantes: peintures de genre ou peintures d'histoire?" In Moureau and Grasselli 1987, pp. 111–12.

Michel 1987b Christian Michel. *Charles-Nicolas Cochin et le livre illustré au XVIIIᵉ siècle.* Geneva, 1987.

Michel 1993 Christian Michel. *Cochin et l'art des Lumières.* Rome, 1993.

Michel 1994 Christian Michel. "De la fête champêtre au triomphe de l'agriculture." In *Paysages, paysans, l'art et la terre en Europe du Moyen Age au XIXᵉ siècle.* Exhib. cat. Bibliothèque nationale, Paris, 1994, pp. 145–59.

Michel 2000 Christian Michel. "Deutsche Ästhetik und französische Kunsttheorie am Ende des Ancien Régime: Encyclopédie méthodique Beaux-Arts." In Fleckner, Schieder and Zimmermann 2000, I, 329–44.

Michel and Bordes 1988 Régis Michel and Philippe Bordes, eds. *Aux Armes et aux arts! Les Arts de la Révolution 1789–1799.* Paris, 1988.

Michel and Rosenberg 1987 *Subleyras 1699–1747.* Exhib. cat. by Olivier Michel and Pierre Rosenberg. Musée du Luxembourg, Paris, 1987.

Milam 1998 Jennifer Milam. "Fragonard and the Blindman's Game: Interpreting Representations of Blindman's Buff." *Art History* XXI:1 (Mar. 1998), pp. 1–25.

Milam 1999 Jennifer Milam. "Fragonard's 'Le furet'." *The Burlington Magazine* CXLI:1158 (Sept. 1999), pp. 542–43.

Milan and Florence 2002 *Il neoclassicismo in Italia da Tiepolo a Canova.* Exhib. cat. Palazzo Reale, Milan and Florence, 2002.

Milliot 1995 Vincent Milliot. *Les Cris de Paris ou le Peuple Travesti. Les représentations des petits métiers parisiens (XVIᵉ–XVIIIᵉ siècles).* Paris, 1995.

Mirimonde 1961 Albert Pomme de Mirimonde. "Les sujets musicaux chez Antoine Watteau." *Gazette des Beaux-Arts* LVIII:1114 (Nov. 1961), pp. 249–88.

Mirimonde 1966 Albert Pomme de Mirimonde. "Musiciens isolés et portraits de l'École française du XVIIIᵉ siècle dans les collections nationales, II. Période Fin Louis XV–Louis XVI." *Revue du Louvre* (1966), no. 1, pp. 195–208.

Mirimonde 1968 Albert Pomme de Mirimonde. "Scènes de genre musicales de l'école française au XVIIIᵉ siècle dans les collections publiques." *Revue du Louvre et des musées de France* XVIII:3 (1968), pp. 125–38.

Mirimonde 1975–77 Albert Pomme de Mirimonde. *L'iconographie musicale sous les rois Bourbon. La Musique dans les arts plastiques. XVIIᵉ–XVIIIᵉ siècles.* 2 vols. Paris, 1975–77.

Moinet 1986 Eric Moinet. "Le départ du braconnier par Lépicié." *La Revue du Louvre et des musées de France* 36 (1986), pp. 296–97.

Molé 1771 Guillaume-François-Roger Molé. *Observations historiques et critiques sur les erreurs des peintres, sculpteurs et dessinateurs, dans la représentation des sujets tirés de l'histoire sainte.* 2 vols. Paris, 1771.

Monnet 1909 Jean Monnet. *Mémoires de Jean Monnet, directeur du Théâtre de la foire.* Paris, 1909.

Monod and Hautecoeur 1922 François Monod and Louis Hautecoeur. *Les Dessins de Greuze conservés à l'Académie des Beaux-Arts de Saint-Pétersbourg*. Paris, 1922.

Montaiglon 1860 C. de Valori. "Notice sur Greuze et sur ses ouvrages." In *Greuze, ou l'Accordée de village*, Paris, 1813. Reprinted by A. de Montaiglon in *Revue universelle des arts* XI (July 1860), pp. 248–61, 362–77.

Montesquieu 1964 Charles de Secondat, baron de Montesquieu. *Persian Letters*. New York, 1964. French ed.: *Lettres Persanes*. Paris, 1931.

Moore 1935 A.P. Moore. *The Genre Poissard and the French Stage of the Eighteenth Century*. New York, 1935.

Morel 1980 Marie-France Morel. "City and Country in Eighteenth-Century Medical Discussions about Early Childhood." In *Medicine and Society in France: Selections from the Annales: Économies, Sociétés, Civilisations*. Edited by R. Forster and O. Ranum. Baltimore and London, 1980, pp. 48–65.

Moscow and Saint Petersburg 2001–02 *Sobraniye Knyaza Nikolaia Borisovicha Yusupova: Uchenaia prikhet* [*The Collection of Prince Nikolai Borisovich Yusupov: A Learned Whim*]. 2 vols. Pushkin Museum of Fine Arts, Moscow, and The State Hermitage Museum, Saint Petersburg, 2001–02.

Moureau 1984 François Moureau. "Watteau dans son temps." In Grasselli and Rosenberg 1984 [French], pp. 471–508.

Moureau 2001 François Moureau. "De Watteau à Chardin: Antoine de La Roque, journaliste et collectionneur." *Mélanges en hommage à Pierre Rosenberg*. Edited by A. Cavina et al. Paris, 2001, pp. 349–55.

Moureau and Grasselli 1987 François Moureau and Margaret Morgan Grasselli, eds. *Antoine Watteau (1684–1721), le peintre, son temps et sa légende*. Geneva and Paris, 1987.

Munger 1992 Jeffrey Munger et al. *The Forsyth Wickes Collection in the Museum of Fine Arts, Boston*. Museum of Fine Arts, Boston, 1992.

Munhall 1964 Edgar Munhall. "Greuze and the Protestant Spirit." *The Art Quarterly* (Spring 1964), pp. 1–21.

Munhall 1968 Edgar Munhall. "Savoyards in French Eighteenth-Century Art." *Apollo* LXXXVII:72 (Feb. 1968), pp. 86–94.

Munhall 1976 *Jean-Baptiste Greuze, 1725–1805*. Exhib. cat. by Edgar Munhall. Wadsworth Atheneum, Hartford, 1976.

Munhall 1977 *Jean-Baptiste Greuze, 1725–1805*. Exhib. cat. by Edgar Munhall. Translated by E. Mornat. Musée des Beaux-Arts, Dijon, 1977.

Munhall 1992a Edgar Munhall. *Little Notes Concerning Watteau's Portal of Valenciennes*. The Frick Collection, New York, 1992.

Munhall 1992b Edgar Munhall. "Notes on Watteau's Portal of Valenciennes." *The Burlington Magazine* CXXXIV:1066 (Jan. 1992), pp. 4–11.

Munhall 2002 *Greuze the Draftsman*. Exhib. cat. by Edgar Munhall. The Frick Collection, New York, 2002.

Nauman 1981 Otto Nauman. *Frans van Mieris, 1635–1681, the Elder*. 2 vols. Doornspijk, 1981.

Near 1983 Pinkney L. Near. "Carle van Loo, 'A Pasha Having his Mistress' Portrait Painted'." *Arts in Virginia* XXIII:3 (1983), pp. 18–27.

Nemilova 1986 Inna S. Nemilova. *The Hermitage Catalogue of Western European Painting: French Painting, Eighteenth-Century*. Florence, 1986.

Neuman 1984 Robert Neuman. "Watteau's *L'Enseigne de Gersaint* and the Baroque Emblematic Tradition." *Gazette des Beaux-Arts* CIV:1390 (Nov. 1984), pp. 153–64.

New York 1990 *Claude to Corot: The Development of Landscape Painting in France*. Exhib. cat. Colnaghi, Seattle and London, 1990.

Nicolai 1769 Christoph Friedrich Nicolai. *Beschreibung der Koeniglichen Residenzstaedte Berlin und Potsdam . . .* Berlin, 1769.

Nieuhoff 1665 Jan Nieuhoff. *Het Gesanschap der Nederlandische Oost Indische Compagnie aan den Grooten, Tartarischen Cham*. Amsterdam and Leyden, 1665. French ed.: *L'Ambassade de la Compagnie orientale des Provinces Unies vers l'Empereur de la Chine*. Amsterdam, 1665.

Nolhac 1925 Pierre de Nolhac. *Nattier, peintre de la cour de Louis XV*. Paris, 1925.

North 1992 Michael North. *Kunst und Kommerz im Goldenen Zeitalter: Zur Sozialgeschichte der niederländischen Malerei des 17. Jahrhunderts*. Cologne, 1992.

***Nouvelles Acquisitions* 1987** Musée du Louvre. *Nouvelles Acquisitions du Département des Peintures (1983–1986)*. Exhib. cat. Paris, 1987.

***Nouvelles Acquisitions* 1991** Musée du Louvre. *Nouvelles Acquisitions du Département des peintures (1987–1990)*. Exhib. cat. Paris, 1991.

Oesterreich 1773 Matthias Oesterreich. *Description de tout l'intérieur des deux palais de Sans-Souci, de ceux de Potsdam et de Charlottenbourg . . .* Potsdam, 1773.

Opperman 1969 Hal Opperman. "Observations on the Tapestry Designs of J.-B. Oudry for Beauvais." *Allen Memorial Art Museum Bulletin* XXVI (1968–69), pp. 49–71.

Opperman 1977 Hal Opperman. *Jean-Baptiste Oudry*. New York, 1977.

Opperman 1982 *J.-B. [Jean-Baptiste] Oudry*. Exhib. cat. by Hal Opperman. Grand Palais, Paris, 1982.

Oppici 1991 Patrizia Oppici. "L'Enfant-modèle et le modèle de l'enfance dans la littérature religieuse du XVII^e siècle." *Littératures classiques* 14 (Jan. 1991), pp. 203–14.

Paillet 1785 Alexandre-Joseph Paillet. *Catalogue des tableaux . . . du cabinet de feu M. Le Marquis de Veri*. Paris, 1785.

Paris 1796 Salon *Explication des ouvrages de peinture, sculpture, architecture, gravure, dessins, modèles, etc. exposés dans le grand Salon du Musée central des Arts, sur l'invitation du Ministre de l'intérieur, au mois de Vendémiaire, an cinquième de la République française*. Paris, an V [1796].

Paris 1800 Salon *Explication des ouvrages de peinture et dessins, sculpture, architecture et gravure, des Artistes vivans, exposés au Muséum central des Arts, d'après l'Arrêté du Ministre de l'Intérieur, le 15 Fructidor, an VIII [2 Sep. 1800] de la République française*. Paris, an VIII [1800].

Paris 1808 Salon *Explication des ouvrages de peinture, sculpture, architecture et gravure, des Artistes vivans, exposés au Musée Napoléon, le 14 Octobre 1808, second anniversaire de la Bataille d'Jéna*. Paris, 1808.

Paris 1930 *Exposition L.-L. Boilly*. Exhib. cat. sponsored by the Société des Amis du Musée Carnavalet. Paris, 1930.

Paris 1963 *La peinture française du XVIII^e siècle à la cour de Frédéric II*. Exhib. cat. Musée du Louvre, Paris, 1963.

Paris 1964 *Le dessin français de Claude à Cezanne dans les collections hollandaises, complété d'un choix d'autographes des artistes exposés*. Exhib. cat. Institut Néerlandais, Paris and Rijksmuseum–Prentenkabinet, Amsterdam, 1964.

Paris 1978 *Les Frères Le Nain*. Exhib. cat. Grand Palais, Paris, 1978.

Paris 1984 *Louis Boilly 1761–1845*. Exhib. cat. Musée Marmottan, Paris, 1984.

Paris 1985 *Les Grands Boulevards*. Exhib. cat. Musée Carnavalet, Paris, 1985.

Paris 1992 *Fragonard et le dessin français au XVIII^e siècle dans les collections du Petit Palais*. Exhib. cat. by José-Luis de Los Llanos. Musée du Petit Palais, Paris, 1992.

Parker 1932 Karl T. Parker. "Mercier, Angelis and De Bar." *Old Master Drawings* VII:27 (June 1932), pp. 6–9.

Parker and Mathey 1957 Karl T. Parker and Jacques Mathey. *Antoine Watteau. Catalogue complet de son oeuvre dessiné*. 2 vols. Paris, 1957.

Pietsch 2001 Ulrich Pietsch. "Meissen, la première manufacture de porcelaine européenne." In *Un cabinet de porcelaines*. Exhib. cat. Musée des Beaux-Arts, Dijon, 2001.

Pillsbury 1987 Edmund P. Pillsbury et al. *In Pursuit of Quality*. The Kimbell Art Museum, New York, 1987.

Pilon 1909 Edmond Pilon. *Chardin*. Paris, 1909.

Plax 2000 Julie Ann Plax. *Watteau and the Cultural Politics of Eighteenth-Century France*. Cambridge, 2000.

Pochat 1986 Götz Pochat. *Geschichte der Ästhetik und Kunsttheorie*. Cologne, 1986.

Pomian 1978 Krzysztof Pomian. *Collectionneurs, amateurs et curieux, Paris, Venise, XVIᵉ–XVIIIᵉ siècle*. Paris, 1978.

Pomian 1979 Krzysztof Pomian. "Marchands, connaisseurs et curieux à Paris au XVIIIᵉ siècle." *Revue de l'Art* 43 (1979), pp. 23–36.

Pons 1995 Bruno Pons. *Grands décors français 1650–1800*. Dijon, 1995.

Portalis 1889 Roger Portalis. *Honoré Fragonard, sa vie et son oeuvre*. 2 vols. Paris, 1889.

Portalis 1910 Roger Portalis. *Henri-Pierre Danloux, peintre de portraits et son journal durant l'émigration*. Paris, 1910.

Portalis and Béraldi 1880–82 Roger Portalis and Henri Béraldi. *Les graveurs du dix-huitième siècle*. 3 vols. Paris, 1880–82.

Posner 1975 Donald Posner. "An Aspect of Watteau 'peintre de la réalité'." In *Études d'art français offertes à Charles Sterling*. Paris, 1975, pp. 279–86.

Posner 1982 Donald Posner. "The Swinging Women of Watteau and Fragonard." *The Art Bulletin* LXIV:1 (Mar. 1982), pp. 75–88.

Posner 1984 Donald Posner. *Antoine Watteau*. London and Ithaca, 1984.

Poulet and Scherf 1992 *Clodion, 1738–1814*. Exhib. cat. by A.L. Poulet and G. Scherf. Musée du Louvre, Paris, 1992.

Poutet 1991 Yves Poutet. "L'éducation du caractère et des moeurs des enfants du peuple d'après les écrits de saint Jean-Baptiste de la Salle." *Littératures classiques* 14 (Jan. 1991), pp. 179–201.

Prakhov 1901–07 Adrian V. Prakhov, ed. *Paintings of the French School. Artistic Treasures of Russia*. [Saint Petersburg], 1906. In Russian; partial translation into French in Alexandre Besnois, ed. *Les Trésors d'Art en Russie*. Leningrad, 1901–07.

Praz 1971 Mario Praz. *Conversation Pieces: A Study of the Informal Group Portrait in Europe and Asia*. London and University Park, 1971.

Procès-Verbaux Anatole de Montaiglon, ed. *Procès-Verbaux de l'Académie royale de peinture et de sculpture 1648–1793*. 10 vols. Paris, 1875–1909.

Proschwitz 1983 Gunnar von Proschwitz. *Tableaux de Paris et de la cour de France 1739–1742. Lettres inédites de Carl Gustaf, comte de Tessin*. Göteborg and Paris, 1983.

Puychevrier 1863 Sylvain Puychevrier. "La Famille Jeaurat à Vermenton. Le Peintre Étienne Jeaurat." *Annuaire historique du département de Lyonne* XXVII (1863), pp. 159–88.

Radisich 1998 Paula Rea Radisich. *Hubert Robert: Painted Spaces of the Enlightenment*. Cambridge, 1998.

Rambaud 1971 Mirielle Rambaud. *Documents du Minutier Central concernant l'histoire de l'art (1700–1750)*. 2 vols. Paris, 1971.

Rand 1996 Richard Rand. "Civil and Natural Contract in Greuze's *L'Accordée de Village*." *Gazette des Beaux-Arts* CXXVII (May–June 1996), pp. 221–34.

Rand 1997 *Intimate Encounters: Love and Domesticity in Eighteenth-Century France*. Exhib. cat. by Richard Rand et al. Hood Museum, Dartmouth College, 1997.

Rand 2004 Richard Rand. "Young Girl Reading." In Conisbee 2004. Forthcoming.

Ranum 1990 Orest Ranum. "Intimacy in French Eighteenth-Century Family Portraits." *Word and Image* VI (1990), pp. 351–67.

Raupp 1983 Hans-Joachim Raupp. "Ansätze zu einer Theorie der Genremalerei in den Niederlanden im 17. Jahrhundert." *Zeitschrift für Kunstgeschichte* XLVI:4 (1983), pp. 401–18.

Réau 1928 Louis Réau. "Catalogue de l'art français dans les musées russes." *Bulletin de la Société de l'Histoire de l'Art français. Année 1928* (1928), pp. 167–320.

Reimers 1805 Heinrich Christoph von Reimers. *St. Petersburg am Ende seines ersten Jahrhunderts . . .* 2 vols. Saint Petersburg, 1805.

Renou 1757 Antoine Renou. *Observations sur la physique et les arts*. Paris, 1757.

[Renou] 1773 Antoine Renou. Dialogues sur la peinture. 2nd ed. Paris, 1773.

Ribeiro 1995 Aileen Ribeiro. *The Art of Dress: Fashion in England and France 1750 to 1820*. New Haven and London 1995 (2nd ed. 1997).

Ribeiro 2002 Aileen Ribeiro. *Dress in Eighteenth-Century Europe, 1715–1789*. Rev. ed. New Haven and London, 2002.

Roberts 1974 Warren Roberts. *Morality and Social Class in Eighteenth-Century French Literature and Painting*. Toronto and Buffalo, 1974.

Roche 1981 Daniel Roche. *Le Peuple de Paris. Essai sur la culture populaire au XVIIIᵉ siècle*. Paris, 1981.

[Roederer 1799] Roederer. "Considérations sur les maisons de jeux." *Journal de Paris*, 11 Thermidor VII [29 July 1799], pp. 1357–59.

Roland Michel 1973 *Autour du Néoclassicisme. Peintures, dessins, sculptures*. Exhib. cat. by Marianne Roland Michel. Galerie Cailleux, Paris, 1973.

Roland Michel 1976 Marianne Roland Michel. "Représentations de l'exotisme dans la peinture en France de la première moitié du XVIIIᵉ siècle." *Studies on Voltaire and the Eighteenth Century* CLI–CLV (1976), pp. 1437–57.

Roland Michel 1984 Marianne Roland Michel. *Lajoüe et l'art rocaille*. Neuilly, 1984.

Roland Michel 1993 Marianne Roland Michel. "La collection du Duc de Choiseul." In *L'âge d'or flamand et hollandais. Collections de Catherine II. Musée de l'Ermitage, Saint-Pétersbourg*. Exhib. cat. Musée des Beaux-Arts, Dijon, 1993, pp. 57–64.

Roland Michel 1994 Marianne Roland Michel. *Chardin*. Paris, 1994. English ed.: London and New York, 1996.

Rorschach 1986 Kimerly Rorschach. *Drawings by Jean Baptiste Le Prince for the "Voyage en Sibérie."* Rosenbach Museum and Library, Philadelphia, 1986.

Rosenbaum 1979 *Old Master Paintings from the Collection of Baron Thyssen-Bornemisza*. Exhib. cat. by Allen Rosenbaum. International Exhibitions Foundation, Washington, D.C., 1979.

Rosenberg 1975 *The Age of Louis XV: French Painting 1710–1774*. Exhib. cat. by Pierre Rosenberg. Toledo Museum of Art, 1975.

Rosenberg 1979 *Chardin*. Exhib. cat. [English] by Pierre Rosenberg. Cleveland Museum of Art, 1979. French ed.: Grand Palais, Paris, 1979.

Rosenberg 1983 Pierre Rosenberg. *Chardin: New Thoughts*. Lawrence, Kansas, 1983.

Rosenberg 1984 Pierre Rosenberg, ed. *Vies Anciennes de Watteau*. Paris, 1984.

Rosenberg 1987a *Fragonard*. Exhib. cat. by Pierre Rosenberg. Grand Palais, Paris, 1987.

Rosenberg 1987b Pierre Rosenberg. "Ce qu'on disait de Fragonard." *Revue de l'Art* 78 (1987), pp. 86–90.

Rosenberg 1988 Pierre Rosenberg. "Le don au Louvre de *l'Adoration des bergers* de Fragonard." *Revue du Louvre et des musées de France* XXXVIII:3 (1988), pp. 250–53.

Rosenberg 1992 *Chefs-d'oeuvre de la peinture française des musées néerlandais, XVIIᵉ–XVIIIᵉ siècles. French paintings from Dutch Col-*

lections, 1600–1800. Exhib. cat. by Pierre Rosenberg et al. Museum Boijmans Van Beuningen, Rotterdam, 1992.

Rosenberg 1995 *Dessins français de la collection Prat XVII^e–XVIII^e–XIX^e siècles.* Exhib. cat. by Pierre Rosenberg. Musée du Louvre, Paris, 1995.

Rosenberg 1999 *Chardin.* Exhib. cat. [French] by Pierre Rosenberg et al. Grand Palais, Paris, 1999. English ed.: Royal Academy of Arts, London, and Metropolitan Museum of Art, New York, 2000.

Rosenberg 2001 Pierre Rosenberg. *Dandré-Bardon ou la jouissance du dessin.* Cahiers du dessin français 12. Paris, 2001.

Rosenberg and Compin 1974a Pierre Rosenberg, Isabelle Compin and Nicole Reynaud. *Musée du Louvre. Catalogue illustré des peintures. École française XVII^e et XVIII^e siècles.* 2 vols. Paris, 1974.

Rosenberg and Compin 1974b Pierre Rosenberg and Isabelle Compin. "Quatre nouveaux Fragonard au Louvre II." *Revue du Louvre et des musées de France* XXIV:4–5 (1974), pp. 263–78.

Rosenberg and Prat 1996 Pierre Rosenberg and Louis-Antoine Prat. *Antoine Watteau 1684–1721. Catalogue raisonné des dessins.* 3 vols. Milan, 1996.

Rosenberg and Rosenblum 1974 *De David à Delacroix. La Peinture française de 1774 à 1830.* Exhib. cat. [French] by Pierre Rosenberg, Robert Rosenblum et al. Grand Palais, Paris, 1974.

Rosenberg and Rosenblum 1975 *French Painting 1774–1830: The Age of Revolution.* Exhib. cat. [English] by Pierre Rosenberg, Robert Rosenblum et al. The Detroit Institute of Arts and The Metropolitan Museum of Art, New York, 1975.

Rosenberg and Temperini 1999 Pierre Rosenberg and Renaud Temperini. *Chardin. Suivi du catalogue des oeuvres.* Paris, 1999.

Rosenberg and van de Sandt 1983 Pierre Rosenberg and Udolpho van de Sandt. *Pierre Peyron, 1744–1814.* Paris, 1983.

Rosenblum 1967 Robert Rosenblum. *Transformations in Late Eighteenth-Century Art.* Princeton, 1967.

Rosenthal 1987 *La Grande Manière: Historical and Religious Painting in France 1700–1800.* Exhib. cat. by Donald A. Rosenthal. Memorial Art Gallery, University of Rochester, 1987.

Rousseau 1966 Jean-Jacques Rousseau. *Émile ou de L'Éducation.* Paris, 1966.

Rowlands 1996 Eliot Rowlands. *Italian Paintings, 1300–1800, in the Nelson-Atkins Museum.* Kansas City, 1996.

Sahut 1977 *Carle Vanloo. Premier peintre du roi.* Exhib. cat. by Marie-Catherine Sahut. Musée Chéret, Nice, 1977.

Sahut 1999 Marie-Catherine Sahut. *Chardin et les enfants.* Paris, 1999.

Saint-Simon 1987 Louis de Rouvroy, duc de Saint-Simon. *Mémoires* VII, 1718–21. Paris, 1987.

Saint-Yves 1748 C.L. de Saint-Yves. *Observations sur les Arts et sur quelques morceaux de Peinture et de Sculpture exposés au Louvre en 1748.* Leiden, 1748.

Salmon 1995 *Versailles: les chasses exotiques de Louis XV.* Exhib. cat. by Xavier Salmon. Réunion des musées nationaux, Paris, 1995.

Salmon 1996 Xavier Salmon. "Un carton inédit d'Étienne Jeaurat pour la tenture des 'Fêtes de village'." *Bulletin de la société de l'histoire de l'art français. Année 1995* (1996), pp. 187–95.

Salmon 1999 *Jean-Marc Nattier, 1665–1766.* Exhib. cat. by Xavier Salmon. Paris, 1999.

Salmon 2002 *Madame de Pompadour et les arts.* Exhib. cat. by Xavier Salmon. Paris, 2002.

Sauerländer 1965 Walter Sauerländer. "Pathosfiguren im Oeuvre des Jean-Baptiste Greuze." In *Walter Friedlaender zum 90. Geburtstag. Eine Festgabe seiner europäischen Schüler, Freunde und Verehrer.* Berlin, 1965, pp. 146–50.

Saunier 1928 Charles Saunier. "François Le Moyne." In Louis Dimier. *Les peintres français du XVIII^e siècle.* Paris, 1928, I.

Savinskaia 1994 L[iubov] U. Savinskaia. "What Type of Russian Collector Was There at the Beginning of the XIXth Century?" [in Russian]. In *Pamiatniki Kultury. Novye Otkrytiia* [*Monuments of Culture. New Discoveries*]. Russian Academy of Sciences. *Yearbook of the Scientific Council of the History of World Culture, 1993.* Moscow, 1994, pp. 200–16.

Schama 1989 Simon Schama. *Citizens: A Chronicle of the French Revolution.* New York, 1989.

Schieder 1993 Martin Schieder. "Jean-Honoré Fragonard und der Pariser Kunstmarkt im ausgehenden Ancien régime." *Kritische Berichte* XXI:3 (1993), pp. 10–20.

Schieder 1997 Martin Schieder. *Jenseits der Aufklärung. Die religiöse Malerei im ausgehenden Ancien régime.* Berlin, 1997.

Schlie 1884 Friedrich Schlie. *Beschreibendes Verzeichniss der Werke neuerer Meister in der Grossherzoglichen Gemälde-Gallerie zu Schwerin.* Schwerin, 1884.

Schmierer 1995 Elisabeth Schmierer. "Campras und Watteaus 'Fêtes vénitiennes': Zur Problematik eines Bezugs." In Elisabeth Schmierer et al. *Töne, Farben, Formen, über Musik und die Bildenden Künste.* Laaber, 1995.

Schnapper 1994 Antoine Schnapper. *Curieux du grand siècle. Collections et collectionneurs dans la France du XVII^e siècle.* Paris, 1994.

Schroder 1997 Anne L. Schroder. "Genre Prints in Eighteenth-Century France: Production, Market, and Audience." In Rand 1997, pp. 68–86.

Scott 1973a Barbara Scott. "The Comtesse de Verrue, a Lover of Dutch and Flemish Art." *Apollo* XCVII:131 (Jan. 1973), pp. 20–24.

Scott 1973b Barbara Scott. "The Duke de Choiseul, a Minister of the Grand Manner." *Apollo* XCVII:131 (Jan. 1973), pp. 42–54.

Scott 1986 Barbara Scott. "The Duchess of Berry as a Patron of the Arts." *Apollo* CXXIV:296 (Oct. 1986), pp. 345–53.

Scott 1995 Katie Scott. *The Rococo Interior: Decoration and Social Spaces in Early Eighteenth-Century Paris.* New Haven and London, 1995.

Scott 2000 Katie Scott. "Chardin Multiplied." In Rosenberg 1999, pp. 61–76.

Ségur 1897 Pierre de Ségur. *Le Royaume de la rue Saint-Honoré, Mme Geoffrin et sa fille.* Paris, 1897.

Seidel 1900a Paul Seidel. *Les Collections d'œuvres d'art françaises du XVIII^e siècle appartenant à Sa Majesté l'Empereur d'Allemagne, Roi de Prusse. Histoire et catalogue.* Berlin and Leipzig, 1900.

Seidel 1900b Paul Seidel. *Les Collections d'Art de Frédéric le Grand à l'Exposition Universelle de Paris de 1900.* Berlin, 1900.

Seidel 1922 Paul Seidel. *Friedrich der Grosse und die Bildenden Künste.* Leipzig and Berlin, 1922.

Senior 1983 Nancy Senior. "Aspects of Infant Feeding in Eighteenth-Century France." *Eighteenth-Century Studies* XVI (Summer 1983), pp. 367–88.

Seznec 1966 Jean Seznec. "Diderot et l'affaire Greuze." *Gazette des Beaux-Arts* LXVII (May–June 1966), pp. 339–56.

Seznec and Adhémar 1957–67 Jean Seznec and Jean Adhémar, eds. *Diderot Salons.* 4 vols. Oxford, 1957–67.

Seznec and Adhémar 1975 Jean Seznec and Jean Adhémar, eds. *Diderot Salons.* 3 vols. 2nd ed. Oxford, 1975–[1983]. Republication of first 3 volumes of 1957–67 edition.

Sheriff 1986 Mary D. Sheriff. "For Love or Money? Rethinking Fragonard." *Eighteenth-Century Studies* XX:3 (1986), pp. 333–54.

Sheriff 1990 Mary D. Sheriff. *Fragonard: Art and Eroticism.* Chicago, 1990.

Sheriff 1991 Mary D. Sheriff. "Fragonard's Erotic Mothers and the Politics of Reproduction." In *Eroticism and the Body Politic.* Edited by Lynn Hunt. Baltimore, 1991, pp. 14–40.

Siegfried 1990 Susan L. Siegfried. "The Artist as Nomadic Capitalist: The Case of Louis-Léopold Boilly." *Art History* XIII:4 (Dec. 1990), pp. 516–41.

Siegfried 1995 Susan L. Siegfried. *The Art of Louis-Léopold Boilly: Modern Life in Napoleonic France*. New Haven and London, 1995.

Siegfried 1999 Susan L. Siegfried. "Engaging the Audience: Sexual Economies of Vision in Joseph Wright." *Representations* 68 (Fall 1999), pp. 34–58.

Siegfried 2001 Susan L. Siegfried. "Boilly: de nouvelles images de la rue et de la circulation à Paris." In Karen Bowie, ed. *La Modernité avant Haussmann. Formes de l'espace urbain à Paris 1801–1853*. Paris, 2001, pp. 280–90.

Slatkin 1973 *François Boucher in North American Collections: 100 Drawings*. Exhib. cat. by Regina S. Slatkin. National Gallery of Art, Washington, D.C., 1973.

Smith 1829–42 John Smith. *A Catalogue Raisonné of the Works of the Most Eminent Dutch, Flemish and French Painters*. 9 vols. London, 1829–42.

Smith 1979 Anthony D. Smith. "The 'Historical Revival' in Late 18th-Century England and France." *Art History* II 2 (June 1979), pp. 156–79.

Snoep-Reitsma 1973 Ella Snoep-Reitsma. "Chardin and the Bourgeois Ideals of his Time." *Nederlands Kunsthistorisch Jaarboek* 24 (1973), pp. 147–243.

Snowman 1990 Abraham K. Snowman. *Eighteenth-Century Gold Boxes of Europe*. Rev. ed. Woodbridge, 1990.

Sotheby's 1982 *Art at Auction. The Year at Sotheby's, 1981–1982. Two Hundred and Forty-eighth Season*. New Jersey, 1982.

Soubeyran and Vilain 1975 Françoise Soubeyran and Jacques Vilain. "Gabriel Bouquier. Critique du Salon de 1775." *Revue du Louvre et des musées de France* XXV:2 (1975), pp. 95–104.

Standen 1994 Edith Standen. "Country Children: Some *enfants de Boucher* in Gobelins Tapestry." *Metropolitan Museum of Art Journal* XXIX (1994), pp. 111–33.

Starobinski 1964 Jean Starobinski. *L'invention de la Liberté, 1700–1789*. Geneva, 1964.

Starobinski 1977 Jean Starobinski. "Le Mythe au XVIIIᵉ siècle." *Critique* XXXIII (1977), pp. 975–97.

Stebbins 1986 Theodore Stebbins Jr. et al. *Masterpiece Paintings from the Museum of Fine Arts, Boston*. New York, 1986.

Stechow and Comer 1975–76 Wolfgang Stechow and Christopher Comer. "The History of the Term *Genre*." *Allen Memorial Art Museum Bulletin* XXXIII:2 (1975–76), pp. 89–94.

Steegmuller 1991 Francis Steegmuller. *A Woman, a Man, and Two Kingdoms: The Story of Madame d'Epinay and the Abbé Galiani*. New York, 1991.

Stein 1994 Perrin Stein. "Madame de Pompadour and the Harem Imagery at Bellevue." *Gazette des Beaux-Arts* CXXIII:1500 (Jan. 1994), pp. 29–44.

Stein 1996 Perrin Stein. "Boucher's Chinoiseries: Some New Sources." *The Burlington Magazine* CXXXVIII:1122 (Sept. 1996), pp. 598–604.

Steland 1994 Anne Charlotte Steland. "Vestalinnen. Ein zeittypisches Thema des Malers Jean Raoux um 1730, angeregt durch ein Werk wissenschaftlicher Literatur und ein Opera-ballet." *Artibus et historiae* 29 (1994), pp. 135–52.

Sterling 1955 Charles Sterling. *A Catalogue of French Paintings XV–XVIII Centuries*. The Metropolitan Museum of Art, Cambridge, Mass., 1955.

Stierle 1972 Karlheinz Stierle. "L'histoire comme exemple, l'exemple comme histoire. Contribution à la pragmatique et à la poétique des textes narratifs." *Poétique* X (1972), pp. 176–98.

Stuffmann 1968 Margret Stuffmann. "Les tableaux de la collection de Pierre Crozat. Historique et destinée d'un ensemble célèbre établis en partant d'un inventaire après décès inédit (1740)." *Gazette des Beaux-Arts* CX (1968), pp. 11–139.

Sutton 1968 *France in the Eighteenth Century*. Exhib. cat. by Denys Sutton. Royal Academy of Arts, London, 1968.

Sutton 1980 Peter Sutton. *Pieter de Hooch: Complete Edition with a Catalogue Raisonné*. Ithaca, 1980.

Swain 1997 Virginia E. Swain. "Hidden from View: French Women Authors and the Language of Rights, 1727–1792." In Rand 1997, pp. 21–37.

Talley 1992 M. Kirby Talley. "Jean-Honoré Fragonard: A Catalogue of Kisses." *Artnews* XCI:6 (Summer 1992), pp. 59–60.

Tavernier 1990 Ludwig Tavernier. "Kunst als Entwurf einer Parallelwelt, Jean-Honoré Fragonard: *La Fête de Saint-Cloud*." In *Die Trauben des Zeuxis, Formen künstlerischer Wirklichkeitsaneignung*. Edited by Hans Körner, Constanze Peres, Reinhard Steiner and Ludwig Tavernier. *Münchner Beiträge zur Geschichte und Theorie der Künste*, 2. Hildesheim, Zurich, and New York, 1990.

Thiéry 1787 Luc-Vincent Thiéry. *Guide des amateurs et des étrangers voyageurs à Paris, ou description raisonnée de cette ville, de sa banlieue, et de tout ce qu'elles contiennent de remarquable*. 2 vols. Paris, 1787.

Thompson 1989–90 James Thompson. "Jean-Baptiste Greuze." *The Metropolitan Museum of Art Bulletin* (Winter 1989–90), pp. 4–52.

Thomson 1981 Shirley L. Thomson. "The Continuity of the Hunt Theme in Palace Decoration in Eighteenth-Century France." Ph.D. diss., McGill University, Montreal, 1981.

Thuillier 1964 Jacques Thuillier. "Documents pour servir à l'étude des frères Le Nain." *Bulletin de la Société de l'histoire de l'art français. Année 1963* (1964), pp. 155–284.

Thuillier 1967 Jacques Thuillier. *Fragonard. Étude biographique et critique*. Geneva, 1967.

Toulouse 2001 *Les collectionneurs toulousains du XVIII siècle. L'Académie royale de peinture et architecture*. Exhib. cat. Musée Paul-Dupuy, Toulouse, 2001.

Trope-Podell 1995 Marie H. Trope-Podell. "'Portraits historiés' et portraits collectifs dans la critique du XVIIIᵉ siècle." *Revue de l'Art* 109 (1995), pp. 40–46.

Trott 2000 David A. Trott. *Théâtre du XVIIIᵉ siècle, jeux, écritures, regards. Essai sur les spectacles en France de 1700 à 1790*. Montpellier, 2000.

Tunstall 2000 Kate Tunstall. "Chardin's Games." *Studies on Voltaire and the Eighteenth Century* (2000), pp. 131–41.

Turchin 2002 Valery Turchin. "The Magical Chiaroscuro of Archangelskoe." *Rossica, International Journal of Russian Culture* 5 (Winter 2002), pp. 33–41.

Valabrège 1895 Antony Valabrège. *L'art français en Allemagne*. Paris, 1895.

Valencia 1989 Catherine Boulot, Jean de Cayeux and Hélène Moulin, eds. *Hubert Robert et la Révolution*. Exhib. cat. Valencia, 1989.

Vallière 1960 P. de Vallière. "Une grande figure suisse au XVIIIᵉ siècle." *Versailles* III (1960), pp. 9–25.

Van de Sandt 1977–80 Anne van de Sandt. "Jacques Sablet *Le Colin Maillard* 1790." In *Bericht der Gottfried-Keller-Stiftung Bern. 1977–1980*, pp. 53–56.

Van de Sandt 1985 *Les frères Sablet (1775–1815). Peintures, dessins, gravures*. Exhib. cat. by Anne van de Sandt. Rome, 1985.

Van de Sandt 1989 Udolpho van de Sandt. "'Grandissima opera del pittore sarà l'istoria': Notes sur la hiérarchie des genres sous la Révolution." *Revue de l'Art* 83 (1989), pp. 71–76.

Versini 1996 Laurent Versini, ed. *Diderot. Oeuvres IV, Esthétique-théâtre*. Paris, 1996.

Verzeichnis 1904 Max Jacob Friedländer and Hans Posse. *Königliche Museen zu Berlin. Beschreibendes Verzeichnis der Gemälde im Kaiser Friedrich-Museum*. Berlin, 1904.

Verzeichnis 1956 Elisabeth Rückert, Gretel Neumann and Günter

Arnolds. *Staatliche Museen Berlin. Gemälde des XIII. bis XVIII. Jahrhunderts.* Museum Dahlem, 1956.

Vidal 1992 Mary Vidal. *Watteau's Painted Conversations: Art, Literature and Talk in Seventeenth- and Eighteenth-Century France.* New Haven and London, 1992.

Vilain 1974 Jacques Vilain. "Jacob-Henri Sablet (ou Jacques)." In Rosenberg and Rosenblum 1974, pp. 592–94.

Vogtherr 1991 Christoph Martin Vogtherr. "Die Auswahl der Gemälde aus den Schlössern für das Königliche Museum zu Berlin." M.A. thesis, Berlin, 1991.

Vogtherr and Evers 2004 *Pater und Coypel. Französische Illustrationszyklen des 18. Jahrhunderts.* Exhib. cat. by Christoph Martin Vogtherr and Susanne Evers. Stiftung Preussische Schlösser und Gärten Berlin-Brandenburg, Charlottenburg Palace, Berlin, 2004. Forthcoming.

Voss 1953 Hermann Voss. "François Boucher's Early Development." *The Burlington Magazine* XCV:600 (Mar. 1953), pp. 81–93.

Vries 1682 Simon de Vries. *Curieuse aenmerckingen der bysonderste Oost en West-Indische verwonderens-waerdige dingen. Nevens die van China, Africa, en andere gewesten des werelds . . .* 4 vols. Utrecht, 1682.

Waagen 1830 Gustav Friedrich Waagen. *Verzeichniss der Gemälde-Sammlung des Königlichen Museums zu Berlin.* Berlin, 1830. Reprint annotated by Rainer Michaelis, Berlin, 1998.

Washington 1999 *The Touch of the Artist: Master Drawings from the Woodner Collections.* Exhib. cat. by Margaret Morgan Grasselli. National Gallery of Art, Washington, D.C., 1999.

Watelet and Levesque 1792 Claude Henri Watelet and Pierre Charles Levesque. *Dictionnaire des arts de peinture, sculpture et gravure.* 5 vols. Paris, 1792.

Watson 1953 Francis J.B. Watson. "New Light on Watteau's 'Les plaisirs du Bal'." *The Burlington Magazine* XCV:604 (July 1953), pp. 238–42.

Watson 1963 Francis J.B. Watson. *The Choiseul Box.* Oxford, 1963.

Watson and Wilson 1982 Francis J.B. Watson and Gillian Wilson. *Mounted Oriental Porcelains in the J. Paul Getty Museum.* Malibu, 1982.

Wells-Robertson 1978 Sally Wells-Robertson. "Marguerite Gérard, 1761–1837." Ph.D. diss., New York University, 1978.

Wescher 1969 Paul Wescher. "Étienne Jeaurat and the French Eighteenth-Century 'Genre de Moeurs'." *The Art Quarterly* XXXII:2 (Summer 1969), pp. 153–65.

Wildenstein 1924 Georges Wildenstein. *Lancret.* Paris, 1924.

Wildenstein 1933 Georges Wildenstein. *Chardin.* Paris, 1933.

Wildenstein 1960 Georges Wildenstein. *The Paintings of Fragonard.* London, 1960.

Wildenstein 1967 Daniel Wildenstein. *Inventaires après décès d'artistes et de collectionneurs français du XVIIIe siècle.* Paris, 1967.

Wildenstein 1975 Daniel Wildenstein. "Sur *Le Verrou* de Fragonard." *Gazette des Beaux-Arts* LXXXV:1272 (Jan. 1975), pp. 13–24 (supplement).

Wildenstein and Co., New York 1943 *The French Revolution.* Exhib. cat. by Charles Sterling et al. Wildenstein and Co., New York, 1943.

Wildenstein and Co., New York 1978 *Romance and Reality: Aspects of Landscape Painting.* Exhib. cat. Wildenstein and Co., New York, 1978.

Wildenstein and Co., New York 1988 *Hubert Robert: The Pleasure of Ruins.* Exhib. cat. Wildenstein and Co., New York, 1988.

Wilhelm 1951 Jacques Wilhelm. "François Le Moyne and A. Watteau." *The Art Quarterly* XIV (1951), pp. 216–29.

Wilhelm 1969 Jacques Wilhelm. "*La partie de billard* est-elle une oeuvre de jeunesse de Chardin?" *Bulletin du Musée Carnavalet* (June 1969), pp. 7–13.

Wilhelm 1974 Jacques Wilhelm. "Les portraits masculins dans l'oeuvre de Louis-Roland Trinquesse." *Revue de l'Art* 25 (1974), pp. 55–65.

Wille 1857 Johann Georg Wille. *Mémoires et journal de J.-G. Wille, graveur du roi.* 2 vols. Paris, 1857.

Williams 1993 Eunice Williams. "*Gens, Honorez Fragonard!*" Exhib. brochure. Fogg Art Museum, Cambridge, Mass., 1993.

Williamstown 1998 Patricia R. Ivinski, Harry C. Payne, Kathryn Calley Galitz and Richard Rand. *Farewell to the Wet Nurse: Étienne Aubry and Images of Breast-feeding in Eighteenth-Century France.* Exhib. cat. Sterling and Francine Clark Art Institute, Williamstown, Mass., 1998.

Willk-Brocard 1984 Nicole Willk-Brocard. "Noël Hallé." In Diderot 1984, pp. 268–76.

Willk-Brocard 1995 Nicole Willk-Brocard. *La Dynastie des Hallé.* Paris, 1995.

Wilson 1985 Michael Wilson. *French Painting before 1800: National Gallery Schools of Painting.* London, 1985.

Wilton and Bignamini 1996 *Grand Tour: The Lure of Italy in the Eighteenth Century.* Exhib. cat. edited by Andrew Wilton and Ilaria Bignamini. Tate Gallery, London, 1996.

Wine 1997 Humphrey Wine. "Two Paintings by Peyron at the National Gallery." *The Burlington Magazine* CXXXIX:1129 (Apr. 1997), pp. 248–55.

Winkler 1932 Friedrich Winkler. "De Troys *Vorlesung aus Molière* – ehemals in Sanssouci." *Der Kunstwanderer* (Feb. 1932), pp. 182–83.

Winnicott 1971 Donald W. Winnicott. *Playing and Reality.* New York, 1971.

Winter 1958 Carl Winter. *The Fitzwilliam Museum: An Illustrated Survey.* London, 1958.

Wintermute 1989 *1789: French Art during the Revolution.* Exhib. cat. edited by Alan Wintermute. Colnaghi, New York, 1989.

Wintermute 1990 *Claude to Corot: The Development of Landscape Painting in France.* Exhib. cat. edited by Alan Wintermute. Colnaghi, New York, 1990.

Wintermute 1992 Alan Wintermute. "One of the Great Sponges The Art of Nicolas Lancret." *Apollo* CXXXV:361 (Mar. 1992), pp. 190–91.

Wintermute 1999 *Watteau and his World French Drawing from 1700 to 1750.* Exhib. cat. by Alan Wintermute et al. The American Federation of Arts, New York, 1999.

Wrigley 1993 Richard Wrigley. *The Origins of French Art Criticism From the Ancien Régime to the Restoration.* Oxford, 1993.

Zafran 1983 *The Rococo Age French Masterpieces of the 18th Century.* Exhib. cat. by Eric M. Zafran. High Museum of Art, Atlanta, 1983.

Zafran 1998 Eric M. Zafran. *French Paintings in the Museum of Fine Arts, Boston.* Vol. 1. *Artists Born before 1790.* Museum of Fine Arts, Boston, 1998.

Appendix: Genre Paintings Exhibited at the Salon, 1699–1789

JOHN COLLINS

WITH THE ASSISTANCE OF
PENNY SULLIVAN

The following is a list of genre paintings that appeared at the Paris Salon from 1699 until 1789 (the year of the last Salon organized by the Académie royale de peinture et de sculpture). The Salons were held only occasionally until 1737, when they became erratically annual. In 1751, a biennial pattern was established.

The list is not intended to be a litmus test for defining genre painting, but rather a basis for further study. In many cases there was not enough information provided in the titles to allow easy classification. Works entitled "tableaux des figures et des animaux," while suggesting the influence of genre painting, were omitted as too vague. Boucher's "pastorales" have been included; however, landscapes in which scenes from daily life were of secondary interest have generally been excluded.

This Appendix is arranged chronologically by Salon year, and then alphabetically by artist. The grammar and spelling of the titles as they appeared in the Salon *livret*, or catalogue, has been corrected; capitalization, on the other hand, has been followed and thus retains its idiosyncratic appearance. Titles are often abbreviated forms of their full *livret* description.

Émile Bellier de la Chavignerie and Louis Auvray's *Dictionnaire général des Artistes de l'École française*, 2 vols., Paris, 1882–85 and *Supplément* of 1887, remains unsurpassed for its useful listing of artist's entries to the Salon, and was consulted throughout the preparation of this appendix.

GENRE PAINTING AT THE PARIS SALONS 1699–1789 BY SALON YEAR

1699

Boullogne, Bon
Une jeune fille qui veut rattraper un oiseau envolé
La Diseuse de bonne aventure
Une fille qui cherche les puces à une autre

Corneille, Michel
Deux femmes dormant

Ubelesqui, Alexandre
Une Vieille qui porte un billet à une jeune fille qui joue de la viole
Une femme qui joue du tambour de basque

1704

Chéron, Elisabeth Sophie
Une fille qui dessine
Deux jeunes filles qui accordent un clavecin
Une Grecque

Christophe, Joseph
Un retour de chasse
Une chasse aux canards par de jeunes garçons
Un jeu du gage touché

Colombel, Nicolas
Deux femmes qui se disposent à entrer dans le bain

Cotelle, Jean
Une petite Bambochade

Desportes, François
Un chasseur qui se repose
Deux chasseurs en différentes attitudes

Gobert, Pierre
Une femme âgée

Marot, François
Une joueuse de Luth
Une Dame à qui l'on présente du Café

Schuppen, Jacques Van
Un retour de chasse du Roi d'Angleterre
Une joueuse de Guitare
Une femme lisant une lettre
Une fille sur une escarpolette

1725

De Troy, Jean-François
Deux Cavaliers et deux Dames en habit de masque sont à déjeuner autour d'une table
Trois petits tableaux très galants: 1) Une déclaration d'amour; 2) Une Demoiselle un peu courbée, tenant d'une main sa jarretière et de l'autre repoussant un jeune homme qui s'empresse à vouloir la lui renouer; 3) Deux dames et un Cavalier qui jouent au pied-de-bœuf

Lancret, Nicolas
Un Bal dans un Paysage orné d'Architecture
Retour de Chasse
Bain de Femmes. Vue de la Porte Saint-Bernard
Danse dans un paysage

1737

Bouys, André
Une Servante qui récure de la Vaisselle d'argent
Deux Servantes revenant du marché

Chardin, Jean-Baptiste-Siméon
Un Chimiste dans son Laboratoire
Un petit Enfant avec des attributs de l'enfance
Une petite Fille assise, s'amusant avec son déjeuner
Une petite Fille jouant au Volant
Une petite Femme s'occupant à savonner
Une Fille tirant de l'eau à une Fontaine
Jeune Homme s'amusant avec des cartes

Chavanne, Pierre Salomon Domenchin de
Un Amusement champêtre

Courtin, Jacques François
Une femme regardant deux Serins
Une femme badinant avec un Écureuil

Delobel, Nicolas
Un Tableau de Famille

De Troy, Jean-François
Un déjeuner de Chasse
Une petite Liseuse
Une toilette de Bal
Un déshabillé de Bal

1750

Boucher, François

24 *Quatre pastorales. Deux amants surpris dans les Bleds; un Berger accordant sa Musette près de sa Bergère; le Sommeil d'une Bergère; un Berger qui montre à jouer de la Flûte à sa Bergère*

Oudry, Jean-Baptiste

44 *Paysage représentant des Légumes et un Jardinier qui tire de l'eau à une Pompe, peint à Beauvais*

1751

Chardin, Jean-Baptiste-Siméon

44 *Une Dame variant ses Amusements*

Leclerc, Sébastien

7bis *Deux tableaux. Des Enfants qui font un Concert; Des Enfants jouant une Scène de l'Opéra d'Armide*

Oudry, Jean-Baptiste

16 *Un Tableau dans le genre Flamand fait pour le Cabinet de Monseigneur le Dauphin*

1753

Chardin, Jean-Baptiste-Siméon

59 *Deux Tableaux Pendants sous le même numéro: Un Dessinateur d'après le Mercure de M. Pigalle; Une Jeune Fille qui récite son évangile*

60 *Un Philosophe occupé de sa lecture*

61 *Un Aveugle*

Hallé, Noël

55 *Une Savoyarde*

Jeaurat, Étienne

16 *Une noce de Village*

18 *Deux Savoyards*

19 *Une Femme qui épluche de la salade*

20 *Deux esquisses sous le même numéro: La Place Maubert, gravée par M. Aliamet; une Foire de Village*

Oudry, Jean-Baptiste

22 *Chienne allaitant ses petits*

1755

Bachelier, Jean-Jacques

77 *Une jeune Fille caressant une Levrette*

83 *Un Repos de Chasse*

Greuze, Jean-Baptiste

145 *L'Aveugle trompé*

146 *Un Père de famille qui lit la Bible à ses Enfants*

147 *Un Enfant qui s'est endormi sur son Livre*

Jeaurat, Étienne

24 *L'Atelier d'un Peintre*

25 *Deux petits tableaux: Un Enlèvement de Police; un Déménagement*

Lagrenée, Louis-Jean-François

126 *Deux petits tableaux: Une jeune Fille tenant un papier de musique; une Fille qui caresse un pigeon*

Le Lorrain, Louis-Joseph

133 *Une jeune Personne en habit de masque*

Van Loo, Carle

17 *Deux tableaux: Deux Sultanes travaillant en Tapisserie; une Sultane prenant le Café que lui présente une Négresse*

18 *Une Conversation*

1757

Chardin, Jean-Baptiste-Siméon

34 *Une Femme qui écure*

Greuze, Jean-Baptiste

112 *Une Mère grondant un jeune Homme pour avoir renversé un Panier d'Oeufs que sa Servante apporte du Marché*

113 *Une jeune Italienne congédiant (avec le Geste Napolitain) un Cavalier Portugais travesti, et reconnu par sa Suivante*

114 *La Paresseuse Italienne*

115 *Un Oiseleur qui, au retour de la chasse, accorde sa Guitare*

118 *Un Matelot Napolitain*

119 *Un Écolier qui étudie sa leçon*

121 *Esquisse à l'encre de la Chine, représentant des Italiens qui jouent à la Maure*

Hallé, Noël

27 *Une Savoyarde*

Jeaurat, Étienne

15 *Le Carnaval des rues de Paris*

16 *La Conduite des Filles de Joie à la Salpêtrière, lorsqu'elles passent par la Porte Saint-Bernard*

17 *Les Écosseuses de Pois de la Halle*

18 *Un Inventaire du Pont Saint-Michel. Sujet tiré du Poème de* la Pipe Cassée, *Vadé, Chant III*

Van Loo, Carle

7 *Trois tableaux en rond: Une Femme qui prend du Café; une Femme qui lit; une Femme endormie*

1759

Chardin, Jean-Baptiste-Siméon

39 *Deux petits Tableaux: Un jeune Dessinateur; une Fille qui travaille en tapisserie*

Drouais, François-Hubert

83 *Concert champêtre dont les Figures sont des Portraits*

Greuze, Jean-Baptiste

103 *Le Repos caractérisé par une Femme qui impose silence à son fils, en lui montrant ses autres enfants qui dorment*

104 *La Simplicité représentée par une jeune fille*

105 *La Tricoteuse endormie*

106 *La Dévideuse*

107 *Une jeune Fille qui pleure la mort de son Oiseau*

Jeaurat, Étienne

11 *Deux petits Tableaux selon le costume des Turcs: Un Émir conversant avec son Ami; Des femmes qui s'occupent dans le Sérail et prennent leur café*

12 *Deux autres petits Tableaux: Une Pastorale; Un Jardinier et une Jardinière*

Portail, André

52 *Un Dessin représentant Une Dame qui lit*

1761

Bachelier, Jean-Jacques

58 *Les Amusements de l'Enfance. Ce Tableau est au Roi et est destiné à être exécuté en tapisserie dans la Manufacture des Gobelins*

Boucher, François

9 *Pastorales*

Chardin, Jean-Baptiste-Siméon

42 *Le Bénédicité*

Doyen, Gabriel-François

92 *Une jeune Personne occupée à lire une Brochure, ayant son chien sur ses genoux*

Drouais, François-Hubert

83 *Un jeune Élève*

Greuze, Jean-Baptiste

100 *Un Mariage, et l'instant où le père de l'Accordée délivre la dot à son Gendre*

101 *Un jeune Berger qui tente le sort pour savoir s'il est aimé de sa Bergère*

102 *Une jeune Blanchisseuse*

105 *Un Dessin représentant des enfants qui dérobent des Marrons*

106 *Autre Dessin d'un Paralytique soigné par sa famille, ou le fruit de la bonne éducation*

107 *Autre, un Fermier brûlé, demandant l'aumône avec sa famille*

Hallé, Noël

18 *Deux Pastorales*

19 *Une Dame qui dessine à l'encre de la Chine*

20 *Une Femme qui amuse son enfant avec un moulin à vent*

Van Loo, Carle

5 *Une Lecture*

8 *Deux Tableaux représentant des jeux d'Enfants*

1763

Baudouin, Pierre-Antoine

148 *Un Prêtre catéchisant des jeunes Filles*

Deshayes, Jean-Baptiste-Henri

47 *Trois Tableaux ovales représentant des Caravanes*

48 *Une Caravane*

Drouais, François-Hubert

117 *Une Petite Fille jouant avec un chat*

118 *La petite Nourrice*

Favray, Antoine

122 *Une famille Maltaise dans un appartement*

123 *Femmes de Malte de différents états, distinguées par la différence des étoffes: celle qui est vêtue de laine est une Esclave*

124 *Dames Maltaises se faisant visite*

Greuze, Jean-Baptiste

134 *Une petite Fille lisant la Croix de Jésus*

138 *Le Tendre Ressouvenir*

139 *Une jeune Fille qui a cassé son miroir*

140 *La Piété filiale*

Jeaurat, Étienne

10 *Un Peintre chez lui faisant le portrait d'une jeune Dame*

11 *Les Citrons de Javotte. Sujet tiré d'un petit ouvrage en vers de M. Vadé, qui porte ce même titre*

Vernet, Claude-Joseph

92 *La Bergère des Alpes, sujet tiré des* Contes Moraux *de M. Marmontel*

1765

Bachelier, Jean-Jacques

40 *Un Enfant endormi*

Baudouin, Pierre-Antoine
98 *Un Confessionnal*
99 *Les Enfants Trouvés; dans l'Église de Notre-Dame*
100 *Une jeune fille querellée par sa mère*

Boucher, François
10 *Deux Pastorales*
11 *Quatre Pastorales*
12 *Autre Pastorale*
13 *Une jeune Femme attachant une lettre au col d'un Pigeon*

Descamps, Jean Baptiste
105 *Trois petits Tableaux: Un jeune Dessinateur; un Élève qui modèle; Une petite fille qui donne à manger à un petit oiseau*

Fragonard, Jean-Honoré
h.c. *L'absence des pères et mères mise à profit*

Greuze, Jean-Baptiste
110 *Une jeune fille qui pleure son oiseau mort*
111 *L'Enfant gâté*
123 *La Mère bien-aimée (Esquisse)*
124 *Le Fils ingrat (Esquisse)*
125 *Le Fils puni (Esquisse)*

Hallé, Noël
17 *Deux Petites Esquisses: L'Éducation des Riches; l'Éducation des Pauvres*

Le Prince, Jean-Baptiste
144 *Pastorale Russe*
145 *La Pêche aux environs de Saint-Pétersbourg*
146 *Quelques Paysans se disposent à passer un Bac*
147 *Une Halte de Tartares*
148 *Manière de voyager en hiver, avec la construction du traîneau dont on se sert*
149 *Une halte de Paysans en Été*
150 *Le Berceau pour les Enfants*
151 *L'intérieur d'une chambre de Paysan*

Loutherbourg, Philipp Jakob
134 *Rendez-vous de Chasse de S.A.S. Mgr le Prince de Condé*
137 *Une Caravane*
138 *Des Voleurs attaquant des Voyageurs dans une gorge de montagne*
139 *Ces mêmes Voleurs pris et conduits par des Cavaliers*

Roslin, Alexandre
77 *Un Père arrivant dans sa terre, où il est reçu par ses enfants dont il était tendrement aimé*

Taraval, Hugues
184 *Une Génoise dormant sur son Ouvrage. On y voit un Éventail à l'Italienne*

1767
Baudouin, Pierre-Antoine
73 *Le Coucher de la Mariée*
74 *Le sentiment de l'Amour et de la Nature cédant pour un temps à la nécessité*

Caresme, Philippe
175 *Le Repos*
178 *L'Amour*
179 *Une Mère qui fait jouer son Enfant*

Durameau, Louis-Jacques
161 *Un Joueur de Basson*
162 *Une Dormeuse tenant un Chat*

Le Prince, Jean-Baptiste
85 *Une jeune Fille orne de fleurs son Berger, pour prix de ses Chansons*
86 *On ne peut pas penser à tout*
87 *La Bonne Aventure*
88 *Le Berceau, ou le réveil des petits Enfants*
89 *L'Oiseau retrouvé*
90 *Le Musicien champêtre*
91 *Une Fille charge une Vieille de remettre une Lettre*
92 *Un jeune Homme qui récompense le zèle de la Vieille en lui donnant une pièce d'or*
93 *Une jeune Fille endormie, surprise par son Père et sa Mère*
94 *La Bonne Aventure*
95 *Le Concert*
96 *Le Cabak, espèce de Guinguette aux environs de Moscou*

Lépicié, Nicolas-Bernard
134 *Un Tableau de Famille*

Ollivier, Michel-Barthélemy
170 *Famille Espagnole jouant avec des Enfants dans un Jardin*

Robert, Hubert
104 *Cuisine Italienne*
105 *Écurie et Magasin à foin peints d'après nature, à Rome*

Taraval, Hugues
146 *Une jeune Fille agaçant son Chien devant un miroir*

Terbouche (Lisiewski), Anna Dorothea
113 *Un Homme tenant un verre de vin, éclairé d'une bougie*

1769
Baudouin, Pierre-Antoine
68 *Le modèle honnête*

Bounieu, Michel Honoré
186 *Le Portrait d'un enfant endormi sous la garde d'un chien*

Chardin, Jean-Baptiste-Siméon
32 *Une Femme qui revient du marché*

Greuze, Jean-Baptiste
152 *La Mère bien-aimée, caressée par ses Enfants*
155 *Un jeune Enfant qui joue avec un Chien*
160 *La mort d'un Père de famille, regretté par ses enfants (dessin)*
161 *La mort d'un Père dénaturé, abandonné de ses Enfants (dessin)*
162 *L'Avare et ses Enfants (dessin)*
163 *La Bénédiction paternelle (dessin)*
164 *Le départ de Barcelonnette (dessin)*
165 *La Consolation de la Vieillesse (dessin)*

Guérin, François
81 *Un Concert*
82 *Un jeune homme qui converse avec une jeune Demoiselle sur les Sciences*

Huet, Jean-Baptiste-Marie
137 *Une Caravane*

Hutin, Charles-François
49 *Deux Servantes Saxonnes*

Jeaurat, Étienne
8 *Un Pressoir de Bourgogne*

9 *Une veillée de Paysannes du même Canton*
10 *Une Femme convalescente*

Le Prince, Jean-Baptiste
74 *Un Cabak, ou espèce de Guinguette des environs de Moscou*
75 *Une Russe jouant de la Guitare*
76 *Un Drogman du Roi de France*
77 *Une Danse Russe*
78 *Une Balançoire à la manière des Russes*

Ollivier, Michel-Barthélemy
173 *Conversations, ou Promenades champêtres, deux Tableaux sous le même numéro*

Van Loo, Louis-Michel
3 *Une Allemande jouant de la Harpe*
4 *Une Espagnole jouant de la Guitare*

1771
Bounieu, Michel-Honoré
203 *Une Dame faisant faire son Portrait*
204 *Deux tableaux sous le même numéro: Une Laitière; une Ravaudeuse*

Caresme, Philippe
190 *Une vue de Jardin, et sur le devant un Espagnol repoussé par une jeune Demoiselle à qui il présente un Bouquet*
193 *Deux petits Tableaux représentant des Buveurs Flamands*

Huet, Jean-Baptiste-Marie
120 *Un Repos de Chasse*
121 *La Fermière*
123 *Une Caravane*

Le Prince, Jean-Baptiste
72 *Un Médecin*
73 *Un Géomètre*
74 *L'intérieur d'un Cabaret*
75 *Plusieurs Femmes au Bain*
77 *Plusieurs Bambochades sous le même numéro*

Lépicié, Nicolas-Bernard
35 *Le Déjeuner frugal*
36 *La Récréation utile*

Monnet, Charles
173 *Un Enfant en Pierrot*

Ollivier, Michel-Barthélemy
182 *Deux Tableaux représentant des conversations Espagnoles*
183 *Trois Tableaux de même genre que les précédents*
184 *Un Espagnol tenant sa Guitare et écoutant une Femme qui lui parle*
186 *Deux Tableaux: Un Homme avec une bouteille et un verre; un Homme qui joue de la Flûte dans une compagnie de Femmes*

Vallayer-Coster, Anne
142 *Une jeune Arabe, en pied*

1773
Chardin, Jean-Baptiste-Siméon
36 *Une Femme qui tire de l'eau à une fontaine*

Jollain, Nicolas-René
157 *Une Femme allaitant son Enfant*

Le Prince, Jean-Baptiste
48 *Une jeune Fille qui se croit malade consulte un vieux Médecin qui, en lui tâtant le pouls, lui apprend que la maladie est dans son cœur*

Titles under artist are ordered chronologically.

Aubry, Étienne (1745–1781)

1775
L'Amour Paternel
Une Femme qui tire aux cartes
La Bergère des Alpes
Un petit Enfant demandant pardon à sa Mère
1779
Le Mariage rompu
*Deux Époux, allant voir un de leurs enfants en
 nourrice, font embrasser le petit nourrisson par son
 frère aîné*
*Les adieux d'un Villageois et de sa femme au
 nourrisson que le père et la mère leur retirent*
Un Fils repentant de retour à la maison paternelle

Autereau, Louis (1692–1760)

1747
*Une Demoiselle occupée d'une Souricière, montrant un
 Chat*

Bachelier, Jean-Jacques (1724–1806)

1755
Une jeune Fille caressant une Levrette
Un Repos de Chasse
1761
Les Amusements de l'Enfance
1765
Un Enfant endormi

Baudouin, Pierre-Antoine (1723–1769)

1763
Un Prêtre catéchisant des jeunes Filles
1765
Un Confessionnal
Les Enfants Trouvés; dans l'Église de Notre-Dame
Une jeune fille querellée par sa mère
1767
Le Coucher de la Mariée
*Le sentiment de l'Amour et de la Nature cédant pour
 un temps à la nécessité*
1769
Le modèle honnête

Bilcoq, Marie-Marc-Antoine (1755–1838)

1787
Un Philosophe et son Élève dans son cabinet
Un Astronome
L'Instruction villageoise
1789
Un Naturaliste
Un Chimiste dans son Laboratoire
*Jeune Fille réfléchissant sur une lettre et des présents
 qu'elle vient de recevoir*
Un petit Enfant jouant

Boucher, François (1703–1770)

1742
Huit esquisses de différents sujets Chinois
1745
Sujet Pastoral
1750
Deux amants surpris dans les Bleds

Un Berger accordant sa Musette près de sa Bergère
Le Sommeil d'une Bergère
Un Berger qui montre à jouer de la Flûte à sa Bergère
1761
Pastorales
1765
Deux Pastorales
Quatre Pastorales
Autre Pastorale
*Une jeune Femme attachant une lettre au col d'un
 Pigeon*

Boullogne, Bon (1649–1717)

1699
Une jeune fille qui veut rattraper un oiseau envolé
La Diseuse de bonne aventure
Une fille qui cherche les puces à une autre

Bounieu, Michel Honoré (1740–1814)

1769
*Le Portrait d'un enfant endormi sous la garde d'un
 chien*
1771
Une Dame faisant faire son Portrait
Une Laitière
Une Ravaudeuse
1775
Une Marchande de Fleurs
Une Mère engageant sa Fille à prendre une médecine
Une Famille faisant des confitures
Une Marchande d'Oranges
Une Femme et un petit Garçon
Un Charretier et sa Femme
Une petite Fille répétant sa leçon
Une Blanchisseuse de bas de soie
1777
La Pâtisserie Bourgeoise
Une petite Fille à sa toilette
*Une jeune Femme lisant et son Fils reposant sur ses
 genoux*
Amusements de Famille à la campagne
Un Buveur de bière
Une petite Fille faisant cuire un œuf
Lecture du Poème des Fastes, par l'Auteur
Correction de Savetier
Des Enfants jouant avec des chevreaux
1779
*Des Femmes au bord d'un ruisseau se disposent à
 prendre le bain*
"Dors mon Enfant"
Une Femme que l'on saigne au pied
Un Enfant à mi-corps, reposant sur un oreiller

Bouys, André (1656–1740)

1737
Une Servante qui récure de la Vaisselle d'argent
Deux Servantes revenant du marché

Brenet, Nicolas-Guy (1728–1792)

1781
*Jeune Fille habillée à l'Espagnole prenant des fleurs
 dans un vase*

Caresme, Philippe (1734–1796)

1767
Le Repos
L'Amour
Une Mère qui fait jouer son Enfant

1771
*Une vue de Jardin, et sur le devant un Espagnol
 repoussé par une jeune Demoiselle à qui il présente
 un Bouquet*
*Deux petits Tableaux représentant des Buveurs
 Flamands*
1775
*Une Femme jouant de la guitare; deux Hommes
 l'écoutent*
1777
*Une Femme qui chante dans un Jardin; deux Hommes
 l'écoutent*

Casanova, Francesco (1727–1802)

1775
*Un Matin, avec des animaux et plusieurs personnes à
 une Fontaine Une Nuit; sur le devant du Tableau,
 une femme vend des Canards*
Un rendez-vous de chasse
Le retour [de chasse]
Un Cavalier Tartare
Plusieurs Personnes à une Fontaine
Deux Cavaliers

Chardin, Jean-Baptiste-Siméon (1699–1779)

1737
Une Fille tirant de l'eau à une Fontaine
Une petite Femme s'occupant à savonner
Jeune Homme s'amusant avec des cartes
Un Chimiste dans son Laboratoire
Un petit Enfant avec des attributs de l'enfance
Une petite Fille assise, s'amusant avec son déjeuner
Une petite Fille jouant au Volant
1738
Un Garçon Cabaretier qui nettoie son Broc
Une jeune Ouvrière en Tapisserie
Une Récureuse
*Une Ouvrière en Tapisserie qui choisit de la Laine
 dans son panier*
Son Pendant, un jeune Écolier qui dessine
Une Femme occupée à cacheter une Lettre
*Portrait du fils de M. Godefroy, Joaillier, appliqué à
 voir tourner un Toton*
Un jeune Dessinateur taillant son crayon
1739
Une Dame qui prend du Thé
*L'amusement frivole d'un jeune homme faisant des
 bouteilles de savon*
La Gouvernante
La Pourvoyeuse
Les tours de Cartes
La Ratisseuse de Navets
1740
Un Singe qui peint
Le Singe de la Philosophie
La Mère laborieuse
Le Bénédicité
La petite Maîtresse d'École
1741
Le négligé, ou Toilette du matin
*Le Fils de M. Le Noir s'amusant à faire un Château
 de cartes*
1743
Des Enfants qui s'amusent au Jeu de l'Oie
Des Enfants faisant des tours de Cartes

1746
Répétition du Bénédicité, *avec une addition pour faire Pendant à un Teniers*
Amusements de la vie privée
1747
La Garde attentive, ou les aliments de la Convalescence
1748
L'Élève Studieux
1751
Une Dame variant ses Amusements
1753
Un Dessinateur d'après le Mercure de M. Pigalle
Une Jeune Fille qui récite son évangile
Un Philosophe occupé de sa lecture
Un Aveugle
1757
Une Femme qui écure
1759
Un jeune Dessinateur
Une Fille qui travaille en tapisserie
1761
Le Bénédicité
1769
Une Femme qui revient du marché
1773
Une Femme qui tire de l'eau à une fontaine

Chavanne, Pierre Salomon Domenchin de (1673–1744)
1737
Un Amusement champêtre

Chéron, Elisabeth Sophie (1648–1711)
1704
Une fille qui dessine
Deux jeunes filles qui accordent un clavecin
Une Grecque

Christophe, Joseph (1662–1748)
1704
Un retour de chasse
Une chasse aux canards par de jeunes garçons
Un jeu du gage touché
1739
Des Enfants qui jouent à l'herbette
Des Enfants qui ornent un Mouton de guirlandes de fleurs

Colombel, Nicolas (1644–1717)
1704
Deux femmes qui se disposent à entrer dans le bain

Corneille, Michel (1642–1708)
1699
Deux femmes dormant

Cotelle, Jean (1646–1708)
1704
Une petite Bambochade

Courtin, Jacques François (1672–1752)
1737
Une femme regardant deux Serins
Une femme badinant avec un Écureuil
1745
Un jeune homme qui répand des Fleurs sur la gorge d'une Femme

Coypel, Charles-Antoine (1694–1752)
1738
Une jeune Veuve devant son Miroir, oubliant le passé et prenant des arrangements pour l'avenir
Une jeune Asiatique tenant d'une main une Bougie & de l'autre une Lettre qu'elle semble lire avec attention

Dandré-Bardon, Michel-François (1700–1783)
1743
La Naissance
L'Enfance

David, Jacques-Louis (1748–1825)
1781
Une Femme allaitant son enfant

Debucourt, Louis-Philibert (1755–1832)
1781
Le Gentilhomme bienfaisant
L'Instruction Villageoise
Le Juge de Village
La Consultation redoutée
1783
Vue de la Halle, prise à l'instant des réjouissances publiques données par la Ville le 21 Janvier 1782, à l'occasion de la naissance de Monseigneur le Dauphin
Un Charlatan
Deux petites Fêtes
1785
La feinte caresse

Delobel, Nicolas (1693–1763)
1737
Un Tableau de Famille
1738
Des Buveurs
Le Portrait d'une dame avec son enfant jouant de la Serinette

De Lyen, Jean-François (1684–1761)
1740
La Lanterne Magique
1745
Un Buveur sur une Treille

Demarne, Jean-Louis (1744–1829)
1785
Une foire de Franche-Comté
1787
Le Messager fidèle
Une Foire de Franche-Comté
Une Foire des environs de Paris
1789
Le Lever de l'Enfant
Comédiens forains
Marchands de Cantiques
Une Foire
Autre Foire où l'on voit un Homme faisant danser des Marionnettes sur une planche
Le Bon Ménage
Un Curé moralisant ses Paroissiens
Un Guerrier de retour chez lui
Un Marchand de cerises
Un Repos d'animaux où l'on voit une Femme jouant avec un petit garçon
Un Marché au foin
Une Femme qui trait une vache
Un Berger qui joue de la flûte

Descamps, Jean-Baptiste (1706–1791)
1765
Un jeune Dessinateur
Un Élève qui modèle
Une petite fille qui donne à manger à un petit oiseau

Deshayes, Jean-Baptiste-Henri (1729–1765)
1763
Trois Tableaux ovales représentant des Caravanes
Une Caravane

Desportes, François (1661–1743)
1704
Un chasseur qui se repose
Deux chasseurs en différentes attitudes

De Troy, Jean-François (1679–1752)
1725
Deux Cavaliers et deux Dames en habit de masque sont à déjeuner autour d'une table
Une déclaration d'amour
Une Demoiselle un peu courbée, tenant d'une main sa jarretière et de l'autre repoussant un jeune homme qui s'empresse à vouloir la lui renouer
Deux dames et un Cavalier qui jouent au pied-de-bœuf
1737
Un déjeuner de Chasse
Une petite Liseuse
Une toilette de Bal
Un déshabillé de Bal

Doyen, Gabriel-François (1726–1806)
1761
Une jeune Personne occupée à lire une Brochure, ayant son chien sur ses genoux
1779
Une Caravane
Autre Caravane

Drouais, François-Hubert (1727–1775)
1759
Concert champêtre dont les Figures sont des Portraits
1761
Un jeune Élève
1763
Une Petite Fille jouant avec un chat
La petite Nourrice

Dumont, Jacques (Jean) dit le Romain (1701–1781)
1748
Deux Tableaux: Une Savoyarde et un Montagnard
Une Fileuse et son Enfant

Durameau, Louis-Jacques (1733–1796)
1767
Un Joueur de Basson
Une Dormeuse, tenant un Chat

Favray, Antoine (1706–1791)
1763
Une famille Maltaise dans un appartement
Femmes de Malte de différents états, distinguées par la différence des étoffes
Dames Maltaises se faisant visite

Fragonard, Jean-Honoré (1732–1806)
1765
L'absence des pères et mères mise à profit

Geuslain, Charles-Étienne (1685–1765)
1737
Un Marchand de Médailles en habit de Pèlerin

Gobert, Pierre (1662–1744)
1704
Une femme âgée

Greuze, Jean-Baptiste (1725–1805)
1755
L'Aveugle trompé
Un Père de famille qui lit la Bible à ses Enfants
Un Enfant qui s'est endormi sur son Livre
1757
Une Mère grondant un jeune Homme pour avoir renversé un Panier d'Oeufs que sa Servante apporte du Marché
Une jeune Italienne congédiant (avec le Geste Napolitain) un Cavalier Portugais travesti, et reconnu par sa Suivante
La Paresseuse Italienne
Un Oiseleur qui, au retour de la chasse, accorde sa Guitare
Un Matelot Napolitain
Un Écolier qui étudie sa leçon
Italiens qui jouent à la Maure (Esquisse à l'encre de la Chine)
1759
Le Repos caractérisé par une Femme qui impose silence à son fils
La Simplicité représentée par une jeune fille
La Tricoteuse endormie
La Dévideuse
Une jeune Fille qui pleure la mort de son Oiseau
1761
Un Mariage, et l'instant où le père de l'Accordée délivre la dot à son Gendre
Un jeune Berger qui tente le sort pour savoir s'il est aimé de sa Bergère
Une jeune Blanchisseuse
Un Dessin représentant des enfants qui dérobent des Marrons
Un Dessin d'un Paralytique soigné par sa famille
Un Dessin d'un Fermier brûlé, demandant l'aumône avec sa famille
1763
Une petite Fille lisant la Croix de Jésus
Le Tendre Ressouvenir
Une jeune Fille qui a cassé son miroir
La Piété filiale
1765
Une jeune fille qui pleure son oiseau mort
L'Enfant gâté
La Mère bien-aimée (Esquisse)
Le Fils ingrat (Esquisse)
Le Fils puni (Esquisse)
1769
La Mère bien-aimée, caressée par ses Enfants
Un jeune Enfant qui joue avec un Chien
La mort d'un Père de famille, regretté par ses enfants (dessin)
La mort d'un Père dénaturé, abandonné de ses Enfants (dessin)
L'Avare et ses Enfants (dessin)
La Bénédiction paternelle (dessin)
Le départ de Barcelonnette (dessin)
La Consolation de la Vieillesse (dessin)

Guérin, François (fl. 1754–1791)
1769
Un Concert
Un jeune homme qui converse avec une jeune Demoiselle sur les Sciences
1777
Un Concert
Des Joueuses de Dominos
1783
Un Enfant qui ne sait pas sa leçon
Le Maître de Harpe
Deux petits Tableaux à la gouache représentant des Voyageurs

Hallé, Noël (1711–1781)
1753
Une Savoyarde
1757
Une Savoyarde
1761
Deux Pastorales
Une Dame qui dessine à l'encre de la Chine
Une Femme qui amuse son enfant avec un moulin à vent
1765
L'Éducation des Riches
L'Éducation des Pauvres

Huet, Jean-Baptiste-Marie (1745–1811)
1769
Une Caravane
1771
Un Repos de Chasse
La Fermière
Une Caravane
1775
La Pêche
La Fermière
Le Marché
Le Retour du Marché
Le Repos
La Solitude
1777
Marché
Une Fermière donnant à manger à ses poulets

Huilliot, Pierre-Nicolas (1674–1751)
1746
Un Usurier et deux Voleurs qui épient le moment de le voler
Une vieille Hollandaise pesant son or au Trébuchet

Hutin, Charles-François (1715–1776)
1769
Deux Servantes Saxonnes

Jeaurat, Étienne (1699–1789)
1739
Un jeune garçon qui jette de l'eau par la fenêtre avec une petite seringue
Un jeune homme qui jette des noyaux de Cerises par une fenêtre
1745
L'Accouchée
La Relevée
Le Goutteux
1753
Une noce de Village
Deux Savoyards

Une Femme qui épluche de la salade
La Place Maubert
Une Foire de Village
1755
L'Atelier d'un Peintre
Un Enlèvement de Police
Un Déménagement
1757
Le Carnaval des rues de Paris
La Conduite des Filles de Joie à la Salpêtrière
Les Écosseuses de Pois de la Halle
Un Inventaire du Pont Saint-Michel. Sujet tiré du Poème de la Pipe Cassée, de Vadé
1759
Un Émir conversant avec son Ami
Des femmes qui s'occupent dans le Sérail et prennent leur café
Une Pastorale
Un Jardinier et une Jardinière
1763
Un Peintre chez lui faisant le portrait d'une jeune Dame
Les Citrons de Javotte. Sujet tiré d'un petit ouvrage en vers de M. Vadé
1769
Un Pressoir de Bourgogne
Une veillée de Paysannes du même Canton
Une Femme convalescente

Jollain, Nicolas-René (1732–1804)
1773
Une Femme allaitant son Enfant
1781
Une petite Fille avec son Chat

Juliard, Nicolas-Jacques (1715–1790)
1781
Une Fête de Village

Lagrenée, Louis-Jean-François (1724–1805)
1755
Deux petits tableaux sous le même numéro. L'un une jeune Fille tenant un papier de musique; l'autre, une Fille qui caresse un pigeon

Lajoüe, Jacques de (1687–1761)
1737
Un retour de Chasse
1738
Concert Champêtre
Repos de Chasse
1742
Une Personne qui travaille à son Bureau, et le Fils de l'Auteur appuyé sur un Fauteuil
1746
Une Dame à sa Toilette, dans un appartement richement décoré
Son Pendant, Une Galerie d'où l'on voit des Jardins
Une extrémité de Jardin avec une Cascade: Une Dame est assise sur l'appui d'un Escalier, un jeune Homme auprès d'elle

Lancret, Nicolas (1690–1743)
1725
Un Bal dans un Paysage orné d'Architecture
Retour de Chasse
Bain de Femmes. Vue de la Porte Saint-Bernard
Danse dans un paysage

1737
Un Festin de Noces de Village
Une Danse au Tambourin
Un Colin-Maillard
Un Sujet Champêtre
1738
Danse champêtre
Concert champêtre
1739
Une Dame à sa toilette, prenant du Café
Un paysage où est un Berger tenant une cage
Des Enfants qui jouent au pied-de-bœuf
1740
Danse champêtre
1742
Une Dame dans un Jardin, prenant du Café avec des Enfants

Le Barbier, Jean-Jacques-François (1738–1826)
1781
Un Canadien et sa femme pleurant sur le tombeau de leur enfant
Un Enfant jouant avec des raisins

Leclerc, Sébastien (1676–1763)
1751
Des Enfants qui font un Concert
Des Enfants jouant une Scène de l'Opéra d'Armide

Le Lorrain, Louis-Joseph (1715–1759)
1755
Une jeune Personne en habit de masque

Lenoir, Simon-Bernard (1729–1791)
1779
Un jeune Écolier mangeant des raisins

Lépicié, Nicolas-Bernard (1735–1784)
1767
Un Tableau de Famille
1771
Le Déjeuner frugal
La Récréation utile
1773
La Vigilance Domestique
La Politesse intéressée
Le Chien obéissant
Le Voyageur de campagne
Le petit Dessinateur
L'Élève curieux
1775
L'Atelier d'un Menuisier
Les Accords
L'Intérieur d'une Douane
1779
Le Jardinier de bonne humeur
1781
Départ d'un Braconnier
Un Vieillard lisant
Le Jeu de la Fossette
Le Jeu de Cartes
1783
La Paysanne revenant du bois
Le Vieillard Voyageur
Un Enfant au milieu des amusements de son âge
Le Déjeuner des Élèves
Le Petit Indigent

Le Prince, Jean-Baptiste (1733–1781)
1765
Pastorale Russe
La Pêche aux environs de Saint-Pétersbourg
Quelques Paysans se disposent à passer un Bac
Une Halte de Tartares
Manière de voyager en hiver, avec la construction du traîneau dont on se sert
Une halte de Paysans en Été
Le Berceau pour les Enfants
L'intérieur d'une chambre de Paysan
1767
Une jeune Fille orne de fleurs son Berger, pour prix de ses Chansons
On ne peut pas penser à tout
La Bonne Aventure
Le Berceau, ou le réveil des petits Enfants
L'Oiseau retrouvé
Le Musicien champêtre
Une Fille charge une Vieille de remettre une Lettre
Un jeune Homme qui récompense le zèle de la Vieille en lui donnant une pièce d'or
Une jeune Fille endormie, surprise par son Père et sa Mère
La Bonne Aventure
Le Concert
Le Cabak, espèce de Guinguette aux environs de Moscou
1769
Un Cabak, ou espèce de Guinguette des environs de Moscou
Une Russe jouant de la Guitare
Un Drogman du Roi de France
Une Danse Russe
Une Balançoire à la manière des Russes
1771
Un Médecin
Un Géomètre
L'intérieur d'un Cabaret
Plusieurs Femmes au Bain
Plusieurs Bambochades sous le même numéro
1773
Une jeune Fille qui se croit malade consulte un vieux Médecin qui, en lui tâtant le pouls, lui apprend que la maladie est dans son cœur
Une jeune Femme fait essayer à son Époux des lunettes qu'un jeune Marchand vient lui offrir
Une Femme qui, en donnant à téter à son Enfant, écoute une vieille qui fait une lecture
Un Homme, au cabaret, présente de l'argent à une jeune Fille
Une Femme se reposant sur un canapé
Une Femme endormie qu'un jeune Homme veut éveiller au son de sa guitare
Une Mère, ayant surpris une cassette qui renfermait un Portrait, des Lettres et des Bijoux, fait les plus vifs reproches à sa Fille qui, malgré l'apparence de son repentir, reçoit encore une Lettre qu'une Servante lui donne en cachette; le Père cherche à lire les sentiments de sa Fille dans ses yeux, tandis que la Grand-mère lit une de ces Lettres
Un Peintre commence, d'après nature, un Tableau
Une Femme Asiatique méditant sur sa lecture
Un Vieillard tenant une cruche & une pipe

1775
Un Avare
Un Jaloux
Un Nécromancien
L'Extérieur d'un Cabaret de Village
Des Voyageurs attendent un Bac
Une Danse de Paysans
1777
La crainte
Un Corps de garde
Une Moisson, à l'instant du repas des Moissonneurs
Une Fête de Village
1779
Un Marché Asiatique
L'extérieur d'un Cabaret
Des Joueurs de Boules
Des Joueurs de Petit palet
Des Marionnettes
Une Auberge
Un Cabaretier avertit un Cavalier que son cheval est prêt
1781
Joueurs de Boules

Le Sueur, Pierre (fl. 1739–1786)
1746
Portrait d'un Joueur de Vielle

Levrac-Tournières, Robert (1667–1752)
1745
Une Dame déguisée en Paysanne et son Fils badinant avec un Perroquet

Loutherbourg, Philipp Jakob (1698–1768)
1765
Rendez-vous de Chasse de S.A.S. Mgr le Prince de Condé
Une Caravane
Des Voleurs attaquant des Voyageurs dans une gorge de montagne
Ces mêmes Voleurs pris et conduits par des Cavaliers
1779
Port de Mer où l'on voit un embarquement

Manglard, Adrien (1695–1760)
1739
Des Enfants qui vont coucher un Chat et d'autres qui mettent des petits Bateaux de cartes sur l'eau
Un Enfant sur un petit Cheval de carton avec des roulettes, promené par ses Camarades, et d'autres qui jouent avec une Poupée

Marot, François (1666–1719)
1704
Une joueuse de Luth
Une Dame à qui l'on présente du Café

Martin, Guillaume (1737–1800)
1773
Une troupe de Bandits fait halte dans des ruines; ils sont aperçus par une jeune femme qui, accompagnée de ses enfants et de sa mère, leur demande la charité
1775
Une Famille Espagnole
1777
Une Femme qui lit, éclairée à la lampe
Éducation d'une jeune Fille par sa Mère

Monnet, Charles (1732–1808?)
1771
Un Enfant en Pierrot

Mosnier, Jean-Laurent (1743–1808)
1789
Une Femme avec une petite Fille
Une jeune Personne méditant sur une lecture

Ollivier, Michel-Barthélemy (1712–1784)
1767
Famille Espagnole jouant avec des Enfants dans un
* Jardin*
1769
Conversations, ou Promenades champêtres, deux
* Tableaux*
1771
Les conversations Espagnoles, deux Tableaux
Les conversations Espagnoles, trois Tableaux
Un Espagnol tenant sa Guitare et écoutant une
* Femme qui lui parle*
Un Homme avec une bouteille et un verre
Un Homme qui joue de la Flûte dans une compagnie
* de Femmes*
1777
Le Thé à l'Anglaise dans le Salon des quatre Glaces au
* Temple, avec toute la Cour du Prince de Conti*

Oudry, Jean-Baptiste (1686–1755)
1750
Paysage représentant des Légumes et un Jardinier qui
* tire de l'eau à une Pompe, peint à Beauvais*
1751
Un Tableau dans le genre Flamand fait pour le
* Cabinet de Monseigneur le Dauphin*
1753
Chienne allaitant ses petits

Pierre, Jean-Baptiste-Marie (1713–1789)
1741
Une Maîtresse d'École
Une petite Bambochade
1743
Bambochade représentant un Voyage
Plus petite Bambochade représentant des Paysans
1745
Une Marmotte avec plusieurs Enfants
Une Bambochade représentant une Ferme
Une Autre faisant Pendant, Un Marché à la porte de
* Tivoli*
Une Danse champêtre
Un sujet de Soldats
Un Vieux et une jeune Femme
1746
Bambochade: Un Port de Mer
Bambochade: Un Marché
Une ferme
Une Fontaine
1748
Bambochade: Paysans qui se baignent
Bambochade: Une Fête dans un Camp

Poitreau, Étienne (1693–1767)
1745
Fête champêtre auprès d'une Fontaine

Portail, André (1695–1759)
1759
Un Dessin représentant Une Dame qui lit

Robert, Hubert (1733–1808)
1767
Cuisine Italienne
Écurie et Magasin à foin peints d'après nature, à
* Rome*
1773
Une petite fille récitant sa leçon devant sa Mère
Un Enfant que sa Bonne fait déjeuner
1775
Le Décintrement du Pont de Neuilly
1779
Une Pêche sur un canal couvert d'un brouillard
Un grand jet d'Eau dans des Jardins d'Italie: on voit,
* sur le devant du Tableau, des Femmes qui jouent à*
* la main chaude*
Une partie de la Cour du Capitole ornée de Musiciens
* ambulants près d'une Fontaine*
1781
L'incendie de l'Opéra
L'intérieur de la Salle, le lendemain de l'incendie
1787
L'intérieur de l'Église des Saints-Innocents, dans le
* commencement de sa construction*
Un Dessin colorié: deux jeunes femmes qui dessinent
* dans les ruines de Rome*
Un jeune homme voulant cueillir des fleurs au haut
* d'un monument ruiné*
Une Marchande de bouquets vendant ses fleurs sur le
* Tombeau de Titus*

Roslin, Alexandre (1718–1793)
1765
Un Père arrivant dans sa terre, où il est reçu par ses
* enfants dont il était tendrement aimé*
1785
Une Dame debout, en satin blanc, devant une glace,
* pour y achever sa toilette*

Schuppen, Jacques Van (1670–1751)
1704
Un retour de chasse du Roi d'Angleterre
Une joueuse de Guitare
Une femme lisant une lettre
Une fille sur une escarpolette

Taraval, Hugues (1729–1785)
1765
Une Génoise dormant sur son Ouvrage. On y voit un
* Éventail à l'Italienne*
1767
Une jeune Fille agaçant son Chien devant un miroir
1775
Un Moissonneur à qui sa femme fait présenter par son
* fils un repas frugal*
Un jeune Berger excitant son Chien à rassembler le
* Troupeau*
1779
Un Médecin d'urine
Un Souffleur ou Chimiste

Terbouche (Lisiewski), Anna Dorothea (1721–1782)
1767
Un Homme tenant un verre de vin, éclairé d'une
* bougie*

Théaulon, Étienne (1739–1780)
1775
Une jeune Fille sur un lit en désordre, un jeune
* homme lui demande pardon de lui avoir arraché*
* un bouquet de roses qu'on voit éparpillées à ses pieds*
L'Heureux Ménage
La Bonne Aventure
1777
La Mère sévère
Les œufs cassés
Une jeune Femme occupée à blanchir; sa mère fait
* manger la soupe à l'enfant qui, n'en voulant point*
* d'abord, jette des cris; croyant qu'elle la donne au*
* mouton, il s'en empare*
Une jeune femme faisant de la bouillie pour son
* enfant*

Ubelesqui, Alexandre (1649–1718)
1699
Une Vieille qui porte un billet à une jeune fille qui
* joue de la viole*
Une femme qui joue du tambour de basque

Vallayer-Coster, Anne (1744–1818)
1771
Une jeune Arabe, en pied
1777
Une jeune Femme, avec un Enfant sur ses genoux, qui
* lui offre des fleurs*
Une jeune Fille qui vient de recevoir une lettre
Une jeune Personne montrant à son Amie la statue de
* l'Amour*
1783
Un Enfant tenant d'une main un pigeon, de l'autre
* une cerise*
Une jeune Cuisinière qui écorche une anguille
Une Marchande de marée
Une Marchande de fleurs
1789
Un Enfant qui fait des châteaux de cartes

Van Loo, Charles-Amédée-Philippe (1718–1795)
1775
La Toilette d'une Sultane
La Sultane servie par des Eunuques noirs et des
* Eunuques blancs*
La Sultane commande des ouvrages aux Odalisques
Fête champêtre donnée par les Odalisques, en présence
* du Sultan et de la Sultane*

Van Loo, Charles-André dit Carle (1705–1765)
1737
Un déjeuner de Chasse
Le Grand Seigneur donnant un Concert à sa Maîtresse
Le Grand Seigneur qui fait peindre sa Maîtresse
1755
Deux Sultanes travaillant en Tapisserie
Une Sultane prenant le Café que lui présente une
* Négresse*
Une Conversation
1757
Une Femme qui prend du Café
Une Femme qui lit
Une Femme endormie
1761
Une Lecture
Deux Tableaux représentant des jeux d'Enfants

Van Loo, Jules-César-Denis (1743–1821)

1785

*Un Orage, avec une Femme qui couvre son Enfant
 pour le garantir de la pluie*

*Un clair de Lune avec un groupe de Figures occupées à
 se chauffer*

1787

*Un Vieillard disant la bonne aventure à deux jeunes
 filles occupées à faire des Couronnes de fleurs*

Des Paysans soupant au clair de lune

*Une Grotte où l'on voit des femmes & des enfants qui
 viennent de se baigner*

Van Loo, Louis-Michel (1707–1771)

1769

Une Allemande jouant de la Harpe

Une Espagnole jouant de la Guitare

Vernet, Claude-Joseph (1714–1789)

1763

La Bergère des Alpes, sujet tiré des Contes Moraux *de
 M. Marmontel*

1775

La construction d'un grand chemin

Les abords d'une foire

Vestier, Antoine (1740–1824)

1787

Un Enfant tenant en sa main un tambour de basque

1789

*Une jeune Personne occupée à dessiner la tête de Vénus
 tandis qu'un Enfant, appuyé sur son bras, s'efforce
 de voir un chat qui joue avec les cordons du
 portefeuille*

*Une jeune Personne en chemise de gaze, jouant de la
 guitare, ayant auprès d'elle un Enfant qui retourne
 un feuillet de son cahier de Musique*

Petit Écolier appuyé sur son livre

Vincent, François-André (1746–1816)

1777

*Un jeune Homme donnant une leçon de Dessin à une
 Demoiselle*

Wertmüller, Adolf Uri (1751–1811)

1787

Un Enfant jouant avec un chien

Wille, Pierre-Alexandre (1748–1821)

1775

Une Danse Villageoise

1777

L'Aumône

*Fête des bonnes Gens, ou récompense de la Sagesse et
 de la Vertu*

Le Devoir filial

Le repos du bon Père

Repas villageois

Des Joueurs de Cartes

Deux Buveurs

Une Dame reçoit une lettre qui l'afflige

1779

Le Seigneur indulgent et le Braconnier

Une jeune Dame lisant une lettre

Un Juif Polonais

*Des Dames de la Ville allant boire du lait à la
 Campagne*

1781

La double récompense du mérite

1783

Les Étrennes de Julie

Les Délices maternelles

1785

Les derniers moments d'une épouse chérie

Les Chanteurs Ultramontains

Intérieur d'un ménage

Photograph Credits

Photographs have been provided by the owners or custodians of the works reproduced, except for the following:

Index

Page numbers in *italics* refer to illustrations